P9-AFZ-539

MEET ME IN THE BATHROOM

View of Lower Manhattan after sunset, circa 2000.

MEET ME
IN THE
BATHROOM

REBIRTH AND ROCK AND ROLL
IN NEW YORK CITY

2001–2011

LIZZY GOODMAN

DEY ST.
An Imprint of WILLIAM MORROW

HarperCollins books may be purchased for educational, business, or sales promotional use. For information please e-mail the Special Markets Department at SPsales@harpercollins.com.

FIRST EDITION

Designed by Michelle Crowe
Textures by Larysa Ray, Azuzl, Kasha Malasha, Nik Merkulov/Shutterstock, Inc.

Library of Congress Cataloging-in-Publication Data has been applied for.

ISBN 978-0-06-223309-7

18 19 20 21 ID/LSC 10 9 8

FOR MARC

CONTENTS

Cast of Characters ix

Introduction: "Youth and Abandon" xiv

PART I: NOSTALGIA FOR AN HOUR AGO

1. "The Place Where Anything Can Happen" 3
2. New York Bands Aren't Cool 7
3. "A Sad Day for the Parents" 13
4. "They Looked Like These Preppy Kids on Acid" 23
5. "Alcohol, Blow, Crack, Death" 29
6. "A Bunch of Little Bands Starting to Creep Up" 39
7. "Ain't Nobody Here for Bottle Service" 43
8. Dance Music Will Save Us All? 47
9. "That Was Really the Birth of DFA" 51
10. "Tomorrow Never Knows" 63
11. "Nobody Was Going to Get Paid. Nobody Was Getting Any Cash." 67
12. "What's the Value of Being a Band?" 75
13. This Whole Web Thing 81
14. "I Mean, We Were Just Stoned" 85
15. Cabs Won't Even Go There 93
16. "They Got Signed for How Much Money?!" 101

PART II: THE CLASS OF 2001

17. "Those Guys All Go So Far Back" 109
18. Some Pretty Good Musical Chemistry 119
19. Like a Gang 123
20. A Girl That Sings Quiet Folk Songs 137
21. The Freak-Folk Fringe 141
22. "The Return of the Rock Stars" 147
23. "Shit, I'll Be in *That* Band" 155
24. Anarchy in the UK 159
25. "Party in a Bag" 165
26. "I Don't Know Who Was Paying for the Drugs. It Wasn't Me." 169
27. "Just Trust Me" 175
28. "British People Are Crazy" 183

29. All Eyes on NYC 191
30. September 11, 2001 197
31. "That Now-Legendary Halloween Strokes Show at Hammerstein" 209
32. "Is Anybody Outside of New York Talking About This?" 213
33. "Cats Started to Get Out of the Bag" 219
34. "It's Our Time . . ." 229
35. "Troubled Souls" 239
36. La Zona Rosa 245
37. "That *$2 Bill* Show . . . Oof" 251
38. "My New York Is Interpol" 259
39. "We Successfully Managed to Make Our Business
 100 Percent Impractical" 263
40. "We Got Away with Murder" 271
41. "House of Jealous Lovers" 275
42. "Losing My Edge" 285
43. "Maps" 293
44. "A Thing That Doesn't Work but Does" 299
45. The Uncool Kids 307
46. "You Could Say We Had No Rules" 317
47. Strokes Versus Stripes 325
48. "I Like This Internet Thing" 335
49. Rock Is Back? 345
50. "Taking All Our Britpop Tricks and Selling Them Back to Us" 353
51. "These Guys Are Going to Be Bigger than Everybody" 361

PART III: THE NEW GLOBAL UNDERGROUND

52. The End of One Era, the Beginning of Another 373
53. "The Famous-as-Fuck Strokes" 377
54. "A Hi-Hat Is Like Working with a Cellar of Exotic Wines" 385
55. "Heroin Just Kind of . . . Crosses a Line" 389
56. "If You Believed What You Read, Williamsburg Was the New Village" 397
57. *Soviet Kitsch* 403
58. The Southern Strokes 405
59. The Columbia Hotel 415
60. "I'm Only Sixteen and I've Already Had Crabs Three Times" 419
61. The James Murphy Show 427
62. *Room on Fire* 433
63. "There's Definitely Some Bad Feelings There" 439
64. *The Wrestler* 443

65. "So People in Their Forties in Boston Are Listening to Interpol!" 447
66. "The Internet Rules, Fuck It" 453
67. Disneyfication 459
68. "When the President Talks to God" 465
69. "We Were All Starring in Our Own Nightlife Type of Reality TV" 471

PART IV: BIRTH OF BROOKLYN

70. "Record Collection Rock" 483
71. "There Is a Lot of Confrontation but I Think It Does Come Back to Faith" 487
72. "The Creative Process, While It Can Definitely Reward the Ego,
 It Can Fucking Bruise It, Too" 495
73. Selling Out Is So Passé 501
74. "We Could Be That Big" 513
75. "Breezier and Lighter and Quicker" 527
76. "Erudite as Fuck" 533
77. "They Came from the Ashes of Jonathan Fire*Eater" 539
78. "It Doesn't Actually Make Any Sense to Describe Music as Preppy" 543
79. "It Wasn't Like We Were a Party Band" 547
80. Halsey House 551
81. The Speed of Buzz 559
82. "I *Wanted* to Get in There Like a Motherfucker and That's What I Did" 563
83. Consider Yourself Served 567
84. "When My Mojo Phase Has Passed, I Don't Think That I'll Stop
 Making Music and Start Gardening" 571
85. "We Warmed It Up for You Fuckers" 577

PART V: "NEW YORK, I LOVE YOU BUT YOU'RE BRINGING ME DOWN"

86. "I Mean, What's More Rock and Roll than Madison Square Garden
 and a Mic Drop?" 587
87. The Last Rock Stars 589

Acknowledgments 592

Index 597

CAST OF CHARACTERS

RYAN ADAMS: musician
TUNDE ADEBIMPE: cofounder, TV on the Radio
ASIF AHMED: manager, Yeah Yeah Yeahs, TV on the Radio, Liars, the Rapture
IMRAN AHMED: journalist
PELLE ALMQVIST: front man, the Hives
SUROOSH ALVI: founder, Vice Media
ANGUS ANDREW: front man, the Liars
CHRIS BAIO: bassist, Vampire Weekend
PAUL BANKS: front man, Interpol
CARL BARÂT: front man, the Libertines; front man, Dirty Pretty Things
JAMES BARBER: former A & R executive, Geffen; producer, Ryan Adams
JASON BARON: founder, the Darkroom
ROSTAM BATMANGLIJ: multi-instrumentalist, Vampire Weekend
PETE BAUER: multi-instrumentalist, Jonathan Fire*Eater, the Walkmen
LAURENCE BELL: founder, Domino Recording Company
MATT BERNINGER: front man, the National
NILS BERNSTEIN: publicist, Matador Records
BEN BLACKWELL: manager, Third Man Records
J. P. BOWERSOCK: guitar teacher, Julian Casablancas and Albert Hammond Jr.
TYLER BRODIE: cofounder, DFA Records
JALEEL BUNTON: drummer, TV on the Radio
KAREEM BUNTON: bassist, the Pleasure Unit
DAVE BURTON: tour manager, Yeah Yeah Yeahs
DENNIS CAHLO: front man, the Realistics
JULIAN CASABLANCAS: front man, the Strokes
BRIAN CHASE: drummer, Yeah Yeah Yeahs
SHAWN CHRISTENSEN: front man, Stellastarr*
BJORN COPELAND: guitarist, Black Dice
GERARD COSLOY: cofounder, Matador Records
DAVID CROSS: comedian
JUSTINE D: DJ, Motherfucker, Tiswas
KIMYA DAWSON: front woman, the Moldy Peaches
AMANDA DE CADENET: TV presenter, photographer

AARON DESSNER: multi-instrumentalist, the National
SCOTT DEVENDORF: multi-instrumentalist, the National
ED DROSTE: front man, Grizzly Bear
WALTER DURKACZ: manager, Jonathan Fire*Eater
JENNY ELISCU: journalist
RENNIE ELLIOTT: drummer, Yeah Yeah Yeahs
JAMES ENDEACOTT: A & R executive, Rough Trade Records
JOHANNA FATEMAN: multi-instrumentalist, Le Tigre
CRAIG FINN: front man, the Hold Steady
WARREN FISCHER: cofounder, Fischerspooner
BRANDON FLOWERS: front man, the Killers
SAM FOGARINO: drummer, Interpol
CALEB FOLLOWILL: front man, Kings of Leon
NATHAN FOLLOWILL: drummer, Kings of Leon
NIKOLAI FRAITURE: bassist, the Strokes
ELEANOR FRIEDBERGER: cofounder, the Fiery Furnaces
JONATHAN GALKIN: cofounder and label manager, DFA Records
RYAN GENTLES: manager, the Strokes
JEN GOLDSWORTHY: former fashion executive and partner to Tim Goldsworthy
TIM GOLDSWORTHY: cofounder, DFA Records; half of production duo the DFA
JIMI GOODWIN: front man, Doves
JASON GORDON: blogger
KIM GORDON: cofounder, Sonic Youth
DAVE GOTTLIEB: former product manager, RCA
ADAM GREEN: front man, the Moldy Peaches
ISAAC GREEN: founder, Star Time International
ANDY GREENWALD: journalist
JAMES HABACKER: owner, the Slipper Room
ALBERT HAMMOND JR.: guitarist, the Strokes
JOHN HEILEMANN: journalist
MATT HICKEY: booker, the Mercury Lounge
JAMIE HINCE: guitarist, the Kills
MICHAEL HIRSCHORN: journalist
DAVID HOLMES: DJ; recording artist
SAMMY JAMES JR.: front man, the Mooney Suzuki
LUKE JENNER: front man, the Rapture

ETHAN JOHNS: record producer, Ryan Adams, Kings of Leon
CHRISTIAN JOY: costume designer, Karen O
DAVE KAPLAN: booker, the White Stripes
ALEX KAPRANOS: front man, Franz Ferdinand
PETER KATIS: producer, Interpol and the National
DOMINIQUE KEEGAN: DJ; cofounder, Plant Records; cofounder, Plant Bar
DANIEL KESSLER: guitarist, Interpol
KELLY KILEY: manager, Rough Trade Records
EZRA KOENIG: front man, Vampire Weekend
GREG KRELENSTEIN: DJ; cofounder, the Misshapes
NIC OFFER: front man, !!!
MARCUS LAMBKIN: DJ; cofounder, Plant Records; front man, Shit Robot
SCOTT LAPATINE: blogger, Stereogum
JEANNETTE LEE: cofounder, Rough Trade Records
JOE LEVY: journalist
SARAH LEWITINN: journalist, blogger, DJ
LEIGH LEZARK: DJ; model; cofounder, the Misshapes
ALAN LIGHT: journalist
ZACK LIPEZ: front man, the Candy Darlings
CHRIS LOMBARDI: cofounder, Matador Records
APRIL LONG: journalist
BRIAN LONG: former A & R executive, Geffen, MCA Records
DAVE LONGSTRETH: front man, Dirty Projectors
STEWART LUPTON: front man, Jonathan Fire*Eater
LESLIE LYONS: photographer
JUAN MACLEAN: front man, the Juan MacLean
JESSE MALIN: musician
NICK MARC: DJ, Motherfucker, Tiswas
MARC MARON: comedian
PAUL MAROON: multi-instrumentalist, Jonathan Fire*Eater, the Walkmen
WALTER MARTIN: multi-instrumentalist, Jonathan Fire*Eater, the Walkmen
PATRICK MATTHEWS: guitarist, the Vines
CONOR McNICHOLAS: journalist
JIM MERLIS: cofounder, Big Hassle Media; publicist, the Strokes
SIA MICHEL: journalist
MOBY: DJ; musician
FABRIZIO MORETTI: drummer, the Strokes

ALISON MOSSHART: front woman, the Kills

PHIL MOSSMAN: guitarist, LCD Soundsystem

JAMES MURPHY: cofounder, DFA Records; half of production duo the DFA; front man, LCD Soundsystem

AUDREY NEUSTADTER: blogger

GEORDON NICOL: DJ, cofounder, the Misshapes

ERIN NORRIS: publicist, Jonathan Fire*Eater

KAREN O: front woman, Yeah Yeah Yeahs

CONOR OBERST: front man, Bright Eyes, Desaparecidos

KELE OKEREKE: front man, Bloc Party

THOMAS ONORATO: doorman, Motherfucker, Tiswas, Misshapes

DAN OZZI: journalist

TODD P: promoter

JENNY PENNY: scenemaker

TRACEY PEPPER: journalist

CATHERINE PIERCE: front woman, the Pierces

MATT PINFIELD: VJ, A & R scout

KID CONGO POWERS: musician

STEVE RALBOVSKY: executive, RCA Records

GORDON RAPHAEL: producer, the Strokes, Regina Spektor, the Libertines

SIMON REYNOLDS: journalist

VITO ROCCOFORTE: drummer, the Rapture

MATT ROMANO: drum tech, the Strokes; drummer, Albert Hammond Jr.

TRICIA ROMANO: journalist

MARK RONSON: DJ, producer

ANTHONY ROSSOMANDO: guitarist, Damn Personals, Dirty Pretty Things

KAREN RUTTNER: publicist, manager, DJ

RZA: cofounder, Wu-Tang Clan

AUSTIN SCAGGS: journalist

STEVE SCHILTZ: front man, Longwave

RYAN SCHREIBER: journalist; founder, *Pitchfork*

ROB SHEFFIELD: journalist

DAVE SITEK: cofounder, TV on the Radio; producer, Yeah Yeah Yeahs, Liars

REGINA SPEKTOR: musician

JON SPENCER: front man, the Jon Spencer Blues Explosion

MARC SPITZ: journalist

CASEY SPOONER: cofounder, Fischerspooner

HAR MAR SUPERSTAR: musician
CARL SWANSON: journalist
CHRIS TAYLOR: multi-instrumentalist, Grizzly Bear
KIM TAYLOR BENNETT: journalist
LARRY TEE: manager, Fischerspooner; founder, Berliniamsburg
CHRIS TOMSON: drummer, Vampire Weekend
STEVEN TRACHTENBROIT: publicist, Big Hassle Media
GEOFF TRAVIS: founder, Rough Trade Records
NICK VALENSI: guitarist, the Strokes
RONNIE VANNUCCI: drummer, the Killers
ANDREW VANWYNGARDEN: front man, MGMT
ALEX WAGNER: journalist
RUFUS WAINWRIGHT: musician
CHLOE WALSH: publicist, Conor Oberst, the White Stripes
RUSSELL WARBY: UK booker, the Strokes, the White Stripes
DEAN WAREHAM: front man, Luna
JACK WHITE: front man, the White Stripes
GIDEON YAGO: journalist
LAURA YOUNG: blogger
NICK ZINNER: guitarist, Yeah Yeah Yeahs

Introduction

"YOUTH AND ABANDON"

When I was a teenager growing up in Albuquerque, New Mexico, I had a cutout of the New York City skyline on the ceiling above my bed. In the same way that you sometimes buy a dress as a reminder to become the person who would wear it, the image of all those anonymous buildings lit up at night was a visual placeholder for my future self.

New York, to paraphrase Bob Dylan, was where I was from, I just hadn't gotten there yet.

My first year in the city was 1999, the summer after my freshman year of college. The plan was to revel in not having a plan. For eighteen years I'd been at soccer practice or doing homework or emptying the dishwasher. Now, for the first time in my life, I had a stretch of totally unplanned, totally unstructured solitude before me. All I needed was a job. So early one June morning, I took my first solo subway ride down to the bottom of Soho. As I made my way north, increasingly drunk on the wine bemused old-school restaurant managers had poured me while they looked over my résumé full of babysitting jobs, I played on my Walkman a mix made for me by a guy I'd met at school that year. It featured songs by bands I'd never heard of: "Lost in the Supermarket" by the Clash, "Why Can't I Touch It" by the Buzzcocks, "Blank Generation" by Richard Hell, "Marquee Moon" by Television.

That's what was buzzing in my ears when I walked into the place that eventually hired me, a café called Pershing Square. It's what was in my ears in the afternoons, as I took the bus across Twenty-Third Street to get the A train to High Street in Brooklyn

to hostess at Pershing Square's sister restaurant, the River Café. And it was the sound reverberating as I hitched a ride late at night back to Manhattan on the maître d's motorcycle. He often dropped me off at this restaurant on Park Avenue, not far from where Max's Kansas City had been, to meet a guy I knew from work, Nick Valensi, who played in a band called the Strokes, because the singer, Julian Casablancas, bartended there.

When you ask people whose art has gone on to matter to millions what it was like to be there *in the beginning,* they'll often tell you there was nothing mythical or portentous about it at all. It was just the way life unfolded. James Murphy was a frustrated indie sound guy with a wallet chain, looking for someone he could really talk music with when he met Tim Goldsworthy. Karen O had to do something to stave off depression during winter term at Oberlin, so she decided to learn guitar. Julian was the kid Nick noticed on the first day at a new school because he was wearing an old uniform from a different school.

To me, Nick was the boy I bummed sticks of Big Red from at work. A lanky city kid who wore girls' jeans from the Gap and cheated off me during wine tests they'd make us take at the restaurant. *Pinot noir is a grape; Champagne is a region.* We'd be at Pershing Square until early afternoon then hang out for a few hours, wandering around Midtown and ducking behind pillars in office plazas to take turns off his one-hitter before I went to hostess and he went to practice. From Nick I learned to play the city like a video game: always keep moving, score points for knowing that diner on south Broadway has killer pea soup or that bar on St. Mark's doesn't card on Wednesdays or that one pool hall on Houston has Monster Bash pinball and stays open twenty-four hours. Every choice, from what you wear to how you walk to which street you turn down next is a potential portal to another level, to a part of the game you haven't even seen yet, to the unimaginable.

———

After that summer, I went back to college, studied romantic poetry, and wrote a thesis on the *Iliad*. Nick dropped out and played *SNL*.

It was a time that felt dizzying, though it turned out to be the calm before the many storms of the new millennium. September 11. Then came the frenetic remaking of New York, and all the weird new phenomena of the rising twenty-first century: the Internet, the iPod, Facebook and Twitter, the colonization of Brooklyn.

In the late nineties, in the couple-year period before all these changes really began, the music scene in New York had a giddy feel to it. We sensed something important had been unleashed, even if it was unfathomable that anyone besides us would ever care. The city felt both expansive and intimate—forgotten by everyone else, it seemed to belong only to us, to the drugs, to the music, to the other kids doing drugs and worshiping music. The Strokes and their immediate cohorts, mostly forgotten bands you will read about here like the Mooney Suzuki and Jonathan Fire*Eater, as well as ones you likely know, like Yeah Yeah Yeahs, LCD Soundsystem, the Killers, and Kings of Leon, were the soundtrack to that fragile era.

But it also wasn't really about bands. We didn't even think of them as bands, exactly. Real bands were professional rock stars, Pearl Jam or Oasis. The Strokes and their like were coconspirators, comrades in the pursuit of "youth and abandon," the shorthand a few friends and I used to describe those nights that started as Tuesdays and ended up as Jim Jarmusch movies: vodka sodas and pizza and dress-up at someone's house, followed by drinks at whatever bar we had a friend working at that night, followed by Interpol with ten other people at some dank after-hours club with moldy carpeting, followed by disco fries at the diner, followed by wearing last night's makeup to ten A.M. class.

We were all—every kid in the crowd and every person on stage—chasing the same thing: a feeling of rebellion, of possibility, of promise, of chaos. We had to find it so we could figure out how to be ourselves, and we couldn't locate it without each other. We were chasing something that called to Charlie Parker and Bob Dylan and Lou Reed and Madonna before us, something I'd been falling asleep to for years back in New Mexico, something that was synthesized for our generation by Nick's guitar when he let it scream for a while before the Strokes crash-landed into the opening

of "New York City Cops" and by Karen O's primal yowl on "Our Time" and James Murphy's intimate, comic despair on "Losing My Edge." We were all chasing New York City. And for a few magical years, we caught it. This book is an attempt to capture what that felt like.

Lizzy Goodman, New York City, November 2016

Stewart Lupton of Jonathan Fire*Eater.

Erin Norris

PART I

NOSTALGIA FOR AN HOUR AGO

1

"THE PLACE WHERE ANYTHING CAN HAPPEN"

CONOR McNICHOLAS: Everybody is living through their own golden age, but you only realize it afterward, so start living it now.

CHRIS TOMSON: It involves a single decade, a single city.

LUKE JENNER: Everyone has a fantasy about New York.

DAVE SITEK: The idea of moving to New York to make it is a really potent thing. It's a narcotic.

WALTER DURKACZ: New York has always been the ultimate dream for people—Shangri-la, Atlantis, whatever. It's the place where you think anything can happen.

CARL SWANSON: It's this place you go to escape America and have your own semi-utopic ideal.

JIMI GOODWIN: We wrote a song called "New York." It was about New York as an idea. A place where anything is possible, a place where you can find complete artistic freedom. We wrote that song on a fucking Scottish island in the middle of nowhere, before we'd ever been to the city; that's how powerful it is.

SIMON REYNOLDS: New York seemed like a city that was at the very edge of everything and on the point of collapse. It was like a raw jungle and the ultimate in decadence and artistry at the same time. In England, New York seemed impossibly far away.

ANGUS ANDREW: And it was nasty. That was important, that things were dirty. It wasn't about a sense of living in New York for a music scene that we wanted to join, it was more of a geographic thing, and sort of a challenge, too.

JALEEL BUNTON: You'd go around the world and you'd have respect be-

cause you are from New York. "Oh, you're from *New York*?" People who don't live in New York bow down to this mythic thing. Because you needed to have a certain courage to live here. Your exposure to everyone was full blast. If you could thrive in this little petri dish of intense humanity, that deserved a bit of honor.

NIC OFFER: Everyone is here to do something. They're here because they're smart, and they were able to cast off the chains of their small town.

CARL SWANSON: You were the weird kid, and you come to New York to meet up with people who are also indigestible to mass culture. You learn from the junkies, the drag queens, and all the other people, people who are themselves.

CHRISTIAN JOY: Growing up, everyone was always talking about how scary and evil New York was, which made me want to go even more.

CARL SWANSON: If you were in your right mind and could sociologically find comfort in the rest of the country, you would not live here. That's part of the appeal.

CHRISTIAN JOY: I think about places like Portland and Chicago, which are really nice, and it's great to go to those places and they're beautiful and the food is great, but I don't know . . . it's almost too easy.

LUKE JENNER: This is a city of immigrants, you know? The Statue of Liberty is a real concept. Same thing with L.A. or London or any other big city. I mean, Paris: Picasso is not from Paris. Like, Madonna is from the Midwest. Every classic New York artist is not from here.

JALEEL BUNTON: People move to New York to become famous. Think of the legacy—Madonna, Jimi Hendrix, Bob Dylan, everybody moved to New York to become famous. The list goes on forever and ever and ever. It's the move-to-get-famous place.

KAREN O: New York was Blondie, Patti Smith, Ramones, Television . . .

MATT BERNINGER: It was Woody Allen's *Manhattan,* to me.

ELEANOR FRIEDBERGER: I got sucked in through movies more than music. I was really obsessed with Martin Scorsese by the time I was

fourteen. I had the fantasy that he was my father and my boyfriend. I don't know why. He's way too short. But that shaped my myth of New York.

RYAN ADAMS: I remember seeing New York in black and white films. Growing up, we watched a lot of old movies and I saw a lot of skylines. I also read a lot of comic books, and I thought that Gotham was New York City. I had it in my mind that I belonged there from a pretty early age. There were lots of cliché small-town-boy-wants-to-move-to-the-big-city-and-do-his-thing kind of things about me moving here, but I'm not embarrassed about any of it. That's how it works. That's how it should be.

ALISON MOSSHART: When I was fifteen or sixteen I took the Greyhound from Florida to New York with a girlfriend. We didn't have any money. We had nowhere to stay. We had, like, backpacks. Both of us were art students and the plan was we were just going to walk the streets all night, find somewhere to sleep, and make art. After like a day and a half, we were starving, like, "Oh my god I would just kill for a fucking cucumber!" But it was great because we did walk the streets all night! And we did find all sorts of crazy trash and weird things people threw away to make art out of. We filled journals and books. I mean, we did so much in three or four days. And we ended up finding a place to sleep and we ended up finding a shower and we ended up getting fed at some point. And it was beautiful.

KAREN O: My thing about New York was just to be around cute, cool guys. There were no boys at my high school that were even close. This was fantasy land where those kinds of guys existed.

MATT BERNINGER: I took the train to New York from Cincinnati, the first time I came here, and coming out of Penn Station into the city was just a total *Wizard of Oz* moment. It always kind of stayed that way.

JACK WHITE: The first time I came to New York was on a Greyhound bus and I stayed at a hostel at age seventeen. New York is confusing to me. I love the Velvet Underground's take, and Woody Allen's grainy *Manhattan,* the New York City of the seventies. That town can have hundreds of personalities—not the people, the town itself. I like it better from afar, but I'm always thankful it exists.

2

NEW YORK BANDS AREN'T COOL

MARC MARON: The fantasy of New York in the nineties was really built on the carcass of seventies New York. That is when the city was really broke and there was something really raw and weird going on. That scene that happened in the 1970s where art and music and the avant-garde all started to mesh, post–the Factory, the era of renegade culture that created punk, was long gone. Done. You're twice removed from the Factory. Twice removed from the original CBGB's. Everyone was really posturing.

MOBY: Seventies New York was the New York that inspired "Walk on the Wild Side" and "Shattered" and the Sex Pistols song "New York." It was such an artistic magnet and inspiration because anybody could afford to live there, and it was so dangerous and dirty.

DEAN WAREHAM: You could drink in the city back then, too. Even as young as fifteen or sixteen you could walk to a deli—I mean, the drinking age was eighteen but nobody really cared—you could buy beer and you could go to CBGB's.

ETHAN JOHNS: New York in the seventies was like some kind of weird postapocalyptic movie. There was a real sense of apprehension on the streets, almost out of control, almost anarchistic. A bit of a free-for-all, really, heightened sense of danger around every corner but a really vibrant place.

JESSE MALIN: New York was scary then. It looked like *Taxi Driver*, those scenes, lights and hookers; the hookers looked like rock stars.

MOBY: By the eighties it was almost like people outdid themselves to be more eclectic and more idiosyncratic. You'd go to see the Bad

Brains, and the DJ beforehand was playing reggae and hip-hop and country-western. That eclecticism was really—it was very exciting, you didn't want to just identify with one style of music or one way of dressing. And the people that came out of that, like Rick Rubin and the Beastie Boys, Jean-Michel Basquiat, myself, to an extent, are all really weird and eclectic, even Madonna.

DEAN WAREHAM: I saw the Ramones. I saw B-52s before they blew up. The Clash. Elvis Costello. Blondie. I saw a lot of great music, but by the time I was playing in bands myself, New York was not such a good place to be for a band.

ROB SHEFFIELD: In the nineties, living in New York or L.A. was kind of a sucker move if you were a band. People were paying attention to music and caring about it, the way they care about TV or food now. There was just so much energy and attention focused on music, there was a sense that your town was just as connected as any other town. The last thing anyone would have done was move to New York to make it as a musician.

MARC SPITZ: You could play on Bleecker Street for tourists or Nightingale's if you were a jam band. If you were a cool rock band, you were lucky if you got to play for beer or cab fare at a party in one of the big lofts in Williamsburg or even further out in bumfuck Brooklyn. There'd be a keg and a bunch of like-minded poseurs in black and no record label scouts. Just postgrad drunks screaming, "Shut up and put on the Pixies."

DAVE GOTTLIEB: By the mid to late eighties, indie and punk and all that was beginning to fracture. It was relevant in New York, but it was splintered and it was small. And it was overpowered by so much else that was going on, because in the late eighties that's when Public Enemy was breaking through on the streets of New York and hip-hop was becoming dominant.

SIMON REYNOLDS: In the UK we got versions of New York that were written by journalists in the *NME,* so they were romanticized. Then with the first rap records coming out, we had this exciting and scary image because we heard about all the murder and muggings and stuff. The stories tended to be written in a kind of hyped

and apocalyptic way. We would read them and be like, "Oh, that sounds incredible!" So you had a whole generation with all these fantasies about New York, based on what you read. There were supposed to be muggers and vermin living under the street.

ALAN LIGHT: End of the eighties into the nineties, when I first started at *Rolling Stone,* I felt like covering hip-hop was what it must have been like to cover bebop in the forties or rock and roll in the sixties when it was just very small and you were aware that this was the most exciting thing that was happening in the world. *It Takes a Nation of Millions, 3 Feet High and Rising, Paul's Boutique, Paid in Full*—every week there was something coming out that just didn't sound like anything you'd ever heard before. And it was all from New York.

MARK RONSON: It was the birth of Bad Boy Records. It was the first time that hip-hop had all these newly minted moguls that were really exciting, because they were making some of the best music around, were coming to these clubs like Life and the Tunnel. I was DJing in smaller, hole-in-the-wall places, but you would occasionally get *Reasonable Doubt*–era Jay Z coming down. I remember one time I was DJing at what became Shine, the New Music Café, and Biggie and Jay Z came down in matching white pimp hats. It was Biggie's birthday. It was fucking crazy to see them on Canal Street.

ALAN LIGHT: It felt like such a cottage industry. There were five of us writing about it and there were four labels and everybody knew everybody. It just felt like it was simultaneously this little tiny secret and also reaching out further and further into the world. But there was very little overlap between the zine/college radio cultures and hip-hop.

JOHN HEILEMANN: The white kids were just like, "Okay, we're going to skip this decade."

DEAN WAREHAM: New York was not a hotbed of indie activity. Alternative was not a New York–centric thing at all. By the nineties, it was all about Seattle. Bands were moving to Seattle.

DAVE SITEK: When I moved to New York, it was a dot-com kind of town. It was like, "Oh, you're going to do an Internet start-up? Move to New York." No one was like, "I'm going to go and re-create the Velvet Underground."

DANIEL KESSLER: People were always looking for bands coming through town, but not for the local bands at all. We were slugging it out. The number of fans we gained from each experience is one I could count on one hand.

GIDEON YAGO: Rock and roll was for people of a certain age.

PETE BAUER: Telling your friends, "Hey, I'm playing a concert this weekend and will you come?" was met with, "God are you kidding me? You're gonna make me go through this?" It was a very uncool thing to do.

JENNY ELISCU: The thing we shared was the Beastie Boys. The oldsters got the Beastie Boys and the youngsters got the Beastie Boys. But the other stuff they would get excited about, it was just sort of like, "I guess you had to have been born in the sixties or something." Circa '94 to '99 the thing you thought of when you thought of a rock band from New York—you might think of a hardcore band or a punk band. Otherwise there wasn't much. It would sort of be like, "Oh, they're from here? Bummer."

ANTHONY ROSSOMANDO: In general what was on rock radio in the mid-nineties was god-awful.

ALISON MOSSHART: I turned the radio off when I was eleven and never turned it on again. What was happening above ground was just so tacky and not speaking to me at all.

STEVE SCHILTZ: One of our first managers in Longwave also managed Wheatus. They had a song called "Teenage Dirtbag"; it was in a movie called *Loser*. It was horrible. He sat me down once and told me, "Okay, Radiohead has 'Creep,' Beck has 'Loser,' and now Brendan and Wheatus have 'Teenage Dirtbag.' You've got to write a song like this. You've got to write a disaffected-youth kind of song and come up with a big chorus." It was so depressing.

ANTHONY ROSSOMANDO: It had just been blown out. All the labels had too much money to spend and were signing anyone. Candlebox, or

whatever that shit that stood in for rock and roll in the mainstream was, it was a bloody soulless nightmare. You just wanted to bury your head in the sand and let someone shoot you right in the face, repeatedly. Nothing on the radio was cool.

STEVE SCHILTZ: There was just no one to look up to.

"A SAD DAY FOR THE PARENTS"

SIMON REYNOLDS: I was trying to remember what was going on in the rock scene before the Strokes, but I can't. Before the Strokes, were there any bands at all?

ANTHONY ROSSOMANDO: There was nothing going on and then there was Jonathan Fire*Eater. That really was the band.

JASON GORDON: Jonathan Fire*Eater was the precursor to the Walkmen.

GIDEON YAGO: They were the first big New York band out of the gate in that era.

JENNY ELISCU: I loved Jonathan Fire*Eater. They were a garage-rock band in the more modern sense of the big umbrella term of garage rock, the Stooges version of garage rock. I loved them. They were awesome. And there was perceptible hype about them from the get-go.

ANTHONY ROSSOMANDO: You'd listen to the radio and say, "The Rolling Stones are so much cooler than this! Why is that? Where are the young people?" That's what Jonathan Fire*Eater was. It was sexy, visceral, not bullshit. It was like, "Fucking rock and roll can be cool again."

KAREN O: I grew up in Jersey and in ninth grade I met Tina. She's still one of my really good friends. She's Armenian and she had red hair and red eyebrows. Black lipstick. She wore those Converse that had platforms, and she was already tall. Oh my god, she was awesome. She got me into Sonic Youth, Pavement, Jon Spencer Blues Explosion, Weezer, P. J. Harvey. She would bring me to see those bands in the city. And she's the one who took me to see Jonathan Fire*Eater.

DANIEL KESSLER: I went to high school in DC. The precursor to Jonathan Fire*Eater was this band the Ignobles and my high school band and their band were on a bill together. They were really good even then. I'd already heard that they'd opened up for Fugazi, and I was a big Fugazi fan. "Wow, a teenage group opening up for Fugazi, how do you get that?"

KAREN O: Those guys had so much fucking chutzpah sex appeal. They're these kind of scrappy skinny effeminate dudes, but just so fucking sexual. Just primal sex oozing out of their pores. It was so awesome.

PAUL BANKS: A lot of my fashion sense was influenced by those guys. This girl I went to high school with in Spain was at NYU with me. Her boyfriend's best friend was this guy Giles. I wish I knew where Giles was, because he was a badass, fucking smart, witty, cool guy. I really admired him. I was a freshman in college and he was that guy who is fucking cool as shit. Anyway he was buddies with them, so I went to see Jonathan Fire*Eater at Tramps with Giles. Somehow, I was even in their dressing room beforehand. I remember the singer pacing around, wearing a white turtleneck and awesome pants. I was like, "Well, this guy Giles is fucking awesome. This Stewart guy is fucking awesome. Who are these dudes?" I never even spoke to Stewart, but his presence was like: "Man, that's what cool looks like."

STEWART LUPTON: Walter was the first guy I met when I moved to DC from South Carolina in fourth grade. I was obsessed with Michael Jackson and I had this big red *Thriller* jacket and a syrupy accent. I didn't know anyone.

WALTER MARTIN: Stewart and I started a band in fifth grade. It was me and him and another guy, our drummer guy, who didn't really do a good job. In seventh grade Matt came to our school and he was this little badass. We asked him to be in the band. He was a guitar player so we had to draw straws to see who was going to be the drummer. He had a drum set so we made him the drummer.

PAUL MAROON: We started playing music together when we were fifteen. We became really tight in high school but it took a little while.

WALTER MARTIN: We were serious. We practiced every week. Every Friday or Saturday. I remember that if someone would not go to practice, it was really uncool.

PAUL MAROON: The Ignobles were a kind of ska band. Then, like all high school kids, we went through the embarrassing phase where you try on every sound. We eventually landed on garage rock when we were nineteen and stuck with that for a long time.

WALTER MARTIN: We had a lot of shows. We opened for Lenny Kravitz when we were in ninth grade during his first tour. I was sort of taller, but Stew was really small and Matt was really small. I think they thought that it was funny that we could actually play when we looked like we were about five. We thought we were really badass and cool, but we were kind of a novelty. You know, up there with the big boys.

PAUL MAROON: Totally a novelty. You know the five-year-old playing a waltz for the parents? It was the ska version of that.

WALTER MARTIN: Jonathan Fire*Eater began slowly. We started rehearsing in DC in Stew's parents' basement and we did our first show in DC and then we all went to college in New York. Except I actually went out to Colorado for a semester. I didn't want to do the band anymore.

PAUL MAROON: Walt and I were really tight and I wanted to be around him so I went out there to Colorado and convinced him to come back.

STEWART LUPTON: We sent Paul on this mission to rescue Walt. They end up passed out in the elevator of Best Western, just going up and down all night. I guess Paul wouldn't let Walt out until he agreed to be in the band.

WALTER MARTIN: I was really touched by that.

PAUL MAROON: Me and my now-wife went on vacation with her mom so I was out in Denver, and Colorado College is something like fifty miles from Denver. I was only eighteen or nineteen years old, but I figured out how to change my flight, and the next day I met with Walter and spent like twenty-four hours putting alcohol

into him and trying to get him to come back to New York.

WALTER MARTIN: We all moved to New York for that second semester of our freshman year.

STEWART LUPTON: Sarah Lawrence was amazing.

PAUL MAROON: Sarah Lawrence was not a college. It was like going to a very, very out-of-control bar. I don't know anyone who actually graduated from there.

WALTER MARTIN: There was no plan in place really.

PAUL MAROON: It never ever occurred to me that anyone would give a rat's ass about what we were doing. Back then there were just so many steps you had to follow. You couldn't record a record yourself. You had to go to a studio and you had to find a guardian angel to actually produce the record and then they had to figure out how to get it into stores.

WALTER MARTIN: We did like the idea that we were trying to make a career of it, make a go of it.

PAUL MAROON: We used to play down in the laundry room at Columbia. You'd play for an hour and fifteen minutes before you would get kicked out. So we would do that over and over again just until they stopped us.

WALTER MARTIN: "Theater" was our big word. We'd be like, "Yeah, we're a theatric rock band." That was our little tagline.

STEWART LUPTON: I've been to Oaxaca four or five times for the Day of the Dead, which is like New Year's, Christmas, and Halloween combined, and that gave me a lot of inspiration for Jonathan Fire*Eater—the sense of theater and . . . so much tenderness.

WALTER MARTIN: We made our first full-length with a white cover that we handwrote on. We didn't even have an apartment yet. We recorded that a week after we got to New York.

WALTER DURKACZ: When I met them they had already recorded their demo.

WALTER MARTIN: That was our first calling card of sorts.

STEWART LUPTON: We dropped out a year after our freshman year. It was a sad day for the parents.

PAUL MAROON: We were spoiled brats, really. We thought that we would be in a band instead of going to college.

WALTER MARTIN: Our parents were horrified that we'd drop out of college and they were horrified by where we were living, and then they saw glimpses of our apartment and were further horrified.

PAUL MAROON: We were all sleeping in one room.

STEWART LUPTON: We had a bed that was a whole floor of an apartment—right over on Houston and Suffolk. It had a nice view of an airshaft and it smelled like garbage.

PAUL MAROON: Suffolk Street was incredible. It was 1.3 rooms with everything around the kitchen sink. And there were just mice everywhere. At one point the trash was piled like five feet high in the middle of the room because no one would take it out. We gave up. We just put the mousetraps on top of the trash. It was really, really, *really* super gross. It's amazing we didn't all get tetanus.

WALTER MARTIN: We each had a bowl that we ate everything out of. Painted on the bottom was everybody's first initial so you knew whose bowl was whose. It was like the three-little-bears kind of thing.

PAUL MAROON: We scratched our initial on the bottom of each bowl, but no one caught on to the fact that M was Matt and W was for Walter, and if you turned the bowl you couldn't tell which was which. We lived with that problem.

WALTER MARTIN: We would make spaghetti or beans and rice every night.

PAUL MAROON: We had a bird, too. We had a parakeet. It was the five of us and a parakeet called Kim.

WALTER MARTIN: Then Kim died.

PAUL MAROON: I was the only one that liked Kim. Part of the reason Kim died young is because she had to deal with us. It was really hard on Kim. Kim didn't want to live if that was what it was going to be like.

WALTER MARTIN: She died the day we moved out, as we packed. Literally.

PAUL MAROON: Kim is buried in Grant's Tomb right next to Grant. I remember the guard asked us what we were doing and we told him,

"We're trying to bury our parakeet next to Grant," and he said, "Okay, but hurry up."

WALTER MARTIN: We all worked during the day. I was a ticket seller at the Met.

PAUL MAROON: I worked at the Met with Walt. We tended to get jobs in teams. And Stewart was in bed most of the day.

WALTER MARTIN: We would sit on a stoop every night and drink Country Club malt liquor. It was great.

STEWART LUPTON: Everything was very new and dangerous and fun and cheap. You know that bar No Tell Motel on Avenue B with the Astroturf and chairs out front? We would sit out front drinking Deuce Deuces, Colt twenty-two-ounce beers that cost $1.75, get some Superbubble, smoke some cigarettes, and check out the girls.

WALTER MARTIN: New York was definitely wilder then. There was so much heroin.

SIMON REYNOLDS: If you went to a café on the Lower East Side you had to get a key to go to the bathroom because they didn't want people fixing up in the toilets.

WALTER MARTIN: One week after we moved to Suffolk Street there was an article in the *New York Times* saying that Clinton and Stanton, the intersection that was like a block from us, was the heroin capital of the country.

PAUL MAROON: The use of heroin on Earth had fixated itself on our corner. That's what our parents thought. Matt's mom got offered "body bag," which is a very, very lethal form of heroin, as she came into our apartment. The mother of another friend of ours from high school brought us leg of lamb as a housewarming present. There were mousetraps all over our place, but we cooked and ate this beautiful leg of lamb.

DAVE BURTON: Everybody drank at the Mars Bar.

DENNIS CAHLO: Wow, that place was disgusting.

ANDREW VANWYNGARDEN: The first time I went to New York as an adult, we went to Mars Bar and were drinking shots of tequila in little plastic cups. I really liked that disgusting place.

TUNDE ADEBIMPE: I got electrocuted at Mars Bar.

ZACK LIPEZ: The first time I went to Mars Bar I went with Dave Burton. He had started taking me under his wing—he was dating one of the bartenders.

DAVE BURTON: It worked like this—if there's seven bartenders working throughout the week, people had their bartender and that's when you went to that bar. If that person wasn't working you didn't go.

ZACK LIPEZ: I sat down at the bar and he introduced us. She was like, "Oh, nice to meet you." She took a bottle of Jameson, put it on the bar, and walked away. I said, "Oh, this is where I'm gonna hang out." No one had any money. You went where you would get free drinks. You had to have twenty dollars to leave at the bar at the end of the night. The joke with the bartenders was that there was only one twenty-dollar bill in New York that just got passed around from bartender to bartender to bartender.

CHRIS LOMBARDI: Then there was Max Fish.

STEWART LUPTON: I started going to Max Fish a lot because it was like two blocks away from our apartment and it was cool and there was no place else to go. It was open 'til four.

PAUL BANKS: Best bar in the world in my opinion, back then. I was a total Max Fish regular.

CHRIS LOMBARDI: Max Fish opened the year that Matador started. We called it "the bar." We knew everybody there and we got free drinks. It was even written about, that to pick up girls at Max Fish guys would say, "Oh yeah, I'm signed to Matador," or the record company guy would be in there picking up girls and doing cocaine with them in the bathroom. If people got laid by saying they worked at Matador, I'm very proud. That's a big achievement.

STEWART LUPTON: It was kind of gutter glamorous on the Lower East Side back then, especially at Max Fish. I really can't describe it unless you're high.

MARC SPITZ: Max Fish was where the art kids drank and hooked up and did dope and fucked in the bathroom. We weren't club kids; they went to Limelight and Tunnel. We were in bands or doing

theater or making paintings or welding shit together. We weren't into techno or trance. We were still into the Velvet Underground and indie rock.

STEWART LUPTON: Right next to Max Fish was this gallery called Alleged Gallery. One night you'd meet Jim Thirlwell and the next night you'd meet Chan Marshall or Elliott Smith. Elliott was around all the time. What a sweetheart. I didn't know him that well, but the few times we did hang out really had an impact on me. Every time was just trying to talk him out of committing suicide. He'd be like, "Give me reasons." And I guess you were supposed to bring up the Beatles.

PAUL BANKS: You just had this feeling that cool fucking people were there. There was a combination of professional skaters and then people that looked like they were in a Larry Clark film, and people that probably were in a Larry Clark film.

MATT BERNINGER: That's the first thing I did in New York City, was go to Max Fish. Scott and I would walk from East Sixty-First Street, where we lived, to Max Fish on the Lower East Side. We would walk sixty-one blocks because we were too scared to take the subway. We knew about Max Fish because some older students in Cincinnati told us. We got a packet for "If you're going to an internship in New York City, here's your packet of interesting places." Max Fish made it in. I remember just feeling incredibly insecure. There was a pool table and we weren't sure the protocol of like when to put up your quarters. And the music was just so fucking great; every song was cooler than anything I had been listening to. And the bartender was just the most sexy, intimidating woman. We felt like imposters.

JALEEL BUNTON: I'm trying to think about how we even heard of that bar.

PAUL BANKS: Jaleel was Mr. Max Fish.

KAREEM BUNTON: My brother worked at Max Fish. I was always there and we'd hang the fuck out. I'd make art there and collaborate with people there. I was there six days a week. It was just the spot.

PAUL BANKS: I always thought, like, they've just got something kind of righteous about them, the two brothers.

JALEEL BUNTON: I've always respected Ulli [Rimkus], the owner of Max Fish. She has an artist's heart. She really only ever hired artists to work there. What was different about that place was her sense of art was what was properly eclectic, not, like, "I've heard of this." My aesthetic was totally different than a lot of the aesthetics that were already there, but it was like, "Oh, that's cool, you can be here too." It wasn't a rock bar, or a bar for just this kind of person or that kind of person, it was a bar for people who were authentic in some way. It just felt like home.

MARC SPITZ: It was magical for a while.

4

"THEY LOOKED LIKE THESE PREPPY KIDS ON ACID"

STEWART LUPTON: I can't believe those guys didn't get laid more. They all had girlfriends. It was not a good time to have a monogamous relationship.

JUSTINE D: We all had a crush on Stewart.

STEWART LUPTON: The other guys in the band had girlfriends and they were very faithful to their girlfriends. They were pretty square for what was going on at the time. I don't want to sound like an asshole, but I was the one that made the scene.

WALTER MARTIN: Stew was a very social guy and people really loved to hang out with him. We were all at bars every night, but Stew was there a lot later than most of us. And he sort of rounded up enthusiasm for his project. So we got all of these really cool scene type of people to come and see us and they told their friends and then people started coming.

ERIN NORRIS: Just like any aspect of the art world, you have to go to gallery shows and air-kiss and shake hands and talk nonsense. You have to. You have to work it, you have to play the game.

STEWART LUPTON: I would meet these really interesting people and tell them about, just put it in their ear: "Jonathan Fire*Eater, Jonathan Fire*Eater, Jonathan Fire*Eater. From DC, from DC, from DC. I'm the singer, I'm the singer, I'm the singer." I'm an only child. It was like: "Attention! Attention! Attention!" I got the name out there, and meanwhile we'd be practicing our balls off.

WALTER MARTIN: We practiced like every night.

STEWART LUPTON: It was in this series of practices where we stumbled

on a sound. It was a really wonderful feeling. We had gone from an amalgam of inspirations to an original vibe over a couple of months. We did three-chord punk rock, but we did it in our own way. It was golden.

PAUL MAROON: I don't know. To me it never seemed like we had any ability at all. I thought we were terrible.

STEWART LUPTON: It was a transcendental feeling. The moment I realized we had something was in this practice space that we shared with a couple of other bands. Even they heard it. The sound centered around the drumming. Matt was amazing. He was a force of nature. He's a kinda short, skinny little fella but he was like Animal from the Muppets on the drums.

WALTER MARTIN: People started liking us. Stew really started being the front man. People were reacting.

STEWART LUPTON: We ended up playing at the Cooler a lot. We had a residency there in 1994.

ALBERT HAMMOND JR.: The Meatpacking District was a desolate wasteland. You went to the Cooler and you were like, "Am I in New York? Where am I?"

STEWART LUPTON: We played four Sundays in a row. The first Sunday it was all of our friends from school and few of the people that I'd met. Hipsters. Those guys had some hipst....er friends too. They came. The second week it was like half full and there was some dancing or whatever. The third week it was packed. And the fourth week it was packed and there were people on tables, making out against the walls, half fucking.

ERIN NORRIS: I'd worked with Nine Inch Nails, Marilyn Manson—I hated him, by the way. What an asshole. Then Jonathan Fire*Eater started to happen. I saw them at the Cooler, maybe their second show, and they just blew me the fuck away.

STEWART LUPTON: We finished and came backstage all sweaty and tired and elated and there's this guy in an overcoat hanging out. We thought, "This guy is homeless." He had a couple missing teeth. Looked like he had seen better days. Real . . . frumpy. Frumpy is

him in a tux. Anyway, his name is Walter Durkacz and he became our manager.

WALTER DURKACZ: I had an intern named Echo and one day she told me about this band from DC called Jonathan Fire*Eater. Obviously it was a great name. I was curious.

STEWART LUPTON: He's like, "I'm going to tell you a secret. Number A . . ." That's how he talked. He's from Pittsburgh, from the *Deer Hunter* section of Pittsburgh. So he's like, "Number A, you guys were really great. Really rockin'. New sound. New sound." And then, "Number B, I've never done this, but I want to manage you." We let him do it mainly because he had this black Cadillac, which was great for picking up girls.

WALTER DURKACZ: I had a '69 Chevy Caprice. It was a beautiful car.

STEWART LUPTON: Turned out he'd DJed back in the day at the Mudd Club and Danceteria, where Madonna and people had played.

WALTER DURKACZ: Based on Echo's recommendation, I went to the Cooler and I saw them play and I thought, "Wow, there's something here."

PAUL MAROON: He came out of the seventies and early eighties New York disco scene. He's just from another land, really. He's a character out of a Martin Scorsese movie. If you ever see a man driving a seventies Cadillac backing up down Canal Street trying to get a parking space, it's him. That's my memory of him. Just backing down four blocks. I think he went to jail for parking tickets. That's not easy to do.

WALTER DURKACZ: You could see they were five kind of cute boys, preppy looking but a little twisted, all dressed in black and wearing ties, and they played this really raw thing.

STEWART LUPTON: We were all good dressers.

WALTER MARTIN: He comes backstage and is like, "You guys need a lot of work." I think he was trying to be a manager from a movie or something.

PAUL MAROON: No one really ever wanted to talk to us about what we were doing so it was very novel that he did.

WALTER DURKACZ: The truth of the matter was they were very raw but that rawness was what made people attracted to them.

ERIN NORRIS: I always have had a love/hate thing with Walter.

WALTER DURKACZ: Erin was a sweet girl. Especially at the beginning, she jumped on board and I appreciated her help. She understood the band.

ERIN NORRIS: Walter was a persona and he just got to them two minutes before I did or I would have been their manager. Backstage after that first Cooler show I was like, "I need to work with you guys." Stewart took me aside and he was like, "I think we just got a manager." And I was like, "Well, I do press."

STEWART LUPTON: One of the reasons we got big was because of Erin. She was our PR woman. She was also a dominatrix, so we had the whole Sex Pistols thing going on.

ERIN NORRIS: I did dominatrix stuff for many, many years because the music industry doesn't pay very well. Especially for women.

STEWART LUPTON: She worked in this place called Pandora's Box, which was an elite dungeon.

ERIN NORRIS: Another place was called Abasement. Crosby and Howard. It's now a Jil Sander flagship store.

STEWART LUPTON: Pandora's Box had a bunch of rooms. One was the Big Baby Room and it had a man-sized crib. One was the Hospital Room, which had an iron table, you know, a morgue kind of vibe. And then the Medieval Room had this wooden wheel that she strapped me to like the Vitruvian Man. And every time I would go around on the wheel she'd put this shit—not whip-its but amyl nitrate—under my nose because it gives you an erection. She was into S & M. She was friends with Richard Kern, who did that book *In Alphabet City*, where he basically just got girls to take off their clothes and call it art. It was art. I liked that art a lot. I knew a lot of those artists.

ERIN NORRIS: The band was amazing. I just totally fell in love. Stewart was the consummate front person, with aspects of Iggy Pop and Joy Division, just in terms of his presence.

STEWART LUPTON: Our fling lasted on and off between girlfriends for

our whole career, sort of. I don't think she would be that excited about me telling you that.

ERIN NORRIS: How is Stewie, by the way? I fucking hate his guts.

STEWART LUPTON: Erin was basically the reason we got big or struck a vein: she busted her ass.

WALTER MARTIN: In 1995 this label called PCP, they approached us to put out a seven-inch. A real photographer took our picture and it felt like we were a real band.

JASON GORDON: The first thing that blew you away about Jonathan Fire*Eater was this organ sound. It was so haunting. It was like everything that you liked about the Doors. And then you had this guitar that was drenched in echo and sound effects, like My Bloody Valentine. But then all of a sudden there is this drummer who looked like he was twelve years old and he's banging out this dance beat. Then there's Stewart Lupton dressed in a white shirt and tie. He wasn't skeezy looking. He was almost clean-cut. He was menacing but dressed like he just got off of work.

KAREN O: Someone said to me once, "It's great how it always seems like they're just on the edge of everything falling apart, that's the exciting thing about watching them." And I was like, "Yep. That's it."

JASON GORDON: It was gothic. It was cathedral. It was menacing. There was such tension. They looked like these preppy kids on acid.

WALTER MARTIN: After that we started getting approached by major labels.

JASON GORDON: Stewart would literally roll himself up into the microphone and put it in his mouth, like he was swallowing it. There is a reason the Yeah Yeah Yeahs were very into Jonathan Fire*Eater.

KAREN O: Oh yeah, they had an enormous influence on me.

DANIEL KESSLER: I was at NYU. All of a sudden you started hearing all this buzz about this band Jonathan Fire*Eater.

PAUL MAROON: Real people were not coming to our shows. There was a lot of label interest because Stew was good-looking but we didn't have fans or anything. There were a lot of industry people trying to sign us because of Stewart.

WALTER MARTIN: He always had really good lyrics. He looked really good too, and so we just kind of really just kept a straight face behind him and tried to play, to just be cool. I would put a hell of a lot of effort into the music, but Stew was definitely the show.

STEWART LUPTON: Those guys, they are true musicians. I was much more into the aesthetic.

"ALCOHOL, BLOW, CRACK, DEATH"

GIDEON YAGO: There was a critical mass of a couple of things that happened that changed the city, and a lot of it was tied to Giuliani cleaning up New York.

DEAN WAREHAM: He did clean things up. You couldn't buy drugs on the street anymore. But fortunately cell phones came in.

DOMINIQUE KEEGAN: The first guys that had a weed delivery service were just passing out business cards at this bar where I used to DJ and it totally worked. I called them the next week. Then that became the norm, you had your delivery guy. It's not like people stopped doing drugs.

MARC MARON: Yeah, Giuliani cleaned the place up, but it was still kind of menacing.

STEWART LUPTON: You couldn't walk down the streets in Alphabet City. A girl would ask you to walk with her. It was scary. You know Needle Park, from that movie *Panic in Needle Park*?—That was Tompkins Park. There were tents in it.

GIDEON YAGO: You have to remember, even as far ahead as 2000, if you would go past Avenue C, it was like going into no man's land.

MOBY: The acronym for Alphabet City stood for "Alcohol, Blow, Crack, Death." So the further east you went, if you wanted to get drunk, you'd go to Avenue A; if you wanted to buy cocaine, Avenue B; crack was on C; and Avenue D was heroin and getting stabbed to death.

ERIN NORRIS: I had a really big apartment on Third between Crack and Dope, between C and D.

JESSE MALIN: We'd play Pyramid and a place called Sin Club on Avenue C, where I heard my first gunshots. Sin Club stood for "Safety in Numbers," because it was really bad down there.

GIDEON YAGO: They would still run helicopters at night in the East Village. The police with raid squads would throw out crusty punks or people that had been itinerant or whatever, making way for new real estate to come in. You know, dust it off and then resell New York and what New York was going to be.

MARC MARON: There was a lot of action down on my street. There was a doorway that was very active. There was just this never-ending parade of junkies in different stages of need. It was that time when the heroin became very accessible; it was very pure and younger people were getting involved because you could snort it.

MARC SPITZ: All the drugs were named after bad cop movies.

DOMINIQUE KEEGAN: Thirteenth and First is where they used to sell Rambo and Terminator cocaine.

ERIN NORRIS: I redubbed a nineties music industry conference called Mac Fest the "Smack Fest" because during that week the keyboardist from the Smashing Pumpkins bit it and he bought the shit on the Lower East Side. The next day I remember looking out my window and there was basically dudes in suits and kids or whatever, at, like, ass o'clock in the morning waving money around like "Where can I get some of this stuff?" That's the junkie mentality— "It killed that guy?! It must be the good shit." That one was called Body Bag.

GIDEON YAGO: I was a denizen of the downtown area for years and years and years. I was out every night and every weekend, going to record stores, going through thrift shops. You'd see people in the street and get to know people at night. There was no social networking. All the people you knew you had to meet analog.

STEWART LUPTON: You wouldn't go out until one in the morning and that was for, like, an appetizer. You'd go out for the night and you'd lose a week. Maureen Tucker made a record called *I Spent a Week There the Other Night* and that was it.

MOBY: I wasn't really daytime friends with anybody.

KAREEM BUNTON: Stewart was always trouble. He was druggy before he got money, and then it just got worse and worse.

JENNY ELISCU: You knew some people were going to hate Stewart or hate Jonathan Fire*Eater because Stewart was so obviously a junkie.

WALTER MARTIN: I think the first time I laid eyes on him after I came back to New York from Colorado I knew. Even then. He looked different.

STEWART LUPTON: I grew tired of the banter and drinking forties on the East Village Astroturf and deviated into hard drugs.

ERIN NORRIS: He had every bit of promise, you know? And then very quickly he took advantage of the dark side that New York had to offer.

STEWART LUPTON: That was back when walking out the door you'd see the dealers. It was just a different time where everyone did everything. Ten dollars bought you a whole day of nirvana.

ERIN NORRIS: He would do insane shit. Like, I'd say, "Pretty please, no drugs today," and I'd come back to the apartment and he'd be sitting on the couch with a wax shmear on the side of his fucking face from the back of the cook spoon. I had cats at the time, and when Stewart would stay over they would piss in his suitcase because it smelled like a place you should piss in, you know? He brought the odor.

STEWART LUPTON: I started getting arrested a lot for possession.

ERIN NORRIS: We were in the drug thing together. I got yelled at a little bit, by Walter, for enabling Stewart. Yes, I was enabling, but it was easy to be enabling. And for the most part I was footing the bill. My rent was $550 a month and I was making $90,000 a year. I have nothing to show for it. I should have, like, three houses. I did a lot of drugs and I bought a lot of drugs for friends.

STEWART LUPTON: I wasn't the only one in a band doing heroin, but I was the only one in my band that did it. They resented the fuck out of me for it. They still do.

WALTER MARTIN: We definitely wrote a lot of instrumental material because he wasn't at practice.

CARL SWANSON: Not long after they put out that first self-titled EP, a scout from Geffen started circling.

MARC SPITZ: There was money in the industry. You would go to the after-party and there would be live lobsters in a tank that starving rock writers like me would shove in our pants.

JASON GORDON: Every nineteen-year-old intern at a record label had a corporate card.

JENNY ELISCU: It was still the era of major labels spending a lot of money on indie because of Nirvana. This Jonathan Fire*Eater thing had buzz. It wasn't surprising that there was a lot of label interest in them.

WALTER MARTIN: The major-label stuff happened really quickly. Geffen Records flew us out to L.A. to see their offices and whatnot. We couldn't believe it.

WALTER DURKACZ: Basically, there wasn't a lot going on at the time and people started being very curious about them. The industry and the press started to come around. Seymour Stein from Sire was very interested. Bob Krasnow, who signed Metallica, was very interested.

MARC SPITZ: Soundgarden had broken up. Oasis had not delivered on their potential. Blur weren't even sounding Britpop anymore, they were sounding like Pavement. There was always going to be Dave Matthews Band. You can't even criticize them, they're just there. It'd be like criticizing pigeons. You can't get rid of them. You just hope they don't shit on you. But the bottom line is there was money and we needed new rock stars.

ERIN NORRIS: There was a huge, huge bidding war. And at the time bidding wars were what press wanted to write about, but I think it actually hurt the band. It was always about the music but then it became about the personality.

WALTER DURKACZ: They were an A & R person's worst nightmare.

WALTER MARTIN: I didn't necessarily think it was that cool that we were being courted by all these labels. It was never like, "Pinch me." It was more like, "This is so ridiculous."

WALTER DURKACZ: The band was really stubborn. They had this kind of, like, "I don't care" attitude. They didn't want to do it. It had to

be pure. It had to be them playing their music on vintage instruments. They didn't want to do videos.

WALTER MARTIN: We didn't want to be in certain publications. We didn't want to have our pictures taken in certain ways.

STEWART LUPTON: We drew out the bidding war as long as we possibly could because we were broke and they would take us out to these epic dinners. I don't even remember the names of some of these restaurants, and I'll never eat there again. We went to, you know, Balthazar with Warner Bros. We were so skinny. It was like, Artful Dodger needs to eat sometime, you know?

WALTER MARTIN: I remember going to meet this guy Bob Krasnow. He was an old industry guy. We went to his apartment on the Upper East Side. The elevator opens and there's a handsome manservant there. Krasnow had these slippers on that had a cursive K on them, and he's just walking around the house. We're all completely hungover and Walter's there negotiating, our toothless spokesperson.

CARL SWANSON: The courting went on for eight months, during which they continued to play shows.

JASON GORDON: There was this theater called the WestBeth in the West Village. It's the theater where they used to do *Hedwig and the Angry Inch* when that first started. I saw Jonathan Fire*Eater play there. It was their first time headlining and they played as if it was Madison Square Garden. Those songs "City That Never Sleeps," "Give Me Daughters"—it was, again, totally cathedral, and there is this hypnotic singer who literally looked like he was performing in a trance, and you were just sucked in. They were so captivating live and there was such tension onstage between the band members. Everyone in that room became a believer. You felt like you were watching a band on the verge. This was right before they got signed.

WALTER DURKACZ: There was a guy with this offshoot indie label who offered to do an EP. That became *Tremble Under Boom Lights*.

DANIEL KESSLER: I fell in love with that EP. It crushed me. I still listen to it all the time. It's still sometimes part of the Interpol playlist in between sets.

JAMIE HINCE: *Tremble Under Boom Lights* is still one of my favorite records to this day. I remember once before a show seeing the bass player sound-checking the bass—it was no bass sound like anyone was doing. It sounded like something that Lee "Scratch" Perry would have been doing, just an absolutely toneless, big sub-bass. He kept saying, "Turn the treble down more, turn the treble down more," until it was just nothing but bass. Just lolling, light-headed, like a bruise.

CARL SWANSON: I remember Stewart telling me they couldn't sign to Sony because it was "too much of a world power."

MARC SPITZ: You think you're the king of the world because you're the king of Ludlow Street.

ERIN NORRIS: The label negotiations went on throughout the spring of '96.

STEWART LUPTON: It was really fun to watch Walter Durkacz argue with these seasoned executives from Geffen because he was this toothless Brooklyn hard-ass.

ERIN NORRIS: I remember sitting with Seymour Stein and Sylvia Rhone at Elektra records and Walter posed this question: "Say we only want to sell five hundred thousand records, and we want to stop right there, we don't want to sell any more than that, what are you gonna do?" Seymour Stein looked around like, "Is this guy retarded?"

WALTER MARTIN: People from California thought Walter was one of those Candid Camera jokes.

STEWART LUPTON: We eventually signed with DreamWorks because they had George Michael, Kool Keith, Rufus Wainwright. Rufus was around during all this time. I loved hanging out with him. We would go out and people would say, "You guys are today's equivalent of Lennon and Dylan." And Rufus would say, "That's a little over-the-top, but thanks." We liked that. We'd go out to get our egos fed.

RUFUS WAINWRIGHT: Stewart was such a sweet, sweet kid. We really had a lovely time together. He was such a romantic figure, so beautiful and so wild, and really kind of deer-in-the-headlights. We did

a lot of drugs together, and we had a couple of moments where we'd just take off all our clothes, but it wasn't sex. He just liked to expose himself, which I really appreciated.

GIDEON YAGO: Jonathan Fire*Eater were these very sexy guys with this lush sound who were signing a million-dollar deal.

PAUL MAROON: Oh yes, the million-dollar deal. People just don't understand how these things work.

WALTER MARTIN: You get the million-dollar deal, but you don't get it all at once. It was a three-record deal and the million dollars is the total for everything you're going to get and you have to pay for your recording. If we had turned in another record, we would have gotten some more money.

PAUL MAROON: I got $800 a month from the band.

WALTER MARTIN: I think I got a check for $18,000 or something one time, which I could not believe. I didn't have a girlfriend at the time so I just went on a trip to Europe by myself for two weeks.

STEWART LUPTON: Walter put his dental plan into our contract.

WALTER MARTIN: We were the second band in history—or at least this is what I've always claimed—to get dental insurance in their record deal. Walter used that deal to get his teeth fixed.

JENNY ELISCU: The general attitude very quickly became, "Oh, everyone is trying to sign them? Well then, fuck them."

CARL SWANSON: There was a bit of a backlash.

WALTER MARTIN: We did a lot of touring and nobody—outside of our hipster friends in New York—nobody would go see us play.

STEWART LUPTON: We were playing to empty rooms, man, we were playing to empty rooms. Still, we went to London like eight times.

WALTER DURKACZ: It was in England that people first started to write about the drugs.

WALTER MARTIN: It was sort of an uphill battle from that moment on.

STEWART LUPTON: Was it me versus them? Yeah, because I was on hard drugs and they weren't. Also, I loved them, but it was like, "Come on. We're in New York! We tricked our parents! This is how far

you're willing to go?! Let's throw down!" It wasn't as simple as "Let's do hard drugs" or not. They were less adventurous.

WALTER DURKACZ: There are some people that have issues with drugs and you will never know it. And there are some people where their addiction can take them over. With Stew it did get to that, to the point where it affected his ability to not only hide the fact that he was on drugs but also to function.

JENNY ELISCU: I mean, there was a junkie at the helm.

ERIN NORRIS: I remember there was a Tompkins Square Park show in the band shell and he basically didn't show up. I think that was my fault, because we were both high as a motherfucker. It was like, "Oh fuck! Do we have a gig?"

WALTER DURKACZ: Basically at that point the band had a lot of money behind them and a lot of pressure and a schedule to keep to. Stewart just didn't understand that now there were certain times where he needed to be on the straight and narrow. He just didn't get that.

DANIEL KESSLER: Their record came out and it didn't do very well. They had some issues.

JASON GORDON: I interviewed them after it came out and I was like, "What's going on with this record, man? Where is the single?" They're like, "That's what the record company said."

JENNY ELISCU: It was over. People forgot they ever existed. Total implosion.

STEWART LUPTON: The band played Central Park July 28, 1998, and we broke up that day. After that show I went to Harmony Korine's. I went in his bathroom cabinet and took some pills. I figured they were Harmony's so they had to be great.

WALTER MARTIN: I literally looked up a college in the yellow pages that day.

DANIEL KESSLER: New York was ready. New York was in love. Stewart was the true rock-and-roll persona that people were craving.

JASON GORDON: A bunch of us were just heartbroken. They were the band that could make it out of New York. They were going to bring the underground sound to the mainstream.

DANIEL KESSLER: There was nothing parallel to that as far as hype. It wouldn't be like that again until the Strokes.

NICK VALENSI: It was always industry people who would mention, "Oh yeah, you guys are like what Jonathan Fire*Eater should have been five years ago," and we were like, "Who the fuck is that?" I'd never heard of them.

"A BUNCH OF LITTLE BANDS STARTING TO CREEP UP"

JUSTINE D: Around the same time as Jonathan Fire*Eater there was another band who was actually really good but also never went anywhere, the Mooney Suzuki. They were playing so much.

MATT PINFIELD: People forget about those guys.

RYAN GENTLES: By 2000 the Mooney Suzuki were the fucking big shit on the scene. They were King Shit of Fuck Mountain.

MATT PINFIELD: They were fun. They had a little MC5 but with a punk edge to it. They were a New York–meets–Detroit kind of thing.

ANTHONY ROSSOMANDO: We played with the Mooneys. I remember them being pretty cool dudes who were just up for it, local kids with a little bit of dosh in their pocket; they could afford to have a good time.

NICK MARC: I loved the way they looked. They were all in black shirts with bob haircuts.

ANTHONY ROSSOMANDO: There were a bunch of little bands starting to creep up. Nobody really had the songs, but everyone had the look or the vibe or the drive to make something cool.

NICK VALENSI: I was the Mooney Suzuki's number one fan when I was sixteen. I went to the Luna Lounge and I saw the Mooney Suzuki and that's when bells went off. I thought, "These guys are so fucking together, and they're so tight, they're so well rehearsed. This is a proper show. It's not just four schlubs onstage, staring at their feet." I got so excited by the Mooney Suzuki, the very next show they did, I brought Julian, Fab, Nikolai. I brought all the guys who I played music with. I was like, "Check out this fucking band!"

NIKOLAI FRAITURE: They had this thing . . . I remember seeing them once at CBGB's. I think it was Julian, Albert, and me and we were kind of blown away. Sam was jumping on the bass drum; it was a total spectacle. John, who was the bassist at the time, had some guy who was tugging on his cord. He walked off the stage and punched the guy in the face. It was like, "Holy shit, this is what we want to do."

NICK VALENSI: At the Luna Lounge, there must have been eighty people at their show. That was a big deal. We couldn't even get a gig at the Luna Lounge at that point.

JULIAN CASABLANCAS: That was pretty much what we were aiming for: the Mooney Suzuki.

GIDEON YAGO: You've got to understand the venues at the time. There used to be a place called the Academy up in Times Square and it was a thousand-person theater. That's where you'd go see the Guided by Voices of the world. Then you had Tramps in the twenties, which is where you'd see the indie rock bands of the day. And then there were the Lower East Side and East Village clubs like Brownies, CBGB's, the Mercury Lounge, Luna Lounge, and I'd even put Maxwell's in Hoboken on there. That was a much smaller level, people who are playing to a hundred and fifty, two hundred people maximum. You'd go there to see all these boutique kind of bands.

DANIEL KESSLER: The two really good clubs to play were Brownies and the Mercury Lounge. A few years later, there were a plethora of venues that opened up, but at the beginning, there was a lot of competition to play those spots.

KAREN O: It just seemed like such a smaller world. You couldn't just find out about things. We would just go walking around putting up flyers, stapling them to lampposts, leaving them at bookstores and record stores. That's what people did.

GIDEON YAGO: You'd go down to the bars to hear rock and roll and to drink. You'd go to get fucked up and meet people who were into the same shit that you were into. It wasn't like there was an expectation that you were going to blink and somebody who was playing a two-hundred-person venue was going to suddenly have

the world's biggest impact on fashion, photography, culture, and cool. That just wasn't why anyone was doing it. It didn't even seem possible.

DENNIS CAHLO: The spots were Don Hill's; Brownies; Mercury Lounge was great; 2A was awesome; Sway was . . . the curtains were always closed; that place Bar 13, that's where the Shout! parties were.

ZACK LIPEZ: We would all go to Shout!.

GIDEON YAGO: The Shout! parties totally, totally, totally, set the ground-work for all 2000s bands. It was where you would go on Sunday nights to dance and drink and listen. God knows how many STDs and drug addictions sprouted out of those parties. For a lot of kids that were already inclined to go digging in record shops and vintage clothing stores to find their gear, it was the equivalent with music. Suddenly you are looking into the Rascals and Easybeats and very early Rolling Stones. It was like finding a good motorcycle jacket for the first time. It was like looking at Steve McQueen and saying, like, "Fuck yeah, I want in on *that*."

KAREN O: Just prior to getting onstage with Yeah Yeah Yeahs at the Mercury Lounge, where I kind of unleashed Karen O for the first time or whatever, I was going to Shout!. My best friend and I would get there early, have like seven cosmopolitans, and be doing knee slides on the dance floor. The dance floor at Bar 13 became where I practiced this persona.

GIDEON YAGO: Now that you had a bunch of people who would put two and two together—"I can play in a rock band and that band can sound like something they would play at Shout!."—there was this immediate audience because you would get all the Shout! kids at your shows. I mean, you could fill hundred-person and hundred-fifty-, two-hundred-person venues with spillover from kids who would go to that party. Everything that followed—the explosion of all those 2000s bands—came out of a combination of Giuliani, the dot-com money, and the concentration of wealth that kind of pushed into downtown, and then the Shout! parties.

SAMMY JAMES JR.: One night at Shout! we got there and everybody was freaking out because I had the *NME* and they had reviewed

one of our singles. We were like, "I don't know what the fuck *NME* is," but it was just like, "A British magazine?! Isn't that great?"

GIDEON YAGO: Also, that whole garage-band thing that was taking place at the time—it wasn't just New York. It was Seattle, Detroit, Chicago, Ohio, all over the country.

VITO ROCCOFORTE: Back in, like, 2000, before we moved to New York, Detroit was one of those cities where there was a few cool bands around. There was this band the Go that was on Sub Pop.

JENNY ELISCU: Yeah, Jack White was in the Go.

LUKE JENNER: They were signed to Sub Pop, and we were signed to Sub Pop, and we couldn't get Sub Pop to pay attention to us because they were too focused on the Go.

JENNY ELISCU: This is all before the White Stripes. By the time the Go's record came out on Sub Pop, Jack was no longer in the band. But I remember seeing this old press photo—the publicist sent it to me—I remember looking at the computer screen as it slowly loaded the photo, and I'm like, "Who is that giant homunculus in the middle with the curly haired, Skinny Puppy, fucking leather vibe?" He was so incongruous with the rest of the band. And that was Jack White.

DEAN WAREHAM: Later, the White Stripes would popularize it, but I felt like in every city all over the world there are bands exactly like that making garage music.

JENNY ELISCU: There's a Detroit–New York parallel in both eras, right? How fucking weird is it that thirty years after it was argued whether the Stooges were inventing punk in Detroit or the Ramones in New York—let's leave the UK out of it for a minute—that you had Jack White in Detroit and the Strokes in New York?

"AIN'T NOBODY HERE FOR BOTTLE SERVICE"

JAMES MURPHY: New York was fucking horrible and I thought that was the most exciting thing in the world. It was like being in the suburbs. There was nothing there so anything was possible.

JUSTINE D: James used to come to my party at Life. I met him there. And he also used to come and hear me DJ at Sway all the time on Mondays. It all happened at once: I started DJing, I had a Monday-night residency at Sway—Rock and Roll Mondays. I worked at Spa, I worked at Tiswas, and then Motherfucker started. It all happened kind of within a year.

JAMES MURPHY: I would go to Spa when Justine was DJing.

JUSTINE D: I'd been a record collector since I was a teenager. And then I just became immersed in the downtown mod scene, which was really two parties, Shout! on Sundays and Tiswas at Coney Island High on Thursday nights. For two or three years straight I was going out five nights a week, just having fun, being a young person in New York.

MARC SPITZ: Don't forget SqueezeBox at Don Hill's. Tiswas, Motherfucker, and, later, Misshapes. These all flow from the river of SqueezeBox. It preceded everything. It was hosted by Mistress Formika, who dressed in drag and wore tons of makeup and gave serious attitude.

ROB SHEFFIELD: Mistress Formika was presiding over the scene at that super-scuzzy club. It smelled like mildew, and that's when people could still smoke there. It was glorious. There was no dress code and no posing; it was just: dance, drink, get up, do your thing, listen to music.

JUSTINE D: They had the most crazy video up on the TV screens. It was like gay porn custom-spliced with seventies cereal commercials. It was so disturbing.

ROB SHEFFIELD: The first time I went, the DJ was so good that I made a tape of all the songs he played that night so I could simulate the experience. From ACDC's "Touch Too Much" to Dusty Springfield's "Haunted" to Led Zeppelin's "Misty Mountain Hop" to the Donnas' "You Make Me Hot."

MARC SPITZ: Everyone who was anyone on the downtown scene was there. Gay, straight, rock stars and celebrities, Courtney Love and Joey Ramone and Debbie Harry and Drew Barrymore.

THOMAS ONORATO: SqueezeBox. I went to all of those. Courtney Love would get up onstage and Drew Barrymore would be dancing on the bar.

JUSTINE D: I first met Thomas there, actually. He is the quintessential seasoned New York doorman.

MARC SPITZ: Everyone had to know Thomas. If he liked you, you were in, but he wasn't nasty like a Studio 54 doorman.

JUSTINE D: He was very mean to me at the door, almost made me cry. Very cunty.

THOMAS ONORATO: I was mean a lot, but also you never truly got my mean side unless you acted like an asshole. But Don Hill, he had ushered in that wave, the whole gay rock thing with SqueezeBox, and then he ushered in Nick and Justine with Tiswas.

NICK MARC: We moved Tiswas to Don Hill's in maybe 1998, and that's when we brought Justine in. It just seemed like an obvious thing to do. She had great taste in music, she looked fantastic, everybody loved her, and she's not a fuckup in any way.

ROB SHEFFIELD: Jenny Eliscu has some stories about the bathroom line at Don Hill's.

JENNY ELISCU: I used to have such a good streak of making out in line for the bathroom at Tiswas! It was kinda crazy. But then they moved them—the men and the women were far away from each other, so you couldn't have a heterosexual bathroom-line make-out anymore. That's when things took a turn.

THOMAS ONORATO: Tiswas mattered to me because I was an Anglophile, whether it was David Bowie or whether it was Blur and Oasis and that was the music that was played there.

JASON GORDON: That was the thing with Tiswas. All of a sudden here is a nightclub that plays Britpop that you love, and they are dropping a Jonathan Fire*Eater song and then they also play, like, the Rapture's "House of Jealous Lovers" and a Strokes song. And a White Stripes song.

JUSTINE D: Tiswas also booked every band just by default of being a local band.

SHAWN CHRISTENSEN: You really couldn't find success in that time unless you were part of that club circuit. All of the bands we're talking about played Tiswas at one point in time or another.

THOMAS ONORATO: I saw the Strokes play Tiswas at Don Hill's with a hundred other people.

JUSTINE D: There was a rumor that either the first or second show the Strokes played there one of the guys had sex with a girl down in the Don Hill's basement, and someone snapped a photo of whichever guy's butt it was.

NICK MARC: There was a curtain under the stage at Don Hill's. Girl Harbor, which was the band that played before the Strokes that night, went behind the curtain after both bands had finished and there's a certain Stroke shagging a girl on the drum riser. They took a photograph of his spotty ass and used it as their next flyer.

APRIL LONG: I have that flyer! The one with Nick's butt!

ROB SHEFFIELD: Justine did Tiswas and this other party, Motherfucker. Motherfucker was just on holidays. It was for special occasions.

THOMAS ONORATO: Motherfucker was really Michael T's party, in the end.

JUSTINE D: Michael T—who's very sassy; I'm sure you know—brought us all together and said, "I have an idea for a holiday-weekend-only rock-and-roll extravaganza. And I want it to be a mixed bag of people, I want it to be drag queens standing next to mods standing next to normal people standing next to ex–club kids." Four hundred people came to the first one. It just happened

very naturally and we had tapped into something. I think because the city was in a state of Giuliani oppression.

ROB SHEFFIELD: You have to remember, the very idea of dancing to rock music was mind-blowing. Tiswas and Motherfucker were fantastic in terms of saying, "Rock and roll is something to dance to! You don't need twenty minutes of German Balearic trance twiddle-step remix in order to justify dancing to something, you could just dance to the Kinks or Supergrass."

JENNY ELISCU: Motherfucker only happened on these three-day weekends and they had it in a few different places—one I remember on the far west side, one in Chelsea, but it was always three floors and it was dark and brick and metal, and you weren't sure where you were, just wandering around a crowded stairway until you're in the disco. It was very gay friendly, which was fucking awesome, and also contributed to the festive atmosphere. But the fact that it was three-day weekends, everyone was, especially at that age, just pretty fucked up.

ROB SHEFFIELD: It was at all of these horrible midtown clubs that you hated to go to. You'd go there and the bouncers would give you a look and you'd think, "Ain't nobody here for bottle service! Everybody's here to get super fucking high and sing 'Warm Leatherette.'"

JUSTINE D: It was a really great time in New York because it was still pretty gritty and we did it in the Meatpacking District when it was meatpackers and black tranny hookers, and people having full-on sex on the dance floor. It was crazy. It was great. With Motherfucker we were able to provide a safe haven for people with a very alternative lifestyle. We always thought that the misfits were the stars.

DANCE MUSIC WILL SAVE US ALL?

DAVE GOTTLIEB: Obviously, when grunge happened, alternative became a big deal. Then, when Kurt killed himself, the whole paradigm shifted because the only band that can wave the flag is Pearl Jam and they recoiled from that. They get in a fight with Ticketmaster, which prevented them from being on the road. They stopped making videos. So, what is alternative at that point? Now REM is a pop band and U2 are playing arenas and stadiums.

JAMES HABACKER: We went from rock music, which was the greatest thing ever, to Lenny Kravitz.

DAVE GOTTLIEB: You have the Beastie Boys doing their thing, but they're leading another world. Sonic Youth is looked at as the band that swung and missed. Teenage Fanclub missed. The traveling circus of Lollapalooza collapsed. You have Oasis and Blur, but they're not ours. In the post-Nirvana days, it's aimless out there.

GIDEON YAGO: When I started at MTV in 1999, I was still in college. There was this running joke about me in the morning meetings pitching a Guided by Voices story. This is during the era of Britney Spears and *NSYNC. Really what was selling was pop music. Britney Spears was selling two million records in a given week.

MARC SPITZ: The biggest band in the world was probably Korn or Limp Bizkit. Papa Roach were on the cover of *Spin*. POD were on the cover of *Spin*. It was the height of nu metal and the biggest star in the world was Eminem. I mean, he was on the cover of *Spin* three times in 2000. Everyone was waiting for the next thing and the next thing was supposed to be dance music.

TIM GOLDSWORTHY: Around '88, we had a big revolution in the UK.

DOMINIQUE KEEGAN: The Summer of Love.

TIM GOLDSWORTHY: In '87 I was wearing all black trying to look like I was in the Velvet Underground, and then it was suddenly about ecstasy: shaved head, all of us out in the field, dancing.

SIMON REYNOLDS: It was initially based around imported music from America—Chicago, Detroit, and New York house music, and techno. But very quickly people started making very homegrown British music. And in England the vibe was determined by ecstasy. So there was a lot of breaking down of gender barriers, sexual barriers, racial barriers, a lot of idealism. People would go along to these parties and raves, not expecting it to have such a strong impact on their life, but it wasn't anything like the typical clubbing. Clubbing in the eighties had been sort of cool oriented, cold and posy. This was people losing it in a mass way, a collective high, dancing all night. Especially the events that were illegal and unlicensed in barns or warehouses; those events had a tremendous electric atmosphere of anarchy. So people embraced that idea of clubbing all weekend without sleep, having that high, and then crashing. You couldn't wait until the next week. You got locked into this lifestyle of raving. After you had that experience, it was quite hard to go back to seeing a band onstage.

TIM GOLDSWORTHY: Electronica—horrible thing but that's what I'm going to call it—was starting to take in Britain. You were seeing people like my first band, Unkle, going from selling a few twelve-inches to suddenly selling a lot and touring and doing festivals and becoming proper bands.

SIMON REYNOLDS: It was about beat and sound culture in Britain. Massive Attack was one of the main Bristol groups, and their whole strategy was they were like record nerds. They took these obscure soul, jazz records, and some post-punk ones as well, and they would take the best bits of them and create new music out of their record collection. That was the big thing. That is where Tim Goldsworthy comes from, the beat scholar and sample scholar. It was a generation of smoking weed, taking other drugs, and being very sensitized to all of sound, the textures of sound, sound that could create intense pleasure and pictures in your mind. A psychedelic dance culture.

JAMES HABACKER: I had a club over in the Meatpacking District called Plush that I opened in '95. It was a dance club. At that point pretty much everyone's attitude was rock and roll was dead and it was all dance music.

MOBY: I remember going to Under Acme to see a friend's band—it was some indie rock band—and there were all these people standing around holding Rolling Rocks wearing flannel shirts, not talking to each other and not dancing. I was like, "This is awful." Then I went later that night to the Limelight and it was like fifteen hundred people on ecstasy, jumping up and down, dancing like crazy, and I was like, "Clearly, this is where I need to be."

JONATHAN GALKIN: This was the era of Twilo, Limelight. I wasn't into the drugs that people were doing there. I like drugs, but that scene . . . I'm not going into a K-hole. It had a sinister vibe. Like, "This doesn't seem nice, I'm not going to make a lot of new friends here tonight." And also—lots of people would slap me for saying this—it didn't seem like it was about the music. It was supposed to be about fun, but then they murdered someone.

MARC SPITZ: Michael Alig was convicted of manslaughter around '97.

JONATHAN GALKIN: That's not how the party's supposed to end.

JAMES HABACKER: The drugs always influence the music. The ecstasy got really good, it got really designer, and then I think at a certain point there was a lot of strychnine in the ecstasy and we all stopped doing it because it was like you'd wake up and all your joints were aching. But there was a period where that was the drug of choice and I think that had an influence on things musically.

MARC SPITZ: In the late '90s, there was very much a post-rave thing still happening. It was Daft Punk, Chemical Brothers, Prodigy, and Moby. He had a real connection at *Spin* because he was like the egghead's connection to hedonism.

SIMON REYNOLDS: The Prodigy became MTV stars.

ALAN LIGHT: *Spin* did a Prodigy cover before I got there. On the one hand it was, "Okay, there's an interesting thing happening here," and on the other hand it was "God, this is being forced down our throats as a phenomenon."

MARC SPITZ: I sort of, like, looked down a little bit on the raver people as maybe a little deluded, the way that you would maybe look at someone who was into *The Secret*. When Oprah said, "Here's *The Secret*, here's how you're going to get your brand-new Volvo hatchback," I was just like, "I'm not sure this is a revolution."

MOBY: There was a lot of reason to believe that rock and roll in any sort of leather jacket, New York Dolls sense was not coming back, ever.

"THAT WAS REALLY THE BIRTH OF DFA"

SIMON REYNOLDS: New York seemed very romantic.

TIM GOLDSWORTHY: When we first came, we were going to these loft parties in Williamsburg and I was expecting the new Liquid Liquid or the new Jungle Brothers or the new performance-art-new-wave-no-wave-someone-slashing-themselves-or-shitting-on-other-people, but no! There were really lame drum-and-bass clubs where people were reading poetry and playing bongos. Then there were the Centro-Flys and Limelights, which were just nasty, not fun. We got over there expecting it to be like we're coming home to the birthplace of all the records that we loved, from the Velvet Underground to Silver Apples to Television to Public Enemy. Like, every single part of my record collection that is important, this is where it happened. This is the birthplace. But instead, we get there and it's just "shoo bee doo doop doop doop" house. We were like, "What the fuck is going on?"

DOMINIQUE KEEGAN: Marcus and myself used to throw parties. There was a lot of money around and the East Village was very quickly becoming gentrified but bars were still cheap.

MARCUS LAMBKIN: Dom always had ideas about starting a label.

DOMINIQUE KEEGAN: I was more, "Let's fucking go! Let's do some shit!" Marcus was like, "I don't want to open a bar, I don't want to throw parties." And I was like, "Shut up, we're doing it." Perfect combination.

LUKE JENNER: When I first met him, James Murphy didn't like two things: he didn't like Bob Dylan, and he didn't like disco.

JAMES MURPHY: I was in a band called Pony.

BRIAN LONG: Pony were good, man.

JAMES MURPHY: And I was in a band called Speed King. Nobody gave a fuck about me.

TYLER BRODIE: I met James at Brownies. He was playing pinball. He was playing in bands but mostly recording every other band that was around at the time.

DOMINIQUE KEEGAN: James was this super-rock-and-roll-looking kid with this long chain through the wallet.

TYLER BRODIE: He would grow his hair out and sell it for wigs. He had really lustrous long hair.

DOMINIQUE KEEGAN: I remember being obsessed with how straight his hair was.

JAMES MURPHY: People grew up in scenes but I didn't have one. I was alone in my town. I was by myself. There was no guidance, no critical mass, but there was incredible unguided access to stuff. I had one of the best record stores in the country within fifteen minutes of my house and that's where every dollar I had went.

JONATHAN GALKIN: I had the older brother getting me into 4AD records. James had Princeton Record Exchange.

JAMES MURPHY: I remember buying the Birthday Party record because of the cover. I was not cool. What I was, was an obsessive audio nerd. It made me no money. Got me no points. That was part of my definition. I wasn't going anywhere. I wanted to, but I wasn't. And oh god, I was aggressive.

JUAN MACLEAN: I was going to school at Providence College, but I didn't graduate because I started my first band, Six Finger Satellite. It was a very post-punk-influenced band with a disco rhythm section, angular guitars, and scary synth noises.

SIMON REYNOLDS: They were the very first group I came across who started referencing the post-punk era again. I did a piece on them in '96 or something, and they were going on about Chrome, and about, I don't know, PIL and the Stranglers. There was no one doing that at that time.

JUAN MACLEAN: James became Six Finger Satellite's live sound engineer.

JAMES MURPHY: Juan and I met in '90 and we did not like each other. But after I started going on tour with them, we became sound-nerd buddies.

JUAN MACLEAN: Around 1994 we spent a lot of time on tour sitting in a van, just James and I, driving everyone crazy incessantly talking about recording. We were just obsessed with it. At some point he had become a fifth member of the band because he was doing so much with the live sound. Then he helped produce our last album. Shortly after that was when I quit the band. I just felt very uninspired. Indie rock in general, which was what it was starting to be called, it had gone in a direction that I really hated.

TYLER BRODIE: I was bored of rock. I assumed we were going to move on as a culture. And that was the problem with all the bands in the nineties, they were all just guitar, bass, and drums—just boring. There's only so much you can do with that.

WARREN FISCHER: Take Elliott Smith. You couldn't get more serious: the singer-songwriter guy pouring his heart out. And I'm not trying to take away from Elliott Smith, because I really respect him, but that is so encoded. Like, how you present that, what kind of photography is associated with that, what kind of song titles you're limited to. There's a history of it that's encrusted with decades of other people doing it: Nick Drake, Bob Dylan, and you can keep going. It's very hard to crack through all this fucking legacy of the genre. It was like, "Oh, so actually that's the most plastic thing that you could ever do."

TYLER BRODIE: James had the only studio that I knew of. It was called Plantain. He liked the name because it was the lesser of the fruits.

JAMES MURPHY: Plantain was my old studio in Brooklyn. The guy who lent us a couple of thousand bucks for the studio said he invested in plantains.

TYLER BRODIE: I'm from North Carolina and I went to film school at NYU. I started doing music stuff the summer in between freshman and sophomore year. My friend and I bought a bunch of gear but didn't have a studio. I wanted to start a record label but James

was always hesitant. I knew he could record sound much better than I could so I figured he'd be a much better person to run a recording studio. Of all the people in the music scene that I met over those years, he was the most impressive. I wanted to see what he could do.

JONATHAN GALKIN: Tyler is a patron of the arts.

TYLER BRODIE: I had all this gear so I basically said to James, "I'll let you use it if I can use your studio occasionally." He had this place in Dumbo. Now it's probably very expensive, but at the time it was super sketchy. You couldn't leave anything in your car or it would just be gone. Maybe six months later the landlords decided to kick everyone out of this studio and around the same time I bought a building in the West Village, so we just moved it all there. Freshman year at NYU I lived in a dorm. I was ready to get out and I had just inherited money, so why not just buy something? I proposed that to my father, who had a lot more money, and we decided we would buy something together. He bought the Plantain building with the intention of giving it to me.

MARCUS LAMBKIN: The big opportunity came through Dom's girlfriend. She knew this guy Tyler Brodie. Tyler approached Dominique.

DOMINIQUE KEEGAN: I met James through Tyler. I was dating an English girl called Charlotte who knew Tyler because he was in NYU film school with Jonathan Galkin and Darren Aronofsky and all these fucking assholes that we just used to rip the piss out of.

TYLER BRODIE: First, I decided to renovate. I had a Labrador and I had a roof and the only way to get up to the roof was a ladder, so I kind of wanted to build stairs to the roof for my dog, Jackson. So I had an architect in for that. He hung out up there a lot. He lived at the studio. Also, we were right next to Integral Yoga and we got all these noise complaints, so it also seemed like a good time to soundproof. The architecture just kept growing. I had started the company but I was still in college, so I interned for myself for credit at school. James would write my reports because he was the only other person officially at the company. I did very well.

MARCUS LAMBKIN: Tyler was giving James a studio space and it was eventually going to be a label.

TIM GOLDSWORTHY: James had done sound for BS 2000.

MARCUS LAMBKIN: Adam from the Beastie Boys had another band, BS 2000, with the guy from Suicidal Tendencies.

TIM GOLDSWORTHY: So he'd been hanging out with Adam Horovitz on tour in Japan.

MARCUS LAMBKIN: Adam and James were buddies.

JAMES MURPHY: We played basketball two or three times a week at PS 41. I'd go hungover. We'd be covering each other, just sweating drugs.

MARCUS LAMBKIN: Tyler wanted a recording studio, a movie production house, and a record label. That was the original idea. He asked Dominique to start a record label and Dom said, "I only want to do it if I can do it with this guy Marcus." I said, "Sure, great, sounds awesome."

TYLER BRODIE: We had Plantain Films and Plantain Records. Originally this was with my friend Jonah Smith, from school. But Jonah and James were just . . . I remember some lunch somewhere where it seemed obvious that it wasn't going to work with them, so I figured I would just keep them separate. I introduced Dominique and Marcus to James on the day—that great day—that *Dr. Octagonecologyst* by Kool Keith came out.

JALEEL BUNTON: We were obsessed with that album, too!

TYLER BRODIE: Dominique and Marcus were making a track for Plant and James was around the corner in the East Village. I was like, "I should put these guys together!" That also didn't go so well. I mean, they got along but we kept the two labels separate. James had his recording studio and then there was Dom and Marcus doing Plant. I say a lot that James had to be separated from people? Yeah, well it was true in a lot of cases. When the Plant building was still under construction, James made the architect, Domitilla Enders, cry.

DOMINIQUE KEEGAN: I would never say James is my favorite person. I would say James is a complete cunt. I have a huge amount of respect for him and a huge amount of love for him but he's a cunt. And his best friends would call him that.

JAMES MURPHY: It's part of the deal. I'm obsessive-compulsive. It's part of the parlance. We can laugh but it's what I'm gonna do. I found a cassette recently of my band practice from 1983, eighth grade, and I realized what a nightmare I must have been. We're playing and the song is wrong and I hear me stop and I hear me trying to be laid-back and say, "Oh, that's wrong. Maybe we can play it right." I'm thirteen years old and I'm already like, "This is not the way I want to play this song." "We're just having fun." "No we're not! We're not just having fun! We have to do this right!" That was already there.

DOMINIQUE KEEGAN: James was going to be Tyler's indie guy and we were going to do the dance label. I love Tyler to death but he's not a super-hungry go-getter kid to make it happen. He would collect these people and kind of set them up and could afford to do that properly.

MARCUS LAMBKIN: When Tyler got the building finished and it was time for people to move in, he basically offered me a job there. He said, "Why don't you come and give up the day job, and come and run the record label from the building?" James was putting his studio in the basement at the same time. You could say Tyler is the classic trustafarian guy. But also, he didn't just waste it away, you know? He was giving a lot of people careers and lives. He did want to do something creative. He wanted to do something really cool and bring together a lot of cool people under one roof and try to make something awesome. Dominique was at work at the record label, and in my time off between cabinetmaking, which is what I did for work, I'd go down into the basement and work on a record. Darren Aronofsky was in the other room editing *Pi*.

TYLER BRODIE: Darren went to AFI and I met him at Sundance the year he had shot his film but didn't have enough money to edit it. So he was at my house editing.

MARCUS LAMBKIN: James was around being James.

DOMINIQUE KEEGAN: When I first met James I didn't realize what a fucking visionary and genius he was. He'd say things and I'd be like, "Whatever. What do you fucking know?" But in hindsight that motherfucker knew what he was talking about.

MARCUS LAMBKIN: James hated dance music at the time and thought it was all C + C Music Factory and the stuff on MTV, and I was like, "Pfff, you and your punk rock." I started playing him good dance music but every time I was like, "Dude, check this out, this is the best record ever," he would say, "That's just a Can sample or Liquid Liquid." Every *single* time I would play him a record, he would play me the original track that it sampled. So it was this great education for me and for him. We hit it off. He really liked the sort of dance music I was playing him. And I was getting schooled. All my heroes, I was just like, "They just sampled all this stuff?!"

JAMES MURPHY: When I was a dummy, I was the rock-and-roll dummy. Marcus was like, "This is Unkle," and I was like, "No, that's Liquid Liquid, that's Suicide, that's Silver Apples, that's Can." I'd play it for him. After that, we got along. He was like, "Okay, you know the records that the guys I like are culling from to make their records. I am drinking from the same well of this stuff that I don't know anything about."

DOMINIQUE KEEGAN: One of the most important things I remember James saying to me and Marcus was to hit things when you are in the studio. Just pick things up and hit them. Just hit things and make sound. That's a pretty good place to start, actually.

TIM GOLDSWORTHY: I came over to New York in '99. February the thirteenth. I remember thinking, "This is the safest place I've ever been to in my life."

JAMES MURPHY: Tim thought he'd get here and there'd be people break-dancing on street corners and he got here and there was a bunch of strollers and it was boring.

TIM GOLDSWORTHY: We got up early on that first morning because of jet lag. We went out and it's, "Ahhhh! There's steam coming out of the streets!" We thought, "This is nuts! This is New York!" We went up to somebody's house to ask for directions, hoping they were going to pull a gun on us, and instead they're like, "Oh, you're not from here?! You should check out this place and that place." Everybody was really nice. It was really disappointing.

SIMON REYNOLDS: The idea of whether or not dance music was truly embraced in America is complicated.

DOMINIQUE KEEGAN: What people expected to happen didn't really happen. Dance music didn't take in America the way it had in the UK, but at the same time, that scene created the first wave of indie kids who really got into dance music, like Luke from the Rapture and James, who was a punk rocker.

JONATHAN GALKIN: I had a context for dance music, well before DFA. Andy, my older brother, was bringing home lots of stuff from Wax Trax!, when house music was active and acid house compilations started getting into the import bins. Dance music came out of the import bin, and the import bin was the cool club.

TIM GOLDSWORTHY: American indie music had completely lost its sexiness. It was all that sorry-I-have-a-penis kind of indie rock, which James was a part of.

JAMES MURPHY: Tim was cool. I was not.

SIMON REYNOLDS: Tim was the archetypal British engineer guy. He had very delicate hands, him being a bit of a watchmaker. That's a British archetype of the guy who owns a lot of records and knows all about music making.

MARCUS LAMBKIN: I was psyched! You know?! I was like, "Tim Goldsworthy is coming over!? Tim Goldsworthy. He's this guy, he makes all my favorite records," and I would always be playing James that Mo' Wax stuff.

JAMES MURPHY: Nobody cared about Tim here, but Marcus was a huge fan.

DOMINIQUE KEEGAN: He was really Marcus's idol. We used to call him Goldfinger, the guy with the Midas touch, Tim Goldfinger, because he was very good. Tim was the original guy with James Lavelle in Unkle, terribly famous guy.

SIMON REYNOLDS: James Lavelle was one of these guys who was a nerd but managed to turn it into cool. I think of him as a breakbeat version of Quentin Tarantino. A guy who built a whole aesthetic around nerd knowledge, the kind of guy who has a huge collection of Star Wars memorabilia and vintage sneakers. The Mo' Wax records were very stylized and well-packaged.

JAMES MURPHY: When I met Tim I didn't like him. He was really cocky and English and aloof.

TIM GOLDSWORTHY: I came to New York with David Holmes, who I think is a forgotten link in all this. Without David a lot of this would not have happened.

JAMES MURPHY: There's pre-Tim and pre-Holmes and then there's post-Tim and post-Holmes. Pre–David Holmes there was no fun. He ignited something.

DOMINIQUE KEEGAN: David Holmes is the biggest prick I've ever met in my life.

TIM GOLDSWORTHY: Well, Dom used to really annoy people.

DOMINIQUE KEEGAN: I actually dislike David so much that it's kind of pushed through to the other side. He's a remarkably smart and talented individual, he just didn't like me from the beginning. There was a personality clash.

DAVID HOLMES: Dominique? I mean, I just know him to say hello to. I don't remember us hanging out.

DOMINIQUE KEEGAN: I think originally Tyler brought him over to DJ.

DAVID HOLMES: Marcus invited me over to DJ. I came over and it just blew my mind. I decided to go back to New York and make a record.

DOMINIQUE KEEGAN: Marcus was really good friends with David from his years of raving in Belfast.

MARCUS LAMBKIN: We'd have these parties 'til six in the morning and then it would be a caravan of cars coming out of Belfast to my mom's house in the suburbs of Dublin, drinking teas, having these crazy comedowns.

DOMINIQUE KEEGAN: David is really such a hustler and such a charismatic person. Peroxide hair with bright orange armpit hair, coming out from Belfast and throwing raves where both Protestants and Catholics would go. In like '89/'90, that was a big fucking deal.

PHIL MOSSMAN: He's really hard as well. He beat up Chris Robinson from the Black Crowes when we were in Los Angeles. I was in the bar with him. He went for a piss, and when he came back,

there were all these security guards running around. He was like, "Tighten your shoelaces. There might be a bit of a bother. I just smacked some hippie in the toilet." Some hippie being Chris Robinson, who just started dating Goldie Hawn's daughter, and it was all over the tabloids. "I've just thumped some hippie. I got him with an uppercut." Apparently Chris Robinson was being a bit of a tool and David said, "Fuck off," so Chris Robinson called David an English cunt, which to an Irish Catholic from Belfast is a punchable offense, so he duly obliged him.

DAVID HOLMES: I can't believe Phil told that story.

PHIL MOSSMAN: David was a lot of fun. He would always be DJing and go out and get into all kinds of scrapes.

MARCUS LAMBKIN: For his first album, *Let's Get Killed*, which came out in 1997, he said, "I'm coming to New York. I want to drop a lot of acid and walk around and record people." We went on these crazy trips, from the Empire State Building to the Twin Towers and everywhere in between, on LSD, recording all sorts of stuff.

SIMON REYNOLDS: David Holmes is one of those guys who is obsessed with soundtracks. The record-collecting culture in the nineties— it's about looking for records that are good to sample. Soundtrack albums, obscure jazz records, fusion records, live records. They were called "bag boys"—they would have the record bag and show up in the couple square miles where all the used record stores were. It was a culture of knowledge about where to find breaks and where to find things to sample. The Chemical Brothers were part of it. It kind of cut across various dance scenes. And David Holmes, even though he is from Northern Ireland, was part of that crate digging, and creating-a-soundtrack-without-a-movie scene. All these people are film buffs, too, but for the soundtracks.

DAVID HOLMES: I've always been into soundtracks. *Midnight Cowboy* is one of my favorites of all time. So I decided to go down that path. When I got to New York, I said, "Rather than me sample, why don't I just go with, like, a tape recorder and just record all the freaks from the street." That was *Let's Get Killed*, which did really well. I became addicted to the city. It just became an addiction.

MARCUS LAMBKIN: David made this great record, and then he wanted

to do another one. So when I met James, I saw the studio, I was like, "You have to come record at this studio, this place is amazing, you have to come see it."

TYLER BRODIE: David Holmes came over to New York to DJ one night but I was in Hawaii. Marcus said, "We've got this guy David Holmes here. Can he stay at your house?" I'm like, "Okay, sure, whatever." So for like a week or two weeks while I was in Hawaii he was just living in my house.

DAVID HOLMES: Tyler was just a really lovely person. Super sweet and super nice. I mean, the fact that he let us stay at his house for like three months or whatever it was was just extraordinary.

MARCUS LAMBKIN: And David flew over with Tim.

TIM GOLDSWORTHY: We had just done the *Out of Sight* soundtrack together.

DAVID HOLMES: *Let's Get Killed* was responsible for me doing *Out of Sight*. I got the call and then I met Steven Soderbergh.

TYLER BRODIE: I come back from Hawaii and hang out. David was like, "Yeah, when you finish your recording studio I want to record in there." He had a record deal, so they were paying money. That sounded good.

TIM GOLDSWORTHY: We got taken out for dinner with Tyler Brodie. Tyler has a brownstone the next block over from where Plantain is on Thirteenth Street, and we were all staying there while we were doing the LP.

MARCUS LAMBKIN: They recorded some stuff and that's where James met Tim. They hit it off.

DOMINIQUE KEEGAN: That was really the birth of DFA.

"TOMORROW NEVER KNOWS"

TYLER BRODIE: We spent two and a half years building this building; we thought we might as well throw some parties.

BRIAN LONG: Those parties were just bacchanalian.

TYLER BRODIE: The guy who lived in the building before was named David Deutsch and he was a successful painter. I've seen his work at the MoMa. There was one floor in the building where he cut out a large chunk of the ceiling so he could work. He painted huge. And where the guy painted the thirty-four-foot canvases I had a basketball goal. So we'd play ball in there. That was also where we had the parties.

JAMES MURPHY: The first DFA party we had Crazy Legs and Rosie Perez on crutches. We invited punk kids, electroclash kids, drag queens, businesspeople, weirdos. Everybody had to feel like it wasn't their place, and it worked incredibly. Everybody was out of place! This is exactly the party we wanted!

TIM GOLDSWORTHY: Then there was also this Saturday night party, which Marcus and Dominique did, called Sticky at a club called Vanity.

DAVID HOLMES: Oh my god, what a fucking terrible name. But actually really apt.

MARCUS LAMBKIN: Vanity was up on Twenty-First Street, which was quite far away for people to go at this stage. Twenty-First Street was, you know, that was pushing it. It was sweating it if we could get people to come up that far. But it was a great venue; it had this big room that was kind of dark and jungle-y with lots of plants and tiger-skin wallpaper. And then they had the shitty little tiny crappy basement.

TIM GOLDSWORTHY: Upstairs they had the main room—I'm trying to think whether it was actually called Sticky or we just called it Sticky because the carpet was really sticky in the basement.

DAVID HOLMES: A lot of lives changed in that basement.

MARCUS LAMBKIN: Good pills were starting to come in.

JAMES MURPHY: This was the Mitsubishi ecstasy era of New York.

DOMINIQUE KEEGAN: For some reason there were a ton of Irish kids in New York this one summer. It was the first time Mitsubishi showed up in New York, which was an ecstasy pill that brought house music back in the UK and in Europe in the late nineties. And it was all over New York all of a sudden.

TIM GOLDSWORTHY: There was this basement area at Vanity, which was tiny, and they were all like, "David, do you want to come and play records down there?"

DAVID HOLMES: I was playing Can next to MC5 next to Alice Coltrane and Blondie, the Stooges, Liquid Liquid, a bit of psych and really killer soul, Stevie Wonder, Public Image, Miles Davis's *Bitches Brew*. I mean, it was just an insane mix of music.

TIM GOLDSWORTHY: Marcus and Dom were playing shit at the club, which was just horrible. Downstairs in the basement it was us and the Irish lot and their crew: Phil Mossman, Darren, myself, and Jen, who's an important part of it. She's now my wife. At the time she was Marcus's girlfriend. It got really fucking Fleetwood Mac by that point.

TYLER BRODIE: It was a weird time. We were young.

DOMINIQUE KEEGAN: Tim started dating Marcus's ex-girlfriend Jen, who's now his wife, but Irish people don't care about that. It's like, "I'd rather my ex-girlfriend date my best friend than some asshole down the street." It was a small country. That's how we are. Your sister is going to end up marrying your best friend. That's the way it is.

TIM GOLDSWORTHY: It was absolute fucking mayhem. We would finish in the studio on Saturday evening. We'd go to Café Loup. Get the lamb. Have a bath. Go out, and then come back probably about Sunday eight P.M. And then have quite a creative few days in the studio after that, believe it or not.

MARCUS LAMBKIN: Holmes was DJing the first night we stuck a pill in James.

TIM GOLDSWORTHY: For the first month or so, James wasn't taking part in the drugs. Because he was still American indie, "Don't do that, it's uncool." He was still with his ex-wife. Her family invented plastic bags. She lived in the same building where Iggy Pop lived, the Christodora building, in a stupid-sized amazing apartment. And she's very old-school American indie. He was coming from his post-indie thing, which was a bit tiring. I don't think it was necessarily that he was a failed rock star. He had been successful at what he was doing. It was more . . . with James, where a switch flipped and then he decided he wanted to win.

JAMES MURPHY: I smoked a lot of pot and then I quit. A lot of my friends were junkies and a lot of people died so I wasn't super like, "Give me some drugs, man." But I was really uptight and had been for some time.

TIM GOLDSWORTHY: So yeah, we weren't pushing the drugs on him too much. But he came out a few times and, in a very James way, every five minutes would be like, "And how are you feeling now? Is it really good? Ah, that sounds amazing. And how are you feeling now?"

JAMES MURPHY: I'd already seen David at Marcus and Dom's party. He wanted to do a basement thing underground after making the record, so we just went. There were just a bunch of people, though we hadn't quite gelled as a crew as yet. We were not yet the DFA wrecking crew. I'd just go and listen.

TIM GOLDSWORTHY: But then it happened. I guess James probably got clearance from his therapist that he should do some ecstasy, because he was big into that. Three-times-a-week therapy since he was like six or something. So one weekend James decides that he can do it and he buys about twenty packs of Juicy Fruit because he's heard or read somewhere that you chew a lot of gum when you're high. Within the first half hour he's so excited that he's handed out his chewing gum to everybody in the club, so now there's a whole nightclub full of people chewing Juicy Fruit.

MARCUS LAMBKIN: That's classic James, to get prepared for something. To get all kitted out and have everything ready.

JAMES MURPHY: I was like, "Sure, I'll try one." I was just going to try it to try it, but then it was the greatest thing ever! It was fucking awesome and I was dancing and I was happy and I had a revelation: This is actually me. I was fully me. I was dancing and I was fully conscious. I wasn't sloppy. I wasn't drunk. I was alert and I was aware that I really enjoyed dancing. "This is me dancing. This isn't the drugs dancing. This is the drugs stopping myself from stopping myself from dancing."

DAVID HOLMES: I watched his life completely change in that moment and it was beautiful.

TIM GOLDSWORTHY: Because David, Phil, and I are old hands at this, we give the signal and David put on "Tomorrow Never Knows."

JAMES MURPHY: I peaked right when David played "Tomorrow Never Knows," which is my absolute favorite song from childhood. And they were all around me chanting my name and pointing at me and I was losing my shit to my favorite song. It was great.

DAVID HOLMES: He just went insane.

TIM GOLDSWORTHY: James was just like, eyes rolling back in his head. And young ladies who were friends of ours started rubbing themselves on him. You could see him having this "ahhhhh" moment.

JAMES MURPHY: People talk about drugs, and it's very dumb but the reality was very clear to me: I was really connected to what I cared about. And after that moment I danced to what I cared about. I was changed.

TIM GOLDSWORTHY: It's like, you can't understand the blues unless shit has happened to you. Well, DJ Harvey said you don't understand dance music until you've had group sex on ecstasy.

MARCUS LAMBKIN: I was up and down the stairs all night, but I do remember coming down at one point and James is on the dance floor with a random girl, the two of them just hugging, him dancing with his eyes closed, you know? Classic. We were all looking at each other, laughing hysterically.

TIM GOLDSWORTHY: After that, James and I could connect properly.

"NOBODY WAS GOING TO GET PAID.

NOBODY WAS GETTING ANY CASH."

JAMES MURPHY: Everyone shared this idea that New York should be better and that stars should exist here. Otherwise go move to Chicago.

SIMON REYNOLDS: Early on, I wrote about DFA, and the framing paragraph asked when was the last time was there was a really cool, local label? There was a void in New York, and that's what DFA tapped into.

MARCUS LAMBKIN: I guess it was weird that James and Tim hit it off the way they did. They hit it off musically in a way I didn't understand, you know?

SIMON REYNOLDS: It did seem like a two-man operation. Odd couple. It was classic archetypes: the very low-key, diffident, intricately minded Brit and the voluble, charismatic, louder American. And he had a great spiel, James did.

JAMES MURPHY: I mostly work alone because I'm too difficult for a lot of collaboration. Like when you get into a deep religious discussion and you get into a conflict like "That's not God and we can't talk anymore." The conflict for me is "I cannot play this music if it's not exactly how I need it to be." I can't hurt people's feelings. It hits this deep conflict where I fall asleep or I get a panic attack. Tim was a special case.

TIM GOLDSWORTHY: Right away with James, I could reference things and he'd instantly get it.

JAMES MURPHY: I soon realized we had an insane amount in common.

We were both huge Smiths fans. Now, in contemporary talk that's like, "Of course, who wouldn't be? What maniac would hate Led Zeppelin?!" But in 1999 it was not cool. There's no explaining that to people. We were both like, "We know that's not cool but that's our taste."

DOMINIQUE KEEGAN: Tim and James loved each other.

TIM GOLDSWORTHY: I liked how Americans have this kind of I'm-working-on-a-car vibe in the studio.

JAMES MURPHY: His first show was going to the Ramones with his brother and my first show was the Ramones. America had grunge and England had acid house. Everything was the same in our formative years. But I was the guy in shitty bands and he was the guy from Unkle. He was cool. I'd never met anybody cool before. I didn't understand. A magazine is calling the studio asking, "What's Tim doing?" It was quite exciting.

BRIAN LONG: That's who he was. He was the guy who'd been doing live sound with Six Finger Satellite and he had this studio and was working with a guy that used to work at Mo' Wax. That was James.

JAMES MURPHY: We developed a secret language. I was very excited to be like, "I'm communicating with somebody! I'm not carrying him! He knows something that I don't know! And I know stuff that he doesn't know!" We were talking about how we were going to take over the world.

PHIL MOSSMAN: So yeah, we were taking the Irish ecstasy, going out every night, working every night on the Holmes record, partying all the time. It went on for months. A lot of writing in the studio. We'd go out and we'd find Jon Spencer on the street, say to him, "Come down and sing a song."

JON SPENCER: I knew those guys, yeah. I asked Unkle to do a remix of the Blues Explosion song "Bellbottoms." In those years we were looking outside of rock and roll or indie. So I met Tim, and then he ended up in New York. I did a guest vocal for a David Holmes record they made in New York.

PHIL MOSSMAN: Holmes asked him to come and sing on this track we

had called "Bad Thing." That was one of the most amazing record-ing sessions I've ever done.

DAVID HOLMES: I had this kind of crazy sort of, like, sermon, from the deep South. And the phrase was "We've got a bad thing going on." Kind of ironic, actually: it was like staring me in the face from the first recording! We did have a bad thing going on! But I played Jon the sermon, and he went into the vocal booth and just fucking destroyed it.

TIM GOLDSWORTHY: By this point, it was turning more and more into a me-and-James kind of party, because I was starting to really love working with Jon Spencer and all these Americans. The dream is starting to come true. And David's just kind of off doing his thing, so it's starting to get a bit rough.

JON SPENCER: There was a whole drama between Tim and James Murphy, and David Holmes. I never understood what happened but it was bad. David does not speak highly of James now and Tim does not speak highly of James.

DAVID HOLMES: I went there with the best intentions to make a great record, and we all partied our asses off, and then things happened, life happened. When there's a bunch of people living together, working together, getting out of their faces together, it's going to end in tears.

JONATHAN GALKIN: There are some raw wounds there. Because David kicked James out of the studio.

TYLER BRODIE: At some point David decided that Tim and James were colluding against him.

DAVID HOLMES: I didn't know James. I thought we were just going to rent the studio and Phil was going to be our engineer. Then James quickly became the engineer. I was making a very big jump from making a sample-based record to working with live musicians.

JONATHAN GALKIN: Maybe David was also threatened because James could play every instrument in the room and David could play no instruments in the room. David was the guy in the room that would say, "I want my song to sound like this," and he would put a record on, and it would be, like, the opening drum break from a

Can song, or a reggae song, or something, and James was like, "I can do that." That is straight-up, like, egos clashing.

JAMES MURPHY: He was like, "We are going to make a record like Can." I was really offended by that. Can were people who worked at the Musée Arteum and the keyboard player won the best young conductor award in Europe and as his reward he traveled to New York and met the Dream Syndicate people and John Cale and it blew his mind and he went back and formed a band with the best free-jazz drummer in Europe and they played together eight hours a day in a house with no distractions. You don't know what the fuck you're talking about.

PHIL MOSSMAN: Like in any Holmes adventure, the chaos ensued. It was a collision of different management styles.

JONATHAN GALKIN: There is a fucking sitar that was bought for that session. That's how out of control things were, who buys a sitar? What Britpop idiot buys a sitar?

JAMES MURPHY: I tried to calm down and try my best, but at the end I felt like it was bullshit. That record was kind of bullshit. Nobody else seemed to be freaked out by that but I was. But boy, was Holmes good at getting people to do things and knowing what people want to hear. That's a real talent.

DAVID HOLMES: We were all friends once. I have nothing against any of them. It was just, when you're partying more than you are working—and, I mean, I think I was drunk every night—of course that's going to alter people's minds and paranoia sets in. When there are narcotics in the mix, it just gets fueled. And people start to sort of do their math and come up with the fucking wrong sums, you know what I mean? It's not anyone's fault. It's actually my fault. I should have said, "Okay, guys, this isn't working. This isn't going to work; if we're going to go out every night taking drugs and getting hammered, and then smoking weed all day, nothing is going to happen." I should have walked away.

TYLER BRODIE: I guess Tim and James were just agreeing more than David was.

JAMES MURPHY: At a certain point we didn't get along with David

anymore. Then Tim and I had a common enemy, so we bonded even more. We were often left by ourselves working. Then we were both frozen out.

TYLER BRODIE: David was just saying, "I don't want to work with James and Tim anymore."

JAMES MURPHY: He pulled a couple of psychological moves on us. I was really hurt. I'm a sensitive person. I take things personally. He was very welcoming to me and then he was kind of a dick to me and I was like, "What the fuck did I do?"

DAVID HOLMES: I wanted to go home, but Phil talked me into staying. So I went to Tyler and I said, "Look . . . The situation is unfixable. We're not getting along. It's a shit atmosphere, it's not working blah, blah, blah, but I would like to stay and finish the record."

TYLER BRODIE: David came to me and was like, "I can't work with them anymore but I still want to use your studio." I had just paid for this massive studio and was hoping to keep it booked for a little bit, so I was fine with that. I assumed James would be back in the studio afterward. James didn't take that very well.

JAMES MURPHY: I got mad. He wanted me out and I was like, "I'm not leaving! This is my studio."

TYLER BRODIE: We went into the big live room, which is soundproof. I don't know if he did that on purpose, but James yelled at me for a long time and told me he would have taken a bullet for me before but now, you know, he wouldn't.

JONATHAN GALKIN: Yeah, I got yelled at too. And James still held a grudge for a decade. That didn't heal.

DAVID HOLMES: Obviously that didn't go down too well. I think it took James a while to get over the fact that we were working in his studio, and he was deeply upset to say the least. He did sort of try to discredit me.

TYLER BRODIE: I was just trying to pay the bills. Anyway, from that point on I just let James handle the recording studio.

DOMINIQUE KEEGAN: David booked a flight back to London.

TIM GOLDSWORTHY: I feel bad about how I treated David at the time. I

was so excited about New York and the new possibilities that I was kind of like, "Yeah, cool, yeah! See ya! Bye!" And I feel a bit shitty about that.

DAVID HOLMES: We spent seven months making something like four or five tracks. I came home and did the other half in like three weeks.

TIM GOLDSWORTHY: So David goes off and James and I are left without any gigs. I'm homeless, but because of the dot-com boom we could just go to our billionaire friends and say, "Could you give us a million pounds to start our own record label?" They'd say, "Do you have any music?" "Nope! But we'll make some!" And that was that.

JUAN MACLEAN: "Death from Above" was originally James's idea for a sound system. It started when he was touring with Six Finger Satellite, because James was always making everything so incredibly loud and bombastic.

JAMES MURPHY: It was my nickname for sound. We just kept it.

PHIL MOSSMAN: I left New York for six or seven months, and when I came back, that's when I started taking James more seriously. It was a massive shock that James had this in him. After Holmes, James was like, "Fuck these guys. I'll get over these insecurities. I'm making a record for myself. I'm going to sing. I'm going to play everything. I'm going to learn how to DJ. I'm going to start a label." It was just this sudden, like, big bang, explosion. It just came out like a flood.

JAMES MURPHY: I didn't have some insane learning curve; the learning curve was just that I learned in the dark. I was the guy on the mountain kung fu–ing.

TIM GOLDSWORTHY: We were DJs, we were music makers, and part of making music is playing make believe. It's just in our nature that if what you want to hear is not there, we're going to get our friends together and play. We were going to spread the gospel of dance music.

JAMES MURPHY: All I wanted was to do good enough work that it was important. I wanted to be important. I didn't know what that meant, even. There's something sad about "Oh, I'll just do my

thing." It's like, fuck you. It just seems safe. I don't want it to just be "Are you humble? Okay, we like you." Would we ever have Lou Reed or David Bowie if that was the rule? How was it okay for a twentysomething Bryan Ferry to be outrageous and be like, "I'm a fucking god," in 1972, and for us to all say, "Of course! That's ordained! That's wonderful." But how dare anyone stick their neck out now? By the late nineties, that's the way things were. "I'll just do my thing." Fuck you. No.

JUAN MACLEAN: Fun and sex were two things that were very much frowned upon in the indie rock world. Dance music for us seemed to be this thing that we could have fun doing; we could DJ and have parties where you actually played music that you liked. It was exciting. Once again we were on our own in our own world, doing our own thing, giving a giant fuck-you to everyone else.

JAMES MURPHY: DFA was a terrible label. We were not making any money. Nobody was going to get paid. Nobody was getting any cash. We were a bunch of crazy people who were doing everything as a giant art project, which was what was fucking amazing about it.

"WHAT'S THE VALUE OF BEING A BAND?"

JAMES MURPHY: Electroclash and DFA had a shared idea: create the New York as it's supposed to be instead of complaining about how boring it is now. New York has a lot of spectators that are waiting for something to happen. If you do something interesting, people are going to go.

LARRY TEE: By the end of the 1990s it got stale. There was an exciting time in the early 1990s, but then, after the clubs got shuttered by Giuliani, it changed the whole vibe of the city. Musically, it was such a boring time in New York. I did the Landmark education course. They said, "What touches, moves, and inspires you?" At the time the only answer was music, so I started investigating, and I found a lot of the new electro acts, like Peaches, Chicks on Speed, DJ Hell, Ladytron. I thought, "Okay, this actually is like a punch in the nose to pasteurized music."

TODD P: Electroclash came out of people from the real art world, the tasteful art world, coming out and chilling with these people who were from the tacky art world. It led to this sort of grandiosity.

CARL SWANSON: Fischerspooner was dabbling in that scene. You know, like, hyper mediocrity.

JUAN MACLEAN: I remember in the early days with electroclash—it was very much a Brooklyn thing in terms of its identity, and we were sitting in Manhattan at DFA consciously deciding that we really don't want to be associated. We were very aware of what electroclash was in that it was going to die and fall off the face of the earth and not have a happy death and we did not want to be associated with it.

JAMES MURPHY: People were poo-poohing it but the people who were poo-poohing it were no fun. I was like, "No, no! This is retarded and awesome! Dressed-up kids and dumb little beats?! If this was 1981 you'd all be collecting the records and paying a hundred and seventy-five dollars for them, but because it's happening now it's not cool." I once had this discussion with Noah Baumbach about the kind of people we are: we wish we'd been around at the Factory, but if we were at the Factory we'd be like, "Oh, this is so boring and these people are so rude and what is that band the Under-somethings? They're so screechy."

TODD P: It was also about the gay scene coming into the warehouse party world, the underground world. If you know the history of New York in the twentieth century, most of the interesting art scenes have been when the gay scene and the straight "We just got out of liberal arts school and we're bohemians" scene hang out together.

WARREN FISCHER: The rock kids were all trying to be bands, but we were asking the question: Why do you want to be a band? What's the value of being a band? Is there any value in being a band?

CASEY SPOONER: I was around a lot of musicians, I knew a lot of musicians, but I always thought that musicians were the most uptight creatives, really concerned with what their peers thought. It wasn't the point of being an artist to me. It was to be dangerous and messy, not caught up in this code of cool.

WARREN FISCHER: Our entire career, to this day, we continue to try to put the idea into different vessels, because it makes it less knowable. "How do you have an art career when you're not an artist? How do you have a music career when you're not in music? Where do you live if you're nowhere?" It's like, we value being nowhere more than being commodified.

CASEY SPOONER: I wasn't really connected to the broader rock scene in New York. They were bands playing music; I was an artist.

LARRY TEE: People kept telling me that I had to do something for Fischerspooner and I was like, "What are they? Oh, that's not a rock band. They're an art-performance, electronic-music band that knows the art world." Matthew Barney–style. Big group dance

numbers and then sharp, pointed electro music. I really needed a rock band, but I was willing to look at everything at that point.

CASEY SPOONER: I'm originally from Georgia.

WARREN FISCHER: I'm originally from outside Los Angeles. I went to school at the Art Institute in Chicago, where I met Casey. I was in art school studying music.

CASEY SPOONER: I have no musical training. I don't really like musicians. I really don't like bands. I don't like band culture. I don't really like people that work in the music business. I don't really like the format of music. Music is a device, a form for me to use.

WARREN FISCHER: We started as a very dismissive, kind of angry statement about electronic music and about performance and its impotence.

CASEY SPOONER: We went to Sam Ash on a research trip to buy sample CDs. Warren got really excited 'cause you could buy the rights for these sample CDs that had all the sounds of popular music that you could just own and use as you wished. It wasn't expensive at all. It was cheap. He got excited about this kind of Duchampian painting-by-numbers ready-made pop idea.

WARREN FISCHER: At the time just being able to burn your own CD was a mind-blowing experience. I became really excited by the idea of being able to make music on a computer that never goes through anything analog. We've always had an aversion to analog. When I was able to make my first song or first few songs and then burn it to a CD and then crank it on my stereo—it's hard to explain how transformational an experience that was. To be able to make something that was so dead was really exciting.

TRICIA ROMANO: They had this totally weird song called "Indian Cab Driver" that was about Indian cab drivers picking up gay men from the gay bars and it was completely offensive and funny.

MARC SPITZ: I remember Jason Roth, their publicist, took me out to some bum-fuck area of Brooklyn, way pre-gentrification, and we were in a black Town Car the label was paying for and I was going to interview Casey for this big *Spin* piece, but even the limo driver had no idea where their fucking studio was, these supposed

newly minted major-label rock stars. We finally get there and suddenly I'm irritated because they were already sort of mythical, but we go up to see them and they're these two schlumpy, yawny guys in sweats sitting around a coffee table thumbing through fashion magazines and eating cereal and planning their next media stunt, and I instantly got the joke and loved them. I got along with Casey. He got the joke too.

CASEY SPOONER: The cover of *Dil To Pagal Hai* is this guy wearing sunglasses and a headset mic, so I kind of copied that Bollywood look and merged it with an American Billy Ray Cyrus motif. This was pre-trucker-hat-mullet trend. Later, that look became cool. But at this point there was no intention of being part of the music business. There was no press. There was no point in making this. Everyone was like, "Why did you make this?" And it's like, "I have no idea." That was where we started.

ADAM GREEN: My impression of electroclash was that it was a person singing karaoke to their own songs. And it would rely on that person's Warhol-superstar power to make you enjoy their show.

WARREN FISCHER: Our first performance was at Starbucks. And I was making electronic music, which I never believed in. I was staunchly anti–electronic music. And we're performing at Starbucks, which was, at the time, worse than McDonald's, in that it was a corporate idea that was feigning activism.

CASEY SPOONER: We were confronting the reality of American consumerism.

BJORN COPELAND: It was the Starbucks on Astor Place.

CASEY SPOONER: For some reason the manager had these two NYU students who were allowed to program performances. They put together this showcase and we performed our one song: "Indian Cab Driver."

BJORN COPELAND: All of a sudden you became aware of younger people who were doing homegrown stuff that was pretty left of center. There weren't a lot of places for it, so those were the kind of weird solutions that people would come up with: playing in a Starbucks on Astor Place.

CASEY SPOONER: Warren and I realized quickly, if we're going to create this pop illusion there had to be dancers and backup singers and costumes. For the second show, I built my first costume. I would start in an all-black hair suit and then I would strip that suit off and change into all-white denim, then that would tear away into the red panties, and then I would change into the white Elvis look. We brought in a wind machine, we brought in lighting. All of a sudden I didn't feel as though I was in some insular world; I felt like I was somehow going to change the world. It was theatrical, it was conceptual, there was an idea I could dig into. I felt like I was doing social work.

NIC OFFER: Each decade pays for the sins of the last. With the nineties and Nirvana it's like you had to throw out all that eighties slick crap, but by the end of the nineties all that so-called alternative stuff had turned into a new sort of slickness and so it just felt like fun. It felt punk to use drum machines and keyboards in the same way that it felt like, "Well, so now we wear these eighties clothes, but wear 'em trashy," you know? The fashion matched the music in that way. I remember I had this one favorite shirt that I found on the Williamsburg Bridge. It was just laying there. I was dressing literally from the street. That sounds made up, but I swear it was true.

WARREN FISCHER: That moment pulled me into the next century, creatively, because I could understand what the value of fun was. I could understand what the value of plasticity was, the value of mistakes. It was joyous.

TRICIA ROMANO: They built in mistakes on their CD. They were playing prerecorded music; there was no band. So they were already poking fun at authenticity. That was a big accusation against DJ culture—that there was no challenge, it wasn't real music. Casey and Warren were commenting on that. It was camp.

CASEY SPOONER: So we did that one song and then we were both like shiiit, that was kind of something.

WARREN FISCHER: I just started building a network. There was a theme. And it was also a moment where a theme didn't have to exist in a city for us, because the Internet was there. We could connect the

dots between France and Germany and Detroit and New York. There was communication. We kind of worked our record deal, without ever meeting anybody.

CASEY SPOONER: And because of the Internet, similar things to ours cropped up in one little neighborhood over here, one over there— one person was in Canada, one person was in Chicago, one person was in Berlin, someone else was in Paris. We started to find those kind of crazy connections.

WARREN FISCHER: It sounds ridiculous at this point, but being able to e-mail people on a daily basis was a habit that was very new in 1998 and 1999. These were the embryonic stages of web press or record labels having websites. The Internet facilitated our presence internationally. It connected microscopic but like-minded themes from different places. Suddenly it's not Chicago, it's not Seattle, it's not New York, it's not Brooklyn, it's not Miami, it's not Chapel Hill, it's just a sound.

13

THIS WHOLE WEB THING

JOHN HEILEMANN: The old version of the music industry was totally blown apart by the Internet, totally blown apart by file sharing, totally blown apart by digitization, by globalization. And I'm a big fan of blowing shit up. I get the despair of the labels and the industry, and I don't really care that much about that. I get the despair of the artist, and I care about that, but I also have a lot of optimism for breaking down bottlenecks and gatekeepers.

LAURA YOUNG: Where did I buy records? Oh, I don't know. I wasn't really into LPs. By that time I had things like Napster.

MARC SPITZ: Napster was already going by this point but people certainly weren't acting as if there was a hole in the boat.

MARC MARON: I didn't know how to download music. I knew a guy who did it on the Lower East Side. He had a computer and was literally doing that all day. But it was weird music. Music from other countries.

MARC SPITZ: The record companies were still spending money. There was still that winky-winky, post-post-payola, satin-jacket, record-company shit going down. That was soon going to be wiped away by file sharing. But at that point everyone was still sleeping at night.

DOMINIQUE KEEGAN: We didn't know it was going to end. In the nineties, CD sales surpassed anything that had existed before in the record industry. It was insane.

JAMES BARBER: Record companies discovered that people in their thirties and forties would buy their record collection again on CD. So people are going to record stores regularly because, "Oh, this week

the Pink Floyd album that I like is coming out again." Everything costs $18.98. So in the nineties, there was a lot of money sloshing around the music business. But it was a one-time deal.

JOHN HEILEMANN: I covered the Napster thing pretty intensely and it was amazing to be in the middle of that fight. There's that moment in *The Social Network* during that scene in the Chinese restaurant where Zuckerberg's buddy says to Justin Timberlake as Sean Parker, "Napster lost," and Sean says, "I don't know what you're talking about. Our company went bankrupt, but we changed the record industry forever and for good." And that's reality.

MICHAEL HIRSCHORN: Napster was a big deal. Napster was this massive disruption. It's not like we weren't in possession of this knowledge. The problem was that we didn't understand it in relation to our own business.

DAVE GOTTLIEB: It was like somebody not seeing their midlife crisis coming. The music industry had always, to that point, come up with another format that was more successful—from seventy-eights, to forty-fives, to full LPs, to cassettes, to eight-tracks, to cassettes, to the CD. They saw it as a benefit. They saw it as something that they could make their own. Because they were content owners. No one saw what was coming on the horizon.

JASON GORDON: I remember when I was at Random House, in our big publicity index there wasn't a folder for "Internet," like, online media. There were these categories for where to pitch people, like arts, humanities, film, book reviewers, arts critics. And I was like, "We need to create a category for the database called 'Internet.'"

JOHN HEILEMANN: The basic attitude of every New York publisher through 2000 was "This is going to go away eventually. This web shit is going to go away." Everybody was getting a website, but not getting it in a way where they believed that it was their future. It was like a defensive thing, like "We kind of have to do this."

GIDEON YAGO: Then the dot-com bubble started to crash in the early 2000s.

JOHN HEILEMANN: The crash happened in March/April 2000; the tech bubble burst, and there was a collective sigh of relief in every maga-

zine office where I knew anybody, which was all of them. Like "Ahhh, this is over now."

ANDY GREENWALD: When I was editing Spin.com I would beg Tracey Pepper, who was editing the front of the book, the "Noise" section, "If you're going to put a band in 'Noise,' can we get an exclusive MP3?" and she was like, "What's an MP3?" That's actually what it was like.

MARC SPITZ: Steve Jobs was still making Pixar movies. Technology wasn't smooth, technology wasn't cool, which is why I thought, "Let them steal their music, because it's going to sound like shit." I didn't realize how hard these young, punk pirates were working.

DAVE GOTTLIEB: I remember I was on a flight back to L.A. and I saw two high school kids with a portfolio of CDs. Only one in thirty was store bought; the rest were burns. So I asked these two kids, "All right, how do you do this? What do you do? Why don't you go buy the CDs?" And they told me, "There was only one good song on it, so it's better if I just make a mix." I'm like, "Okay, but you have this Dave Matthews CD." The kid says, "One person buys it and we all trade it." I was just sitting there thinking, "Oh my god. We're dead."

14

"I MEAN, WE WERE JUST STONED"

JAMES MURPHY: The Rapture was supposed to be the vehicle for DFA's world domination.

TIM GOLDSWORTHY: I'm back in England for a minute and Justin Chearno takes James to see the Rapture.

JAMES MURPHY: Justin's the shit, a secret A & R weapon.

LUKE JENNER: For me the stage is like a white chalk outline that's like, "Do whatever you want in here."

JAMES MURPHY: The Rapture came on and they had a klaxon going around for ten minutes while everyone's trying to plug in their stuff and Matty looked like he was nine years old and Luke came out with this scarf and the hair and out-of-tune-ly destroyed the place. I said, "This is the best! This is terrifying!" They weren't saying, "Hey, guys, hope you're having a good night." There's none of that. It was like after the show they were going to jump into a sewer. And they were fuckable.

TIM GOLDSWORTHY: I get a call on my cell phone from James after he had just seen them, which at that time must have cost a hundred and fifty pounds. "This band is great! They're perfect! We need to produce their record!"

JAMES MURPHY: The Rapture were the catalyst for everything next for DFA. It was like, "We are going to make that record for you, a record like Air's *Moon Safari* or Radiohead's *OK Computer*," the record you needed to own to feel like you knew what was happening.

TIM GOLDSWORTHY: I saw them as soon as I got back to New York and I

thought they were amazing. Luke would still carry on even if he had broken all his strings, then immediately try to get laid after the gig. It was fun.

JAMES MURPHY: We were going to build the entire party around this band.

TIM GOLDSWORTHY: We talk to them and we find out that they are signed to Sub Pop. They have like five hundred quid to make their LP. We said to Sub Pop, "We'll do the LP for free if you give us a couple of the tracks that we can put out as twelve-inches for the dance remixes." So that starts kicking off. Meanwhile, the Rapture are basically living with us.

LUKE JENNER: I was hanging at DFA every day. I didn't have a house.

TIM GOLDSWORTHY: I'm giving Luke socks and pants and stuff.

VITO ROCCOFORTE: We just booked a tour, which back then meant, you know, a list of phone numbers. You called kids and set up basement shows. But we booked a tour from Seattle out to New York and that was it. We sold everything we owned and then just piled our equipment in the van and came here. There wasn't a scene. There weren't a lot of bands. There wasn't a lot going on at all in New York and everybody knew that. There were a lot of other cities where there was way more going on. You moved to New York not because there was some great scene; you moved because there was nothing going on. And because it was New York fucking City. We needed the energy and we needed to be able to have to hustle a little more to get us going. We came for the city.

LUKE JENNER: We were good. We were ready to go. The city was wide open.

VITO ROCCOFORTE: A lot of us came from the hardcore scene in San Diego, where there's Gravity Records and all those hardcore bands. It was really loud, really abrasive, kind of attacking.

NIC OFFER: I happened to be hanging out in Portland and I saw them play to eight people at a Todd P show. I feel like they were very Wall of Sound or Spacemen 3, but really brutal, very ferocious.

LUKE JENNER: I really needed that aggressive energy. I grew up in a really unsafe house. I'm an incest survivor; I had a very traumatic

childhood where nobody listened to me. I was also a frustrated baseball player. I just need to be seen and heard.

VITO ROCCOFORTE: We put out our first record on Gravity, because we loved that label. But we were really bored with that indie rock/ punk scene, in terms of the shows. Everyone would just kind of stand there and be like, "Hmm." If they really liked it, you couldn't even tell.

LUKE JENNER: I worked at Angelica [Kitchen]. I was a delivery guy. I rode a beach cruiser around the East Village. It was a dream because, my first week, I delivered food to Joey Ramone. Joey fucking Ramone answers the door and he's like ten feet tall, and he's got an eye looking one direction. I'm like, "Dude, this is fucking nuts!" I deliver food to him and also the Beastie Boys. I'm just standing there at their door with food and they're like, "Does anybody have any cash?" I would make juice for Russell Simmons every day. My favorite one, though, was when Molly Ringwald came in. I had a really big Molly Ringwald crush. She came in and I was cutting daikon or some shit. It was like, "Dude, New York fuckin' City!"

DOMINIQUE KEEGAN: James was like, "This guy really needs a job." Luke had never had a job. Work was the most alien thing he could think of. I had to teach him how to sweep the floor. So we gave him a job at Plant Bar.

GIDEON YAGO: Plant Bar, on Third Street between D and C, that was a big dot-com ecstasy electronic music hangout. And like all the things that sprung from DFA, it was about that spirit of "Let's get fucked up and go out and party."

SUROOSH ALVI: James Murphy was the fucking bar back, and Dominique was one of the owners of the place.

SIMON REYNOLDS: It was a great scene. Crowded, smoky, vibrant.

DOMINIQUE KEEGAN: I came from a very entrepreneurial background and I knew that there was more money in selling alcohol than in anything else. We were a load of stoners, hence the name Plant, which was actually short for Plantain.

MARCUS LAMBKIN: Dom lived in this building in the East Village on Third Street that had this bar on the ground floor called Latin in

Manhattan. The owner was this dodgy Puerto Rican guy. He was Dominique's landlord. The bar was always empty. Dom was like, "If you give me the place and let us take it over, I'll turn this thing around." He wanted to expand the whole Plant thing and kept it going, and me being a cabinetmaker as well, I gutted the place, renovated it, designed and built it, and we got James to come in and put in the sound system.

DOMINIQUE KEEGAN: Marcus wanted to have an ant farm in there.

TYLER BRODIE: Instead there was, like, this whole wall of clear, foggy plastic that basically looked like glass, but then on the other side was plants, so it looked like, you know, a plant bar.

DOMINIQUE KEEGAN: I spent a lot of time on Canal Street experimenting with different materials until I found the right one. Our friend Mel got behind there, carefully placing each dried leaf with fishing line and under lighting so there would be different amounts of blurriness. Later, Swedish architects would come and photograph it for design magazines but, I mean, we were just stoned.

TYLER BRODIE: I was not involved in the bar financially. I got free beer and they used our name. It was just a perfect spot. It had a seventy-four-person occupancy, a great DJ booth, and this sound system James designed.

MARCUS LAMBKIN: What did James want? Way too much power. Waaay too much.

DOMINIQUE KEEGAN: It was built on hustle. One night we were sitting getting fucked and I was like, "James, if you were going to build your dream sound system, how much would it cost?" He was like, "Ten grand." I was like, "Okay, ten grand, fair enough." I got the money out of this digital jukebox company, Muzu. We gave them a party with this DJ from L.A. and I said, "Ten thousand, and I'm going to spend it on the sound system." They said, "Sure, but you've got to put up a plaque in the bar: 'Thanks to Muzu.'" We did the party and two weeks later the Internet bubble burst. That I managed to get a check out of them was a fucking miracle. I really felt like I got the last check that anyone ever got from the dot-com bubble.

GIDEON YAGO: Giuliani caused a major shift in the look and feel of the

East Village, but then you couple that with people in their early to mid-twenties making really good money in the dot-com boom and wanting to fucking party. Lost spaces, little forgotten pieces of New York, suddenly seemed like great spots for concert venues. Rich dudes with dot-com money got into the business of opening bars or starting record labels.

TODD P: It was the afterglow of the New York dot-com explosion. You always think dot-com equals Silicon Valley but there was this Silicon Alley thing, and there was all this IPO money in New York. All those rich people were buddies with people who did metal sculpture who also went to Burning Man who also had a whole floor of a warehouse in Williamsburg. And those were the parties where you could get laid.

GIDEON YAGO: Then when the dot-com bubble started to crash in the early 2000s, you had a lot of people who were smart, creative, out of work, with a little bit of severance pay, and many of them started to go into making music.

LUKE JENNER: Plant Bar became a hub of the scene.

PHIL MOSSMAN: It was a big deal for James because that's where he learned DJing. It was a clubhouse for that scene. I was an insider so I didn't give a shit. Luke from the Rapture, pulling pints around the bar? I always thought it was a bit of a shithole, to be honest.

DOMINIQUE KEEGAN: We lived upstairs and what went on upstairs was even wilder. Originally, the bar had this huge mirror down the side of it. Our living room was a dungeon so I took the mirror upstairs. For a while, it was up on my wall, but of course eventually someone said, "Let's take it off the wall to do lines!" Before, we were doing them off a plate. A white plate, which made no sense.

TIM GOLDSWORTHY: Darren Aronofsky would turn up at Plant Bar with a wifebeater on, leaning on the bar, "Hey, guys, what are you drinking?" He's such a tosser. He really reminds me of the super-nerdy Dungeons and Dragons kid who really wants to be cool.

DOMINIQUE KEEGAN: Film people are annoying.

LUKE JENNER: Every day I would open the bar listening to *Ziggy Stardust* and *Screamadelica*. They put $10,000 of sound equipment in

this bar and you could fit, like, maybe twenty people on the dance floor. Maybe. They had this amazing sound system and I would just sit there. No one would come in for, like, six hours, so I'd practice DJing, just goofing around.

DOMINIQUE KEEGAN: As opposed to having regular bar backs like anywhere else, people who are hardworking, we just hired kids who really needed a job. It was so enjoyable though because all these kids came from totally varied backgrounds but none of them had any concept of a work ethic whatsoever. I would walk in and see twenty-five empty glasses.

LUKE JENNER: And they never fired me! One time I left the door to the bar open. Another time I locked somebody in the bar. A customer! All night! They passed out in the bathroom and I forgot to check.

DOMINIQUE KEEGAN: Poor customer.

LUKE JENNER: I lived on Houston and Avenue A so I would sometimes just walk home with a pint of Guinness. What a fantastic job.

DOMINIQUE KEEGAN: Matt from the Rapture started working there when he was nineteen.

MARCUS LAMBKIN: We used to call Matt "Malibu" because he drank Malibu and Coke at Plant. He was too young to get in. We used to have to sneak him in.

DOMINIQUE KEEGAN: Our cleaner was this amazing old black guy called Marvin from the seventies. He loved Marvin Gaye—wore the knit skullcap with the beard. I didn't find out until years later that he had done fourteen years in prison for armed robbery. It was Marvin who discovered the guy asleep in the bar. We always left Marvin extra money for cleanup he had to do that wasn't his job. This, like, four-hundred-pound Dominican dude would come and work security. I remember him asking me, "Hey, Dom, what's your door policy?" I said, "If they look like junkies let them in and if they look like they have any money, tell them to fuck off."

LUKE JENNER: There was this weird writer enclave that would hang out. And then, you know, Interpol and the Yeah Yeah Yeahs, and those bands.

DOMINIQUE KEEGAN: Oh yeah, Nick Zinner was there all the time.

KAREN O: There was a little patch where it was a regular spot that we used to hit. My friend Dan—I went to Oberlin with him—he used to DJ there, so we used to go and hang and check out his DJ set and Luke was probably bartending. He's a strange dude, right?

LUKE JENNER: I didn't know Karen very well but she once came early to the bar to talk to me. She was really concerned about being in a band. Like "Should I keep being in a band? Should I just not do this?" Obviously there was a right answer to that question. Obviously she didn't want to not be in a band, but for some reason she was just feeling that way that day. I was like, "You're right next door to being really famous. If you just hang out for five minutes someone will come here and hand you a pile of money. You're super talented." It was a weird moment. I don't know if this is true, but there was a rumor that she wasn't allowed to talk to me because apparently her boyfriend at the time, the dude from the Liars— gigantic Australian guy, huge, like, ten feet tall—apparently he was afraid that something was gonna . . . All he knew was I was the other dude around who was into ESG.

KAREN O: I was a pretty bad flirt back in the day. A criminal, criminal flirt. I was making up for lost time.

MARCUS LAMBKIN: We had Felix da Housecat come down after every gig. Ad Rock played there with Kathleen Hanna one night. We had Fatboy Slim popping in, and everybody playing for free.

LUKE JENNER: I remember walking to Plant Bar one time and there used to be this famous graffiti piece by this famous graffiti artist . . . can't remember who, but the Strokes were taking their picture in front of it. You know, to be very New York. I remember *glaring* at them, just being like, "Fuck you guys." There was this fashion designer, I can't remember his name either, but he hung out with the Chloë Sevigny crowd and made these really weird circular bags. Julian Casablancas showed up one night to fight that dude, because he had said something derogatory about the Strokes. That guy was huge, like the high school quarterback. Jack White and Julian Casablancas, those dudes will fuck you up.

DOMINIQUE KEEGAN: Friday nights we would close at four and we would kick everybody out except for our few select friends. We had these

big steel gates and we'd lock the gates, but we had a secret entrance to our building and at four or five people would start knocking at the gates and the phone would start ringing.

JAMES MURPHY: Sometime during this time, we celebrated my thirtieth birthday. For a cake Tim brought me Roxy Music's *Stranded* LP with thirty lines of cocaine on it. This is the cocaine era of New York.

DOMINIQUE KEEGAN: There was a very strange, I presume Puerto Rican, woman that used to come in, drink a lot of Heineken, and dance. She had rather obese legs and she used to try to give these young hipster kids lap dances. She scared them out of their minds! I finally had to ban her because she was so frightening. *She* was the weirdest person in there.

TIM GOLDSWORTHY: Plant was important because you could go out and you could have fun until two in the morning. But the power that comes out of continuing that fun until ten o'clock the next morning in a group of like-minded people is incredible. You're getting into a magic area there. An awakening. Plant Bar gave us a space to do that.

15

CABS WON'T EVEN GO THERE

DOMINIQUE KEEGAN: We're talking about a time when the East Village was the most important neighborhood. Williamsburg was just starting.

TODD P: Brooklyn had the worst of both worlds—it was seen as both being where your grandma's from and also a place where you're going to get killed.

LUKE JENNER: Brooklyn was where you'd go if you were twenty and you didn't have a fucking clue. If you were cool in your town and you were, like, ready to graduate, or you went to Oberlin, you moved to Brooklyn. You would get off the L at Bedford and people would be looking at your shoes because they'd never seen shoes that looked like that before. It was baby cool, it was like training wheels for being cool. Alphabet City, Lower East Side, that was it. That was the coolest place in the world at the time.

DOMINIQUE KEEGAN: I used to go to Williamsburg because I had a friend that lived there and because there was this great weed spot on South Second and Driggs. They sold these huge dime bags.

AUSTIN SCAGGS: You could go into any bodega and buy weed. You could buy like a nickel back in the bodega. It was fucking nuts.

SUROOSH ALVI: It was a lot grittier; none of the luxury buildings were there, none of the—I hate to use the word "yuppies," but it wasn't a family scene, no strollers. There was no money.

JUAN MACLEAN: I only knew the name. "Brooklyn." Like, I didn't know where it was. I probably didn't even know that you could

take the subway and get there from Manhattan. There was simply no reason to go there.

DAVE SITEK: I moved to Williamsburg, and I called my friends in Manhattan and said, "Come out to Brooklyn." It was like I was asking them to go to China on a single-engine prop plane. "I'm not going all the way to Brooklyn. Brooklyn!?" I mean, you couldn't even get cabs out to Williamsburg.

JUAN MACLEAN: DFA was very Manhattan-centric. The building is still in Manhattan. That's what real New York seemed like at the time, because we were all referencing this old-school Lower East Side noise art-rock scene.

ASIF AHMED: The CB's culture just completely dissipated and all the rents in Manhattan started getting jacked up during that first dot-com bubble. Everyone had to move out to Williamsburg. I was like, "I spent my entire life coming to Manhattan, now I've got to go to fucking Brooklyn?! I've got to take the J to the G?!"

GIDEON YAGO: At the end of the day, people lived in Brooklyn because it was cheap.

DAVE SITEK: It was so cheap. That's why it attracted so many creative people. And it wasn't just music. All these really incredible painters and artists of all kinds wound up in Williamsburg because you could get a warehouse and you could make as much noise as you wanted and no one complained.

BRIAN CHASE: I guess at the time it felt . . . it felt free, in that artists like to have a little room to make a mess. There were a lot of people moving here for that reason, but without any pretense, just because it was a place that allowed for that possibility. Open loft spaces that didn't feel precious. They weren't "loft spaces," they were just loft spaces.

DAVE SITEK: That all kind of led to the impression that "Oh, this is where the artists live."

ELEANOR FRIEDBERGER: I went to New York for a week and I said, "If I find an apartment by the end of the week, I'll move here." One day I walked from Carroll Gardens to Williamsburg and I was like, "I think this is where I'm supposed to live." Manhattan wasn't even

an option. It was where I went to work. I didn't really know anyone who lived in Manhattan.

TUNDE ADEBIMPE: The way I met my first band was at a loft party. I didn't know anybody, so I went out on the balcony and smoked a cigarette. I looked down and there was this kid stumbling across these rooftops. He was staring at me and I waved to him. He gave me this signal of "I'll be right there." He climbed up the fire escape from another roof, came up the wall, and goes, "Do you have a beer?" We went through these people's fridge at this loft, took a six-pack, and left. And eventually I wound up starting a band with that guy. That's the way things happened then. There were no cell phones. E-mail was what I did with maybe two friends from high school. After that night, we lost track of each other, bumped into each other a week later. "What time is it?" "I don't know, three o'clock?" "Wanna go get some forties and hang out in the street?" "Yes, yes I do." I'd lose track of him again, bump into him again, and it was like, "Where are you going?" "I'm going to this rehearsal space to play with my friend Dan. Do you want to come along?" "Sure." Then we're in a band together. The idea of synchronicity, of just being free in the streets, that whole idea of having the time and space to get bored, that existed in Brooklyn then.

ELEANOR FRIEDBERGER: Living in Greenpoint, you would just see somebody and be like, "Who's that?" Because there weren't that many people who weren't Polish. It really was that simple.

SUROOSH ALVI: The Brooklyn music scene was Yeah Yeah Yeahs, Interpol, Rapture. Nick Zinner was living on Metropolitan Avenue. Interpol was practicing underneath our office on North Fourth. Every day we'd see them, Carlos coming in with his fucking crazy outfits. Paul Banks. We were friends with all these guys. We were coming up together.

GIDEON YAGO: *Vice* was seven card tables in a building. And that building was also where Interpol had their practice space.

DANIEL KESSLER: There was a bit of camaraderie there.

KAREN O: I've always seen those guys as masters of mischief and perversion. More playmates to have fun with, you know?

SUROOSH ALVI: We moved from Montreal to New York around '99. We had an office in the city for six months or a year, on Twenty-Seventh Street. We'd moved to the big city with our new investors, having gone from welfare to being paper millionaires overnight. We got fancy offices on Twenty-Seventh Street with pink couches, gold cappuccino machines. I won't get into the details of what our business plan was, but we just spent way too much money too fast, the bubble burst, the economy collapsed, and our main investor was out. He retreated to Nantucket and we're sitting in our office on Twenty-Seventh Street going, "Where is everyone?" So we retreated to Brooklyn. Triple Five Soul, the clothing company, were our friends. They had a space on Wythe and North Fourth, and they were like, "You can work in our warehouse." We did a midnight move. We rented a van and stole all the furniture from the fancy office. Not all of it—we didn't take the pink couches. We took plants. I unscrewed the mirrors from the bathroom myself. Tables, file cabinets, all stuff we still have, and we moved out to Williamsburg.

GIDEON YAGO: You'd see *Vice*, this free magazine, in the lobby of the pizza place next to CBGB's.

ROB SHEFFIELD: I read it. It was always stacked somewhere. You would read it while waiting in line for the bathroom everywhere. That's where it was. The do's and don'ts were really funny. The writing was really good. Even when it was terrible it was very chatty-slash-bitchy.

KAREN O: I loved the do's and don'ts! They captured it all. They had their finger on the pulse.

GIDEON YAGO: It felt like the more upscale version of zine culture. They covered local bands and comedians and writers and photographers and cool skaters. It was a blog before blogs. If what brought you to the East Village and rock and roll in the first place was looking for a place to belong, looking for a community to be part of, *Vice* was the must-read paper.

DANIEL KESSLER: I remember first seeing it—this free glossy magazine from Canada that was pretty raunchy—and thinking, "How are they getting away with this?"

SUROOSH ALVI: On a Saturday night back then, on your walk home, you'd see some old-school crackheads and you'd see some prostitutes.

JALEEL BUNTON: We shared that rehearsal space with Interpol. It was the only rehearsal space around. It was on hooker row.

SUROOSH ALVI: There was one coffee shop, the Verb Café; one bookstore, that little minimall on North Fourth; and that was it. Williamsburg was sketch.

JALEEL BUNTON: There was always at least four hookers working, Hasidic minivans driving down the strip. That was a big staple. Their bread and butter. And that was also the drop zone, between Berry and Wythe. But the hookers would be fixing their makeup in the side mirror. I was friends with them. At the end of the day, it was the same three or four fixtures. For the record, I didn't fuck with them. Some of the hookers were so, so rough. There was this one who liked me and when she stared at me, I swear to god, she took her head off and put it back on. She was so high and so out of it all the time that she just looked ferocious, truly demonized. It was sad. It was intense.

SUROOSH ALVI: We had Larry the crackhead, who would shadowbox outside our office every night. He once chased our friend Eddie down the street with a rusty screwdriver.

JALEEL BUNTON: Larry! Larry was the sweetest crackhead you'll ever meet. He was once an up-and-coming boxer. I don't know what happened. But he'd be out there, high as shit, mostly naked, sweating. He had chalk and he would draw "WBC Champion" on the ground, making a little ring, and he'd be out there sweating. He was a character. He'd always be like, "You need a speaker?! I got a speaker. You need a refrigerator?!"

SUROOSH ALVI: When we first moved into our office on North Fourth, in the mornings, we'd come in and walk up stairs that were covered in syringes and crack vials. You'd have the prostitutes giving blow jobs to truckers. We'd be like, "Do you mind?" And they'd look at us like, "You're in our house, motherfuckers." And we're like, "Right, sorry."

ELEANOR FRIEDBERGER: This girl that I lived with, Helen, she got a job at the Verb Café on Bedford and the person that she worked with the most was Kyp Malone from TV on the Radio. I would go and meet them after work and we would get all the sandwiches and food that didn't sell and we lived off of that.

NICK ZINNER: I needed a job and Karen needed a job, so we all worked at Triple Five Soul for like twenty-five dollars a day.

SUROOSH ALVI: Triple Five Soul were a brand that we carried and sold in our other stores in Toronto and in L.A. They're friends of ours.

NICK ZINNER: We had those jobs thanks to Sitek.

DAVE SITEK: Triple Five Soul was just like a B-boy hip-hop clothing company. They made hoodies. But the thing that really made them stand out was that they had secret pockets so you could put bags of coke or weed in what you thought was the label; you could peel it back and there was a little pocket in there. We were friends with the people who started it. Karen and Nick needed a job, so I was like, "Oh, just come sell these clothes with us." It didn't make any fucking sense. Nick selling B-boy clothing? It was all just to help pay the bills while we were figuring out the struggle. Those two are like my brother and sister.

GIDEON YAGO: The only other thing around was Kokie's, which was, like, the local bar where you could buy shitty cocaine. The coke bar, called Kokie's, I mean, come on.

SAM FOGARINO: I wish I could say I didn't remember Kokie's but I was very familiar. I was like, "This is . . . No way, for real? It's called Kokie's and you can go in and there's coke booths for you to do your coke in?" God, I love New York.

ALEX KAPRANOS: That bar was amazing, but when I first started out with bands, the idea of doing cocaine, it was like, "That's fucking yuppie drugs, you know? Like, who can afford *cocaine*? What kind of a guy would take cocaine?" We were like, "That's not us. That's what bankers in London would do."

SUROOSH ALVI: I started a magazine only because nobody would give me a job. We were trying to fill a void, trying to talk about the things that aren't being talked about, give a voice to people that

don't normally have a voice. If we're doing an article about prostitution, let's get the prostitutes to write the article. Let's get the guys dealing the drugs to write the articles about drug dealing. Let's get the guys in the bands to review the music. It was just our community. We were in a community of musicians, drug abusers, and prostitutes, and we all needed something to read.

"THEY GOT SIGNED FOR HOW MUCH MONEY?!"

JUAN MACLEAN: DFA was a Manhattan thing. Brooklyn was dangerous. You didn't go to Brooklyn because it's terrifying there. Then, around probably like 2002, James and I went to Luxx in Williamsburg. That was really, like, my first awareness of Williamsburg. There was someone DJing there and whoever it was played my record. That was really big. I think it was the first time I had heard my record in a club. It was really exciting.

ROB SHEFFIELD: Basically, there was Club Luxx on Grand Street, which is a fucking dump and a half, and on Saturday they had Berliniamsburg.

LARRY TEE: My club Berlinium started out in Brooklyn. It just exploded. I bought a loft in Brooklyn and all was good. Suddenly I was DJing around the world. Hedi Slimane was there every week, practically, with a pad and pencil. We were borrowing from him too. He said Williamsburg was the new Berlin and that's why we named our club Luxx Berliniamsburg.

ROB SHEFFIELD: It was cheap to get in. There wasn't a velvet rope, there wasn't a VIP list. If you wanted to get in, you got in, even wearing a T-shirt and jeans; there was no clothesology going on. Everyone was just there to dance and to listen to music and if you were me to jot down notes about the song you were hearing and hopefully try to find a copy. People were there for the druggy aspect of it. There were some pretty long lines to the bathroom. But it was the whole idea of going out to a club just to dance. To me going to a place like Twilo would have felt like filling out an application.

SIMON REYNOLDS: Twilo is where all the visiting European and British DJs and bands would play. Thousands of New York kids would come and take loads of drugs every week.

ROB SHEFFIELD: This was a refuge from all of that. It was a refuge from the bottle service. Bottle service at Club Luxx or even Don Hill's would have been a bottle of Clorox. Like, scrub your own corner of the floor to stand on. The deal was, you didn't have to deal with a velvet rope and a clipboard and bottle service, but you couldn't yawn. You couldn't sit on the floor, and you couldn't yawn.

CARL SWANSON: The Larry Tee and electroclash thing, for me, that's what the era really was. It was the beginning of Scissor Sisters, and as it turns out, it was the beginning of Lady Gaga.

ROB SHEFFIELD: It's funny that the kind of sound that they were doing at Club Luxx, six years later Lady Gaga was selling out Madison Square Garden with it, and blatantly, like, not trying to play it down, because that's where she came from.

TIM GOLDSWORTHY: What did I think of that scene? I thought it was fun.

LARRY TEE: Everybody performed for us at one point or another, from James Murphy to 2 Many DJs to Soulwax, from the Libertines to the Yeah Yeah Yeahs.

TIM GOLDSWORTHY: It was fun but it was obviously flawed because there wasn't anything of real substance to it. Everybody wished there was but there wasn't.

CASEY SPOONER: We went from the first big New York gallery show to our big breakthrough moment. We played this show and there was a power outage. One of the editors from *Index* magazine was there and he thought it was staged. *Index* did a cover and things started to build.

TRICIA ROMANO: When I first saw Fischerspooner I thought they were ridiculous because I didn't understand, but when you put them in an art gallery then it has a sort of frame.

CASEY SPOONER: Two months later we did another big gallery show at Gavin Brown's and this is the show that Larry Tee came to.

LARRY TEE: I was blown away.

CASEY SPOONER: My feelings for Larry Tee are complicated. On one hand, I have such fond memories for what he did for me and how supportive he was and how he was there from the get-go, but on the other hand I'm really disappointed that he went to *Rolling Stone* and leaked the financial numbers.

TRICIA ROMANO: There was a bidding war over Fischerspooner because Larry Tee was in charge of pimping them out to all the labels and trying to get the hype going. And he's very good at this.

CASEY SPOONER: At that point we were already signed to Jeffrey Deitch's label—he gave us a studio and the support of the gallery. We were already making all this stuff without label support. We were working toward the biggest New York gallery show we'd ever done. And in the middle of that, that's when we get a call from a record label. They wanted to fly us on the Concorde to London. So we said, "We'll go on the Concorde."

VITO ROCCOFORTE: Fischerspooner got signed to a crazy deal back then. Who knows if this is all made up but someone was like, "A million pounds." And you're like, "What?" I mean, I loved that song "Emerge" but they were an art project, really. That's what made them awesome. But a major-label band? It was like, "This is crazy."

CASEY SPOONER: Everyone loves to talk about the money thing with us, but it's because Larry Tee leaked the numbers and he wasn't supposed to. He did it to promote himself.

LARRY TEE: I started working the record companies off each other. It was going to be a small deal for them at first and then we got Warner interested. Then we got Ministry of Sound involved and finally it went up to a $2 million deal.

TYLER BRODIE: That was big. I just remember hearing that number. Everyone was getting, you know, five grand to get an album made.

CASEY SPOONER: Basically, we just said no to everything all the time. We were like the girl they couldn't have. And eventually, we got an offer we couldn't refuse.

TIM GOLDSWORTHY: It was like, "Fucking hell! They got signed for how

much money?!" They weren't really part of our scene. They were just seagulls who swooped in with fancy videos, stealing Wire's best song and nailing it all onto the whole electroclash press. All of a sudden they were the kings.

CASEY SPOONER: I tried to deny the number, I tried to deny it for years. I avoided it as much as possible, but there was just no way I could cover it up. It changed the perception of the project and it made it more about a swindle and less about a celebration. That really pissed me off. Meanwhile, the Strokes and the Yeah Yeah Yeahs made equal if not more money, but that's not part of the story. They're *artistic*.

WARREN FISCHER: I remember that DFA was doing a party at the Apartment or whatever that place was, in Chelsea. We went and Tim Goldsworthy came up to me and said, "I just want you to know that I think 'Emerge' is the most brilliant piece of techno I've heard in a long time." I knew that there was some love, but they also had a bigger machine. They had a different trajectory with the whole label and all of that.

TIM GOLDSWORTHY: They are such fucking leeches, those guys. They were just like, "Oh, what are you up to? How are you doing it?" I don't trust them at all. Opportunists, without a doubt. But we had suddenly become aware that there was more going on than we thought.

CASEY SPOONER: I think out of $2 million I made $200,000. I bought a suit and I went to Italy. I went on this Italian vacation for two weeks with my boyfriend and we got so fat. I felt like Richard Burton and Elizabeth Taylor. It was hard for me not to be like, "Oh my god, I'm rich! Caviar for everyone!" I was so white trash about it.

JAMES MURPHY: Electroclash mattered to me because it was fun.

ROB SHEFFIELD: I loved it. It was a very democratizing kind of dance music. It was very defiantly non-esoteric. Electroclash is one of those things that, like, within days of the name being formed nobody wanted anything to do with it. It was the kind of thing where everybody that was blatantly electroclash was like, "No! We're not electroclash!" You get lots of people complaining that it hurt their careers, but at the time it tied into this whole thing of Williamsburg

and DFA and this entire movement to open the physical pleasures of club culture to people who were not card-carrying members of club culture. In a way it was sort of like the Ramones going against prog rock back in the day. They were like, "Yeah, you can have the time signatures and the costumes and the dry ice and the smoke and the light show. We're just going to go, 'One, two, three, four, hey ho, let's go.'"

JAMES MURPHY: It was about going to all those parties and finding the fun and trying to take whatever worked into DFA.

TIM GOLDSWORTHY: James was hugely influenced by seeing what Fischerspooner did. Not musically but being like, "Wait, if you take this and you take this and you take this and just push to the head of the queue, that's an amazing business model!" He was just absorbing everything, like, "Oh, what's the best store? What's the best magazine? Who's the coolest person?!" James was beginning to bridge that gap between that aggressive businessperson and the record nerd.

MARC SPITZ: You could not pay me to listen to a Fischerspooner album. I remember walking out of their Hammerstein show as soon as the confetti came down and Casey stopped "Emerge" for the fifth time just to let people know it was a tape. But I utterly respected the rock-and-roll swindle aspect of it. They really were like the Pistols of the late nineties. They took the last of the record company money. They really did.

Leslie Lyons

The Strokes at Café Noir in Soho,
December 2000, after one of the
Mercury Lounge residency gigs.

PART II

THE CLASS OF 2001

"THOSE GUYS ALL GO SO FAR BACK"

JAMES HABACKER: You just knew: rock is coming back. This is a rock town.

NICK VALENSI: I remember what Julian was wearing the day I met him in middle school: blue jeans and a white button-down shirt. The shirt had the name of his former school on it—which was funny to me, that he wore the uniform from his old school to the first day of his new school. I was thirteen, he was fifteen.

JULIAN CASABLANCAS: We met at orientation at the Dwight School.

FABRIZIO MORETTI: Dwight sucked.

STEVE RALBOVSKY: The acronym is "Dumb White Idiots Getting High Together." Dwight is where the kids that get thrown out of other schools go.

FABRIZIO MORETTI: It was always pretending to be a good school. It's just a bunch of rich people, but you know what? It prepared all of us for what the truth is: everybody is just faking it.

JULIAN CASABLANCAS: I think Nick chose a team for some nature walk out in the Bronx. That's when we decided to become friends.

NICK VALENSI: It was also my first day at that school, so obviously neither of us knew anybody. They broke people off into groups, and I asked him to be a part of my group. We were the only two people with long hair. He looked like someone who I might be able to relate to.

NIKOLAI FRAITURE: Julian was cool even before the band. He was cool from first grade. We went to Friends School, on the Upper East Side. I don't remember meeting him but I remember when our

friendship was solidified. We were six or seven. Our school had a water main break. It was in the morning so it was right after class started and everyone had to go home. My parents were working and they couldn't come to pick me up, so Julian told me to come home with him. The water main didn't get repaired for three days so I just stayed over.

FABRIZIO MORETTI: Nikolai was always around. Julian has this very attractive way of being, even on a subconscious level. People run the risk of wanting to bend towards his wishes. And at that time, the way I saw it, Nikolai was the only one who *Julian* would bend to. That changed, but I remember Nikolai's school got out later than ours, and Julian would wait for what seemed like a long time, for him to come home and just hang out.

NICK VALENSI: Fab was in my grade at Dwight—I didn't have classes with Julian, but I had English and French with Fab.

FABRIZIO MORETTI: Then they found out Nick was actually better at French than they initially graded him so he moved. We were all friends. But I always felt like I was chasing them, like I wasn't cool enough. They would kinda let me in every once in a while. They were thick as thieves, those two. I would try to hang out with them, and it always felt like a privilege when I did.

NICK VALENSI: He was a very, very innocent, young-seeming individual. And very funny, but also he was the kind of kid who could be the teacher's pet a little bit, but also be the class clown a little bit. Girls liked him, guys liked him. He didn't really have problems with anybody.

MATT ROMANO: Fab was a good student.

FABRIZIO MORETTI: I felt like I always had to get good grades, so I had to work hard, but all I wanted to do was hang out with those guys. And they could not give a fuck about grades. But they were both highly intelligent. That's something I learned about Julian in the very beginning. He always seemed very detached, but when he was forced to answer the question, he would get it right.

MATT ROMANO: Julian was a little older, the bad boy but really talented and cool.

FABRIZIO MORETTI: They had a whole code, a whole code that was much older than we were. They were rebellious in a way that I had only seen from them. Like, I didn't know what being rebellious was until I met them. I drank my first beer with them. I smoked my first joint with them. It seemed like they had an understanding of what it meant to really, like, live in New York City. Yeah. And I was this kid who always—I didn't feel like a Brazilian, I didn't feel like an Italian, and I certainly didn't feel like an American. So I was walking around trying to find my identity through New York City, and these two guys seemed to know exactly what it was like to be themselves.

MATT ROMANO: Julian's home life wasn't great in high school. He kind of lived with Fab for a while. He would come over for dinner and stuff.

FABRIZIO MORETTI: There was a spell where Julian lived at my place, because he had no place else to go.

JULIAN CASABLANCAS: I had it in my mind to move toward music. I was secretly attempting to get into it. But Nick, he played guitar since he was a kid.

NIKOLAI FRAITURE: The first time I met Nick, were going to a music store on Forty-Eighth Street, Sam Ash. He was much younger than Julian and I were—he was thirteen and we were fifteen—but then we got home and he played "The Star-Spangled Banner" by Jimi Hendrix and I was like, "Holy shit."

NICK VALENSI: Right away Julian and I started doing music together. He started writing songs basically right away.

JULIAN CASABLANCAS: I wanted to sing. I recorded myself singing a Pearl Jam song or something.

NIKOLAI FRAITURE: That's what we listened to, Pearl Jam and Nirvana.

JULIAN CASABLANCAS: I was singing along and I thought, "Man, look at me go! I'm ripping this song up!" Then I listened back and I was just so devastated and hurt at how bad my voice was, how out of tune and just bad it sounded. I thought, "Wow, okay. Well, that's the end of that."

FABRIZIO MORETTI: I loved music. And I played the drums. Well, I

pretended like I played the drums. I still pretend to play the drums. Tomorrow I'm going to learn. But I loved music and I wanted to play for the fun of being able to play, but I always felt like I was never good enough at anything to be the main guy. So when I saw Nick and Julian being interested in music, I was like, "Oh, maybe I can hang out with them, go for a ride with them," you know?

NICK VALENSI: Fab found out that I played guitar, and one day he was like, "I play drums, we should get together and jam. I have drums in my house." For a New York kid to have drums, that was a big deal. He also said, "My brother has this Gibson Les Paul." I'd never even fucking held a Gibson Les Paul. It was like the holy grail of guitars! So I got to Fab's house and he did have a drum kit set up in his bedroom. It was an awesome drum kit, but he did not know how to play. He just did not know how to play.

FABRIZIO MORETTI: It was more like towels with a drum kit hidden somewhere underneath them. In a closet. I struggled so hard to get "poom-tick-pat-tick" together, right? And in comes Nick; he sits down, and he's like "rat-tat-poom-tick-rat-tat-poom-rat-tat-poom-tick-poom!" And I'm like fuck, man! But they were really excited that somebody played drums in New York City. Or somebody had the means to play drums.

NICK VALENSI: Then there was this other guy, Danny—the three of us had this quasi-heavy-metal-band thing going on for a while.

JULIAN CASABLANCAS: Nick and Fab and Danny would go to these studios on the West Side, which used to be a wasteland. There was this spot Vinnie's, where you'd go and pay seven or ten bucks an hour to record. They'd play, like, Nirvana and Bob Marley songs, and a few Metallica-sounding originals. I kind of tagged along and just watched. I wasn't ready to play in front of other people.

MATT PINFIELD: The Strokes had the vibe and they had the look but they were also, like, dudes. People always compared them to the great New York rock bands like the Velvet Underground, but when you ask them what they listened to growing up, it was grunge. They were into Nirvana and Pearl Jam and Soundgarden.

NICK VALENSI: Danny was really hell-bent on being the singer. He was a really great guy and he really wanted to sing, but god bless him,

he just couldn't sing. And he was possessive. He didn't like that I was also playing music with Julian. At one point, I just said, "Look, man, I can't play with you anymore. You can't sing. I want to play with this other person." Fab was a little torn between the two but then Julian and I invited Fab to be our drummer.

FABRIZIO MORETTI: I don't believe in god, I don't believe in an order to things, but I'll be damned if I didn't know that there was something there with these guys that I, like, *needed* to be there for. I remember getting really upset that I missed a phone call from one of them, I can't remember which one, but my mom was like, "So-and-so called," and I was like, "What?!"

RYAN GENTLES: Those guys all go so far back. Albert knew Jules since they were eight years old. He met Jules when he was eight!

ALBERT HAMMOND JR.: Julian and I went to boarding school together in France.

JULIAN CASABLANCAS: Before Dwight, I was kind of messing up in school as usual so I got sent to the boarding school that my father had gone to and that he loved. I had a roommate who had some video games, Street Fighter II and shit. People would come over and play.

ALBERT HAMMOND JR.: We connected in a way where he was like an older brother. We hung out in his room and played video games, that kind of thing. I was like a little kid to him, even though really, it was only a two-year difference.

JULIAN CASABLANCAS: Albert was a little younger so I wasn't really friends with him then, but he was one of the only other Americans there. I kept a pretty low profile at that school. I mean, it was a pretty big culture shock.

RYAN GENTLES: Those guys knew each other before they even had sex for the first time, which, if we're talking about Valensi, he was probably seven or something. He was fucking thirty-year-olds when he was seven. They're characters.

NICK VALENSI: To be honest, having music definitely gave me something to do after school. It also gave me hope that I could be doing something that I enjoyed doing and also maybe have a reason to

be. That gave me a lot of hope. When you're born in New York and raised in New York, you see so much and do so much. I was a very jaded New Yorker at thirteen, the guy with the coffee and the cigarette. You're acting like a twenty-year-old, but you're thirteen years old.

FABRIZIO MORETTI: Drinking was the thing to do.

JULIAN CASABLANCAS: I go too hard at things, I don't mess around. I just go all the way.

NICK VALENSI: Julian's drinking was always a problem—or, it was certainly an issue to be dealt with, starting in high school.

NIKOLAI FRAITURE: For a while it was Ballantine's, but before that, with Julian, it was Olde English. We went straight for the malt liquor, just like in the Dr. Dre videos.

FABRIZIO MORETTI: We were probably subconsciously adhering to certain rules that we as humans have to adhere to, to become tribal. Because it's in us to function that way, to form tribes. And in order to do that, there's always some kind of ritualistic passing of spirits, or even juices, you know what I mean? In drinking together we were learning how to talk to each other, and how to listen, which eventually led to music, which was the fucking fountain that was building up inside of Julian and the rest of us.

NICK VALENSI: We were just going heavy with the drinking, man, all through high school. I went really heavy through high school, and so did Julian. Fab and Nikolai were maybe the tamer ones. But when Julian would drink, he was scary. Mean, very, very aggressive.

MATT ROMANO: Once early on, when the Strokes were on tour in Europe, Albert, Julian, and I went to Amsterdam. We got stoned and were walking around the red-light district. I don't even remember what I asked Julian, but I said something. It took him a minute to say anything back, but then he turned to me, looked at me directly in the eyes, and was like: "Fuck. You." Later, when we got tighter, I was like, "Dude, why did you do that? It really hurt my feelings." He was like, "I'm sorry, man, I was probably just fucking with you." But having that dude go, "Fuck you," right to your face, it was like, "Mehhh, I want to go home." I was scared.

ALBERT HAMMOND JR.: So after boarding school, I went back to L.A. and Julian went back to New York. I finished high school in L.A. I had a friend of mine I played music with. I wasn't that great, but I started dressing like I was a musician. Two of my best friends, they started doing a lot of drugs, a lot of cocaine, and I did it with them for a little bit but inside my head I was like, "No, I can't do this, I need to make it first before I can delve into this, I don't feel I've earned the right to party like this." So I got this calendar out and I started writing X's on it to go through days, and finally I got enough days where I felt comfortable, where I hadn't done any drugs. But I knew I had to get out of L.A. I got accepted to NYU, but I didn't want to go to college. So I deferred. I remember I was in L.A., watching Wimbledon all morning, from six to ten, just watching it, but kind of depressed, and I was like, "If I'm deferring, maybe I need to move to New York and get a job and just kind of see . . ." My mom found this eight-week film program. She was like, "Why don't you just go take a film course there at the New York Film Academy." It's actually where Max's Kansas City used to be, weirdly enough, though I didn't know anything about that place or anything else yet. I knew nothing about New York.

JULIAN CASABLANCAS: Eventually I dropped out of school to go study music. I was flunking. I was always terrible at school. I left and got a GED and went to Five Towns, which is a vocational music school that anyone can go to. But I learned a lot there.

ALBERT HAMMOND JR.: I created this total fantasy, "Oh, this is perfect, I'll go and reinvent myself in New York. I'll discover myself at this film course." I go there with my mom to find an apartment, and we finally found a place on Twenty-Second and Lex, right across the street from Elite modeling agency, owned by Julian's dad. It had "Casablancas" on the outside. My mom was like, "Didn't you go to boarding school with a friend of yours named Casablancas?"

JULIAN CASABLANCAS: By this point Albert had moved to New York.

ALBERT HAMMOND JR.: My mom left a little bit before the film school started and I would just hang out by myself, make dinner at home, and go to . . . what was that place on Twenty-something between Fifth and Sixth? Tramps! I used to hang out at Tramps all the

time. I'd get other people to buy me drinks, or I'd use the line of "I'm filming a movie," and try to get a girl to be in the movie. It was great; the girl who did my last movie, she bought me my first red Converse! Eventually I walked into Elite and said, "I went to school with Julian. I just wanted to see if I could either leave my number, or . . ." It was September of '98, before cell phones. I went in and this guy described me to Julian. "There's some terrorist outside who went to boarding school with you."

JULIAN CASABLANCAS: Once I hung out with him in New York I feel like it was kind of a no-brainer.

ALBERT HAMMOND JR.: I met Julian and Nikolai first, before I even tried out for the band. We went to Ryan's Daughter and had margaritas. I was never a big drinker. I was more of a stoner in L.A., so I was pretty wasted already, and then they were like, "Let's get forties!" I was like, "You want beer after this?" So we get forties and we're hanging out on the east park, Eighty-something, drunk.

NIKOLAI FRAITURE: Oh yeah, Carl Schurz Park, with the L.A. boy.

ALBERT HAMMOND JR.: It was a fun little bonding experience. Then I went home and threw up everywhere.

JULIAN CASABLANCAS: It'd be more interesting if I told a magical version, but I do remember that the band was not sure, and that Albert was nervous.

FABRIZIO MORETTI: We were rehearsing in the Music Building.

NIKOLAI FRAITURE: Room 203.

FABRIZIO MORETTI: And Albert came in in a suit.

ALBERT HAMMOND JR.: When I walked in, it was kind of like they were still in high school and here I am, where it looks like I've played professionally in another band, even though Nick was a much better guitar player than I was.

NIKOLAI FRAITURE: He was kind of suited up and we were still very New York nineties.

FABRIZIO MORETTI: We were probably wearing something that was like a hodgepodge of grunge and Metallica outfits. And then he walked in with his pants way too high.

JULIAN CASABLANCAS: Am I saying the other guys weren't sure about him? No, I mean, well, they didn't know him! He was nice, he had cool taste. If anything he influenced the style of the band.

FABRIZIO MORETTI: And I had curly hair but I cut it short, until I saw Albert walk in with curly hair and it was long. I thought, "Wait, I could do this?" I wanted to look like Kurt Cobain, but I didn't have the hair for it. Albert gave me wings. He gave me hair wings.

ALBERT HAMMOND JR.: How I'd walk out at eight in the morning to a diner back then, when I was eighteen, was what I would later wear on *Saturday Night Live*. The theory of it, when I started at sixteen, was that I didn't want to be turned away. I wanted to be typecast so it would be easier to buy cigarettes. I just felt like it was the closest thing I could do to dress like my idols. When you start dressing like that, you stop being a kid.

NICK VALENSI: It was very clear, from the minute Albert showed up, that something was happening.

JULIAN CASABLANCAS: I was 5 percent worried that people would not get along or get into an argument. You never know what could happen, but I didn't really have a doubt that he should be in the band. It seemed perfect.

NICK VALENSI: The first time I met him he was wearing a fucking suit. We were all wearing jeans and T-shirts and New Balance sneakers and Albert showed up in a suit. Everybody all of a sudden was like, "Okay, hold on a second, let's start thinking about this." This was in New York, at a studio. We rented a room in the Music Building where we rehearsed. Albert showed up. He had a 102 fever. It was midnight. Our rehearsals would start late at night because we all worked and we were in school and stuff. We didn't play very well and Albert didn't sound great—we didn't sound great—but there was a vibe there, just in terms of how he looked and how he played and how he fit in with the group. The dynamic was there from the get-go.

ADAM GREEN: The Strokes are largely first-generation Americans, like the Ramones. But the Strokes had a kind of European outlook on a lot of things. I remember thinking that those guys were actually pretty refined. I felt like I was like somebody from the suburbs. I

felt like I went to the mall, while the Strokes seemed to have access to another world.

ALBERT HAMMOND JR.: So I went and I tried out. I thought it was a disaster. I went home. I kept on calling Julian, but he didn't tell me he was going on a trip and I couldn't reach him. This was before cell phones. I was like, "I didn't get in, I didn't get in." Then he later told me, "I thought you were in before you even came to play music." So that was very exciting. And within a few weeks of that we moved in together.

NICK VALENSI: We had brainstorming sessions for a few weeks about what we should call the band, making lists, and it was starting to feel futile. Then Julian just blurted out "the Strokes" when we were all in a rehearsal one day. "What about that one?" Everybody was like, "Stop, that's it!" Then the Strokes' first gig was at the Spiral on September 14, 1999.

SOME PRETTY GOOD MUSICAL CHEMISTRY

DANIEL KESSLER: I met Paul at an NYU summer program in Paris. He was just out of high school but he carried himself with a certain sense of confidence and maturity for someone his age. He took himself seriously, and other people took him seriously.

PAUL BANKS: I thought Daniel had a neat sense of style and I thought he was pretty together. He was just a nice guy, whereas I was kind of wild in my way. I was smoking weed with the teacher, you know what I mean? I didn't smooch the teacher, but, you know, it was a guy teacher.

DANIEL KESSLER: I knew he played guitar and sang, or he told me that.

PAUL BANKS: I was busking outside of the Centre Pompidou and Daniel was more, "I'm gonna go back to my brother's apartment and we're gonna go see a film and have dinner, if you'd like to come." Whereas I was sort of like, "Whatever, man, do you have any weed?"

DANIEL KESSLER: I've got two older brothers. One is a literary agent. He lives in Paris.

APRIL LONG: Daniel's other brother was an editor at the *NME*! I remember being in the office and an early Interpol single or the demo turning up—I was reviewing the singles—and he was like, "Ugh, it's my brother's dumb band."

DANIEL KESSLER: To this day, Paul's a pretty tardy person. Back then, as an eighteen-year-old, we were in this French class together, and he'd come in, and it would be a crazy tale about why he was late. It really did happen, in a way, but it was part of his disposition, too.

PAUL BANKS: I'm a mess sometimes.

DANIEL KESSLER: But he always carried himself with an air of confidence, an air of belonging; even as an eighteen-year-old, he wasn't awkward or shy. We talked about music for a minute, and I could tell we didn't aesthetically have a lot in common.

PAUL BANKS: I listen to old hip-hop.

PETER KATIS: Since the beginning of our relationship, Paul Banks has been trying to get me to appreciate hip-hop. He once played me this brand-new guy, at the time, called Kanye West.

PAUL BANKS: It's funny because I don't listen to what you want to hear I listen to. I always get the feeling—I'm in England and people are asking me what my influences are and I'm saying it and they're just kind of looking at me like, "Are you done?" What I listen to doesn't come across in our music.

DANIEL KESSLER: I just had a feeling about Paul.

PAUL BANKS: The first clue I had that there was something to Daniel was when we were taking the final exam in this course—this is with the teacher that I'd smoked hash with. I'm sitting there, doing my exam, and Daniel calls the teacher over and he just says, "I can't do this right now." And he left. He just fucking walked out of the final exam. I was like, "Look at Daniel, man! Look at the fuckin' badass who just said fuck it to the final and left!" I was kind of like, "All right, there's something to that guy."

DANIEL KESSLER: At some point I'd realized, "If I don't try to do something with music, I might be pretty sad in my life." I was never an overly confident person, so to me it was about owning up to the fact that whether it works out or not, if I don't at least try, I'll be miserable. I really understood that, by that point. So when I met Paul I was on the lookout.

PAUL BANKS: Back in New York, after we were back from Paris, Daniel walked up to me outside of my dorm. I was living off Third and he was living off Thirteenth. He walked up to me outside of my dorm with this buddy of his who was the highest person I've ever seen in my life. I've never seen anybody as stoned as his friend was that day. That was again, for me, a good sign. Like, if Daniel's roll-

ing with dudes that are that fucking high, then that's another little window into his personality. One thing I noticed early on is Daniel's got tremendous friends. All of Daniel's friends are excellent, excellent people. So, Daniel said, "You know, I've got this band. Do you wanna come see us rehearse one day?"

DANIEL KESSLER: The first time I saw Carlos. I was in this lecture class with him and he was asking questions. I was like, "Really, dude?"

BRIAN LONG: Carlos wore dresses in college.

PAUL BANKS: I'd see this guy once in a while, wearing a black velvet skirt down to the ground and a skintight black T-shirt tucked into the black skirt with a giant crucifix and black hair, walking around, like, super regal. You know, fingers-up-to-the-world vibe. He didn't give a fuck.

DANIEL KESSLER: We had this class together, it was World War I history, and I was going to drop it. Carlos dressed similarly to me, in a button-down shirt, stuff people weren't wearing. I stayed after class one day and went up to him. It took all the courage in the world to ask him if he played music. But we started talking and we had similar stories. He had a similar pair of old-school Doc Martens to me, the ones with the stitches; we started talking about that.

PAUL BANKS: I'd seen him around and thought, "I like that guy too!" Like, "That dude in the shirt is fucking nuts and I like that about him." But we never met. So when I walked into that first rehearsal and there's the guy that walks around in the monk's outfit, I was like, "This is yet another good sign."

DANIEL KESSLER: I got the guys together in the dorm room and we had some pretty good musical chemistry from the start.

19

LIKE A GANG

JESSE MALIN: The thing with the Strokes is they were a real band. A band should be a gang, running down the street, chasing a bus, breaking windows, breaking hearts. Those guys had that.

NICK VALENSI: We felt like a gang.

NIKOLAI FRAITURE: We thought that's what a band was.

ALBERT HAMMOND JR.: That was something we actually really thought about. I remember being like, "No, we have to all go together." When we walk down the street and they see five guys, people would yell out, "The Beatles!" The idea is, if they're yelling that out and they don't even know who we are, they'll come to the show. One day they'll see something in *Time Out* and be like, "Oh, I remember those guys, they're always hanging out and getting drunk." Plus, it makes it easier if you're trying to meet a girl: "Here's a flyer." It's a starting point for a conversation. We made really, really cool flyers.

JOE LEVY: I first met them at a Weezer show at Irving Plaza. Albert and Fab followed me into the bathroom to give me a gig flyer while I was at the urinal.

J. P. BOWERSOCK: They had branding before people even talked about branding. One of them would mail out these elaborate postcards with brilliant graphics. And somewhere along the line, Julian had tried working for his father's modeling agency, which didn't work out, but when they had shows he persuaded some of the models to come. Word got out about that. It was a brilliant move. This was back before the Internet. The Internet was a few message boards and e-mail and porn. They hadn't figured out what to do with the

Internet yet. But with the Strokes, you'd get this beautiful card in the mail and you'd think, "Interesting."

ALBERT HAMMOND JR.: The flyers thing was all thanks to my dad, really.

NICK VALENSI: Albert moved to New York with a credit card that his dad paid the bill for.

ALBERT HAMMOND JR.: When I told him I was leaving college, I was like, "I'm kind of scared but, you know, we have this chance." His dad, weirdly enough, did the same thing for him. His dad, who had no money, bought him amps and guitars for the whole band, so I feel like maybe he was just paying it forward.

NICK VALENSI: When it came time to get gear, those little things that are necessary in a band can add up. Guitar strings, cables, this guy needs a bunch of drumsticks because he keeps breaking them, we need a PA for our rehearsal room. It doesn't seem like a lot, but I didn't have guitar strings and guitar cables, and now all of a sudden we did. I'm very grateful and appreciative to Albert Hammond Sr. for paying those fucking credit card bills.

ALBERT HAMMOND JR.: Nick would do some bookings, I would do some bookings. I remember Julian saying, "No, not Tuesday, we have to get Thursday or Friday," and so we'd go back, "Sorry, man, can't do it Tuesday." It was just funny, the back-and-forth. You're young and you feel like you have good stuff, you can have a little bit of an attitude. You need to have a little bit of an attitude.

RYAN GENTLES: They were so hardworking at promoting themselves, all five of them, all the time. In some bands it would be like, "Maybe tell that guy to stay home." But not with them. Girls were swooning and they were just so cool. Nick and Julian, they're tall, imposing figures; you notice them.

KELLY KILEY: That's what made them so appealing. In a weird way they were like a boy band: "That one's the dreamy one," and so on.

STEVEN TRACHTENBROIT: With the Strokes, there were five personalities, like the Beatles. I'm certainly not comparing them to the Beatles, music-wise, but in terms of you had your John, Ringo, George, and Paul. Later, they each got their own individual *Spin* covers.

JENNY ELISCU: They were all very engaging, immediately.

KELLY KILEY: They were just this gang, this force that was going to take on the world.

NICK VALENSI: We'd print up like a thousand flyers, and then each of us would take a couple of hundred and go out and go hit the town, go to whatever club was going on, Spa or Sway or Shout!, whatever those cheesy things were called.

JUSTINE D: They were running around at the clubs. The Strokes were younger, and they didn't care about promoting themselves or saying certain things or making out with certain girls. Which was cool because you felt like you couldn't penetrate them, in a way.

JASON GORDON: They were detached from the scene and they were everything cool about the scene at the same time. They had that gang mentality that everyone seemed to want to be part of. They were the cool table. I hate to put it like that, but it's true, they were the cool kids. And then they were writing these amazing garage rock anthems.

JUSTINE D: For some reason I remember what I wore to their first show at Tiswas: red boots and a red leopard-print blouse and tight black jeans. They played to five people, but I walked in and I thought, "Who's this pretty good band? They're all really good-looking." You don't see that very often. Like, where they sound good and all the band members are handsome. But what was so strange about them was right after they were going around the audience with magazine copies of *V*—and I still have the magazine—they were featured in *V* magazine before they even got big, I guess because of their family connections. And a few of us thought, "What a strange band that they're already in a notable high-fashion magazine and no one really knows who they are." But they created such a buzz about themselves. Back then, if you outright self-promoted, it was frowned upon.

NIKOLAI FRAITURE: We were always serious. I mean, it was always: this is what we're going to do. I know I had nothing else. No plan B.

NICK VALENSI: Those parties were fun, don't get me wrong, but part of it, for me, felt like, "This is work. This is going to be my job, I'm going to Shout! tonight and I'm going to talk to a million people and hand out all these flyers and get these people to come see my band."

PAUL BANKS: I must have crossed paths with the Strokes at Bar 13. I wish I could have met them and bro'd down with them, you know? I do. I'm a great admirer. And I'm sure they had better coke.

JUSTINE D: They were naughty.

MATT BERNINGER: After that show I saw them play at Don Hill's; everybody went to Mars Bar and they were there too. I remember Julian Casablancas looking down the bar at the girl who I was with. He was looking at us and giving her bedroom eyes. I was like, "Jesus Christ, this guy can do anything!" Like, literally, if he had walked up and kissed her, she would have walked out the door with him, you know? I was like, "Fuck, that guy is cool."

KELLY KILEY: Boyfriends didn't like the Strokes.

NICK VALENSI: Getting a gig at the Mercury Lounge was the goal. There was no higher echelon than that. The Mercury Lounge would have national touring bands that came through. Real bands. Bands who weren't from New York. And there would be a tour bus outside. There were no tour buses parked outside the fucking Luna Lounge.

RYAN GENTLES: I really liked booking my band's shows and trying to get us press. I liked all that stuff. When my band broke up I knew I didn't want to start another band because they're pains in the ass, but I liked the idea of helping other bands.

BRIAN LONG: Ryan was just this cool, enthusiastic kid. He had been in a band. And then he realized that he was better at not being in a band.

RYAN GENTLES: I interned at Geffen and at the Mercury Lounge when I was at school. When I was done interning, they gave me a job working the door and assisting the booker at Mercury. Then she left, I was done with school in the summer of '99, and I got her job.

JIM MERLIS: Ryan was my intern at Geffen Records. My assistant, Anna, referred to him as "Weezer" because he looked like Rivers.

BRIAN LONG: We all called him Weezer.

JIM MERLIS: It turned out he was a card-carrying member of the Weezer fan club. We didn't know that until years later. He always had this really funny smile around the office, like he was up to something.

RYAN GENTLES: There are certain bands you like, and then certain bands you don't like, but you have to book them. I'd always book the ones I liked together and the bands I didn't like together. I'd say, "If they like that, then they probably like this other shitty band." And then I'd put all the bands I liked on one night, like, "I'll have something fun to look forward to." It's not like any of those bands were friends, though everybody kind of ended up knowing each other. There was no science behind it. I was twenty-one.

ALBERT HAMMOND JR.: Ryan was *the* guy. We'd started playing around, and after you play around for a while, you meet people. There was a time when I ran into him probably fifteen times just out at shows and stuff.

RYAN GENTLES: I wasn't friends with them at all but every time I went out they were there in the audience for the show, all five of them. "You guys are out again?" They were like a gang out promoting all the time. It got to the point where it was somewhat embarrassing.

ALBERT HAMMOND JR.: It's funny to think about now, because he's one of my best friends, but it was like, "There's Ryan Gentles. Should we go talk to him?" He was a big deal.

JULIAN CASABLANCAS: I met him once outside of Arlene's Grocery. I was, like, some punk kid, "Oh, you wanna manage us?" He'd probably remember better, but I think I was pretty direct with him.

RYAN GENTLES: The Strokes asked me three or four times to manage them.

JULIAN CASABLANCAS: He was the man that everyone wanted—he booked Mercury, he had power, so he was probably used to people kind of posturing in front of him. He was, you know, playing it cool, acting unimpressed.

ALBERT HAMMOND JR.: We wanted to get to the Mercury Lounge, and we wanted to sell it out.

RYAN GENTLES: I wasn't managing anybody at that point. I was a booker at a club. I told the Strokes no two or three times. I made twenty-eight grand a year, I'm on easy street over here. I was rich, to me.

ALBERT HAMMOND JR.: He didn't want to do it at all.

JENNY ELISCU: It's unusual to hire a booker from a local club as a manager. It didn't feel at any point like they were trying to craft a path. I really believed them when they said, "We're just friends who want to play music together and we don't have any goals beyond that."

ALBERT HAMMOND JR.: It was like, "Here's a guy who's a year or two older than us." It just reminds you of the Beatles' story. You meet all these managers and they're, like, fifty, and they feel like lawyers. Yes, of course, everyone wants to make money, I'm not saying we didn't, but money isn't as exciting as when a song is really good and you know it and you can feel it, it runs through the crowd, and you can record it well and you're on tour. That's more exciting than if they just said, "You made a million dollars!" We wanted someone who could sell us without us being there. That's what a manager is; they're selling you, but you're not there.

RYAN GENTLES: A lot of managers tried to manage them, and they wouldn't go with anybody. They said no to everybody; they wanted someone their age, who was up-and-coming like them.

NICK VALENSI: We were doing shows in New York as the Strokes. We had a bunch of songs that weren't on our first album. We did those for two years.

FABRIZIO MORETTI: There was a song called "In Her Prime." And a song called "This Life" that turned into "Trying Your Luck." Those songs started to feel crisper. Sharper and more metallic. Sleeker.

NICK VALENSI: Then one day at rehearsal, Julian had one song that we started playing, "The Modern Age." Suddenly it was like, "Whoa, we need more like this one. We should get rid of these other ones." The others were trying to be more musically complex, like Doors-y, with some baroque elements in there. "The Modern Age" was like, "Whoa, this feels like a Velvet Underground song." It was so cool and simple.

JAMES ENDEACOTT: That song just blew my mind.

NIKOLAI FRAITURE: My brother had given Julian *The Best of the Velvet Underground* at Christmas dinner one year. That's when we found another channel.

NICK VALENSI: It felt really full, even though there wasn't all that much going on. All the parts fit together like a puzzle. It came together so easily. He wrote it and we played it and it wasn't like we had to hammer away at it for a long time; it sounded right in an afternoon. Then they just started coming.

JULIAN CASABLANCAS: I was a big Velvet Underground/Lou Reed fan. People thought we sounded like Television because Television was a New York band influenced by the Velvet Underground. That's why we sounded like them, but that's not what we were listening to. I was listening to Lou Reed.

NICK VALENSI: "The Modern Age" wasn't the first *Is This It* song that was written, there were some before, but once "Modern Age" came up, it was like, "Yeah, we need to sound like this." Then "Last Nite" closely followed.

CARL SWANSON: The Strokes were trying to literally embody an idea, be part of a continuity.

AUSTIN SCAGGS: They were writing the autobiography of the East Village.

JOE LEVY: This all happened in a place where other things happened a long time ago. This was a block away from the St. Mark's church where Patti Smith and Lenny Kaye started what would be the Patti Smith Group. They started it there because that's where Jack Kerouac read and because at the time Patti lived down the street. And it wasn't by accident that she lived down the street on Tenth Street, because the whole Andy Warhol crowd used to live in the East Village and the Velvet Underground used to play on St. Mark's Place. All of this stuff doesn't happen by accident, it's not a coincidence. It's not a straight line either—you don't go, "Oh, Velvet Underground, Patti Smith, Karen O." It doesn't go Velvet Underground, Strokes. It's a long distance to travel from one to the other but there is a continuum, there is a vibe, there is a place where those bands have roots. It does matter, it matters to the sound.

ALBERT HAMMOND JR.: I remember when I knew. I remember it so clearly even though we were still so tiny. It was snowy and we were playing Luna Lounge. There were forty people, but it felt good, it

was a good forty. We played "Modern Age" and "Last Nite" for the first time. After that show it was like, "Yeah, we're better than the other people who are playing." I don't even say that to be mean. You just felt the energy when we were playing those songs, like, "I wish I was seeing it and not playing it."

J. P. BOWERSOCK: The first time I saw them was at Acme Underground.

ALBERT HAMMOND JR.: I had this Rickenbacker, like John Lennon's Rickenbacker from Hamburg, short scale, that used certain strings. I was walking in the West Village to get strings, and I ran into this guy. He said, "I sell the strings that are on these guitars, they're handmade in my apartment." I was like, "Okay, this seems like I might get raped . . ." Nick or Fab or somebody came with me. "Wait out here; if I'm not back in five minutes, something happened." I went in his apartment. It was on Seventh between A and B. I got the strings and I said, "Do you know anyone who can fix guitars?" He was like, "Yeah, go to Richie's Guitar Shop on Eleventh between A and B." So I find Richie. I got my guitar and Nick's guitar that we still use to this day at Richie's. Then, who did I meet from Richie's? J.P., who became Julian's and my guitar teacher.

J. P. BOWERSOCK: This was back in the days where they were still super nervous. Julian puked before the show.

KIMYA DAWSON: Like me, Julian had paralyzing stage fright, so before every set, I just remember he would come up to me and be like, "Mama!" We would just hug.

ALBERT HAMMOND JR.: That's always been an insecurity of mine—Nick is so good at guitar, and I've always been the second runner-up.

J. P. BOWERSOCK: Richie had two guys he recommended for guitar lessons. I was the below–Fourteenth Street guy and he had another guy for above Fourteenth Street.

ALBERT HAMMOND JR.: We called J.P. "the guru."

J. P. BOWERSOCK: What Julian was mostly leaning on me for was that he wanted every note planned out, nothing left to chance. They were one of the first bands I knew that practiced in their rehearsals to a click, and not only once a week but four or five nights a week. They were deadly serious about being super tight, so every note

had to be worked out. Julian wanted to work out every note of the guitar solos too. After the lessons we would just get a six-pack and hang out.

ALBERT HAMMOND JR.: Julian and I bought a car for five hundred dollars that we called Steven. It was a 1984 Gran Torino, orange on the inside, black on the outside. We never got insurance, we never got plates. One time we all took Steven out to this house Nick's mom had rented on the beach. We stayed up all night drinking beers and woke up the next day with all these bug bites. There were so many great nights like that.

RYAN ADAMS: Those guys always had cars. I was like, "Why do you have cars in the city?!" They always had cars.

ALBERT HAMMOND JR.: Ryan would always throw parties at his house after our shows.

RYAN GENTLES: I had a three-bedroom apartment. I lived with four dudes—Dennis from the Realistics was one of them.

DENNIS CAHLO: It was a one bedroom, on Second Avenue between Thirty-Third and Thirty-Fourth. I walk past it and still get shudders.

ADAM GREEN: It used to be a bordello right before Ryan moved in. So johns would still buzz the door.

DENNIS CAHLO: There was a bedroom right next to mine, a tiny piece-of-shit closet that was the sex room. Whoever went in there, it was "If this van's a-rockin', don't come a-knockin'"—that kind of thing.

ADAM GREEN: My first introduction to Julian was one night when there was a party at Ryan's house. I guess the Strokes had had a show that night and they ended up there. Julian came in really fucked up, took some girl into the bathroom and broke the shower.

DENNIS CAHLO: It was mayhem. You'd walk out at seven in the morning to make eggs and there would be piles of people on the floor. I'd be walking over them, screaming, "I have a job, man." Nick Valensi would be in the kitchen, still awake, saying, "I really admire your work ethic." And I'd go, "Fuck you. Get a job, asshole!"

MOBY: I became friends with the Strokes long before I saw them live. I was a drunk and they were drunks.

SARAH LEWITINN: Everyone knew Moby. I remember going to his house with Gideon for a Fourth of July party and Natalie Portman coming and she was making fun of him for using the word "rad."

MOBY: I mainly knew Julian and Albert. Three A.M. in a basement somewhere, drunk, trying to find cocaine, doing cocaine in the bathroom with someone and talking about the Stooges. Being at Lit at six o'clock in the morning going, "You know what!? We should start a band!" It makes my teeth hurt just thinking about it.

JENNY ELISCU: Oh man, Lit . . .

SARAH LEWITINN: I once shared a bathroom with Hilary Duff at Lit and it was just one room and when I was too shy to pee in front of her she and her friends turned their backs and she sang the Smiths to me.

JENNY ELISCU: The place that if I ever would have died from doing heroin—it would have been at Lit.

JUSTINE D: Lit was basically like a catacomb outside of Rome. It had this feeling of . . . those were some of the most decadent nights. Everyone was there. It was the best fun. Especially in that basement back room. I mean, me being pretty square, I would walk back there, shake my head, and just walk out.

ALBERT HAMMOND JR.: Julian and I lived on Second Avenue between Eighteenth and Nineteenth, which was a perfect apartment for us, because we had two bathrooms; it was like a dumbbell. He had his own room and bathroom, hallway with a kitchen and washer and dryer, and I had my own room and bathroom. It was cheap, and it was fun. But we were so opposite; I was neat and organized, and my room was all nice. His room was just a mattress on the floor.

DENNIS CAHLO: That apartment was also disgusting.

ALBERT HAMMOND JR.: I remember one morning Julian came in, hungover, and got in bed with me. It sounds like we slept together, but it wasn't like that, we were nineteen years old. It came from a very pure, just natural place, when you feel completely comfortable with someone. I imagine everyone has had that in life, where they can take a shit or fart or just be themselves, be quiet in a room, while someone else is there, and feel like you're alone. I never got

that comfortable, I don't think, living with someone else, even girl-friends.

CATHERINE PIERCE: Did Nick tell you the balls-in-the-mouth story? One of them passed out with their mouth open and they thought it would be hilarious to bet someone else that they wouldn't put their balls in that person's mouth. I think Albert put his balls in Nick's mouth. Albert loves to pull his balls out.

ALBERT HAMMOND JR.: Pulling my balls out at parties started because I heard that when Julian was younger he would do that.

CATHERINE PIERCE: Before parties I'd say, "Baby, my mom is going to be there, do not pull your balls out, okay?" We knew it was a fun party if his balls came out at some point.

ALBERT HAMMOND JR.: One night early on Fab and I had walked down from Thirty-Eighth and Eighth to Don Hill's, which was at Greenwich and Spring. We were drinking forties. We must have finished one or one and a half, and we were pretty drunk. So we got there and Fab and I were talking. This guy walks up and said, "I don't know who looks more like Syd Barrett, you or you." Fab was looking at him, and I turned around and was like, "My balls look like Syd Barrett," and I had my balls out. Fab was on the floor laughing and the guy just looked petrified and walked away. So ever since then, it could be at a really nice restaurant, it could be anywhere, I'd just be like, "Uh huh, uh huh, yes, I agree." Then you look away, and someone would notice that my balls were out. Obviously, it would happen more when you'd get drunk.

MARC SPITZ: They were such city kids. The first thing Julian said to me, he said, "Do you play pool?" I said, "Yeah." And he said, "You wanna play me?" And I said, "Yeah." And the first thing he said after that was "You're about to get fucked in the ass, my friend." And then he fucked me in the ass.

JIM MERLIS: The first time I met Fab they had just stolen a bunch of guitar picks from the shops at Forty-Eighth Street. We were at a photo shoot. Fab was dating this girl Cassandra at the time, and Cassandra got her coat stolen. So the whole time during this photo shoot, he was like, "Who steals a fucking coat, I can't believe

someone would steal a coat," and I was like, "I can't believe you don't see the irony in this, you were stealing picks earlier today!" He's like, "But, Jim, who steals a coat?" I was like, "Who steals guitar picks?! They're a quarter!" It was like hanging out with a bunch of Holden Caulfields.

NICK VALENSI: At that time, I was working at a restaurant. Fab worked in a smoothie shop, Julian worked at a restaurant, Nikolai worked at a video store. Albert worked at Kim's Video. We just had normal jobs. And we'd meet up at night and just smoke. We all smoked cigarettes at the time. We had that very small little rehearsal room in the music building on Eighth Avenue and Thirty-Eighth Street and we'd just stay in there all night and drink forties of Budweiser or Ballantine's.

JULIAN CASABLANCAS: We would record three or four songs and then everyone in the band would be like, "Let's put it out! Let's go play!" And I was always, "No, this is not good enough, we should destroy this thing and start anew." But, eventually, we had finished a demo and I did have this moment where I was like, "Oh wow, this could get us signed."

GORDON RAPHAEL: I would always go to Luna Lounge to see bands and hang out with friends, and that's where I first saw the Strokes. I was curious and I kinda liked something about them but I wasn't really convinced. They looked like they were very proud of themselves and very stylish, but they didn't have the musical aspects yet. Young Fab, the drummer—I think he was nineteen or twenty when I met him—every time he hit the drum it looked like he put his entire neck and back out. I thought he was going to break his spine in half, so I was watching him very closely, just waiting for an accident to happen.

ALBERT HAMMOND JR.: Someone told me about Gordon and I was like, "I'll go check it out, I'll go talk to him." In a weird way I was always the business side to the band. I held the money because everyone trusted I wouldn't spend it. So I met Gordon, I don't remember how.

GORDON RAPHAEL: After the set, I gave them a little card I had made up and I got a call from Albert.

ALBERT HAMMOND JR.: I went to his studio and was like, "This is a cool vibe." Then I told Julian to go meet him. That's when we did the EP.

JASON GORDON: When I heard that EP I told everyone, "This is going to change New York music. This is going to put New York music back on the map again." The energy in that EP, the rawness, the vocals, the attitude, the everything. I played that EP for everyone and I knew. I was like, "You will fall in love with this, you won't be able to listen to it one time, you'll be listening to it on repeat and then you will want to go see them live." That was the feeling. Before that EP, New York music still felt like this small little tribe, and then all of a sudden here was this, like, band where you knew they can top the world. You felt like that about them.

MATT HICKEY: The Strokes actually sent us a three-song EP in the mail. We used to sit upstairs on Friday at the end of the day and go through the boxes and envelopes that people would send you and bring up some beers and roll a joint and just throw something on. "Oh, that's bad. That's bad." The one that the Strokes sent in came with a note I will never forget. It said, "Hey, we're the Strokes. We're from New York. We used to play the Spiral"—which was the place across the street from the Mercury Lounge—"but it burned down, so I guess we've got to play the Mercury Lounge." We thought it was a really great note.

RYAN GENTLES: I really wanted to help them, so I started sending the EP around. I said, "Give me fifty copies." They didn't. They gave me one. So I made fifty copies at the Mercury Lounge and started sending them out. The phone started ringing. "Who's this band you sent me?" I knew I liked them, but I had no idea anyone else would give a fuck.

ALBERT HAMMOND JR.: We had small goals. Early on we were like, "We're not going to tour, we're going to make it in New York, what's the point of going around and building up attention, having no one show up? You can be in the middle of nowhere and you have to get out of this small town. New York is a big town, so if we can make it here . . ."

RYAN GENTLES: It was Matt Hickey who said I should send it to Geoff at Rough Trade.

MATT HICKEY: We listened to those three songs that whole evening, over and over again. At that time I was just beginning to work as an A & R person for Rough Trade Records in the UK. Geoff Travis was smart enough to know that a guy who is booking twenty-eight bands a week in New York City is probably going to come across something.

GEOFF TRAVIS: Matt phoned up at about seven o'clock in the morning and played about ten seconds of the EP over the phone, and that was it. That was the moment.

A GIRL THAT SINGS QUIET FOLK SONGS

BRIAN LONG: The Strokes were rockers. They were steeped in the history of rock. The Yeah Yeah Yeahs were art kids.

NICK ZINNER: I met Karen at the Mars Bar. We had a bunch of mutual friends and we just started hanging out all the time. She was just finishing NYU and I'd already been here a couple years. I had this other band, Challenge of the Future.

DENNIS CAHLO: Nick Zinner played on every single record that came out of New York for a while.

MARC SPITZ: Around '97, '98, there would be these parties in Brooklyn, where it'd be artists living in full warehouse floors, so you could have a whole band come in and play. And I can't tell you how many parties I went to where there was a keg, the Missy Elliott record playing; and then a shitty band with a lead singer with a beard; the guitar player in those shitty bands always seemed to be Nick Zinner. Nick was hands-down the only interesting thing about every band he was in, until he met Karen O. He already looked the way he looks. We called him Midget Elvis—he had a Nick Cave–upsweep Elvis hairdo that was inky black, and he's about probably five foot three, five foot four. And he's just really proportionally tiny. The guitar looked huge in his hands, but when he played it, he grew fifty feet.

CONOR OBERST: Nick and I met before I moved to New York. I always fall in love with people, girls and guys, and he looks like a doll out of a goth comic book. Also, he's the coolest guitar player. We got to be pretty tight. He's even come to Christmas in Omaha a couple of times. He's Jewish, so he claimed he never had a proper Christmas,

so I was like, "Oh, my mom, Nancy, will hook you up." He had his own stocking.

KAREN O: Growing up, I was pretty reserved and a good kid and good student. I doodled a lot. I was an outsider kid for sure.

BRIAN CHASE: I grew up in the suburbs of New York and I was a teenager in the nineties. New York is a place that's always been a hodgepodge of cultures and varied histories. I grew up studying jazz and classical and at the same time playing in Green Day cover bands in basements. Then I went to Oberlin.

NICK ZINNER: We're art school kids. Karen studied film. I studied photography. Incredibly useful degrees.

KAREN O: I wanted to be a filmmaker. I only started playing the guitar once I went to college.

JALEEL BUNTON: With Karen it's a little different because she's not an instrumentalist, but those guys are really good at masking the fact that they can really fucking play. Nick is the dude who was sitting there when he was twelve being like, "I'm going to learn how to fucking play 'Eruption.'" They actually have chops.

KAREN O: A buddy of mine, he introduced me to Neil Young, who I have to say was extremely influential. He's got that super-unconventional voice, but so much feeling, so much heart. His voice and Jeff Mangum's from Neutral Milk Hotel, they were the two people who got me thinking I could be a singer. I wanted to sing my heart out like those guys.

BRIAN CHASE: Karen and I were freshmen at Oberlin the same year. We lived in the same building. We all called it the Monastery and the Nunnery because it was like the one and only non-coed dorm. We were there begrudgingly, so we kind of stuck together. There was this orientation field trip for freshmen into Cleveland, and that's where I first met her, on the bus.

KAREN O: Oberlin has a winter term, which is two months that you're supposed to take off. Ohio in February is just fields of snow, kind of oppressively depressing; the suicide rate in February especially is just brutal. So what you're supposed to do is choose a project or two. The project I chose that winter term was learning how to play the guitar.

BRIAN CHASE: I started taking drum lessons when I was five or six. I went to Oberlin for music. The logistical plan was to maybe get a job and work my way into the downtown New York scene. If you'd asked me then what my fantasy was, I would have said playing in a band led by John Zorn and living in Brooklyn. Some people from Oberlin had already set up a home base there. But I was also playing rock and roll at the same time.

KAREN O: The first song I ever learned was by Mazzy Star. As soon as I learned to play a little guitar I started writing music. I didn't care about really knowing how to play. I know pretty much as much now about playing guitar as I knew then. I'm dead serious. It's slightly embarrassing. From the four lessons I took when I was eighteen years old, I've been able to write hundreds of songs. You don't need to know much to write a good song.

BRIAN CHASE: Then Karen transferred to NYU.

KAREN O: I was studying film.

NICK ZINNER: I felt the chemistry from the first time we ever played music together, which was summer of 2000. We were just hanging out in her old apartment above Odessa. I lived in Williamsburg, in an illegal loft with ten other people. That's a cliché at this point, I know.

KAREN O: Yep, 249 Metropolitan.

ASIF AHMED: I met Nick through an artist friend that was a waitress at Kate's Joint. People were always dragging us over to Kate's Joint for the un-fried popcorn chicken. I met Karen when she lived upstairs from Odessa. I didn't know who she was, I just thought she was a girl with a really shitty haircut.

KAREN O: My first show ever in New York City was at the Sidewalk Cafe open-mic night. This was maybe '99, 2000? I was twenty-one. I even remember what I was wearing—this weird polka-dot black and white dress that I found at some vintage thrift store. I think Christian Joy was in the audience that night too. I think she was one of the few.

CHRISTIAN JOY: Yes, I remember thinking, "This girl is hilarious!"

KAREN O: I did like four or five songs or something, and I remember

I got a tattoo the same day, you know, to commemorate the beginning. I got a tattoo of a bee on my shoulder. I'm so noncommittal, and it was like, "I just want to commit to something in my life. This is a day where I'm starting a new chapter." Then I did that show. My first show ever.

NICK ZINNER: She was playing songs she'd written on acoustic guitar for me and I was like, "Those are rad, let me record them and play on them." I immediately knew I would be making music and be somehow involved with her for a while. I felt it. Just, *wooooosssshhh.* Immediate connection. So we did this Unitard project.

GIDEON YAGO: Unitard was this gentle folk band.

NICK ZINNER: Very simple. Very, *Paris, Texas.*

ADAM GREEN: That's actually how I thought of Karen. I thought of her as a girl that sings quiet folk songs.

NICK ZINNER: I think our first show was at that place at Ninth and A, Sidewalk. On an open-mic night. It was around the time of that whole freak-folk thing.

THE FREAK-FOLK FRINGE

J. P. BOWERSOCK: Back in the eighties and nineties, everyone knew that whatever music was happening was happening downtown, but it wasn't a coherent scene. There was a downtown avant-jazz scene. There was a hippie stoner jam-bandy thing going on around Wetlands. The West Village had a big folk scene. Then you have a guy, Lach, who's got a little more edge to him. He ends up booking Sidewalk Cafe and decides it's going to be an antifolk thing.

ADAM GREEN: Antifolk symbolized punk folk music. They found the West Village folk scene to not be very accepting, so they started acoustic open mics on the East Side. It was drawing on Woody Guthrie music, psychedelic music, Tom Waits, all kinds of different things.

KIMYA DAWSON: They were getting booted from the folk clubs, so they did their own thing and called it antifolk.

ADAM GREEN: It had a lot of humor, and the emphasis was always on original material.

JUSTINE D: Adam used to come to all the parties. He's such a sweet, strange kid.

ADAM GREEN: I was the intern at a record store in my town upstate. I'd just hang out there so much that they'd give me $20 to organize the records. I'd ask a lot of questions and I got an education in old vinyl. Kimya ended up working at that store as well.

KIMYA DAWSON: I was home for Christmas one year and I had seasonal work at a record store. Adam Green was this, like, twelve-year-old kid whose mom would always drop him off.

ADAM GREEN: Exile on Mainstream Records.

KIMYA DAWSON: He would bring in his tapes and be like, "I make songs!" "My parents are out, let's have a party!"

ADAM GREEN: When I was really young, I wasn't allowed to go to shows by myself so my parents would basically have Kimya, who is ten years older, be my babysitter. There were a few things that every high school kid did in New York at that time: you'd get ripped off buying nickel bags of weed from Washington Square Park, the delis would sell you beer without an ID, and you'd go to shows at Wetlands or the Cooler. So Kimya would always end up backstage at a show and I would be pounding at the door, like "Let me in!"

KIMYA DAWSON: Eventually, I moved to the Pacific Northwest for school.

ADAM GREEN: She went to Evergreen.

KIMYA DAWSON: Adam came out to visit.

ADAM GREEN: Washington was really exotic to me. It was the center of a lot of great music I had gotten into from getting into Nirvana—bands like Beat Happening and the Vaselines. The Pacific Northwest made a big impression on me. I liked a lot of the vibe. I liked that people were sort of never in a rush to do anything and no one had to take a shower.

ROB SHEFFIELD: I'm sure a lot of people have mentioned the very first *Portlandia* skit, "The Dream of the Nineties Is Alive in Portland." When Carrie says to Fred, "Remember the nineties? Remember no one had a job and everyone slept until eleven and maybe showed up for work at the coffee shop? Then they had to take off early to go to their clowning class?" "A place where young people go to retire." There was enough prosperity—not just economic prosperity, but in terms of cultural energy. And the thing is, every town was like Portland back then. People really cared about bands. There were audiences in all of these small towns paying a lot of attention to music.

ADAM GREEN: Before that trip, the Moldy Peaches was just a theoretical band.

KIMYA DAWSON: Back in New York, when he was thirteen and I was twenty-one, he had been playing with some kids and, one time, asked me if I wanted to come over. They recorded all this stuff on a four-track and then they said I should sing something. "Just make something up!" I was a camp counselor for ten years and so I just belted out 'Little Bunny Foo Foo.' Next thing I knew, Adam put it on a seven-inch. After that, if I was in New York to visit my parents we would get together and record a couple songs. So the first Moldy Peaches album was recorded over a nine-year period.

ADAM GREEN: We always liked the idea of dressing up. I would always just wear costumes. I know some people don't have the feeling for it, but if you're that kind of person that always pictures yourself wearing some pirate hat and then you get that pirate hat, you're like "Fuck yeah! This is the one I've always wanted!" That's an incredible feeling.

KIMYA DAWSON: When Adam ended up out west, we got a couple friends to play a show with us, so we could pay the electric bill.

ADAM GREEN: With the Moldy Peaches, the second we knew we were going to play live, it was like, "I'm going to be like Bruce Springsteen with the bandanna." Our friend Jess, who's the guitar player, was like, "I'm going to be a chicken in a Ghostbusters outfit! And then Kimya's going to be a Thundercat!" It was on.

KIMYA DAWSON: I had insane stage fright. I could get onstage if I was a rabbit, but it was really hard to get onstage as me.

JENNY ELISCU: The first time I saw Moldy Peaches, Adam was dressed like a sailor and Kimya was dressed like a hamburger and I was just like, "Whaaaat is happening?"

ADAM GREEN: I was on this weird couch-surfing adventure on the West Coast. Then I started to get homesick.

KIMYA DAWSON: Adam went back to New York. He was like, "I can't live out here anymore."

ADAM GREEN: I came back but now I was living in the city. I had a job at Rags-A-Gogo on St. Mark's Place. I'd listen to Skip Spence and Jamiroquai and Tricky. I met Karen O at Rags-A-Gogo; she used

to come in. One time she had a dance party in the store. She really liked dancing. Then, sometimes I would put on my own album, if there were people I wanted to meet. People would ask what it was and I'd say, "Oh, that's my album." One of the people I met was Albert from the Strokes. He came into Rags-A-Gogo in his three-piece suit. I was also wearing a suit. We were two kids having a conversation about how we were both wearing a suit. I kept on seeing him around and he kept on giving me a flyer for his band. I remember thinking, "These guys are probably terrible." Then I actually saw them at the Grand Saloon, this country-western bar on Fourteenth Street. I remember Albert's hands going crazy—he was playing all these chords. I was just like, "You're incredible!" They were already really good.

HAR MAR SUPERSTAR: The Strokes loved the Moldy Peaches, like they loved me, because we were the freaks, and they'd be like, "Check these freaks out."

JENNY ELISCU: They were the Strokes' little buddies.

JIM MERLIS: I played in a band in the late eighties and early nineties, and every other band that we were billed with, we felt this competition, and we didn't like them and we didn't become their friends. That's the exact opposite of what the Strokes did. As hard as they can be, they really championed a lot of people.

KIMYA DAWSON: They're total goofballs! We were a lot more alike than people thought. Everybody was like, "How did this happen?" The perception was "Oh, the Strokes and their denim and their Converse." They just came across as being very, very cool.

ADAM GREEN: I had gotten a notebook sometime around my last week of dropping out of college and it became my favorite accessory. I just would walk around Central Park and smoke weed and write tons of lyrics. Eventually I started playing on the subways, like the N/R train station on Eighth Avenue, and people really responded. I'd play my own songs. I'd play Moldy Peaches songs. One day somebody told me, "Have you ever tried playing at the open mic at the Sidewalk Cafe?"

KIMYA DAWSON: Adam had moved back to New York, but then one day he called me up. "Hey. I booked us a show, can you get here for it?" And I was like, "Well, shit."

ADAM GREEN: Kimya was sick of living out there. I told her there was this crazy thing going on in New York called antifolk. I told her all about it. She said, "I want in. I'm coming back."

KIMYA DAWSON: We had a lead guitar player who wore his guitar backward and had a chicken mask on. We had a drummer who was more like a child in a cowboy hat; he just banged on the drums. I went to them and said, "Wanna go to New York?"

REGINA SPEKTOR: I started going up to Sidewalk Cafe open mic when I was in college.

JENNY ELISCU: Regina would later date Jack Dishel from Moldy Peaches. She was part of the scene.

STEVEN TRACHTENBROIT: Regina came with her own great story of moving from Russia and leaving her piano but keeping up her chops by playing on the windowsill of her synagogue. She was totally quirky, but people liked the story.

REGINA SPEKTOR: Maybe that's the immigrant thing. You're always the person who has the slightly irregular socks. Like, you're a little bit of an outsider everywhere you go.

ADAM GREEN: I first met Regina at Sidewalk. She had a really solid family that would come in from the Bronx to all her concerts.

KIMYA DAWSON: The Sidewalk Cafe was where a lot of the people who were feeling outcast all sort of landed at the same time.

KAREN O: It was literally two blocks away from where I lived, above Odessa, so I would eat there all the time, and I knew that anyone could just go and do whatever they wanted; that was the vibe.

ADAM GREEN: Paul from Interpol played acoustic at Sidewalk.

PAUL BANKS: I definitely played at Sidewalk back in the day and saw the Moldy Peaches there. I played a song called "On the Esplanade" and some guy called out, "It's pronounced 'espla-NOD,'" and another guy called out, "You look like Luke Skywalker."

REGINA SPEKTOR: I still get asked about freak folk.

ADAM GREEN: People never want to be called anything, but I really welcomed being called antifolk. It gives people a framework. The best part about it was that it doesn't mean anything. No one knows what it means! It's perfect! I mean, honestly I feel really, really lucky to have gotten called anything.

"THE RETURN OF THE ROCK STARS"

ALBERT HAMMOND JR.: I remember when we heard about Geoff Travis, I was so excited but everyone was like, "Who is this Geoff Travis? I don't know if I trust him."

SIMON REYNOLDS: Rough Trade was one of the main, pioneering post-punk labels. They were the big player in terms of cool post-punk music that actually got to a relatively large audience. They had the Raincoats, they had Cabaret Voltaire. They had a lot of the really important groups of that era. And then they distributed, in collaboration with other distributors around the UK, all the other important records on other labels, like Factory. The guy that was the visionary behind Rough Trade was Geoff Travis. He had this A & R knack for seeing what was marginal but could become bigger than marginal, the Smiths being the paradigm.

BRIAN LONG: Travis is legendary at finding young talent.

JENNY ELISCU: If he's finding stuff, it's not because he found it that it succeeds, it's because he genuinely knows what is the best stuff.

SIMON REYNOLDS: But Rough Trade also had a slightly unglamorous image, ultimately. People started saying they were a bit like the hippie capitalists that sprung up in the late sixties. By the eighties they changed tack and actually started to try and have pop success. They started to see themselves as more like a small major label than an independent label. There was a problem with overreach, there was some kind of collapse in the distribution structure, and it went down.

KELLY KILEY: It was toward the latter half of 2000 that we got sent the Strokes' music.

GEOFF TRAVIS: The label had closed down. It wasn't really in existence. We were just managing people.

KELLY KILEY: We were just in the process of getting the Rough Trade name back and there were only about seven of us working in the office at the time.

RYAN GENTLES: Geoff called and said, "I want to put this out and sign them and I'll bring them over to England to do a show as soon as they're free, if they're willing to do that with me." I said, "I'll talk it over with them." So I called them and said, "I'll manage your band."

JIM MERLIS: I didn't know Ryan was working with the Mercury Lounge. I hadn't seen him in a year and I didn't know his name; I knew him as "Weezer." I was at a Sloan show at the Bowery Ballroom and he approached me. He said, "I'm managing this band, I'd love to send you some music." I said, "Why don't you call me tomorrow," partially just so I could get him to say his name, since I couldn't remember it. He either sent me or dropped off a three-song CD. I was really impressed.

RYAN GENTLES: In the beginning it wasn't me managing them, we were managing us. That's how we felt. We split everything equally, which is very unusual. The idea was just to keep us all equal so that guy doesn't have a Corvette while the other guy has a jalopy. That would make tension in the studio. It was Julian's idea. I didn't propose it.

NICK VALENSI: Our first gig at the Mercury Lounge, if I'm remembering correctly, was in August 2000. It was hot as fucking hell outside, and the air conditioner was broken so it was like 110 degrees inside. We were really worried that people weren't going to want to stay in there, but people did. Sweaty people. I remember I was wearing a leather jacket even with the lack of air-conditioning. You gotta stick with the plan; you can't deviate.

RYAN GENTLES: Over the next five months, I booked them shows out of town. I told them, "You can only play in New York once every two weeks," because they were starting to get a draw and I didn't want to fuck that up, so I booked them these little shit shows in Connecticut and Philly.

NICK VALENSI: I wanted to play all the time. That's why we started going to DC, we'd go to Baltimore. I remember going to fucking Delaware.

RYAN GENTLES: It was terrible, playing to three people, but they were playing and they didn't care. We'd all just get drunk together and hang out.

ALBERT HAMMOND JR.: We drank, smoked, and there were times when I got speed, pills, pharmaceutical stuff that we all took.

NICK VALENSI: Ephedra. Diet pills. That was a big drug, for me, personally, at that time, just to stay awake on the road. Cigarettes, weed, and ephedra. You balance the ephedra out with the weed and the alcohol.

ALBERT HAMMOND JR.: In the early days, we all shared in that.

NICK VALENSI: We toured in a van for a long, long time. I didn't have a license then, so I didn't drive. Fab didn't have a license either. Nikolai did have a license, but we were not always comfortable with him behind the wheel, so the main drivers were Albert and Ryan. Julian would drive by day, occasionally, when he wasn't drinking. Although there was a time where, in the middle of the day, we were driving somewhere, on the freeway, and our van just started to shoot forward and stop, shoot forward and stop. Julian was behind the wheel. We said, "Julian, what the fuck is going on?" He's like, "I don't know, man, I have my foot on the gas." We broke down at the side of the road and could not figure out what the fuck was wrong with the car until someone, I don't remember who, realized that we were just out of gas.

RYAN GENTLES: Then I booked them a residency in December of 2000 at the Mercury Lounge.

JULIAN CASABLANCAS: That was a big moment for us.

DANIEL KESSLER: When I saw that—a local band doing a residency at a great club like the Mercury Lounge—I thought, "What the fuck, really? That's crazy." The fact that there was that demand and that they were selling out was incredible.

CRAIG FINN: Those shows are sort of legendary.

RYAN GENTLES: They played every Wednesday.

ADAM GREEN: Ryan asked me if I would be the opener for the first show. They were all really welcoming to me and then told me they wanted me to open all the residency shows. I said, "Well, I have this other band called the Moldy Peaches . . ."

ROB SHEFFIELD: Jenny Eliscu called me; she said, "The Strokes are playing Mercury Lounge."

JENNY ELISCU: I was writing my master's thesis at the Pink Pony, right around the corner from the Mercury. You could still smoke, and I had a friend who worked there and would refill my cup. So I was there all the time that December. The third out of four shows is the one I finally saw and it wasn't very well attended. I was kind of surprised. And people didn't seem to know whether they liked it or not. They seemed to be in the classic arms-folded New York stance.

GIDEON YAGO: It wasn't like suddenly the heavens had opened.

JENNY ELISCU: But I loved them immediately.

ROB SHEFFIELD: Moldy Peaches opened. Kimya was in the sheep suit and Adam was in his little Robin Hood outfit. It was really, really good. They were fantastic.

ADAM GREEN: I was jealous because the Mercury Lounge gave the Strokes beer, and for me that meant they had made it. They bought them beer!

ROB SHEFFIELD: So then the Strokes come out. People playing the Mercury Lounge had to walk through the crowd. Usually they would be very hesitant, trying to make a discreet entrance, as if they knew they looked a little silly. I had never seen a band walk through Mercury Lounge like they did this on purpose. Like they did this every show. But the Strokes turned that into their entrance, just walking right through the crowd with their guitars above their heads.

FABRIZIO MORETTI: That was one time I remember feeling really cool, walking through one of the sold-out Mercury Lounge nights. From the front of the place to the fucking stage, they were just there to see us. It was the first time I felt like I was looked at, and it felt really good. That was also the last time it felt good.

ROB SHEFFIELD: And then they were phenomenal. They were absolutely fucking great. They were so into it. They were so passionate. Like, people would talk about them in print as being jaded or remote but that's the opposite of how the music sounded. It was very . . . it was very enthusiastic. Very gung-ho. Very boyish. Very sexual. There was this great part where Julian was looking at the crowd while they were playing "Last Nite" and says to someone in the front row, "Don't fucking yawn." It was really funny. I loved the idea of a band where if you were standing in the crowd and you were yawning, you were a target.

MARC SPITZ: Julian wanted the shows to be good, as a proud, hardworking musician. Not as a rock star. It wasn't a party. It was more like a track meet, something he felt like he was training for.

ADAM GREEN: Those shows had an element of hysteria to them, which was cool because I hadn't seen that yet. For any of the bands that were my age, I hadn't gone to a show where people were genuinely losing their minds.

ANTHONY ROSSOMANDO: It was almost like they paid everyone to freak out. There were all these models there. It was ridiculous.

ROB SHEFFIELD: They were trying! It wasn't cool to try. They were really vain and very preening. They were very funny. They had a real sense of humor about themselves onstage. Playing this role that they enjoyed and that they knew was ridiculous. They actually wanted to be rock stars, and they acted like rock stars. It's like Richard Hell said about the New York Dolls. They saw themselves as stars first and musicians second. Nobody would have cared if the Strokes didn't have the songs, but they did.

GIDEON YAGO: I do remember thinking, "This band is really tight!" Coming just after grunge, where the emphasis was on the distortion pedal and just let one sound bleed into the other sound, these guys cut chord changes and moments in the songs into each other. Everybody talks about Television but I kept thinking about the Buzzcocks. It was party music. It wasn't mopey music. It was dance music.

ANTHONY ROSSOMANDO: Those guys got it together quick. It was inspiring, like, "Ah, two-and-a-half-minute songs—one idea, song done, another idea." It was like, "Duh."

JIM MERLIS: You have to remember what other music was around at the time. There was nothing.

RYAN GENTLES: Jim Merlis was one of the people I sent the demo to. He pulled me aside after the first Mercury Lounge show and said, "I'm in."

JIM MERLIS: It was so funny because before the show I was Mr. Cool, "I don't know if you need a publicist . . ." and after I was suddenly saying, "We need to meet really quickly."

JENNY ELISCU: Having Jim Merlis on their team meant something. He'd been Nirvana's publicist.

JIM MERLIS: I think the show was a Friday, and on Monday we had our first meeting, at 2A. The other interesting thing about that meeting was that Juliet [Joslin, now Casablancas] was the bartender downstairs at 2A. So the first night I met both of them was the night they met. She and Ryan went to college together.

RYAN GENTLES: I was an RA and her roommate was a klepto. We became friends. She was obviously into music, she looked cool. We never had any type of sexual relationship, not a kiss or a cuddle, anything; we were just buds instantly. When I started working with this band, I told her I needed help. She was still in college, but she'd help me part-time between classes, and then she dropped out when the band got more popular and I was able to pay her a salary, and after that, she got a raise. Then she met Julian and got another raise.

JIM MERLIS: Max Tepper, who worked in our office, he knew about the Strokes but he hadn't told me about them. He was tough, hated everything. Max said, "I hear that guy's an asshole," about Julian. After the show I said, "Quite frankly, I don't really care."

JENNY ELISCU: I was the right age to appreciate it because I didn't feel any resentment about them being the same age as me. I just thought the music was fucking cool. I mean, there were presentation elements that needed work. It has always been true that Julian is both trying way too hard and really just not trying at all. But I could see the vibe they were going for, either intentionally or unintentionally, and it was cool.

JIM MERLIS: They didn't exactly do what Nirvana did to hair bands, but those Limp Bizkit bands did become kind of obsolete around that time. Punk rock had morphed more into that Green Day–ish thing, which has nothing to do with CBGB's in 1977. Jenny Eliscu kept saying to the band, "You don't understand, there's not been something good in New York in decades. Decades." It was the return of the rock stars.

RYAN GENTLES: Jim Merlis said, "I'll do this for free, they're so good, they're going to get a deal, I'll do it until you get the deal and we'll just work it out." I was like, "Great. This guy at Rough Trade in England is going to put the record out."

"SHIT, I'LL BE IN *THAT* BAND"

JALEEL BUNTON: The reason you grow up wanting to be a rock star is 'cause you're like, "I don't know how to communicate so well, and if I could just make this fucking song, I don't have to."

PAUL BANKS: Some of my dissatisfaction with life started with seeing a really beautiful girl and having this unbelievable longing and sense of sadness about the lack of connection, or the lack of awareness of my existence. So what I would do, the only thing that would keep me in my own skin would be to say, well, I'm going to make something so fucking good that I'm worthy of that thing that I lust after. If I got everything I wanted from girls, I wouldn't write shit.

DANIEL KESSLER: I remember the first time I heard Paul sing. It was amazing.

PAUL BANKS: I started playing guitar when I was thirteen, fourteen. By fifteen I'd tell guidance counselors, when they asked, "What do you wanna do?" I said, "I want to be a rock star."

DANIEL KESSLER: At that time, before Sam joined, it was Carlos, our original drummer, and me. We had already been playing, so we had songs. We had an early version of "PDA" and maybe "Roland"?

PAUL BANKS: My feeling was "Okay, I'm not looking to be in a band, but I walked into a room and Daniel and Carlos were playing "PDA" and it was "Shit, I'll be in *that* band."

DANIEL KESSLER: Early on, I'd been singing a lot more than him. Paul was still finding his place. He wasn't even sure if he was going to stay in the band.

PAUL BANKS: I quit after a couple months because my ego was annoyed that I wasn't writing songs, that I was only going to be a guitar player. I remember I played him one of his own songs and said, "If you can write that, you don't really need me. There's all the talent in the world right here. Just do your thing, I'll do my thing." Before Interpol I had a song where I sang, "There are no pretty girls." I did that in my apartment in '96. The chorus was the sound my phone made when I took it off the receiver for a while. I was experiencing very deep depressions at that age.

DANIEL KESSLER: I called him up and I was like, "Wait a minute. What if you come back and you sing?" Then Carlos and I went to the smallest room at Funkadelic Studios. We were playing a very slow, ambient piece of music and all of a sudden Paul started singing and we were like, "What the fuck, he can really sing."

PAUL BANKS: I had sung before—and this is the fascinating part about being in a band: I was of the Elliott Smith, four-track home-recording school. But my quiet delivery wouldn't float the boat with the drummer in that small concrete room. So my vocal style from the early days developed based on me shouting my own lyrics so they would be audible over the drums.

DANIEL KESSLER: That day we heard Paul sing, we really knew. There were a couple of moments like that in the band. The first rehearsal with Sam, same thing.

SAM FOGARINO: I'm from Philly but I was kind of up and down the East Coast trying to find something, you know? I had been playing in a band in Miami for about five years and I was kind of heartbroken that nothing ever really panned out aside from a couple seven-inch singles and a full-length that was kind of too little too late. So I traveled around and eventually, in '97, landed in Brooklyn with about $50 in my pocket and all my worldly possessions in a car. It was a Ford Escort.

PAUL BANKS: We parted ways with our first drummer without knowing who our second drummer would be.

SAM FOGARINO: The path to serendipity was led by this guy Doug Henderson, who was a recording engineer. He pulled me aside and said, "I can see you're frustrated as hell. Daniel's band just recorded

and their drummer sucks." Doug got me the tape and I thought it was really good but it just didn't hit me. It was about two years later, in 2000, that Daniel and I met up again and he gave me what is commonly referred to as *The Great EP.* It was just an EP with hot-pink lettering in that Interpol Helvetica font. And it was recorded at the Rare Book Room. I thought, "Oh my God, this is good." It still had the roots of punk in there but there was a lot of atmosphere, and Paul's lyrics just got my attention. I was like, "Here it is. This is it." We met up once before the first rehearsal, briefly, for a drink. I remember Daniel saying, and trying to be as kind as possible, but saying, "Carlos is very sarcastic and arrogant, and Paul is very cold and distant. Don't let it bother you."

PAUL BANKS: Carlos is an intense and very complicated guy. He's . . . inflexible. So that creates tension right there. And Daniel is very mild-mannered, but he's got a game plan, he's got a long view, he's got an overarching concept; he's got his goals but he's very tight-lipped. And then I'm more of a sloppy, loose person, which I think in some ways is repulsive to other people who are more rigid and inflexible.

SAM FOGARINO: At this point in time I was used to jumping into the fray, used to arriving at the party well after it started. So I could be a loner for a little while.

DANIEL KESSLER: The first rehearsal with Sam was instant magic.

PAUL BANKS: I just remember when he hit the kick drum, I could sense the precision. Tight, powerful, and precise. And he looked cool. Sam also brought a DAP to that first rehearsal. And he made the best recording we ever heard of the band. One of the songs was "The New." My parents were in Spain at that time so on my college summer break, I went home to Spain and I had this cassette. I remember playing it to this girl that I was hanging out with at the time. I was so excited about what we were doing, I wanted people near me to hear it. She didn't get it.

SAM FOGARINO: I was looking for Interpol but I didn't know it.

DANIEL KESSLER: Being a band in New York is fun but it's not fun. It's expensive and you're broke and everyone is scrounging for money and you get your rehearsal space for an hour or two and your equip-

ment is all broken, so you spend your first hour saying, "The thing's broken . . ." That was a very hard time. We spent four years without having anyone pay any attention. It was like being in the minor leagues. But it gave us time to develop. By the time we did get attention we were solidified and had our foundation, and it was very hard for an outside force to penetrate that.

ANARCHY IN THE UK

JIMI GOODWIN: The Strokes were one of those bands that people saw and then instantly wanted to form a band.

LAURA YOUNG: It just has to be the perfect cross-section of right place, right time, right music, right image.

APRIL LONG: I was in the *NME* office the day that James Endeacott, the wild-haired roving party maker from Rough Trade, brought in the Strokes demo to play. I said, "Oh, that's that band I saw in New York at Don Hill's. I have a picture of that guy's butt!" He brought it in, played it, then left, and James Oldham put something else on. We're sitting there, and then James said, "Let's listen to that demo again." We basically never took it off.

RYAN GENTLES: There was one song on the radio, "The Modern Age." It was all based on that song, and this photo Leslie Lyons took that ran in the *NME*.

LESLIE LYONS: We shot one of those Wednesday nights in December 2000 at the Mercury Lounge residency. My assistant and I watched the show and then I got right behind the camera and began shooting. That first night we shot until two or three A.M. in the tiny room off the bar in Mercury Lounge. I wanted them the minute they stepped offstage. Afterward, we moved locations to Café Noir in Soho. I can't overstate the strength of their personalities, really. Their shadows have more personality than most people.

RYAN GENTLES: She took pictures the second night of the residency and sent them right over to Geoff. It was the classic picture of them hanging around, all fucked up. That picture is, in our history, kind of famous. And as soon as those pictures ran in *NME*, that was it.

It was that photo, them being from New York, and their names. They had these cool fucking names.

JEANNETTE LEE: I remember that first day we heard their CD we were calling out the names, like, "Is this a real name? These are rock-star names, they can't be true! Could it possibly be that they look good as well?" They did.

VITO ROCCOFORTE: English indie rock was just boring. There were all these post-Radiohead bands. Everybody in indie rock was trying to be Radiohead but there's only one Radiohead.

DAVE GOTTLIEB: We're talking about a time when Coldplay was considered alternative.

CONOR McNICHOLAS: Post-Britpop there was this terrible nether-land that was filled with Travis and Coldplay. Steve Sutherland described *NME* readers as being the stinky kid in the school playground with the big parka on who you didn't want to speak to. Suddenly when the Strokes turned up, we were the cool kids again.

KELLY KILEY: They arrived on a wet January morning, got out of the bus, and it was just like, "Oh my goodness, they are here." They just looked so cool.

RYAN GENTLES: We first went to the UK in January of 2001.

KELLY KILEY: Even from that first time they stepped off the bus they were stinky. Albert, not so much, or Nikolai, but the others just stunk. There was too much partying to be had to clean your clothes. They wore the same clothes all the time.

KIMYA DAWSON: They were all younger than me so I was kind of the mom and I remember saying to them, "Don't you want to remember this shit?" And they were just like, "Woohoo!" Party mode.

KELLY KILEY: It was funny because they were also sophisticated. Like, they made fun of the English food; there were no good sushi bars.

JULIAN CASABLANCAS: We hung out with all the Rough Trade people—we were friends with them.

JEANNETTE LEE: Julian has always seemed to be struggling with himself.

KELLY KILEY: That first day we took them into the Rough Trade shop. It was raining and they weren't appropriately dressed, no thick coats, just thin denim and leather jackets. Then we went out that night. I just remember standing at a pinball machine with Julian and him telling me all about his stepfather, just really complex, in-depth stuff.

GEOFF TRAVIS: Julian's not comfortable.

JEANNETTE LEE: He's uncomfortable with himself. He's always like, "Do you think I'm an asshole? I'm an asshole . . ."

GEOFF TRAVIS: "Don't talk to me, I'm an idiot."

JEANNETTE LEE: He's always struggling with communication.

GEOFF TRAVIS: But at the same time, that is a major brain calculating every single thing.

JEANNETTE LEE: Julian is incredibly affectionate when he's not being standoffish. I mean, there's so much hugging and kissing all the time. English people are very reserved. They're like, "Hello." He's like, "Come here!" Julian is this big bear. It's kind of shocking.

RYAN GENTLES: We did a few club shows, and they all sold out.

KELLY KILEY: There had been all this hype. Jeannette and Geoff had just gone to see them in New York, and literally six weeks later, they're here in freezing-cold January. People were just fawning over them.

KELE OKEREKE: Around that time, *NME* had a free CD on its cover that included "The Modern Age." That was the first thing that I heard and thought, "Hey, this is cool."

LESLIE LYONS: By the time the Strokes hit the stage they were already superstars. The pictures were all over the English press and their shows were backing up what people were seeing in the pictures. Nothing was left behind in New York. The look, the sound, the energy was presented in full force. It's like the Mercury Lounge residency was a big bang and the particles just started spreading far and wide at an accelerated speed.

APRIL LONG: The big show was at the Astoria.

KELE OKEREKE: I saw the Strokes at the Astoria with Peaches and Trail of Dead. They were on second and it didn't feel like anybody knew who they were. I don't know what anyone was expecting but by the end of it I was completely like, "Who *are* these guys?"

APRIL LONG: They went on to completely take over that tour. None of the other bands were talked about afterward. They were fucking fantastic. I remember Fab, who was, what, nineteen or something then? I remember he had a phone number—his mother's, I think, but it could have been a tour manager's—pinned to the inside of his jacket in case he got lost. I mean, that's what they were like.

ALBERT HAMMOND JR.: When you first start, it's not even money. No one was like, "What hotel are we staying at?" It was like, "We're going to England to play music?! This is everything already."

KELLY KILEY: The night at the Barfly was also big. It's a really small venue, but there must have been about twenty thousand people there, if everyone who says they were there actually came. Julian was sick before the show, then went on and just nailed it.

JEANNETTE LEE: That was their moment in London.

RUSSELL WARBY: They were tremendous. It was a tiny room, but they absolutely took it over. Afterward, we all piled into the back of this van they had and went back to the Columbia Hotel, where they were staying. The really peculiar thing is all of these people that were in the van, including me, were serenading the Strokes with these songs that we'd just heard. We've heard them once or twice and we're now singing them all back to the band. They just sort of sat there stunned. .

KELLY KILEY: You can get rooms for five at the Columbia. We were arranging for them to come over in January and one of the things that sticks out in my head was Ryan saying, "I can stay in the same room as them." I was thinking, "This is weird, why is this old dude in the same room as them?" He must have picked up and he said, "You do know I'm the same age as them, don't you?"

RUSSELL WARBY: At the Columbia we had quite a lot to drink, and people fell asleep, including me. I fell asleep sort of propped up against the bed. I remember waking up, maybe sort of four in the

morning, and seeing Nikolai in bed with a big smile on his face, and his boots still on.

JIM MERLIS: I went over to London for those shows. No one paid for me to go, I just wanted to be there. And I stayed at the Columbia Hotel. I remember getting a call in my room. This was before they'd played, just after we'd all arrived and were settling in. I went up there and it was the six of them—Ryan too—they're all in a bed watching TV. It kind of stank. Real boy odor. They were all barefoot in bed together and they smelled like rock stars. They said, "We just want to tell you, we want to do this for the rest of our lives." It was so sweet.

25

"PARTY IN A BAG"

KAREN O: The beauty of New York, the genius of New York, is that you can leave your house and run into someone and hang out with them, and then they take you to the next place and you run into other people and before you know it, you have a posse. And you're launching into the night until four in the morning on some adventure. That aspect of New York, which is the most genius part of the city, is what it feels like to be in a band in New York. You collect your crew as you go along, in a seemingly random way, but there's something that connects you, and the criteria for that something is pretty minimal. Which is also the beauty of being young.

NICK ZINNER: I used to call Karen "a party in a bag." Like, "Oh, we should totally invite Karen, she'll set the party on." She had this infectious, super-wild, didn't-give-a-fuck, awesome, fun, silly thing.

DAVE SITEK: Karen can rage. And everyone's invited.

NICK ZINNER: New York when I moved here was awful because everyone was so serious and cool and into heroin. All the bands were dark and serious. We had our dark band—Unitard was super dark. But that lightness, that silliness, was inside us, and Karen was an expert in bringing it out and embodying it. We really needed that and New York needed that too.

KAREN O: I was all about getting free and causing trouble. All I wanted to do was cause trouble. Like, if I had a night where I didn't cause trouble I'd be really disappointed in myself. I lived for it.

DAVE SITEK: The most drunk I've ever been in my life is definitely with Karen, and the most trouble I've ever gotten into in my adult life is probably with Karen, and the most fun I've had has probably

been with Karen. It's just her ability to defend the sandbox against the adults. She defends the right to just be creative and follow your bliss.

KAREN O: I had a lot of buddies who were just as into causing trouble as I was; Christian Joy might be the primary one. I had a couple of girlfriends who would just get kicked out of everywhere, just fuck with the wrong people, but they were the right people because they were asking to be fucked with!

CHRISTIAN JOY: She can be this normal, shy woman who's in the kitchen cooking food and you don't have any impression that she might be this amazing performer. And then all of a sudden the other side of her comes out. Karen has this dual personality.

MARC SPITZ: I first interviewed Yeah Yeah Yeahs at some douche-baggy bar on the corner of First Avenue and Houston Street, where people go for, like, chicken wings and blood transfusions. It was like, "Why are we meeting there?" It was Nick, it was Brian the drummer, and then this skinny, frail-looking, mousy chick in a blue hoodie pulled all the way over her head. I thought, "Who's this?" and then I realized, "Oh, it's Karen. She is acting absolutely nothing like the sort of microphone-blowjob-giving, beer-spitting Karen O that she is onstage." Which is, you know, what happens. You have this persona—you don't live that way.

ASIF AHMED: Offstage she's like a librarian. Painfully shy and private. I would actually make fun of her about it, like, "No one wants to know what you do offstage anyways because you're fucking boring." There was nothing to report.

KAREN O: At my elementary school we had to do a lip-sync performance of "Wild Thing." It was a small private school; there were probably seventeen of us in the entire grade and out of that there were four or five girls. I was the lead singer. The girls wore poodle skirts and I was the boy—I slicked my hair back and I wore these sunglasses that were so dark I couldn't see out of them. I got up there and I just went nuts. I was pretty unaware of the audience watching—the kids, the teachers watching. It actually did freak a lot of the teachers out, and probably the kids too. I was a goofy kid but I was pretty mild mannered, and then it was like this thing

came out. So there were glimpses leading up to when I got onstage with Yeah Yeah Yeahs for the first time.

ROB SHEFFIELD: Karen probably told you that the impetus for Yeah Yeah Yeahs was that she was always going to indie rock shows and people were sitting on the floor. She was like, "I hate that."

NICK ZINNER: At some point Karen was like, "Let's start a rock band!" My first reaction was "Ugh, why? We have this cool thing here with Unitard. We're playing these great, haunting ballads." I was playing slide guitar. They're really cool songs! But she was like, "No, dude, trust me, dude"—she used to talk like a seventeen-year-old Valley girl, or Valley boy, actually: "Dude, dude, come on, dude." I started to get into the idea. We started telling everyone, "We're going to start a rock band and we're going to be fucking awesome."

ASIF AHMED: I was kind of the only younger manager at the time; everyone else was 180 years old. I was also the East Village bar-fly. Three sips of alcohol and I'm like, "Let me tell you something about the music business . . ." Meanwhile, I'm twenty-three.

NICK ZINNER: One night Karen and I were in my loft with a drum machine. We drank brass monkeys and literally in two hours wrote four songs, and two or three of them were on our first EP. "Bang" was the first song we wrote. After that, our bar bragging was validated and it was also heightened. We came up with a name a week later. We were at some bar on Avenue A. We overheard someone just saying "Yeah yeah yeah" to someone else and that was it. We had a name, we were telling everyone how badass we were; eventually we knew we were going to have to play some songs.

RENNIE ELLIOTT: In the beginning it was Karen; Nick; Jack Martin, also on guitar; and me.

NICK ZINNER: There was a month and a half that Karen and I played with different people.

RENNIE ELLIOTT: I'm not sure why exactly they asked me; we were good friends, but I really wasn't a great drummer.

NICK ZINNER: We tried playing with a keyboard player, but none of these things were working. It was a nightmare, just really, really hard.

RENNIE ELLIOTT: The first practices were at Tu Casa Studios. Karen and Nick came with the song ideas and Jack and I joined in. They had already decided on the name and had some of the songs that were on the first album. Karen and Nick were best buds and had a very strong creative musical connection from the start.

NICK ZINNER: It was all taking a long time. And then our friend Dave was like, "Hey, you guys are always talking about your band that no one has ever heard of. Do you want to open up for the White Stripes at Mercury Lounge?"

"I DON'T KNOW WHO WAS PAYING FOR THE DRUGS.

IT WASN'T ME."

RYAN GENTLES: The *Modern Age* EP came out in the UK on Rough Trade January 29, 2001, basically right at the end of that minitour. While we were in the UK, Doves asked us to open for them as main support on their upcoming U.S. tour, which was going to be in February/March. So when we got home, we went on tour supporting them.

DAVE GOTTLIEB: In the 1990s, RCA was a cemetery, but they had turned it around. They had Dave Matthews Band, Christina Aguilera, the Verve Pipe. I got there right as Christina was exploding. They had rebuilt themselves by having a couple of one-off hits like the "Macarena" that brought in revenue.

RYAN GENTLES: Geoff Travis offered to give us fifteen K tour support to do the Doves shows, which was amazing, as he didn't have us for the U.S. territory at all. It was just on the condition that we pay the label back once we got signed in America, which of course we did. By that time, we were well embroiled in negotiations with RCA.

DAVE GOTTLIEB: When I got handed the Strokes' single by Steve Ralbovsky he said, "I want you to come see this band, they're playing at the Bowery opening for the Doves." I listened to the single and I went, "Okay, this is different." I went to the show. I remember them coming out and ripping through three songs. I grabbed Ralbovsky, who was standing in front of me, and said, "Any major label that signs this band is on crack." He was like, "I don't under-

stand. You don't like it?" I'm like, "No, it's fucking great. But this is not what we do."

BRIAN LONG: When I was at MCA I had the second big meeting with them. I took them to a Chinese restaurant on the Bowery right below Canal. We had a big round table, and they were real smartasses in a very entertaining way. They were very "Impress us." And it was hard. We had Blink-182, you know?

DAVE GOTTLIEB: I mean, the show was as fresh and memorable as any—it was probably one of the top five rock shows I've seen in my life. Right there in that room at that moment they were seizing their opportunity, they were looking like no other band out there, but that's a problem. At major labels, it's about following. "How can we follow doing what somebody else has already succeeded doing?" Not "How do we cut a new path?" And RCA, despite having the Foo Fighters and cutting somewhat of a path with Christina Aguilera, still was not confident enough to think, "You know what, we've got the fucking Clash and we're going to make this happen. This is the future of rock and roll." That's what it would take and that's why I was saying any record label would be on crack because they would be trying to break what their livelihood was.

BRIAN LONG: They didn't sound like radio! The radio sounded like rap rock. But that was what was great about them, because things change. You know, radio changes.

DAVE GOTTLIEB: You could tell that if you got it right with the Strokes, it would make a certain type of music irrelevant. Something else on your roster that has been vibrant and important, it would be gone. Something like the Strokes is going to be shocking in the same way that grunge was shocking to the world of hair bands.

BRIAN LONG: Of course I wanted to sign them, but you know what I was told? "They don't sound like the radio. Go find something else." I took them out in January of 2001 and it was probably in April 2001, I get a call from the president of MCA and he goes, "You're the one that was telling us about that band the Strokes from New York, right?" I was like, "Yeah. You told me you didn't

think they sounded like the radio. So I stopped pursuing them." "Think you can get 'em still?" That's one of the fallacies of that structure—it often doesn't reward foresight.

RYAN GENTLES: The RCA guys had actually flown out to Toronto to see the band on that Doves tour. That's when Steve Ralbovsky and Jack Rovner made their big impression.

STEVE RALBOVSKY: Their prior experience with label representatives had put them off. People were asking them about what they did in their spare time; they wanted to know more about the band's relationship with John Casablancas, they wanted to be chummy and show how cool they could be. We weren't really showing up to show off. And Jack delivered a youthful head-of-company articulateness.

DAVE GOTTLIEB: The Strokes loved Jack because he never said no. And he responded to Ryan and the band whenever something was up. He wasn't doing that with everyone.

STEVE RALBOVSKY: And I think they liked a lot of the bands that I had signed and worked with in my day, back to the Beastie Boys and Rick Rubin.

RYAN GENTLES: By the time we returned from that tour, we knew it was RCA's deal to fuck up.

NICK VALENSI: The signing experience was very exciting. Dinners, drugs, expensive wine. I don't know who was paying for the drugs. It wasn't me. You're sitting with people who have what seems like an endless expense account to basically do whatever you want, and their job is to impress you and to show you a good time. I certainly took advantage of that. We were still in a van at this point, show-ing up to dinner in Converse and jeans you've been wearing for a month. We would choose the restaurants. We'd sit down and ask for the wine list, pick out expensive wine, sometimes to the horror of the people who were there with you. It was really fun. We were kind of at the tail end of the over-the-top record label excesses.

RYAN GENTLES: I didn't choose the label, but I did do this: I said, "I like Interscope, I like Epic, and I like RCA." I broke down to ne-gotiations to see who I could get, and I was pitting them against

each other to see who would give us what I wanted out of a deal, because all Julian knows is he wants to make records. I knew that I wanted to own *Is This It,* the first record, and I asked the three labels, "Can we own this record? I don't want to give it to you, you can release it, but we want to own it." Two said no and one said yes, and that's who we signed with. All the other deal points were identical. We might have even taken a little less from RCA on some deal points, because I wanted the record. We own it, we can release it if we want, anniversary edition; it's all ours, we can put it out on our own label, it belongs to us. Not even Elvis or the Beatles own their records.

DAVE GOTTLIEB: You felt a groundswell happening that summer of 2001. They did a dozen or so dates with the Doves and they were selling out everywhere they played. Then they'd go play a two-hundred-seat club in Philly on a Wednesday night and it is packed and people are going bonkers and you're going, "Um, there's no record out. How are you finding this?!" This is where this band's story is different from those before. Because this is where the Internet comes into play—people have CDs they're burning and passing to each other. That was already happening.

RYAN GENTLES: After the Doves dates in February/March, we got offered four or five support slots opening up for Guided by Voices, which was a dream come true for the guys.

ALBERT HAMMOND JR.: They were my favorite band, so we were just excited and it became a big influence on our sound for our first record, really, more so than people give them credit for, more than Television, I'll tell you that. I hadn't even heard of Television. I had maybe heard about them but I never investigated. I just knew, "Oh yeah, that guy Verlaine or whatever."

STEVE RALBOVSKY: I managed Tom Verlaine for a while. They were more impressed that I signed Ween.

JULIAN CASABLANCAS: The dream for me was to be in a band like Guided by Voices or Built to Spill, and just be big enough to have a fan base and be able to do it for a living. That was the goal, and it wasn't anything beyond that.

NICK VALENSI: No one at any point ever said, "I want my song to be

on the radio," or "I want to sign to a major record label, I want to go headline the Reading Festival." No one was thinking that. We didn't even fucking talk about those things, but in my mind, I would have been happy if we could just get to that Guided by Voices indie level of success. If we could tour clubs and do this for the next ten or twenty years, I'd have been happy as a fucking clam. I'm telling you I'm not an ambitious person, I'm not.

FABRIZIO MORETTI: Bullshit. We were ambitious. The several levels of Dante's Inferno that we had to go through emotionally within the band to be able to stick to it, was crazy. That's ambition, that's like the definition of ambition. Even beyond what is mechanically necessary for you to survive in this world, you emotionally and psychologically need to want it. That's why people revere athletes. It's almost self-preservation to say we didn't care that much.

RYAN GENTLES: The Strokes continued to record from the time they got back from those GBV support slots in early spring, all the way through the summer, well before the deal with RCA was even done. We were recording the album anyway, using money from a publishing deal with Warner/Chappell that we signed earlier in the year. Not that we needed a lot. I think the whole album cost about twenty K all in, not including the advance paid to Gordon, of course, which came from the label, eventually.

GORDON RAPHAEL: We recorded *Is This It* between March and April 2001 at Transporterraum in Alphabet City.

MARK RONSON: I had my recording studio on Second between A and B, which was where the Strokes recorded that first album. There were these jazz guys, they had two other rooms in the basement. They said, "I hope you're a little better a neighbor than the last kids we had," and I said, "Who were they?" "This fucking band, these kids, there were pizza boxes everywhere, beer, their friends coming in, they're making massive amounts of noise," and I asked, "What were they called?" and he said, "The Strokes." At that point, I didn't know any of those guys, but they already were heroes. I was like, "Are you fucking kidding, do you not know who the Strokes are?"

RYAN GENTLES: I remember watching *Mallrats* a lot in the basement.

I remember Gordon smoking a lot of weed, sometimes freaking out because Julian wanted to go sixteen straight hours in the studio. He was always very driven.

GORDON RAPHAEL: They were a little pickier than I was used to.

JULIAN CASABLANCAS: Gordon just had the right ingredients for us. We tried to do the same songs with other people and they sounded totally stale. Gordon is the king of understanding abstract information. You'd get further by saying, "Could you make it sound more yellow?" than you could saying, "Take out the bottom end," or something. He'd get it.

RYAN GENTLES: Gordon is such a great interpreter of musicians. Julian won't say, "That hi-hat is too trebly, turn the bass up or the treble down." He'll say, "I need the hi-hat to sound like the rich guy who hangs out at the party and doesn't talk to girls, waits for them to come and talk to him," and Gordon is like, "Okay." That's almost verbatim how I've heard him describe a hi-hat sound. "It's too much like the way a sleeping bum smells on a Friday night when he's had too much booze; I don't want it to smell like that, gussy it up and shave him. That's the snare drum sound I want." He talks in analogies like that and Gordon understands them.

ALBERT HAMMOND JR.: Julian had stressful moments and so did Gordon, but for me, I just felt like it was going to happen. So I let it go a little bit. I believed in it. I'd listen to the songs we were doing with Gordon and they'd all just gel. This was when everything was fun. We had the songs, we knew what we wanted to do, we had the right person, we had the momentum. You're not thinking—your gut just feels it.

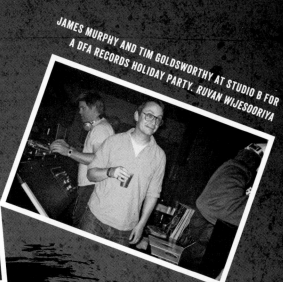

JAMES MURPHY AND TIM GOLDSWORTHY AT STUDIO B FOR A DFA RECORDS HOLIDAY PARTY. RUVAN WIJESOORIYA

TIM GOLDSWORTHY AND JAMES MURPHY AT THE PLANTAIN RECORDS STUDIO, TAKING A BREAK FROM WORKING ON REMIXES, MARCH 3, 2006. RUVAN WIJESOORIYA

fuck off you cunt
go away

deathfromabove

misanthropists

plantain/the dfa
225 west 13th street
new york city, ny 10011
dfa@plantain.net
www.plantain.net

TYLER BRODIE (BACK ROW, FAR LEFT), JAMES MURPHY (BACK ROW, FAR RIGHT), AND FRIENDS IN THEIR BASKETBALL UNIFORMS. TYLER BRODIE

THE ORIGINAL DFA BUSINESS CARD. TIM GOLDSWORTHY

CARLOS D, DANIEL KESSLER, SAM FOGARINO, AND PAUL BANKS OF INTERPOL IN THE BASEMENT AT BROWNIES, CIRCA 2000. *INTERPOL*

SUROOSH ALVI DRESSED AS THE HAMBURGLAR FOR THE *VICE* PARTY AT SPA, FEBRUARY 2002. *NICK ZINNER*

DAVID HOLMES, PHIL MOSSMAN, AND FRIENDS, CIRCA 1999. *PHIL MOSSMAN*

KAREN O AND ANGUS ANDREW IN NEW YORK CITY, MARCH 2002. *NICK ZINNER*

MARC SPITZ AND GIDEON YAGO BACKSTAGE AT THE SLIPPER ROOM, CIRCA 2002. *DAMIEN OSTLING*

CASEY SPOONER PERFORMS WITH FISCHERSPOONER AT STARBUCKS IN 1999. ALEX EISERLOH

NIKOLAI FRAITURE HAS DINNER AT THE RADIO CITY CAFETERIA. COLIN LANE

STEWART LUPTON OF JONATHAN FIRE*EATER. ERIN NORRIS

LIVE! AT THE MERCURY LOUNGE
THE NEW SOUND OF NEW YORK!
Mercury Lounge 217 East Houston Street 212.260.4700
8:00pm: Thursday—August 31—2000

featuring
THE STROKES
THE REALISTICS
RADIO 4 "NEW SONG AND DANCE" out now on Gern Blandsten
FRENCH KICKS new EP out this Fall!
RADIO 4
THE FRENCH KICKS

JOHN MATHIAS

ALBERT HAMMOND JR. BACKSTAGE AT THE GREEK THEATER IN LOS ANGELES. COLIN LANE

MATT ROMANO BACKSTAGE AT THE GREEK THEATER IN LOS ANGELES. COLIN LANE

ALBERT HAMMOND JR. AND GEOFF TRAVIS IN LEEDS AFTER THE CARLING FESTIVAL, AUGUST 2002. *COLIN LANE*

COURTNEY MILLER, NIKI KANODIA, SARAH WILSON, SARAH LEWITINN, AND LIZZY GOODMAN AT THE MAGICIAN ON THE LOWER EAST SIDE FOR LIZZY'S BIRTHDAY, JUNE 9, 2003. *NIKI KANODIA*

AMANDA DE CADENET, NICK VALENSI, AND RYAN GENTLES AT LIT FOR THE RADIO CITY AFTER PARTY, AUGUST 2002. *COLIN LANE*

A DIORAMA MADE BACKSTAGE BY RYAN ADAMS SHOWING WHERE HE WAS WHILE WATCHING THE STROKES PLAY RADIO CITY. COLIN LANE

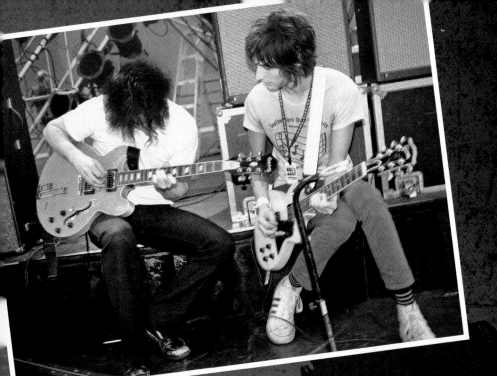

NICK VALENSI TEACHES JACK WHITE THE CHORDS AND CHANGES FOR THE STROKES' "NEW YORK CITY COPS" BEFORE ONE OF THE RADIO CITY GIGS. JACK LATER SURPRISED THE CROWD BY COMING OUT AND PLAYING WITH THE STROKES. COLIN LANE

NICK VALENSI AND MEG WHITE BACKSTAGE AT RADIO CITY, 2002. COLIN LANE

RYAN ADAMS TALKS TO BECK BACKSTAGE AT RADIO CITY, CIRCA 2002, WITH NICK VALENSI. COLIN LANE

KAREN O, BRIAN CHASE, DAVE SITEK, AND FRIENDS CELEBRATE THEIR TAKEOVER OF SXSW (AND THE AUSTIN CHRONICLE COVER), MARCH 2002. NICK ZINNER

PEOPLE WATCH THE LIARS/YEAH YEAH YEAHS SHOW FROM THE WILLIAMSBURG BRIDGE AND EVERY ADJACENT ROOFTOP. RUVAN WIJESOORIYA

YEAH YEAH YEAHS PERFORM AN EARLY GIG IN WILLIAMSBURG WITH THE LIARS (NOT PICTURED), AUGUST 2002. BRIAN WAS PLAYING A BROKEN DRUM KIT. THE MAKESHIFT STAGE WAS IN AN EMPTY LOT. RUVAN WIJESOORIYA

CHRISTIAN JOY ENJOYS THE VICE PARTY AT SPA, FEBRUARY 13, 2002. NICK ZINNER

DAVE SITEK AND THE VAN, SOMEWHERE IN KANSAS, EN ROUTE TO SXSW, 2002. NICK ZINNER

THE KILLERS AT AN EARLY SHOW IN 2003. *THE KILLERS*

ALBERT HAMMOND JR. KISSES THE VINES' CRAIG NICHOLLS BACKSTAGE AT CBGB, WHILE LAURA YOUNG LOOKS ON. *UNKNOWN*

KIMYA DAWSON OF THE MOLDY PEACHES. *ANDREW KENDALL*

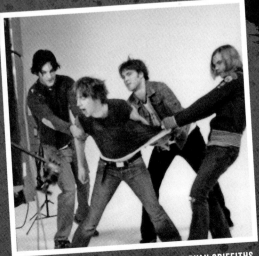

PATRICK MATTHEWS, HAMISH ROSSER, AND RYAN GRIFFITHS TRY TO RESTRAIN CRAIG NICHOLLS DURING THE VINES' ROLLING STONE COVER SHOOT. *HAMISH ROSSER*

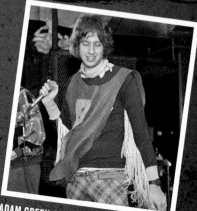

ADAM GREEN OF THE MOLDY PEACHES. *ANDREW KENDALL*

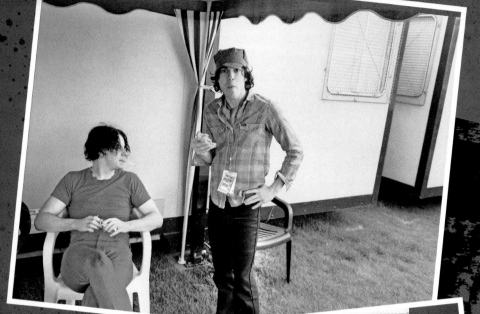

RYAN GENTLES WITH JACK WHITE AT THE CARLING
FESTIVAL, GLASGOW, AUGUST 2002. COLIN LANE

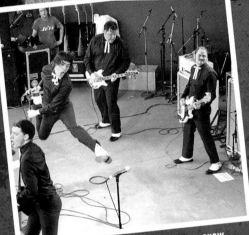

AUDREY NEUSTADTER AND LAURA YOUNG,
JUNE 2003. AUDREY NEUSTADTER

THE HIVES PLAY STUBB'S AT SXSW,
AUSTIN, 2004. BRIAN BATTJER

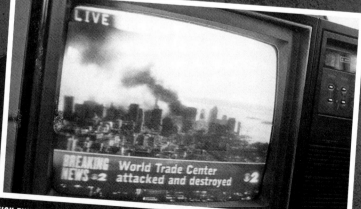

NICK ZINNER

"JUST TRUST ME"

HAR MAR SUPERSTAR: I used to go to the White Stripes' early shows in Minneapolis, so we kind of knew each other. I'd just get wasted and hang out. At some point Jack started calling me Minibar—that's my nickname, Minibar Superstar. "Hey, Minibar!" They were always really good, they were always amazing. The White Stripes had that thing where everybody in the audience wants to fuck one or both of them.

KID CONGO POWERS: The big deal was the White Stripes at that time, and their booking agent, Dave Kaplan, was also booking us.

DAVE BURTON: David Kaplan was an old friend of mine. We were at Mars Bar one night and he said, "I need an opener." I said, "I'll get Yeah Yeah Yeahs to do it." Dave said, "What's Yeah Yeah Yeahs?" And I said, "Nick and that girl at the end of the bar over there." Dave also knew Nick from the bar. So he was like, "Oh, I like Nick." And that was that.

DAVE KAPLAN: Dave asked, so I put them on. They were the first of four.

ZACK LIPEZ: It was Yeah Yeah Yeahs, my band . . .

RYAN GENTLES: The Candy Darlings, remember them?

KAREN O: They were friends of ours.

ZACK LIPEZ: . . . then Kid Congo and White Stripes.

KID CONGO POWERS: I met the White Stripes that day.

JACK WHITE: He was working at a vintage store nearby and Meg and I happened to stop in there.

KID CONGO POWERS: Cherry, on Orchard Street. The White Stripes came in. They were eyeing these red and white fifties striped—of course—old men's bathing suits which would have been worn as hot pants, kind of Speedo like, but more fifties looking. I was like, "Oh! You are the White Stripes!" Because I had seen their publicity photo for the show and it was very clear they were who they were. They were wearing red and white at the time: always red pants and a white shirt or vice versa.

JACK WHITE: We were very excited to meet someone from the Gun Club. We didn't know he'd also been in the Cramps!

KID CONGO POWERS: They were a little geeked out. They were pretty shy at the time; they were really young. They were fans of Gun Club and other stuff I had done. They were very respectful and really nice. And we ended up doing a lot more shows with them, became friendly.

CHLOE WALSH: I was the White Stripes' publicist at the time and they were in New York but they didn't have a hotel. They were sleeping on sofas. I couldn't think of anywhere that they could go and do photo shoots and interviews. So I said, "Would you mind—we could do this at my apartment?" They said, "No, that's fine." I had two cats and Jack was ghastly allergic, but he didn't say anything. So by the end of the day he was like, all puffy. But I remember, I had the Strokes' EP, 'cause I loved it, and Jack saw it and he had never heard them, but people were asking him about them in interviews, so he put it on. He kind of . . . his reaction was along the lines of "That's it?! Three songs?" Meg was not remotely interested. Jack complained a lot about New York. He hated it. He still hates it. He was wearing his red pants and a white T-shirt and he asked me to find a Sharpie and he had Meg write on his T-shirt NEW YORK CONFUSES ME. We went outside to the bottom of my street on Ludlow and Canal, and had their picture taken with the Twin Towers behind them, and NEW YORK CONFUSES ME on the T-shirt. Those were their early press shots.

ZACK LIPEZ: I really loved the White Stripes' album and I wanted to become friends with them. It was clear that we weren't going to become friends.

HAR MAR SUPERSTAR: Yeah, it just depends on your relationship with him. To some people, Jack is a total crazed maniac, but he's never been to me, to me he's always been a goofball.

NICK ZINNER: I don't think we knew who the White Stripes were.

KAREN O: I knew who they were. A friend of a friend introduced me to the *De Stijl* record and I really liked it.

NICK ZINNER: Rennie, our drummer, couldn't make it because, like every other musician in 2000, she played in four bands.

RENNIE ELLIOTT: I was in three other bands and working full-time and seriously getting into playing the banjo.

NICK ZINNER: There was this very specific moment I remember outside my loft. I suggested we just play as Unitard. The White Stripes gig was a week away. I was certain there was no way we could get a drummer. Karen just said, "No, dude, my friend Brian from Oberlin just moved down here. He'll learn everything. He can play with us."

BRIAN CHASE: I think she must have called me on the phone. Because that's what people did. She probably called me at my parents' house. She had to talk to my mom. "Hey! Is Brian there?" I grew up on Long Island, in Huntington. And when I finished Oberlin I moved in with them, the parents. I was technically still living with my parents.

NICK ZINNER: Karen said, "Just trust me." So I did. We had one practice with him.

BRIAN CHASE: She gave me a cassette tape and I learned the songs.

NICK ZINNER: Some people assume that I'm responsible for all the instrumental music. I would just like to clarify that when we're writing and trying to come up with stuff, Karen is not just standing there with a microphone.

KAREN O: We are all over- and underacknowledged! Or acknowledged, maybe, for the wrong things. Like, Nick is obviously the best looking in the band.

NICK ZINNER: Brian is a great beer spitter.

KAREN O: I write a mean bass line and keyboard line.

ZACK LIPEZ: I remember loving the White Stripes. And I loved Kid Congo. He's a charmer.

KID CONGO POWERS: I knew Nick already. He had been hanging around with my band Knoxville Girls. He had coincidentally been in Europe when the Knoxville Girls were on tour in Europe, traveling by himself. And one day, we were in Amsterdam, driving down the street, and we see Nick Zinner walking down the street with a big baguette. Even then he had that hair. He looked like his hair was going very fast, like he was going very fast and his hair was following. So we said, "Nick, get in the van with us! We have these dates in Holland!" He was our road crew for a few days. I knew Nick was a rock star by looking at him, but he was a very quiet young man. I didn't get a lot of information out of him. I knew Nick had a band, and I had heard from a friend that it was good, so I was excited for the show.

DAVE KAPLAN: I want to say it was kind of sloppy, but whose first show wouldn't be?

NICK ZINNER: Brian's snare broke so we had to borrow Meg White's snare drum. I remember they were nice but when we were setting up Jack was really bummed that there was another band without a bass player that was opening up for them.

JACK WHITE: A lot of times I would say things out loud that, for people who don't know me well, might make them think I'm extremely concerned about something because of the sound of my voice. It's usually just me thinking out loud. I talk to myself too much too.

KID CONGO POWERS: The White Stripes were the start of the duo. Now the duo is everywhere, but then not so much. No duo was particularly popular, especially playing rock music. No one was able to pull it off.

JACK WHITE: Our band's problem in the early years was that local promoters would say, "Oh, wouldn't it be cute to put our local two-piece band on there to open for them?" Or "The White Stripes must hate the bass, let's book a band that has no bass to warm up." Any of our reactions had nothing to do with whether we liked whatever band and their music or not, it was about us not wanting to be lumped in

with anyone else, wanting to stand out whenever we could, trying to push forward. So yeah, when we roll into Blah Blah Blah, Ohio, and there would be a no-bass band with a girl on drums booked to play with us, we'd say, "Of course." We always wished for a band that was the exact opposite of us so we could have a contrast. But we also of course loved playing with like-minded people, and Yeah Yeah Yeahs definitely were. We should've been better friends back then, we were a lot alike, but we didn't get to see them enough because of the touring.

KID CONGO POWERS: I had no idea what the show would be like and I don't *really* remember what the music was like; I remember Karen.

DAVE KAPLAN: Karen always had stage presence, that's for sure.

KAREN O: I had a plan. I wanted to go up there looking like a sweaty punk rock star. I was wearing these wide bell-bottom pants with a white wifebeater. I didn't wear a bra. I cut out these hearts that I wore as pasties underneath the white wifebeater. My plan was to douse myself in olive oil before I went onstage. I thought if the oil kind of seeped in it would be a little sexy but it just looked like I had humongous nipples.

KID CONGO POWERS: After the show, I turned to whoever was next to me and I said, "Wow, something is happening here. She's already fully formed and she is *there*. This is their first show, and she's already all there. She's totally unself-conscious. I don't even know if she knows that she's going for it or not, and that's the beauty of it. And it's not unnatural, I don't think she's rehearsed this, but I think it's just happening." She was completely in the moment and that's all you can really ask from a singer.

NICK ZINNER: From the beginning, it was definitely her spotlight. My feelings on that are mixed because I don't like being in the spotlight, so I was happy, but also saw how totally fucking intense it was for her. It's a lead-singer thing. She's amazing. Born to do it, or whatever it is parents say.

KID CONGO POWERS: Of course, the White Stripes were great too. It was clean. They were already fully formed too, in a different kind of way. It was like, "Wow, that kid Jack can play the guitar really well!"

KAREN O: I was kind of hoping that the White Stripes would catch us. I must've drunk like four or five margaritas before I went on, and we went on really early. I was really nervous. But I was also pumped. I was ready. You know, when you have that hope that someone else is watching you, you really want to pull out all the stops.

JACK WHITE: I loved that show and was very impressed with Yeah Yeah Yeahs. I love strong females in music very much, and when I saw Nick on guitar, I remember I wished I was the same size as him, physically.

THOMAS ONORATO: That's one of the only moments in my life where I'll be able to say, "I was there." More so than any other time with a music artist, when I saw Karen O onstage at Mercury Lounge, I was like, "Oh, you're gonna be famous, oh, you've got it. I get it."

JACK WHITE: That was one of the best New York crowds we had back then at that show.

KID CONGO POWERS: The crowd was a mix. The White Stripes were there and you knew it was just the very beginning for them—there were a lot of industry people, and also there were a lot of kids, a lot of young people. I remember saying, "I feel like a really dirty old man up here."

JACK WHITE: For some reason I think P. J. Harvey and Vincent Gallo were backstage. We took a photo with them. I asked what the name of this new band we were in this photo together was and Vince said, "Hopeless."

KID CONGO POWERS: I knew with the White Stripes something was going to happen. That was very obvious. I'd been around the block, I'd been around a long time, I could see. With Yeah Yeah Yeahs the music was pretty crazy, so I wasn't sure. But I did think, Karen is already a completely unself-conscious, fully made rock star. She's up there, doesn't give a fuck, is fantastic and in the moment. That was not something you see. People are self-conscious, people are calculated. But she was just there. Present. Boom.

NICK ZINNER: I think Jack White stayed at Karen's house after.

KAREN O: Yeah, he played Super Mario Kart or something.

JACK WHITE: A girl and I stayed at Karen's house. I forget the girl's

name, but I remember looking at her dress through the mirror on the wall in Karen's room as the girl lay sleeping. That was very nice of Karen to let us stay there. Meg and I loved when bands stayed at our house as well. On the road, I always want to go through people's books and things, but I never have the courage to be that nosy and intrusive. Karen's place was like that.

NICK ZINNER: I mean, we didn't know them, but the show was really fun. I remember there was an English person in the crowd that night. It was mostly our friends and then this one English guy. Afterwards, he said, "You guys should really come over to England." We were like, "What the fuck, are you serious? That's crazy! That's the craziest thing you could ever say."

BRIAN CHASE: I'll tell you what I remember about that first show: I remember that before I knew it, it was over.

"BRITISH PEOPLE ARE CRAZY"

ALBERT HAMMOND JR.: I have to tell the truth . . . Fab punched a mailbox. Someone was making fun of Adam Green, and he went to protect him.

KELLY KILEY: I've never known a band to get security so quickly.

LAURA YOUNG: The first time I ever saw [the Strokes], in the middle of the show, Julian started staring off into the distance, like totally dead-eye staring. Then you just see him jump offstage into the crowd, and there was a kerfuffle. He was getting into a fight. Very quickly one of the bouncers came in and broke it up, but I was like, "Oh my god, this is so awesome. This is my first Strokes show and Julian's getting into a fight!" They had this reputation in the press of being bad boys. Drinking a lot, getting into trouble. That was their whole persona, cool New York, don't-give-a-fuck type of dudes. So I was like, "Holy shit, I can't believe I'm seeing this!" We hung out after the show, and I remember overhearing Julian talking to some random dudes and he said, "He was giving me the eye." That was his explanation as to why he jumped into the crowd. It wasn't that he threw something at me or that he spat at me, it was "He was looking at me funny."

ALBERT HAMMOND JR.: Everyone thought we were fighters. I couldn't care less about fighting. I want to fight off women, not men.

ADAM GREEN: We were in Glasgow and some guys decided that they didn't like my Robin Hood outfit.

FABRIZIO MORETTI: We were waiting for chicken tikka masala late at night. Or chicken korma. I can't remember what it was. A chicken dish that was delicious when everything else is closed and you are

so hungry and so wasted. Some man started to make fun of Adam's outfit in that Glaswegian drawl where you barely understand what he's saying but you get the intonation. So I said something about how he should go fuck himself.

ADAM GREEN: Fab was like, "Fuck you! I like his Robin Hood outfit."

FABRIZIO MORETTI: Julian was a little more sober and probably more realistic and he was like, *"What?!"* And he grabbed me and pulled me outside.

ALBERT HAMMOND JR.: Julian was like, "Come on, dude, this guy is big, let's get out of here, there's no point in fighting, British people are crazy."

ADAM GREEN: Fab was just so angry, he just punched a mailbox and broke his hand. And that's how they got Matt Romano.

MATT ROMANO: It was a big moment for me. That was essentially the beginning of my adult life. I was outside cutting the grass when Ryan called. My mom answered. She said, "Ryan, he's outside cutting the grass, can I tell him to call you back?" And he was like, "Could you go get him? It's kind of important and I'm calling long-distance." I guess she hears me talking and I ask, "Mom, I have a passport, right?" That was it.

KELLY KILEY: During that second UK tour, after the EP had come out, there was lunacy. They played Oxford and Kate Moss was there. It was "Of course she's going to be there, this is the new thing, so she's going to get on it as early as possible."

KIM TAYLOR BENNETT: I remember Albert being quite thrilled that Kate Moss was there.

RUSSELL WARBY: I don't think that when Kate first met the Strokes that she thought they were especially nice to her. They were a bit like, you know, "Hi," being very cool about it. I'm sure she would have liked them to be very excited.

KELLY KILEY: I loved how Julian would not give a shit about any of the celebs—he just didn't care. You'd think he'd be the one, but that was Nick. Even quite early on. Later, after Nick met Amanda de Cadenet, they'd say: "We've seen these Hermès cuffs, can you get them for us?" Julian likes nice things, but I don't think he wanted

to be as ostentatious. Julian has always been the most reserved, the most against all of the adulation, the celeb stuff, and just more . . . conservative, or down to earth. Julian is a control freak, but he was the most real.

JIM MERLIS: One day Nick says to me, "I have this new girlfriend, she's English, she's older," and I was like, "Who is she?" and he's like, "You don't know her, her name's Amanda de Cadenet," and I was like, "No, I do know her, I used to be Courtney Love's publicist, remember? I totally know Amanda."

MARC SPITZ: She was John Taylor's wife. And she was like, seen stumbling around with Courtney Love, when Courtney was trying to be a movie star.

AMANDA DE CADENET: I moved to LA in like '95 or '96. I had a little kid. She was one. I was like the only teenager I knew that had a kid. It was so crazy. And I was really famous in the UK and I really hated it and I just needed to be an anonymous person and figure out what the hell I wanted to do. I was so young. We live many lives, right? I had already lived like five lives by the age of thirty.

THOMAS ONORATO: Coming to America has erased her past, because no one knows that she was a VJ on *The Word* in the nineties. You can find clips of her on YouTube interviewing people like Flavor Flav.

AMANDA DE CADENET: It was a live late-night music show where, like, Nirvana and the Smashing Pumpkins and the Chili Peppers played for the first time on television in the UK. I interviewed all those people. And then Britpop was just exploding so we had Oasis and Blur and the Happy Mondays—it was that whole time of just insanity. Music was my culture and those were my friends and I had grown up in that—I had become like a household name very young, I had that experience. And then my first husband was in Duran Duran.

JAMES ENDEACOTT: I remember talking to Nick about her. He's like, "You know Amanda de Cadenet?" And I'm like, "Yeah, she's really well known in the UK. She's got quite a bad rap over here. People don't like her." She has a reputation as a wild party child that was a little bit off the rails; that wasn't very good at TV presenting; that

was very, very young when she married the guy from Duran Duran. Just a rich kid. Nick had no idea and why should he?

JIM MERLIS: Nick has a thing for older blond women. Before Amanda he was dating Pearl Lowe, who was married to one of the guys in the British band Supergrass.

JAMES ENDEACOTT: That world, the Kate Moss-y Pearl Lowe-y world, once that world found out about you it's like, phewww . . .

KELLY KILEY: Pearl had a reputation, and Nick was young, but he was totally into it. She used to turn up at the hotel and they'd disappear together. That went on for quite a while, until Amanda. I remember, later, Amanda was at the *NME* Awards, and Pearl was there. She was saying to me, "I can't believe Amanda stole my man, she's supposed to be one of my best friends."

NICK VALENSI: The previous time we'd been in England, we went to these indie nights at clubs in London. We were in the loudest club in the world, and there was this guy sitting in the corner of the club, surrounded by kind of slutty-looking girls, and he was playing the acoustic guitar in this super-loud club. He wanted to talk to me, show me songs he had written, telling me he's starting a band. He was with this Italian girl, and the whole thing felt like there was sexual undertones. They were obviously together, but there was kind of insinuations of "Well, maybe we'll all get together tonight," that kind of thing. He wanted to come back to my hotel with me, and I was like, "No, man, I'm sorry, I have to go." I remember leaving, thinking, "That guy was fucking crazy." I think the club was called Trash.

JENNY PENNY: Trash was like the Misshapes of London.

PAUL BANKS: We went all the time. Because we were a band from New York, we could get into those clubs and jump the line.

APRIL LONG: That party was a petri dish for all kinds of, you know, London ne'er-do-wells. It was also a little bit less indie, a little bit more dancey, which was super fun because again, at that time, there had been no dancey-dancey for quite a while.

CALEB FOLLOWILL: Trash was fucking *amazing*. We would walk in with sunglasses on and people are just handing you stuff and you're just

putting it in your mouth. It was like the movies, like John Travolta walking into a bar; we would walk in the bar and people would just be handing you drinks, drugs.

NICK VALENSI: So then we went to England to do our second tour, and Geoff Travis from Rough Trade said, "I have this great band, they're called the Libertines, and they're going to open for you." We get to the venue, the first gig of the tour, and who is the guy who's fucking singing in this band but the crazy guy with the acoustic guitar from the night at that club. It was Pete Doherty! He remembered me very clearly. He knew who I was the first time I met him.

CARL BARÂT: They were on Rough Trade in England and that was a big thing. And we had been to see a gig in Liverpool. We jumped the train. Their EP had just come out and we stole it from the shop in the station and we were looking at the lyrics on the way up. We were like, "These motherfuckers from America—we wear those clothes! We do this!"

ALBERT HAMMOND JR.: I remember meeting Pete Doherty and Carl in Liverpool. They gave me acid and tried to get on our bus. Then six months later they had formed a band and were opening for us.

NICK VALENSI: I could see that Pete kind of looked like Julian, and I could see how they dressed like us. I didn't think their music really sounded like us, though. We're musically very precise, we have very tight arrangements, and they're very loose. Pete and Carl certainly looked . . . not that different from us.

ADAM GREEN: The funniest thing is they were all in suits and I remember thinking, like, "Wow, they're already wearing these fucking suits. They're trying to be like the Strokes!" That had already seeped in.

CARL BARÂT: I think the boys were kind enough to lend us some money after the show. We went for some chips and then departed company. I think it was Nick who pulled out a fan of notes and I pointed out which ones I'd like. He'd possibly not seen pounds much before and maybe we took a little bit advantage of that.

JEANNETTE LEE: Julian really did not take to Peter. His response was "Who is that guy?"

JULIAN CASABLANCAS: I mean . . . we played shows with them, I think, somewhere. Leeds, or I can't remember where. I never really bro'd out with those guys.

JEANNETTE LEE: Peter is trying to pick everybody's pocket, trying to take everybody's credit cards when they are not looking. Also, the Libertines had a very open attitude toward drugs as well. I mean, they didn't bother to try to conceal it.

GEOFF TRAVIS: Peter wouldn't hide anything from the chief constable.

JEANNETTE LEE: I asked Pete Doherty once—we were at *Top of the Pops* studios and I asked him, "What was the first band you ever heard or you ever saw that made you want to be in a band?" and he said, "The Strokes." I nearly fell off my chair because the Strokes seemed like about six weeks old to me. Most people would say something from the sixties but he said the Strokes.

GEOFF TRAVIS: We know that the Strokes had a big effect on the Libertines, in the sense that when they heard it they realized they had to up their game and they probably changed their sound. And of course we put them on with the Strokes deliberately, to galvanize them.

MARK RONSON: I remember asking someone what the Libertines were and they said they were like the British version of the Strokes, and I remember being like, "Well, I have the Strokes, I don't really need the British version." I know English kids who are seven years younger, who that band was so seminal that they'd cry if "Can't Stand Me Now" comes on at a certain point in the evening. It didn't grab me, and like I said, if this is the British Strokes, well, we have the Strokes. I wasn't super interested in it.

ADAM GREEN: When we got to Sweden it was the same thing with the Hives. I was like, "Really?! This is in Sweden?!" It was hilarious. When we got to Sweden they were like, "Oh, well, we're going to play a show with the Swedish Strokes." The Hives are really good but they're not the Swedish Strokes.

RYAN GENTLES: The album came out that July in Australia, and a few months later in the UK.

CONOR OBERST: That summer, the summer of 2001, was really the

summer of the Strokes over there. We were touring England and that's where I first saw someone walking around with that original T-shirt. I thought, "The Strokes. Do they mean, like, 'have a stroke'? Or a pool stroke?" It kind of looked like "The Storks" if you looked at it wrong. The record wasn't out in America yet but in every club we were playing they'd be playing it as we walked in the door.

RYAN GENTLES: The UK version had "New York City Cops" on it.

CONOR OBERST: My drummer, Matt, was singing that song all the time when we were on tour in Europe. We got stopped with drugs, going from Christiania, an anarchist community in Copenhagen, into Sweden. Only time I've been strip-searched in my life. There's an eighty-year-old Swedish officer spreading my cheeks looking for stuff. He was nice. Anyway, after that, Matt switched his singing to "Swedish border cops, Swedish border cops, they took our hash!"

CONOR McNICHOLAS: The Strokes did this brilliant thing of giving everybody permission to self-consciously be a band.

JEANNETTE LEE: They touched the same spot in me as seeing the Sex Pistols and the Clash had. Not because they sounded like them but there was something about the energy.

MARK RONSON: I was obsessed with that record. Their song "Someday" starts with that kick and snare before the song comes in. I took that and chopped it up for Rhymefest's first album. I'd see Albert out, we'd all be fucked up, and I'd be like, "Would you come play guitar on this song if we redid it?" He'd called me one night and said, "I got your message, yeah, is this the part you want?" He put down the phone and picks up a guitar, and I hear him playing the part. I played that recording for *everyone*. I played it for my girlfriend. "How cool is that?!" I mean, I was obsessed. There was a coffee place on Second and A that I used to go to, and I saw Nick and his massive dog. I'd be like, "Oh shit, that's Nick . . ." I'm like, "It's so weird that I'm acting like a giddy schoolgirl." It even feeds into the stuff I did with Amy Winehouse because when we were doing the demos for *Back to Black*, when Amy first came

to New York, she would play me the songs she'd written on the guitar, then she'd leave me overnight to experiment with different arrangement ideas until I had something. I remember her coming to the studio as I was putting the verse to "Rehab" together. I was like, "Let me try this kind of beat." And she was like, "Are you trying to make me sound like the bloody Libertines?" If I had been only in my own hip-hop world, it wouldn't have occurred to me to make some of those records. I think that's part of the reason that Amy's record was so massively received by the *NME* and those indie places. I mean, partly it because she was such a firebrand and looked like such an outcast rebel awesome iconic figure, but it's also that they were all guitar-based records. "Wake Up Alone"—there hadn't been anything like that with guitars in it in soul music for twenty years. And that's my debt to New York.

GEOFF TRAVIS: The Strokes' arrival was a bomb in the middle of a plastic pool.

CONOR McNICHOLAS: Suddenly, it was okay to be a star.

29

ALL EYES ON NYC

JUSTINE D: Nothing was happening and then everything happened.

ALEX WAGNER: Things were coalescing around New York culturally in a way that they hadn't in a long time. There was this momentum. And maybe it didn't yet feel like it mattered on a national level, although of course ultimately it would, but if you were into the downtown rock scene it was an incredibly fruitful moment. There was the feeling that every night there was some awesome thing that was going to happen.

JIM MERLIS: I remember going back to the office after that first early meeting with the Strokes, and it was like, "Hey, you young guys in the office, if there's anything else like this out there, please, let me know." We never did that. We never called meetings.

ADAM GREEN: Rough Trade came to New York to sign us.

KIMYA DAWSON: Basically, after the Strokes got signed to Rough Trade they told Rough Trade they wanted them to sign us too, and they did. Geoff Travis came to see us play at Sidewalk.

ADAM GREEN: They took me to Pick a Bagel. I always hear these stories about how you get signed and you make them take you out to Nobu and shit. Rough Trade took me to Pick a Bagel. We signed for $1,000. After that, everybody got signed.

ALISON MOSSHART: The Kills' stipulations for signing with Rough Trade in America—they were just opening an office there—was that they had to put their office in the Chelsea Hotel. In room 103. And they did it! It was fucking awesome, because their office was

next to my room, so I would just go over there and see how everything was going, then go back to bed. It was great.

ELEANOR FRIEDBERGER: We had a five-record deal with Rough Trade. And we got a bigger advance each time. We had all this creative freedom. It was really incredible. In Geoff Travis, you couldn't dream of a better cheerleader. It wasn't until much later, when we made the record with our grandmother, that they were like, "What the fuck are you guys doing?"

NICK VALENSI: You can't underestimate how important it is for an American band to get across the Atlantic.

CONOR McNICHOLAS: It was immediately like, "They're brilliant, what else have you got? Anything?" It was like the Beatles being exposed to all of this amazing blues and early rock and roll in Liverpool, because that's where all the American soldiers were coming through on the ships and so the record stores happened to have these tracks. It was the same thing, with all these kids stuck over here, desperate for all the cool stuff that was coming out of America. Except we had e-mail.

MARK RONSON: Americans take it for granted, because they have it. If you live in New York, you can go out at any time and see a good indie band. If you live in New Orleans, you can go out and see jazz any time you want, blues in Chicago, whatever it is. In England, when a new record comes out, you're the guy who works in a record shop that's literally just got this box of a hundred forty-fives from the States in 1962 and is about to open them up. It's not made in England, so you get so excited and you take out the records and say, "This is incredible."

DANIEL KESSLER: It was funny, we couldn't get arrested to save our lives six months before the Strokes took off, then all of the sudden it was lunacy. That's the game. I think sometimes about *The Wire*. In this business, it's a hustle.

LUKE JENNER: I was really excited because I would go on Avenue A to this magazine store and buy copies of *NME* and be like, "Dude! This is all happening around me and eventually they're gonna find me!"

DANIEL KESSLER: It was a fever. British journalists needed story angles on a weekly basis, and fortunately, there were a lot of good bands here.

MARK RONSON: It became almost like the sixties again. It really made the *NME* a super-relevant New York publication again—"That's where we have to go to read about our things."

DEAN WAREHAM: They had all these weeklies, like *Melody Maker* and *NME*, and they were geared toward teenagers who want to read about bands every week. I mean, these are national magazines that are available at every train station all over England.

ANTHONY ROSSOMANDO: Everybody over there is so goddamn passionate about music.

DEAN WAREHAM: Whereas here we had these little fanzines that you could find at certain select stores if you sought them out. And of course, radio, we had college radio, but they had John Peel. Whatever he was playing, everyone was listening to.

ANTHONY ROSSOMANDO: In England, America is a much bigger deal than it is at home.

ADAM GREEN: I remember when Kimya and I went to England to play with the Strokes. We arrived and the Strokes are playing *Top of the Pops* that night, so we go to the television studio. We started walking around and everyone was saying, "Oh, you guys are the Moldy Peaches! We just read about you in *NME!*" We were blown away. We didn't know anything about England and we'd obviously never experienced anything like that before. People were stopping us on the street and inviting us into their houses. We basically went from New York to England and just never worked another job again.

STEVE SCHILTZ: It's important to remember that this was before Friendster, MySpace, Facebook, Twitter. At that time, there were probably only like two or three pictures of the Strokes. Even though I was their friend, that's how fucking cool it was, how convincing it was to see them in a magazine looking like the coolest band you ever saw in your life. I believed it so much that I thought I

would never be friends with them again. They were mysterious. They were gone.

SAM FOGARINO: We went over to the UK, before we were signed, before we even had management, to do a little tour and record a Peel Session, which was a big deal. The Strokes had just been there and it was a frenzy. It was a craze. The next thing you know, as a result of that trip there was this issue of *NME*—the cover just said, "We Heart New York."

ROB SHEFFIELD: That cover is legendary. They asked the Strokes about seventies New York, like, they asked about CBGB's and I remember they're like, "What? CBGB sucks. Don't go there. We wouldn't play there."

JIM MERLIS: That was Nick. He's very blunt. I was like, "That's the funniest thing I've ever heard," and he was like, "I wasn't trying to be funny," and I said, "I know, that's why it's even funnier."

SAM FOGARINO: The Strokes were at the top of the list but there was Interpol in there, with no record deal. We just had this single out. Being the older guy, I said, "Oh, I remember when *NME* did 'We Love Seattle.'" It was just a decade prior, you know? Something was shifting. I knew it was just a matter of time.

JASON GORDON: And that was the thing: it wasn't about one band igniting all of this. It was this energy that surrounded all these bands. Maybe not between the actual band members, but between the people that would see all these separate bands. It used to be, "Punks don't go to dance shows. Dance kids don't go to rock shows." Now, suddenly, it was "I am a punk, and I am going to go dancing at the Rapture show tonight."

LUKE JENNER: People just thought of us as a disco Strokes. They were like, "We need to sign a band like the Strokes, and you're it!" And we were like, "Cool! Here's my bank account number."

STEVE SCHILTZ: The Strokes happened and you realized, "Oh, wait, these guys are like twenty-one years old, their manager is twenty-two, and they're the coolest thing happening, *and* they're friends of ours!?" You start thinking, "Wow, maybe you don't have to listen to this bullshit from people that say they know everything about the music industry. Maybe we can do this too."

MATT ROMANO: So, we'd been on this insane European tour after the record came out in the UK. We were supposed to go to Japan and Australia next but first we went to the West Coast and did a string of shows. San Diego, San Francisco, L.A., Vancouver. This was my first trip to L.A. We were staying at the Hollywood Roosevelt on Hollywood Boulevard, very cool, very old Hollywood. Spike Jonze came down to say hi. We were having a good time. That little West Coast run ended, and after that we were supposed to go to Japan but everybody's just fucking exhausted. Fried. So we decided to stop in Hawaii on the way for a little vacation. There we are on the west coast of Oahu; everybody is just coming down off the road and feeling good. We cancel the Japan trip. We come home, and then September 11 happened.

SEPTEMBER 11, 2001

JESSE MALIN: As people will tell you, it was one of the most beautiful days in New York, weather-wise.

ALBERT HAMMOND JR.: I was in my apartment with Julian, Nineteenth and Second Avenue. We saw the buildings fall from our window.

JULIAN CASABLANCAS: We didn't have any view except of the Twin Towers, that was the only thing you could see.

KAREN O: Nick and I hung out the night before and I just crashed in his room. He went to work early that morning. When I woke up, around ten or eleven, everyone was watching it on the television in the loft.

PAUL BANKS: I was on Grand and Ludlow, where I lived.

SAM FOGARINO: I was in Greenpoint, Brooklyn. I watched them fall from my roof.

ALBERT HAMMOND JR.: It was weird to see it from far away because it started to fall, but there was a delay with the sound. You could almost still see it standing, even though you knew it was falling, and all of a sudden, it wasn't there anymore. It looked so unreal. You're in such shock that you don't even realize you're in shock. You were like, "It fucking fell. The whole fucking thing fell."

PAUL BANKS: I had a job then—at that point I was doing data entry for *Scholastic News*. This is after I bailed on doing a real career. I was just doing shit work. I woke up to 1010 WINS every day, and some chick phoned in and said, "A plane crashed into the Twin Towers." I thought, "Ah, cool, I'll go see that." Because I'm thinking, "It has to be a Cessna, some moron in a Cessna just crashed into the Twin Towers." I walk down and see Armageddon happening.

KAREN O: I just kind of wandered the streets. I don't even remember how I got back to the East Village, but there was literally this toxic haze, like toxic smog that was just sitting over all of downtown. On Avenue A you couldn't see five feet in front of you.

MOBY: It's my birthday, September 11. That morning, of course, I was drunk from the night before, and the phone started ringing at eight something. I remember thinking, "Who would call me at this ungodly hour on my birthday?" It kept ringing and kept ringing, and I was like, "Oh, something bad must have happened." At that point I heard the second plane hit the tower. I ran up on my roof. I was a mile and a half away from the Twin Towers. The only time I'd ever experienced anything like that was watching a Jerry Bruckheimer movie. That's exactly what it looked like, it looked like cinematic CGI.

PAUL BANKS: You know how in movies like *King Kong*, women put their hands over their mouths and run the other way? I saw that for real. That's not just a film trope. That's an animal thing that humans do. A reflex.

MOBY: It's that thing where 99.999 percent of what we experience is stuff we've already experienced: you touch a teacup, and in some archetypal, compartmentalized level, it reminds you of every other teacup you've touched. The weight, temperature, everything about it. Rarely do we experience anything genuinely new. I looked up and saw these huge flames billowing out of the Twin Towers, and my brain couldn't process it, because I never . . . I couldn't figure out what was happening. There was this lapse of "I don't know what I'm experiencing," and all the roofs of all the buildings around me were covered with people screaming and pointing.

TUNDE ADEBIMPE: I was asleep and I got a phone call from my friend Zach. He just said, "Wake up." "Dude, what the fuck?" "Get up, get up. Dude, a plane just flew into the World Trade Center." And I said—keep in mind that my friends and I have a long history of pranking the shit out of each other—"Fuck you," and hung up the phone. The phone rings again, he's like, "No, dude, seriously, go to your roof, go to your roof." I went upstairs and it was right after

tower one had been hit. I stood there for a while and ran downstairs, banging on Dave's door.

ALBERT HAMMOND JR.: Julian's girlfriend, Colleen, wanted to go visit someone at a hospital. We went and it was like paranoia on the streets. Someone's cell phone wouldn't stop ringing, and they couldn't stop it and everyone started to run away from them because they thought it was a bomb. So we just started running too.

JULIAN CASABLANCAS: It was just like . . . mayhem. Mayhem, chaos . . . I kind of . . . I don't love talking about it I guess.

KAREN O: Everyone was really forlorn and depressed. I remember going to Odessa and it was really crowded and everyone was just drinking themselves into a stupor. It was palpable. Collective grief.

TUNDE ADEBIMPE: We all walked down onto Grand Street in Williamsburg. We all stop there and we're just staring at it when this guy walked by us. If this were a movie, that guy would be foreshadowing the next fifteen years. We're all staring at this building, freaked out, just really really freaked out, wondering what's happening, and this guy stops next to us. He's got a briefcase and a tie. He's a little bit older than us, and he's like, "Oh my god. A lot of clients of mine were in that building. I probably just lost a lot of clients." We all looked at him. And before we realized what was happening, we were holding Dave back 'cause he was about to beat the shit out of this guy. We were all thinking, like, "What the fuck is this dude even doing here?"

ALEX WAGNER: I was editor in chief of *Tokion* magazine at the time and the offices were downtown, on the Lower East Side, on Clinton between Rivington and Delancey. I walked into the office that morning and we just heard people start screaming. Half an hour later people started walking up the street covered in ash and they started flying fighter jets over Manhattan. You heard the sound of an airplane at low altitude, and it was totally terrifying. You didn't know whether they were going to start flying planes into Manhattan. It was this feeling, something that is super foreign to Americans, which is you are completely unprotected and totally alone.

JOHN HEILEMANN: I remember in that first week or so, British friends of mine saying, "What about the Blitz? We got bombed for years. The city got bombed by the Nazis for years. Get over it." And I remember saying to them, "Come on, guys, this has never happened here before. Give us a little bit of time."

CONOR OBERST: I think I successfully avoided flying for six months. I was scared.

PAUL BANKS: I volunteered that whole day. My roommate Sebastian and I get on these MTA buses and we drive across the West Side Highway. We take off our T-shirts so they can be used as tourniquets for all these people we're going to rescue. They're teaching us CPR. You know, this was official. But we're just standing around. I wound up kind of saying to some fire marshal guy, I was like, "Are we gonna go in? Are we gonna do anything?" And he said, quote, "We're waiting for that building to come down." So I can vouch for the fact that they knew ahead of time that building seven was going to fall. Whether there was a conspiracy or not, I don't know. But I didn't do shit. I just stood around on the West Side Highway with my shirt off, with the volunteer group all fucking day, until sundown. But the one thing that I took away as being really, really memorable was seeing a bus full of firefighters going to the site. Fast-forward a couple of hours. It's dark, and the bus comes back with all the lights on inside, showing the firefighters completely covered in ash. I can see their faces and the look was deep dejection. That shit was heavy.

NIC OFFER: I was in Brooklyn. We watched it on the roof and then we walked down to where you could see Manhattan from the water. It was all, you know, Hasidic Jews and Puerto Rican kids rolling blunts and everyone all just in it together. I remember someone saying, "This is like Pearl Harbor." Then we went to McCarren Park and hung out on the grass and that night we went to Union Pool and there was nobody there so we came back to our house and got really high and played house music. And danced. It was the Prince "1999" kinda thing, you know, the world's gonna end, so let's fucking party.

JESSE MALIN: We were just out of our minds. I didn't know what to

do. I just walked down the street, and the streets were kind of dead at that hour. I bumped into Patricia Field and I started talking to her. Nobody's phones are working. I just ended up in a bar in the afternoon. I ended up at Niagara. I walked in there and just got behind the bar and I just started tending bar to everybody.

NICK VALENSI: That evening, that night, after shit had kind of died down, we all met up. I remember we were all talking on the phone, "What are we going to do, what are we doing? Let's go to the studio, to the rehearsal room."

ALBERT HAMMOND JR.: We rehearsed that night.

NICK VALENSI: We drank and played and worked on new music and also discussed what was going on with this "New York City Cops" debacle. There was just so much going on, all these cops and firefighters who had just died. We didn't want to be insensitive.

RYAN GENTLES: September 11 was actually the release date of *Is This It* on vinyl, which is why it still has the track "New York City Cops" on it.

ALBERT HAMMOND JR.: Our album was coming out September 24. Suddenly people were talking about taking "New York City Cops" off the record.

MATT ROMANO: That was a bummer.

ALBERT HAMMOND JR.: We were like, "No, no, no!" Julian was like, "It's just a song. I don't care. It had nothing to do with . . ." At a time like that, though, people get hysterical.

DAVE GOTTLIEB: I remember an e-mail coming in from somebody who worked with retail, and he had written this paragraph about how he had put the Strokes record on and it got to "New York City Cops" and it made him angry because he was looking out of his window and seeing the ashes of the Twin Towers and this song made him take the CD out and throw it away.

KIMYA DAWSON: We ended up leaving on the U.S. tour not even two weeks later. Everybody asked, "Are you going to cancel your tour?" We said, "We can't cancel our tour. People need this right now."

VITO ROCCOFORTE: The Rapture had a tour booked, and we left a week afterward. It was really interesting because we got to see the rest

of the country's take on 9/11. I remember being in Cleveland and the front page of their free paper was "Are We Next?" People really cared and generally worried but you just saw how distorted things got so quickly, like from what we saw and experienced to what people were imagining. That front page of the paper wasn't uncommon. There was a lot of fear. There was shit like Mexican people getting beat up in the Midwest because people thought they were Arabs.

ALEX WAGNER: I remember, just after 9/11, driving down to the ICA in Philadelphia, and people were still really freaked out. I was in the car with one of my friends from India, and some jaywalker looked at us through the window and just started yelling at us, assuming we were Muslim because we were brown.

VITO ROCCOFORTE: And the police, really intense police scene and weird graffiti on overpasses and stuff. People were really angry. I was really angry. I remember being in the Midwest and we got pulled over a lot on that tour 'cause we're in a white van with New York plates. Everybody was on such high alert.

ANGUS ANDREW: We went on tour and our first show was in DC two days after 9/11, so we drove past the Pentagon. It was such a crazy time to be on the road in a brown beat-up van with New York plates, because the whole country was in shock. We were traveling around as sort of spokespeople for what happened. Like, everywhere we'd end up, that was what was talked about.

REGINA SPEKTOR: You got to see how much New York means to the entire world.

MARC MARON: After 9/11, people started to come to gawk at the fucking smoking rubbish. I remember getting mad about that. It became a national wound that represented something to people who were nationalistic. I'm not saying they're bad but the idea was, they were coming to support us, and it didn't actually feel like that. I understand that it's a national wound and you need to come and see it but we were just trying to get on with our lives and it seemed a little morbid to come visit that thing before they even cleaned it up. It was a whole city with PTSD, trying to function. That melting-metal smell . . . it went on for months. It was gnarly, dude.

TUNDE ADEBIMPE: Giuliani had been so vilified, everyone was so like, "Fuck this guy, he's an evil motherfucker." Then, the day after 9/11, we started to call Manhattan "Flaghattan" because there were American flags everywhere. Instantly Giuliani is a hero. He's standing with W., hanging out, smiling.

DEAN WAREHAM: All of a sudden Rudy Giuliani went from someone everyone hated to someone everyone loved.

CARL SWANSON: People were scared of New York, and 9/11 totally changed that. We now had America's mayor, and there was this idea that you were cheering on the city.

VITO ROCCOFORTE: There were tanks across Houston. It was crazy, for a long time.

TUNDE ADEBIMPE: Basically, we were like, "This is end times."

ALEX WAGNER: There was this sense of "There is no place for me to hide." Like, nothing matters, and everything is temporary. We were walking around a grave site, breathing in the dust of smoking bones every day. That part was really fucking dark. There was also this pronounced sense of individual destiny-making. If you didn't already know it, now you really knew that you were going to have to do it on your own. What happened with Bush versus Gore in 2000, in combination with September 11. I mean, if you believed in institutions, if you believed in the moral arc of the universe inevitably bending toward justice, those two events are cataclysmic. Now you knew that there were no systems or institutions in place that were going to make it okay for you. Your life was going be something that you determined.

ANDREW VANWYNGARDEN: I was a week into my freshman year at college and that's such an impressionable stage. I was a virgin and I was meeting all these new people and was just bright eyed and *wow.* Then September 11 came and I got so deeply freaked out, paranoid, and just knocked off of my foundation of what reality was that it totally just fucked me up.

JOHN HEILEMANN: The 9/11 thing is part of the globalization story, the story of interconnectedness—that America is more porous and more connected. We're porous and we're permeable and we're more connected to and interwoven within a global culture that a lot of

people here didn't understand very well or understood only partially and had minimized. Even before people didn't like George W. Bush because of the invasion of Iraq. Even before that, they decided they wanted to destroy us and kill us and they were going to wreak havoc and that came as a surprise to a lot of coddled white college kids.

VITO ROCCOFORTE: I don't know what it did to music, but afterward it just seemed like everybody partied really hard.

NICK MARC: Tiswas wasn't that far away from the World Trade Center, and there was the smell of the fire in the air, but we were there that Saturday. And people came down. It wasn't that packed, maybe sixty or seventy people. But the following week? Jammed. I think people just wanted to dance and forget the horror for a few hours.

ROB SHEFFIELD: If you were living downtown at the time, honestly you really needed a reason to just get the fuck out of there. It was really, really, really good to have a place to stand around and be surrounded by strangers in the dark watching a band, rather than the crowds of people in the city to look at the ruins and smell the smoke, which is what it was like during the day. It was a time when every band that came to town would play a song by a New York band. They would do this little gesture of solidarity for the encore, and sometimes they would come and be visibly wigged out onstage. People were still wearing gas masks. We then folded them up in our pockets for the walk home. You could tell that really freaked out some of the bands. I remember Stephen Malkmus played the Roxy in late October, early November 2001. You know him, he's not very emotionally fallible. He said something like, "Here we are playing the West Side. The West Side is the side of broken dreams, from downtown to all the unwritten doctoral dissertations up at Columbia University. But that's about as Bono as I'm going to get today." Then he ended with "Satellite of Love." The drummer was singing the Bowie part and he was singing the Lou Reed part and it was so fucking beautiful. Like a lot of boys, he could express his feelings only through Lou Reed simulation.

ASIF AHMED: After 9/11 happened, everything kind of shut down mentally. There was no showboating. Everyone was really nice, free

bus rides; it was like the city of brotherly love, really, and everyone suffered together.

SAM FOGARINO: For a couple months thereafter there was a great sense of paranoia and New York bonded together. It was like, "Oh, man. I'd rather be in shitty New York with people pissing on my leg."

JESSE MALIN: I thought September 11 would scare away all the poseurs, but it actually made everybody sympathetic. It was like, "We've got problems but we're all working on them." And then, culturally, I think because the music had so much of that special energy, somehow the energy of the city coincided with the music. The sound of the city was just kind of amplified; you felt like sound waves were coming from this specific place and reaching far and wide.

TUNDE ADEBIMPE: After 9/11 we basically decided there's no reason for being here besides to make the things we like to make and share them or not share them, because who's keeping score now? Try to find some kind of joy or meaning in your own life because it's suddenly really fucked up outside. Dave and I just said, "You know what we should do? Since the world might end—we should just stay inside and work. If we're going to die, we should probably just make a ton of shit that we like first."

DAVE SITEK: For better or for worse TV on the Radio was addressing that it happened. We just couldn't avoid talking about it. "I was a lover before this war." I was thinking about getting laid and now I'm thinking about dying in the fucking eternity.

TUNDE ADEBIMPE: You were convinced that any second, at the door, there's going to be some bad guys. And we'll be like, "Hey! Listen! We don't believe in America either! Look at this Minor Threat record! Really, we're with you!" But they'd shoot us anyway. That was how it felt after 9/11. And that was when we decided that we were going to keep making stuff. That was when we started working on the *Young Liars* EP.

SAM FOGARINO: I'd say for a minute we probably collectively thought that it was over, that we were not going to make a record. But then it became fuel for the fire. New York puffed up again and said,

"You picked the wrong city. You picked the wrong one," and on a microscopic level this little band, Interpol, is going to put out a fucking record anyway.

ED DROSTE: That fall I felt like no one really knew how to fully process what was happening and as a result everyone kind of went bonkers crazy. I don't know whether it was a result of the tragedy, I just remember that's when a lot of the craziest parties started. And that's when I moved to Brooklyn and immediately was exposed to all this new stuff.

ANDREW VANWYNGARDEN: It was the starting point of my friendship with Ben [Goldwasser]. We started hanging out and playing music together. It shocked us in a way that released some sort of desire to act out.

JESSE MALIN: There was a lot of fear and a lot of nervous energy. And all that makes for sex and coke and good music.

VITO ROCCOFORTE: People were like, "Fuck it." It was wild, it got really fun, and it seemed like there was a lot more drugs everywhere all of a sudden.

SARAH LEWITINN: Post-9/11 NYC had the energy that you were gonna die anyway—taking a subway, opening mail, walking down the street—so why die sober?

MOBY: For the next six months, everyone I knew was suddenly like, "This is the end of times, I'm already a drunk; instead of going out five nights a week, I'm going to go out seven nights a week. Instead of taking ecstasy four nights a week, I'm going to take ecstasy every night."

SUROOSH ALVI: The bubble burst, and the economy collapsed, and 9/11 happened, and it went into this five-year vortex of New York became a massive den of iniquity. So much booze and coke—it was a super-promiscuous town.

RZA: I feel like 9/11 froze our city. It definitely froze me. It numbed us, but at the same time it numbed those who were successful, but those who were striving to come on, it inspired them. That's usually a paradox; you'll see one thing stop and then something else grows.

ANGUS ANDREW: It was an incredibly horrible event, right? That's established. But it was also very inspirational. When something like that happens, on your doorstep, and you're there, it becomes the center of the world, and you feel like you're in the center of the world. That's inspiration in itself. It made you want to pick up your pen and write something down.

CARL SWANSON: Right before 9/11, it was July of 2001. I had my birthday at Campbell Apartment in Grand Central. Right next to it was this staircase. This was a Saturday night, so no one was around. And you know how they have those walkways? We walked across those walkways in Grand Central, on the roof, and it was kind of the most amazing thing. It wasn't so much that the city was abandoned, it was that it was open, and not secure. That you could get to the roof of Grand Central, drunk, on a Saturday night. That changed. It changed because of money and it changed because of 9/11, and sometimes I think those things are connected. I don't really know how they are, but once this place was thoroughly secure, then it could also be thoroughly monetized. In a weird way, in retrospect, all the paranoid hippie stuff was right.

TUNDE ADEBIMPE: That guy in the suit? He was the canary in the fucking coal mine. I feel like New York was about to turn into what it is now way earlier, and then 9/11 paused it.

"THAT NOW-LEGENDARY HALLOWEEN STROKES SHOW

AT HAMMERSTEIN"

MOBY: Everyone who lived in Lower Manhattan expected New York to be . . . done. "It's going to go back to the way it used to be, but not in an interesting way. It's going to be dirty and scary and empty." But 9/11 focused the world's attention on New York and in a weird way, it really boosted tourism. Suddenly more and more people were coming to New York and being surprised at how much they liked it.

JASON GORDON: People wanted to look at New York, they wanted to celebrate New York, and the Strokes were at the center of that. Here was this true New York band.

RYAN GENTLES: *Is This It* finally came out in America that October.

JIM MERLIS: Then there was that now-legendary Halloween Strokes show at Hammerstein.

ROB SHEFFIELD: That Halloween show was the greatest.

GIDEON YAGO: They had never headlined a venue that large before in Manhattan.

JENNY ELISCU: I was with Gideon that night; he was wearing devil horns.

GIDEON YAGO: I was dressed like the devil that night, although it's probably more appropriate to say I was dressed like a member of the Hives/Faint/Refused/Interpol with horns because my outfit was basically a black suit, black shirt, and red tie. It was always suits and ties at that point.

CRAIG FINN: I was distracted by baseball. The Yankees were in the World Series, so I did the New York thing and only saw the head-lining band—the Strokes. They didn't move. They didn't do any-thing. They were so cool.

GIDEON YAGO: This new style of mod was a counterpoint to all the red-hatted/dreadlocked/Limp Bizkit–y bro bullshit that constituted mainstream rock and roll at that time. A dinner jacket at a bar was no less subtle a statement than a Mohawk in '74, a nod to the sea change going on downtown, the self-identifier with the new tribe of sleaze that the Strokes were definitely the forefront of. It felt intimate, an in-joke, not yet baked, calcified, or fully formed, something you could still help define.

ROB SHEFFIELD: Albert's guitar teacher opened that show with his surf band.

LAURA YOUNG: The Papaya Kings!

ROB SHEFFIELD: Everybody was hating that band! It was hilarious. There were these dancing bikini girls onstage and they played this really funny song called "Great Big Jerk." It was just about being a great big jerk. After that it was the Moldy Peaches, who were so, so good. At that point they were getting so much better from show to show that it was like seeing a different band every time.

ADAM GREEN: It was the biggest place we had ever played. I was so ner-vous. But it was Halloween and we were the kind of band that was made for Halloween. I wore something pink, I think. I remember everyone in the Strokes switching their jackets like right before they went on.

ROB SHEFFIELD: Then the Strokes came out. Their entrance music was Jonathan Richman's "The Morning of Our Lives"—but just the end of it, where Jonathan's saying, "We're young now . . . now's the time . . . to have faith in what we can do." The Strokes just played the final minute of the song as their entrance music. It was so unbelievably exciting. It was the kind of moment that made me grateful to be alive.

ADAM GREEN: The city smelled like barbecue.

ROB SHEFFIELD: This is six weeks after 9/11 and it was a lot of people's

first time going out to a rock show since then. There was such a warmth to that night that you actually thought for a moment they might come back and play an encore.

GIDEON YAGO: Almost everyone was there that night. I remember the after-party upstairs at the Hammerstein. Nick Zinner was there. I think the Interpol guys were there. Longwave. Radio 4. The French Kicks. Every major-label talent scout. A few professional models. All the DJs, all the drug dealers, and a couple photographers who are now all big names. But it wasn't joust-y, it was fun. Affirmation of a little Saturnalia after a long couple weeks of the city belching smoke and planes flying into things. There were still missing-person signs everywhere.

STEVEN TRACHTENBROIT: I remember being at the sound board during the Strokes' set, feeling the entire floor just bouncing. All that energy, from the Strokes, from eighteen hundred people, you just felt in the floor.

JIM MERLIS: I remember Albert sliding on his knees at the moment when the lights went up.

GIDEON YAGO: All the rest got away from me after that—I'd be lying if I said I wasn't on massive drugs that night, and I was certainly not alone. I'm sure I was at the Library, 2A, and the Slipper Room. I woke up in a bed with some stranger and my suit looked a lot cheaper in the daylight.

CRAIG FINN: That first record is unstoppable. It was just such a moment, such a good sound, such good songs, that it was almost, "What are you going to do now?" I think that that's what happened, besides playing shows for a million people and dating models and all that.

KIMYA DAWSON: The Strokes became ambassadors, the embodiment of that leather jacket, denim, sunglasses cool New York City in people's minds. "That's New York City music. They're the new Velvet Underground."

ROB SHEFFIELD: The idea of New York as a rock star was something people were very concerned with.

DAVE GOTTLIEB: September 11 did affect all of this greatly. I mean, for

Is This It to come out literally two weeks later? It made it hard for all the people that wanted to be cynical about the Strokes or take shots at them. Instead it became about, "All right, this is an underdog." September 11 made Yeah Yeah Yeahs and the Strokes and Interpol, it made them all underdogs because they became representative of something larger.

JESSE MALIN: You could feel New York was getting the love, mostly coming from overseas, but once it hit here, the kids were getting into it. It wasn't like some old thing. It wasn't some Lester Bangs thing. Or some art thing. It was young kids and hot chicks! It was decadent. You could hear these new bands in the shops when you were in the suburbs, in Urban Outfitters. It was beyond the city. It was an idea.

STEVEN TRACHTENBROIT: Leaving Hammerstein with Fab that night, there was no security or fans. There was no after-party guest list or any of that. Not yet.

ADAM GREEN: Afterwards, we were all in the street and everyone was trying to figure out what to do next. Everyone felt like something had happened. It was like, "We can go downtown now and we can go out to the normal bars that we would usually go to and hang out with each other, but the fact is that something has changed."

JIM MERLIS: That was the beginning of the lunacy that came next.

GIDEON YAGO: Six months later, a night like that could never have happened. Six months later, they didn't belong just to New York City anymore.

"IS ANYBODY OUTSIDE OF NEW YORK
TALKING ABOUT THIS?"

GIDEON YAGO: When September 11 happened I suddenly became an important person. They were talking about firing me at MTV the week before. There I was, this dude who is into itty-bitty indie rock bands, wearing Buddy Holly glasses. They just didn't think that I fit. Then the world changed and suddenly I had a much more important position. They gave me my own TV show.

VITO ROCCOFORTE: The Strokes' success couldn't help but pave the way for everybody from New York. There were tons of great bands before them and after them, but in terms of that shift there's before the Strokes and after the Strokes. All the labels were trying to sign bands, and the media attention, for everybody, was just crazy.

DEAN WAREHAM: I would get on the phone and people would ask, "What do you think about Osama bin Laden? What do you think about the Strokes?" These were the two things that were going on in my town.

APRIL LONG: I remember being in Florida visiting my mom and going into Target and seeing the fake vintage T-shirts, and realizing that it wasn't just a local New York City thing anymore.

PAUL BANKS: The first time we went to England, every person that we met said, "Do you know the Strokes?" The second question was "Are you friends with the Strokes?"

VITO ROCCOFORTE: We did an *NME* photoshoot in the park in the East Village and these young tourist girls came up to us like, "Are you guys in the Strokes?" We we're like, "Yeah!" And we gave them autographs.

SAM FOGARINO: I got a kick out of all these European journalists thinking we're all friends. Me and Daniel, we'd do interviews together, and we would joke about, "Yeah, we have lofts together and, you know, Julian doesn't like his eggs too runny and Nick doesn't get up until late afternoon. You can't make noise until then because he's such a little prissy." We would just go on and on and on.

VITO ROCCOFORTE: It was annoying, but it was funny.

MARC SPITZ: Alan Light had been editing *Spin*, and I was still in the frame of mind of "All right, well, I guess I better learn to like Coldplay." Because they're better than Limp Bizkit. You know what I mean?

ALAN LIGHT: I remember feeling so skeptical. We wanted to believe so bad. Everybody started talking about the Strokes, but I was like, "Is anybody outside of New York talking about this? Or are we just so desperate that we want this to be happening?" I just had the sense that this could be interesting but this really also could be nothing.

JIM MERLIS: Alan Light wasn't into it, but Sia replaced Alan and she was the one who really championed the Strokes at *Spin*.

SIA MICHEL: I came to *Spin* in December '96, when it was owned by Bob Guccione Jr. and was still in the Flatiron district. I was hired as an assistant editor and my desk was in a windowless storage closet that still had brooms and mops in it on my first day. But I was psyched because I'd never had an office before.

TRACEY PEPPER: Sia was always the smartest person in the room. She's a bit quiet, so not everyone knew how brilliant she was, unless you worked with her; then you absolutely knew it.

MARC SPITZ: Julian and I were drinking once at that bar on Thirteenth and A and he saw a photo of Sia. He goes, "That's Sia?" And I said, "Yeah, that's Sia Michel, the editor in chief." "She's beautiful." "Yeah, she's really good-looking." "She looks just like Rebecca De Mornay." And I'm like, "She also gets Traci Lords."

JIM MERLIS: Of course at *Rolling Stone* the Strokes already had Jenny Eliscu in their corner. I think she'd done her first piece on them by the Halloween show. But suddenly they all came aboard like gang-

busters and it became this New York City pride thing, because all of a sudden these other bands started springing up.

AUSTIN SCAGGS: We were talking about bands like Limp Bizkit and covering the swing revival and all that garbage. Boy bands. All these things that were happening in L.A., or somewhere else, and that we looked at as a joke but regardless were forced to cover. Then all of a sudden, like right here on our fucking doorstep, right where we live, the world is changing.

MARC SPITZ: It was like when I first heard Adam Ant or the Clash or the Smiths. We were then looking amongst the larger *Spin* staff, and even some of the cooler *Rolling Stone* people like Jenny Eliscu and Rob Sheffield, for kindred spirits. We became evangelical; it became our mission to get them more press. But it also became a competition.

JENNY ELISCU: After that first Mercury Lounge show, I just started telling everyone about the Strokes.

ROB SHEFFIELD: It was all Jenny Eliscu. For all these New York bands she was such a proselytizer. She was the saint of this whole environment, completely selflessly spreading the world. She was not like, "You should hear this band, but I get to write about them first." She was like, "No, you should write about them and I should write about them and we should all write about them!"

JENNY ELISCU: But at first, nobody cared.

AUSTIN SCAGGS: Sometimes at *Rolling Stone* you've got to get beaten over the head with what's going on to eventually pay attention to it.

JENNY ELISCU: The insult Joe Levy used in the early days about the band was "Oh, you really wish you got to see the Jam, Jenny." I hadn't listened to enough of the Jam at that point to have that strong a reaction, but then I immediately went and did listen to more of the Jam and I was like, "You know . . . Levy . . ."

JOE LEVY: What I meant was that there was an excitement—a moment, a movement—that she missed out on. It wasn't about the music of the Jam, which I could have given a fuck about. It was about Paul Weller making statements out of the past that mattered in the present—that resonated with fans and in the press. That was

some shit, but it wasn't going to happen again. Except I might as well have been talking about myself, because that was some shit I missed out on. She missed out on nothing. She was right.

ROB SHEFFIELD: Jenny's piece ran in the issue with Julia Stiles's face and then the headline above said something like: Tina Fey, the Strokes, Questlove—things that are up-and-coming and cool. Those were all the next big things in 2001.

JENNY ELISCU: I remember at that Strokes show at Bowery, Tracey Pepper went up to Jim Merlis and asked why *Rolling Stone* knows about this band—I must have written a single review or something at this point—and he said, "Because they go to shows." Meaning me; I went to shows.

TRACEY PEPPER: Who told you that? That does sound like something I would do. If it happened, I must have been pissed. We were so competitive with *Rolling Stone*. A band like the Strokes belonged in *Spin* first, not *Stone*. Our readers were their audience, not *Rolling Stone*'s baby boomer readers. I was friends with a lot of editors at *Rolling Stone* and liked them a lot as people, but I wanted to crush them professionally.

MARC SPITZ: It's December 2001. September 11 had happened. We were all a little post-traumatic. It was the *Spin* Christmas party at the Slipper Room, which was James Habacker and Camille Habacker's bar on Orchard Street, on the Lower East Side. I'd had a few. We had just made U2 Band of the Year. U2, from Dublin, who'd been around for twenty years, who released an album called *All That You Can't Leave Behind*, which was not as good as their last five albums before the album that came out before it, which was their worst album. But because it was not pop, they won the Grammy, and they won Artist of the Year at *Spin*, which, at the time, was prestigious. Like, literally, it made the AP wire.

SARAH LEWITINN: That's how desperate the music world was. I was insisting that Muse win that honor for *Origin of Symmetry*, an album not even available in the States, which fell on very deaf ears. I stand by my claim, though.

MARC SPITZ: The Strokes were still a front-of-the-book band. But they were moving up quickly. I thought, "We're *Spin*!" I believed

in us getting there first and beating *Rolling Stone*. We're at the Christmas party, and I said to Alan, "God himself opened up the skies, parted the heavens, and handed us"—"us" meaning *Spin* and "us" meaning New York after 9/11—"this fucking band. This is the Band of the Year. What the fuck are you doing putting U2 on the cover as the Band of the Year? U2 are not the Band of the Year. This is not 1987, this is 2001." And I probably said a lot of other things that I don't remember because the next morning I got a phone call from Tracey Pepper, and she said, "Marc, if you wanna keep your job, call Alan and apologize. Immediately." And I did. And Alan, who had seen a lot crazier and a lot tougher than me, accepted my apology very graciously. I kept my job. And within, I would say, maybe six months, give or take, Alan was gone. He left *Spin* to start his own magazine. Sia was the editor in chief, I was assigned the Strokes' first cover story, and they were Band of the Year in 2002. By then it was apparent to everyone on the street, and everyone in England, and everyone who gave a shit about culture, that the revolution was real this time, and the Prodigy wasn't it. It was Julian and Fab and Nick and even Nikolai and . . . Albert. Especially Albert.

33

"CATS STARTED TO GET OUT OF THE BAG"

MARC SPITZ: You know how they say Black Flag got in a van, and they brought punk rock to the world? The Strokes got on a bus, and they brought "downtown cool" to the world. Along with the Internet, they were changing everything, not just music. They were changing attitudes. The Strokes were making New York travel with them. I saw kids in Connecticut and Maine and Philadelphia and DC looking like they had just been drinking on Avenue A all night. Sixteen-year-old kids in white belts and Converse Chuck Taylors with the greasy hair—hair that had been clean a week ago. Those kids had probably never even smelled the inside of a thrift store before *Is This It* came out. They found a band that they wanted to be like. They found *their* band.

APRIL LONG: The Strokes really did create the blueprint for the international hipster look of the aughts—the skinny jeans, leather jacket. You can add a mustache or a flannel shirt, but the baseline is essentially still the same, even now.

MARC SPITZ: You know that scene in *24 Hour Party People* where they see the Sex Pistols at the Free Trade Hall, and then the very next thing you see is them ripping their old posters down? Like, that's what it was like in the fall of 2001. Other bands' posters were instantly irrelevant.

JIM MERLIS: We held off on doing any TV until *Saturday Night Live.* It was Jack Rovner's idea—"Let's have the first appearance be *Saturday Night Live*." I remember he called me and Ryan up to his office to have this conversation, and he thought he was going to have to try to convince us, and we were like, "No, that's awe-

some." They were so nervous and stoked, and it was really sweet.

NICK VALENSI: We were so excited to play *Saturday Night Live*. That was a really big thing for us. I don't remember getting that call, though. Every day at that point there were new and exciting opportunities being presented. My brain kind of had to go numb because if you get emotional and excited about it every time, you're going to drive yourself crazy.

BEN BLACKWELL: It was kind of hilarious when the Strokes were on *Saturday Night Live*. Albert was wearing a Yeah Yeah Yeahs pin. That was big news.

KAREN O: At the time if I'd run into one of the boy bands, they'd all ignore me! I swear to god, I couldn't get anyone to look me in the eye.

ALBERT HAMMOND JR.: No way! I talked to her! I wore a Yeah Yeah Yeahs pin on my jacket the first time we played *Saturday Night Live!* It's just got to be hard with all those guys. It was even hard between just the guys.

JIM MERLIS: As a publicist, all these things, these opportunities— there was no map, no phenomenon like this before. Also, it was already the beginning of the backlash, because they were getting so popular.

JESSE MALIN: People were jealous and angry.

JALEEL BUNTON: When something blows up, you find out about it first in New York—the culture is usually right in your face. You see a band that's become a wild success and they are right next to you. It's not like I read this in a magazine, no, they're sitting at the bar, living the same life right next to you, except their life is awesome and yours totally sucks. It's hard to be in that proximity.

FABRIZIO MORETTI: I never felt comfortable. Ever. I felt stressed out most of the time.

NICK VALENSI: It was all very exciting, but you almost had to just respond by doing something normal. I just did a lot of drugs.

MARC SPITZ: They would talk in code about drugs, but it was a pretty thinly veiled code. Like in *True Romance*, they called cocaine Doctor Zhivago. I'd actually never seen *True Romance*, and I didn't

know what they were talking about. I thought they were talking about a fucking Julie Christie movie. "Oh, are we gonna go back to the tour bus and watch, you know, Omar Sharif?"

MATT ROMANO: They got a lot of shitty press at the time because, you know, "He's John Casablancas's kid and they don't have any talent and they're rich prep school kids getting all this press."

PAUL BANKS: People in other bands had this real need to say, "Somebody else writes their songs," or "They're just rich kids." You had to find some way to not accept the fact that there's actually five dudes out there that are cool as fuck that are writing insanely awesome music. And they did it by themselves. They are cooler and better than you are, and they will steal your girlfriend. That was just a really tough pill for a lot of people to swallow, including me.

KIMYA DAWSON: By that point the Strokes are getting huge so Adam and I are invited to New York City parties where you go in and people are like . . . fancy. Models everywhere. I remember thinking, "How is this happening?" I would go in my bunny suit because I was scared shitless. It was just like, "I'm not going to fit in if I try to dress nice."

GIDEON YAGO: The Strokes developed a cadre of comedians and *SNL* cast as fans, like David Cross, Horatio Sanz, and Jimmy Fallon. Those guys really gravitated to the Strokes. I mean, Jimmy is only a couple of years older than me. He wasn't omnipresent but as they started to blow up, he was a guy that you would see backstage hanging out.

ALBERT HAMMOND JR.: We're huge *Mr. Show* fans; like 99 percent of our inside jokes are *Ace Ventura* or *Mr. Show* or *Tommy Boy. Mr. Show* was like our bible of communication.

MARK RONSON: David Cross had—certainly at that time—a little more indie appeal than Jimmy Fallon. Jimmy Fallon, girls loved him, college kids loved him, but it was easy to be a little snooty to Jimmy because he was on *SNL* and he was good-looking.

RYAN GENTLES: Jimmy opened for the Strokes, actually.

MARK RONSON: I was playing in Jimmy's band, then. And I remember the first night on that tour, it was in Boca Raton, and it was this

outdoor shopping mall. They must have been giving out these individually wrapped chocolates, because we were just being pelted. And Jimmy was being heckled by this guy in the front. The passes for that tour said "the Wicked Scepter Tour."

MARC SPITZ: Wicked Scepter are a gay metal band from a *Mr. Show* sketch. They don't realize they're gay even though they have anal and oral sex with each other.

ALBERT HAMMOND JR.: Meeting David Cross was weird. We met him at 7B. He was in the bar and we kind of went up to him.

JULIAN CASABLANCAS: I think we invited him to a show or something.

DAVID CROSS: That was my local, 7B. I was there by myself, just hanging out, because I was friendly with all the bartenders. I was at the bar, and they were at a table. They were kids. They were looking at me, then looking away, looking, looking away. I didn't think much of it. I think Juliet [Joslin, now Casablancas] was the one who eventually came over, because she was the girl. They were big fans, etc. I must have heard of the Strokes, because when I moved here, the girl I was dating had an advance copy of their album and I remember listening to it over and over again while painting my apartment in terrible New York City heat.

ALBERT HAMMOND JR.: After we met him it was kind of like . . . we got that out of our system.

DAVID CROSS: They were really nice and just respectful, polite, qualities you don't necessarily apply to musicians. A bunch of us went across the street and hopped the fence at the park to get high, the one on Seventh and B. I remember Nick not being able to hop the fence very artfully. I thought, "That's kind of adorable. What kid grows up in the city and doesn't learn how to scale a fence?" It's a tiny fence! And yeah, they were *Mr. Show* fans but it didn't ever get like, "Oh, I have to leave, this is getting uncomfortable," and believe me, with some people it does. They were totally cool, and then we became friendly. We were all in the same neighborhood, same circles.

STEVEN TRACHTENBROIT: There was something about the East Village, everyone seeing each other at the same bars. I remember those

guys all played softball together in Central Park—David Cross and James Iha and Ryan Adams and Macauley Culkin. Random.

DAVID CROSS: Fucking Julian knocked in a couple of homers. I was like, "Jesus, that guy . . . who knew?" The other thing about those guys is there was a lot of making out, not in a sexual way, but in a making out way.

ALBERT HAMMOND JR.: I always found it funny to kiss men.

DAVID CROSS: I remember being in that bar upstairs at Irving Plaza and Julian kissed me, and I'm going, "Whoa, what the fuck?" But also having this crazy rush of emotions, because I know he's not gay, and I'm thinking, "Oh, that was fucked up, that was weird, but I guess it wasn't really unpleasant. That's nothing I'd ever do again, I don't think. Huh, that was interesting." It was my Bowie/Mick Jagger moment.

ALBERT HAMMOND JR.: I like how weird people get. I revel in their weirded-outness.

DAVID CROSS: He's a good kisser! Fully shaved, soft, supple skin. I think he has access to really nice creams and lotions.

CATHERINE PIERCE: Before Albert and I were together, we all went out to some show. Moby was there, and Andy Dick was there; Albert was there. I think Albert ended up at the strip club, somehow. Andy and Albert were making out.

ALBERT HAMMOND JR.: Was that when I kissed Andy Dick? Catherine was like, "What are you doing?" and I was like, "Who gives a shit?" It was probably before we'd gotten any coke, so I was just too drunk. I chased Catherine for a year. We first met when the Strokes were finishing *Is This It*. I went to Mercury Lounge. I was getting a beer when I saw her onstage and I was like: "She will be mine." I had left her a flower with my name and number, saying, "If you ever come back to New York . . ." Six months later, she came to New York. It was the summer, when we were doing Reading; I came back from Reading and we started hanging out but she didn't want to date me.

CATHERINE PIERCE: Yeah, he pursued me. I grew up in Birmingham, Alabama, which is so culturally shut off. I was so naïve. I went to

New York when I was sixteen; it was the first time I met people with different ideas and people that believed different things, and it was so exciting to me, and I just thought, "Oh my god, this is life." Most people in Birmingham get married at twenty, have kids really young, and I just realized I wanted to go explore life, and that seemed like the perfect place to do it. But it wasn't until Albert started dating James King, that's kind of when I was like, "Wait a minute . . ."

ALBERT HAMMOND JR.: I met her at the *Spider-Man* movie premiere. I asked for her number that night when I saw her and then I called her. But I wanted Catherine.

DAVID CROSS: I had a couple of really awkward, embarrassing moments with those guys.

CATHERINE PIERCE: I love David. I did ridiculous things with those guys; I smoked crystal meth with them. I didn't know it was crystal meth! I was such an idiot. David invited them all over, and he was like, "I have this stuff called glass," and I was like, "What's glass? That sounds pretty."

DAVID CROSS: Julian once crashed at my place, and he wanted a blanket, but I didn't have one, so I gave him a mattress cover and I remember him, as he's sleeping, saying, "I'm sweating, this comforter is really heavy." He probably lost two pounds that night. Right after that, maybe six, seven weeks later, my then girlfriend and I were invited over to Julian's and his then girlfriend Colleen's place. We had a very nice dinner, bottle of wine, and I go, "Oh man, I have this videotape my friends sent me." I'm friends with the guys in Nashville Pussy, and they will send me videotapes and DVDs of all this crazy weird shit that they collect, stuff you'd now find on YouTube, but this is pre-YouTube. I had no idea what it was, just thought it would be funny. We put it on and it's the nastiest German bestiality porn. I'm like, "Uh . . . whoa, I didn't . . ." And of course the more you're going, "I had no idea!" the more it doesn't seem like a viable defense. It was really awkward.

JENNY ELISCU: New Year's 2001 was that show at the Apollo.

GIDEON YAGO: Yeah, cats started to get out of the bag at that point.

CATHERINE PIERCE: That show with Guided by Voices and David opening was a total blur. I remember it being amazing, and dancing, having the best time, singing every song, looking at all of them onstage, thinking that they're like a boy band in the sense that they all have their personality and they're so dynamic, but they're fucking cool and they play instruments too.

RYAN ADAMS: That Apollo show, man, that was one of the best shows I've ever seen. They had lighting like I'd never seen before, where they were all in silhouette and the background changed colors and the place was going nuts. I remember Ryan Gentles nearly passing out several times because Julian kept going off the front stage. Ryan was like, "Ah!! He's going to fucking kill himself!" I was like, "He's pretty loose, if he falls he's just going to bounce." They would finish a song and Albert would put both of his arms in the air, like "I did it!" They were just pure. They were some of the purest people I've ever met.

DAVID CROSS: That was one of the top five worst experiences I've had. It was brutal. And I knew it was a bad idea. And I tried to convince them not to do it. And they were very adamant about doing it anyway. People were rude. I just turned my back to the audience and talked into the microphone and said, "Look, guys, I'm contractually obligated to be up here for forty-five minutes." It was New Year's Eve and I wasn't billed, it just said "special guest," so nobody really knew that I was going to be doing this. Everyone is timing their night out, "Oh, I'm going to go get fucked up, I'm going to come to the show, then I'll go see the Strokes and Guided by Voices." No, sorry, first you have to sit through forty-five minutes of a guy who thinks he's funny. A year later, I was at a show at Maxwell's in Hoboken, and I ended up getting into a fight with a guy who was at that show. He was still angry because I fucked up his high, so he pissed on me from behind. His name was Taliban Jim, and he got this nickname because during 9/11 he was out in the streets screaming that the revolution had started.

GIDEON YAGO: By the time they got to Coachella that spring, it was just Strokes mania.

RYAN GENTLES: Drew came to Coachella.

JIM MERLIS: I get a call from Drew Barrymore's publicist or manager saying, "Drew and Cameron Diaz want to go backstage at Coachella, can you help me, through the Strokes, do that?" I was like, "Wait, you need my help to get them backstage?"

RYAN GENTLES: I was the first person to greet her. She wanted to come and see the band, so the manager goes, "I'm going to take her back to the trailer," and nobody was there except for Fab. I was like, "Oh, I don't know where they are; well, Fab, this is your friend Drew Barrymore," and it was like, "Oh, nice to meet you." "I'll go get the rest of the guys, hang out here, have a beer," and Fab was like, "Cool." She just came by herself. We left for like twenty minutes, Strokes played their set, and when Oasis took the stage, Fab was making out with Drew Barrymore on the side of the stage. Then they dated for five years.

JIM MERLIS: I didn't go out to Coachella. Two days later, in the office, I get sent this huge bouquet of flowers, and it's like, "From someone, thanks so much," and I couldn't figure out who it was from, and all of a sudden I'm getting calls from the *People* magazines of the world asking, "What's up with Fab and Drew Barrymore?" and I'm like, "Oh my god, the flowers are from Drew!"

DAVID CROSS: Fab had his string of girlfriends and there was one of them where I'm like, "Oh, that's not going to end up good, that can't possibly . . ." Because you just knew the other person involved, and you were like, "This is not meant to be, this kid is going to get his heart broken."

JIM MERLIS: Coachella would have been like, "Yeah, go wherever you want." They didn't need my help getting backstage, they needed my help meeting the band.

DAVID CROSS: Do I think of Drew as a heartbreaker? Well, look at her history. And she's super sweet. I've met her a couple of times, and she is in that same vein of Fab, just a genuine sweet person, but I think also very true to herself in the sense of "I love this, I love this . . . no, I don't love it, bye!"

CATHERINE PIERCE: Drew's been famous since she was five years old; everyone in the world knows who she is, pretty much. There was a

force around that was bigger than them, and it was really interesting to see that dynamic. Everyone wanted to know what she was going to say, everyone wanted to know what she was interested in. It was a big deal. It became normal eventually, she's very down-to-earth, in ways, but at first it was like, a bigger thing had come along.

34

"IT'S OUR TIME . . ."

NICK ZINNER: Really, the way we write is essentially waiting for Karen to be inspired by something. Once she enters that world, then you can follow. It's just melody, shape, and will. Getting into that world where you're not hyper-judging everything and overthinking. Things just happen, they come from somewhere you don't understand. Art, with a capital A. It's inexplicable, and fantastic in its inexplicable-ness.

ASIF AHMED: I've got to hand it to Nick, he's definitely talented and he's definitely the true artist type. He doesn't put anything on. I think he's insecure like any artist, but he's fucking talented. He'd be a great, *great* producer. He does it instinctively. Karen does too, and Brian. They were kind of a perfect band.

KAREN O: How do I know when I've got something? It's totally unintellectual. I feel almost like a little kid. I get, like, butterflies in my stomach or I get a wave of euphoria or I get the chills or I cry. I have very visceral and physical reactions to it. If it's not right I feel like I want to throw up or I want to pull out my hair. It's a different kind of intelligence, emotional intelligence. Your intellectual mind sucks, you know? I wish I could just put that part of my brain away for good.

NICK ZINNER: The first time I ever felt that feeling of "Yeah, we really have something that I want to share" was for our first EP. I was psyched.

KAREN O: Totally, the first EP was when it happened.

BRIAN CHASE: We had a rehearsal space on Avenue B where we recorded it.

NICK ZINNER: It was just a demo, just something to help us get shows at the Mercury Lounge or Brownies, opening for other bands. But I felt that urgency and need to transmit it to the world.

ASIF AHMED: I had the EP that Karen had given this bartender at Odessa. People kept giving it to me. At one point I found myself with nine copies of this fucking thing in my apartment. I finally played it one night while washing dishes. "Our Time" came on and I was like, "Fuck, this is a great song!" My friend Rachel suggested I manage them. I'm like, "I don't know . . . Brian looks like Eddie Munster, the other guy looks like Eugene Levy, and they're all really pretentious."

KAREN O: Asif was only a few years older than me, he was younger than Nick, so he just seemed like another kid, another playmate, looking to get caught up in our monkey business. I think we also heard he was capable of making really great deals.

ASIF AHMED: We met up at this horrible dump of an Irish bar, One and One. They were already talking to a bunch of other managers but they were kind of freaked out by the established old people. Because I was around their age and everyone already knew me, it was easier. I spent probably a good twenty, twenty-five minutes making them laugh, trying to warm them up. Even to the point where I would, like, take a piece of brownie or something and black out a tooth and smile, shit that you would do for kids. That's what they needed.

DAVE SITEK: Asif is the original reality TV star.

KAREN O: We weren't ready for some serious, uptight manager who would do a really good job with us. We wanted someone who was fun and funny and kind of as much a mess as we were. We wanted someone to be able to relate to and Asif, oh my god, he was a mess, totally fucking irreverent, really ballsy, audacious. He was hilarious and dangerous, a loose cannon, and just in it for the fun, too. A lot of the psychology with the music is: "What can we get away with? Let's see how far we can go." And that was Asif's vibe. He was like, "Let's see what we can get away with." He dug our EP and found his way into hanging out with us and we thought, "Hey, this guy is cool, let's have him be our manager."

ASIF AHMED: We had a kinship in that we were suburban, middle-class and had an appreciation for pop culture.

SUROOSH ALVI: For the *Vice* five-year anniversary I decided we should throw a party. Yeah Yeah Yeahs' *Master* EP had shown up to our office just before that. The self-manufactured, not-even-in-stores one. I remember the day it came in. Eddie was listening to it and I was like, "What is this?" He was like, "I don't know, this just came in the mail, but it's fucking great." The address on the back was Metropolitan Avenue. It was Nick's apartment, if I recall. We got in touch with them, interviewed them for the magazine, and I booked them to play this party. I can't remember the rest of the lineup but they were the most memorable thing that whole night.

DAVID CROSS: The first time I remember seeing Yeah Yeah Yeahs was at a weird fashion *Vice* thing at one of those dumb clubs. I think it was called Wet.

SUROOSH ALVI: It was at Spa in Manhattan.

JUSTINE D: It was called Spa Wednesdays. It was more fashion and art people. But we only played rock. We had a *Vice* party there—and this was before *Vice* really blew up—and Yeah Yeah Yeahs played for $400. I know the budget because I managed Wednesday nights. A thousand people were there. At that point, they had been playing Brownies—tiny venues.

SUROOSH ALVI: It was one of these perfect parties. We had a line around the block; we got McDonald's to cater the party. We illegally put the McDonald's logo on the flyer and basically took seven hundred fifty bucks, gave it to interns; they went to the Union Square Mc-Donald's and bought everything. We had costumes: someone was the Big Mac, I was the Hamburglar, and we walked around with trays of food. The crowd was like a pack of wolves—when people are drunk like that it's like, "McDonald's, oh my god, it's so good." The vibe was just building, and the energy level was so high.

KAREN O: I remember being beyond trashed. The hedonism and debauchery of that time was off the chain. *Vice* seemed to really embody that, so when you couple that with us, in that moment in time, it was a good combination but also a horrible combination.

DAVID CROSS: There's like ten, fifteen shows I remember where I was just blown away, like, "Holy fuck, these guys are amazing." One of them was one of Yeah Yeah Yeahs' first shows. They just blew me away, they were so good, and so impressive, and as cliché as this sounds, a breath of fresh air. This was so real and raw and heartfelt and organic with a sprinkling of importance. And she was a girl. Still is, in fact.

KAREN O: I remember there being an instant mosh pit—we don't usually have mosh pits, but there was one. I'm lucky that I don't have some horrible disease, because I just remember asking pretty much anyone in the crowd, "Give me your beer!" They'd hand me half of some super-spitty pint of something and I'd just be like, "Blaaaah!" Down the hatch!

SUROOSH ALVI: Karen was partying and wasted, and they fucking killed it, like blew the roof off the fucking place. It was the show that launched their whole fucking thing, the bidding war and everything. The hype level went from "Hey, there's a cool band in Brooklyn" to "Oh my god, this band, Yeah Yeah Yeahs." It shot them into outer space.

KAREN O: There was just such urgency and self-destruction, just the need for release, hedonism, and *Vice*, they were all about it. They kind of prided themselves on it, and so did we.

JOE LEVY: I made a point of playing records I knew nothing about on Wednesdays. Their first EP was provocatively packaged around a theme of dominance and submission. It was a girl wearing a necklace that said "Master" in big gold letters.

MARC SPITZ: Yeah, they were an exciting band. That little EP got the shit played out of it at the *Spin* office. She was bold in her lyrics, and there were a lot of people on staff who, like, really got off on what she was bringing to the scene. "As a fuck, son, you suck." People were like, "I'm about that. I like that. That needs to be said." She brought some good put-the-rock-boys-in-their-place sort of energy.

KAREN O: Do I think being a girl had anything to do with our outsider status as a band? I think it had everything to do with it.

APRIL LONG: Karen O was the first immediately iconic female to emerge from a small music scene in a way that made a big impression in sooo long. She was like a Debbie Harry but for our generation. And it was incredibly inspiring to see. I mean, everything she did was so freaking cool.

KAREN O: I remember going to see this James Chance show at the Cooler back in the day. There was some boy there—just the dregs, the bottom of the barrel, but at that point in my life, I was into it. He was totally blowing me off and I was getting wasted. But Debbie Harry was there. I go up to her and say, "Yeah . . . I'm in a band and, uh . . . sometimes I just feel like a girl in a boy's world, you know?" I'm a total drunken twenty-year-old stranger trying to harass her. She was just like, "Honey, just enjoy it while it lasts." It was really disappointing at the time. I was like, "That is terrible advice!" It felt condescending or patronizing. I was like, "What the fuck!?" It felt cynical. But in hindsight, she's totally right, man! She's right as rain! None of that shit matters. I mean, it does matter because it's shaped us and it's shaped our career and it's shaped who I am as this artist. I am a girl in a boy's world and like lot of women in a lot of different fields, I felt really isolated. But it also doesn't fucking matter. Enjoy it while it lasts.

ROB SHEFFIELD: That Yeah Yeah Yeahs EP was really hard to find and should have been hard to find because it sounded like crap. Nick once told me that it was on a cassette and he put his jeans in the laundry, so the tape went through the laundry, and that's what they mastered it from. I was like, "You know what, dude? I believe you. It sounds like it was recorded in a Dumpster."

JOE LEVY: With some sense of pride I will tell you that *Rolling Stone* was the first national publication to cover them, possibly the first print publication to cover them. That record arrived in the office, I played it, I went to see them, and I put them in the magazine. Things don't usually happen that way.

ASIF AHMED: Yeah Yeah Yeahs played a big show that December at Brownies and every fucking manager was there, still trying to sign them; every fucking label was there. It was at that show that Karen said from the stage, "Our manager, Asif, is standing in the back."

She was wasted of course. But that's how I found out, officially, I was managing them. Then everyone turned to me and it was like walking dead. I'm like, "Mommy!"

APRIL LONG: People were crawling all over each other to get to the stage. It was already mayhem. They had much more of a huge impact for me than some of the other bands, because I was like, "They are raw, but so alive, and so, so sophisticated, and fucking amazing looking."

JOE LEVY: I saw them three times at Brownies in that period and they were three of the best shows I've ever seen. All of the things that people talk about when they talk about Yeah Yeah Yeahs were there. Karen O grabbing three beers in her fist, drinking one and pouring the other two over herself and over the mic stand. You know, all of this unhinged, deeply hilarious, completely spontaneous behavior. At the first show it was all girls in the front, they were all her friends, they were giving her drinks, and there was this sense that there was something happening here and it involved girls, all in on a secret that nobody else understood, which was completely exhilarating. Because 99.999 percent of the shows you go to, you're lucky if there's a single girl there, let alone the sense that girls are not just participating but in control.

CHRISTIAN JOY: I feel like a lot of girls, myself included, finally felt like we had someone onstage we could relate to, someone who did not give a fuck in the same way we did and didn't mind being dirty and unsexy and was just being herself and was not a dude. I think we felt like we owned the moment. We would go to the shows and go absolutely bonkers in the front row. Karen was our fearless leader. We would come out of the shows absolutely covered in bruises, dirty, and drunk. We were totally arrogant fuckers just like boys. It was the first time I felt like I had women like myself around.

ASIF AHMED: Karen was the only girl but she knew that she didn't want to be exploited as a novelty.

KAREN O: I get grilled a lot about "Are you a feminist?" And "What do you have to say about it?!" And I always come up short. I do feel like the work speaks for itself. I just want it to really be in the work

rather than the talk. I do always feel like I disappoint because I'm not on a soapbox.

JOE LEVY: But let me stress again that, yes, everyone had the sense that we were seeing something special, but not important. It was a fucking nobody rock band on Avenue A in New York City. There wasn't any chance it was going to turn out to be important.

JASON GORDON: Yeah, I mean, it was really just a fun time in New York and it didn't seem like it was going to ever explode nationally. You're like, "These bands are awesome, but who is ever going to listen to a band with a song called 'Bang'?" She's talking about a guy's penis in that song! That's not going to be a mainstream band, they're never going to be on radio, they're never going to sell out a place bigger than Bowery Ballroom.

NICK ZINNER: In the band I was playing in before, we tried so hard for two years. When I met Karen I'd already given up any hopes of doing it for reals. So it was all 100 percent sincerity.

ASIF AHMED: At first the most controlling of the band was Nick. He didn't even want my name on the website. None of them did. They just wanted my e-mail at the bottom of the page. No one wanted a manager because it was not cool. I'm like, "You know what's also not cool? Poverty." But they didn't have that worry as much because they grew up—I wouldn't say privileged, but they grew up with parachutes. It shouldn't be held against them. They're incredibly down-to-earth people. But you could tell they were really educated, and no one who is that educated is poor.

JON SPENCER: We invited Yeah Yeah Yeahs to play with the Blues Explosion on a West Coast trip, and it became a package thing with Yeah Yeah Yeahs and the Liars. At the time, Karen was dating Angus [Andrew].

KAREN O: Liars were huge for us. They were a brother band. They were the best band as far as I was concerned—this is how we felt before Angus and I got together, though it wasn't that long before I tried to, you know, bag that one.

ASIF AHMED: He's very . . . I'm trying to think . . . Jack Nicholson

in *Easy Rider* but Australian. Very smart, very pensive. He was a big stoner. And monosyllabic. "Yeah, mate." "Sup." Yeah, but amazing onstage. They were in love, love, love, love. Couldn't separate them.

KAREN O: He was ever so dreamy. And seemed totally unobtainable. And he also liked to play the whole "I'm gay" thing—he'd use that as a kind of cock-block thing, but just between him and chicks, and it would just magnetize him.

JON SPENCER: They would alternate; one night Yeah Yeah Yeahs would play first, then the next the Liars would play first. They were together in a bus on this tour.

KAREN O: I remember being in the audience at a Blues Explosion concert and just psychically trying to send the message "Just look at me, just look at me, just look at me." If he even glanced over in my direction, I would be like, "Yes!" So when I finally met those Blues Explosion guys, like when Jon and Cristina were in the same place where I was, I felt legit. Like, "I'm legit because they're here." They were really quite the New York couple of the nineties.

JON SPENCER: When they came along, that was at the time when I began to think, "These are no longer really my peers." Up until that time I had always toured with people I had known or people my same age. It began to sink in that these are people who are a good generation below. We also toured with them in Australia, which was interesting and a bit embarrassing, because at that time it was some of the last tours we did with a promoter that we worked with for several years, and they were being wined and dined and courted by labels and definitely by this promoter. We were just sort of along for the ride even though they were our support act.

ASIF AHMED: We did Yeah Yeah Yeahs' publishing deal first. I remember negotiating that in Heathrow Airport over text. I was sitting in the smoking lounge screaming at the lawyers, screaming at the publishing woman, because there was this 1.5-million-dollar deal looming over us and in the meantime I was just trying to get another thirty grand to cover lawyer fees. Later, I remember cutting them their checks with the business manager and they just seemed

so unaffected by the whole thing. We handed them the checks and they were just like, "Cool. Thanks . . . so anyway here's a new song." Meanwhile I'm like, "Fucking cocksucking little bitches!" These were big checks! Like, ridiculous checks!

NICK ZINNER: The first tour was March 2002. We went down to South by Southwest. That was our first big tour, opening for Girls Against Boys. Dave Sitek, later from TV on the Radio, was our roadie/driver, and he rented this minivan.

KAREN O: The minivan tour.

DAVE SITEK: The brakes gave out on that van and so I went to a Pep Boys and bought all new calipers and replaced the brakes on the side of the road. They asked, "How do you know how to do that? Like, what the fuck?" That's what they depended on me for.

ASIF AHMED: Before they left for their first South by Southwest show. Dave Sitek was their tour manager, and I made them lunch. They left them on the curb outside the fucking apartment, those bitches! I remembered all their birthdays. I'm like a little mom: "Here's your lunch and who has gotta go tinkle before the road trip?"

DAVE SITEK: I met Nick first; I think it was the second Yeah Yeah Yeahs show ever, at Don Hill's. There were probably sixty people there. Brian and Nick came out onstage and started playing for a while, and I was like, "This is pretty wild." Then Karen came out in a gold lamé one-piece covered in olive oil and sang as if there were a million people out there. We were just shocked.

KAREN O: I thought it was our first Maxwell's show. We really left an impression on him.

NICK ZINNER: He's sort of like our spiritual mentor. He's the raddest dude. He's like a thousand years ahead of everybody.

KAREN O: I call him my hairy Polish-American muse. Dave was one of the handful of people I've crossed paths with in my life where from the moment I met him I felt like I had known him my entire life. In a pretty significant, like, "we-were-probably-related-to-the-same-mother-in-a-past-life" kind of way. From the moment I met

him, there was no doubt in my mind that he wasn't a stranger. I felt that with Nick too.

DAVE SITEK: Yeah Yeah Yeahs asked me to go on tour with them because I was the only person they knew that had ever been on tour. We went around the U.S., down to Austin and back, and other places in between. I'm a nutcase and I told them I was unqualified, but they didn't care.

"TROUBLED SOULS"

LAURA YOUNG: The Strokes had the persona of being hard-edged, drunk rock-and-roll dudes and Interpol were dark and mysterious. You know, troubled souls.

SARAH LEWITINN: In my mind, it was Blur versus Oasis, Interpol versus the Strokes. And I'm on Team Interpol, even though the rivalry didn't exist. I'm sure they're friends.

APRIL LONG: I observed the rivalry thing with much amusement, because they were all of a larger whole. It wasn't, you know, Limp Bizkit versus the Strokes. It was Interpol! If you liked smart, stylish rock music, chances are you would probably like both of them. But yes, the perception of a rivalry existed, so that was amusing.

KAREN RUTTNER: I was still in college at the time and cool kids at Columbia were into the Strokes. I hated those kids, so I was kind of like, "Fuck the Strokes. I don't give a shit about that band, because those guys like them." I just—I wasn't into people that were alternative for the sake of being alternative. When the Strokes first arrived they struck me as a cultural identity band in a way that grossed me out. They were so "cool," you know?

SARAH LEWITINN: Gideon Yago would always go to 2A and hang out with the Strokes. I would always go to Lit and hang out with Interpol. The Strokes wrote pop songs, Interpol wrote—that shit's not gonna be on the radio.

JUSTINE D: Interpol used to come to Lit all the time, and the Strokes never went.

AUDREY NEUSTADTER: The very first show I went to in 2001 was to see Doves at Bowery Ballroom. I got there early to see the openers I

had read about in the *NME*. I don't specifically remember what I read, but I remembered the name and the buzz around them. The band was the Strokes. I didn't immediately fall in love. All the songs sounded the same to me, and they were much more raw than what I was into at the time, which was Doves, Elbow, Placebo, Starsailor, South. The very next show I went to that year was to see Arab Strap at the Bowery Ballroom, and sure enough, Interpol was the opener. They had a huge impact on me. They became my New York band.

KAREN RUTTNER: I just didn't care about the Strokes. I was an Interpol chick.

DANIEL KESSLER: It's hard to keep a band together when shit's not happening. Basically, you have to break up, or you have to be like, "No, we're really doing this." There's no reason to be doing it other than that you really want to. Later, you can have all this other crazy shit happen, but that foundation of no one caring stays in you. We kept going even though we were getting rejected by every single record label. Even Matador.

BRIAN LONG: Stylistically they were just so far away from what was considered cool. The eighties were not considered cool at that time.

ANDY GREENWALD: So the summer of '98, I interned at Matador and at *Spin*. But Nils Bernstein, who everyone knows and is a wonderful human being, he's the one who had rescued me from a pointless internship and gave me things to do. A couple years later, in 2001, he called me to come into the office, and he played me Interpol. He said, "Here is this band, we're thinking about signing them, and there's some people here who really think it wouldn't be a good fit." He played me the record, and I was like, "This is good." I had nothing to do with it. They were going to sign them. I don't mean to sound important. They wanted a band to go do coke with. They did. But the tastemakers there were split.

PAUL BANKS: Daniel had been sending demos. Matador had said, "Thanks, but no thanks." I remember saying, "Fuck them. Fuck them forever," because they didn't want us. Little known to me, Daniel just kept continuing to be in touch with them, in his level-

headed way. He was the one not taking it personally. If I had been running the band, we'd be nowhere—because fuck them—but he kept on.

DANIEL KESSLER: We sent the first two demos to Gerard at Matador and he politely said nice things but turned them down.

GERARD COSLOY: Daniel hounded me via e-mail off and on over an eighteen-month span and unlike a lot of folks who we turned down, he managed not to take it super personally. We established a rapport of sorts.

CHRIS LOMBARDI: Daniel's really, really persistent. He kept sending Gerard stuff. Later, they were opening for one of our bands, Arab Strap, and I went and saw that show at Bowery Ballroom. I went upstairs to check them out and Carlos had his armband on.

MARC SPITZ: Carlos was just pretentious, poncey, like, "What kind of high school drama class did you walk out of?" He was dressed like whoever played the bass for OMD in 1983, you know?

CHRIS LOMBARDI: I was thinking, "I'm not really sure what those guys are doing up there, but whatever they're doing, they have their thing pretty down pat. They're doing it well." I remember smiling about it. I probably watched two songs and then went back downstairs and had another drink, but it stuck with me.

SAM FOGARINO: We did a little UK tour, and while we were in England we also recorded a Peel Session. That was a priceless experience. I can still remember how I felt that day. It was all recorded and mixed in one day and we were listening to it and John Peel really captured what we were doing. It sounded like Interpol live. That's what really led to Chris Lombardi signing the band to Matador.

CHRIS LOMBARDI: I went to Europe, to my dad's house in France. I was driving around like a maniac through the mountains in this big fancy BMW and I put that record on. It was like, "Fuck."

DANIEL KESSLER: I think he liked it quite a bit.

CHRIS LOMBARDI: As soon as I got back to New York I called up the tour guy and I said, "Let's talk about Interpol." The four or five songs on the CD-R just had a vibe. I liked it. I think I said, "This

could either sell pretty well or this could sell really well. This could be a big deal." Then we brought them in.

GERARD COSLOY: It didn't hurt that we actually liked the demos. It was hard at that point to get a total handle on where Interpol were really coming from because there wasn't a ton of positive chitchat surrounding their early NYC appearances, at least not within our social circle.

JIM MERLIS: A friend of mine from college, his assistant was the lead singer of Interpol. Paul called me up and said, "Will you come check us out?" and I had a splitting headache the day I saw them. I thought they were terrible, but they might have been great. I was just in such a bad way. It was just post-Strokes.

GERARD COSLOY: But it was around the time Daniel sent a version that was awfully close to what would go on to be the commercially released version of "PDA" that we had our "Maybe these guys are for real" moment.

DANIEL KESSLER: When we got invited in for a meeting with Matador, that was big.

SAM FOGARINO: God, that was very awkward. Gerard was being very coy. I remember him saying, "We're not offering a deal, but I like you guys and I think a lot of labels are going to be coming up with some offers. You should be prepared." I remember thinking to myself, "What? You would have us sitting here in your office just to tell us that?" And then shortly thereafter there was a proposal, and then it was on.

GERARD COSLOY: We ended up offering them a super-cheap—by the standards of the day, anyway—deal, and went into planning discussions without ever having met or hung with them before. The first time I met Carlos was in the Matador elevator on the way upstairs to the first of those meetings. In retrospect, that was sort of insane, and not at all typical of how we did things at the time. We were jumping into bed, if you'll excuse the analogy, with a band we didn't really know as artists or people. Luckily for all sides, getting to know them was a lot more fun than we could've anticipated.

JIM MERLIS: I imagine they were wearing suits at that show I saw that I barely remember at the Bowery Ballroom.

PAUL BANKS: I haven't worn a suit in years. I don't really care. I wear a dress shirt. I'd like to wear a T-shirt, but that doesn't feel right. I take playing live seriously. Nowadays, I'd rather go to a photo shoot in a swimsuit, but onstage I still dress formally because that's what matters to me.

APRIL LONG: They wore suits. They did.

SARAH LEWITINN: God bless them, because they could've looked like accountants, but they looked awesome.

JASON BARON: We all had the same tailor: Paul and Carlos, and even Daniel. He was this dude Craig Robinson. He had a studio just above Union Square. Who went to him first? Carlos, of course.

APRIL LONG: They had huge sartorial influence. I have friends who were in Nottingham, in the midlands of England, when Interpol came out, and they told me that suddenly everybody wanted to go out wearing suits. Nottingham is not a town where people wear suits. After Interpol, everyone wanted a well-cut suit. They were some slick-looking guys.

CHRIS LOMBARDI: That's something that people didn't appreciate. People in those days dressed in ripped T-shirts and grungy—not in the musical way—they were wearing that punked-out vintage thrift store–y, ironic–T-shirt–type bullshit. Interpol dressed like rock stars. I mean, Carlos was this guy with a fucking armband on and hair greased in a certain way, wearing a fucking holster and smoking onstage, showing off his profile.

JENNY PENNY: Carlos and I went on vacation in Hawaii and had special shorts made for swimming.

BRIAN LONG: Carlos does know how to be a rock star.

JENNY PENNY: I remember he invited me to his thirtieth birthday party at Pianos, and it was Thomas Onorato at the door, and Justine DJed. She played "Fat Bottomed Girls" and everyone laughed. I thought it was the most hilarious thing ever. He likes curvy girls.

JASON BARON: Carlos and I were a good team. We'd go out; we liked to do the same things, stay out late at night, getting wasted, but he

liked bigger girls and I didn't. So it was a good combination. At whatever time in the morning, we wouldn't have any conflict.

HAR MAR SUPERSTAR: Going to Carlos's apartment, that was the other world. There would be, like, three chubby chicks and an analog telephone and a record player, no sign of a computer or cell phone.

NILS BERNSTEIN: They would just yell. If walls could talk in that apartment they would scream.

NICK MARC: We used to call him Kraftwerk Carlos.

CHRIS LOMBARDI: The pomp was just incredible. Before they were rock stars, Interpol looked like rock stars, so when they actually became rock stars . . . I mean, that's the thing about bands: they either have to be somebody you want to be or somebody you want to fuck.

PAUL BANKS: Lombardi is an epic dude. At that meeting, he was sitting there at the big table in their office. He'd probably been out all night partying with some other band and he was just sitting there in a custom button-down with his initials on the breast pocket, wearing a velour blazer and really nice pants, with the bottom shirt button open and his fat rolls hanging out.

SAM FOGARINO: Paul was like, "There's my mentor." They became fast friends. And the next thing I know, we're recording *Bright Lights* in Connecticut.

LA ZONA ROSA

NICK ZINNER: By the time we got to South by Southwest shit had just gotten super crazy.

DAVE SITEK: This was 2002, spring of 2002.

DAVID BURTON: They stole the show that year.

NICK ZINNER: Three weeks before that tour started, we'd managed to just crawl our way onto a Kill Rock Stars showcase, but by the time we arrived in Texas we had been moved onto this much bigger bill in this giant place, playing a prime spot. It was fucking packed with English people. That lone English guy from our first show at the Mercury Lounge, the guy who told us we should go play in England and we laughed? He'd turned into like three hundred English people.

DAVID BURTON: Somebody put them up at, like, the Grand Hyatt. They'd been taken out to dinner at the Four Seasons and a food fight erupted at the table.

KAREN O: It felt like an overthrow. We set out to conquer, with the invincibility of rebel youth times a hundred, fueled by tequila and really, really naughty prankster behavior. We were also fueled by all these people wanting to find us and woo us. The poor guy who ran La Zona Rosa, where we played, he probably hates us to this day. The first thing he told us when we got there was like, "Hey, you guys, you know, I hope you have a good show. Welcome! Just do me a favor, I put a lot of love into decorating these backstage rooms, make sure you don't . . ." He was basically just inviting us to destroy those rooms by saying that.

CHRISTIAN JOY: There was this English guy who wanted to manage the band and he kept buying frozen margaritas for Karen and me. We just fucked with that guy the entire night.

APRIL LONG: Christian Joy was the visionary behind all of Karen O's costumes. That's something to remember—the impact of all these bands on the fashion world was felt fairly quickly. Suddenly, everyone wanted to dress up, you know? The Strokes looked so cool, you wanted to look cool. The vintage leather jacket and the Converse became The Look. By the time you got Yeah Yeah Yeahs, I remember, right away, writing pieces about Karen O's influence on fashion. They were fairly instantaneous game-changers.

ASIF AHMED: I think they stayed with me partially because Karen liked that I got along with Christian. Christian was Karen's barometer for bullshit.

KAREN O: It never really occurred to me to pretty myself up, and one of the reasons for that is that I had a totally irreverent punk rock badass partner in crime in Christian. We're both pretty contrary. If people are into this trend, we want to do the other thing. That's ingrained in me and that's ingrained in her too.

ASIF AHMED: Christian Joy made that band. If Karen was dressed up like you or me on the fucking stage no one would look at her.

JOE LEVY: The Strokes were people who said, "Let's go out dressed every day as though it were a show day." Karen O said, "Let's have somebody make me an outfit for the show," and this is unusual. This is pretty fucking excellent.

KAREN O: She made some of the ugliest things I've ever seen, so ugly that sometimes it made me want to cry because I had to get into it and go onstage and perform in it. Sometimes it felt like a practical joke, you know? I wanted to cry.

CHRISTIAN JOY: We were both just starting out and ugliness just kind of happened. It definitely added to her performance because people would talk about Karen's art-project costumes, and that's essentially what they were. I mean, the first stuff was just hideously ugly. She rocked it and really made it something, though.

KAREN O: A lot of Christian's costumes are really impractical to wear.

My tit would pop out the side of it and I'd be trying to keep it up the whole time. It was kind of like our ongoing fighting and struggling with each other. It was the opposite of worrying about "Do I look pretty in that?" It was on a completely different planet from that kind of thinking.

APRIL LONG: As a female in the music industry I felt like, "Ugh, should I be wearing jeans and sneakers so that I can fit in with the boys?" I had been told, when I started at *NME*, by an older male journalist, "They're not going to know what to do with you, because you're a real girl who wears makeup and dresses." I felt in order to move in this world I'm going to have to defeminize myself. So to see Karen with her stuff out in her ripped stockings and her red lipstick and her overt sexuality was absolutely stunning. I think that's what people responded to. It wasn't just the fashion, it wasn't just the Christian Joy creations that were so cool, it was to see this woman owning her sexuality and owning the stage. It was her as much as it was what she wore.

KAREN O: That's the thing; every photo you'd see would be basically the most unattractive, ugly moment of every show, but it's pretty awesome that that's what they wanted to showcase. The real. The gritty, visceral, *bleh* real. That's what they wanted to show. Not everything looking immaculate and right. They actually wanted to showcase the punkest-looking shot of me they could find, which would always be the most unattractive.

CHRISTIAN JOY: The first dress I ever made her was called the "What's Eating Karen O Dress" and she called it the "Baby on a Bad Acid Trip Dress." She wore it onstage and she totally rocked it out. I remember standing in the audience at Bowery Ballroom just dying laughing. I think she was really drunk too. She probably had to be really drunk to wear it.

ASIF AHMED: Her personality onstage was inspired by the designs; she goes into another place. Karen is a very, very talented person but she never pushes her own limit by herself; it's always someone else pushing her.

KAREN O: It's a little bit sadomasochistic, things that happen between us, but that's what appeals to me. We're like brothers.

CHRISTIAN JOY: If we got into an argument, we would beat each other up. We would go back to a hotel just covered in dirt and mud and barefoot.

DAVID BURTON: So at La Zona Rosa it was Karen and Christian. Nick and Brian probably had squared off in a little corner just to be safe. I mean, it looked like somebody had staged the mess in their dressing room.

KAREN O: "Take good care of the rooms." Ha ha ha.

DAVID BURTON: Backstage at La Zona Rosa was about the size of a bathroom. Karen and Christian were wearing Clinic's masks.

ROB SHEFFIELD: Clinic used to wear gas masks as part of their stage gear.

CHRISTIAN JOY: Well at one point Karen decided that we should go next door and steal Clinic's masks. Things got pretty out of hand and we made a bit of a mess, grabbed the box of masks, and went back to Yeah Yeah Yeahs' room. I remember hearing a knock on the door and we tried to quickly hide the box of masks under a sofa cushion. The owner comes in and goes, "I told you girls if you wreck my room you're out of here." So we marched out, Karen as our proud leader, chanting, "We're Clinic!."

DAVE SITEK: And then Karen pushed Courtney Love and it was a whole thing.

KAREN O: I have no recollection of Courtney Love being there that night, though; that was a myth.

DAVID BURTON: Asif knew Courtney and introduced them. Karen's like, "Get out of my way you fucking b-i-t-c-h." That's all true.

CHRISTIAN JOY: I have no idea if she was there! All I remember is being hungover the next morning and Asif, always larger than life, coming in and saying, "Okay, which one of you pushed Courtney Love into the craft service table?"

DAVE SITEK: I don't know what was on her agenda, I just know that she was there and she was not on our list, and she just bullied her way backstage. As soon as the whole show was over, I put Karen, Brian, and Nick in a minivan and I was like, "Get them the fuck out of here . . . now!" I had to go do damage control, but I bailed

too, I bailed on my responsibilities. I was like, "I'm not going to go to the principal's office for this! I'm just going to get our merch money and get the fuck out."

KAREN O: I have no recollection of that. I mean, I never saw Courtney. I don't believe she was there but that's what people tell me. I absolutely do remember trashing the dressing room.

CHRISTIAN JOY: We were all caught up in the moment and trying to figure out what and how to do things as they happened.

NICK ZINNER: We were all pretty freaked out by the vultures descending. We were the "It" band, or whatever, and there was so much crazy hype. It felt good but it also felt super weird. Weirdo label people were calling me at home and on my cell phone. It was like, "How did you get this number?" Mistrust, defenses up. But I also recognized how fortunate we were to have this happen, because that shit never really does.

"THE $2 *BILL* SHOW . . . OOF"

JULIAN CASABLANCAS: It's a little bit of a blur, I've gotta be honest, that era.

GORDON RAPHAEL: The Strokes had toured for like a year and a half straight. They were at the pinnacle of how incredibly tight and powerful they would become.

HAR MAR SUPERSTAR: I was on that first big U.S. tour.

RYAN GENTLES: This would have been early 2002.

HAR MAR SUPERSTAR: It was me and Longwave. It was wild. There was the infamous San Diego night where Julian lost his voice and Steve Schiltz from Longwave had to sing the whole set.

STEVE SCHILTZ: People were up asking for their money back. I don't think he was fucked up at that show but I think he had partied the night before, or, you know, the month before, the whole month.

HAR MAR SUPERSTAR: Julian was so bummed; there's nothing worse than losing your voice on tour. He was in the front row high-fiving everyone; he at least gave it that. That night we went to Chad Smith from the Chili Peppers' house party. Julian was being an enfant terrible a little bit. That's kind of when I started behaving like his little bodyguard.

JIM MERLIS: Yeah, that tour got messy, to the point that Steve was doing sound checks for whatever band member wasn't showing up.

HAR MAR SUPERSTAR: Nobody was showing up for sound check.

JIM MERLIS: He told me terrible stories, of Albert in particular, really bad stuff. Steve was freaked out.

HAR MAR SUPERSTAR: Yeah. When you're a fashion icon and you just reinvigorated all of rock music, you're like, "Well, I guess I have to be that guy, Guns N' Roses party guy."

JIM MERLIS: Albert, who fell the furthest, I think, was initially the straightest of all of them.

HAR MAR SUPERSTAR: The U.S. leg of that tour started in San Diego and did the whole West Coast, the Midwest, and some East Coast stuff. Flights were like a hundred dollars, because nobody would get on an airplane after 9/11. It was one of those tours where everybody got weird almost-pneumonia and kept drinking right through the antibiotics. Everything was imploding with them on that tour, before we got to L.A. That's when everybody was getting really fucked up. Everybody. Everybody who's a totally sane person now was totally insane then, me included.

DAVE GOTTLIEB: Around the same time, Julian punched John Voigtmann, who worked at RCA's international division, at a French TV show, because he didn't want to perform in front of a live audience. That's real. That really happened.

JIM MERLIS: Yes, It did.

DAVE GOTTLIEB: John calls me and says, "I just got into a fucking argument with Julian and Ryan and they're saying they're not going to do this show." I'm like, "Are you fucking kidding me?" I call Ryan. It goes to voice mail. As I'm hanging up, John calls me back and says, "Julian just punched me in the face. He came back in the room, he said something to me, I told him something else, he turned to walk away and then turned back and just slugged me in the face. He broke my glasses. He's fucked up."

HAR MAR SUPERSTAR: I started with them in Orlando, that House of Blues in Disney World, with shrimp trays and everything. Then we went through the South, Mississippi and Texas; they went to Mexico City. We met again in Austin and kept going all the way to L.A., where they did that *$2 Bill* show.

JULIAN CASABLANCAS: The *$2 Bill* show . . . oof. People are saying that it was the beginning of the end. Oh, I don't . . . I don't want to get into that.

ALBERT HAMMOND JR.: That *$2 Bill* show was amazing! We did six songs live to television. There was just an excitement between Roman Coppola, who directed it, and the band.

FABRIZIO MORETTI: That was a moment of success for us, I felt. Because it was our idea and MTV bent to it—it was like this machine was bending to our will. And after it was done, I remember Julian got a phone call from Lauryn Hill, who congratulated him on the show. To me that was like, "*What*?!"

JULIAN CASABLANCAS: The whole idea behind it, from the intro credit to the light-up floor, the cameras, came from the Elvis special.

RYAN GENTLES: Roman Coppola had just done the "Last Nite" video and had a good working relationship with the band. Julian had seen this Elvis special, where he performs in the round, and it inspired him to do something similar, so we got MTV on board and it went from there.

HAR MAR SUPERSTAR: I remember my brother and I were in the front row and we got moved to be replaced with some teenage girls.

ALBERT HAMMOND JR.: We'd met Roman to do the "Last Nite" video, and Roman, like Gordon, was a great vehicle. His ideas and our ideas just gelled and we created stuff right away, whereas most people would be like, "You can't do it like that, it won't look like that."

JIM MERLIS: They played two shows in L.A. when they were in town shooting *$2 Bill*. That tour was when the famous people really started showing up.

DAVE GOTTLIEB: Courtney Love was at the Roxy show in the fall.

KELLY KILEY: Julian couldn't be bothered with famous people, whereas Nick was quite into it.

DAVE GOTTLIEB: People are saying Julian didn't care about celebrity? Oh, he cared. He absolutely cared. He loved the attention. He loved that Courtney Love was there and fawning over them.

HAR MAR SUPERSTAR: She wrote that weird "Julian, I'm a Bit Older Than You" song.

JIM MERLIS: Courtney brought Winona Ryder, right after she was caught shoplifting. It was like, "This is awesome." But Courtney

was lecturing Julian on "This is your *Bleach;* your next record has to be *Nevermind.*" She is always very entertaining. After she left, Julian was like, "She was really cool; that was awesome," and Nick says, "Julian, she wants something from us." She was still in the recording business, so she needed their coolness.

ALBERT HAMMOND JR.: It's not that it didn't register, famous people showing up backstage, but maybe at that point, I still felt like a younger kid; I just wanted to go and hang out. It was like, "I'll come and say hello, but I'm not going to sleep with you, you're not going to give me drugs, I'm going to go do something else." Basically, after a show, you're buzzed, so if you're not going to get laid, you're going to go somewhere else, do you know what I mean? If you have to talk to a lot of people who are just talking to you, you're like, "Uh-huh, uh-huh, who's that over there, uh-huh, I don't care . . ." If they said, "Lou Reed came to your show and wants to speak to you," I would sit down and gladly listen to him talk for hours, but Winona Ryder and Courtney Love? I'm like, "I hope they enjoyed the show." "There's a Victoria's Secret model, and she just wants to sleep with you, Albert." I'm not saying that happened, but that would be like, "All right, bring her in." But otherwise it's kind of awkward.

JIM MERLIS: I remember earlier, in the summer just before the album had come out, they played the Troubadour in L.A. You know about the after-party bar area upstairs? We were there, and Joe Strummer is there. I'm talking to Fab, and Joe Strummer taps him on the back and says, "Hey, great show, mate," and walked out, and Fab was like, "Cool, thanks, man." I was like, "You have no idea who that was, do you?" and he was like, "No, who was that?" and I said, "That was Joe Strummer!" And he was like, "Holy shit, he must think I'm the biggest dick," and I was like, "No, Fab, he thinks you're the coolest person in the world."

HAR MAR SUPERSTAR: In L.A., at that MTV thing, that's when Nick and Amanda de Cadenet were hooking up, too, that happened *that* night. Everyone was like, "That's weird, Amanda just took Nick." It was one of those things where everyone's like, "Is this a dubious situation?" and instead it turned out to be awesome.

RYAN GENTLES: I introduced all the Strokes to their wives, by the way.

They all come to the manager to meet the band. Nick and Amanda met at the MTV *$2* special. Amanda came up and said she wanted to meet Nick Valensi. I think she had put some pre-thought into that. She met him and a week later, they were together, never to be separated again.

NICK VALENSI: Amanda knew someone who was working that shoot, so that's where we met.

AMANDA DE CADENET: I looked at Nick and he was sitting down with his guitar in his lap. I looked at him and he looked at me and I had this moment of like, "If you don't turn around and run this is going to be a long haul with this one." It was really weird. I said, "Hey, do you want to go get some sushi?"

CATHERINE PIERCE: Albert told me, "Nick's in love! Her name is Amanda. She's this actress." It was all very exciting. We were all kids. I remember seeing Amanda going backstage, and she had on this white lace dress, and she looked like such a woman. I was like, "Wow. She's a real woman."

NICK VALENSI: That was a weird time for me, personally, not for the band. I had just come out of an episode. We were on a long, long tour, and I had, for a few weeks before that, started doing some drugs which I no longer do.

HAR MAR SUPERSTAR: I felt bad. I brought a couple of dudes . . . I was flying in a private plane for that tour, because my friend had a four-seater Cessna; it was to get miles so he could get his pilot's license. My ears were fucked, it wasn't pressurized, and we brought another friend who brought all this Klonopin. I was like, "Do not give it to the Strokes, whatever you do, please, I don't want to ruin this tour and be the guy who took it down." Of course, all of a sudden everyone's on Klonopin and having mind–freak-out meltdowns, jumping out of windows. I had to send that guy home. "Thanks for the plane, but get the fuck out of here, you did the one thing I told you not to do." I felt almost 100 percent responsible. Everyone was going to get the drugs anyway at some point, but just those particular ones really fucked with a few people's heads.

NICK VALENSI: It was pills. Mainly Klonopin. And I mixed that with a lot of other stuff. And it put me in a really, really bad place. I was

blacking out and being an asshole and not remembering being an asshole to my friends and being an asshole to everyone. Trashing hotel rooms and getting myself in a lot of trouble. I know it happened because I've been told and because I got the hotel bills in the mail.

HAR MAR SUPERSTAR: I think one of my favorite memories is we played Vegas, the House of Blues, and that show was really fun. After the show, it was one of the nights where everybody chilled out and went gambling together. It was, "Oh shit, these guys are high rolling on poker tables," and I had no idea but they were totally stone-faced poker guys. There were some weird meltdowns that night, later. But I don't want to get into that.

NICK VALENSI: One bill was from a hotel in Las Vegas. Seven thousand dollars. It was a bad time.

AMANDA DE CADENET: Nick was hanging on for dear life, emotionally.

HAR MAR SUPERSTAR: Everybody started pulling apart at the seams, just because everybody was going in their own weird direction, dealing with the craziness.

JIM MERLIS: That's when things started becoming less fun. I think it's probably the drugs, and all of a sudden these new people start coming into the fold, and it's very hard, when someone's saying how great you are, not to listen to them and not to believe it, and it was a combination of just exhaustion, drugs, and sycophants.

APRIL LONG: There was that feeling of "The Strokes, they're our band, they're the band of the New York indie kids." And then, "No, they're the band of the London indie kids." And then it became like, "No, now they're the world's band." They were no longer ours. And you always kind of bristle at that. When you find out Nick is dating Amanda de Cadenet, it's like, "What?! Wasn't she married to John Taylor?" That's one of those surreal moments when you realize, "Okay, they don't belong to just us anymore."

HAR MAR SUPERSTAR: And it all ended in L.A. at the *$2 Bill* show.

NICK VALENSI: I remember getting to L.A. and starting to feel . . . not a profound transition, but kind of a realization that you're not invincible, you can't do exactly whatever you want to do without

consequence. That was a time, for me, when I realized, "Okay, I can have fun, I can have my cake and eat it, too, if I'm more careful about it. I need to be a little more careful."

JULIAN CASABLANCAS: I mean, I've never really thought about it, but that show is probably symbolic in a lot of ways. People were kind of becoming superstars, and like, not remembering the goal of being a great band.

"MY NEW YORK IS INTERPOL"

PAUL BANKS: We recorded *Turn on the Bright Lights* at Tarquin Studios in Connecticut, with Peter Katis.

SAM FOGARINO: Peter and I had known each other for a couple years already. He had built this studio in the attic of his Fairfield mansion. We were going to all these studios that were really small and I just didn't feel it. I finally said, "My friend Peter has this mansion and a really good recording facility. We could probably get it done under budget." And it all worked out.

PAUL BANKS: The studio is a big, old . . . I don't know if you'd call it Victorian, a few-hundred-year-old house that was once a mental hospital for kids. The whole top floor is a studio. So you just come and live with Peter as a band and make your record.

SAM FOGARINO: We all had our own rooms and I did a lot of cooking for everybody. We'd take runs to the supermarket and smoke a lot of pot.

PAUL BANKS: I don't think I ever did drugs at Pete's house. Maybe just weed.

SAM FOGARINO: I cooked lots of pasta. I'm of Sicilian blood, so if I can't do that I get a demerit.

PAUL BANKS: Carlos didn't want to be out of the city.

SAM FOGARINO: Peter soon came up with a very simple phrase: "Shut the fuck up, Carlos." Everybody took it in good stride, even Carlos himself.

PAUL BANKS: That wasn't because he hated nature. Carlos would go camping before he was a city guy. He had dreadlocks and was

kind of hippie, but his social life was very important to him. He didn't want to miss out on his social life. So it was more like "Can I bring this girl to the studio, then, if we're going to stay the night?" or "Can I go back to the city and come back tomorrow for the session?" And he did, he brought girls. He had his cake and ate it too.

SAM FOGARINO: Did we need to get the hell out of the city? Yeah, totally. In the city there were too many distractions. Everything would have been in close range, be it alcohol or cocaine or girls.

DANIEL KESSLER: Most of the songs that are on the demos ended up on the first record.

SAM FOGARINO: Daniel was fretting over how long things were taking because that's what he did and that's what he does. And there was a couple creative arguments, but nothing out of the norm.

PAUL BANKS: I was a big fan of the music we were doing, felt like that couldn't be fucked with, but I had my issues with my vocals. The first time we ever did a demo I said to Carlos, "Dude, I feel like I should sing 'PDA' an octave up because my voice sounds fucking weird." I don't identify my voice as being that bass-y. That baritone that I'm known for? It was "Where the fuck did that come from?" I was not a fucking singer at all when the band started. I wanted to emulate how we sounded in the rehearsal spaces, but when you get into a good studio and it's like a fucking spit guard and a five-thousand-dollar microphone, it's pristinely clear. So when we did that record, I was just drunk a lot. I was on scotch, because it was wintertime. If it was summer it would have been vodka.

SAM FOGARINO: He was just insecure about his voice. Nobody else felt that way.

PAUL BANKS: One thing that pissed the band off was when we did "Obstacle 2," the "I'm gonna pull you in close" line, I did something that's totally unconventional. We recorded my vocal with distortion on. Whereas, like, every other producer for every other song ever, it's like, "Just sing it clean, so we can have options, and

then I'll put distortion on." I said, "No. No one should ever hear it that way. Print the distortion on my vocal, and this is the vocal take." Later, when they heard the vocal, Carlos said, "Can you turn the distortion down?" And Peter told them, "Nah, there is no turning the distortion down. That's the vocal." Carlos was pissed.

SAM FOGARINO: Paul has this thing, going back to how he would describe the most simplistic drumbeats in a very complicated and detailed way—that's how Paul operates. It doesn't matter if he's not speaking the language; he doesn't care. What he wants to get done has to get done. He knew what was right, even if there was a little bit of a lack of confidence; aesthetically he knew what he was going for and he was dead-on. A lot of people would give in if they couldn't explain themselves, but he refused. It was like, "I don't care if you don't understand me. This is how I want it done. Figure out a way to understand me." So at that point the record was done and three songs that would end up on the next album, *Antics,* were already written. We recorded *Bright Lights* and finished it and it was mixed, and we had some downtime before we started really doing anything. And I remember Daniel saying that we really need to seize this downtime because as soon as we start hitting the road it's going to be that typical thing: you have your whole life to write that first record and six months to write the next. So we took that energy from being in the studio and recording this record and went right back into the rehearsal space. Then we went on the road for a year and a half.

DANIEL KESSLER: All I ever wanted to do was make a record. When we started doing our first tour and selling out, I wasn't even shocked as much as it was happening too fast. It was nothing I expected or thought would happen or even hoped would happen; my dream had already happened, in a way.

SARAH LEWITINN: I remember, one time, when, like, Interpol's first album came out, their manager, Brandon, came over with a friend. We were just doing tons of cocaine and listening to the Interpol album. Brandon was so in love with the band and couldn't believe what a wordsmith Paul Banks was. I remember him just feeling

this sense of pride for Paul about this one line, "Don't waste wine when there's words to sell . . ." We were on the roof of the building, looking out at New York, talking about how gorgeous the album was. This was before the development of the Lower East Side. The Lower East Side was still short. It literally had not grown up yet. And the sun was coming up. It was just the perfect New York album. My New York is Interpol.

"WE SUCCESSFULLY MANAGED TO MAKE OUR

BUSINESS 100 PERCENT IMPRACTICAL"

ROB SHEFFIELD: I'd heard of DFA but I didn't focus on it as a brand-slash-trademark-slash-name until the "House of Jealous Lovers" single.

BRIAN LONG: I remember hearing the first Rapture record on Sub Pop and that was interesting, but it was also really angular and rough. Then the DFA guys got ahold of it.

TIM GOLDSWORTHY: At that point Luke was in his full Robert Smith phase. Dark black hair-sprayed, back-combed hair. I started playing them classic old dance music.

LUKE JENNER: What is true is that Tim was very into dance music. Tim knew a shitload. I read a quote once where he said, "It's really great working with the Rapture because they really knew a lot about music and they were equally into T. Rex as well as really legitimate, classic house music." We were. And he felt the same way. We would go to the DFA offices, just me, James and Tim and Vito. That was it. There was nobody else for years. I'm the last person who got to spend two or three years with James Murphy with undivided attention. Like, his wife doesn't get to see him that much. We would just sit there, high-five each other, like, "This is going to fucking be huge."

VITO ROCCOFORTE: We started really getting into dance music. It's hard to imagine now, but back then things were really stratified and really broken up into these small worlds that didn't cross over. The

idea of indie rock and dance music blending was a really strange thing. Now every indie rock band does it. But then, no one did.

TIM GOLDSWORTHY: With the money that Tyler was giving us we bought all those machines that made all those records we all loved. "This is how they made this sound and we can put it on your record." But it took a bit of fighting because it was new.

JAMES MURPHY: The Rapture were really freaked out about the production. They thought there was way too much production.

DOMINIQUE KEEGAN: A huge part of it was the way James and Tim engineered the drums. They were like, "Instead of putting guitars in the foreground we're going to turn the kick up and the hi-hat and tune the drums so they sound like a disco kit."

LUKE JENNER: We butted heads. I had all these ideas in the studio, and he had all these ideas, but James had a stronger personality than I did. I couldn't bulldoze him. I could bulldoze everybody in my life, but not him.

JAMES MURPHY: We made a quick demo and talked a lot about how we were going to take over the world. Like, why not? "What's this fucking indie rock thing you make in your house? Fuck that! We have a world-class studio. Luke, you're going to be singing and sometimes I'm going to run in and tackle you and you won't know what's coming."

VITO ROCCOFORTE: We had never even been in a proper studio so we were like, "This is awesome."

LUKE JENNER: I didn't want to put out "House of Jealous Lovers" because the delay wasn't right on the guitar, and James was like, "We're not fixing it. This is it." I was like, "No, we have to fix it." He was like, "No. It's done." James is pretty bold. He's the boldest human I've ever met. DFA was the cult of James.

JEN GOLDSWORTHY: Oh completely, it's like Scientology.

LUKE JENNER: The cult of James is, James tells everybody what to like and everyone does it. He tells you what kind of car to buy. I mean, we all went to the same therapist! Everyone got their hair cut at the same place! I was actually very rebellious, I didn't get my hair cut at that place.

TYLER BRODIE: Do you know about the therapist? I never met him, I don't even know his name, but I do know LCD's "Someone Great" was later written about him.

TIM GOLDSWORTHY: That's not about a love affair. That was written the day that James's therapist died.

LUKE JENNER: The only places you were allowed to go were DFA and Plant Bar and that place to get your hair cut or the therapist. Those were the allowed places. DFA is still like that. James is just, "This is the kind of bass guitar that everyone plays," and like, "Here's how you mic a drum." James was terrifying to me because I was the alpha male in most situations, but not with him.

ROB SHEFFIELD: We were all just wondering why that Rapture album isn't coming out. It's so funny, bands and their producers. The whole story of Joy Division and Martin Hannett, Nirvana and Butch Vig—it's like, "Why are you here? Oh yeah, you're giving me the sound that everybody else wants, the sound that everybody will be imitating three months from now."

JAMES MURPHY: We made "House of Jealous Lovers" and for a year it sat on the shelf. The band was uncomfortable. We were telling them, "Leave the nest, leave Gravity Records, leave indie rock. Let's go compete with Radiohead and Blur!" I don't know what they were going through, obviously their own psychic nightmare.

VITO ROCCOFORTE: We were trying to make a house record with what we had as a live band. That was "House of Jealous Lovers," but after we recorded it, we weren't sure about it. We sat on the record for a year.

TIM GOLDSWORTHY: Meanwhile, we went to South by Southwest, which was awesome.

JAMES MURPHY: That was a watershed moment.

TYLER BRODIE: I was down there at the film festival with *The Ballad of Ramblin' Jack*. This was back when they did both film and music at the same time. We all went and the Rapture played.

JAMES MURPHY: Tyler was there for film, so we went to some crazy film party where people were putting out baguettes of cocaine.

TIM GOLDSWORTHY: We had done a session with somebody the night

before and I said to James, "Instead of going to bed for four hours, let's just do lots of cocaine!" So we do. James orders us a car to the airport. On the way, we realize that of course everybody in the music scene in New York would be on that plane, so in the limo I'm just freaking out and I decide I need to come down. I take a downer. For whatever reason, I'd ordered a he-man breakfast that I'm obviously not going to eat. I'm just carrying it around in my hands and it's leaking everywhere and of course that's when the downers start kicking in. We get on the plane early and by that point I'm just like Stephen Hawking with this fried breakfast all over me, just coked out and on downers just going, "hdfsdklfjdls." Then, one by one, everyone who's anyone in the music scene starts walking past us, boarding the plane. At that point we probably made an impression.

JAMES MURPHY: We flew there, didn't sleep. Took a lot of quaaludes and a lot of cocaine.

TIM GOLDSWORTHY: We land in Austin and luckily we sober up by that point or I would have a terrible tattoo. We go to the Sub Pop showcase.

JAMES MURPHY: The Rapture were first on the bill, then there was a bunch of mediocre forgettable shit. If a gun was put to people's heads they'd never remember who was playing after them.

TIM GOLDSWORTHY: We're drinking Lone Star beer and James is like, "You have to keep up with me." We find the head of Sub Pop and corner him.

JAMES MURPHY: Jon Poneman. I attacked him.

TIM GOLDSWORTHY: We just start in on him about the Rapture, like, "This is the best band you've got here, you fucking idiots! This is brilliant, blah blah blah blah."

TYLER BRODIE: The Rapture were still signed to Sub Pop at this point.

JONATHAN GALKIN: We were basically paying for the Rapture's recording ourselves.

JAMES MURPHY: We are hitting him up for drinks, which was meaningless because we were already on a lot of drugs. He was humoring me at first, getting me drink tickets, but then I was too fucked

up. I'm kind of shouting, "Why are they first! You don't believe in them! This is the best band you have! There's no one near them." And he was like, "Okay, buddy."

JONATHAN GALKIN: The quick way to sort of break it down is, with the one release that did come out on Sub Pop, the EP, those tracks were more faithful to the old Rapture sounds. And given James and Tim's way, and more time, "Out of the Races and onto the Tracks" would have been another twelve-inch like "House of Jealous Lovers." It's a very similar vibe.

TIM GOLDSWORTHY: I'm thinking that we're doing the Rapture a huge favor. Then, the next week, Sub Pop is like, "Well, we can't put this record out. This is horrible dance music." They asked for four of the demos, decided to put those out and then drop the Rapture. So *Out of the Races and onto the Tracks* came out.

JAMES MURPHY: That was the Sub Pop EP.

VITO ROCCOFORTE: We had a two-album deal but Sub Pop let us off after that EP. They were totally cool about it, actually. Jonathan Poneman was a stand-up dude. In hindsight, you know, we were kind of young and thought we deserved everything. But yeah, they let us off, and then we started recording at DFA.

JAMES MURPHY: We got them out of the deal, but I wanted to kill Luke because he gave them "Out of the Races and onto the Tracks" for that EP, which, in my mind, was the second Rapture twelve-inch. "House of Jealous Lovers" was the perfect first twelve, and that was the second one. A monster follow-up.

TYLER BRODIE: With Tim in the picture, James had finally become confident enough to do the label for real.

JAMES MURPHY: Tim was cool. It was the guy in the movie that nobody likes and then the prettiest girl in school goes out with him and now the world was his oyster. Tim just gave me confidence. I went out all the time and yelled at people and dived off the bar. I was never mean or cocky. I was having fun. It was so easy to be the most fun guy at the party now. After Tim, suddenly it became the late sixties and seventies for me: "I'm going to do tons of drugs and say crazy shit and I'm going to be in the movie."

TIM GOLDSWORTHY: We spent about half a year finishing that Rapture record. In the meantime James started LCD Soundsystem with Pat and we got in touch with Juan, who was looking after troubled kids in New England or something.

MARCUS LAMBKIN: Juan was teaching fucked-up kids, kids with troubles.

JUAN MACLEAN: Everything had become so fascistic in what was once a deviant culture that it was actually the opposite of what I was interested in. I quit Six Finger Satellite and I thought, "I never want to have anything to do with music ever again. I don't even want to listen to music anymore." I was just so disappointed and bored with it.

TIM GOLDSWORTHY: He was in a bad marriage and was just in a bad place. So we told him to come to New York for a while. Have fun again. Start making music.

JUAN MACLEAN: Tim Goldsworthy largely taught me electronic music programming. I would come to New York and sit with him and he would show me how to do it. It was pretty difficult back then. Then one day James and Tim bought me a sampler at a pawnshop. I had a couple of synths and a computer. Tim gave me a bunch of software, and I just went home and started making music. I would send James and Tim CDs because the Internet wasn't fast enough back then. You couldn't e-mail music back and forth, so I would send them CDs of tracks I was making, and eventually they picked out the two best ones and told me to come work on them in the studio and that's how I made my first twelve-inch.

MARCUS LAMBKIN: Studios were terrifying to me. I was a carpenter and a DJ. But when the Propellerhead software came out it was like, "Oh my god, look, you can make dance tracks all in your laptop?!" We started smoking tons of pot and noodling around for fucking months on end, basically getting nowhere. Of course James was like, "Stop fucking around on the computer!" He gave me a 909 [drum machine], said, "Hey, go home and play with that." He got me off the computer and really interested in making music properly. He's very good at that sort of thing.

JAMES MURPHY: I have a thing I call "school assignments." The anxiety of making music is so intense, so I say, "Okay, you are allowed to use one drum machine. No samples." That kind of thing.

MARCUS LAMBKIN: It was Tim too. He was like, "I'm not going to sit here and make hits for you. You need to fucking learn how to do it, you know?"

DOMINIQUE KEEGAN: Marcus's name, "Shit Robot," was something James made up. James and his nine-year-old brain. I think "DFA" and "LCD Soundsystem" he made up when he was like nine also.

JAMES MURPHY: I like naming stuff. I named Shit Robot. I named DFA. I create shells.

JUAN MACLEAN: With DFA in the beginning we were making this very dumb kind of electronic music. I'll stand by it as about as dumb as you could get. That was something that James and I actually valued at the time, being dumb in a way that was kind of a fuck-you to everything that was going on in electronic music and also in the indie rock world.

JAMES MURPHY: Have you ever seen our business cards? There's no information on them. Just two hands shaking and then it says, "Fuck off, you cunt." There's no phone number, no e-mail address, no website. The lightning bolt was a doodle. We made the art and took pictures. Everything was handmade. It's personal. What I always wanted, the ultimate goal, was if the fourteen-year-old me found DFA, he'd be like, "This is crazy!"

WARREN FISCHER: What DFA did with the Rapture, and then with their broader brand—they took the punk rock roughness and applied it to dance music. It was connected to New York new wave but never really abandoned the punk rock side of it. And visually, all their stuff always had this crudeness to it, where they're adopting the zine culture. It was amateurism and that punk self-determination thing.

JONATHAN GALKIN: We successfully managed to make our business 100 percent impractical.

40

"WE GOT AWAY WITH MURDER"

ASIF AHMED: It took Yeah Yeah Yeahs a year to sign. We almost signed with Warner but then we did a meeting with Seymour Stein and he fell asleep in the goddamn dinner meeting we had later that month! And then Karen said something, totally innocently, about him falling asleep in the dinner meeting and it got printed in *New York* magazine.

MARC SPITZ: I saw Seymour Stein asleep at a Hives show at the *Spin* party at South by Southwest one year. I thought, "This is the best live band in the world and he's sawing wood?"

ASIF AHMED: Everyone knows about the sleeping thing, but you don't talk about it!

MARC SPITZ: There were people watching him sleep instead of watching the band. But he put out the Smiths in America, so, you know, he gets a pass.

ASIF AHMED: Every label Yeah Yeah Yeahs met with told them to get rid of me, but none of the labels factored in that Karen would tell me this every five minutes.

SUROOSH ALVI: They had a fucking lunatic manager. It was one of these things where you've been a manager for a long time and all of a sudden you have a band that everyone wants. You can be cool about it or you can be a fucking lunatic, and he was basically telling all the label bosses to fuck off. It was bad. Craig at Atlantic really wanted Yeah Yeah Yeahs and their manager is throwing drinks in his face calling him a major-label corporate evil piece of shit.

ASIF AHMED: I was kind of a loose cannon. I was like Mel Gibson in *Lethal Weapon* but darker and less talented and handsome.

KAREN O: Our management has always been really protective, effective as a buffer. We've heard the horror stories but they just sound like horror stories. It's hard to relate to them because we've been pretty protected from that.

ASIF AHMED: The deal that we did was respectable. It wasn't millions of dollars. I wanted them to recoup, because I also knew that if they were going to get a million and a half or three million dollars, they'd stop working. No one would work. EMI offered them a million five after that fucking EP came out and I'm like, "They have nine songs! They're not worth it!" I remember being in Brighton, loading in the truck, when Brian's father called me and said, "What the fuck is going on? You're turning down a million five?!" I'm like, "I'm doing this for a reason! If I take a million five, the label is going to own the catalog for the rest of the band's lives."

NICK ZINNER: From the beginning we set it up so that we wouldn't have any interference from the record label world, managerial world, a lot of those things which a lot of bands have. They're constantly having people fuck with their sound or style or image or songs. But we kind of set it up from day one not to ever have to deal with that.

ASIF AHMED: They were adamant about staying on Touch and Go and Wichita, where they'd done their EPs. The band didn't even want a major-label logo on the fucking CD case.

SUROOSH ALVI: There was still an aversion to majors at that time.

ASIF AHMED: Every band cares about image. If you find one that says they don't, they're fucking lying. Some bands want that legacy to say, "We were good enough to be signed to a major." But Yeah Yeah Yeahs didn't care. The indie thing was important to them because of the lack of pressure. They knew they were good; Karen knew she was good, she just didn't want to say it. No one wanted to say it because that's when the kind of weird postmodernist, pre-Pitchfork era of "whatevs" kicked in. It's cooler to be, "Meh."

KIM GORDON: When Yeah Yeah Yeahs signed, Karen asked me about Interscope. At that point we were so over the major-label thing. We were like, "You can do it if you want, if that's what you want.

What do you want?" A lot of people who want major-label deals don't realize how much work is involved. They expect you to work a lot.

NICK ZINNER: I remember Karen saying we are serious people in an unserious band. I try to stand by that, to not get too precious about things, to not have every little decision be the end-all and be-all of your entire personality.

ASIF AHMED: The turning point was when then they get their first royalty statement back from Wichita: thirty-two dollars. I called them, and I was laughing so hard. They were like, "Why are you laughing?" I'm like, "It's for thirty-two dollars!!!" They started laughing, too. Karen was like, "Okay, we'll call you back." Maybe two hours later she called me. She wasn't laughing at this point. "All right. We're going to do the major."

KAREN O: When we signed the deal to Interscope I was just thinking, "Out of all the majors, we choose the one that has Marilyn Manson, Eminem, and Dr. Dre."

ASIF AHMED: They liked Interscope because Interscope was the most flexible. I didn't like Jimmy Iovine too much—I still don't like Jimmy Iovine too much—but I respected him.

NICK ZINNER: We went with Interscope because they were like, "We like what you're doing fine, we wouldn't want to touch a thing." We were like, "We want that in writing."

ASIF AHMED: Nick was really, really guarded for the first year; he didn't let me do anything. Understandably. He's got friends that were in the same boat as he, the fresh new band, and then got fucked.

KAREN O: I remember thinking they were a little bit more confrontational as a major label.

NICK ZINNER: At the very beginning we wanted to reach kids, teenagers. That is the time when music is the thing that you identify with and identifies you and shapes your soul and your future self.

KAREN O: The most basic thing that I wanted was to break out of the sort of indie bubble and be able to reach more people, instead of being stuck in the indie world. All that changed later—Adele's on an indie label, XL—but at the time, it was like, either you stay at

the indies and you never really break out or you make the leap and try to get the word out.

NICK ZINNER: It was about creative freedom, about being able to, at least at the time, work on other projects and have that not be a big deal.

KAREN O: We wanted to give back from what we took. I wanted to see if we could broaden our audience. I can't even remember how the money thing came into play. Our management kind of took the lead on that.

NICK ZINNER: We got away with murder.

ROB SHEFFIELD: Labor Day weekend 2002 there was an all-day festival under the Williamsburg Bridge, in the parking lot. It was a Todd P show. Yeah Yeah Yeahs headlined. The Liars played. The Rogers Sisters. It was an all-day thing, and it was the kind of thing where people were climbing on nearby buildings and jumping on cars to get a look. This is when people still complained about coming out to Brooklyn. It was exciting that this was happening and so many of my bands were playing at the same time. It was Labor Day so the trains weren't running that often, so anybody who was there walked there. I remember being really excited and hoping there would be some other fans there. Yeah Yeah Yeahs went on last and they were the best. I'd seen them before, but it was the best I had seen them at that point. They played "Our Time," and everyone is singing "Our Time," and it really did feel like our time. It was this parking lot full of people that the song was for.

DAVE SITEK: New York had literally blown up and Karen's singing, "It's the year to be hated." That was like that most potent statement ever and it came from a band playing punk songs for kids. You had all these other high, intellectual-minded people not addressing it at all. And we were just like, "Whoa, Karen distilled it to like its most essential element and made it a pop song, and who thought that was going to fucking happen?"

ROB SHEFFIELD: It would have seemed really weird to think that people were going to start caring about that song all over the world.

"HOUSE OF JEALOUS LOVERS"

JAMES MURPHY: Luke was going to be my rock star. And then he bailed.

LUKE JENNER: James abandoned me. It was really hard for me to get over James being an artist because he was supposed to take care of me, and James didn't want to take care of me. The same thing I needed in my wife, I needed in James. But James needed to go be James.

DOMINIQUE KEEGAN: Basically, "House of Jealous Lovers" happened and that springboarded everything else.

LUKE JENNER: The classic-rock thing was all about the album. To make the definitive statement, like *Blonde on Blonde*. Rock is an album genre. A lot of post-punk is about "This entire record sucks, and maybe your entire career sucks, but you have this one awesome song."

ANDY GREENWALD: That one awesome song finally came out in the spring of 2002.

ROB SHEFFIELD: It was dance music that attracted a rock audience. The way it combined those two things was really startling.

JASON GORDON: It took forever to come out as a proper single, which was frustrating as they had been playing it live—along with a few other tracks from *Echoes*—for more than a year. But it was so good. I'd even gotten ahold of a copy of "House of Jealous Lovers" that had a different and longer intro than the studio LP version. I'd spin that bootleg version and it always got a massive response. People would freak the fuck out.

ROB SHEFFIELD: That was the song that everybody liked, and it was funny because it was hard to find in New York for a long time, back when records were objects and they sold out. Every copy in New York was sold out and every listener wanted to hear it. It was punk rock that's not pretentious and dance music that's not pretentious and, like, not like compromising on either end. It's very aggressive on both fronts. That song was such a total soundtrack to that entire year.

MARK RONSON: As a DJ, I had to go and buy that twelve-inch the minute I heard it.

LUKE JENNER: "House of Jealous Lovers" is DFA record number one. They got Morgan Geist to remix it because he was a legitimate house music guy, and they were like, "If we get this guy to remix our song, dance music stores will carry this record." They're smart.

JAMES MURPHY: The Rapture were the coolest band on the planet for a couple of years. The most dangerous.

THOMAS ONORATO: So tight, so talented; they all could sing. And you could dance to the whole show. They are one of the best live bands I ever saw.

LUKE JENNER: My first fear when "House of Jealous Lovers" was successful was that it was going to go away. I would just lay awake in a cold sweat for a year, just thinking, "It's gonna fucking disappear. It's gonna be over." And obviously at some point it didn't, and I started making money.

DOMINIQUE KEEGAN: That twelve-inch did really well. Launched DFA, really. And the British press, like always, was waiting for the next big thing so they jumped on it big-time.

LUKE JENNER: I knew from watching *Don't Look Back* and every episode of *Behind the Music* and reading every rock book that that's how you get famous. You go to England. That's part of the paradigm. So I was obsessed with that. When we were talking to Sub Pop I was like, "You need to get me to fucking England!" They were like, "You need to tour the U.S.!" We would just sit there at DFA and they had *i-D* magazine and it had this two-page spread on post-punk and it had all these New York bands and they were

like, "People are gonna be stoked on you, you actually get to go to England." That was the plan, make "House of Jealous Lovers," go to England, which worked, by the way. Andy Weatherall played it, who's like this really important guy in England, and we all watched that on the Internet in the DFA offices and we were just like, "We fucking did it! We did it!"

SIMON REYNOLDS: Andy Weatherall is key. He had been through post-punk, had been through lots of scenes, and then he became a DJ and a producer and worked with Primal Scream. He was a sort of gateway figure for this rock-indie side of things, and the dance thing. He was one of the people who paved the way for DFA.

LUKE JENNER: Now people think of us as a Brooklyn band but for a long time people thought we were English.

DOMINIQUE KEEGAN: The Rapture just went for it, and it was deserved. That song was such a breath of fresh air in what was such a stale dance music scene. House music had become really boring.

LUKE JENNER: "House of Jealous Lovers" not only galvanized indie rock but it totally galvanized dance music. Straight up! I mean real dance music. I met Felix da Housecat, an old-school dance music guy, and he came into Plant Bar at four A.M. with a George Clinton–style crew of ten weirdos, all pretty drunk, and said to me, "Are you the kid who made 'House of Jealous Lovers'?" And I told him I was. I was still working the bar, and he looked and me and said, "You're never gonna have to work again. You're set for life. That song is awesome, good job."

TYLER BRODIE: *Out of the Races and onto the Tracks* had gotten them out of the Sub Pop deal. And James and Tim were recording their first record, *Echoes*, but it took a while. And they weren't formally signed to DFA yet.

JONATHAN GALKIN: Tyler has a weird side because he was the guy who would just get in the van with the Rapture and just fucking disappear for two months. He would go to France and he would lose his shoes and walk around with no shoes.

TYLER BRODIE: It was great! Basically, they knew I filmed stuff, and we got along great and we were good friends. They asked me to come

on tour and film and then I just stayed for a while. We started in like a $200 van that would break down all the time, sleeping in very confusing situations—asking if anyone had a place we could stay at the end of the show. The worst was Washington, DC, in the middle of the summer and there was only one air-conditioned room. I was in the vestibule where every time someone opened the door it hit me in the head. Even later, when I would spring for hotel rooms, I always got stuck sharing with Luke, and Luke snored really bad. This was all before cell phones. I got the first cell phone for the band and we used it for years. Ten years later that cell phone would get calls for the Rapture—"Hey, Luke needs to be in a movie, can you get a message to him for us?" We became really good friends. But then it slowly evolved and they got managers.

TIM GOLDSWORTHY: That's when the Rapture got Asif as their manager. So the Rapture went from living in a van to seeing the people getting signed for millions and realizing that they have probably a better LP than anybody around.

ASIF AHMED: I had them, Liars, Yeah Yeah Yeahs, TV on the Radio, the Prosaics . . . I had a lot of bands. At the same time. And I was going crazy.

JAMES MURPHY: Asif. Yes, I wanted to break his jaw.

SUROOSH ALVI: Asif wanted to ruin everyone else and then he ruined himself. That was a whole other thing.

JAMES MURPHY: He was a know-it-all. And he didn't know what he was talking about. Asif was the deal maker.

ASIF AHMED: James considered me public enemy number one; he thought I poisoned the well against him. And the thing is, I didn't do any of that. I remember having meetings with him, talking about his childhood, whatever—we actually got along really well. I said, "What would it take to make this a more agreeable situation for one and all?" Because he was definitely a very ego-driven, ambitious person. I mean, mind you, Luke was a very ambitious person too, Matty was incredibly ambitious. But what's-his-nuts, James Murphy was very, he was, like, king HNIC. No one is fucking with him.

TYLER BRODIE: The conflict was over the *Echoes* album.

JAMES MURPHY: The plan was they would have stayed with us. EMI wanted to make a deal with DFA. I wanted to protect them, so I wanted them to go with us to EMI.

TIM GOLDSWORTHY: We were getting the deal with EMI together and we could have taken the Rapture with us to EMI, but they didn't want to come.

JONATHAN GALKIN: It was around this time that David Holmes actually came back around because he had started his own record label in England. This was after we put out "House of Jealous Lovers." He showed his face, and it was with the intention of hearing this new music we had been working on, so maybe his new label being funded by Universal UK could sign it. There was a very dramatic day here, with James hiding the tapes. This is the only time James has almost hit me. I said, "Everything is fine, David Holmes is not going to sign the Rapture. I'm telling you, it will never happen. I would never let that happen. We've come too far." Because this is when, like, there were starting to be little bidding-war-type things.

ASIF AHMED: The record was already in the can, and there was just this concurrent initiative to sign the label up to a bigger-distribution kind of imprint, with EMI. And then we were talking to Universal. I was talking to Mercury. James hated Richard O'Donovan and hated Gary Gersh. I remember this super-fucking-fancy label dinner with Lucian Grainge, Lyor Cohen, and Gary Gersh. I mean, it was, like, everybody. This whole thing was all purely about money.

TYLER BRODIE: When I was out on tour with the Rapture, they were not really signed to us yet. I didn't know that but the worst part was they didn't know I had anything to do with DFA. We toured for a while, and one day, we're really trying to finally sign them, and James and Tim are like, "You've got to come into the lawyers' office with us to convince them, because you're such great friends with them." So I do. And it was just the lawyers battling and it was terrible. I didn't really say much. The next day, we go back on the road, we went to Massachusetts, and the band asks, "What were

you doing in the lawyer meeting yesterday?" And I said, "What do you mean? I own part of the company." I mean, they would talk shit about what James and Tim were trying to do, or about how the negotiations were going, but I just assumed they trusted me enough not to say anything.

JONATHAN GALKIN: They never even asked who Tyler was, which is so perfect. He was just some guy from the building that they knew. That really sums it up. No one is asking questions in the room. Tyler was the guy paying all the bills!

TYLER BRODIE: I still wanted them on the label. That was probably the only time I really put my foot down. I mean, I'd been on the road with them for a year.

VITO ROCCOFORTE: The idea was we were going to be on DFA. That was what we wanted to do and then, you know, all of a sudden we weren't going to be.

ASIF AHMED: It was a world deal with Universal, out of the UK. Because they had to override James Murphy, the Rapture had to buy out the masters from James. Not to sell state secrets, but it was a pretty healthy deal.

VITO ROCCOFORTE: We had a falling-out with DFA over the signing to a major label. We wanted to sign with them. We kept getting these crazy offers and we were split as a band internally on what we wanted to do.

ASIF AHMED: Vito and Gabe, and I think Matty, all wanted to stay with DFA. Well, Matty wanted just the opposite of whatever Luke wanted. Like if Luke said, I think we should all have falafels. Matty's like, I'm never eating Middle Eastern again. They would just be contrarians for the sake of being contrarians. To my memory, it seemed as though everybody but Luke wanted to stay. I think Luke wanted to go because he wanted money. He said that since he wasn't getting along with people, he might as well make money.

VITO ROCCOFORTE: Everything took off so quickly; there was no distribution deal and we were sitting on this album, *Echoes*, with all this crazy amount of hype over "House of Jealous Lovers." We had

every major label taking us out, putting us up in hotels, buying us dinners that cost more than my rent. It was right at the end of the era when labels would do that. They saw the writing on the wall but they were still spending money like they did in their heyday. Everybody wanted to be sure they didn't miss out on the next Strokes, but if you really took a step away, it's like, "Really?" I really like *Echoes,* but we were a pretty raw band.

JAMES MURPHY: I was worried about them psychologically, and about them getting screwed and people talking in their ears. We met all these labels and I fucking hated the Mercury people and got into this tearful argument with the guy who ran Universal. They're like, "We have the biggest market share, we know what we're doing," but I was like, "What do you know about this band? If they don't work immediately you're going to ignore them," which is what happened.

ROB SHEFFIELD: It took so long for the album to come out. It sat around for a year. By the time it came out everyone was sick of *Echoes.*

ASIF AHMED: The number, by the way, soup to nuts, for the Rapture's Universal deal was 1.8 million dollars. For four records, but I think only two options were picked up. I think they did three records. I sold them off. I gave them to Paul McGuinness right after that deal, I was so stressed out.

ROB SHEFFIELD: The rest of the Rapture songs are unknown.

TIM GOLDSWORTHY: That was very sad. Stupid fucking idiots for doing it, really. They broke a lot of people's hearts and they ended up destroying themselves, because they made shit records after that. The ego just got totally out of control.

SUROOSH ALVI: Money changes everything.

TIM GOLDSWORTHY: James and I were basically additional members of the band. We tried to explain it to them—they got signed for a million and a half for that LP and once you get this cut out, that cut out, you're going to be comfortable for a year. It's not life changing. And you're going to throw it away. But people like Jimmy Iovine and what's-his-name Cohen [Lyor Cohen], the Def Jam guy, seeing them work a band is fucking amazing. It's like David Blaine.

How they work people is an art form. Especially with somebody damaged, they just do and say all the right things.

VITO ROCCOFORTE: I enjoyed dinners to a point. Nothing is ever free.

LUKE JENNER: Signing your life and your artistic well-being away to someone who doesn't like music is not a good idea. I spent the next five years in meetings with people who didn't like music, trying to tell them about acid house. "And in college I liked Dave Matthews Band. I don't really buy music anymore but I had an internship at college radio and now I work here and I have your band in my hands." That's not a good feeling.

TIM GOLDSWORTHY: James is a very aggressive person and he turned the Rapture betrayal into a kind of anger. I went along with it, which wasn't my nature, and I really regret that. We were partners at the time and I was like, "Yeah, I trust this guy and if that is where we're going to go, we're going there." James's parents had died around this time, and a combination of that, him inheriting a lot of money, seeing Fischerspooner and shit bands make lots of money, David Holmes, all of that had a huge effect on him. It became: "I've got the plan." He was going to fuck the Rapture over. He was going to be bigger than them and he was going to get a bigger advance and he was going to destroy them. He's a bully without a doubt. Psychologically aggressive. Three days of therapy a week for twenty years gives you serious weapons.

DOMINIQUE KEEGAN: James was also going through a hard thing at the time. Both his parents died that year.

JAMES MURPHY: My parents died in 2001. My mom died in April and my dad died in August. So when the towers came down I was pretty blasé about it. To me it felt really normal. "Well, my dad's dead. The person that held the world together while I was a crazy person is gone."

DOMINIQUE KEEGAN: He was sleeping on the couch at the DFA office.

TYLER BRODIE: He had a roommate who got married and he was like, "I can't live with my roommate and his wife, that's too much." He didn't have a place and I guess he had broken up with his girlfriend who had a place. But he said it motivated him. Every morning

people would come into work and he would have to deflate the air mattress.

DOMINIQUE KEEGAN: He was stone-cold broke. And then suddenly he was on the cover of *NME* and we were partying our fucking asses off. There was a lot of cocaine around, alcohol was always there, and weed was always there, and then we had this friend who introduced us to quaaludes, which was just the best thing we'd ever done.

JAMES MURPHY: That was kind of a lonely period. But something really radical happened. It broke me free, in a way. Every day I thought, "I'm going to die." "Losing My Edge" and the next wave of energy and combat was really driven out of that.

LUKE JENNER: James is a fighter. Literally. He was into ultimate fighting and his dad was a really good football player.

JAMES MURPHY: Luke was the star. The whole story was them and us, the Rapture and DFA, and I'm their sound guy. So when they left, we were like, "What the fuck are we going to do?" EMI were going to make the deal with us, with DFA anyway, but without the Rapture we were like, "Really?" We didn't know what we were going to do next.

TYLER BRODIE: I guess what happened was we signed a deal with the Rapture and then both of us got bought out, so we made a ton of money. We got a million and a half dollars and they got half and we got half. That was for *Echoes*. I wish I paid more attention to this stuff but it wasn't really my concern. As long as people were continuing to make music, it didn't matter. I was like, "We'll start with some new band."

JAMES MURPHY: When the Rapture left, I was so angry and so hurt. Tim and I felt broken. We took a meeting with Britney Spears to do a song.

JONATHAN GALKIN: I begged them to do that. I will totally take the credit or the blame for that. They were not so into collaborating with anyone else. And James even at that time was like, "I'm not giving someone else my time." And "Who the fuck is this girl?" kind of thing. But part of them, at that time, was also kind of curious. I mean James also took a call from Janet Jackson. I sat right

next to him. He put it on speaker. She was like, "I love that song 'Losing My Edge'; it's got a real grit to it. I hope we can work together." He's like, "Okay," and that was it. Never heard from her again. Anyway, Britney Spears did show up. She had a bodyguard, who sat upstairs right outside that door on a folding chair, never moved. She came here with her Starbucks and Marlboro Lights, as you will. Tried one track. Tim had worked out, like, an instrumental and she had laid out vocals, and James was down here, too. I think he tried to cowrite some lyrics or something with her. I have the track. It's good. It's awesome. It sounds somewhere between, like, Liquid Liquid and "I Feel Love" by Donna Summer. I played it for people; I remember people saying, "Oh my God, this will be amazing."

TIM GOLDSWORTHY: She had the icing off of two Magnolia cupcakes and four cans of Red Bull, did some really strange ad-lib vocal takes, and then just disappeared and was never heard from again.

JONATHAN GALKIN: It was one of those things that we just didn't really understand, where pop stars just start little fires at different studios all over the world. And maybe by the end of the album some A & R guy comes behind them, listening to what happened and saying, "That one." That guy came here. It was Jive Records. And I remember him saying, "I like it. I got to tell you, man, it's too hip."

"LOSING MY EDGE"

JAMES MURPHY: My career as a front man was accidental.

LUKE JENNER: The whole time we were making *Echoes*, me and everyone else around him were just like, "You need to make your own fucking record because you're . . . domineering." And so he did it.

JAMES MURPHY: At some point it dawned on me that I had to do it. If I thought it was such a good idea for the Rapture to go with us to EMI, then I had to do it myself. I had to show that I meant it. I thought, "If I sit here and complain about how bullshit their leaving is and do nothing, I'm just as guilty. I can play, I can engineer, I can sing and do all the instruments, and if I can't make something good from all that, then, tough shit for me." I went to EMI and said, "I have a band now."

JONATHAN GALKIN: They were like, "Hey, fuck the Rapture, we're still psyched on you guys." EMI eventually imploded and everything went to shit, but they took care of James. They kept us alive. We felt justified because it was like, "These guys totally could have taken care of the Rapture, too."

DOMINIQUE KEEGAN: "Beat Connection" was the record I adored.

JONATHAN GALKIN: He had "Beat Connection" by this point. He worked on that one record for maybe nine months. He had gone up to well over, a hundred versions of the song—a tempo change, a new bass line, a little something where, like, no one else would notice—but he just couldn't, couldn't lock it in. That's very much his personality.

LUKE JENNER: For a year and a half I had a conversation with James Murphy like, "Disco's great!" and he was like, "No, it's not. I like house music, but I don't like disco." James is super methodical, and

he puts everything in little boxes. At the time James also didn't listen to jazz, even though he has an Ornette Coleman tattoo on his shoulder; it says, "This is our music," which is from an Ornette Coleman record. But he was afraid to get into it because he was like, "I'd just get too obsessive and I wouldn't be able to concentrate." He's, like, super OCD, so he's really careful what he puts his attention on and exposes himself to.

DOMINIQUE KEEGAN: I thought "Beat Connection" was fucking amazing. Five minutes of drumming with an arpeggiated synthesizer and then, "It's the saddest night out in the USA . . ." That was my number one DJ record for four years.

JAMES MURPHY: "Beat Connection" was what I worked on for a year. "Losing My Edge" was quick.

JONATHAN GALKIN: It sort of came spilling out of him, as he was ranting into this tape recorder, which I think is right by my desk to this day. It was a mini cassette recorder.

TYLER BRODIE: An ex-girlfriend of mine brought Pharrell Williams to this show at Tribeca Grand and James met Pharrell—that's when he was like, "I'm losing my edge to this kid." He was like, "This guy knows what's up, I'd better get my shit together."

THOMAS ONORATO: What's that song where he talks about all the influences? "Losing My Edge." That song says it all. He's talking about being at the first Can show, all these other historic music events, but feeling so old. Feeling eclipsed by those coming up behind you, appropriating all your references. I related to that song so much.

JONATHAN GALKIN: I'm the "Internet seeker." James would say, "You've never heard *Future Days* by Can?" And I was like, "No, but I just ordered it." And, he'd say, "Jesus Christ! It took me fifteen years to find that record!" Not that he wasn't buying vinyl on eBay, but I was just the epitome of, "Never heard it, I'll have it in two days and by the way now I know everything about the record. Here's where it was recorded and here's the gear, and here's the lineup, and, James . . ." I'd just be reading this off, you know, whatever the version of Wikipedia we had at the time.

ANDY GREENWALD: The thing that makes pop music so great is the way it parallel-parks on the bleeding edge of cool: nothing could be better at this moment than this beat, this feeling, this chorus. It takes something ephemeral and impossible, and for three to four exhilarating minutes, it makes it accessible and real. "Losing My Edge" is a song that's already bled out. It sticks its nose in all the parts you're supposed to ignore: jealousy, resentment, sarcasm, age. But it's not obnoxious in the way "funny" music often is. The real trick is that it's hitting you while it's heckling you—the song bangs, even if the vocalist is a crank. I still don't quite know how he did it. Most breakthrough singles are about first love. "Losing My Edge" is about first loss. And the second. And the third. And etc. etc. until everyone is just a jaded music critic in the bar right after the ugly light switches on. And you're dancing too much to care.

DOMINIQUE KEEGAN: The beat from "Losing My Edge" came from a present Ad-Rock gave James. It was a ghetto blaster, with a synthesizer on the top of it.

JAMES MURPHY: Adam Horovitz gave me a beatbox that he bought at a garage sale on the way home from a furniture-buying trip. I said, "I want to make a song with just this."

DOMINIQUE KEEGAN: James locked himself in the studio. He wanted to do all his writing and recording in the studio overnight on his own. He just pressed record and played live drums over one of the beats on that synthesizer.

JAMES MURPHY: I had the song in my head all the time.

JONATHAN GALKIN: I was there when James Murphy played "Losing My Edge" for the first time. I thought it was terrible. In hindsight, how did I not get it, but James was a slightly unhinged character at that time, so hearing that scared me, like maybe he's really coming unglued.

MARCUS LAMBKIN: I remember the first time I heard that song. I remember James bringing me downstairs, "Hey, we did this thing, you know? What do you think?" It was just, "Holy shit, that's fucking amazing."

TIM GOLDSWORTHY: Do I like that track? No, I hate it, to be honest, because I know the things that are being ripped off. "Losing My Edge" is a direct rip-off of a Killing Joke track. Directly. I hate it because it's devalued those tracks. Tracks which I love I can't listen to anymore.

JAMES MURPHY: I'd inherited a little money when my parents died and I took an apartment. I made the twelve-inches and we put the band together and went on tour a little bit. We played a few festivals. I was so aggressive. I felt like I lost a lot and therefore I had nothing to lose. I had no money but I remember I had an offer from a publishing company for $350,000 and I was like, "No, because it won't change my life. If you have a million dollars cash, I'll take it so I can buy an apartment and live like a rich person or the child of a rich person. Then I'd have this apartment. But everything else is cocaine and shoes. I'm just going to develop tastes I can't afford and I'm going to do a bunch of drugs," so I didn't take it. Tim and John were married and started having kids and stuff. I'm the scary one. I'm the one who doesn't care. I'm the one who counts down to death. But I rented that apartment, I went to a farm studio, and I recorded the first record. I paid for it. And when it was done I played it for EMI.

JONATHAN GALKIN: The EMI deal was for LCD and for the label, DFA Records. Separate deals. LCD was signed for a more traditional album deal and then the label deal was more of a first-look deal, even though they ended up saying yes to everything, which in hindsight was totally wrong. I wish they said no more, and then we were just allowed to release it through other means. They were like, "Yeah we'll put out Black Dice." And even if it sells five thousand or ten thousand copies worldwide, for us doing it ourselves we'd be like, "Cool, we sold ten thousand copies of a completely insane record!" But for them it was "It's a total failure and that's dropped." Everything we did wound up being one and done.

JAMES MURPHY: I had a revelation that it was easier than I thought. I was afraid and I suddenly became unafraid. Was that the beginning of LCD? Yeah. The combination of David Holmes leaving,

the Rapture leaving, working on "Beat Connection" and Tim saying the drums sounded really good.

JONATHAN GALKIN: The first LCD twelve-inch was "Beat Connection" and "Losing My Edge."'

ROB SHEFFIELD: I still remember Justine playing "Losing My Edge" for the first time. This would have been the summer of 2002. It was three in the morning at Don Hill's. I had no idea what it was and had to Google it the next day. That happened a lot at three in the morning at Don Hill's. I'm jotting down lyrics and there's maybe a dozen people left in the bar and they're all just trying to buy drugs so anytime you go to the bathroom three people would follow you. I'd be like, "Sorry, dude. I think the kitchen is closed." I was already a big fan of James Murphy's productions and his DJing, but I had never heard his voice before and I was like, "Holy shit." I was like, "Who is this?! What the fuck song is this?" Because he was literally describing the room I was standing in, so he was describing everybody's Saturday night. Who are all "these Brooklynites in their little jackets and borrowed nostalgia for the unremembered eighties"? There was a fuck load of that to see.

MARK RONSON: "Losing My Edge," I dug, but it was almost too clever for me.

MARC SPITZ: Jason Roth from *Spin* came in and said, "You have to hear this." He played "Losing My Edge." This is before it was released, it was like a bootleg or something that was going around. The first thing was this sense of excitement, like, "Wow. He's mentioning all these reference points that are like . . . insider name-checks." And then—it sunk in. "Oh. Oh no, this is not good." Once the sort of elation wore off, you realized that he was taking the piss. And there was no being a rock snob again after that song. It's kind of like what—what Kiss or the guys from Iron Maiden must have felt like when they first watched *Spinal Tap*. James Murphy reduced rock snobs like myself and himself to an utter cliché in eight minutes.

MOBY: LCD were always funny. James is very talented, they made some very good records, but it's interesting, because it's almost music as journalism, it's like the songs describe things that have hap-

pened. Like "Daft Punk Is Playing at My House," that's journalism. And "Losing My Edge." It's hard to say this without sounding a little petulant, but almost everything he mentioned in the song, I *was* there.

JAMES ENDEACOTT: All those early DFA records; everybody was just desperate to get them. They were super cool here in London. You were in the know if you knew those records. And "Losing My Edge," that song is so prophetic. Now any hipster kid is like "I was there when LCD Soundsystem played their last show" or "I was there when the Strokes did this or that."

TRICIA ROMANO: I didn't buy James Murphy as a rock star. James was so funny and so nice and I really liked him, but I just didn't really want to watch him sing songs. To me, he wasn't a rock star and they didn't make dance music.

JOHANNA FATEMAN: I didn't really get it. I guess I wasn't acquainted with who James was lampooning in that song. And it also didn't go with his personality, because he wasn't cynical or jaded. My impression of James was just this big teddy bear that was just excited about everything. But I mean I thought it was good. We were happy for him.

TRICIA ROMANO: But I will say that "Losing My Edge" was pure brilliance because it was totally applicable both to dance music and to jaded rock-and-rollers. I used to make fun of Frank Owen from the *Voice*—he seemed so much older to me when I was twenty—but he liked to come into the office and brag about going to Paradise Garage and I'd be like, in my mock obnoxious British accent, "Back in the day, we used to craft our own disco ball and we used to walk five miles in the snow to get to the gig." "Losing My Edge" was a send-up of that guy. Everybody knew that guy! And that fucking beat is filthy. You can't get enough of that beat. That and "House of Jealous Lovers" were the only rock/dance records that really penetrated. And those two records really did help merge those two scenes, where the rock stars would DJ at the dance parties and the dance kids would actually tolerate them.

ROB SHEFFIELD: James Murphy wasn't an emaciated teenage boy in a mod suit and skinny tie that he bought last week.

JAMES MURPHY: I knew Nick and I'd seen Yeah Yeah Yeahs play at the Parkside and I really liked it. And I loved the Strokes. But I wasn't immersed in it. They were not in our world. We were making our world.

ROB SHEFFIELD: He gave a very interesting interview to *Mojo* around the time *This Is Happening* came out about body image. He was like, "I liked all this music that only skinny boys liked. And I always felt not skinny enough." I was really surprised that he said it because nobody says stuff like that. He was there with his stubble and his hair but he was also totally serious. And it was really interesting.

ANDY GREENWALD: I interviewed James with Tim at the DFA headquarters in 2003. In the interview, Tim was smart and quiet and James was hilarious and loud. He was a rock star on the tape recorder long before he picked up a microphone. What I remember best was how skilled he was at using his age as a weapon instead of a shield. Sure, he was very self-effacing about how long he'd been in "the business." He talked a lot about his time working with Six Finger Satellite, and all these other indie bands that seemed positively ancient to me, even then. But instead of being hemmed in by his experience, he was liberated by it. He'd stood around, bored, tapping his feet at punk shows for so long, the idea of doing blow and dancing until dawn wasn't absurd—it was absurdly appealing. I was the "young" guy writing a story about the new cool scene. But this joker in the XL T-shirt was running laps around me. Because, unlike all the other bands I was writing about, he didn't give a shit about where he lived, what he wore, or how he lived. It wasn't a pose for him. It was fun. That gave him power. I think when "Losing My Edge" hit, he finally realized how much of it he had.

JAMES MURPHY: Did I want what happened next to happen? I didn't think I was going to take up so much time. The band really was kind of a lark. I'll make a record, we'll do a little touring. I didn't know you could tour with demand. You could just keep getting invited to play good things. I remember I went to Pianos once around that time, after "Losing My Edge," and there was a guy I didn't know at the door and the guy was like, "Oh, no problem, James, come right in." And I was like, "What?"

43

"MAPS"

KAREN O: You can liken it to the young men that fight a war and have these extreme experiences and come back just utterly bonded to the people that were with them. You forge these friendships because it is such an extreme lifestyle, being in a rock band and touring the world, especially when you're doing it when you're really young and you don't have much control over your life. Everything just feels out of control all the time. The other metaphor I see is there's a Western where there's some guy who gets knocked off his horse but his foot is still on the stirrup and he's just being dragged by this fucking mustang or something—that's how it feels to be in a successful rock band in New York.

MARC SPITZ: They were about to release the *Fever to Tell* record, and everyone felt like it was going to be an important record. Karen was regarded as the new P. J. Harvey, in that she was a real rock star. She was thought of as someone who was going to need to be reckoned with.

KAREN O: The whole experience was really overwhelming, basically. All of a sudden we went from there being hype around us to really seeing the effects of it. We were doing these shows in the UK, our first headlining shows over there, and it was just total fanaticism. It was a glimpse into the future, seeing what it might be if we broke in the U.S. It was overwhelming and it was hard to process.

DAVID BURTON: Karen was a young woman on a meteoric rise basically going from her bedroom to the boardroom. And she was a very emotional girl. And she also wouldn't take care of herself. She had

terrible habits, to the point where even the old roadies didn't eat like she did. But she also had youth on her side.

NICK ZINNER: We did *Fever to Tell* ourselves.

ASIF AHMED: With Dave Sitek producing.

NICK ZINNER: We felt a lot of pressure. I think Karen felt most of the pressure. Things were going super, super fast recording this thing. We'd done all the rough basic tracks in like a day or two days and meanwhile we were supposed to play the Reading Festival in two weeks. Karen totally put the brakes on and canceled that shit. She was like, "This whole thing is spiraling out of control and we need to get a solid foundation first."

ASIF AHMED: Oh yeah, that was a real fun conversation to have. They canceled it two weeks before, or maybe a week. I just shit my pants.

DAVID BURTON: I remember being $10,000 poorer that year. But I understood. I remember sitting in my house in Dublin and them saying, "Yeah, we're not going on tour." I was packing my bag for the airport. My first question was how was I going to eat that month.

ASIF AHMED: They were only playing the BCC Radio 1 stage at Reading. It was in the afternoon, and I think they were only getting five thousand pounds per show. And then they offered us fifteen thousand. They thought I was playing hardball. And I said, "No. She's just not getting on a plane, she's literally going to be in a salon getting her mustache waxed. She's not getting on a plane." I really said that to the promoter.

KAREN O: Before we knew it there were all these other shows being booked, including Reading. I can't remember if we'd even started the record or hadn't finished it but I definitely felt like I was on the verge of a meltdown. I knew that if we just continued the way we were going I was going to burn out much too quickly and that what was more important than pleasing promoters and believing all this hype was to just to get our record done. The record was more important than dragging ourselves around on the road. And for me personally, just like, health-wise.

NICK ZINNER: She gets sick really easily. We were always really sick. I

used to get bronchitis on every tour. I was also smoking a pack a day.

KAREN O: I was at the tipping point, you know?

NICK ZINNER: Initially my reaction was go go go go go. I'm a Sagittarius—momentum, movement, traveling, being busy, that's my natural habitat. It's what I like doing best. Whereas once things started to accelerate and get crazy, that's when she first started to buckle. It affected her physically, emotionally, in every single way. She is Sagittarius/Scorpio cusp. So with her there's this kind of push-pull.

JON SPENCER: We used to call them the "Maybe Maybe Maybes." That was the joke. Once when we were in England, they came to us in a dressing room and said—somebody had a cold or something—and said, "Would it be okay if we didn't play tonight?" I didn't know what to say. How do you respond to that? I think I may have said, "Well, yes, I don't care." It just seemed so weird that they were asking permission and I couldn't believe that they would even do that. When we started with Pussy Galore, it was always incredibly hard early on, and a lot of it was just miserable, but you got to play. You know—no money, terrible food, sleeping on people's floors, playing the worst shitholes around; you could feel like crap but you'd still play. So that was a little weird but also cute, I guess.

ASIF AHMED: You know what? She wasn't dramatic, she was overwhelmed. I don't think any of them had any expectations of where the whole Yeah Yeah Yeahs thing would go. The most ambitious one at the time was Nick, just because he'd been at it for a long time. He is considerably older than the other two.

KAREN O: I had to demand it too, because the idea of canceling shows at that point was frightening for everybody. Everyone thinks, "You're going to piss the promoters off, you're going to piss the fans off . . ." It's so taboo.

DAVID BURTON: A lot of it had to be anxiety. Also she wouldn't have been warming up properly so I can only imagine what shape her throat was in. You're like, "Man do you not know what fucking tea is? You can do as much coke as you want but you've got to buy a box of Throat Coat tea." I'm sure the label was pretty upset. Fans

weren't happy because there'd been a lot of cancellations already in their career.

KAREN O: But I just felt if we didn't go that route it was going to end up badly.

JALEEL BUNTON: I watched what happened with Yeah Yeah Yeahs. I was living with them when the first little *Rolling Stone* thing came out, around the first EP. I remember this girl riding her bike down the street in Brooklyn one day just screaming, "YEAH YEAH YEAHS ARE PLAYING!" They didn't control that. Once they signed, there was a groundswell. They're great; they're good friends of mine and I think they're an amazing band, but you have no control. "I'm in this thing that's happening, I am in the center of this thing."

ANGUS ANDREW: What felt private for a while, or felt like we were working in our own space, started to feel a bit claustrophobic.

JALEEL BUNTON: The thing I realized from watching Yeah Yeah Yeahs is that it happens outside of you. Before I knew them, I'd see their posters everywhere and it'd be like, "Who the fuck do they think they are?" Later, I was getting on the train one day, and there was a poster of us, and I was like, "That's not me, that's the thing that they're selling. I didn't put my poster up here, someone else did that." It happens outside of you.

BRIAN CHASE: With Yeah Yeah Yeahs it does come down to heart. There's always a sense of looking past boundaries or expectations and just staying in touch with a spirit that feels, like, just really excited and pure.

DAVID BURTON: In hindsight, it's easy to say it was the right call because it clearly didn't hurt them. They kind of went on to do things their own way.

CHRIS TAYLOR: Well, then they had that "Maps" single, and it was like, "Holy shit, they're a real band!"

ASIF AHMED: That was their signature.

ANDY GREENWALD: That's just a universe-slaying song.

SUROOSH ALVI: They wrote a hit! Those fucking weird art-project kids wrote a beautiful hit, and it went global.

NICK ZINNER: "Maps" was another big moment when we knew we had something.

KAREN O: It was just a love song I wanted everyone to hear. And they heard it.

ASIF AHMED: Nick writes some of the better songs but Karen did write "Maps." One hundred percent.

KAREN O: We wrote it in Nick's room with the blue drum machine and a four-track recorder. I was really lovelorn at the time. "They don't love you like I love you" was straight from a love letter and I just plucked it out of there because I thought it had a good ring to it. Just a simple statement that really stuck with people. You know, I say "love letter" but it was a fucking e-mail. Motherfucker. You know what? I'm going to rewrite history right here. I wrote it with a quill. It was a feather quill, written in blood. It might as well have been.

JALEEL BUNTON: I remember when that record came out, because Dave produced that record, and they played it for me. That was the first song of theirs that I was like, "What are you doing? This is the single for the record." Dave said, "No, they don't want to put it out." I'm like, "This is insane. I'm the dummy who likes the B-sides, whatever, but this song is the song, it is *the* fucking song, there's no doubt about it." And that record stalled until that song came out.

ASIF AHMED: A full nine months. I think a full ten months. The album came out the week of my birthday, in the spring of 2003, and then I think "Maps" hit January or February of 2004.

SUROOSH ALVI: This was Brooklyn proving that it could. It's such a simple, beautiful song. That song is the perfect representation of the idea that, stick to the art, stick to making something of quality, and it will work. When they made it, they weren't trying to write a hit, they were like, "Here's a sweet little love song." It's actually a weird song. It's super minimal, lots of empty space, and then Nick's amazing fucking guitar jam at the end, and then they're out.

KAREN O: You never know what's going to hit. You might think, "Oh, this song or that song," but it's rare that you're actually right. But we knew it from the moment we wrote "Maps." The moment it came out. There was just something about that one.

JOE LEVY: It's deeply romantic. Deeply romantic in a way that is not at all cynical, and this goes through some sort of current of New York rock. It is in the Velvet Underground, it is in the Ramones, it's in that Yeah Yeah Yeahs song. It's a sentimentality that has to connect through a sense of struggle and grit and fuck-you.

ASIF AHMED: The thing is, they were willing to wait.

"A THING THAT DOESN'T WORK BUT DOES"

BRIAN CHASE: When we were growing up, it was really Liars and TV on the Radio that were our mates.

KAREN O: Those were our peers.

DAVE SITEK: I showed up in late '99, early 2000. I was in Baltimore, where I'm from, and I was in a ten-year relationship. We broke up and I just went nuts. I was like, "Well, fuck it, if I'm going to live on the edge, I might as well live on the edge with my brother and in New York." So I moved to New York.

TUNDE ADEBIMPE: I moved to New York in 1993.

JALEEL BUNTON: When I lived here first I was playing with my brother, Kareem, and one of my best friends, who had come to go to the New School. When we first moved here our band was called Mudbone, a live hip-hop band. Later, we changed and became Pleasure Unit.

PAUL BANKS: I used to go watch Pleasure Unit all the time—I crashed a rehearsal of theirs beneath Max Fish one night. Jaleel was playing bass—but the rumor was he was one of the greatest guitarists in town.

JALEEL BUNTON: Yeah, Paul was one of our few supporters and we really appreciated that.

DAVE SITEK: My brother had been living in a place around the corner from where Nick, Angus, Aaron, and Karen all lived, on Metropolitan. There was a Laundromat there, on Metropolitan and Driggs. I remember getting my stuff out of the truck and there were just heroin needles all over the ground and little baggies of drugs. It was totally nuts.

TUNDE ADEBIMPE: I came for school. The third year I was asked to leave, which is a nice way of saying you're failing out. It was a combination of my being a nonverbal hyper introvert plus being in film school with a bunch of eighteen-year olds with no stories to tell but wearing a baseball cap and sporting a beard thinking they were Steven Spielberg or George Lucas. It was annoying. Then I found animation. Basically I was asked to leave because I spent more time in my basement in Williamsburg than I did in class.

JALEEL BUNTON: We grew up in Kentucky, and Chicago was the next biggest metropolis. There were a lot of big indie scenes in Chicago, but the music scene there wasn't mine. It wasn't what I needed. When you're playing in a Midwestern town there's really only one alt culture. It's like, "Okay, punk rock hippie disco rave pop!" I liked that about the Midwest, it's less judgmental. But the music wasn't in my strike zone. The music that I was into was a little more heavily influenced by black culture. And I just knew I wasn't going to find it in the Midwest. I did think I'd find it in New York. And I was right about that.

TUNDE ADEBIMPE: I wasn't worried about school. It felt like my education was just being in New York. I met so many really great artists and people who came at the same time I did for the same reason. The second month that I moved to New York, I was walking around the East Village and I see this older, balding man with a big beard coming toward me. I'm like, "Why does that guy look so familiar?" And it's Allen Ginsberg. I'm like, "Oh my god, you're Allen Ginsberg!" And he gives me this look, the I'm-going-to-the-deli-man-so-what look. I learned to stop saying that. I had fire-engine-red hair, an army jacket, and rimmed glasses. I remember going home to Pittsburgh and having my mom just be like, "What is wrong with you?" I was like, "This look is going to bring forth exactly the type of person I want to meet and make the exact kind of person I want to go away, go away."

DAVE SITEK: I had $165 when I got to New York. My brother was like, "You might want to do something about that."

TUNDE ADEBIMPE: Dave moved into this loft I was living in; his brother, Jason, was one of my roommates. It was kind of a rotating cast of

characters. We had up to eight roommates at any given time. So Dave moved in, but I didn't see him for a while.

DAVE SITEK: We lived on South First and Havermeyer, above this fish market. It smelled unreal, but our rent was like $450 a month. The L Café had just opened, the wine store, coffee shop. Oznot's Dish opened. That was the neighborhood. I started painting immediately. I was selling paintings in the street, and that's how I became friends with Tunde. He said to me, "You have no clothes and no furniture, but you have paint and drum machines?" I was like, "Yeah, that's kind of the vibe."

TUNDE ADEBIMPE: We just found pictures of that place recently and my room is essentially a big mess of books and paints and just crap all over the floor—shit that I'd drag in from the streets and make into stuff. I was walking to the bathroom one day and the door in Dave's room was open. I see a mattress with a bunch of paints on it, a desk with a bunch of cassette tapes, tons of empty cigarette boxes and cartons. I thought, "I'll be friends with this kid."

DAVE SITEK: Karen referred to our old loft as the sandbox because she would come to our house and there was like paint, paper, and silk-screening stuff everywhere, and it was just me and Tunde and my brother making whatever the fuck we wanted with whatever medium we wanted. Playing in the sandbox.

TUNDE ADEBIMPE: We weren't paying anything to be there, and if you'd seen it, you'd know why. I mean, there was plywood on the windows. We didn't have windows for a really long time. We'd spend most of the night painting and then go out in the morning and sell stuff.

DAVE SITEK: I mostly set up on the corner of West Broadway and Spring. At the time there was this older woman who was a hot dog vendor and that was her corner. I just became friends with her by default because I would set up next to her. I ate a lot of hot dogs for that first year.

TUNDE ADEBIMPE: She was awesome. That was fun.

DAVE SITEK: She always looked out for me. All the art galleries would call the cops on an artist if they set up in the street, so when the

cops would come, she would defend me. She'd scream, "He's not doing anything! Leave it alone!"

TUNDE ADEBIMPE: I was also working for this animation show called *Celebrity Death Match.* I was one of the first animators on that show.

DAVE SITEK: My stuff was, for a lack of better description, children's art with adult subject matter. Not porno shit, but just really bizarre, surrealist stuff.

TUNDE ADEBIMPE: It was hilarious. He made this enormous painting of a bullfighting ring and a matador with a bull in it. It was probably six feet by four feet and he had done it on this weird fancy dining table top thing, but every face in the arena, he had cut out of a magazine and pasted it up, and there were like two hundred or three hundred. To take the painting into town, he put eye socket screws in it, attached his guitar strap, and carried it into town on his back. It was Dave and this big circle getting onto the train.

DAVE SITEK: I had always been making music. I was in bands when I was a teenager, but I didn't really want to be in front of people. So by this point I was making experimental music on my own just for fun. It wasn't like I was going to produce other people. The only reason that I started producing was because of this band in Baltimore called Love Life. I love their band, and I was just too impatient for them to go into a studio and record with someone, so I just recorded them myself so that I could get the record faster.

TUNDE ADEBIMPE: The night Dave and I started making songs together, we ended up putting six of them on this disc called *OK Calculator.* We silk-screened covers and hid the CDs in furniture stores or bookstores. We had an e-mail address on the back, so people actually started writing in being like, "I found this CD, what is this? What's going on? Who are you guys?" We left this stack of them at the Verb Café for people to take, and that was about it. I don't think it went any further than trying to make art and music together. Then Dave started producing with Yeah Yeah Yeahs, so he'd be gone a few months and I'd just get back to what I was doing.

JALEEL BUNTON: Everyone in the band had been here for some time already. Everyone had done the time in the coffee shops, had done

the time in the whatever other job. Everyone in the band has a grunt side. We grew up grunt people, did grunt work. We never really saw the people that didn't live in the world of I-work-at-some-shitty-coffee-shop.

DAVE SITEK: When I was Yeah Yeah Yeahs' tour manager we talked about doing their record. So I rented a studio in the neighborhood called Headgear. That's where we did *Fever to Tell*.

KAREN O: I can't even remember how he ended up producing our record, it just kind of happened. I remember him giving me a few burned CDs of stuff that he had worked on. I guess he was just a buddy, and we felt immediately like we were family with him. And we didn't know anyone else. That was probably one of the biggest reasons we worked with him, because we didn't know anyone else. Then, of course, he ended up being fucking really masterful.

DAVE SITEK: After *Fever to Tell*, the Liars asked me to do their record. Because all these bands were doing it all analog, the Liars were like, "We want to do it all digital!" I didn't know how to use Pro Tools, so I bought a Pro Tools system and then I recorded me and Tunde making music, just so I could learn how to use Pro Tools. The *Young Liars* EP is actually just me learning how to use Pro Tools. We had no intention of it coming out. Tunde and I weren't really a band. But we gave it to Karen and our friends, and then Karen gave it to Corey [Rusk] at Touch and Go Records, and then he was like, "I want to put this out." It was kind of an accident.

MOBY: For me, personally, musically the most exciting thing to come out of that world was TV on the Radio. Everything else was good, but good in a way that you expect it to be good. TV on the Radio, especially that first album, was so much better than the sum of its parts. The sum of its parts were perfectly fine, but the synergistic sort of magic of that . . . And that amazing voice, and it was an introduction to soulful African American elements with electronics in indie rock.

TUNDE ADEBIMPE: A friend of mine, we were once talking about how he realized that he was gay, and he basically said, "I realized that I was going to bed with more men than women." That was how it was with TV on the Radio. At some point I had to admit it to

myself. I was like, "I've been in a band on tour for more time than I haven't, so I guess I'm in a band."

DAVE SITEK: After the Liars record, I just kept getting asked to do stuff. Gradually I was painting less, and doing more and more music.

TUNDE ADEBIMPE: The first TV on the Radio shows, Dave would have a sampler and I would be up there with just a loop pedal, singing and just making shit up. We would just mess around and improvise, taking themes from the audience. I remember I made a song called "My Baby Looks Like Santa Claus in Red Drawers" when someone suggested underwear as a theme.

DAVE SITEK: After *Young Liars* came out we got asked to play more shows. Kyp joined, and then it was me, Kyp, and Tunde.

JALEEL BUNTON: I really liked the EP. I thought it was amazing. All the stuff that I was describing about music, everything that I was going for, it had. It was this electronic thing, but it wasn't overly electronic; it still felt organic and soulful, but also referenced, in its omission or its inclusion, all of the other things that were cool that were going on in music. They were doing it better than I was doing it. It was a similar aesthetic, but they had pulled it off.

TUNDE ADEBIMPE: He'd seen a couple of the shows at Stinger. That's where we played, every Wednesday and Saturday. Stinger is on Grand Street. It was just a saloon. But there was a sign behind the bar that said, "Get naked, you get a free shot. Oral sex, you get three free shots. Fuck on the bar, you get an open tab." And all those things happened. You'd see the sign and you'd think, "This has got to be pretty hot!" It's actually not hot when you're having a drink with a friend, and you look behind you and there's a dick in someone's mouth. But so one day Dave and I were walking into the Verb, saw Jaleel coming up. We started talking and he said, "Yeah, I saw you guys, and you need me." The balls on this dude!

DAVE SITEK: I knew who Jaleel was because all of my friends know Jaleel. When we got asked to do real shows, we thought, "We should get a real band." So I go to Jaleel, who's the best guitarist out of anyone I've ever met hands down, and ask him to play drums. He was like, "You know I don't play drums," and I said, "That's perfect! It's exactly what we need."

JALEEL BUNTON: Yeah, we'd made this recording with me on drums even though I don't really play drums, just for fun.

DAVE SITEK: And then we got Gerard, who's the other best guitarist we knew, to play bass and keys.

TUNDE ADEBIMPE: Maybe there's some Grimm's fairy tale where someone is walking through the forest and he's on a quest and he meets someone who turns something into stone, and he's like, "Join my quest, you will need this." It was totally like that. Like a series of people just saying, "You need me," and us saying, "You're right."

DAVE SITEK: What is TV on the Radio? I mean, I don't even know. Honestly, I have no idea. It's just, like, a thing that doesn't work but does. I look at us like a rubber band in the sense that when you're a kid and you have a rubber band on your wrist and you pull it and it snaps. You get that little sting. That sting is what happens when all of us finally get to the same thing. We pull in all different directions, pull away from each other, but it always ends up snapping back, and in that moment something really authentic and true ends up happening.

THE UNCOOL KIDS

ED DROSTE: There was a Brooklyn-versus-Manhattan element. I had more encounters and interactions with Yeah Yeah Yeahs, TV on the Radio, and Liars than I did with the Strokes. The Strokes happened and I was totally into it but it felt separate.

CHRIS TAYLOR: I loved the Strokes and I really liked that first Interpol record. I listened to LCD Soundsystem. I really loved those bands, I just didn't see how any music that I might ever make would have anything to do with that scene, just because I was so not rock oriented.

KAREN O: I didn't really peg Interpol or the Strokes as arty, whereas Liars and TV on the Radio were kind of nerdy but definitely arty. We related more and identified more with some of the artier bands. We weren't very arty, but we were arty enough.

ANGUS ANDREW: Yeah Yeah Yeahs, TV on the Radio, that was pretty much our group of friends. We didn't know the Strokes or Interpol. They were already big. But anyone from Brooklyn, we'd see them or played with them. It was a very tight community.

CHRIS TAYLOR: It almost became kind of annoying. People were so damn friendly about it. You'd walk to the coffee shop and you'd have to stop and talk to a lot of people. It would take a really long time, just because you knew everyone in the neighborhood and everyone was so nice and would ask you about your band and how everything was going. It wasn't like a competitive thing, which is not very New York. It was nice.

ANGUS ANDREW: I mean, we were living in a loft with people from TV on the Radio and Yeah Yeah Yeahs, right at Bedford.

ELEANOR FRIEDBERGER: I remember, early on, seeing Karen and her boyfriend from the Liars walking down Bedford with their arms around each other, and I just remember thinking, "Oh, they're cool."

ANGUS ANDREW: But apart from the physical reality of being in the same area at the same time, what connected us was not having a sense of a direction about what we all should be doing. There wasn't a sense of, you know, one of these bands is doing something that we should all be trying to achieve, so we gathered around that band. It felt like everyone had their own direction to go. We all felt quite different to each other. And that felt good. You could admire someone else's work, even though that's not the work that you yourself want to be doing. That was the big connection. There wasn't a through-line of the sound. I'm sure in hindsight the words "post-punk" and "art whatever" come up, but it certainly didn't feel at all defined then. And maybe if you spoke to all the people in the grunge world, they would have said the same thing. But it didn't feel like we were all moving to Seattle to play one kind of music. It felt more random.

ED DROSTE: TV on the Radio, !!!, a lot of those bands were really playing what seemed, retrospectively, to be hyper-illegal shows in Brooklyn.

NIC OFFER: We went to this party at Mama's in the East Village and all the food and drinks were free, it had like amazing DJs and people were doing really whacked-out sets and there were drugs around—it was the last time I heard of heroin being at a party. It felt very much like the last vestiges of the old New York. We were like, "We should throw a party in Brooklyn like that—a party is a gift to the world!" We had this huge space. So I called everyone in my phonebook whether I remembered who they were or not. That was the point.

ED DROSTE: There was this space called Happy Birthday Hideout; it was just a single staircase up, packed with five hundred people. An insane fire hazard. People would take over entire floors. People would just donate their living spaces for one massive party where there would be a roof element and an inside element and like a mix of different concerts.

ANGUS ANDREW: When I think about it, visually, what I see is the Twisted Ones' space. Those guys brought a lot of this together.

TODD P: That was about a guy named John Fitz, who was the first person to do the kind of shows I do—the first person in the area to do the kinds of shows that I got associated with: loft, warehouse parties that were a little dangerous. He had an organization called Twisted Ones, and he basically did the punk rock shows.

ANGUS ANDREW: The visual aesthetic they represented with their posters, and the shows that they put on, ended up being really important.

TODD P: Fitz did these shows at a couple of warehouse spaces, but a main one called Mighty Robot.

ANGUS ANDREW: Mighty Robot was really the epicenter for a lot of these bands and a lot of the touring bands that came through there that also influenced us and were of the same mind-set.

VITO ROCCOFORTE: Brooklyn was a really fertile area, but it hadn't been . . . mined, planted. Whatever fucking metaphor I'm going with here. Another person who was really important was Todd P, because he did all of this DIY stuff.

ROB SHEFFIELD: God bless that fucking man. He's so unsung and he's done it for so long. Nobody who's actually accomplished so much has so little ego about it. It's the kind of thing where I'm in awe of him and what he's done and usually when I see him it's at some kind of show where he's absolutely breaking his back to make everything happen and he's carrying amps and he's carrying equipment and he's moving things and he's looking up at the sky to see if it's going to rain to see if they need a tent.

DAVE LONGSTRETH: Todd P used to run a club back in Portland called 17 Nautical Miles. That was just a great, youthful, all-ages space where a lot of my friends' bands played. Todd knew me from that.

TODD P: I'd been doing shows for Dave since he was at Yale and would come down all the time. His brother had been in a band that I'd booked in Oregon.

DAVE LONGSTRETH: I remember thinking that I wasn't very interested in the New York scene as a social environment, but it seemed like

every time I came down here and played one of these Todd shows, it was often super interesting and confusing and eye-opening and I met a lot of people. I was totally uninterested in Manhattan. I played a show there once and there was one dude who was writing a text message, and I remember just being like, "Oh my god. How rude. How ridiculous. This is, like, *Manhattan* behavior." But Todd's shows were interesting.

ANDREW VANWYNGARDEN: After I moved to New York, I went to Todd P parties. I actually worked the door at three or four Todd P parties, taking money. I liked how crazy the venues were.

DAVE SITEK: He was a promoter and he was just putting on shows, finding venues that weren't even venues.

DAVE LONGSTRETH: One of the first ones I played was on top of a fridge in the corner of this place, Above the Right Bank, in South Williamsburg.

ELEANOR FRIEDBERGER: Brooklyn was just . . . amazing.

CHRIS TAYLOR: When I first moved to Brooklyn, Chris Bear, who plays drums in our band, moved into the same loft as me; we built it together. We were in this band, and at that age when you really have the energy and ambition to do all of this. There's just things that you don't care about that allow you to be free and experimental and take big risks and live in a dirty place and you don't give a shit. Rent was really cheap, $600 a month. Chris and I were vegetarians because it was cheaper—we cooked rice and beans so many nights. We priced it out. We knew the cost of the beans and the cost of the rice and we bought the onions and we're like, "Okay, cool, this whole food element of life is under five bucks." We can buy a Yuengling, which was like a dollar fifty, which was definitely a choice beer at that time, and that was enough. You find a cheap bike, so you don't even have to take the subway. That and some money for weed, that was your budget. That was all you needed.

DAVE SITEK: It was so cheap that you could afford to take risks and fail. If you failed at what you were doing it didn't matter because you were in Williamsburg. If you failed in Manhattan, it was different.

ELEANOR FRIEDBERGER: I rode my bike everywhere. I got all of these

amazing jobs that were so easy and stupid. I would work these office jobs, then go out every night, and I could afford to pay my rent.

ALEX WAGNER: I think of the Brooklyn bands as gentler. Easier to digest. These are groups of people who have much more space and time to think and develop their sound. They're nerds. They're not doing blow with waitresses at three o'clock in the afternoon, you know?

KAREN O: I was in an Uber the other day and the driver asked, "What do you do blah blah blah?" I usually don't say much, but he was really grilling me for it, so I told him, and as we were driving, he pulls up this picture of us, with me in the middle, on his phone. He goes, "That guy on the right"—meaning Nick—"he looks like he was born to be in a band, and that guy on the left"—meaning Brian—"looks like he should be sitting in front of a computer." By the way, this was one of the more stylish photos of Brian I've ever seen, like a very rock-and-roll photo, and he still like looks like he should be sitting in front of a computer. I mean, Dorkasaurus Rex.

DAVE SITEK: What brought Gerard, Jaleel, Kyp, Tunde, and I together was the fact that we're all nerds. We read a lot. Naomi Klein. I remember *Shock Doctrine* made its way around our band the day it came out. You're talking about people who are reading, and talking about all this other stuff. It filtered into the music. We developed a language for ourselves with each other, to understand each other and make sense of the world. TV on the Radio is like a book club. Really nerdy people doing really nerdy shit.

AARON DESSNER: That period, like when Yeah Yeah Yeahs and Interpol and the Strokes were exploding, I sometimes think of that as our pre-history. We've always been the tortoise relative to what happened at the beginning of the 2000s. We were spectators and fans of it.

CHRIS TOMSON: The National are an interesting case. They were a band for a while before people started paying attention.

MATT BERNINGER: Scott and I came to New York together in the later nineties. We actually took a train from Cincinnati the first time. I don't know why we did that. We thought it would be cool. We were

with a couple of other college friends. We all came up for internships because we were all in design school in Cincinnati.

SCOTT DEVENDORF: We didn't come here with a big ambition.

MATT BERNINGER: The first place we lived was right around the corner from where the cover of *Manhattan* was shot, underneath the Queensboro Bridge, where Scott and a bunch of other people slept literally shoulder to shoulder all on the floor.

SCOTT DEVENDORF: Matt lived in the Gowanus area. It was pretty hilariously rough.

MATT BERNINGER: It was such a cliché. It was a raw unconverted loft space next to the canal, which would change colors every hour and different smells would come up from it. I lived in one of those places where there were cars burning outside the house and people would dump stuff at the end of the block because it wasn't a through street. In addition to all the burning cars, I think somebody was buying close-to-overdue milk and rebottling it in this warehouse across the street because once a week, in the middle of the night, they would just pour all the stuff they couldn't use into the street. I'd come out my door and quite literally the streets would be filled with milk, which turned into a lyric. Another time, I came out and there was a cardboard box in the middle of the street, kind of right outside of our door, where all of the rotten milk would be festering, and it was just sitting there by itself in the center of this dead-end street. I wanted to just go to work, but I had to go look. So I open the box and there's a headless chicken and a double-ended dildo inside.

AARON DESSNER: I ended up in New York because of college. I went to Columbia. Everybody else moved for work—Scott and Matt were both graphic designers, and Bryan is a fiction editor.

SCOTT DEVENDORF: Aaron, Bryce, and my brother, Bryan, had a band before moving here.

MATT BERNINGER: Scott and I were friends; we had a little band when we were at school, and then his brother and the other guys were in a different band. Everybody ended up in New York. Scott and I

both had jobs at new media companies, right when the bubble was blooming.

SCOTT DEVENDORF: Obviously New York has all the cultural stuff but also professionally it was one of the hubs for doing design work.

MATT BERNINGER: I had a good job but I was kind of miserable. I went to Other Music and Kim's all the time. I would buy records and put my headphones on and work on websites with my headphones on. I was trying to escape the anxieties of being a professional, just trying to find a girlfriend. It was the same way everybody gets into music. It's empathy. It's that you empathize with lost souls.

ED DROSTE: I came to New York for school.

CHRIS TAYLOR: I'm from Seattle, but Seattle was really boring. I pretty much wanted to move to the East Coast since I was nine.

MATT BERNINGER: I worked a few blocks up from Mercury Lounge in the Puck Building and Scott ended up working there too. I would just leave my work every day and go down to Mercury Lounge by myself at like six thirty or seven, whenever they would open up. I would go early and start drinking Jack and Cokes at the bar. I felt like a total—not a fish out of water, but I was kind of a timid fish, in not-such-timid water. Mercury Lounge was kind of my mecca.

AARON DESSNER: We all grew up in Ohio, so we always sort of felt like outsiders looking in.

MATT BERNINGER: We didn't know what kind of band we were for a long time.

ED DROSTE: I honestly started making music in my bedroom totally unrelated to what was going on around me. It was actually more due to a depression and a confusion that was personal rather than, like, "Oh my god, there's a cool scene going on, I'm inspired and want to be a part of it."

CHRIS TAYLOR: When Grizzly Bear first formed, in the beginning, Ed wouldn't stand during shows. He sat in a chair, and I was like, "Oh man, we're so screwed." Like, "This is never going anywhere." The music was so weird and inaccessible, it had nothing to do with Interpol or the Strokes at all, and I was always kind of bummed

about that. I was kind of like, "Shit, I wish we weren't all so weird."

ED DROSTE: I remember so clearly all of those bands exploding. But I was a spectator.

AARON DESSNER: Interpol's rehearsal room in 2000, or maybe it was 2001, was right next to ours, so we would see them in their suits and kind of cower in the hallway and lament our lack of style.

MATT BERNINGER: I remember saying, "Listen to that band next door." I was blown away by them. We thought, "This is where the undiscovered bands come to practice, the people who are really good."

SCOTT DEVENDORF: We'd stop playing and hear songs off that first record and we'd be like, "Oh great. We got a long way to go."

MATT BERNINGER: A month later *Spin* magazine was doing a big feature on them and photographed them in the hallway of this practice space. They had, like, props and balloons set up and we had to kind of weave around. They had their suits on and we had our khaki pants and our work shirts. We were walking through what was probably Interpol's first photo shoot. It felt humiliating but also motivating. "Those fucking guys right next to us!? Yesterday they were right next to us, and now they're in *Spin* magazine?" That kind of shit happened a lot.

AARON DESSNER: Matt was at one of the very first Strokes shows at Don Hill's. There was like thirty people and he was raving about it.

MATT BERNINGER: On nights like that, I would just go home to Brooklyn, to a smoke and a six pack, and just start writing lyrics.

AARON DESSNER: We were aware when that Interpol EP came out with "NYC" on it. And everybody shit their pants. It wasn't intimidating, it was actually just so inspiring.

MATT BERNINGER: We would have liked to be the Strokes, but we were already older and from Cincinnati. We didn't own anything made out of leather, and Converse hurt my back. I was a New Balance guy already. So we couldn't be the Strokes. We knew we couldn't be and shouldn't try.

CHRIS TAYLOR: All those bands, those people were all on major labels and had very successful careers. Our whole chill, hug-core spirit

was a little bit slower paced. And that was definitely more of a Brooklyn thing.

DAVE SITEK: We had no aspiration of it taking off into the outer world. We were not in that headspace. When everything in New York was blowing up, all of our friends were headlining these giant festivals, and we were still making nine-minute songs about global warming. We were like, "Oh, we're cool over here, man." And to us, the idea of commercial success was never part of the equation. We weren't really friends with that world.

ELEANOR FRIEDBERGER: It only seemed weird that bands like the Strokes and Interpol were around at the same time as us when they started doing so well and I thought they were so bad. I just didn't give a shit about that stuff.

"YOU COULD SAY WE HAD NO RULES"

JENNY PENNY: Interpol were just so crazy good. I'd sometimes just sit by the sound booth and cry. You even knew at the time that it was super special. You knew, "This is amazing."

MOBY: Maybe a year after the Strokes broke, an old friend of mine from Connecticut, Peter Katis, played me a record he had just made by some band called Interpol. He said, "Oh, you might like this, because you like Joy Division." I listened to it and said, "This is really good." Then they blew up.

THOMAS ONORATO: Interpol were hometown favorites, then, all of a sudden they have a song on *Friends*. Do you remember that? I was at a friend's house who was watching the next-to-last episode of *Friends* where one of them professed their love to another one . . .

SARAH LEWITINN: Joey to Rachel! I only watched that episode for that moment.

THOMAS ONORATO: . . . all of a sudden this song starts playing, and I'm like, "Oh my god, this is an Interpol song on *Friends*!" I was so confused. But obviously it was good for them.

NILS BERNSTEIN: After *Turn on the Bright Lights* came out, everything ramped up.

DANIEL KESSLER: We went back out on the road, in the UK at first. It wasn't like we had a smash radio single, but we had a song getting played at certain times of day on radio stations.

ROB SHEFFIELD: Before I saw them live I was already a fan. I didn't know they were such handsome bastards. I was like, "What the fuck? Who are these dudes in the Dolce and Gabbana suits? Can't

they leave anything for dorky dudes? They sound like this and they're hot dudes that are well dressed? Fuck them."

PAUL BANKS: You know the guy in Pavement playing Letterman in shorts? That's not because he forgot he was doing Letterman that day, you know? All bands think about what they wear.

ROB SHEFFIELD: The suits were another anti-nineties thing. They were dressing up and doing a show, a show where they would play this super-fucking-mellow, dramatic rock. Art rock. It had none of the stasis and stagnation of art rock but all the pomposity and pretension. I mean, it cannot be said often enough that they put out their debut album and the first song on it was called "Untitled." Thank you very much. This is a historic level of ego. It's like, "Wow, this is some serious poser shit," and it was part of the appeal of the music.

JOE LEVY: Interpol is not a New York band, for me. They dabble at international sound, and it's why their sound comes from a British band as opposed to one out of New York.

NILS BERNSTEIN: I never thought they sounded like Joy Division. I never got that and I still don't.

MARC SPITZ: I know firsthand that you don't want to ask Interpol about sounding like Joy Division. They will tell you that they don't sound like Joy Division and their fans will tell you that they don't sound like Joy Division . . . but they sound a bit like Joy Division.

PAUL BANKS: What used to be upsetting to me was, if I were to die, my obituary would mention Joy Division. It was like, "I've got to just put enough work behind me so that the *New York Times* is not going to mention this fucking guy, Ian Curtis, in my fucking obit."

DANIEL KESSLER: I get the whole, "Oh, it's a cross between this and that." I get it. The whole post-punk thing but what's frustrating is it's something you're baptized with. You're wearing it around your neck.

PAUL BANKS: It just feels dismissive. But I also look at it as "Boo-hoo. The world didn't give you a fucking blow job for the first thing you did." People focus a lot on the superficial aspects of the band, like fashion and shit, and I don't want to even perpetuate that thing by talking about my bitterness.

ROB SHEFFIELD: Boy, they were good. They were really good.

SAM FOGARINO: I think a lot of it—the increase in partying—had to do with the bus. It symbolized upward movement. We weren't in a van anymore. That meant the venues were getting a little bit bigger and people were really catching on. It wasn't for nothing. We didn't just decide, "Well, let's get a bus and go into debt." Business-wise it all made sense on paper. And that's when I started noticing that I didn't have to move a muscle. It became easier to meet people; the party would just gravitate toward us.

JENNY PENNY: Fans would always invite them over to a house or one of their hotel rooms. The most fun was when we went to the Midwest and someone would invite us to some huge house in the middle of nowhere, and give you any drugs you wanted. And beer. There was this girl who hung around, Alexis, who we all agreed was the most insane person on the entire planet. One time we were in this car, on the way to some party at someone's house in San Diego, and when we got there she goes, "Oh my god, Jenny, I did something really bad. I peed my pants." So we go to this house party and she pushed me into this room and locked the door and went through some girl's closet. She pulled out a jean skirt, put her pee-soaked pants in a plastic bag, put on the girl's jean skirt, and we went to the party.

DANIEL KESSLER: I guess you could say we had no rules.

PAUL BANKS: Carlos and I were the guys who partied. Daniel was always a little more measured.

DANIEL KESSLER: They had a sort of libertine way about them. Self-preservation was not on their agenda. They were out for "What does the night have to offer?" I didn't pursue debauchery quite like they did. But while we were touring, I had a lot of fun; it was a really nice time meeting people, going out, touring the world, traveling, going to this bar and that bar, getting drunk.

SAM FOGARINO: I just remember getting on that bus and thinking, "This could end tomorrow. I'm just going to savor this in every possible way."

ANTHONY ROSSOMANDO: For every scene, there's always someone who is creative, who's not a musician or player; he's creating an atmosphere where people come together and get high and listen to great music and have really long, involved discussions that they don't re-

member about really personal things. For this scene, Jason Baron was that guy.

PAUL BANKS: Jason photographed Interpol in London.

JASON BARON: It was right before the album came out. Interpol was the first band I ever shot—for *NME*.

PAUL BANKS: Carlos and Jason hit it off, and then I would tag along with those guys. Jason just knew how to party.

JASON BARON: We became friends very quickly. We had a lot in common.

SARAH LEWITINN: I'm trying to think how I first met Jason. There was a hotel room? Interpol was there? He was friends with Carlos? Let's be clear, a lot of people met because of cocaine.

PAUL BANKS: Then he moved to New York and opened the Darkroom, the biggest and most amazing party scene of that era. He single-handedly made that happen.

JENNY PENNY: After Darkroom opened, that's all it was, just Dark-room, all the time.

JASON BARON: I came over to New York for a friend's wedding with a carry-on piece of luggage and just stayed. When anyone from New York would go overseas, they'd be the last people standing. So all over the world, the thought was "Those people are crazy! Let's go to their city, and when we go to their city, we're going to be crazy, too." When people would come to New York from anywhere else in the world, I was kind of the point man if you wanted to get in trouble. I was an excuse for a lot of breakups.

ANTHONY ROSSOMANDO: The stories I have from the Darkroom with Jason . . . fuck. It was called the Darkroom, and darkness descended, my friend.

JENNY PENNY: You'd go every night. You'd get a drink upstairs, a double of something, and go straight to the basement, and just see who showed up. Jason also lived upstairs, so there was that.

JASON BARON: You develop a lot of new friends really fast in New York. I guess there's an international degenerate underground.

ANTHONY ROSSOMANDO: Jason was an excellent host and the grand wizard of enablers. He was constantly just like, "Let's do this, take this upstairs, what about these two? Yeah, she's hot . . ."

JASON BARON: Honestly, I could abstain from sex for, like, ten years and still be proud.

SARAH LEWITINN: We all lost years of our life in that place.

ANTHONY ROSSOMANDO: It was like swimming in a pool of cocaine; it was just diving into a sea of white.

JASON BARON: One of the funniest ones is that Australian band, Jet. I get a phone call from one of them and they're like, "Have you seen our singer?" I'm like, "No." They're like, "He's in your bar." I go downstairs, and this dude is just chilling there. They're supposed to be in DC opening up for Oasis in fifteen minutes. He's like, "What's up, bro?"

ANTHONY ROSSOMANDO: Yes it was dirty, but you'd also have emotional heart-to-hearts in there with people that you'd only see in that room. I only saw Paul Banks there. I think Paul lived under Jason's couch. I also think that Paul had clean sweaters waiting for him there.

JENNY PENNY: Paul always wore extra layers.

ANTHONY ROSSOMANDO: I looked awful, I was dirty, I had shit under my nails. But Paul! He'd have this sweater tied around his neck like fucking James Spader—James Spader of the music scene.

PAUL BANKS: Anthony who?

ANTHONY ROSSOMANDO: It was more wild than other bars. At those other places, you still had to go to the bathroom to take drugs, or the kitchen, the weird room. The Darkroom was more . . . community based. No one was too possessive about their drugs. There was an abundance.

JASON BARON: The first week we were open the Libertines had the after-party for their Bowery show at Darkroom. I gave those dudes a couple of free beers and they didn't leave for a week.

JENNY PENNY: I'd come home at ten A.M. every day. I would just go home and take whatever sleeping pills someone had given me. I'd

put on a movie in my bedroom and try to sleep. I had a blanket nailed to my wall to block out any sunlight, and my roommate was always leaving for work or something.

PAUL BANKS: I'd wake up around two. Or when I'm really rolling, five P.M., six P.M. Coffee, then maybe Bloody Marys before coffee or right after coffee, then beers in the early afternoon. And then maybe pool after dinner. Then, from playing pool, Whiskey Ward to Max Fish for more pool, and then Darkroom until close, and after that, Jason's place until six, when I would try and get back to my girlfriend at what I thought was a respectable hour, rather than go to the full eleven A.M.

ANTHONY ROSSOMANDO: I remember sharing sunglasses with Paul a couple of times. Somebody was keeping some spare cheap sunglasses around. Talk about being prepared for the inevitable . . .

PAUL BANKS: Jason and I became close, close friends. I loved spending time with him.

JASON BARON: Me and Paul would be hanging out, watching *Saturday Night Live,* and he'd be like, "Yeah, I like that band," and twenty minutes later, that band would show up at the bar.

PAUL BANKS: I was like a fixture in his apartment from four A.M. to six A.M.

JASON BARON: Then there was Bushie.

PAUL BANKS: Bushie is amazing. He was a coke dealer who would beat people up . . . and play street ball and wear awesome sneakers. He was so fashion-forward. He would be wearing neon windbreakers. He was like a male counterpart of MIA, but way earlier; that's how ahead he was in terms of fashion.

JASON BARON: Paul and I would be at my place playing chess, and I'd go knock on Bushie's door, just to see what he was up to. Bushie would open the door buck naked. Just this little white dude buck naked with eighteen girls behind him, piles of drugs everywhere, and he'd be like, "You want some?"

PAUL BANKS: I remember one day when he came down from his apartment upstairs to supply the party at Jason's, wearing just sneakers

and a T-shirt. He was bending over, you know, balls out, and I don't think he was aware that he had no pants on. He was just gone.

KAREN RUTTNER: There was a story that went around that Axl Rose showed up in the apartment one night.

JASON BARON: Yeah. He did. This was pre-kitsch, cool-again Axl, this is Axl with cornrows, before *Chinese Democracy*. I was hanging out—I think Paul had just left—and I was just sitting there with some people when someone's like, "I'm bringing Axl by." I'm like, "Fuckin' all right," and the dude came by. He had the tight curls. He was wearing hip-hop clothes. He kept going, "Yo, you want to hear the CD?" talking about *Chinese Democracy*. I convinced him my CD player didn't work. He was the last one out, shaking beers in my apartment.

PAUL BANKS: I always had an inclination toward that world. When you go out and it's late at night, you're seeing something that's more real. You're seeing people loosened up. Loose around the edges. And real crazy shit can happen. People get into real fights, and people get fucked up. At that age, I felt my only way of accessing real things was in a dark room late at night where drugs are involved.

DAVID CROSS: It's important to point out that this wasn't all some romanticized hellish rabbit hole of shit that we went down. It was never a plan. It was more that you'd be out, you'd find yourself at the Darkroom, then you'd be upstairs, and then whatever. Those nights would happen. You'd go see a band, and you know the people who hang around bands, the shady people. You end up there because you're bored, and why the fuck not? You're in New York fucking City and you're a celebrity. I'm not proud of it. That's just what the life was.

STROKES VERSUS STRIPES

DEAN WAREHAM: I remember doing interviews around this time and everyone was just like, "Is it true that the Strokes and White Stripes have saved rock and roll? And New York is the place again?" It was like, "I guess so."

RYAN ADAMS: When the Strokes and the White Stripes played Radio City, everybody did kind of go, "This is it. This means we did it."

BEN BLACKWELL: The Strokes/White Stripes Radio City gig was August of 2002.

RYAN GENTLES: We did those shows together, one at Irving Plaza and one in Radio City, and two in Detroit. It was Julian's idea. Julian and Jack had talked about it; they said they wanted to do a tour, and Julian said, "Let's just do a show in your town and a show in our town," and Jack said, "Let's do a small one and a big one," and we split everything fifty-fifty. That created a friendship.

JACK WHITE: Julian and I got along well.

RUSSELL WARBY: I'd made sure they met. We took Jack to a show that the Strokes played in Leeds. They had been really blissfully unaware of each other. I can remember telling the Strokes about the White Stripes and they didn't know of them. And the White Stripes did not know the Strokes personally, but Meg liked the Strokes' record.

JACK WHITE: In England I was very interested in the Strokes, and very disinterested in what I felt were tabloid-y mags trying to figure out how to make us into "rivals." I was not interested in that nonsense at all. I liked their band very much.

RUSSELL WARBY: So I made sure they met because it can be quite competitive, you know? I wanted it to be a situation where they could play together.

JACK WHITE: At an early point Nick Valensi and I stayed at the same hotel in London and we got to sit and talk. He brought up that we were sort of in the same boat over there in London with all the new attention. I agreed, and Meg and I took a train to Leeds to see them play. I loved their show, but it was the first time I saw a band not do an encore on purpose, and I remember thinking that might not be a good showmanship idea. Who knows? The show was great.

BEN BLACKWELL: The Detroit shows were first.

JACK WHITE: Julian stayed at my house and slept in my childhood bedroom, even wore my pajamas. He came into my room in the middle of the night thinking it was the bathroom and we laughed. He had a broken ankle or something though, so it was hard getting into our local Coney Island in the morning for breakfast with his crutches.

RYAN ADAMS: I was at those shows at Radio City. I remember standing on the side of the stage right before Jack walked on to play "New York City Cops." Beck was standing there too, because they're friends. Julian had a broken leg, so that was a bummer for him, but he still totally kicked ass.

BEN BLACKWELL: After one of the New York shows, we all ended up at that bar across the street from Manitoba's, 7B.

RYAN ADAMS: Everybody went downtown in the back of a pickup truck. I remember thinking, "Someone is going to die," because everyone was pretty wasted.

BEN BLACKWELL: This is the power that the Strokes had in New York City at that time. We're walking into 7B, and Fab is just like, "Hey, man, my buddy doesn't have his ID, but he's cool, I totally vouch for him." And the guy just waved me in. So, I was like, "Wow, these guys fucking own this city, don't they?"

NICK VALENSI: Okay, but the White Stripes were huge! They had put out *White Blood Cells,* they were on MTV, they were really big.

HAR MAR SUPERSTAR: It was all about the Lego video, "Fell in Love with a Girl."

JACK WHITE: I have twenty or so nieces and nephews, and I remember them wanting to watch that Lego video a second and third time, which shocked me. I couldn't believe young kids wanted to experience something Meg and I had made. The childish theme was one we revolved around a lot, so that was a magical moment to see it come full circle.

ROB SHEFFIELD: It was June 2001 when I saw the White Stripes for the first time. I saw them with Jenny Eliscu, of course. Jenny was just an absolutely selfless booster, and she was never wrong. It was at Bowery, and it was just the two of them; they did not stop between songs and they were not fucking around. They played fast and kept doing it without sort of hemming and hawing, and there was that intensity and that enthusiasm. It's weird how much of it just comes down to that word: "enthusiasm." Like, these are not, like, stare-at-the-floor-and-diddle-and-tune-up-and-make-grumpy-faces-at-the-sound-guy bands. I get why musicians have to do that. But I fucking hate it. It was mid-June, a Sunday evening show that felt like an afternoon matinee because the sun was still up when we went in. Ninety percent of the people at the show were there because of Jenny. I remember they did both "Jolene" and "Stop Breaking Down" and I was stunned they had the chutzpah to do these sacred songs, and even more stunned they had something new to tell me about them. They did all these songs from the *White Blood Cells* album, which hadn't come out yet, so none of us had heard them before. I thought they were doing a cover of the Clash's "Sound of the Sinners" but it turned out to be "Hotel Yorba." If I recall correctly they ended with the Marlene Dietrich one. Man, that's a show I'll never forget.

MARC SPITZ: The White Stripes' publicist, Chloe Walsh, was just so persistent, to her credit—no one was writing about them. They'd already put out the *De Stijl* album, which was also amazing, but no one knew that yet.

ROB SHEFFIELD: *White Blood Cells* had just come out and was so great, but it was funny, I hadn't heard the first two.

MARC SPITZ: So Chloe was trying to get them some mainstream love. She kept harassing me to listen to this record, *White Blood* something. I'd played it once and I didn't hear it.

ROB SHEFFIELD: At that show, someone just climbed onstage and sang "You're Pretty Good Looking (For a Girl)." This guy kept yelling for it and like, Jack was like, "I don't feel like doing that one," so he just climbed up onstage. He was wearing a muscle shirt and a red bandanna and mascara, looking like Paul Stanley trick-or-treating, and was no spring chicken either, and I thought, "This guy must be famous, or in a seventies band, or at least a friend of Jack's," but no, he was just a really big fan who really wanted to hear that song. The next day, I walked up to Rockit Scientist in the West Village to buy any White Stripes albums they had. The guy said, "Funny you should ask. A lot of people have been coming in and asking for those today. They're all sold out." I bought the last White Stripes record he had in the store, which was a CD copy of the debut, and I was glad to get it. Every other record of theirs sold out that morning.

MARC SPITZ: Chloe kept after me and I was like, "All right. Here, I'll listen to this fuckin' album one more time." So one morning—it was probably around one in the afternoon, and I was having breakfast, which would probably be a line of cocaine, four Camel cigarettes, and a large coffee, and maybe a chocolate doughnut. And something clicked when he said, "Said it once before, but it bears repeating now." And it was like, "Wait a minute. That's kind of great." And I played it again, and then the riff got me and just spun my head around like a blender. That riff was so good and fast and dirty and you could actually see someone in your mind playing it. Whereas like, you couldn't really see Sugar Ray making their records, in your mind. They didn't sound like people made them. They sounded like they hired people to make them. So I went back and I listened to the whole record. And *then* I heard, like, "Dead Leaves and the Dirty Ground," "Hotel Yorba," and I felt a palpable shame. It would be easy for me to say, "Yeah, I was into it from the jump." But I was in a bad, cynical place, because it was my job to write about Mark McGrath.

ROB SHEFFIELD: The most popular band in the nineties was Pearl Jam and lots of people were wondering where the bands like them were. The guys that are not trying to do a mega-angsty theatrical production about their parents and their upbringing and their anger management issues—just dudes with guitars that want to rock. I have a friend who was a janitor and I would pass promos on to him sometimes. He was a biker guy, and he was like, "I like Pearl Jam, why the fuck didn't those guys make another record?" And I'd say, "Actually, dude, they made another record last year and the year before that and you never heard it because nobody cared. They're making lots of records. Like, they're about to put out seventy-two live albums this week." But I remember I said to him, "I've finally got one for you. The White Stripes." They were the only band I told him about where he was like, "Yes." Even if you were not invested in the idea of cool or invested in the idea of New York or even invested in the idea of newness, then you could still rock.

JENNY ELISCU: The first time I saw the White Stripes, I went to see Sleater-Kinney and I got there early and they were opening up. It reminded me of Royal Trux, first and foremost, except Royal Trux were always a little too scuzzy and sleazy. They had that album cover of a toilet full of poop, which kind of bummed me out. Like, I get it but I needed something a little bit cuter and more twee, in a way, not that the White Stripes are twee, but that early stuff, even some of the music on *De Stijl*, has more of that classic indie rock Kinks-y thing. So I was just like, "Who the fuck are these idiots?" I mean, it was, like, really scrappy, and Meg White was a terrible drummer, but they were fucking awesome. And I definitely didn't remember ever having heard their name before.

ROB SHEFFIELD: Six months later it was completely different. I think they did four nights at Bowery and they were all sold out. I remember seeing Bette Midler there and I was like, "Oh, this is beautiful." It wasn't, "Oh, now this is over." It was the opposite of over. The fantasy we always had about all the bands that we always liked in the nineties was "Man, if they could actually play their music in front of people and people heard it, they would like it"—whether it was true or not. It was happening with the Strokes and the White

Stripes and you could tell because Bette Midler was showing up to see the White Stripes at Bowery. It was like, "Wow, this is crossing boundaries."

JENNY ELISCU: Radio City, I mean, obviously is a venue artists recognize; it's like playing the Greek Theatre: you're like, "Wow!" You would have dreamed of it, and it feels like a real moment in your career. And even though both bands were big enough to play it on their own, it was like, "Ooooh! Together, wow! Now, that's cool!" It felt like undeniably a hot ticket.

MARK RONSON: That show was the first time I saw Jack White play guitar live. I was completely blown away.

JENNY ELISCU: For one of those shows, *Rolling Stone* hosted a party afterward at Lit, the darkest-lit place on earth.

AUSTIN SCAGGS: That was really the big night. I had just met all those guys, and I told Ryan Gentles about one of those illegal poker places, and he's like, "Oh yeah, we've got to go to that." So I took him and then all of a sudden, Julian was coming with us. I was starstruck. I thought Julian was just untouchable. He was the most elusive one, the most drunk one, the most . . . He was scary. A very intimidating kind of presence. But then we all started playing poker. Ryan started hosting poker tournaments in his house.

HAR MAR SUPERSTAR: They were totally stone-faced poker guys. I don't know who the best player is. You could ask Ryan. He'll say it's him.

RYAN GENTLES: Sean Lennon had a poker game at his apartment, and taught me how to play, and I was hooked. I wanted to do it more regularly, and Julian got way into it and convinced me to do this, and Austin Scaggs. So I started hosting. It was me, Julian, Albert, Fab, Austin, Sean Lennon. It turned into a thing where I did it every week with a bunch of different players.

CALEB FOLLOWILL: I always beat those guys at poker. The first time I went to Ryan's, I was so green, and it was so infuriating to them because I would lay down my cards and be like, "Is that good?" And they were like, "You motherfucker." Just one winning hand after another.

AUSTIN SCAGGS: You were right in the center of the vortex, in the middle of your everyday life.

JENNY ELISCU: That party after the Radio City shows was good. I don't remember if Jack came actually, now, but I'm pretty sure. But the Strokes all came. It was like, if I have to go to a Strokes after-party, it was the party that you would actually want to go to. You'd want it to be at Lit, you'd want Justine to DJ. But there were elements that made it feel like part of the new era of, of the new awkward era of everyone wants to meet these guys.

RYAN ADAMS: It was the first time I saw the competition. The Strokes invited the White Stripes to their biggest New York show, but the White Stripes were already on their own path to get big. I remember there being a moment of me going, "How's this going to play? How's this going to feel later to the Strokes?" Everybody talked about that show being a big deal, but I think because the White Stripes were on that bill, it lessened the feel of the Strokes going, "We did it! We conquered New York City for New York City rock again!" Because as everyone knows and says, it was a no man's land before that. But there was talk that night, or at least there were subtle undertones, spoken or unspoken or both, of, "Was it a bad idea to have the White Stripes be there?"

MARC SPITZ: I don't know . . . It wasn't the Strokes versus the White Stripes in a Beatles-versus-Stones kind of way, or a Blur-versus-Oasis kind of way. Really early on, even, there was a show at the Bowery Ballroom—and I can't remember who was playing; it might have even been the White Stripes, or maybe it was Yeah Yeah Yeahs—and I saw Julian and Jack together, and they were chatty, and maybe had their arms around each other. And I felt like, "Well . . . they get it." You know? It wasn't like *them* versus the White Stripes. It was all of us versus Coldplay and Limp Bizkit . . . and George Bush and al-Qaeda, you know? It was the cool kids fighting back.

STEVEN TRACHTENBROIT: Jack is super creative, super independent minded, and Julian has that same thing; he has a lot of ideas. I'm not necessarily a big fan of Jack, but I like the fact that he's always

pushing something, and I feel like Jules is trying to do that, he's trying something, he has a vision. Sometimes it works, sometimes it doesn't. You have to put yourself out there, you have to do it. Jules has that capability, but he stopped himself, and I feel like Jack didn't stop himself, and so he succeeded. He won, out of the two. The Strokes opened up the door for all of these bands, and the White Stripes just went, "Thank you very much," and passed right through.

MARK RONSON: What you have to remember is that at that time, there were no great rock records that you could play in a hip-hop set, there were no quote-unquote black rock records. There hadn't been in ages. The Strokes were cool and people liked them because they had the kind of jump-up rhythm, but they were hard ones to play on a dance floor. Then "Seven Nation Army" came. I remember being at Sound Factory, a hip-hop party, and Kid Capri was DJing that night. Kid Capri is a pillar of old-school New York hip-hop and seeing him throw on that song in the middle of his set, I was like, "Wow, this shit's finally come around." Jack came and played guitar on a song on my first album, but then he heard the record when it was finished and he didn't like the rap that Freeway had done on the track, so he made me take him off the song. I wrote him a letter. I was like, "Listen, I know you don't like this rap, you might not get what he's talking about, but you mean a lot to people in rap and I wish you could see what it's like when you play 'Seven Nation Army' to a club of seven hundred young black kids at two in the morning. Your music means something to these people."

RYAN GENTLES: For the VMAs that year, right after the Radio City shows, MTV wanted to have a battle of the garage bands, between the Strokes, the Vines, and the Hives. They wanted the Strokes to play on the main stage. Julian was like, "No, I'll go play on the Video Music Awards—but I just want to play my song and we're done, that's cool, I won't do this weird thing where I play a thirty-second snippet and then the Vines play theirs. We're not competitors. I like those bands, but some of the songs I don't like, and I don't want to make people think we're part of that scene." That's Julian. Everyone's like, "He's crazy, you have to make him do this." And I say, "All right, I'm going to bring him to lunch and we'll try

to talk him into it." "Fine, we'll show him." Then we get to lunch and he's like, "No." And eventually they're like . . . "Okay."

ALBERT HAMMOND JR.: When MTV wanted us to do the VMAs, we said, "Okay, we'll play the VMAs, it sounds awesome, we saw it when we were kids." When it was "Oh, you want us to do it as a medley with the Vines and the Hives?" No. I didn't want to be defined by these other bands, which is nothing to say against those bands, it's just a decision. It's so early on in your game, you're trying to push really hard to be perceived bigger than you are, so you can push forward. It's a catch-22. You learn.

PATRICK MATTHEWS: Before we played the VMAs, we first came to New York in early 2002. We played Mercury Lounge, and later, CBGB. The Strokes were there. I remember one of them had a joint and offered it to me and I just didn't like joints, so I didn't take it. Another time, at a music festival in Scotland, I was standing in the back stage area and Albert walked past and he put his hand out to shake and I dropped my cigarette like a hopeless rube. They were really intimidating.

HAR MAR SUPERSTAR: I took Kelly Osbourne to the VMAs that year, when White Stripes won everything. The Strokes were there, and then afterward they played that Milk Studios party with Mos Def's band.

JIM MERLIS: Cornerstone put this party together with Levi's. The idea was to be a sort of anti-VMA party. Mos Def and the Strokes played. Rufus Wainwright came and Dr. Dre came, and it was insane. I remember seeing Dr. Dre watching the Strokes and digging it big-time.

ALEX WAGNER: That was a legendary party.

JENNY ELISCU: That was a fucking lame party. You could tell what a clusterfuck it was from down the block. There was some shitty, clipboard door person who couldn't get me in. We ended up getting in anyway, only to have it be too dark, too impossible to get a drink or use the bathroom, just this cluster of gross chaos and people trying to make the scene. I mean, it was gross, it was ethically gross, you know what I mean? It was the kind of thing where people were people were gonna piss in the trash can. And as some-

one who had seen the Strokes play to, like, fifteen people at some club in Philly, it was like, "Fuck everyone." It definitely felt like, "Oh no, those of us who loved them up until this point are going to leave them now to a bigger world." It's a classic thing where if you got in on the ground floor, it's because you don't want to be a part of that world, and then you're happy for them to get there, because you want your friends and the things that you love to do well, but I felt sad. Like, "That's it, I'm not gonna see those guys as much anymore," you know?

JIM MERLIS: We, as a company, Big Hassle, got paid, I think, twenty thousand dollars to get press to it. I was like, "Really? You want anything else?" That's all they wanted.

JENNY ELISCU: I wonder how those guys felt about that party. They probably were not really capable of taking it in at the time, because they were having so many experiences like that. I wonder if what we know now as, like, a shitty corporate hipster party was just in its nascence then. I wonder if the Strokes were accidentally part of the foundation of that entire weird zone. They were so cool, so many people wanted to glom onto them; that helped give rise to a bullshit aesthetic-based version of something that to a lot of us was genuinely meaningful.

JACK WHITE: We all had a lot of opinions and worries about what was happening and what was the right next thing to try; it was powerfully exciting and energetic. People really loved music all around us and you could really tell. You can't manufacture that kind of energy in the world of the arts; it has to be decided by the mob and god herself.

48

"I LIKE THIS INTERNET THING"

JOHN HEILEMANN: The obvious thing to say is that the same overriding forces of technology that caused the commercial, economic, and cultural fallout that changed the music industry and changed music are also the forces that changed the industry that covered the music industry and music. That's all just of a piece. Of course there would be outlets online, whether it was individual blogs or Pitchfork, that would rise up to cover this new phase of the industry.

BEN BLACKWELL: At that Radio City show I remember thinking that the three new songs the Strokes played were so good and I pretty quickly got a recording of that show. I think it might have even come from that girl Laura Young who ran that Modern Age blog.

IMRAN AHMED: As new bands editor at *NME*, I was very aware of the New York music bloggers. I used to look at the Modern Age blog every day.

LAURA YOUNG: I was working at *InStyle* as an intern and they had a freebie table. I was in the research department and I remember somebody coming over and they were like, "Oh, hey, you like music, right? I found this CD." And it was *Is This It* with the UK cover and "New York City Cops" on it. I remember seeing it and flipping out. I went home and listened to it and that was pretty much it.

BEN BLACKWELL: Laura was very instrumental. When the White Stripes played Letterman and we walked out the back door, she was there. She was always writing about whatever we did, both the White Stripes and the Strokes.

LAURA YOUNG: With Napster, there was a lot of free music around, or music that you could get for no money very easily. And being in

New York, you have some of the best concert venues at your fingertips and thousands of bands coming through here trying to get press. So it just worked.

JASON GORDON: Laura was the first one that I got acquainted with that had a blog about music. It wasn't like her blog was anything exceptional. It was just wonderful that here was this blog about a girl who is obsessed with two bands that are amazing, the White Stripes and the Strokes, both of whom were still playing at Mercury Lounge at that time. And I was at those shows. It was like, these are my people.

IMRAN AHMED: Laura's blog, which was named after the Strokes song, obviously, was probably the most important because Laura was obsessed with the White Stripes and the Strokes. She was like the New York arm of what we were doing in the UK, but because she was much more in the thick of it, she would go out and take photos of the White Stripes and the Strokes doing stuff in New York and it seemed really relevant.

SARAH LEWITINN: Back then, there were no cameras. I had a digital camera, but you had to host photos on Flickr or something. When you managed to post photos online, it felt like a really big deal.

SCOTT LAPATINE: This was way later, and obviously Arcade Fire are not a New York band, but it sort of represented that era: I saw them play at Mercury Lounge at CMJ in 2004, and I was in the front and taking photos on a cheap camera and putting them on Stereogum, and *NME* was like, "We want to run your photos in a big two-page spread." I was like, "Seriously? And you'll pay me?" If you had a camera, you were in the game.

IMRAN AHMED: I also used to look at Sarah Lewitinn's [Sarah's] So Boring [Ever] Since [She] Stopped Drinking blog every day.

SARAH LEWITINN: I started blogging a little later than Laura. We had a Fourth of July party on the roof of our apartment on Rivington Street, and it was craziness. I was shitfaced trying to clean up and I ended up cutting myself. Multiple people saw me freak about the mess, clean up, cut myself, ignore the cut to finish cleaning, and I think they were like, "She has had so much to drink that she can't

even feel her cut." It was a gash, really. So my brothers confronted me. I stopped drinking but they would still call me every day and every night to check up on me. I decided to make the blog so they would stop calling me every day.

MICHAEL HIRSCHORN: Sarah was a kind of mascot. She was this, like, teenage virgin, Sabbath-observing party girl. She was highly fetishized.

SARAH LEWITINN: By the way, I started drinking again less than a month later.

MARC SPITZ: Ultragrrrl was my discovery. I was recently hired at Spin Online; we were still part of AOL. And she instant-messaged me. This is, like, back when I didn't even know what the fuck an instant message was. It was just like, "What is this box appearing on my screen?" She said, "I really like what you're writing, you should give me a job." And I said, "Why?" And she's like, "'Cause I'm Ultra." And I said, "What the fuck is an Ultra?" She came in and she looked like an alien, with a man's sort of bleach-blond-yellow, Tweety Bird quiff. And she had no eyebrows; she'd bleached and plucked them.

SARAH LEWITINN: I remember telling Marc, "They were evil, they had to go."

MARC SPITZ: She was this anime, like, *Aeon Flux* person. I told Ron Richardson, my boss at the time, I said, "Hey, you've been talking about how we need an intern . . ." It was like a puppy. "Can we keep her? Can we keep her?" Alan Light was editor in chief. And Sarah and I would go to Alan, who wore button-down shirts and trousers, and we'd sort of prance around him in our feather boas and leather jackets and hope he'd notice us and, I don't know, make us stars. Meanwhile the guy is trying to keep the magazine from going under in a world where Creed are selling ten million records. We were hipster mosquitoes up in his shit, going, "*Spin*! *Spin*! Party!" Sarah was my partner in stirring shit up.

ANDY GREENWALD: I love Alan, but he didn't give a shit about Spin.com.

ALAN LIGHT: It felt like it was bulletin boards and it was chats and it was fun. Online was a good excuse to have those kids around and

give them something to do and sort of develop them a little bit and develop some of this kind of coverage. But I don't remember having any sense of who was reading this.

SARAH LEWITINN: In the early days blogging was fun because it was just so stupid and raw and bizarre and human. I was working at *Spin* at the time, but no one at *Spin* thought anyone was reading my blog. I didn't think anyone was reading my blog. You didn't have trackers to mark the traffic you were getting.

JOHN HEILEMANN: People would say to you, "This is bullshit, it will die, it is unsustainable, it will go away, this is not the future."

TRACEY PEPPER: They were downstairs and the magazine's staff were upstairs. It was dark where the online team worked and there were no windows. Truthfully, I didn't pay that much attention to online. None of us did. I have a vague memory of being asked for interview outtakes that they could use online and my grumbling about it. It was just extra work for us.

ANDY GREENWALD: We were so left alone and ignored. We had such autonomy. We were running our own reviews of records. We had a full-time video person, we did all of these incredibly cool features— Chris Ryan doing karaoke with Cat Power all night. Crazy shit like that. We had every band that's big now come into our office and play acoustic on video, but no one had broadband except for college campuses, so no one could watch it. We had Death Cab for Cutie and Spoon and Interpol and all these bands come and sit on our couch and no one cared. No one in the office cared. No one even noticed.

SARAH LEWITINN: I knew about Interpol way before they signed to Matador. I had a copy of their demos. I played it for my friends at *Spin* and they liked it too. We would go see their shows. It would be me, friends from *Spin,* and the girlfriends: Paul's girlfriend, Daniel's girlfriend, Sam's girlfriend, and the seven girls that banged Carlos that week.

DANIEL KESSLER: I don't know what position Sarah had at *Spin,* way back in the day, but they took her seriously. She was a teenager, but she was really passionate, and she had their ear. We went in and did

a *Spin* web session. It was in their conference room. It was the days of, "We'll take anything you give us."

ANDY GREENWALD: This was around when Pitchfork launched, by the way. So later they were doing everything that we were doing first.

JOHN HEILEMANN: There was the world of mainstream publishing in New York City, which had not really accepted the idea that the Internet was here to stay. The idea that it would even be a coequal element of their publishing model, let alone the idea that it would be dominant, no one thought that. No one thought that and anyone that claims they thought that is full of shit.

RYAN SCHREIBER: There was still that fear that if they published everything online, who would buy the magazine? The print publications were extremely guarded about the Internet, wary of it, and their lateness allowed us, allowed Pitchfork, to establish ourselves as the authority because there was no other existing authority on the Internet.

IMRAN AHMED: Another one, maybe a little later, was Stereogum. I looked at Stereogum every day.

SCOTT LAPATINE: I bought Stereogum.com in 2003. The name comes from a song lyric from the band Air.

IMRAN AHMED: And there was one other one . . . Product Shop NYC!

JASON GORDON: When I was really young, growing up on Long Island, I had a print zine that I made in my house called *American Mod*. It was an awful name, so we changed it to *Product Shop NYC*. I was just fan of music and I started interviewing bands like the Make-Up, Jonathan Fire*Eater, Blonde Redhead, D Generation, and Weezer. After college I came back to New York. I decided to leave the music industry, because in college I discovered this website Napster and thought, "I am not going to work in this industry that's going to die. I am going to go into book publishing!" Ugh. But I was friends with all these people in the music industry in, like, the '90s and early, like, 2000s, and I was going out to shows all the time and meeting all these bands. I was at shows, like, five days a week in 2001.

ROB SHEFFIELD: The collapse of Britpop has a lot to do with this. The people who are interested in these bands in the early 2000s ordinarily would have been interested in bands from London, and the sort of cultural turf that the New York bands operated was turf that had been abandoned by Britpop. Suddenly there weren't London kids in skinny pants and leather jackets anymore. So people all over the world who looked to that, they found it in New York. I mean, it's funny, when the Stokes started and people said, "The Ramones! Television!" They don't sound like those bands at all. They sound like Elastica.

AUDREY NEUSTADTER: In college, I discovered a deep love for music, especially indie and Britpop. When I moved to New York, I started going to a few shows, mostly British bands passing through, and I became an avid *NME/Uncut/Mojo* reader. I was going to Rebel Rebel, Other Music, and Tower Records on a weekly basis to buy imports before they were released in the U.S. Interpol was my band. When I first saw them, I immediately connected with the Joy Division references. By the late nineties I was obsessed with message boards. When I had to choose a name for those forums, I picked "Melody Nelson" as my handle, since I had been a big Serge Gainsbourg fan for years. All my friends in New York were big music fans, and as I started going to more and more shows, a lot of them were interested in knowing what I had to say about the shows and bands. I launched my blog in the fall of 2002.

ROB SHEFFIELD: Audrey's blog, which was indeed called Melody Nelson, plus The Modern Age and Sarah's So Boring, a few other more short-lived ones like New York Doll, really erased the barriers between fan and reporter. In the nineties they would have been fanzines, but these blogs were accessible all over the world instantly, which meant they were influential. Very girl dominated, which wasn't necessarily the case with eighties or nineties fanzine culture.

SIA MICHEL: I remember reading Stereogum and The Modern Age, which Sarah introduced me to, and of course I read her blog too. What I really liked about the early blog era is that young women

who might not have felt like they were welcome in the still very male-dominated rock critic world were finding a voice and a new way to cover the scene. There was something about it that reminded me a little bit of the riot grrrl zine era. These bloggers were an interesting mix of fan, reporter, cool hunter, and authority. Now everyone has a social media megaphone, but at the time it seemed so striking that anyone could weigh in about music. I also really liked Fluxblog and the MP3 blogs that followed. I remember how exciting it was to sit there and so easily listen to the exact tracks you were reading about.

ROB SHEFFIELD: There were boys doing them too, like Jason Gordon, but it seemed like it was the girls who were tastemakers. *NME* in this period was basically a weekly UK magazine reporting on what was in NYC rock-girl blogs last week.

MARC SPITZ: This was an era where the *NME* was calling the people in these bands as if they were part of a gang, like Julian wasn't Julian Casablancas, he was Julian Strokes. It wasn't Paul Banks, it was Paul Interpol. Like a sort of tabloid-ization of the scene, which actually had the effect of making everyone closer. The bloggers were the same in a micro way. On the scene in New York, it wasn't Jason Gordon, it was Jason Product Shop. Like, his last name was his blog. Melody Nelson wasn't that blogger's name. It's a Serge Gainsbourg fictional character but that was her calling card, that's what you called her. Laura Modern Age or Miss Modernage. Nobody called her by her last name. I still don't know how to spell Ultragrrrl's last name. I think it's with two N's?

ROB SHEFFIELD: I remember when Yeah Yeah Yeahs were on the cover of the *Face,* and in the story there was a photo Nick Zinner took onstage with Karen rocking out at Bowery Ballroom and the photo cracked me up because you could see all these faces in the front row who were NYC rock-girl bloggers—Audrey from Melody Nelson, Laura from the Modern Age, etc.

JASON GORDON: You didn't feel like anyone was even reading it, except for like your ten friends.

TRACEY PEPPER: I have no memory of reading any blogs except Sarah's. And I definitely didn't see them as a threat. I was very snobby

about journalism. I wasn't interested in reading the special thoughts of people who fancied themselves writers.

ROB SHEFFIELD: The bloggers weren't really critics, as far as I could tell; they weren't interested in arguing about why you should or shouldn't agree with them. They only had time for the bands they liked. If they didn't like a band, they just didn't write about them. But there was absolutely no way to bullshit these girls. They had zero incentive to pretend to like a band they didn't like. Also, iPods had just been invented, so almost all these girls were part-time DJs, which was now suddenly an incredibly easy job that required zero technical skills or record-collecting tendencies.

JOHN HEILEMANN: The mainstream magazine publishing world did not really capitulate to the fact that the web was here to stay until 2001, 2002, when it didn't go away. When the web didn't collapse along with the tech bubble. The tech bubble collapsed and everyone exhaled, and then the web didn't go away and traffic kept going and people were like, "Wait, huhhh . . . ?"

LAURA YOUNG: When did I realize something was shifting? A year or two after I started. I had already graduated college so I was working some internship right out of school. There was a moment in like 2002 or 2003 where I was just someone writing, and then these other people are commenting on it, which was kind of strange.

SARAH LEWITINN: I first realized people were paying attention, like for real, when they started trash-talking me online.

SCOTT LAPATINE: I went on my honeymoon. I was going to have to take a break from blogging, and at that point, I couldn't just shut it down for two weeks. I had a college friend take over. It was like, "Hey, Jim, here's the password, maybe you can keep it updated while I'm away." And when I got back, he had leaked half of the Strokes album *Room on Fire.* Suddenly I'm dealing with all of these legal complaints.

JASON GORDON: All of a sudden I started getting e-mails to me saying, "You should come to this show." It was not even hard.

LAURA YOUNG: It was weird to me that people in marketing or people involved with actual bands were contacting me and offering me tickets. It was like, "Stop trying to ruin my fun by getting all business-y on me."

ROB SHEFFIELD: By the middle of 2003, bands like the Strokes and the Stripes and Interpol would be playing bigger sold-out shows that were harder to get into, but the girl bloggers were already on the trail of the Stills or Franz Ferdinand or the Go! Team or whoever. All of us at every level of musical journalism were paying attention to what they had to say.

SARAH LEWITINN: Eventually, I got hired full-time by *Spin*. Sia hired me. I remember she called and offered me something and I just said, "Okay!" And she was like, "You're supposed to negotiate!"

MARC SPITZ: What Alan politely tolerated was exactly what Sia, his successor, responded to. She did make us stars. In that world anyway. She wanted these rock-and-roll people in the office. A couple of them at least.

TRACEY PEPPER: Sarah was blogging about partying with up-and-coming bands, like the Killers and the Vines. She'd come into my office all the time and tell me about some band that was about to blow up and she was nearly always right.

MARC SPITZ: She was just picking these bands, one after another. She would be chattering about Interpol, and then you'd hear they signed to Matador. She'd be chattering about My Chemical Romance, and then you'd hear that they signed to Warner Bros. She would be chattering about Muse, and then they broke. She would be chattering about the Killers, and then she actually helped them get signed.

SARAH LEWITINN: I had started my own label, Stolen Transmission, out of my apartment. That actually was thanks to this guy Rob Stevenson who was in A & R at Island Def Jam. I met him when I was balancing a wineglass on my head at the label's holiday party, back in 2001, and he hired me to scout for him. I was managing My Chemical Romance at the time, and telling him about Interpol and

the Strokes, and he was like, "You should do a singles label and sell them on your blog," so I did that with a bunch of bands; they sold out like hotcakes. Then I got a book deal and the record label offer, so I quit *Spin*. Rob asked me to come over to Island Def Jam to help him, and he offered to help me with Stolen Transmission. Stolen Transmission became an official partnership between Rob and me.

JASON GORDON: I was a twenty-four-year-old kid going to my day job in book publishing and then moonlighting. I was getting credentials to cover the 2004 Democrat convention, where I was the publicist for Barack Obama, who was a state senator at the time. I was hanging out with him before he gave his keynote speech. I would be secretly finding time in between moments like that to post on Product Shop. It was like an alternate life. It was ridiculous.

SCOTT LAPATINE: I was working at VH1 and for a while it was definitely like having two full-time jobs. It was work. I had a lot of flexibility, so if I was working on a post for an hour or two during the day, I would just stay late at the office. I was often at the office until two A.M. or whatever. But I was getting some feedback like, "Hey, some venture capitalists might invest and turn this into a business," and I had already been selling adverting, which was just an easy thing, so at a certain point, money was coming in from Stereogum and I was frustrated at work, so I just quit.

RYAN SCHREIBER: I recruited a lot of bloggers to write for Pitchfork. I felt very much like the bloggers were my peers. They were doing what they did for the same reasons that I was doing what I was doing, which was just love of, passion for this music and this culture. I felt a kinship with them.

LAURA YOUNG: At that time I remember the Internet was whatever. I was really focused on "I want to work in print. I want to be a print journalist." Like, "That means that you're the real deal." But at some point I was like, "Wait . . . I like this Internet thing."

ROCK IS BACK?

JULIAN CASABLANCAS: The Vines, the Hives, and White Stripes and us, I think those four bands was the initial vibe.

PELLE ALMQVIST: I realized something very important: a musical movement is a style of pants. Think about it: San Francisco 1967—you know what pants that is. New York, 1977—you know what pants that is. Disco? You know the pants. There were baggy pants and ripped jeans in the nineties. Nirvana had them, Soundgarden had them, and Stone Temple Pilots, Pearl Jam, they all had the same pants. They don't really sound that much alike but they had the same pants, so obviously it's a musical movement! Then there was Limp Bizkit and Linkin Park. They had the same pants. It was obviously a musical movement! And then we had the Strokes, the White Stripes, and us with tight pants. It's a musical movement! For the record, our pants came from a company called Tiger of Sweden. They're good pants.

MATT PINFIELD: I remember when I first saw the Hives play it was like, "Who the fuck are these kids?"

HAR MAR SUPERSTAR: It's totally weird rock-and-roll circus theater.

JACK WHITE: The first time we met the Hives was on *Top of the Pops* in London. We hadn't been introduced yet, but while we performed our song on the stage across from them, the Hives all stood in a row on their stage with their hands behind their backs, motionless. I loved them so much for that! Still one of my favorite things I've ever seen in my life. It wasn't approval, or politeness, or a battle-of-the-bands competition move or anything, or maybe it was all of

that, or maybe they were just trying to make us laugh, which they did! Gorgeous idea.

PELLE ALMQVIST: A lot of what we've done is trying to set an example for other bands to do and then they can do it instead of us. But no one ever really takes the torch, so we still have to run with it.

JACK WHITE: Howlin' Pelle is incredibly funny, one of the funniest people I've ever met.

PELLE ALMQVIST: That whole garage rock revolution happened in Sweden earlier, in the late nineties. By 2000, there was a bunch of Scandinavian garage rock bands making their way in Europe. But we always felt like we were our own thing. We put out our first record in '97. We did a bunch of touring in '98. Put out some records and then, in 2000, we put out *Veni Vidi Vicious*, which is what made it happen for us.

MARC SPITZ: The Hives had cred coming in because Alan McGee, fresh off Oasis success, signed them to Poptones.

ISAAC GREEN: Alan McGee had started Creation Records and had some of the biggest bands ever in England, including Oasis; disappeared; closed Creation; and then started the Poptones label, which was very millennial, almost dot-com-ish.

MARC SPITZ: They eventually signed to Universal for some ridiculous amount of money, but they had respect out of the gate because of the UK cool-hunter thing.

CONOR McNICHOLAS: After the Strokes, the record labels saw the shift, so you had this weird international garage rock culture emerge, where you had the Hives from Sweden, you had the Vines from Australia, you had the whole Detroit thing. We were *desperate*, fucking desperate for anybody who could play guitar. So many of those bands were shit, but we just needed stuff to fill the pages, and the kids needed something to get excited about.

SARAH LEWITINN: The Vines all met because they were working at the same McDonald's down in Sydney, I think. Which is funny because all Craig, the singer, ever ate was McDonald's. Kinda makes you think they were destined to be famous in America, right?

MARC SPITZ: The Vines were just goofy kids.

STEVE SCHILTZ: Nobody knew at the time that Craig had Asperger's. He just seemed batshit crazy.

PATRICK MATTHEWS: Craig was very quiet but he was also very funny. We were friends because he was funny and he liked music, but I think the whole nutcase thing definitely comes from smoking pot, because he didn't really have a temper until pot came into his life.

PELLE ALMQVIST: We had nothing to do with anything contemporary in rock and roll at the time. We thought our success would come in punk rock clubs all over Europe, but that would be pretty much it. The aim was to make a record that we were really proud of. No one would buy it, and then we would get jobs.

PATRICK MATTHEWS: We had really ambitious managers. Nothing probably would have happened if it hadn't had been for those managers.

MATT PINFIELD: People wanted the three-or-four-minute punk rock songs. That's the great thing about garage rock. And because of the Strokes, all these bands also knew then that they could start a career overseas and bring it back. Not since the Ramones and Blondie had that been a factor. These bands *knew* you could get really big overseas

PELLE ALMQVIST: I was so happy when that first Strokes EP came out that I e-mailed them—"Hey, I'm in a band too. Love it, love it, love it." Then we did a European tour with a bunch of other bands— twenty-two people in a tour bus. Super illegal. And the first show was at a club called Molotow in Hamburg, Germany. It's a room that fits maybe 200 people and there was a line of like 6,700 people outside. We sold all the T-shirts we had bought for our entire European tour that day. That's when we realized that, you know, this might actually work. The world was starting to make sense.

PATRICK MATTHEWS: We recorded *Highly Evolved* from July 2001 to Christmas Eve, in L.A. We were signed to Capitol and it was all organized for us, so it wasn't so difficult. Someone just said, "You're going to record here with this guy," and we were like, "Cool! He

recorded Beck!" "And then you're going to stay in this hotel and it's all taken care of." It all came down to our managers. Someone else was skillfully manipulating the press for us, getting a lot of stuff in *NME* and getting us that buzz-band reputation. We were just playing. We went to England, played a couple tiny places with the Libertines. We did a promo tour in America.

STEVE SCHILTZ: One of their many managers saw Longwave at Gig on the Green and he liked the band. We did one tour with them; it was in Europe and I remember we had a bus. One of the few times we had a bus, and that was exciting. Immediately Patrick was the guy we talked to. I remember being in some city, just sitting in a dressing room talking to Patrick about how he had to make a decision about going back to med school or not. Craig just seemed batshit crazy. And Hamish, the drummer, was very sweet and very, like, hired gun—he gave our drummer a copy of *Modern Drummer* magazine, like, "Hey, I'm done with this if you want to check it out." And our drummer was like, "Pfff." I mean, not to be a dick but we're like, "What?" and then like, "No, man." We found out he had been in some, like, Beatles tribute band before that. He was like Topper Headon from the Clash. When Topper Headon joined the Clash, all of a sudden he started wearing letter jackets and the sailor's cap. He had, you know, an identikit.

MATT PINFIELD: The Vines obviously had a Nirvana kind of thing that did very well. I liked part of that record. I loved the title track, "Highly Evolved," I just didn't know if I thought the guy was legit. You know what I mean? But I love those songs.

IMRAN AHMED: The Vines felt quite on the fence of whether they were actually any good or not. I thought Craig Nicholls was such an intriguing character, but there wasn't much depth coming from him. He was pulling silly faces in *NME* every week. In hindsight, with him being diagnosed with Asperger's, it all makes a bit more sense. At the time it just felt odd. He clearly wasn't well.

MARC SPITZ: I did the Vines' first piece for *Spin*. I was backstage at Letterman with the band and their friends and people from their label and publicity team. The band and I were in a locked room for most of the time before the performance, just filling the room with

a wall of weed smoke. I was taking notes and studying Craig and he was really stoned and calm, almost catatonic. And then they go out and Letterman was like, "Here they are, kids . . ." They play "Get Free" and by the middle of the song it sounds nothing like the single and Craig is just braying like a donkey and then they finish the song and he knocks over the cymbal stand with his guitar neck, and throws the guitar at the drummer. The drummer throws up his sticks like, "Fuck this," and Craig runs onto the set and flings himself into the guest chair, then gets back on the mic and starts screaming. Letterman called them "troubled teens" and asked Paul Shaffer if Craig was all right.

PATRICK MATTHEWS: Someone asked Craig about the Letterman performance and he goes, "Well, the buildings seemed really big in New York and I was a little bit homesick," and that was his explanation for it.

SARAH LEWITINN: Yeah, and later that night Craig was jumping in trash cans and pouring water on his head and running down the empty streets of the Lower East Side shouting.

IMRAN AHMED: But the songs were brilliant. And they stand up. If it hadn't been for the Vines, there wouldn't be an Arctic Monkeys—they've gone on the record in the past and said, "One of the reasons we formed the band was because of the Vines." If you were twenty-one, the Vines are just great. The Vines played their role. They were important; they were fun; they were, like, trashy; it was an intriguing story. All the other bands talked about them.

MARC SPITZ: The Hives would have seemed like the more high-concept of the two but they were actually much less manufactured. The Hives were punk rock kids from Stockholm who had this atypical sophistication and beauty. The arrogance is a put-on. The rock scene in Stockholm is like this Nick Hornby wet dream. Everyone is sensitive and a record collector and drop-dead beautiful. The Hives knew B-sides. They knew Peel Sessions. They were really formal, even when they were out eating and drinking. Very studied and polite. And live, Pelle and Niklas, if you watch them, are basically controlling the crowd like DJs. They're more like a Kraftwerk type of band than a Stooges type of band. It's puzzling

that they're pretty much the best live band I've ever seen because even though they're sweating they're computing.

PATRICK MATTHEWS: At the MTV Video Music Awards that year when they did the Battle of the Bands, we shared a dressing room, and the singer for the Hives is quite haughty. He sort of strutted around.

PELLE ALMQVIST: I know other bands turned it down. I wish they asked us first. You get a feeling that the White Stripes would have said no. But we felt ruthless enough to just say, "Fuck it."

PATRICK MATTHEWS: That was another thing organized on the record company level, and it was just ridiculous. The Hives were on the jutted-out stage right and we had the entire main stage, where mine and Craig's amps were twenty meters apart, and then they had, like, you could ring up and vote or something. Ugh.

PELLE ALMQVIST: The VMAs felt kind of corny, but we got to meet J.Lo.

PATRICK MATTHEWS: The gift bags were great. I remember that they had a PlayStation, some hair gel, and like twenty-five different kinds of cocktail salt.

JENNY ELISCU: At the time I remember not really caring for the Vines. I liked the Hives but I just thought, like, "Now everyone's a Strokes. Is that what's going to be happening now?"

RYAN ADAMS: The Strokes were going to maybe be on the cover of *Rolling Stone*. It was going to be them or the Vines and they did the Vines. As a fan of those guys, and as a friend, but mostly just as a Strokes fan, I remember thinking what a travesty that was. That was just a huge mistake.

PATRICK MATTHEWS: I remember getting phone calls from someone at Capitol to organize the photo shoot for the *Rolling Stone* cover, and I remember saying to her, "I know you're joking but I'll turn up to this photo shoot." She kept going, "No no no, we've got the cover." It was like I was being tricked.

MARC SPITZ: The cover line just read: "Rock Is Back."

ROB SHEFFIELD: Yeah, I wrote that story. That's still a little traumatic. It was just sitting in a room with this dude from the Vines doing

bong hits constantly and literally the only topic that would get him going was talking about the Strokes and the White Stripes.

PATRICK MATTHEWS: Rob had a really calming influence on Craig.

MARC SPITZ: The cover of *Rolling Stone* was still a big deal. It always is. They are sometimes late to the party but there's still no greater confirmation that you are in the center of culture at that moment. So seeing the Vines on the cover over the Strokes or the White Stripes was a little strange. It was kind of like the fourth band in the queue cut to the front of the line when nobody was looking. And the Strokes, etc., were reduced to "with," like they were guest stars on a sitcom called *Rock Is Back*. Starring the Vines . . . with a special appearance by Jack White as . . . the caretaker.

ROB SHEFFIELD: This was a cover shoot where we had to airbrush eyeballs into Craig Nicholls's eyelids because he was incapable of opening them at the photo shoot. So the cover is the other three members of the Vines holding him upright while he makes a dazed expression. Rock is back? Yes it was.

"TAKING ALL OUR BRITPOP TRICKS

AND SELLING THEM BACK TO US"

CONOR McNICHOLAS: The Strokes' arriving opened the door for the White Stripes, and as soon as that shift happened, there was this massive demand for bands from anywhere we could get them, but there were no British bands to fulfill it, because nobody there had picked up a guitar in like ten, fifteen years. Everyone in England sold all their guitars and bought decks and sold all their decks and bought keyboards. Until that key moment where Imran Ahmed turned up in the office with a CD and said, "This band is called Franz Ferdinand," and everyone went, "That's a really good name." He said, "They have this song, and it has the lyric 'Words are poison darts of pleasure,'" and you could feel the whole office just go: "click." We love lyrics. It was the first time a British band had written a lyric that anybody gave a shit about since Blur's *Parklife*.

IMRAN AHMED: I'd been at *NME* for a year and I was keen to put my stamp on things. I'd arrived just after the first wave of excitement of the Strokes and the White Stripes. My experience of these bands, who I'd written about, was that American acts would often only be around for a few weeks at a time. As new bands editor at *NME* I was very strongly on the lookout for a British band in the great history of the Smiths or the Stone Roses, someone who seemed as fresh as those guys.

ROB SHEFFIELD: When Franz Ferdinand came out with their first single, "Darts of Pleasure," at the end of 2003, it was really comical at first to see what was going on—here's a Glasgow band who are clearly inspired by the Strokes and the White Stripes and what's

happening in New York City and what blog girls are dancing to at Don Hill's, they're trying to capture that skinny-tie drainpipe-trousers mod-beat aesthetic and sell it back to New York City, just like the Beatles did when they sold Chuck Berry–inspired rock and roll back to America forty years earlier.

IMRAN AHMED: Franz had been subject to a real bidding war—I believe Laurence at Domino remortgaged his house in order to sign them.

LAURENCE BELL: They were just so good that there was no way that people wouldn't like them. To what extent, I really didn't have any idea. I thought, "Oh, they'll be, like, somewhere between—on the popularity scale—somewhere between Pavement and the Strokes." I thought we'd sell, you know, up to half a million records. We ended up selling four million records. On the first album.

IMRAN AHMED: Everyone at *NME* loved Franz from when they first heard them. They appealed to some real core *NME* values: art school kids, well-read, into great music—clearly Orange Juice and Talking Heads. I definitely pushed to get them on the NME Tour and to have the Vines kicked off so Franz would get their first cover.

ALEX KAPRANOS: I'd had a key realization a few years before. I'd been in a band called the Karelia, and we'd been signed to a heavy metal label—we were doing this vaguely foppish indie music coming from Glasgow, and it just really didn't work. We got dropped. So, at twenty-six, twenty-seven, I was like, "Okay, so that's it. I'm not going to have a career in music. That's fine." Also, it was the ass end of Britpop, and in Britain everyone seemed to be listening to electronic music or something vaguely acoustic, like Coldplay. So I thought, "Ah, well, I'm still gonna play in bands, but I'm gonna have to work in bars." That was an important realization, because it meant that I was doing all the stuff with Franz Ferdinand with absolutely no idea, in my head or anybody else's, that we were going to do this to make money to pay our rent.

TUNDE ADEBIMPE: Failure is the best. After you fail, you're free.

ALEX KAPRANOS: Music was all very social. It was an excuse to socialize and go out for a drink. That's how our band started. We

just hung out with each other, and we'd go to parties together in Glasgow. Bob, our bass player, didn't play an instrument when we got the band together. I got a bass from Mick Cooke from Belle and Sebastian, because we were in another band together. In fact, the band started off over an argument we were having, over a bottle of whiskey. My argument was that anybody that likes music can be a musician. Whether they'll be a good musician is a different story. But so I said, "Come on, I'll show you how to play the bass. It's really not that hard."

JALEEL BUNTON: This entire story is based on kids around the world being like, "Oh, I can do that now?" You don't have to be able to play scales and put intricate things together, you can just mean it.

ALEX KAPRANOS: What you like is as much a part of your makeup as what you don't like. And at that time, around 1999 to 2001, there was a wave of artists who were performing just with laptops. Your whole weekend was spent watching some guy move a mouse around. That just epitomized everything I hated about live performance. This music that was technically quite revolutionary was fucking boring. Maybe not boring to listen to in certain circumstances, but as a performance it was fucking awful. There was a lack of humanity, rawness, a lack of sweat and stink. There wasn't anything powerful about it. For us, there was a rebellion against that programming side of things. We used synthesizers, but we used crappy, old Italian synths that we picked up at secondhand shops that you had to play by hand. We wanted to play it rather than program it.

JUSTINE D: I love Franz Ferdinand because they have this kind of retro, very gracious rock-and-roll-type performer thing. They have a level of showmanship that a lot of new bands don't have. They think that they can just stand up there. It's different if you're My Bloody Valentine or a shoegaze band, kind of mopey—that's its own thing—but otherwise, put on a show! I'm here to be entertained, you know? And Franz Ferdinand did that.

ALEX KAPRANOS: There was also a distinct club scene that was going on in Glasgow at that time too. I was immersed in that. There were a couple of places, but particularly this one club called Optimo.

LUKE JENNER: Scotland weirdly has a dance music history. Soma put out the first Daft Punk record, and that's a Scottish label. They just really get it. For whatever reason.

ALEX KAPRANOS: "House of Jealous Lovers," by the Rapture, had a big impact on that club in particular.

CONOR McNICHOLAS: You Americans, at the time, had never been taken over by dance music and ecstasy culture quite the way we were. But over here, post-Britpop, it so completely ate popular culture. Music was just dance music, nothing else. Nothing else could really get a look in. It was the totality of being sixteen to twenty-five. It's just what you did.

ALEX KAPRANOS: "House of Jealous Lovers," that was first. Then "Losing My Edge." When that came out it also had a massive impact. And Optimo definitely would have been the first place I heard it.

VITO ROCCOFORTE: When we first toured England, we played Optimo. We'd played this weird hardcore festival in northern Belgium, which was horrible, just muddy and we didn't belong there, then drove overnight into Sunday to play Glasgow at Optimo. We didn't know what it was, we're like, "This is gonna suck. It's a Sunday." We were all like, "Um, dude! This club's fucking amazing!" The show ended at two and we went to an after party until, like, noon the next day. I made friends that I still have to this day.

LUKE JENNER: They party for four days in a row in Scotland. By day three they don't have their shoes, they stink, they're like on some fucking insane cocktail of drugs and drinking, and it's just like, "Go to sleep, dude!" and they're like, "No way, mate!"

VITO ROCCOFORTE: James Murphy was doing sound for us on that tour. So he was hanging out.

PHIL MOSSMAN: Everything with LCD started off on the dance scene. Our early shows were at clubs like Optimo. The UK was kind of clammy leading up to that. It was all like Manic Street Preachers and the Skinny Boy and Primal Scream, Stone Roses. Big cheekbones. Attitude. Oasis. Attitude or a moody DJ. No one was cheery. No one was approachable. So LCD was different. It would be on our club night where everyone was E'd up, and there'd be a DJ, and then there'd be this band.

ALEX KAPRANOS: James is funny. I remember seeing them play in Glasgow and somebody in the front row had thrown a glass of water over him, which was probably intended as a friendly thing. In Glasgow they just chuck their pints everywhere if they're having a good time. James, he took it the wrong way, and he threatened to kill this guy in the front row. It was like, "Oh my god. This guy is taking on a Glasgow audience. Like, he's got balls."

PHIL MOSSMAN: That show was interesting. We pulled up into Glasgow on the bus and Rangers had just beaten Celtic over the whole season by like one goal. The whole town just erupted into fucking überviolence, like sectarian football violence everywhere. Protestant and Catholic as well. Just driving through the town, you'd see fighting in the streets, bottling each other, things just kicking off. So, the sound check was done, and everyone was like, "Should we go and get something to eat?" And as the only Brit I was like, "Listen, please do not fucking go outside. Do me a favor." I remember Tyler was like, "I'm gonna go for a run." He was putting shorts on and his running shoes. He got fucking half a block and came right back. Someone had already beat someone up and the guy was unconscious, leaning up against a bus stop. Tyler was just like, "Okay, no jogging today." But then the show was amazing.

ALEX KAPRANOS: Obviously this music we were listening to on the dance floor for all these years, that's what we wanted to play as well.

IMRAN AHMED: I remember Franz Ferdinand had this line about their aim being to "make records that girls can dance to and to cut through postured crap." It was very sharp and you would hear their records in the same clubs that played LCD Soundsystem. They took their cue from the Strokes and LCD and became the UK arm of that NYC/DFA ethos. Guitar music you could dance to. It made the whole scene so much more fun than it had been in years.

PAUL BANKS: With Franz Ferdinand, I heard an EP before the first record. Daniel had heard it first.

ALEX KAPRANOS: That's when it all really collided, when we opened up for Interpol really early on.

DANIEL KESSLER: That was in the summer of 2003; it was before their record came out. It was before "Take Me Out," for sure. They were playing it in their set, but it wasn't a hit yet.

PAUL BANKS: Oh, they were amazing. It was really nice. It wasn't something where there was, like, this sense of "We're being up-staged." It wasn't that. Well, it was and it wasn't.

SAM FOGARINO: Small venues, in Europe, on the *Bright Lights* tour. That was fun.

PAUL BANKS: We got along. But at that point I was in full-blown party mode. So I don't remember having too many intellectual conversations. I was pretty fucked up. And Alex and I didn't . . . it's not that we didn't hit it off, I just think that maybe we were similar personality types. I'm not about to be the guy to go up to him and be like, "Let's be friends." And he is the same. So maybe we would have both really liked each other, but we didn't really get there. I do remember seeing the drummer in the dressing room one day, with a smoking hot girl. I don't know if she was an exotic dancer or something, but it was his girlfriend. He was like a guy in, I don't want to say a Guy Ritchie film, but whoever Guy Ritchie is inspired by—an old British cinema gangster guy from the sixties or seventies, but in real life. Not a big guy and definitely a very nice guy, but you just had this feeling like, I do not want to fuck with that guy. That guy will knock all your teeth out, then go play an amazing rock show like John fucking Bonham, then go bang four strippers, and not sleep for two days.

MARK RONSON: I remember the first time I heard a Franz Ferdinand song was at a Strokes show, before they went on. It was that Central Park show when they played SummerStage. I remember hearing "Take Me Out." Obviously, they're a great band and would have found their way, but if the Strokes hadn't existed maybe they wouldn't have had as much exposure.

JAMES ENDEACOTT: Alex is a little bit older and slightly more calculated and they had been around a little bit. They did take elements of the Strokes—in the first record there are a lot of Strokesisms—but it's more measured. It was almost like an exercise in art rock.

ALEX KAPRANOS: There was something that I quite liked about a lot of the bands that were appearing at that time as well. You definitely had it with Interpol, you had it with the Strokes, you had it with the White Stripes, you had it with the Hives—it wasn't just a bunch of guys getting together to play music. There was some thought behind it. That's why you get that journalistic, cliché phrase "fully formed." It's not fully formed; we've still got things to do. *But* we've actually thought about what we're going to do before we've done it.

ROB SHEFFIELD: Franz Ferdinand thought, "Wow, look at all these New York bands taking all our Britpop tricks and selling them back to us. We're going to go do it with better songs." They did it with better songs. And they were a better band. They're still a better band. I mean, Alex Kapranos was in a fucking ska band called the Amphetameanies before Franz Ferdinand. And then he heard the Strokes and Interpol and was like, "Well, what the fuck am I doing this for!? We're going to do Britpop and we're going to go to New York and girls are going to scream and throw their underwear." And that's exactly what they did! I saw them at Northsix for the first time and it was like Beatlemania in real life.

"THESE GUYS ARE GOING TO BE BIGGER

THAN EVERYBODY"

MARC SPITZ: Yeah Yeah Yeahs didn't want to do press. The Strokes didn't want to do press. Their dreams were coming true and they weren't looking the way that they imagined. They were bewildered. There was a sense of bewilderment with the Strokes that Jack White didn't have, that the Hives didn't have, and that the Killers certainly didn't have. It's a certain wiring: you have to be Nick Drake and you have to be Liam Gallagher, in the same package. You have to be a real sensitive artist person, and you have to say, "Bring it. Bring the fucking horde on, I'm going to lead it."

LAURA YOUNG: The Strokes become the stepping-stone for doing something else. So, when a band like the Killers or whoever comes along where they're kind of Strokes-y but they're a little bit more commercial, they're a little bit more poppy, but they've got good songs, got good songwriting, now the labels know how to market that shit. They know *who* to market it to. That band is no longer a concept that you have to understand or have to figure out; you're familiar with it and you're familiar with who buys it, so it becomes an easier sell.

MARC SPITZ: The band that wanted it, and were fucking ready for it, were the Killers.

BRANDON FLOWERS: There was a drought not just in Las Vegas but in music before the White Stripes and the Strokes and Franz Ferdinand came and injected a little bit of style back into rock and roll. I mean, it was bad. And Vegas was particularly bad.

HAR MAR SUPERSTAR: The Killers guys are all nice. Brandon was always super nice. He knew that they were going to blow up really hard. I think he purposely didn't do anything crazy or offensive or get on anyone's nerves, because he knew he was going to get hated on at some point for being in the biggest band. At first it was like, "These guys are really good," then all of a sudden it was like, "Oh, there's no question these guys are going to be bigger than everybody."

RONNIE VANNUCCI: We work hard. I've been in tons of other bands and no one wanted to work as hard I did, until I met these crazy ass-holes. Of course, now they're fat and lazy.

BRANDON FLOWERS: When I met Dave Keuning, our guitar player, I was working at a restaurant, a brasserie, and then the Aladdin hotel.

RONNIE VANNUCCI: Dave was actually a lot crazier back then. He wore these weird moon boots.

SARAH LEWITINN: Dave was going by the name Tavia Go at the time. I have no idea why. Dave's awkwardness is like a vortex in the room, and then Brandon's awkwardness is this whole different beast, where he's like Mickey Mouse discovering things for the first time. They were like children.

RONNIE VANNUCCI: Brandon looked like Kid David Bowie.

SARAH LEWITINN: The only person that could engage people in conversation was Ronnie.

BRANDON FLOWERS: I used to go to Forum Shops, in Caesars Palace. It's like the best mall on the earth. They had a Virgin Megastore. And I used to spend a lot of time in there because it was exciting. It was the only place in town you could get the *NME* and *Q* magazine. They had imports and they had this wall that had the Top 40 records on it with headphones and stations for listening. It was just heaven for me.

RONNIE VANNUCCI: I was a wedding photographer at the time, on the Strip. And I was in school full-time, studying music at UNLV. The first time I met Brandon I got a call—it was the last day of school, and I had a brand-new cell phone. One of those little red Nokias. I remember thinking, "Whoa, it's, my first call!" It was my room-

mate, Anne, our mutual friend. The Killers' drummer couldn't do this last-minute gig, so we played a show together. They were great. Brandon was just totally unafraid. He was more of a screamer back then, less of a smooth-as-silk kind of guy. My girlfriend at the time, who's now my wife, said, "They like the shit you like, you should be in their band." The first record I ever bought was *The Head on the Door* by the Cure and I knew all about Depeche Mode. I'd even permed my hair at one point because of Martin Gore. I looked like a French poodle. The point being, I like rock and roll. So do they.

BRANDON FLOWERS: I read about the Strokes in *Q* magazine and I saw their picture, and just hearing the way that they were described was exciting. I was lucky I found that first EP. That Virgin Megastore actually had an import of the *Modern Age* EP, the one with the target on it. I showed it to Dave and we were really into it.

RONNIE VANNUCCI: Brandon and Dave, they liked Bowie, and at the time in Vegas nobody liked Bowie. Nobody wanted to be like that. People wanted to wear trucker hats.

BRANDON FLOWERS: It felt like Julian had a lot of the same influences that I had but it was all through Manhattan, not Vegas.

NICK VALENSI: We had similar influences, but they took a certain group of those influences and wore it on their sleeve a lot clearer than we ever wanted to. More sparkly and less subtle.

RONNIE VANNUCCI: I remember hearing *Is This It*. I was like, "Oh, it's cool. It's got such a cool sound. Who turned down the bass? Why does this sound like it's coming out of a rat's asshole? It sounds like headphone bleed, but it sounds great." They didn't give a fuck. And I like that.

BRANDON FLOWERS: I felt like the Strokes were kindred spirits even though I'd never met them. It was exciting that someone was doing it, and it was depressing because they were doing it so well. But that feeling didn't set in until *Is This It* came out. At first, I was like, "Okay, I've heard their first offering on this EP, but I'll buy the record and it'll be whatever." Then the record destroyed the EP. I genuinely felt depressed for months.

RONNIE VANNUCCI: Brandon and Dave gave me a demo CD and it had "Mr. Brightside," "Replaceable," and a song called "Newsman" on it.

BRANDON FLOWERS: The only song that we kept was "Mr. Brightside." Everything else that we had we knew wasn't good enough. So we started building again. The Strokes helped me realize that I wasn't good enough yet.

RONNIE VANNUCCI: The temperature of what was going on at the time was the complete opposite of what we were trying to do. We looked different, we played different, we were sort of unashamed of all of it and just totally went for it and didn't give a fuck. We'd play a sports bar with thirteen people in it and we'd act like it was Wembley.

BRANDON FLOWERS: You're trying to keep the ear to the ground and then you hear about the Libertines and Franz Ferdinand. Obviously something was happening and it was really exciting, but it was also scary because you didn't know if there was going to be room for you.

SARAH LEWITINN: Brandon and I used to talk on the phone all the time. People weren't texting or e-mailing each other; if you wanted to talk to someone you gave them a call. He was obsessed with the Strokes. Actually, he was obsessed with everybody that was in a band. I remember he could not believe that Karen knew Carlos, and that Carlos said he would maybe mention a Killers song in something he was writing somewhere. Anyone we introduced Brandon to, he would already know everything about them.

HAR MAR SUPERSTAR: Brandon always seemed like he was always in the background, studying.

RONNIE VANNUCCI: At that point we'd written "Jenny Was a Friend of Mine" and "On Top" and then we sort of reworked "Mr. Brightside." We'd written "All These Things That I've Done" and "Somebody Told Me." And we started playing places that were up our alley. We played this place called Tramps, which was a tranny bar most of the time.

BRANDON FLOWERS: There was a Vegas website called LVLocalMusic Scene.com and it made you want to make a demo because you

could put three songs and a picture and a paragraph about you on the site. That's how Braden Merrick, our first manager, found us.

SARAH LEWITINN: No one had music online. That's the thing. There was no MySpace yet. If you had a song up on your site, that was a project, you know? So I found this website and it was, like, TheKillersBand.com. They had one song up. I was listening to Dexys Midnight Runners' "Come On Eileen" on my headphones and I remember thinking, "I'm stopping 'Come On Eileen' to listen to this song and if this song is not as good as 'Come On Eileen,' I'm going to be really upset." I press play and fifteen seconds into hearing "Jenny Was a Friend of Mine" I was, like, IMing Rob Stevenson from Island, who'd asked me to check them out in the first place, "You have to sign this band, they're the best band ever!" He was like, "Everyone's passing." I was like, "Everyone's an idiot."

RONNIE VANNUCCI: Braden was a scout for Warner Bros. and he got us this showcase in L.A. Seymour Stein was there and Tom Whalley was there, all these big industry-executive types. We knew who Seymour Stein was but we didn't know who Tom Whalley was. "Oh, he's the president of Warner Bros." "Oh, cool." It was the first money I've ever made in the music industry. I got a twenty-five-dollar check. I was like, "It's twenty-five bucks. I could really use it right now but I'm not going to cash it." I still have it.

BRANDON FLOWERS: All the major labels turned us down in America.

RONNIE VANNUCCI: I don't think we even stayed in L.A. We had rented gear and I think we flew back the same night. It was a really weird gig. Tom Whalley said, "Nah . . . no." Same with Seymour Stein. But there was this one English dude there who said, "What the fuck, sure . . ." He'd just started up this little tiny label called Lizard King.

BRANDON FLOWERS: We knew the story of the White Stripes and the Strokes and how it started in England. So we thought maybe we were lucky that we had that chance. In September of 2003 they flew us over and we played four gigs. We got great write-ups in *NME,* and that was it. Everything changed.

CONOR McNICHOLAS: I went to their first-ever gig in the UK. It was at Dublin Castle in Camden. Brandon with his great spangly keyboard and a couple of bored people standing at the front saying, "What the fuck is this?" They had keyboards, and nobody was allowed to have keyboards. The rules had just been set: bands had guitars—it was two guitars, maybe one—drum, vocal, bass, that's it, sunshine, none of this fucking crazy keyboard shit, we're not back to Paul Oakenfold. But they turned up with keyboards and melody; they brought melody to the party in a way nobody else had done.

RONNIE VANNUCCI: You had to go to England so that the States would know you're cool.

CONOR McNICHOLAS: There was this second wave, where the majors had woken up by that point. With the Killers it was almost instantaneous.

RONNIE VANNUCCI: We got in under the wire, foot in the door, right before it closed. We were in England for like a week, we played four or five gigs, and of course when we came back every record label in the States said, "Can we take you out?" We ate really well for two months. In this business, everybody is just guessing.

MATT PINFIELD: They were still pretty young and naïve at the time but their songs were so great.

RONNIE VANNUCCI: We knew we were going to get a record deal but we also knew that record deals can be bespoke, they can be a custom-fit thing just for you. There are so many horror stories of bands getting reamed, and we were working-class dudes; we all worked in hotels off the Strip somewhere. We knew, just from instinct, not to take the first fucking banana in front of you. So the deals got sweeter and sweeter, and to be honest, we were just really enjoying the whole prospect of it all, just eating at nice restaurants, meeting all these great people. We were all in our twenties. We were eager. It was crazy.

SARAH LEWITINN: Rob told me not to send their music to anybody. "I don't want other people to know about them before I see them." And I was like, "No problem!" And then I e-mailed "Jenny Was a Friend of Mine" to everybody I knew. That should have been a

sign about how people should be doing A & R in the Internet age, which is, like, don't hold the thing as precious, just fucking let it run!

BRANDON FLOWERS: She was a fan. She got the music and she was waving our flag. You can't put a price on that.

SARAH LEWITINN: I sent their music to all the bloggers and all the young girls that were going to the shows. So when they played Don Hill's in New York, before they got signed, there were all these girls up front singing along to every song. People who had passed on them were wondering, "What the fuck is going on?"

ROB SHEFFIELD: They would come to town and they'd be such stars. I mean, New York made them. *Made* them.

BRANDON FLOWERS: Being from Vegas, I was intimidated by New York. I'm still intimidated by New York. It's New York!

SARAH LEWITINN: They were like children, but they also had this competitive edge, especially Brandon. I was also best friends at the time with Brandon Reilly, from this band Nightmare of You, and Brandon Flowers was, like, somewhat upset that I knew another Brandon that was also trying to be a rock star. Seriously.

HAR MAR SUPERSTAR: Brandon is also not as much of a partier.

SARAH LEWITINN: They didn't drink a lot. They weren't that fucked up. It was just their profound, unbelievable awkwardness that made them seem like they were on drugs.

ROB SHEFFIELD: I assumed the Killers were a very cokey band. They sounded very cokey.

SARAH LEWITINN: I remember the first time the Killers were in *Spin*, in the "Next Big Thing" issue. I had chosen all the bands and wrote about how Brandon was like a fallen Mormon because he drank and smoked a little or whatever. He called me and was like, "I can't believe you said that! I can't show my mom." But I never remember him doing drugs. I did them in front of him one time and he got really upset by that. We were at Misshapes and I had a little bag of coke. I had a Parliament cigarette with that little carved-in filter, which I stuck up my nose, and he said, "You shouldn't be doing that!" and I was like, "Shove it."

HAR MAR SUPERSTAR: He would amusedly observe, have a beer or whatever. That's why they're bigger than all of us who enthusiastically enjoyed the spoils of war.

RONNIE VANNUCCI: Nobody really got too deep into all that. I had an uncle that ended up dying from drugs; he overdosed. I knew, "Hey, don't be an asshole, have a good time but don't fuck everything that moves. Be cool, be a gentleman, but have a good time." We all had that mind-set.

SARAH LEWITINN: Brandon's drug is music. Pure obsession. We used to pore over issues of *NME* looking at what people ate.

RONNIE VANNUCCI: We were always a little bit on the outside.

HAR MAR SUPERSTAR: Julian wanted to be like Guided by Voices but by the time you get to the Killers, they knew there was more to be had.

SARAH LEWITINN: Brandon wanted it. I don't think he ever knew the difference between being in a tiny little band playing to five people and being David Bowie, because everyone he could read about in a magazine was David Bowie to him. He had that hunger that comes from just not knowing anything else.

BRANDON FLOWERS: I don't know if I ever settled into the scene. I don't know if I was comfortable with it, because I was such a fan of those guys that paved the way, so it made it hard.

HAR MAR SUPERSTAR: I remember seeing their poster on the side of the Whisky in L.A. It was there for two years, a giant wall-sized poster for their first album. I was like, "They're banking a lot on this," and six months later it was multi-multiplatinum.

LAURA YOUNG: Take it out of the context of music and think about it in, like, technology and business. It's the same thing. At this time you have MySpace and Friendster. "Oh, those Friendster dudes totally screwed the pooch on that one." It's never the first person that does it that succeeds. Obviously the Killers made a shit-ton more money than the Strokes ever will. It's about seeing the Strokes, and then the Killers coming from where they come from and being a little bit savvier about how they ran their business and their deals.

RONNIE VANNUCCI: We come from the West Coast, you know? I just had a conversation with a person that grew up in New York in an

affluent home with just excess, excess, excess. We didn't have that. We had fucking horse shit and gun smoke, you know what I mean? It's Vegas. My mom was a cocktail waitress, my dad was a bartender. Where we came from—service industry, working-class—we heard stories about the celebrities and how they'd act. My parents would come home with stories of "Sammy Hagar stiffed us" or "Steven Tyler is an asshole." So that was always in the back of my mind. If somebody gives you good service, give them a nice tip; it doesn't matter where you are. That will always be there. I still know the value of twenty bucks. I'm rich now, but I'm still poor.

Yeah Yeah Yeahs on their phones.

Nick Zinner

PART III

THE NEW GLOBAL UNDERGROUND

THE END OF ONE ERA, THE BEGINNING OF ANOTHER

ALEX KAPRANOS: The first place we ever played in New York was that back room at Pianos on the Lower East Side. There were these posters all around the venue that said, "Thank you for not dancing." It seemed so perverse to us—like, we got this band together because we wanted to make people dance. After every song I remember saying to the crowd, "Thank you for not dancing."

TUNDE ADEBIMPE: You had to have a cabaret license for people to dance.

DOMINIQUE KEEGAN: At Plant Bar we got our first cabaret violation back at the end of 2001.

TUNDE ADEBIMPE: You'd see those signs and it seemed like a joke, like the Death Star or the Empire was coming down on you. There was no way people were going to comply.

LUKE JENNER: It was fucking retarded.

JAMES HABACKER: I very intentionally did not become a cop. That was a choice. So to be asked to police my own crowd? I wasn't going to do that.

DOMINIQUE KEEGAN: The rule was, you can't have any more than six people dancing.

JAMES HABACKER: Back in the nineties, when I had Plush, we totally lucked out because Giuliani decided just at that moment that he was only going to allow cabaret licenses in certain little districts, and the Meatpacking was one of them. It was all hookers and literal meatpacking. They didn't care. It was easy; I went down myself to Consumer Affairs and filled out the paperwork and got us a cabaret license. I mean, this was still in the days where in order

to get approval from the fire department we bribed people in cash. That kind of thing doesn't happen anymore.

DOMINIQUE KEEGAN: The whole thing originally comes from a 1926 law.

JAMES HABACKER: It actually started with La Guardia. Before La Guardia was mayor there were slot machines in all the candy shops. It was a very different city. He took all that out, took out all the nickelodeons and set up these cabaret laws. You had to have a license, both for dancing and for music. Charlie Parker couldn't play in New York because he was a drug addict. Birdland was named after him but they refused to give him a musician's license, so he could not play here. Then in the seventies, there was a group that managed to defeat that aspect of the cabaret laws, but the dancing law was still on the books.

NICK MARC: It was basically a racist law in the first place, because it was to cut down on jazz clubs in Harlem.

JAMES HABACKER: So it had been on the books all along, but no one applied it until Giuliani was elected. Giuliani came out of the Knapp Commission. He was a federal prosecutor. The Knapp Commission began this investigation into corruption in the New York City police department and he was one of the big dogs involved in all this. That's where he made his career, with Serpico and Lindsay. Basically, he was the biggest gangster, and when he got to be mayor he decided that nobody was going to be taking a dollar. You couldn't pay off the elevator guy. You used to be able to get anything done and it got done quickly, but after Giuliani, suddenly it became this whole bureaucratic thing. He saw it as a way to make a lot of money. It wasn't any less corrupt. It's still a grift, you're still handing them tons of money, but it's going to the city.

TRICIA ROMANO: They hated nightlife.

JAMES HABACKER: Plush was a total drug den; I never dealt drugs, but everyone was doing coke. It was just a mess, but it was a fun mess. And we never got hassled. Then I opened up the Slipper Room and they just hassled us unbelievably. We couldn't get a cabaret license. It was a lot harder than it had been in 1994.

TRICIA ROMANO: They actually had an agency inside the city dedicated to shutting clubs down.

JAMES HABACKER: The nightlife task force would come around—cops, the fire department, they'd have the environmental control board there. And they'd just go through the place. They would always come on a Friday or Saturday of course, shining flashlights in everyone's face.

DOMINIQUE KEEGAN: The first time we got a ticket I was DJing, I was playing Prince's "Kiss." The guy came in undercover, ordered a Coke, and we had to go to court.

TRICIA ROMANO: They used the cabaret law to shut down places that had a DJ in the corner, like Plant Bar, where you'd go see James Murphy DJ or people like him. That's what was really sad; it was putting a stake through the heart of that world.

LUKE JENNER: I used to go to work at the bar and it would be fucking padlocked.

DOMINIQUE KEEGAN: We tried to stop people dancing. We put up our "No Dancing" signs and we enforced the no-dancing rule and the business started really suffering.

SIMON REYNOLDS We just thought it was absurd.

DOMINIQUE KEEGAN: We had a little blue light switch at the front of the bar and all the DJs were instructed to put on a Radiohead record if that light went on. The idea was that because of the bottleneck, by the time anyone got from the front to the back of the bar, you could stop the dancing by playing *Kid A*.

JAMES HABACKER: It was arbitrary and capricious and if you weren't careful they would just put you out of business.

DOMINIQUE KEEGAN: Luke called me one night and said, "The place is crawling with cops. They're padlocking the place. You'd better get down here." It was one of James's birthday parties. Tim was DJing and he had never been briefed on the rule with the light. I had moved out of the upstairs apartment by that point, for my own sanity. I jumped on my bike and rode down there. The marshals were padlocking the gate; Luke was scared shitless. I called our lawyer. After that, we were open for another month. I should have just

driven it into the ground until they closed us down. It was kind of an end of an era. I should have just let it go. It was over.

LUKE JENNER: They put up a really nice high-rise next door. That's what killed me about Plant Bar, they put this really expensive high-rise next door. And that's why everyone moved to Williamsburg.

"THE FAMOUS-AS-FUCK STROKES"

JULIAN CASABLANCAS: Albert said he was going to move across the street and it was like, "Okay . . . I'll move in with you!"

ALBERT HAMMOND JR.: This was *Is This It* money.

CATHERINE PIERCE: I love moving, I was like, "I'll set us up appointments to look at apartments!" I called and set up all these appointments, and then Julian just said, "We're moving across the street." There's a massive, gorgeous building across the street. It was like, "All right, we're moving across the street."

RYAN ADAMS: Second Avenue and Eighteenth Street, the Rutherford building. The haunted children's hospital.

ADAM GREEN: Second Avenue is, for some reason, a very conducive place. For ten years I lived there, on Seventeenth between Second and Third, and Julian and Albert lived right there too. And then Ryan Adams lived there. Mark Ronson grew up there. It was a weird corner.

RYAN ADAMS: We all frequented the same pasta place. We were all getting spaghetti Bolognese at the same place. Or carbonara. The carbonara was unbelievable. And they were open twenty-four hours.

JESSE MALIN: I met Ryan because he was at a D Generation gig in Raleigh. This is when he was in Whiskeytown. We started talking music: Bad Brains, Replacements, Sonic Youth, Neil Young. I realized we share a lot of stuff in common, so we stayed in touch; he'd call me up in the middle of the night—"I'm writing songs!"— and I'd think, "This kid's got so much energy and enthusiasm." We don't do that in New York, nobody calls anybody up that excited.

CALEB FOLLOWILL: I was in Nashville, Tennessee, and I was going to a writers' night to listen to songwriters. I was sitting there having a drink when, "Holy shit," I realize that's Ryan Adams. There was this pretty girl talking to him and then I realized, "Holy shit, that's Winona Ryder." I kind of became starstruck for him, not for her. Like "This dude is doing it right. He's a natural. He's at this shitty little bar and he's got Winona Ryder with him. That's crazy. And that's what I want."

JESSE MALIN: He came back from Nashville, after he made *Heartbreaker*, was living in New York again, and we were pretty much out every night. You'd be at Niagara and Ryan would be writing a song in one corner.

ALAN LIGHT: He was in some weird phase, writing letters to Jack White about how he was mad about something about Meg.

BEN BLACKWELL: He dedicated one of his albums to Meg White for saving rock and roll.

MARC SPITZ: We all loved *Heartbreaker*; we all loved his follow-up, *Gold*. And then he became known for things other than the music. There were rumors that he was dating a bunch of famous people. And there were rumors that he was a junkie. And there were rumors that he had recorded a Casiotone version of *Is This It*. Like, note for note.

RYAN ADAMS: I was trouble on wheels back then.

JESSE MALIN: When Ryan came here, he had such a romantic heart; he really connected to the romance and classic style of New York: everything from the Jewish, neurotic Woody Allen to food, architecture; to bonding with the Strokes and hanging out all night.

AUSTIN SCAGGS: I would see Ryan Adams at the bar, you know?

RYAN GENTLES: Ryan was such a New Yorker. Even though he's from North Carolina, in his heart, he was Mr. New York. He hung out at all the same bars as us, Niagara and Black and White. He was a big Strokes fan. He used to call them the "famous-as-fuck Strokes," like, "Oh, how are the famous-as-fuck Strokes doing? They're famous as fuck." That's how he'd refer to them, because he's obsessed with these kinds of things.

JESSE MALIN: I remember being in a card game at Ryan Gentles's house at seven in the morning with the Strokes guys; Ryan and John Mayer showed up. He was the only one sober; he beat everyone's ass at the table.

RYAN ADAMS: One night I was hanging with the Strokes guys and Ryan. We were really stoned because we were basically always smoking pot. It was very late. Fab would always play me a song that he had written, some beautiful romantic song. So one night, jokingly, I'm almost certain Fabby said, "Dude, what if John Mayer was playing that guitar right now?" And I said, "I can make that happen." And they all said, "You're full of shit." I said, "Give me three fucking beers"—because there were only so many beers left at that late hour—"and I'll make it happen. I'm a goddamn genie in a bottle." And we died laughing. Now, I lived down the block from John Mayer and he'd been talking to me about his new song for a while. So I texted him, because he was always up late back then. I said, "Come to this apartment. Bring an acoustic guitar. I really want to hear your new song." I didn't tell them that I'd done it. So everyone is sitting there and I was like, "Let's all take bong hits." I really wanted it to get crazy. We smoked some bong hits; I probably did some blow. I started to drink my three beers. The doorbell buzzer rings and I open the door and John Mayer walks in with his fucking acoustic guitar and they were all slack jawed. John sat down and played the fucking acoustic guitar—three or four songs that probably have gone on to be huge—while those guys just sat there staring at me like, "Oh my god, you're a witch." The next day John was like, "Hey, man, next time maybe less cigarette smoke? That really hurt my throat." That apartment was like an airport smoking lounge.

GIDEON YAGO: Ryan Adams, he was one of those guys where I just remember being like, "I just don't know." I didn't take to him very well. I mean, that to me was the beginning of the end. He was a dude in an alt-country band who moved to New York and totally co-opted all of the Strokes' albums.

RYAN GENTLES: The Strokes had a clause in their contract that I would be their exclusive manager for the first five years, and because we

were all starting out with no experience I was like, "Sure." Then I asked them if I could manage other artists, they said yeah, I took on Moldy Peaches and Ryan Adams.

ALBERT HAMMOND JR.: Ryan got close to him, Ryan and Ryan, a little R & R. And I was also friendly with him.

FABRIZIO MORETTI: He would come over to our apartment a lot, and I remember him playing a lot of songs. He's always willing to play a song.

ALBERT HAMMOND JR.: When he shows you a song, he doesn't stop for hours. You're like, "Oh, that reminds me of a song I wrote." And you grab and play a G chord and he's like, "I know what you're talking about," and he grabs the guitar back. There's no way to play music with him. It's the Ryan show, always. Where most people, if someone was getting on their nerves like that, would be like, "Stop," I would just take it for as long as I could.

RYAN GENTLES: I introduced Jim Barber and Ryan Adams. Courtney [Love] was dating Jim at the time.

JAMES BARBER: Courtney thought the Strokes were a positive cultural influence. She was doing this MTV special. And she wanted them on.

MARC SPITZ: She was like their Yoda. Their coke Yoda. I'm not saying she gave them cocaine. I mean, most everyone was on cocaine, but it seemed like as soon as they really made it she was all over them. And she was not in the best shape at the time. Maybe not the Jedi you want whispering in your ear about how to be a rock star.

RYAN GENTLES: I was friends with Courtney; she would call me at random hours to give me advice. I'd be shopping for groceries, and my phone would ring. "Ryan, it's Courtney, we need to talk. I read this article." It was that kind of thing. Then she did this overnight-broadcast thing for MTV.

MARC SPITZ: It was called *24 Hours of Love* and the premise was that she would take over the MTV soundstage, the one in Times Square, for twenty-four hours. It was set up like an apartment, with a bed and shit.

ALBERT HAMMOND JR.: We were just out late one night with Ryan Adams and someone said, "Oh, yeah, Courtney Love's doing this thing. Do you want to go?" I said, "Sure."

RYAN GENTLES: I thought, "Great, a chance to get on MTV, it's hard to get on MTV." I was like, "Great, another way to infiltrate the Christina Aguilera world." It was a total disaster. Manager fail.

FABRIZIO MORETTI: All I remember is being in bed with Albert.

ALBERT HAMMOND JR.: It was just weird. She and Ryan were just doing their thing, what Ryan always does: talk and play. Fab and I were just like extras in a movie, which we were fine with. It was kind of fun. It wears off, though.

RYAN GENTLES: Ryan stole the spotlight, because Ryan loves the camera, and my guys do not. Ryan was like, "Let me play you some songs!" He loved it.

RYAN ADAMS: I was so sick, ironically. I was sick and I was on a bunch of meds. I told them; I was like, "Dude, I'm really not feeling good," and they were like, "You have to go with us! We don't want to go if you don't go. We're scared." They talked me into it.

ALBERT HAMMOND JR.: When you're fucked up and the idea is funny, you just do it. It's almost like when I was a kid and I was like, "It would be great to take acid and go to the pajama jammie jam at school." Then you get to school and you're like, "Why did I think this was such a good idea?" You have to have a twenty-minute talk with your dean and you're trying to hold it together. Same thing. You're like, "Oh yeah. We'll go up there and hang out with Courtney Love. By the time you're in a taxi and you're in traffic, you're like, wait, what are we doing here?

RYAN GENTLES: She was all strung out and drunk; it was almost embarrassing. She was running up and down the hallways naked. She'd try to make out with people. Strangers.

ALBERT HAMMOND JR.: Oh, she was fucked up. You could see the makeup while they were filming. It was like her nose was just falling apart. Someone was making sure she was decent. It was just gross. It was dark. It wasn't fun. It was just the coldest environment

possible. Fucking Ryan Adams and Courtney Love, man.

RYAN GENTLES: I actually adore her in a way. She's so smart. But I don't know her, I don't think anybody knows her.

JENNY ELISCU: Gentles briefly managed Ryan Adams during that era, which seemed to not go great.

RYAN GENTLES: Ryan and I were buds. And went down to New Orleans and made *Love Is Hell*. Then I had to quit, because the Strokes exercised a clause in their contract that said I wasn't allowed to manage other artists.

FABRIZIO MORETTI: I remember the band feeling jealous about Ryan paying attention to anybody other than us. And there was this sense that Ryan's success was built on our backs, a little bit. He didn't plan to be a manager; he kind of fell into it because he was the liaison between us and Geoff Travis. He was coming up with us as if he was part of the band. So why would he be able to have sex with other people if we weren't allowed to, you know what I mean? In this marriage.

NICK VALENSI: Look, Ryan, when he first started managing us, had zero experience managing anything. Basically, Ryan was learning as he was going, as we all were. But as a result of that, naturally there would be times when Ryan would drop the ball a little bit, and there would be things that he just didn't know, situations he didn't know how to handle, which is understandable. But then when he also took on other clients, other artists, like Ryan Adams, Adam Green, he started dropping the ball a little bit more.

DAVE GOTTLIEB: You can't know what you don't know.

BRIAN LONG: Yeah. There was a lot of consternation that this kid was managing the Strokes and didn't know what the hell he was doing. But I thought it was kind of cool, kind of punk rock.

JIM MERLIS: Ryan was in a very tough spot, as he is today. He's hired because Julian wants him there. He can't go against him. Even if Ryan knows better, there's nothing he can do. He's in a really fucked-up situation. Anyone else would have gotten fired, you know what I mean? But he's still there.

RYAN GENTLES: They feel like I skew my favor toward Julian. He's

the guy with the vision and writes all the fucking songs! It's like, "What do you mean?" If he quits, there's no band tomorrow, but if somebody else quits, you can probably find a replacement, and that's not being mean to them, they all say it, too. Those were the early days where they were all still young, and nobody was famous yet. Now, after they've had success, I think everyone in the band knows that and feels that way about Jules; I think they all know this guy has the vision and he has something that's intangible, and you just have to go with it, and you don't always have to agree with it or see what he sees. Also, they know me as an outsider, still. We've been together all these years, but they've known each other since they were fucking five. When it's the six of us, I'm the outsider, I'm still the new guy.

ALBERT HAMMOND JR.: Julian had a very clear thing, and we liked to do things a certain way. I think a lot of things they might blame Ryan for is stuff the band just doesn't want to do.

RYAN GENTLES: Do you know how many times I begged the Strokes to do some shit and they just said no and it was idiotic and everyone in the world knows they should do it? The band sometimes just said, "No, we know better." You're an adviser, they're the stars. We work for them.

AMANDA DE CADENET: They're the band that turned down a million dollars for some Heineken ad. That's dumb.

DAVE GOTTLIEB: We got a request from Heineken for, it was either "Hard to Explain" or "Last Nite." I think it was "Last Nite." It was $600,000.

AMANDA DE CADENET: Ryan has taken a lot of flak for not being able to do things that we all think they should have done, but nobody can get these fuckers to do anything they don't want to do. You can have manager skills up the ass, it's not going to mean anything to this band. They do whatever the fuck they want to do.

RYAN GENTLES: By 2002, it was clear who the boss was, and it wasn't me.

GIDEON YAGO: Honestly, nobody knew what they were doing. It was like you had these kids who had read Andrew Loog Oldham while

stoned and maybe owned a copy of Donald Passman's *All You Need to Know About the Music Business*. They were all glorified fans.

RYAN GENTLES: When they were making *Room on Fire* they said they felt my attention wasn't all theirs. They wanted the office to be their clubhouse and said, "You have to stop managing Ryan Adams." It sucked. He's super talented, and I was ambitious, and I liked his music a lot, and I still do. How did he take it? He took it real bad.

"A HI-HAT IS LIKE WORKING WITH
A CELLAR OF EXOTIC WINES"

HAR MAR SUPERSTAR: They were so mythical.

JIM MERLIS: I remember being in a bar on Houston Street, and the bartender said, "Are you Jim Merlis?" and I said, "Yeah," and he said, "I've heard about you, you're a publicist." "Yeah." "I play in a band. Drinks are on the house here." It happened again at 2A. People knew who I was. I was getting a lot of demos, and even the bands I was taking on, I was like, "You know it's not going to be like that, right? It's not me, it's them." It's hard to put it into proper context. A band like Interpol, or, later, Vampire Weekend, it was nothing compared to what was happening with the Strokes, nothing.

NICK VALENSI: There's something very cool about being a part of the thing that helped open the door. Being the first one in the room is very exciting. But what inevitably happens is other people show up and end up having way more success than you do. Being the leader of the herd, you're probably going to die. You really want to be middle of the pack. The first one in the herd doesn't make it, generally. That's the metaphor.

RYAN GENTLES: As soon as *Is This It* came out it made them feel like we had to put out another record right away. They wanted to go into the studio immediately and fire it out. They didn't want to be like a lot of bands who come and go and you only know their one record. So they rushed into writing and making *Room on Fire*.

MARC SPITZ: Ryan was trying to keep things together, run this ship, but it was clearly, like, a bigger boat than he had ever captained

before. In 2002, on that last tour for *Is This It*, you felt eyes on you that weren't there. They were being watched and they knew they were being watched. They were watching me. I was watching them. The record company was watching all of us. The world was watching the movement to see if it was bullshit. But in hindsight, I realize why the label was there. It was not about *Is This It*. That record had been out for over a year. It was about: what's next? It was about *Room on Fire*.

STEVE RALBOVSKY: I like to go visit my bands on tour stops; it gives us a chance to catch up and have a late afternoon or evening before a show to kind of go over the current laundry list of stuff to do with whatever part of the cycle you're in. I met them on the road in Portland. I wanted to initiate a conversation about the next record: what about somebody other than Gordon? Knowing full well that they and he would want to control the proceedings, and frankly, they kind of earned the right to do it their own way. So we're having this conversation at a little bar, having a little smoke break outside, and I mention Ric Ocasek of the Cars, because I knew Albert loved them. Then we went back inside to the table. Julian sat back down and I said, "What about this guy Nigel Godrich?" Nigel Godrich could do no wrong. He worked with Beck and he worked with Radiohead. Julian said, "You mean the guy that does Radiohead? He would work with us?" I said, "Yeah, we can ask."

GORDON RAPHAEL: I went to a meeting in New York at the Wiz Kid Management office, right before they were making *Room on Fire*, and I saw Nigel Godrich's name on a board and I got really jealous. I was heartbroken. I said, "Julian, are you going to record with Nigel?" He said, "Yeah, we want to see if we can get a Radiohead sound, their sound is so great."

STEVE RALBOVSKY: The tryout lasted ten days. They worked on "Meet Me in the Bathroom" and one or two other songs. It was just so hard going method-wise for Nigel. He wanted to record a certain way and Julian wanted to record a certain way. Nigel was more "Let's just record it as a band and we'll subtract and add later on."

Julian wanted to get every instrument individually recorded and then layered. So the methods were conflicting.

J. P. BOWERSOCK: They were using the digital technology. Nigel is a brilliant tape splicer. You couldn't ask for anyone better to get the Strokes, who operate in a digital mode, to record on tape. It seemed like such a good idea on paper, but the working methods were completely different.

JIM MERLIS: Steve has hilarious stories about J.P. coming into the studio and it not sounding good and J.P. coming up with theories about the certain sound waves and the band was like, "Yes, yes."

STEVE RALBOVSKY: J.P. would kind of stand over Nigel's shoulder and say, "You know, this isn't really how we do it."

J. P. BOWERSOCK: I came to every day of the session and Nigel would not let me in the control room because he didn't want anybody looking over his shoulder. He's Mr. Hot Shit Producer. Correct. You are Mr. Hot Shit Producer. My respect for you is toweringly huge, but I could translate to you what the Strokes are asking for! He wanted none of it.

JIM MERLIS: Nigel was like, "Who is that guy?" Disaster.

GORDON RAPHAEL: Recording the drums, Julian said, "I really like your drum sound but can we work on the hi-hat?" Julian told me that Nigel said, "Julian, a hi-hat's a hi-hat." Now, I know from working with Julian that for him a hi-hat is like working with a cellar of exotic wines from all over the world: "Do you want that one, or maybe that one—smell the bouquet!" A hi-hat for him was worthy of days of tweaking. That's all that Nigel Godrich said, and the next day we were on the phone and right after that I was flying over from London to start recording. I don't know if it's true, but that's what they told me.

STEVE RALBOVSKY: Poor Nigel Godrich was in a state. He didn't want to let anybody down, but he felt like, "Maybe they're not ready, maybe I'm not the right guy for it." We had lunch in Soho one day and he said, "I just don't think I can do it." He was really emotional, really upset about it. I said, "It's not going to work. You

gave it your best and they just really weren't ready for it. They just weren't ready. They had to do it themselves."

JIM MERLIS: I'd love to hear what those Nigel Godrich recordings sounded like. I never even heard it. I think Steve heard it, and Steve said it was great.

J. P. BOWERSOCK: When they finally parted ways with Nigel, we all went bowling. I said to Nigel, "Dude, I would have loved to have been a resource for you." But that was just foreign to his way of working.

STEVE RALBOVSKY: So it was back to Gordon. At a different studio.

"HEROIN JUST KIND OF . . . CROSSES A LINE"

JAMES BARBER: I was in the studio with Ryan Adams making *Rock n Roll* when all of that went down between him and Ryan Gentles. Ryan Adams—he was pissed off.

RYAN ADAMS: There was nothing unfair about it. I didn't have a contract with Ryan. We just were working on good faith and that's how I work with everybody. I don't do contracts.

JAMES BARBER: There was no other way it could happen though, because Ryan was not going to change his business relationship with the Strokes. He was vested. But it definitely was fuel for Ryan Adams. Like, "I'm going to show the Strokes. You guys want a New York rock record, here's a New York rock record."

RYAN GENTLES: Ryan Adams thought the Strokes hated me and said I should have fought to keep managing him. But you know, they did me a favor. Ryan, I loved him, and now he's sober, I'm sure he's a different guy, but back then, it was pills and everything. Forget it. Just up all night, wanted you to be at his disposal.

MARC SPITZ: Ryan was working on his follow-up to *Gold*. He had no idea what kind of record he wanted to make. He was down in New Orleans and *Spin* sent me there to profile him. We get down there and it's just a mess. He was just—he was just *high*. In New Orleans the bars never close, so we could get out of the studio at four . . . and go to a bar. No matter what bar we walked into, the bartender would go, "Oh, hey, Ryan." So we know that he had been here before. And he would have all these, like, little greasy baggies of shitty coke. There's probably, like, 9 percent coke in there, but, like,

all that 9 percent plus the 91 percent of whatever else was in there was in his bloodstream, you know, fucking up his record. Ryan seemed haunted, and really self-destructive in an almost gleeful way. Like, I saw him literally running through the streets of the French Quarter at five in the morning, with the sun coming up, singing "Frère Jacques" at the top of his lungs. Something in his head was chasing him.

RYAN GENTLES: He needed a team of managers working around the clock for him, and I didn't have that kind of operation.

MARC SPITZ: Do you know that scene in *Manhattan*, where Yale is breaking up with Diane Keaton, and she goes, um, "Right, I understand, I could tell by the sound of your voice over the phone—very authoritative, you know . . . like the pope or the computer in *2001*." I love Ryan Gentles, but that's kind of like what he was. He was like Neville Chamberlain, ceding all this power to Hitler. "Sure, you want . . . you know, you want Eastern Europe? Just take it."

CATHERINE PIERCE: Julian thought Ryan [Adams] was a bad influence on Albert.

ALBERT HAMMOND JR.: Ryan would always come and wake me up at two in the morning and have drugs, so I'd just do the drugs and kind of numb out.

CATHERINE PIERCE: That apartment was two levels. Albert and I were on the upper level, Julian and Colleen were on the lower level, and there was an odd cutout in the floor, this strip, maybe where there was supposed to be a heating vent or something, a long strip, you could look down and be like, "Hey, guys . . ." You could hear everything. I could hear him whispering sweet nothings to her in the morning. It was cute. And they probably heard . . . Albert and me fighting like cats and dogs because he was an addict and I was trying to stop it, and you cannot stop that.

ALBERT HAMMOND JR.: I knew I would shoot up drugs from a very young age. I'd been wanting to do heroin since I was fourteen years old.

ADAM GREEN: Albert's always been pretty lavish.

ALBERT HAMMOND JR.: It's the perfect drug. It really is. I was home.

CATHERINE PIERCE: He used to say, "I love drugs, I'm not an addict, I love drugs!"

ALBERT HAMMOND JR.: I'm not sure where it began. Everywhere? I'd find it anywhere. When things started getting bigger, everything else just became easier, because people will just get you things because you ask for it. You're backstage and one day you're like, "Oh, we're out of beers," and all of a sudden there's another case of beer, and you're like, "Oh, that didn't happen before." It's also money; you have a certain amount of money, so you do a certain amount of partying, and then the money becomes more, and then all of a sudden you can indulge constantly.

KELLY KILEY: I just remember the trip when—obviously this was not the first thing they said to me, but at some point they said, "Get us drugs."

ALBERT HAMMOND JR.: In that *Room on Fire* time, I definitely got into a lot of pills and the beginning of opiates. That Oxycontin kind of thing. With a glass of wine? Ha! No, like cut up an eighty with coke and mix it. I was always pretty extreme.

CATHERINE PIERCE: Albert and Julian really loved each other and were kind of dependent on each other. Julian's acceptance was really important to Albert, and I think Albert's opinion was really important to Julian.

ALBERT HAMMOND JR.: When Julian and I stopped living together, that's kind of when it changed.

JULIAN CASABLANCAS: I thought I pressured him to stay roommates. I was definitely more into it than he was. But then it just kind of took its natural course. We didn't have a falling-out or anything, but he had a longtime girlfriend, he was engaged. Nothing negative happened. I wasn't like, "I'm out of here, bro!" And he was like, "No! Why? Papa, no! Don't go!" No way.

ALBERT HAMMOND JR.: We were such perfect living partners, because even though we were so different, we were both very carefree. Our doors were never closed, even when girls were over; you could just come in, it was never like, "Oh, am I interrupting you?" When we

first moved in together it was more a celebration of the dream of leaving home, and we could share in that. And guess what!? We're also going to play in a band together! It was innocent. I feel a lot of the drugs and alcohol I did were to chase that feeling of just being young.

CATHERINE PIERCE: It was such a weird time, because everybody was simultaneously psyched about "Oh, we're all becoming famous, this is awesome, let's all hang out." But it was also like, "Wait, Ryan's a bad influence."

ALBERT HAMMOND JR.: I remember Julian threatening to beat Ryan up if he hung out with me, as a protective thing. He'd heard that Ryan would come and give me heroin, so he was just like, "If you come to my apartment again with heroin, I'm going to kick your ass." I hadn't really been doing it in baggie form until Ryan showed up. He was definitely a bad influence.

RYAN ADAMS: That's so sad because Albert and I were friends. If anything, I really felt like I had an eye on him in a way that they never did. I was around and we actually spent time together. He would show me his songs. It was like, "No one ever listens to my music, but do you want to hear it?" I would be like, "Fuck yeah!" I loved him so deeply. I would never ever have given him a bag of heroin. I remember being incredibly worried about him, even after I continued to do speedballs.

MARC SPITZ: The New Orleans sessions were a bust, so Ryan came back to New York to record with Barber, who I knew as Courtney Love's boyfriend. He called me. "Hey, uh, Marc, it's Jim Barber. Why don't you come to Niagara, I wanna play you something. I'm making this really great record with Ryan." Ryan can't make a bad record in spite of himself. He's talented. He had that song, um, "Note to Self: Don't Die"; it was a good song. And that song which I think is literally called "This Is It." But by this point Ryan's made the transformation to full-on Stroke and not just coked-out Gram Parsons wannabe. He's now added heroin to the cocaine. I know this because I did heroin with him in the basement of Black and White.

JULIAN CASABLANCAS: Did I specifically tell Ryan to stay away from Albert? I can't remember the details, to be honest. I think heroin

just kind of . . . crosses a line. It can take a person's soul away. So it's like if someone is trying to give your friend a lobotomy—you're gonna step in.

RYAN ADAMS: I didn't do drugs socially and I don't remember doing drugs with Albert ever. I wanted to smoke cigarettes and drink, like, dark red wine or vodka and write all night. I've just always been this wannabe beat poet guy, Hunter S. Thompson, Jack Kerouac. I want to stay up all night, and you can't do that on heroin. I wanted to drink but still feel totally capable of operating a helicopter. I wanted to be drunk but be able to do calculus.

MARC SPITZ: Ryan told me he wanted his life to be like a movie. He didn't want to live real life, he wanted life to be like this romantic, tragic nouvelle vague movie where the hero dies at the end. He was framing his own legend. And part of it would be an early death. There's no other reason to do as much heroin and cocaine as he was doing.

RYAN ADAMS: I loved doing drugs in New York City so so so so fucking much, and I will never tell somebody to do it or not do it. I never have felt a day of regret or remorse for any drug I ever did because I very much felt like there was some kind of urban alchemy. I did drugs with the idea of creating in mind.

JAMES ENDEACOTT: Albert getting into smack was just ridiculous.

RYAN ADAMS: I do remember thinking that the Strokes guys were way more into heroin than I was.

JAMES ENDEACOTT: Julian was dabbling, as we say. He was a dabbler. I don't think he was a frequent user but he was definitely a dabbler. I just know that heroin was around and that he wasn't like, "Oh my god!"

RYAN ADAMS: It was very dramatic, the way it all went down, very much in the style of *The Godfather*, where the family business was being attended to. The family included me and the other artists Ryan was spending time working with.

FABRIZIO MORETTI: I'm sure Ryan Adams has his own story and it's grandiose and beautiful and whatnot, but he's not that major of a player in the Strokes' history.

RYAN ADAMS: I was asked to meet one single person in a bar and I got there and it was the whole band and Ryan. I was more or less given a lecture, a hypocritical lecture, and then they told me that I was not going to be part of their scene anymore. It was very weird.

JULIAN CASABLANCAS: I was trying to protect my friend. It didn't help. I don't know, maybe that isn't my place, but if I had to do it again, I would have done the same thing.

RYAN ADAMS: I remember that conversation, that talk at the bar, being a lot of blame and a lot of vibes. The impression was "You turned him on to this," but the irony is—and I think I said this that night to Julian—that he was talking about the drug that he came to my apartment several nights ago asking for. Not Albert, Julian. Julian was so angry at me that night. I think Julian was looking for me to be upset. I just remember feeling dirty. I remember feeling like, "What the fuck did I do?" It didn't make any sense. But I just said, "Okay, man, well, do you want another beer?" He said sure, so I ordered a couple beers and went to the bathroom. I couldn't have been gone more than two minutes and when I got back they were all gone. For the record I finished my and Julian's round.

JAMES BARBER: Albert magically stopped doing heroin the minute Ryan Gentles didn't manage Ryan Adams anymore, right?

RYAN ADAMS: It was easy to brand me as the problem. I would suspect that they soon learned that I was not the problem.

NICK VALENSI: There might have been a night that would have ended up drug-free if Ryan hadn't showed up, you know? Not to say Ryan was an angel, because he certainly was not; he was a severe drug addict. But is it fair to label him as a bad influence? No, that's not fair at all. Everyone was down. Whoever was doing drugs, no one was getting forced or peer-pressured into doing it. People did it when they wanted to do it, and by the way, a lot of people in my circle, in my band, didn't even fucking do drugs. Nikolai doesn't do drugs; Fab doesn't, barely, once in a blue moon. Julian's thing at the time was more drinking, anyway. Julian would do drugs so he could keep on drinking. Albert was more . . . he had more of a romantic relationship with it.

ALBERT HAMMOND JR.: For me the drug stuff was the release. I don't know how to explain it. Success depressed me.

JULIAN CASABLANCAS: It was all exciting and amazing but at the same time I always just felt like it was not on steady ground.

JAMES ENDEACOTT: That was a particularly dark time. It had lost its fun. It had lost its spark. They weren't a gang anymore. It splintered.

RYAN ADAMS: That night at the bar, I just remember thinking, "I just lost some friends," but I didn't understand why. There was a lot of weird little dramas along on the pathway to that. You know, the stuff that makes all the Shakespeare plays work. But at the same time that all seemed to be part of the soup of that time. And strangely, counter to the reputation of me being a madman, I actually was pretty Zen about a lot of it. I never pressed them after that. I didn't call or get mad or retaliate. I moved on.

"IF YOU BELIEVED WHAT YOU READ, WILLIAMSBURG WAS THE NEW VILLAGE"

SUROOSH ALVI: Something happened. We all retreated to Brooklyn because we were poor, right? Cut to a year or two later, somebody decided to call *Vice* the "hipster bible." Some magazine wrote an article about how awesome it was in Williamsburg with the music scene and *Vice* being here, and it just kind of became part of our identity. The *Sydney Morning Herald* wrote an article about this very corner, North Eleventh and Wythe, and suddenly all these tourists showed up to take pictures of it.

ALEX WAGNER: *Vice* was definitely the most well positioned to capitalize. They understood the scene and were documenting the whole thing already, and then all these bands blew up, and the magazine blew up, and all the groundwork that was laid in the partnership between advertising and editorial—they were right where they needed to be to explode.

TODD P: It's important to note that nightlife changed in New York with the smoking ban.

TUNDE ADEBIMPE: The smoking ban we could understand way more than the dancing ban. Only one of those is a health concern— depending on how bad of a dancer you are.

TODD P: You couldn't smoke in bars anymore, and people still wanted to smoke like crazy. When the city started enforcing the smoking rules really hard is also when they started enforcing IDs. It took until about 2008 before all the bars actually started closing at four, because they used to all stay open until seven. But once you

kick people out on the street, you end up having people yelling at each other, and then you have noise complaints. Noise complaints means the whole bar scene gets more regulated. That changed the whole vibe. So that's a huge difference, and that's part of why the warehouse parties got so popular so fast. That's part of why Brooklyn happened.

JIMI GOODWIN: All of a sudden everything was Williamsburg this, Williamsburg that. If you believed what you read, Williamsburg was the new Village and some warehouse venue out there was fucking Café Wha?.

JESSE MALIN: It became, "Move to Brooklyn, be in a band, wear a funny shirt!"

TODD P: The parties started to become a good, cool scene to go to, not to mention the whole underground vibe of "Oh, they're selling alcohol illegally, it's kind of a secret." "Oh, it's in a neat location"; there's a little bit of real estate voyeurism in going to these different lots and spaces too. The thing is, it had gotten to a point where everything happening in Manhattan, because of the stakes and expenses of opening up a place, and the impossibility of doing something underground, everything got quite deliberate. And it got really, really contrived and commercial, because by definition, when you have to get some guy to give you five hundred grand to open a bar, he's not going to be like, "Here's your five hundred grand, just run it on a good vibe."

VITO ROCCOFORTE: I think Northsix might've been the first venue to open up.

ROB SHEFFIELD: Northsix had the thing, which is so crucial to any rock scene, where you might hear a band, an opening band that you've never heard before that would become your next favorite band. The first time I saw the Hold Steady I was there to see Les Savy Fav who I love. I had never heard of the Hold Steady. They came on and I was like, "This is a band? They don't look like a band." They started doing "Positive Jam" and by the end of their set, I had my new favorite band and I was like, "That's just it because it's this place."

JULIAN CASABLANCAS AND KIM TAYLOR BENNETT IN THE BACK OF
THE BUS, SOMEWHERE IN THE UK, CIRCA 2002. KELLY KILEY

FABRIZIO MORETTI JUMPS INTO
JULIAN CASABLANCAS'S ARMS
BACKSTAGE AT THE GREEK THEATER
IN LOS ANGELES, NOVEMBER 2002.
COLIN LANE

ALBERT HAMMOND JR. WITH
THE SET LIST FOR THE STROKES'
GIG AT THE CARLING FESTIVAL,
AUGUST 2002. COLIN LANE

ALBERT HAMMOND JR. NUKES A TACO IN THE MIDDLE OF THE NIGHT
AT SOME GAS STATION ON THE WAY FROM READING TO LEEDS,
AUGUST 2002. COLIN LANE

NICK ZINNER AND CONOR OBERST DRESSED UP FOR HALLOWEEN. *BUTCH HOGAN*

KAREN O, ASIF AHMED, AND MICK ROCK AT THE LONDON FORUM, NOVEMBER 16, 2004. *LIZ VAP*

NICK ZINNER AND KAREN O LIGHT UP AT SPACELAND, LOS ANGELES, NOVEMBER 2001. *NICK ZINNER*

KAREN O AT THE COOLER, FEBRUARY 2001. *NICK ZINNER*

NICK ZINNER

LEIGH LEZARK AND GEORDON NICOL OF THE MISSHAPES. *BRIAN BATTJER*

BRIAN BATTJER

FROM LEFT TO RIGHT, THE PRODUCERS OF MOTHERFUCKER: JOHNNY T, JUSTINE D, MICHAEL T, AND GEORGIE SEVILLE AT THE ROXY, EARLY 2000S. *ALEXANDER THOMPSON*

MADONNA AT MISSHAPES, CIRCA 2005. *BRIAN BATTJER*

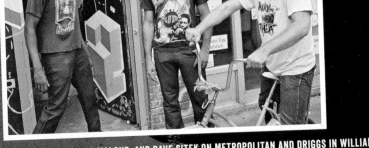

TUNDE ADEBIMPE, KYP MALONE, AND DAVE SITEK ON METROPOLITAN AND DRIGGS IN WILLIAMSBURG SHORTLY AFTER TV ON THE RADIO'S *YOUNG LIARS* EP WAS RELEASED. *RUVAN WIJESOORIYA*

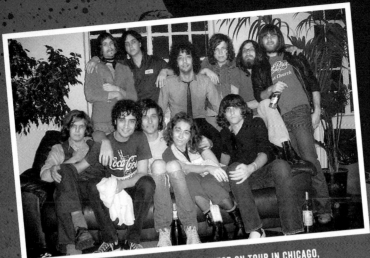

THE STROKES, KINGS OF LEON, AND REGINA SPEKTOR ON TOUR IN CHICAGO, OCTOBER 19, 2003. *RICHARD PRIEST*

JAMES MURPHY AND TIM GOLDSWORTHY, THE EARLY YEARS. *TIM GOLDSWORTHY*

LUKE JENNER OF THE RAPTURE. *LUKE JENNER*

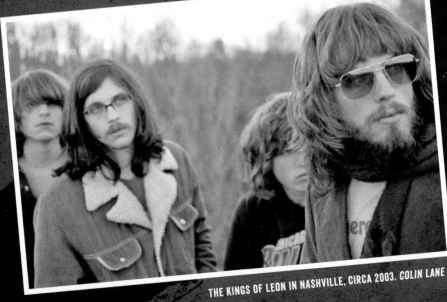

THE KINGS OF LEON IN NASHVILLE, CIRCA 2003. *COLIN LANE*

JALEEL BUNTON, GERARD SMITH, AND TUNDE ADEBIMPE OF
TV ON THE RADIO, ON THE ROAD IN AUSTRALIA, JULY 2006.
NICK ZINNER

ELEANOR FRIEDBERGER ON A ROOFTOP IN BROOKLYN
BEING SPRAYED WITH A HOSE, JULY 2003. *RUVAN
WIJESOORIYA*

PAUL BANKS CHATS WITH A FRIEND AT 7B,
SEPTEMBER 2004.

THE WALKMEN AT SXSW, MARCH 2002. NICK ZINNER

CHRIS BAIO, EZRA KOENIG, AND ROSTAM BATMANGLIJ AT FRIDA KAHLO'S BLUE HOUSE, MEXICO CITY, MARCH 2009. *CHRIS TOMSON*

KAREN O, JAMES MURPHY, AND NANCY WHANG, NEW YORK CITY, MAY 21, 2010. *NICK ZINNER*

ALBERT HAMMOND JR. SMOOCHES MACAULAY CULKIN. *COLIN LANE*

KAREN O HAILS A CAB, MARCH 2007. *NICK ZINNER*

NIKOLAI FRAITURE, NICK VALENSI, AND JULIAN CASABLANCAS LEAVE THE STAGE AT THE GREEK THEATER, LOS ANGELES. COLIN LANE

EZRA KOENIG, NEW YORK CITY, JUNE 2009. PIETER M. VAN HATTEM/CONTOUR BY GETTY IMAGES

SARAH LEWITINN DRESSED UP AS CARLOS D WITH THE MAN HIMSELF, AT MOTHERFUCKER'S HALLOWEEN PARTY, THE ROXY, NEW YORK CITY. LAWRENCE LEWITINN

JAMES MURPHY AND TIM GOLDSWORTHY, MANHATTAN, OCTOBER 3, 2002. JEAN-CHRISTIAN BOURCART/GETTY IMAGES

MATT BERNINGER OF THE NATIONAL. DAVE MEAD

JAMES MURPHY BACKSTAGE AT MADISON SQUARE GARDEN, PRACTICING FOR HIS FUTURE, OCTOBER 2004. NICK ZINNER

DANIEL ROSSEN, ED DROSTE, CHRIS TAYLOR, AND CHRIS BEAR OF GRIZZLY BEAR BACKSTAGE AT A FESTIVAL, MAY 25, 2009. TIM MOSENFELDER/GETTY IMAGES

ZACK LIPEZ AT MARS BAR, FEBRUARY 2001. NICK ZINNER

TRICIA ROMANO: You started seeing a lot of rock-star DJs in Brooklyn. You'd have Interpol bring their iPods or their CDs and go DJ a party.

ROB SHEFFIELD: At Northsix, there was always going to be a surprise happening. I went to a show once and Carlos and Nick Zinner were DJing, just in the basement of Northsix. I forget even what band I was there to see.

TRICIA ROMANO: DJ culture was so purist. The idea was that you had to be really skilled, you had to be studying this for ten years. You can't just plug in your iPod. But people were like, "Well, let's just see what Nick Zinner would play." All of a sudden you'd have these parties where there were guys who were real DJs who would be paired with Nick Zinner or Franz Ferdinand, and they were the marquee because they were the rock stars. You started to really see those two worlds collide. And of course, LCD Soundsystem was a big part of it as well. Like the Rapture, LCD Soundsystem really married the two worlds.

VITO ROCCOFORTE: The first big Brooklyn DFA show was at Warsaw. It was us, Black Dice, Juan MacLean with James playing drums. James brought in a ripping PA, like twice the size of what was in there. It was so loud. I remember sitting in the dressing room and there was a line around the building. We were like, "Holy shit, there's people here?! Crazy people!" It was packed and that place was big, especially for the time, so that was a real moment for DFA. And it happened in Brooklyn.

ALEX WAGNER: The gentrification was beginning, and by "gentrification" I mean that in the most rudimentary way: white people started moving into neighborhoods where previously there'd been white ethnic working-class people or minority ethnic working-class people. You could still get these cool spaces, you could set up offices over there, and there was just so much more room. You could create a scene where none had existed previously. You didn't need the built-in history of the Manhattan cultural matrix. You could forge your own territory with space and low rent in Brooklyn.

CHRIS TAYLOR: I lived in a big loft space that my roommates and I built. It was on North Eleventh and Berry, which is now the armpit

of Williamsburg. If there is ever, like, a Williamsburg street at Epcot Center it would have to be North Eleventh. You had a record store, you had a cocktail bar, a bowling alley, a barbecue place, a hip hotel, *Vice* magazine around the corner. It was just, "What the hell happened?" It was totally vacant when I moved there. It was nothing.

ALEX WAGNER: There was not a Brooklyn identity yet. Brooklyn just felt newer. And I think that made it easier for people to kind of pave over Brooklyn's history. That's why Williamsburg is all new condos, right? Or lofts that have been converted and the rent has quadrupled. I don't mean to short-shrift artists who came up in Brooklyn—much respect to Biggie Smalls—but there wasn't the same kind of entrenched artistic scene there to protest the gentrification in the way that there has been in Manhattan.

SUROOSH ALVI: This was the era of zero culpability, nonstop partying, and creativity.

ED DROSTE: My friends Sophie and Lisa started a fashion line, Vena Cava. Lisa lived in a bodega storefront, and they couldn't really use their natural light because it was just an exposed window, so they would keep the metal barricade down most of the time. They had these crazy Halloween costume parties.

ALEX WAGNER: I remember thinking, like, "I wasn't alive for the sixties and seventies, but this is what it was like."

TODD P: The guys from !!! and I started this dance party at Tommy's Tavern, where they'd play old soul records. This was 2002, 2003, right after electroclash. People were in the mood to dance, but they'd gotten sick of that music. Tommy's was a super-seedy bar where homeless guys went to shoot up or fuck each other. We used to call it the Murder Bar. They had served food to the old Irish worker guys in Greenpoint years ago, but they'd gotten rid of the kitchen, and they just had this cheesy room in the back with bad disco lights that was closed all day long. There was a needle exchange on that block. And a weekly motel. We thought it was the perfect place to have a party!

ED DROSTE: No one had a problem going out until like four or four thirty on a Wednesday, every Wednesday.

ROB SHEFFIELD: The first time I heard James Murphy DJ was opening for Black Dice. The singer Vince Martin, who was a Greenwich Village folkie from the early sixties, was also playing. I remember James played Donna Summer's "I Feel Love" into Hawkwind's "Silver Machine" and I was like, "Holy shit! That is some visionary shit!" Really, that sums up the whole DFA style right there, a DJ badass enough to play those two songs back-to-back, and you know what? Nobody stopped moving. Everyone was totally into both those songs, like they were both from the same freaky place. Here we were in Brooklyn, with the Black Dice, an extreme noise band; James Murphy DJing; and Vince Martin playing his songs. He's in his seventies at that point, and he's explaining his songs, all the stories behind them. It was just amazing. "Wow, this is all these different generations of the same New York bohemia dream. Leave your town and go to the city and meet all the other scroungers and hustlers and phonies who are bullshitting the same way that a new generation of phonies are going to be bullshitting a couple of years from now." James's set was like a bridge from early sixties Bleecker-and-MacDougal bohemia to Bedford-and-Metropolitan noise, forty years later. It was beautiful. And it definitely happened in Brooklyn.

SOVIET KITSCH

REGINA SPEKTOR: I didn't know about the Strokes when all of New York already knew. I was just playing around the city. This guy Alan Bezozi came to one of those shows, and he was friends with Gordon Raphael.

GORDON RAPHAEL: After *Is This It*, the first thing I did was go to England. The nicest thing the Strokes did, other than hiring me to do that record and being cool, was they put my picture the same size as their picture on the record, so people started recognizing me. I was in England, going to parties and fielding jobs nonstop. This was the dream life! I had a royalty check, I had a cool apartment, and I was working in really good studios where English engineers were making me tea.

REGINA SPEKTOR: Alan said, "Gordon's the producer of the Strokes and he's been living in London, but he's going to come through and we should do a song with him." He was saying "the Strokes" like it should mean something.

RYAN GENTLES: The Strokes were recording *Room on Fire* with Gordon at TMF Studios on Twelfth Street between University and Broadway. It closed down as soon as we were done recording; we were the last record recorded there.

GORDON RAPHAEL: Alan said to me, "I got this girl Regina Spektor, you want to record her?" I said, "No, actually, I've recorded the coolest bands in the world this year and I'm fucking tired." He said, "Come on, Gordon, she's this twenty-one-year-old Russian girl, don't you at least want to meet her?" So I said, "Okay, I'll meet her but I'm not recording anything."

REGINA SPEKTOR: We did one song.

GORDON RAPHAEL: We met at TMF Studios and up comes this young girl wearing some really funky clothes who had a big smile and was really cute. She shook my hand, and I said, "What do you do?" There was a piano nearby, and she pulls a chair over and whips a drumstick out of her purse, puts her left hand on the piano, and starts singing some of the most outrageous lyrics I'd ever heard. Like Joni Mitchell and the Moldy Peaches in one. It was "Poor Little Rich Boy." I'm thinking, "People are going to love this. I love this! I have to record this."

REGINA SPEKTOR: He gave me the Strokes' record, *Is This It,* which I still hadn't ever heard, and we started making my record, *Soviet Kitsch.* So in the backdrop of making that record, I'm listening, on my CD Walkman, during my five-hour daily subway ride, to the Strokes record. I really got into it. It got so into my soul. It was like a sickness. I fell in love with that record.

GORDON RAPHAEL: I couldn't stop thinking about Regina's album. I wanted to play it for Julian. But Julian hated everything I ever played for him. Why would this rock-and-roll guy even want to hear a girl playing piano? But one day, in the studio for *Room on Fire,* I said, "Would you like to listen to something?" And he looked at me like, "If you dare . . ." I played "Poor Little Rich Boy," and to my surprise he said, "Play another one." I played "The Flowers." He said, "Make me a CD of this, I need to take this home." I was thinking, "Oh my god, if I tell Regina Spektor that Julian Casablancas is taking her CD home she's going to do a dance." So the next day, I'm by myself tweaking something on the computer, when Julian comes up behind me and gives me a big hug and a kiss on the cheek, which he always did, and he started singing "The Flowers" in my ear. Then he picks up an acoustic guitar and plays it. He says, "I wrote these same chords three years ago but her chorus just kills mine."

REGINA SPEKTOR: It was very exciting.

RYAN GENTLES: Gordon took Julian to a show that she was playing and when he saw it he was like, "Oh, she's gotta come on tour with us."

THE SOUTHERN STROKES

BEN BLACKWELL: Right before *Room on Fire* came out, the Strokes were in Detroit, playing at the State Theatre. Kings of Leon were opening, and that was their first tour. Regina Spektor was on the bill too: Regina Spektor, Kings of Leon, and Strokes.

NICK VALENSI: Our A & R guy, Steve, he found Kings of Leon. The Southern Strokes, that's how they were pitched to me.

JENNY ELISCU: Steve was very prescient with Kings of Leon, for sure.

STEVE RALBOVSKY: Their manager Ken Levitan is an old friend of mine. He had this guy who worked for him who found Nathan and Caleb.

CALEB FOLLOWILL: I always knew I wanted to make music. We were at my grandma's house in Jackson, Tennessee, when we wrote our first song. Nathan was always a drummer, but I didn't play an instrument, so we wrote it a cappella and we continued to do that. We'd listen to old soul music and old country music and started writing tunes like that. Then we got to Nashville and people were drawn to us for some reason, but the record labels and everyone—thank god—they were scared of us. They knew that there was something wild about us.

NATHAN FOLLOWILL: I mean, not a lot of country artists will sing a song called "Trani."

CALEB FOLLOWILL: Nathan and I would go in there with the Nashville songwriter at nine o'clock in the morning, they'd be drinking coffee, and we would tell them what the song was about, and they would be like, "It's way too early to be singing a song about that."

But it was a blessing in disguise because they kept pushing us off until we got better and better, honed our craft. Then we met this guy Angelo.

STEVE RALBOVSKY: Angelo Petraglia was very much the big brother. He showed them his record collection and helped them write these songs, and they did some demos.

CALEB FOLLOWILL: We'd smoke hash and listen to the Rolling Stones and write thirty songs about, you know, Jesus and fucking and incest.

STEVE RALBOVSKY: Ken gave me the music and I listened to the songs and I liked them. He said, "Okay, well, I'll bring them to New York and they'll sing in your office."

NATHAN FOLLOWILL: It was me and Caleb, and our buddy Angelo, and Ken Levitan went with us.

CALEB FOLLOWILL: We stayed in Hell's Kitchen.

NATHAN FOLLOWILL: At the luxurious Washington Jefferson Hotel. The room was so small that Caleb could flush the toilet from his bed. I think our first meal was at Rosie O'Grady's. We went in there and the person that was working asked if we were in a band and we were like, "Oh hell yes! We're famous!" We proceeded to eat there for three days in a row, the same exact place. I mean, I hate French onion soup and I ate it every day just because we felt so proud that they had recognized us as guys that were in a band.

CALEB FOLLOWILL: We got in there right at the end of New York being so cool. We were going to bars and there was still smoking, and everyone was doing drugs right out in the open and everything was just happening.

NATHAN FOLLOWILL: Our very first cab ride, coming in from the airport, Angelo gets up front with the cab driver, and me and Caleb are in the backseat. We're just amazed—you can see the lights driving in, and we're like, "Oh my god, that's the biggest downtown we've ever seen in our lives!" The cab driver starts talking to Angelo and we're not really paying attention. Then Angelo kind of turns around and gives us a look of slight panic. The guy is saying, "You know what

I'm going to do when I leave here?" "No, what?" "Well, my wife is fucking my best friend right now, so I'm going to go home and get a butcher knife and kill both of 'em. I'm going to cut her throat and I'm going to fucking gut him." And he is dead serious. Angelo is going, "You know, sometimes you can just talk things out, man," just totally trying to defuse the situation, and then he texts us from the front seat: "This guy is a total fucking nut job. I've seen a lot of weirdos in my life in New York, but this guy takes the cake. Just don't say anything. Do not engage him. Let's just try to get to the hotel alive." So that was our first-ever experience of New York City, a cab driver telling us that he was going home to kill his cheating wife and best friend. I think we even kept looking in the papers the next day to see if a woman from Queens had been butchered.

CALEB FOLLOWILL: We went to nine labels and got seven record deal offers, which was pretty crazy. It was just me and Nathan and Angelo. We had an acoustic guitar and a tambourine and we won them over.

STEVE RALBOVSKY: I loved it, I flipped.

JENNY ELISCU: Steve called me up one day and said, "These guys, they came into my office, two brothers, they had weird Beatles bangs . . ."

NATHAN FOLLOWILL: Early on our sound was so Southern rock. We got compared to Lynyrd Skynyrd and Allman Brothers and all that. But the crazy thing is we never even listened to that kind of music. Oddly enough, our first show in New York was at Mercury Lounge and one of the Allman Brothers was there. I think it was someone from *Rolling Stone* that recognized the guy and was like, "Hey, so what do you think about people saying that these guys are going to carry the Southern-rock torch?" He said, "Wait, what do you mean? I thought they were British." The writer had to tell him we were from Tennessee. He thought it was just us trying to dress the part and sound like it, you know? Southern rock royalty did not even know we were Southern.

JENNY ELISCU: They were huge fans of the Strokes and they sang a cappella in Steve's office. Nathan played drums on his legs and

Steve was like, "This is cool as fuck." Immediately he was in love.

STEVE RALBOVSKY: I said to them: "What do you guys know about RCA Records?" And the two of them said in unison, "The Strokes."

CALEB FOLLOWILL: If you ever wanted to be in a rock-and-roll band, and you watch the Strokes come out, it was like, "Holy shit, *that* is a rock-and-roll band. And *that* is what I want to be."

NATHAN FOLLOWILL: By that point the whole world was ready for some dirtiness and sweat and some sex and some rock and roll. I think it could not have come at a better time. If we'd come along three years earlier? Hell no. You're not going to compete with *NSYNC for space at a Virgin record store. That's just not going to happen. I mean, the White Stripes were tryin' to do it during all that pop stuff and it didn't happen until after that pop stuff died down. Everyone was like, "Check out this amazing new band the White Stripes!" And I'm like, "They've actually been making records for a while, just no one gave them the time of day because it wasn't 'Hit Me Baby on My Butt One More Time' or whatever." We would go buy jeans and then have our mom sew them and then make 'em so tight—our mom did all of our tailoring for us, and our hair. She was basically a one-stop shop. Back then, I can remember Jared having to straighten his legs out so stiff just to pull them on, and then we would lift him up and he could not bend his knees for a good thirty minutes. What do they say, they say style over comfort, or something? We'd even wear girls' jeans when we could find them to fit us properly, but sometimes the pockets were a little too girly for us on the back and we're like, "Shit, that's not rock and roll at all." Kids here in Nashville would laugh at us with our skintight girls' jeans and our uncles would be calling us their nieces. After we saw the Strokes, we were like, "If we want to wear skinny jeans and grow our hair out and wear Converse and vintage T-shirts, awesome, that's cool, who gives a shit."

STEVE RALBOVSKY: So after that showcase, which wasn't really a showcase, I said, "Well, let's go hang out later. I'll show you guys where the Strokes would hang out and drink and have fun when they made their first record." So I took them to 2A. And we sat upstairs,

you know, kitty-corner from Gordon's TransporterRaum on Avenue A. We sat there and they told me their whole life story.

KIM TAYLOR BENNETT: Every nugget you heard about the Followills' backstory was more outlandish than the last. Okay, they were three dirt-poor, Southern sons of a preacher, plus a cousin; fine. But then you found out Followill Senior was an evangelical Pentecostal preacher, while their mom, Betty Ann, led worship and the boys assisted. They were homeschooled, but they had no home to speak of because the family would travel the Southern states in a Chrysler spreading the word of God. Pop music was verboten. Then the next chapter of their childhood unfolded and you heard their dad was seduced by the very sins he was campaigning against—alcohol and women—and he divorced Betty Ann. Of course this fall from grace rocked the boys to the core and the next step was the boys falling for rock and roll. That tension between the exploration of hedonism and the tenets on which they were raised was for sure part of their early appeal.

NATHAN FOLLOWILL: One time we did an interview with a magazine and they showed up with DNA swab kits. They wanted a saliva sample from all of us to run a DNA test to see if we were all truly related, because they thought it was a made-up story that the label had put together. I swear to god.

STEVE RALBOVSKY: That was our first date. At 2A.

NATHAN FOLLOWILL: We were just amazed that this . . . that it was a bar full of Strokes, like people that looked like them, that dressed like them. We were like, "Holy shit, this is a way of life for these people, this isn't just them acting."

STEVE RALBOVSKY: Now, at the time I was thinking of them more in the tradition of the Band. They called themselves the Followills, because that was the family name. And in fact, the reason why Ethan Johns produced their first EP and later albums was because of the Ryan Adams *Heartbreaker* record. I initially saw them much more folksy and rootsy. Sort of post-church rustic Levon Helm, Woodstock Dylan and the Band, Van Morrison thing—those were the antecedents, whether they knew them or not. That's what I was feeling.

NATHAN FOLLOWILL: Everyone was learning to play their instruments together. Jared had never played before, Caleb had never played before; our cousin Matt had taken lessons five years earlier; I had played drums, but the last time I played drums was in church when I was seventeen.

ETHAN JOHNS: Jared was fifteen when we made that first EP.

NATHAN FOLLOWILL: Jared was still a freshman in high school, Matt was a sophomore in high school.

ETHAN JOHNS: They just pinned me to the back wall the first time I saw them. It was like, "Holy shit, these guys are amazing!" I thought on every level that they were incredible. Caleb, lyrically, I mean, he's a good writer. Really interesting. "Wicker Chair" is an amazing song for kids to write. "Trani," off the first album, that's an extraordinary lyric for a twenty-year-old guy to be writing. They were really eager to learn. They were totally committed to what they were doing and obviously hungry. Hungry to get out of the situation that they were in. They had a pretty extraordinary childhood.

KIM TAYLOR BENNETT: You only had to spend five minutes with them to realize they weren't some record industry ruse. No matter how bad shit got or how badly they might behave, the Followills stick together.

NATHAN FOLLOWILL: We actually had a couple of meetings with RCA. The first time we met with them, Bob Jamieson was the president and he took us out in a 1986 limo with a pimp-looking driver and blasted Run-DMC and got us shitfaced, so that was fun. The second time we went back to New York, they brought out the big dogs—at Atlantic, we met Ahmet Ertegun and we did not even know who that was. We left and Angelo was like, "Holy shit! You didn't know who that guy was?" And we said, "Who? The old turtle-looking guy they just brought out from the office back there?" And then Angelo told us he signed Ray Charles, he signed—and just went down the list. But Ahmet was so funny. In the meeting he said, "I'm going to give you some advice: don't let the record label fuck this up. Y'all are too good for this shit, don't let 'em fuck it up." And the guys at Atlantic were all, "Ha ha ha, he's joking, guys. Ahmet, you kidster, you." But he was dead serious. Great advice.

CALEB FOLLOWILL: When we went to RCA and we actually signed the deal, it was me and Nate signing the record deal and then we had Jared with us, who was a little tiny teenage kid, and my mom and stepfather, and the record label gave us a limousine. We went to the Yankees game; they put us up, with a steak dinner. It was old-school rock and roll. We were the last of a dying breed to get that deal.

NATHAN FOLLOWILL: There's a picture of us signing our record deal in New York City. My mom, my stepdad, and Jared, they're all in the picture with us. But we didn't know yet that Jared, this little thirteen-year-old kid happy to be in the big city and proud of his big brothers, was going to become our bass player. Our mom lost all three boys at once. She was not too happy with that. But she's happy with the Mercedes now.

CALEB FOLLOWILL: I remember walking out of RCA and seeing a massive picture of the Strokes on the wall. I was like, "That's going to be me."

STEVE RALBOVSKY: When we were recording the EP we didn't want to do it in Nashville because we didn't want Nashville to be part of the story. We went to Memphis. We commissioned videos. We filmed them recording. We filmed them driving around in a van pointing out different places around Memphis and Jackson where they had lived when they were younger, relatives' houses and stuff. And it turned into this eight-minute film that really was the lightning rod for UK media. It was the thing that our publicist over there took around to show to editors at *Mojo* and *NME* and people were fascinated. It was the Southern Strokes, this too-good-to-be-true story about the alcoholic preacher dad and getting homeschooled and driving from town to town for church revival meetings.

JENNY ELISCU: Steve sent me a press kit and some music. Eventually there was someplace we were able to fit them in *Rolling Stone*. So literally the very first interview that they did was a phoner with me. It was with Nathan. He was awesome.

IMRAN AHMED: The best bands always have their own universe. They kind of land from outer space and have their own world that you can plug into. Kings of Leon, being from the South in the U.S.,

were very different. They were really young. They had this insane story. And the songs were great.

NATHAN FOLLOWILL: We had done an EPK [electronic press kit] earlier that had "Holy Roller Novocaine" and all that stuff on it. The Brits had just picked that up, started playing "Molly's Chambers" and "Holy Roller," and it blew up. So we're halfway through making our first record in Los Angeles and our manager said, "Man, we got to go over there. Y'all are hot right now, we need to go over there, put a face with the music, and start making the rounds." We were like, "Well, shit. We're halfway through our first record, we have like five songs, are you kidding me?" But we went and did it anyway.

CALEB FOLLOWILL: We'd only played a few handfuls of concerts, you know? We were still very green. And the night before we left for England, were staying in this condo in a little suburb of L.A. There was this little Thai restaurant across the street where we would go every night and drink sake every night and eat. There was this girl working there that I kind of thought was cute, and that night she just kept pouring me sake and I kind of blacked out. As the story goes, we were walking down the street back to our apartment because we had this early flight, and I fell into the bushes right in front of a bunch of cops, and they just kind of laughed at me. I went upstairs and we all went to bed and the next morning I woke up and there was a glass table in the living room that was completely shattered. Apparently someone had pissed in the closet. I think all of it was me, but I didn't know. We got on the airplane, and I had full-on alcohol poisoning. It was awful. We were sitting in coach, I was, like, in the middle, and I was in a barf bag the whole time. So we finally land in London; I'm just a weak shell of a man. We get into the car and they put on XFM and the first song was "Molly's Chambers." We pulled over and we're all dancing, like, "Holy shit! Our song's on the radio!" We got back in the car and three songs later was "Red Morning Light." So we pulled over again and danced again. By the time we got to the hotel, they had played five of our songs. What a great country.

NATHAN FOLLOWILL: We came home from that trip and the fire was lit.

STEVE RALBOVSKY: I also sent that EPK to Ryan Gentles, with an EP. I didn't ever think they would watch it. I thought it was so different to what the Strokes were culturally, geographically, background-wise, that they wouldn't like it. Well, the opposite happened. (A) They actually watched it, which I'm still surprised that they took it out of the box and put in a VHS tape. And (B) they loved it. Ryan called and said, "We want to see if these guys will go out on tour with us." And that began a really intensely productive relationship.

MATT ROMANO: We still had the Wiz Kid office on Seventh Street and I was working there at the time, doing the fan club, when Ralbovsky sends over this VHS EPK. Me and Juliet [Joslin, now Casablancas] watched it and we're like, "Oh my god, these guys are fucking great, they have to open for the band!" The office wasn't just the office, it was like the clubhouse, and Fab came in and watched and he didn't like it. They weren't totally sold, but then Julian liked them. Julian was the cool kid. He has this thing where, to this day, everybody that is close to him and has worked with him wants to please him like a parent. So the Kings came on tour.

CALEB FOLLOWILL: We played a concert in New York. They would never tell us who is at the show 'cause they don't want to make us nervous. I remember walking offstage and it was Ben Kweller, Evan Dando, and the Strokes, and we were just, "Holy shit, this is really happening. These people actually really are into what we are doing." We started to talk and we just hit it off. And I know Julian was always a big fan of our personalities and the way that we shot straight and didn't give a shit about the consequences. It just went from there. When we went on the road with them every night, he would give a heartfelt speech about us and say that we were the real deal and not to take us for granted. We became close.

NICK VALENSI: It seemed like it was a very natural thing to do, to invite them on tour with us, because our music was so in line and we had the same record company, the same A & R guy. And they were big potheads, like me. It made sense.

THE COLUMBIA HOTEL

HAR MAR SUPERSTAR: The Columbia was like a weird youth hostel for bands. Mick Rock was always sitting in the lobby, waiting to find the new guys.

NICK VALENSI: The first time we went to England we stayed at the Columbia Hotel; we met a few other bands.

KELLY KILEY: It was a rite-of-passage hotel. All our baby bands stayed there.

ELEANOR FRIEDBERGER: My brother got scabies there once. It was disgusting, but it was cool.

KAREN RUTTNER: It was essentially the London equivalent of the Riot House in L.A. It was super cheap, kind of shitty, and that's where all the bands stayed. It had a lobby bar that was open pretty much until they started hating you. Like, that was the rule. They would stay open until everyone started pissing them off and then they would just randomly shut down.

NATHAN FOLLOWILL: That's the first hotel we ever stayed at in the UK, in London.

CALEB FOLLOWILL: I wouldn't call it a hotel, it was a shitty little place, but every band was staying there. Interpol, the Datsuns—every band you can imagine. I mean, as soon as we walked in, we checked in, a guy came up to us and asked us if we wanted heroin.

NATHAN FOLLOWILL: We were all little stoners, that's all we did.

CALEB FOLLOWILL: My manager grabbed him by his throat and slammed him against the wall and said, "Don't you fucking ever talk to these guys again." And we didn't even know. We were like, "Do we know that we want that?"

NATHAN FOLLOWILL: *NME* magazine had a little concert series where there were five or six clubs throughout London and you would play a different one every other night. We kind of made the rounds. But we stayed at the Columbia. I remember band names there that I don't even think are around anymore—like the Star Spangles. The bands in that hotel scared the ever-living shit out of us. That is why we did not do drugs. Those guys. I mean, guys shooting up out in the open. I mean, guys coming out of the closet with their pants down and a girl coming out right after them. It was full-on; there will never be a place like that ever again.

HAR MAR SUPERSTAR: We all lived at the Columbia Hotel. The lobby of that hotel at three in the morning every night would be me and Karen O smashing the little chandelier, and somehow it would be put back together when we'd all wake up. Kings of Leon would be in one corner and the Killers in the other. You'd Indian leg-wrestle with My Morning Jacket in the breakfast room. Jim James took me down.

BRANDON FLOWERS: Did we stay at the Columbia Hotel? Yeah we did. Shit.

RONNIE VANNUCCI: We would share, like, one or two rooms.

HAR MAR SUPERSTAR: You'd get a room that had five smaller-than-twin beds, so you and your band would look like a pack of gum.

BRANDON FLOWERS: I remember well we were all sharing rooms and we took turns throwing up in the bathtub.

RONNIE VANNUCCI: I never drank before. Brandon got me into drinking. And I remember he and I just throwing up in an avocado-green bathtub, together. "Blehhhhhhhhhhh!!!!" I never throw up in the bathtub, I'm a toilet guy. Flush it down.

PAUL BANKS: That was the best. We stayed there on that first tour. Sometimes there'd be this really old, horrible, fucking asshole bartender, just being belligerent. He would still be serving everyone drinks until five in the morning but just talking shit all the while. But there was also this young guy that everybody really liked. I want to say his name was John. We would just be sitting there, in this room off the lobby—a big, big room—just getting fucking

plowed. Then, if you separated off with somebody there were conference rooms that you could find for privacy. Or there was this large women's bathroom with sofas in it that you could . . . you know.

KAREN RUTTNER: I remember one time the Interpol guys had tried to buy cocaine, and in London at the time it was hard to come by. They had been swindled. Somebody sold them like eighty pounds of baking soda. They tried snorting it. I felt really bad for them, and I had Adderall because I was in college. I said, "Don't worry, guys, I got this. I got this." I was just chopping up lines of this blue shit on the table.

PAUL BANKS: I'm pretty sure we weren't doing drugs on the tables. But that could've also simply been because you wouldn't want to publicize to the other forty people that you were packing.

KAREN RUTTNER: It became one of my favorite places to go to. There was this one particular night, Carlos brought me there. The Polyphonic Spree were there in their robes, even though it was long after showtime. Har Mar was in his boxer shorts, dancing on a tabletop. The Datsuns were all on ecstasy, because it was one of their birthdays. I think Carlos was on ecstasy. I was on Adderall. Bobby Gillespie was there too, and Mick Rock and Evan Dando . . . who was barefoot, walking around the lobby, basically in circles. He introduced himself to me twice in the span of an hour. I was just like, "This is the coolest thing ever." I was coming from fucking Barnard! I had gone to yeshiva on the Upper East Side, had a totally sheltered childhood. Basically Carlos adopted me. He was like, "You're my date for the night." And that was that. So, he took me out and then the rest was history. I wouldn't call it dating, but yeah, I slept with him that night. And my poor friend that I was staying with called, like, my mom, because I didn't come home. She was like, "Where were you?" I was like, "Ohh, I met this band."

NATHAN FOLLOWILL: I won't name the band because they're friends of ours now and the guy that said this is not even in the band anymore . . .

CALEB FOLLOWILL: Interpol.

NATHAN FOLLOWILL: We were already kind of self-conscious and it was like rock-and-roll summer camp. There were so many bands there. We knew that we were the flavor of the month, so we tried to keep to ourselves. But I remember the elevator opened and we got out and it was the lobby floor. We were going to the bar and this one guy from this band was standing there and goes, "Oh look, it's Lynyrd Skynyrd." And we were like, "You vampire-looking motherfucker, like, we will break this bottle and cut you. You have no idea who you're fucking with right now."

CALEB FOLLOWILL: Yeah. When we were in the Columbia, everyone was doing blow on the tables and banging in the closets and doing all this shit, so we're like, "Sweet." We're smoking a joint and we're walking around in our bell-bottoms and our mustaches and Carlos from Interpol walked up and said, "Hey, are you guys from *Almost Famous?*" And my brother said, "Hey, are you a fucking mortician?" I was like, "Nice, Nathan!" He shut up. So I thought that we didn't like them, but now I'm actually very, very friendly with all of those guys. But not Carlos; he's a mortician.

NATHAN FOLLOWILL: I think I called him McFly. I'm not sure. But by the end of that night we were like, "Fuck this, we can hold our own. This is every man for himself."

"I'M ONLY SIXTEEN AND I'VE ALREADY HAD CRABS THREE TIMES"

REGINA SPEKTOR: It was the Strokes and Kings of Leon and me. It was trial by fire.

SARAH LEWITINN: I remember those shows—this was before *Room on Fire* came out.

JENNY ELISCU: Kings of Leon immediately felt like a perfect thing for the Strokes' audience. And I loved Regina. She is amazing, but it definitely felt . . . I guess having seen Moldy Peaches open for them previously, it would be weird to say it felt incongruous, but it did feel like they were challenging their audience by choosing something so aesthetically different.

STEVE RALBOVSKY: Regina was more like Kate Bush or something; it didn't really fit with the styles and the sounds of those other two bands.

REGINA SPEKTOR: The very first day I ran off the stage crying. There were these three frat boys in the front row who were like, "Go fucking home." I looked to the right and all of the Strokes dudes were on the side of the stage supporting me. I played the whole set and then I dashed to my dressing room and I was just crying with mascara running down my face. Fab and Julian, they came up and said, "That was great!" I was like, "Everybody hates me!" They told me that I had to toughen up. If I'm scared, I still think about that moment.

RYAN GENTLES: Yeah, she had a tough time. She wasn't received too well by a bunch of kids who were trying to get drunk off beer in

Chicago, you know? She had a hard time. There are two big old party-rock bands coming up and Regina was there with just a little voice on a piano banging on a box with a drumstick.

STEVE TRACHTENBROIT: She got booed every night but it was good for her. It toughened her up.

JIM MERLIS: I didn't love Regina; those records were too quirky for me. I thought she was one of those people who was like, "I have talent, but I'm not really going to use my talent, I'm just going to be strange." Give it to Julian, he saw the commercial potential there.

RYAN GENTLES: Julian pretty much single-handedly got Regina Spektor her deal. That was all him. He took her CD to record labels and made appointments and brought her in.

STEVE RALBOVSKY: I came into my office one morning and Julian had slipped me a handwritten note on a rumpled sheet of paper with a CD of Regina Spektor songs. To paraphrase, it read: "She's great. I would really like her to become part of our family. Really hope you like this." This was not something he ever did. You knew he was a supporter of other bands, but he wasn't a going-out-and-talking-about-bands kind of guy. For him to advocate was really kind of a serious thing. And I could see it had merit. I could see where he was coming from. Her life story was fascinating and there was a coolness about her. She was hard to approach. She was awkward, and in conversation she would curse up a storm, telling the whole story about how they got here from Russia. I think he was captivated by her outsiderness.

RYAN GENTLES: And then everybody passed. If those labels knew what I knew, they would have just signed her. Julian is the most remarkable human being I've ever met in my life. Most people have five senses, but he's got six. I've worked closely enough with him to see him so many times defy the odds against what seems like the practical, logical thing that I just trust him inherently. He's not always right, but his fucking track record is seriously impressive.

STEVE RALBOVSKY: With the Regina thing, I thought, "Well, I might do this to make you happy but . . ." But you always worry about

signing bands' friends. I also thought it would be good for Regina to separate herself from that pack, because you don't want to ever be a protégée of the Strokes.

RYAN GENTLES: Of course DreamWorks eventually signed her, and she's been wildly successful.

REGINA SPEKTOR: The Strokes themselves basically funded me on that tour. I would go and eat my meals with them and they would always pick up the check. I would do the reach, but Albert would get it or Julian would pick it up, or Nick. Even if I went and had lunch at the airport with Nikolai, he would pay for it. They fed me. I would go to my dressing room and it would have, like, chips and salsa, and I would go to their dressing room and it would have, like, cold cuts, and they would say, "Go ahead, eat, drink." They shared everything and it got me through. I remember, on the flight back home, when the tour ended, they upgraded me and I flew fancy.

RYAN GENTLES: Look, it's not Mötley Crüe in 1987. This is the girl who Julian handpicked to come on tour with us. We wanted her to hang out. We wanted her to feel welcome. And she was one person! She was a little tiny mouse and she was like the nicest girl ever and "please" and "thank you" and shy and bashful and meaning not to impose.

CALEB FOLLOWILL: Regina, what a class act she is. So sweet. She was in the locker room at all times. It was just all boys mooning each other.

RYAN GENTLES: It wasn't like she was some bird and we were like, "Wow, look at the rare talent on tour with us—please, come right in, drink our beer, hang out with us, please." You know? It was equal.

REGINA SPEKTOR: I became a cousin. Kings of Leon were a family and the Strokes were a family and I got to be the cousin.

BEN BLACKWELL: It was a fucking awesome bill if you think about it. Regina Spektor, Kings of Leon, and Strokes. Julian was still reckless Julian then, climbing ladders on the side of the stage, jumping into the crowd.

ALBERT HAMMOND JR.: I remember lots of cocaine, lots of late nights. So debaucherous. Regina, Caleb, Julian, and me, we just never slept.

Everyone wanted to keep up with us, because you just want to keep on hanging out longer.

NATHAN FOLLOWILL: Let's just say that was when we first got introduced to the big bad world of things that will make you able to party until five A.M. every single night.

ALBERT HAMMOND JR.: I was doing a lot of cocaine and what was funny was when Caleb and I would do some, he'd be like, "Don't tell Jared about it," and I'd do some with Jared and he would be like, "Don't tell Caleb." I'd go back and forth. In the meantime, I was doing double duty over here. "I won't tell anyone anything."

NATHAN FOLLOWILL: Julian left the bus at one point and stayed with Jared in his room for, like, five days straight. The crew would all be anxiously waiting, like, "Okay, shit, where is Julian?" And then he would just get off our bus, like, "Hey guys." We had a pretty vicious basketball rivalry between the Kings and the Strokes, so that was a lot of fun. They are all tall and there are five of them, so that is a slight advantage, but they were playing in high-heel boots or something, so at the end of the day, it was evened out.

ALBERT HAMMOND JR.: Everything was becoming a little more comfortable. You'd go into your hotel room, and think, "Wow, we're staying here?" Julian I were still rooming together. Back then, our roommate situation was me and Julian, Fab and Nick, and Nikolai and whoever. Poor Nikolai.

NATHAN FOLLOWILL: That whole tour was just an after-party.

ALBERT HAMMOND JR.: One night we were staying at the Mandarin Oriental in Miami and at eight o'clock in the morning Julian threw my phone from the hotel into the water.

CALEB FOLLOWILL: We've done lots of crazy shit together, thrown tables off of buildings and stuff. If they didn't tell you about that, I won't. I'll just say that all I did was aid. I didn't want someone to go off the building, so I just helped. It was not a one-man job, but it was one man trying to do it, and I was like, "Fuck, this guy is going to die, I'm going to help him."

ALBERT HAMMOND JR.: Ask Caleb about midget porn.

CALEB FOLLOWILL: How much time do you have?

NATHAN FOLLOWILL: We had a nice little competition going of who could shock the others the most with their taste in all things sexual. I'm not sure who won. I think a couple people dry-heaved, but I don't think anyone actually puked. But to me a dry heave is a win, isn't it? Like, if you get to the point where you might lose your lunch, especially with worldly guys like us and the Strokes, it takes a lot. I want to say it was our contribution that won. We were a little more adventurous because we were pent-up Christian boys just looking for a sweet release. So I'm going to say it was us that introduced them to the midget porn. What I know for sure is, it was there, it was watched, and it was enjoyed by most.

NICK VALENSI: They were very young. Jared, the bass player, was fourteen. Literally, I'm not even exaggerating. He should have been in ninth grade, and he was on tour with us. It was really not an appropriate environment for a fourteen-year-old. It wasn't really appropriate for anyone.

STEVE TRACHTENBROIT: My favorite Jared quote was from *NME* or *Q*. He said, "I'm only sixteen and I've already had crabs three times." I was like, "Good for you, man."

JENNY ELISCU: I mean, those guys were kids, they were really young. And they were kids from small-town USA. Every year they have this family reunion where they like to joke about the high percentage of people there who don't wear shoes. I mean, what's more innocent than being barefoot?! The Strokes were gritty, New York school boys, whereas I couldn't have imagined Kings of Leon getting on the subway by themselves, you know?

NATHAN FOLLOWILL: They were young too. Had Jared not been nine years old, they would have been considered a young band as well. But with the Strokes it was kind of like it's your freshman year at high school and your brother is a senior: takes you though the ropes, tells you what girls to stay away from, which teachers are assholes.

JENNY ELISCU: I remember I reviewed a show they played at Irving Plaza for *NME* and wrote some line about how by the end of it there wasn't a pair of dry pants in the house, and then the next time I saw them, Jared, who was like sixteen at the time, was like,

"That thing you wrote about the girls with their pants . . . did you mean . . . like . . . girls . . . you know?" And I'm like, "Yes! What else would that mean?" Just delightfully sweet, down to earth, and unsophisticated.

HAR MAR SUPERSTAR: Me and Kings of Leon went to Sadie Frost's house in London with Kate Moss one night and played guitar in her tree house for like nine hours.

ANTHONY ROSSOMANDO: Her kid's playhouse! I first met Kate Moss up at Sadie's. There was like a kiddie slide, and in the morning, we'd be all high on MDMA, in a little kiddie house playing guitars. I was involved with some very weird things at her place, like a threesome on the top floor with her friend and I look up and there's pictures of Jude Law and her and the kids on the wall, and I'm like, "What am I doing . . ." She was so up for it, those Londoners are up for it. But Kate, I cheated on my girlfriend with Kate. I fucked up in the biggest way possible. So why did I do it? Because Brendan Benson and Jack White grabbed me at the bar at the Dorchester and said, "You're the one, do it for the USA."

MATT ROMANO: I've heard these Kate Moss stories where I've been like, "Are you telling me that if I was two doors down at four A.M. last night I could have fucked Kate Moss?"

HAR MAR SUPERSTAR: Kings of Leon were still really innocent, like little kids. That night, before we went to Sadie's, we were all at a weird bar, dancing, and I was dancing with Kate. I'd just met her a week before or something, and they said, "How did you do that, how do you just dance with her?" And I was like, "Just go up and dance with her! It's easy, she's super nice." And I remember the dudes being like "Okay. . . ." and trying to dance with her. Three hours later, we're all in a treehouse, playing guitars together, making out. I was like, "See!?" Their confidence levels skyrocketed. It's fun to watch that kind of confidence develop, and you're like, "Dude, take what you want, it's right there."

REGINA SPEKTOR: The energy was really big. With Kings of Leon and the Strokes.

STEVE TRACHTENBROIT: I saw people dressing up as the Strokes for Halloween. Grown-ups.

REGINA SPEKTOR: There were a lot of people around that wanted stuff from them, wanted to be around them. Kind of a groupie vibe all the time. And so there was a feeling of "Let's band together and protect ourselves." There was a lot of stuff that I didn't get, that was draining or difficult. I didn't understand that kind of pressure. I just saw the fun stuff, like when we got to L.A. and they were on the cover of *Rolling Stone* and it was amazing to watch them squeal like little kids.

RYAN GENTLES: Yeah, we got the cover on the second album.

CALEB FOLLOWILL: It was a nutty tour, but we learned a lot. We grew a lot, and our music changed on that tour. And from then on, all of us were trying to outdo each other. When the Strokes would make an album, we were the first ones to hear it. And when we would make an album, they were the first ones to hear it. We'd all sit there nervously watching their reaction, and they'd do the same. We would always be like, "We're going to be better than that record." And it'd be like, "All right, motherfucker, we're going to be better than *that* record."

AUSTIN SCAGGS: Oh, the Kings are competitive to the point of "I'm going to be skinnier than you." Even that kind of shit. "My jeans are going to be skinnier than your fucking jeans. My mom is going to sew me the skinniest jeans." I'm sure the first night the Kings met the Strokes, they were awestruck. I mean, they were their heroes you know, their blueprint. But the second night they wanted to tear their heads off. They were as friendly you can be when you want to tear someone's head off and shit down their skull.

NICK VALENSI: Now Kings of Leon and Regina Spektor are much bigger stars than we are. They certainly both have a lot more mass pop appeal than the Strokes do, and I feel great about that. I feel incredibly surprised.

THE JAMES MURPHY SHOW

ANDY GREENWALD: When I left high school I cared about two things: I cared about indie rock—Guided by Voices—and I cared about Biggie; I was really into hip-hop. Then I went to college and in college you make friends based on what band posters people have on their wall or what CDs they have. On the first day of school, I found these friends, who I am still friends with, who had a Guided by Voices box set. It was like, "That's it, we're friends." But I remember playing them a Nas album and they looked at me like I was defiling a child. They couldn't understand why I would listen to this if I liked something so demonstrably good. It all felt very balkanized. And what was thrilling about James Murphy and the music DFA was doing—and the beginning of Napster culture—was suddenly it felt freeing. You could jump from one genre to the other. You could publicly say you liked one thing and another thing, you know? James articulated that in a way that was incredible because he had spent all of those years with bands like Six Finger Satellite and stupid indie rock bands that he had worked with. He had the cred, but he was also, "I like to do a lot of blow and dance all night."

LUKE JENNER: Have you read *Retromania*? Simon Reynolds talks about LCD and our generation of bands as basically the first true collage artists.

DANIEL KESSLER: LCD was unique. They came from a different place. It wasn't so black and white. They were many different things at once: a live band, a dance band . . .

ALEX KAPRANOS: When you heard LCD Soundsystem, it was like, "Oh, right, so they're doing it over there as well." Before you'd have the punk rock kids, the indie kids, and then you had the clubbing kids. Those groups didn't really socialize that much, and then suddenly everyone came together.

JUAN MACLEAN: It went from being a group of people who were entirely living in the moment, doing things basically for fun, to a few of us experiencing pretty quick and immediate success.

PHIL MOSSMAN: Pat and James had been flirting around with LCD for years. It was kind of a joke thing. Then James did those songs and suddenly he had this band, LCD Soundsystem—he named the band after his sound system. Then, suddenly he was like, "I want to do some shows. Pat's gonna play drums. I want you on guitar. This girl Nancy is on keys." And he kind of headhunted Tyler from !!!, and poached him, and that was it.

JUAN MACLEAN: "Losing My Edge" made it so James could launch LCD Soundsystem as a band.

PHIL MOSSMAN: Our first show was in London.

MARCUS LAMBKIN: "Losing My Edge" blew up and suddenly it was "Come to London and play this song live." And he's like, "I don't have a band." And he gets Nancy and Pat, you know, all of his friends together. All of these people have careers now! My whole career is entirely indebted to him.

JUAN MACLEAN: It just opened up all the doors for us. I signed a publishing deal that gave me enough money that I could quit my job teaching and just focus on music. I mean, it was for an absurd amount of money.

PHIL MOSSMAN: But it wasn't like a communal thing. I would've loved to have been more of a part of the writing process, but that just wasn't up for discussion. James locked everyone out.

JONATHAN GALKIN: James is a singer-songwriter. A lot of that first record is James playing everything. That's like some Prince shit: "This is what you do. Play this bass line and play it like a monkey. Got it? No! Don't do that. Play with your thumb, just your thumb." Literally.

PHIL MOSSMAN: He became very opposite of Dave Holmes in a way. Whereas Holmes was like, "I need you to do this. I need you to do that," James was like, "I understand what you're doing, but I can actually do it myself. I don't need to hire people." That was him beating Holmes: "You can't even fucking play anything. You can't engineer. I'm a great engineer. I'm a great drummer. I'm a great guitarist. I can program synths. You can't fucking do anything other than play records and I've learned how to do that now as well." He did it all himself.

JONATHAN GALKIN: Look, James Murphy is the James Murphy show and you have to, if you're going to be in the room, you just have to know what you're in the room with.

PHIL MOSSMAN: He didn't appreciate producers that came up as DJs. He didn't buy it. He wasn't fucking buying it. Whereas we were all sold on it because that's how records were being made in England. LCD was a big fuck-you. It was like, "Fuck you, Dave Holmes. Look what I can do!" I remember there was a poll of coolest people of 2001, and James was like number eight and Holmes was number nine. James was like, "Yeah!" He was really fucking excited that he was one above Holmes on the cool list. He's very competitive.

JONATHAN GALKIN: It's why he hates producing other bands—competitiveness. "I can do it better. Why are you doing it like that?" Not that he's always right.

ANDY GREENWALD: I did this story on them. I went over to the DFA office and interviewed James and the other guy, Tim. It was in the West Village, like on Eighth Avenue. I sat with Tim and James and I remember Tim didn't talk very much and James talked a lot. He was a star.

JUAN MACLEAN: The problem was that Tim got left behind because he was the one that didn't have his own thing. He had DFA Productions, which was entirely dependent on working with James. So James goes off on tour with his new band and Tim is stuck back home with literally nothing to do.

TIM GOLDSWORTHY: I enjoyed making music more than anything else. So when LCD started I was fine. I have absolutely no interest in being a frontline artist myself.

JONATHAN GALKIN: Even when James left, like when "Losing My Edge" took off, he put the band together and kind of self-funded for them to get to England. Tim, his instinct was like, "It's shit, mate," and he'd just go upstairs. If I was Tim, I would think, "Well, I'd like to be a part of that." Tim could have jumped on that train if he wanted to. Also, in EMI's original deal with LCD, Tim, as James's partner, got a deal too. A record deal, which triggered hundreds of thousands of dollars for Tim.

TIM GOLDSWORTHY: When we signed the EMI deal for all that money there was an open deal for me at exactly the same level as LCD. But the idea of that is just horrific to me. I like being me and I can't do the thing of creating another character. Artists are a special type of person, and I don't want to become that special kind of person.

JONATHAN GALKIN: It was a six-figure advance. EMI said, "You want half? Okay. Can we hear what you're working on, the same way we heard 'Losing My Edge' and wrote a check?" He said, "No." So they were like, "Okay, then, no."

TIM GOLDSWORTHY: James and I both set out to create DFA to change our lives for the better. I was living in New York. I had managed to get rid of my old life. I was making fun music with my friends. I was with the woman that I loved and also getting respect from people who I cared about. It was a win/win situation. And James was finally in a band—his band, which he wanted, and he was being James.

JONATHAN GALKIN: But still, we supported Tim.

TYLER BRODIE: We bought him a lot of gear to record an album that he never recorded.

TIM GOLDSWORTHY: I did make an album. We had a bit of a budget from DFA Records, and they paid for my friend Darren to come over from the UK for a couple weeks. We bought some equipment and made an LP. But the plan was that James was gonna come back and help me with it, and finish it off, as I had helped him with LCD. And that didn't happen.

PHIL MOSSMAN: James was going through this reinvention of himself where nothing is impossible. Honestly, he's like a manic explosion of übercreativity. He became a kind of Superman, and Tim's En-

glish, very reserved. Surely he could've made his own record, but I don't think he had that mania.

JONATHAN GALKIN: We never heard a note. No music ever came of this and no money was ever gotten from EMI.

TIM GOLDSWORTHY: When I kinda played it to people, I didn't play it to them—I just snuck it in, and the usual reaction was, like, "Whoa, what is this weird 70's prog jazz stuff?" It's very Stevie Wonder with a bit of British prog in there. It sounds horrendous, that description, but, yeah. So nobody was that keen on it, to be honest. And . . . you know, Jen and I had just had our first child, so the idea of going on tour . . . And also I had already started falling out of love with DFA, so the idea of tying myself more into DFA, without the support . . . I didn't really feel supported. It was very, "Oh, God, Tim's doing his weird stuff again."

TYLER BRODIE: Maybe he was just like me, scared to release his own stuff. I don't know. It's weird.

TIM GOLDSWORTHY: I'm not sure how much DFA were aware of how far it had gone along, but the LP is there at DFA. I never picked up the hard drives. It's just at the studio. There's about eleven tracks. The songs were all called "Love," and they were just numbered. Like, "Love 4" or "Love 7."

JAMES MURPHY: When two dogs meet and they smell each other, one dog is bigger. Tim was above me. I wouldn't have deigned to tell Tim what to do. I would never have tried to get something from him or given him "school assignments." I wouldn't have dared. There's nothing weird about panicking to make your own record and mix it. I think he should have made the record and I would have loved to have helped him, but he didn't want anything to do with that. He would have had to ask me. I make records with people where I basically make the record. I have no problem with that. I'll write the song. But to try to do that with Tim would be psychological insanity.

JONATHAN GALKIN: Originally, there was also a plan where Tim would help James make his first record, produced by the DFA. James went to that residential farm in Massachusetts. A studio farm. They had nice gear; it is very residential and chill out there. James went for

like three weeks. Tim, in great Tim fashion, protested this LCD project and said, "I'm not going to the farm and I don't want to help you. Go do it yourself."

TIM GOLDSWORTHY: Johnny Clicks! That's what he does, just clicking away at the Internet. I honestly think you could buy an iPhone app to do what John does.

JONATHAN GALKIN: I didn't say this to him, but I was thinking, "What are you doing? You're blowing it, dude. That's another train that's leaving. You should be part of that, even if you're just in the room. What are you going to fucking do here for six weeks? Go sit on a farm! Go twiddle knobs up in Massachusetts." He didn't want to do it. Didn't want to give James the satisfaction of, like, "Okay, this one is for you." It was very selfish.

TIM GOLDSWORTHY: LCD wasn't a problem for me, especially at the start, because we did cowrite.

JAMES MURPHY: Tim was not involved in making the first LCD record. Well, Tim was involved in "Yeah" and a little bit in "Beat Connection," but it doesn't matter because to me he was so critical to those songs. Tim liking the drum sounds in "Beat Connection" was such a big deal to me.

PHIL MOSSMAN: James and Tim were working together in the early, early part of it, but very quickly I think James thought, "I can do this programming. Actually it doesn't look that difficult. I can figure that out." He figured it out and then pretty much shut the door on everyone.

JONATHAN GALKIN: Honestly, Tim really shit on a lot of stuff that James was doing, like turned up his nose. He was snobby. So he was like, "It's a bit shit, mate." It's a lot of that, "It's a bit shit."

JUAN MACLEAN: Tim's role was the guy with his arms folded in the back of the room. Even physically in the studio that was his stance. He was that guy.

TIM GOLDSWORTHY: As soon as the prospect of big money came in, James put up the barriers. "I'm going to write this all myself. I don't need your help. This is my thing." I'm just like, "Okay, dude. Whatever. That's fine."

ROOM ON FIRE

ANDY GREENWALD: One thing about the 2000s is that everything happened too fast. The time that passed between Nirvana and Candlebox probably was two or three years. The time between the Strokes and Longwave was like eighteen months. And there were diminishing returns. The Strokes weren't really *that* big. Everyone needed them to be that big and desperately wanted them to be big, but they kind of weren't.

BRIAN LONG: Bands like the Strokes, they sucked on the proverbial major-label tit, drank the last gulp of milk that was there. They were the handoff from one era to another era. They prospered financially from that nineties alternative rock era but they are paying for it. I remember when their second record came out, we really liked them and were championing them, but we were all wondering if they could develop in a way that would make an interesting career. The analogy we used to make was, will they end up making a *London Calling*? Could they be that? Are they that creative and that musical? Or is it going to be just cutting different colors from the same swath of fabric? And that's kind of what's happened.

J. P. BOWERSOCK: The backlash against the Strokes' second record was strong. Which is so funny because it was as good as or better than the first.

STEVE RALBOVSKY: I stand by *Room on Fire*, it's a great record.

JESSE MALIN: It's actually even better than their first record.

JIM MERLIS: Julian doesn't want to be produced, and my frustration with that second record is if it was mixed a little differently, it would be a classic.

DAVE GOTTLIEB: *Room on Fire* is as good as *Is This It;* the problem was the band did not sell it. You'd ask, "What's your vision? What are your goals? What do you want to do here?" They didn't really have an answer. They'd say, "Well, we wanna do a video where we're all Simpsons characters." And they wouldn't be joking. Their big marketing idea was "We want to get a riverboat on the Mississippi and have contest winners come and go up and down on the riverboat and we'll play." My thing was "Don't put people on a boat." And anyway, it was going to cost $750,000.

MARC SPITZ: I had first heard that album at this restaurant that used to be under the old Wiz Kid offices on Tenth Street. Danal, it was called. Julian played me "Under Control" and "What Ever Happened?" and one more song; I think it was the single.

DAVE GOTTLIEB: "12:51" was the first single, because Clive Davis wanted it, because the promotion department wanted it, but it was the wrong choice.

MARC SPITZ: Julian was very nervous. He was very apprehensive about that record; he really, really wanted it to be successful. I felt like he was under a lot of pressure. I felt like he wasn't a hundred percent happy with it. I felt like maybe he wanted it to sound differently . . . Maybe more of a step forward. Maybe not a Gordon Raphael record. I invited him to the book release party for my novel and we wound up at the Library afterward and after that, we ended up with these two girls back at my apartment doing coke all night. I can't remember their faces or their names. They were hipster girls. I don't know whose coke it was. It wasn't mine. But Julian, he kept playing the album on my little red boom box. And he kept going, "I don't know. I don't know. I don't know." And I was like, "It sounds really great, man. It's gonna be great." Because I thought it was a great record. And he kept going, "I don't know." I had a copy of the first Talking Heads record, and he played that song "Don't Worry About the Government" over and over again. And he was saying, "Oh, well, I wish it sounded like this. I wish it sounded like this." And I was like, "It does sound like this!" It was good New York, new wave music, with melody and good lyrics and personality. And he just wasn't hearing what he heard in his head on that

particular record on that particular night. And I don't think he was making the music that he wanted to make, as beautiful as some of those songs are. And I don't know if he felt like the Strokes were holding him back, or his circumstance was holding him back, or the drugs and the booze were starting to hold him back and he was getting a little sick of them, or the lifestyle, or the city . . . but that's what it seemed like.

DAVE GOTTLIEB: Then they made the *Tron* video, which was something else that I was vehemently opposed to. Roman Coppola made great videos for them. His creative influence was there on "Last Nite" and it was there on "Hard to Explain." I was like, "Why do you guys want to make a video that looks like *Tron*?" "Well, we love that movie." I'm like, "Listen, I was the demo when that movie came out and it sucked. It's not a cultural touchstone. This isn't going to resonate with the people who are your audience. It's not. It's not going to make sense." I told Ralbovsky, "The video is not good enough." He goes, "Because the band didn't want this song and you see it on the screen." And he was right. You watch that video and they are bored. The point is, no one liked the second record because the band didn't position it. They waited to do press until it was too late. They went with the wrong single because of Clive. I think Ralbovsky's version was they put it on the label to make that call on the first single, and now they have something to be pissed off at the label about if they fail. But that's kind of the wrong attitude to have at that point because the most important thing is what you do first on your second record.

JIM MERLIS: Anyway, when the reviews started coming in they all said that it sounds exactly like the first record.

CARL SWANSON: The Strokes came up just as the crisis of the music industry was starting to really happen.

DAVE GOTTLIEB: If the Strokes had happened five years earlier, they would have sold two or three million records, not one million records, because of the Internet.

J. P. BOWERSOCK: During the making of the Strokes' second record, the head of RCA got replaced by a bean counter.

DAVE GOTTLIEB: The label was going through a lot of executive changes at the top. And by this point you knew that there were people finding Strokes music through other means.

ROSTAM BATMANGLIJ: I read about the Strokes in *Rolling Stone*, about how they'd only released three songs and they were selling out shows in New York. This was back in 1999 or maybe 2000, so of course I went on Napster and I downloaded their three songs.

JOHN HEILEMANN: The moment when it first became clear that the combination of digitization—which had been affecting the music industry for a while in the form of compact discs—and then networking was going to pose the same kind of fundamental existential challenge, that moment is a moment of terror and exhilaration. These were the first set of bands that were bewildered by but also exhilarated by and thrilled by the opportunities that come with that kind of breakdown and shattering of the old traditional structures.

DAVE GOTTLIEB: You have to sit there and go, "Okay, this is going to happen faster than it did with grunge, because of the Internet. It's going to happen faster." So how do you prepare the record company to succeed with it and how do you prepare the band to succeed with it?

J. P. BOWERSOCK: CD sales were about to dive because of digital files. The industry put nothing in place with how to make money in a digital world and clung to the old model because it was so profitable, but the old model was dead. Suddenly a rock band, even a great rock band like the Strokes, meant nothing because a pop band was going to have ten, twenty times the sales. So that's where you put your money. That meant the label didn't get behind them, to a degree.

STEVE RALBOVSKY: Look, phenomena, by their nature, don't repeat. The Strokes were clearly a phenomenon and just by its nature, there couldn't be another phenomenon. Anything that followed, whether it was as good or not, it was never going to achieve the same accolades.

MARK RONSON: Okay, yes, being first out of the gate makes you a target, but when you are the first to plant your flag in the sand in the way D'Angelo was for modern soul music, people will always care, because you helped them discover something. You have to be better

than everyone else, as well, not just because you're first. You also have to be great.

MOBY: The Strokes were the first band of that era that actually went beyond just being PR darlings, and suddenly people were buying the records. It's also interesting, in their case, because they never sold that many records, but they made really good records. The reach, the awareness of them was so much greater than the record sales.

DEAN WAREHAM: It's hard to make something perfect. They made a perfect record and that's hard to do again. But I don't feel for them because I'm sure they're doing fine. Maybe not in their heads but in their bank accounts. I feel bad for people who are broke. But I can see why it's hard for them. Because as big as they are they still didn't get Kings of Leon huge.

JENNY ELISCU: It's important to zoom out and look at what happens when a genuinely, so-fucking-good-it's-insane band happens—it's always disappointing on the commercial scale. The Stooges were never a commercial success. I think it's more about the DNA of the underground. The best things from the underground, the most worthy of a huge audience, are also built to fail. And yeah, the Internet culture of today accelerates the pace at which you're looking for the next example of the thing, and we get bored with the thing, because everyone knew about it so quickly and disseminated it so quickly. Hipsters get over shit so quickly. And our era is the rise of the hipster as a genuine commercial force. But it's really important to state that there's a difference between the underground and hipsters. The underground is real and permanent. I'm a member of it. And we reject the mainstream. And always will. And so even the best things that deserve to be as big as the Beatles, like the Strokes—it's just like, they can't resist sabotaging themselves somehow. It's just part of them, you know? Because they're part of the underground. They have an underground sensibility. It's more art than it is commerce. And that's what makes music great, and that's what makes some of the best music sometimes unlistenable to almost everyone. The Killers were never part of the underground, and Kings of Leon were never part of the underground. Fuck no.

"THERE'S DEFINITELY SOME BAD FEELINGS THERE"

PHIL MOSSMAN: Tim and James began it all together and then . . . not. And knowing those two, there was probably never a discussion about it. It was probably just, like, Tim wouldn't show up one day, so James got fed up with him not turning up. So he just did it himself and then probably just stopped inviting Tim down to the studio.

JAMES MURPHY: One day he said to me, "I'm just going to pop out for a minute." And he never came back. I called him and I said, "Where are you?" "I'm at home." "But you said you were going to pop out for a minute." "Yes, but I didn't say I was going to come back."

PHIL MOSSMAN: Oh yes, if Tim's got some kind of bee in his bonnet, then yeah, he's likely to not show up for something. He'll just go out for milk and not come back.

MARCUS LAMBKIN: Let's just say everyone has their own story. Toward the end, there was a lot of Tim not being around and coming in and doing stuff, but James is very much a get-stuff-done sort of guy. He's not going to wait around for some English dude taking his sweet-ass time, drinking cups of tea, let's just put it that way.

JONATHAN GALKIN: I tried to navigate and negotiate all of this stuff, but they did not want to hear it from me, neither of them. Fuck no. When they were around each other in the office there would be this heightened, surreal politeness. And then as soon as James would leave, Tim would be like, "That fucking cunt. Have you heard 'Losing My Edge'? What the fuck is that shit, mate?" Or then Tim leaving and James being like, "Dude, he's driving me crazy. You know that remix that's due? He still hasn't done the drum programming, he was down there for twelve hours yesterday.

He told me he was going out to dinner and then he never came back. And when I asked him why, he said, 'Well, I didn't say I was coming back, I just said I was going out to dinner.'" I'm not joking.

TIM GOLDSWORTHY: Dance music has a beautiful history of strong, powerful lyrics. To change that to "Daft Punk is playing at my house my house" . . . It was just, "Fuck off, you're ruining it." I couldn't support him.

MARCUS LAMBKIN: James was blowing up and becoming Mr. Famous. He was now the name that everyone associated with DFA.

JAMES MURPHY: He probably said that I said that my time was more valuable. He spent much more time. He spent so much time. And what he did was beautiful, at times.

MARCUS LAMBKIN: The injustices Tim felt were magnified by the fact that James was not there. They were still working on stuff as a production duo, but James was on the road a lot with LCD. So he'd roll in, have only one day, and he'd come into the studio, boom boom boom boom boom, it's done and out.

PHIL MOSSMAN: James is very well-rounded with his capabilities. If you put him in a studio on his own, there's nothing he can't do. He's a fantastic engineer and he's wide but shallow on every instrument he knows. He's not an expert on anything, but he can knock a good tune out on any instrument you care to put in front of him. He's self-sufficient.

MARCUS LAMBKIN: Tim had all the opportunities that James had. He just decided to not take them. I'm sorry, but I don't want to hear your little sob story.

JONATHAN GALKIN: I have never heard a piece of Tim Goldsworthy solo music in my entire life. I'm not sitting on seven tracks he turned in. I don't have the unreleased Tim Goldsworthy record, I don't have a single song. Not a single song.

TIM GOLDSWORTHY: The LP in parts is all at the studio. Though, I'm not sure they know that, to be honest. Send me a copy if you find it!

MARCUS LAMBKIN: Anything that he's ever played me is amazing, but his standards for everything are just ridiculous.

JUAN MACLEAN: When they eventually left, Tim and his wife, Jen, they left almost literally in the middle of the night.

TYLER BRODIE: Really, it was so weird. Tim came over and asked, "Can I meet with you?" I'm like, "Okay . . ." He said, "Yeah, you know how things are going downstairs?" And I was like, "Yeah, it's going really good!" Because I wasn't paying attention at all. Tim was like, "Wait, what?"

JUAN MACLEAN: I didn't know they were leaving. We have friends that didn't know they were leaving. It was definitely not the case that they were being banished or anything like that. I think things had become so difficult between James and Tim, and Tim just felt like it was the only thing to do.

MARCUS LAMBKIN: James got super famous and clearly when every magazine and everyone in the world is saying you're the greatest thing since sliced bread, he might have got a little bigheaded at times. There's definitely some bad feelings there and maybe things weren't that awesome, but we all make choices in our lives and I don't see how anybody was ostracized.

TYLER BRODIE: We did not kick him out. He left us. He told me that he didn't want his child to grow up with an American accent, so he was moving to England.

JONATHAN GALKIN: I was here the night he left. I was working late. He hadn't been here. I swear we had changed the locks, and he had to buzz to get in. He was coming from his going-away party, at Milk & Honey. That was James and Tim's spot.

TIM GOLDSWORTHY: Milk & Honey was like a little church, it was somewhere to escape to.

JONATHAN GALKIN: Earlier that night someone said, "Are you going to Tim's farewell party at Milk & Honey?" And I was like, "Are you shitting me? Is he leaving? What do you mean?"

TYLER BRODIE: He came over to my house and asked to buy a certain piece of gear and I said, "Let's talk about this in the morning with everyone, all the partners." Then that piece of gear was missing the next day and Tim was gone. We've never seen him since.

TIM GOLDSWORTHY: Tyler is just a crazy stoned multimillionaire. James is a sociopath.

JAMES MURPHY: Americans are much more prissy and prudish and jealous about shit. Britain has a long history of whining and saying it's not fair. Watch *America's Next Top Model* and watch the British *Next Top Model*. What do American girls say? "I'm not here to make friends, I'm here to win." What do the British girls say? "It's just not fair! It's ridiculous! It's not fair." They're both awful. Self-deluded, no self-analysis, but one of them is like, "Fuck you." They burn bridges and start swinging, and the other one's like, "It's not fair."

JONATHAN GALKIN: One thing you have to keep in mind is that Tim and James have very different pasts. James had a decade of "failed" indie bands—"failed" in quotes. Tim had a decade of being part of something that was wildly successful, another moving train that he said "fuck you" to, to another James, James Lavelle. So there were parallel universes of the nineties for each of them. James's indie bands sounded like other indie bands that didn't do as well as those other indie bands. He was always second fiddle, the perpetual opening-act kind of thing. And Tim was Tim, the Mo' Wax star.

WARREN FISCHER: I was sad that Tim left, and I don't know what happened. Never really got to the bottom of that, but he was the one, in my mind, who brought the European perspective on electronic music to New York. And then James was like, "Yeah, but I just want to dance." Somehow, those two in a room created that sound, and from that, they were able to mount a revolution.

THE WRESTLER

CHRISTIAN JOY: Karen was just such a maniac in the beginning. There was nothing like it. I mean, rolling all over the place, amazing star power. She's really shy and I think it was pretty cathartic for her to have this really intense release.

KAREN O: With the 9/11 thing, it was the first time that the States had been penetrated in a really profound way, which burst the bubble, right? And when you're living a fifteen-minute walk from where it happened, you feel that in a much more apparent way. It just feels so much scarier. The security blanket was just completely torn off. Like, if they could achieve that, then what next? We were living with that danger. People needed release. There was this urgency, all of a sudden, for release. I was all about urgency, which is why we called that first record *Fever to Tell*. You never knew how long anything was going to last; every moment was ephemeral.

HAR MAR SUPERSTAR: Karen is more "go hide under a couch for two days and come back with an album." She can be really chill or she can be really intense. There was definite inner turmoil, not even between the band members, I think just with herself. She had weird freak-outs.

ASIF AHMED: Karen had a meltdown; I think it was in Birmingham, England. She kicked in a tour poster that the promoter had framed, and then she threw this massive tantrum and then doused me with iced tea. I chased her down the hall and doused her with a gallon of milk.

HAR MAR SUPERSTAR: She can be shy but with Karen, if it's five people in her house, then all bets are off.

KAREN O: We were riding that wave of that New York revival but it seemed like a really small scene that we came out of. Even though there was the Internet on the horizon and there was this new promised land of being able to reach and be heard by a worldwide audience all of a sudden with much less effort, it was still just on the horizon. Then all of a sudden the world starts taking you seriously as a band, everything is changing, the hype machine is moving, and you are just surviving . . . We toured for three years behind that same record. We'd written it in 2000 and we were still touring it in 2004. We had to survive that insanely precarious razor's edge that you walk on as a band that's hyped so young, trying not to get fucking sliced down the middle.

CHRISTIAN JOY: After she fell off the stage in Australia she started to slow it down.

KAREN O: I'm half Polish, and when we finally got to Poland in 2006, we got this amazing host who took us around, telling us all about all the culture. And I'm pretty detached from my roots because my dad had a single mom. He was fully Polish but he just didn't fully connect, so it was all news to me, basically. But I remember our host saying, "Here in Poland the way we like to live is 'Who knows if there's going to be a tomorrow, so let's take on the night like it's our last, every fucking night.' I was like, "No wonder. Duh." That, coupled with the melodrama, is me in a nutshell with music. I related to that so much. That's how we felt around that time: 'Who knows what tomorrow could be, so let's make it count tonight.' That idea was such a huge inspiration and motivator, which unfortunately ended up with me falling off the stage. And then I knew I needed to shift gears.

HAR MAR SUPERSTAR: It was a festival, Livid festival, in Sydney. I was there for that. She fell off the monitor.

KAREN O: During the song "Rich," I was on the edge of the stage, sort of draped over the monitor with my legs in the air. And I was really drunk. I flipped off headfirst, hit the guardrail, and landed on my back. Then the monitor fell on my head.

HAR MAR SUPERSTAR: She was leaning over the monitor. It was pretty terrifying. She was just getting into the show. She was kind of in a

weird mood already before she went onstage and then she was just going for it and doing more of a dangerous show.

KAREN O: I was kind of lost in that thing of being a spectacular performer that people like to see self-destruct onstage. And that was the way I could blow off steam, because there was just an enormous amount of angst I felt at the time and at that age. The amount I was injuring myself was just escalating, escalating, escalating. When I saw that film *The Wrestler*, it was basically: "That's me." I totally related to that because the more that Mickey Rourke hurt himself the more ravenous his audience was, and in response to that, the more the expectation he felt to provide that for them. And that's kind of where I was.

HAR MAR SUPERSTAR: All of a sudden she was on the monitor and it just tipped and she was gone. The monitor fell on her head. That's how I remember it. It was a five- or six-foot drop; she landed right on her head. She didn't get up. We were all silent.

KAREN O: Security pulled me back up. I was limp but still singing the fucking song. After I finished, I asked our tour manager to feel a bump on my head that was rapidly becoming another head. Someone brought over a big bag of ice in a red cloth. I was wearing a red ensemble, so people in the audience thought it was all an act. I sang "Maps" and then said, "I'm sorry that we have to end the show early. I'm going to the emergency room."

HAR MAR SUPERSTAR: I helped Dave Burton get her in the ambulance.

KAREN O: The next day, I looked like I had elephantitis. I couldn't walk without pain. But I was a serious trouper, dude. I played a show two days later and my boyfriend at the time, Angus, pushed me out in a fucking wheelchair.

HAR MAR SUPERSTAR: She was kind of a zombie for days after that. That scared her.

KAREN O: It could have been nasty. I mean, the only thing that saved me from breaking my neck and my spine was the fact that I was so wasted that I was limber. I fell off like a wet noodle. But then again I probably wouldn't have fallen off if I wasn't that drunk, so . . .

HAR MAR SUPERSTAR: You don't want to go back onstage after you fall off onto your head. Getting onstage almost killed you.

KAREN O: I kind of learned the hard way what I could do and what I can't do and what I was capable of. That really informed and set the course for me.

HAR MAR SUPERSTAR: She just didn't want to be there as much as she thought she did.

CHRISTIAN JOY: I mean, how long can you keep up with that?

ASIF AHMED: They started getting the nickname "the No No No's" in the business. They would turn down a lot of stuff, like *SNL*. They would turn down magazine covers. There was the *Vanity Fair* issue, the music issue 2004. Wherever Liz Phair is in that lineup, it's supposed to be fucking Karen O. In Karen's defense, she was very noble. They agreed never to do covers without all three of them. Everyone just wanted to talk to Karen because she was this captivating girl. I remember getting a wonderful call from Jimmy Iovine where he told me to go fuck myself because of *Vanity Fair*. I was in London with the band and their families and my phone rings. Everyone saw my face just kind of dropping, because the caller ID says "310–865" and the "1000." That's the Interscope main line. I knew that it was Jimmy Iovine calling because we said no to the *Vanity Fair* thing.

KAREN O: I'm, like, Year of the Horse and you know what they say about horses: you can lead a horse to the water but you can't make them drink. The creative projects and how I took things in and how I learned, I always had to do it my way in the end, you know? I would drink up what looked tasty, but I could never be forced.

"SO PEOPLE IN THEIR FORTIES IN BOSTON ARE LISTENING TO INTERPOL!"

SARAH LEWITINN: Interpol was my new Radiohead. *Antics* was the album I couldn't hold my breath for any longer.

SAM FOGARINO: I remember being well-prepared to make that record.

DANIEL KESSLER: We were very focused, which made it feasible for us to do *Bright Lights* and *Antics* very close together.

SAM FOGARINO: After all that touring, we just got so much better. That's what a band's supposed to do. You're supposed to play music. And we did a lot of it. So we were able to go in and just nail it.

PETER KATIS: With the kind of success that those guys had, the pressure is there. It took forever. We just couldn't get it done. We went past our deadline and in the end the label was like, "If you don't have it done on this day, the record won't come out this year, it will get bumped to next year." I remember we were mastering on a Friday night, just finishing, and I'm heading to the door. Paul's like, "I'm used to this, but you're not. Are you ready for this? You're not going to like this." I'm like, "What?" And he opens the door and the sun is coming up.

SAM FOGARINO: When we finished mixing the record, Matador got us a limousine to take us from Bridgeport back to the city. The time was so tight that we were doing the sequencing in the limo. The next day we were going right into a rehearsal studio to go tour with the Cure on the Curiosa Festival. No breather for anybody.

DANIEL KESSLER: That tour was really fun.

JENNY PENNY: That was when Carlos was wearing the holster all the time. I loved the holster. It was hot.

SARAH LEWITINN: Carlos looked like Hitler Youth. Which, being a little Orthodox Jew from Jersey, was my, like, jungle fever.

SAM FOGARINO: It was this full-blown touring festival. Robert Smith curated the whole thing. And there we were opening, playing right before the Cure. It was insane. We'd arrived at another level.

PAUL BANKS: Robert is a total dude. You see the photos and you think that guy might know how to write poetry, but in reality you hang out with him and you think, "I bet he's really good at soccer."

SAM FOGARINO: Robert would hop on our bus and play cards. He was a card shark, man. He was really good.

JENNY PENNY: Karen won money from Robert.

KAREN RUTTNER: We were playing in the back of the bus and I think it was something like a $20 ante. Robert asked me if I wanted to be dealt in, but I told him I didn't have the money, so he put in $20 for me and I won! He kept trying to convince Carlos to play too, but Carlos insisted that he didn't gamble. Robert then told Carlos that walking down the street every day was a gamble.

PAUL BANKS: Another time, a very late-night hotel-room situation with Robert and the management, I remember him saying that they never did festivals unless they were headlining. And I remember kind of feeling the implication there, like here I am, not headlining your festival. But I didn't get a sense that it was intended to put me in my place. It was just, we were talking late in the night. And what he said happened to really resonate with me. In the same way that I've always loved that Vincent Gallo will only be in the magazine if he's on the cover. That's a sign of greatness—people that will go to those lengths. But I felt at the time, "I don't live in a world where we can fucking do that. I'm going to take what I can get."

SAM FOGARINO: I remember it was my birthday on that tour and I was DJing this big old after-party. I couldn't believe that I was standing there with Robert Smith on my birthday and DJing. At that point I was like, "How could it get much better than this? This is insane." I think that was in Toronto, Canada. I remember him leaning over

and saying, "Are you having fun, Sam?" And I was like, "Yeah." And he's like, "Because you look so serious." And I was like, "Yeah, that's me having fun. That's what it looks like."

SARAH LEWITINN: According to my blog, it was Tuesday, October 21, 2003, when I first heard the new songs. I wrote: "Speaking of Interpol, I saw them last night in concert and their new songs made my heart beat in my pants."

KIM TAYLOR BENNETT: It's such a sexy album. And bold. It was a tweak and innovation enough away from *Turn on the Bright Lights* to not be considered derivative, but the DNA of those songs was still familiar enough that from the first listen you just fell in love. It helps that "Slow Hands" was such a huge hit—their biggest. As a galvanizing party anthem of the era it was right up there with the Strokes' "Last Nite" and the Killers' "Somebody Told Me."

SARAH LEWITINN: I remember riding my bike around Soho while listening to it and singing along at the highest volume possible, while dodging cabs. I was singing, "I AM THE SCAVENGERRRRRRRRR BETWEEN THE SHEETS OF UNIONNNNNNN," while riding down Centre Street.

KIM TAYLOR BENNETT: The summer of 2004 was the Curiosa tour across the States, but I was super excited that they were coming back to Europe in the fall. I'd interviewed Interpol a couple of times already, but this time I was following Bloc Party on the first few days of that European tour.

DANIEL KESSLER: Bloc Party was opening for us on the *Antics* tour, right when their record was coming out and before they blew up.

KIM TAYLOR BENNETT: On the way to Amsterdam I remember one of them saying the last time Interpol played there they'd all taken mushrooms, had an amazing time, and ended up in a club where they saw Nietzsche's face on the bathroom wall. Hilarious. So Interpol. They liked to party pretty hard but of course they'd see a *philosopher's* face in some skeevy club toilet! So the plan was to get to Amsterdam and for everyone to take 'shrooms.

SAM FOGARINO: The only faces I can see are melted.

DANIEL KESSLER: That was great. I remember it very, very well.

SAM FOGARINO: This is what I remember: "Oh, look, Sam's here! Oh my god, he never hangs out. Are you going to hang out with us tonight, Sam? Oh my god, he's going to eat some mushrooms! Oh my god!" And I was thinking, "If you keep this up, I'm not going. It's not that big of a deal. Old guy likes to have fun, too." At that point I was in a serious relationship, and I was happy to hang up the "Hurricane Sam" hat. I would get in trouble in private. I was more Hotel Room Guy, by that point. But I did go out that night and then proceeded to get violently ill. Even before we left the dressing room I projectile-vomited in the bathroom. I remember going, "Why am I here?" I went back to my hotel and, again, threw up on the way. I finally got back to my hotel, realized I had some hash, smoked some hash, sat in a bathtub, and watched five episodes of *Family Guy*. It was a night of extremes.

DANIEL KESSLER: That night, there was a gigantic entourage of people. We had played the Paradiso.

JENNY PENNY: I have those photos. I have photos of everything.

KIM TAYLOR BENNETT: Yeah. Jenny Penny was there; she was dating Carlos at the time. So she was on the Interpol bus. Someone had procured these bitter kernels of mushrooms, and we were eating them.

PAUL BANKS: 'Shrooms would always make me very happy. I would say my favorite drug is 'shrooms. I mean (A) they're natural and (B) I never had a bad trip. I liked that kind of hallucinogenic, because I felt like I've always been a very open and honest person to myself, so I wasn't afraid of any dark corners.

DANIEL KESSLER: We all took them backstage at the Paradiso—it's a legendary church. It's historic; there's all these Nazi bullet holes in the side of the building, or that's what they say, I don't know if it's true, but it makes sense. It felt like a Front 242 club, which was the wrong sort of thing on mushrooms. I don't know who it was, but someone out of the clan was fixated on some graffiti that they saw in the bathroom that they swore was Plato or Socrates or something like that; they wouldn't let it go. We had to get out, it was a bad scene.

KIM TAYLOR BENNETT: So we go to this club and it's this weird industrial, goth-y kind of club, and it's everybody, all of Bloc Party, all of Interpol, all the crew. Meanwhile, somehow Jenny and Carlos have brought along this couple, and there's some previous connection . . . I don't know what the idea was there, there was a sexual vibe, but I don't know what was going on. They were goth-y.

JENNY PENNY: The last time we had been in Amsterdam, Carlos and I had a threesome with her. I loved her and thought she was so fun. But then this time, when we came back, she had a boyfriend and she couldn't do anything.

DANIEL KESSLER: There's twenty-five or thirty of us, just walking through Amsterdam.

KIM TAYLOR BENNETT: Eventually we make it back to this hotel room.

DANIEL KESSLER: It was Carlos's room, this lime-green room. It could use remodeling. We were all peaking. It's mushrooms, you're not able to control shit.

KIM TAYLOR BENNETT: Carlos had maybe dropped E and there was maybe cocaine around. But Carlos was being sort of a weird. He was being sort of an aggressive overlord of the situation. There was something about his vibe that was very unsettling.

PAUL BANKS: According to Dave, something pretentious that Carlos was doing was pissing him off and making him get dark. Carlos's hair straightener might have been involved. Maybe he was making a scene about his hair straightener. That could be enough to set him off, if Dave P was tripping balls and Carlos starts bitching about his hair straightener. But like I said, it was a really fun night.

SARAH LEWITINN: This was around the time when *nobody* could be trusted with an anticipated album because they almost always ended up online, so publicists had to organize these sort of field trips for editors and writers of magazines to hear a CD that had basically been welded into a player. Nils [Bernstein] invited the *Spin* crew to a hotel in midtown to hear the album. Now, when Radiohead's *Kid A* came out in 2000, a bunch of us were invited to the Hudson Hotel to listen to the album on sick speakers and

it was catered. By 2004, when *Antics* was coming out, we found ourselves in a hotel room with Ritz crackers, beer, and a tiny little tinny-sounding boom box. That's how far the industry had fallen.

APRIL LONG: *Antics* obviously was the album that kind of propelled them into the next level. And that was a surprise. They were an unlikely band to take off in the way that they did. *Turn on the Bright Lights* was a dark album and one that you would think would be fairly oblique for a lot of people. I mean, so beautiful and rich, and unlike anything else, but for me the Strokes always sounded like a band that could be big. Interpol, despite that sophisticated richness of the sound, and despite how incredible they looked, and the fact that their shows were riveting and powerful and all of that, it still surprised me. But I remember when my older sister asked for *Antics* for Christmas. I was like, "Oh! So people in their forties in Boston are listening to Interpol!"

NILS BERNSTEIN: Initially, Interpol was lumped in with the Strokes, but by the time *Antics* rolled around they were their own thing. *Antics* did better than *Turn on the Bright Lights*. And when *Antics* did as well as it did, suddenly at every show there would be these A & R guys from big labels snaking their way backstage. They were being heavily schmoozed in front of us for years.

"THE INTERNET RULES, FUCK IT"

PAUL BANKS: I remember being in Madrid months before *Antics* even came out and some guy came up to me and said, "I love 'Evil.'" I was like, "What?"

CHRIS BAIO: My best friend, Michael, e-mailed me over that summer being like, "Yo! *Antics* leaked! Go download it!" I downloaded it on Soulseek and just drove around at home in Westchester with my friends—this is between my freshman and sophomore year—smoking a lot of weed and listening to that album constantly.

DAVE GOTTLIEB: Nobody wanted to hear it. Nobody believed it. People at labels had been saying Napster was just like kids making and sharing tapes.

DANIEL KESSLER: *Bright Lights* was before the shift, and *Antics* was after. *Bright Lights* was a word-of-mouth thing, college radio, record stores championing it, getting bigger with every tour. By 2004, we were already part of a new era. Our record leaks three months before it's supposed to come out? Right there you see the past is over.

DAVE GOTTLIEB: What could the industry have done? I remember being at a meeting early on, where one of the groups suggested we buy Napster. My attitude was "That's a great idea." The executives at that point, who were freaking out, wanted to shut it down, but my attitude was "Why are you doing this? This is the world's greatest listening station. This is all kids are asking for. They want to hear as much of the record as possible and then be able to buy it."

JOHN HEILEMANN: They were trying to kill the symptoms, thinking they were attacking the disease. They weren't and also it wasn't a disease. It was a mutation. It was evolution. And also, not stoppable.

DAVE GOTTLIEB: Instead, Metallica sues its fans for using Napster. The fans stood up and said, "Fuck you! We're going to use it more."

RYAN SCHREIBER: They were coming to twelve-year-olds' houses and arresting their parents and fining them obscene amounts of money, ruining their lives. It was the ugliest tactic imaginable from a PR perspective, from an optics perspective.

ALAN LIGHT: Yeah, that just caused total outrage. People were furious. I don't know whether Metallica ever fully recovered in some ways. They were just seen as the worst kind of . . . I mean, the fact that they showed up to the lawyers' office with a list of the names of their fans just drove people crazy.

RYAN SCHREIBER: Though they had been shitty for a while, Metallica were still a very respected band, but that was the turning point at which they became fully a joke. A rock band being this caricature dinosaur.

JOHN HEILEMANN: There was just this global denial: "If we sue you out of existence, we can make this go away."

PAUL BANKS: *Antics* leaking wasn't a big deal to me, personally. Daniel had worked at record labels; he had more perspective and he worried about it. I was really still on the tip of, you know, "Fuck, man! This is happening. This is working out!"

DANIEL KESSLER: It was June and the record wasn't coming out until late September. I don't remember being overly pissed; I think I was more disappointed in the fact that you work so hard on something. It's just kind of lame. I want the surprise. I like the unveiling of plans so that people get the "This is what we've been working on, ta-da!" But, that said, I realize if it leaks we adjust, and whatever happens, we adjust and you deal with it.

TUNDE ADEBIMPE: When we were touring *Cookie Mountain*, people would bring burnt CDs to get signed, way more than once. "I just want you to autograph it." I remember doing it in one case because I could see in the person's eyes that they had no idea how horrible or offensive that was.

MARK RONSON: I've been in meetings with senior executives at labels who say kids still want to hold that tangible CD, that there's some-

thing about ownership. I've had to stop them and say, "With all due respect, you absolutely do not understand. You cannot teach a sixteen-year-old-kid who has always had music for free that he suddenly has to pay for it. He doesn't get the concept."

EZRA KOENIG: People my age, basically, our entire adolescence was spent online, but in that early modem, AOL chat room world. It's something of a source of pride, that we were the generation that experienced that whole tumultuous change in the online world. It basically meant coming of age, becoming twelve and thirteen, starting to flirt with people, finding weird, perverted chat rooms. We were at the perfect age. And by the time we were fifteen or sixteen, you could start downloading stuff on Napster.

JOHN HEILEMANN: Remix culture is a huge thing in this era and it's conceptual as much as it is practical. You live in a world where chopping shit up and reconfiguring it and making shit out of found art seems normal, much more normal than it was when music was more regimented.

NIC OFFER: When I first moved to Brooklyn, we were rolling in a crew and there was this one guy who was in this cooler band that I had really looked up to, and I was saying something about Neil Young and he was like, "You know what, you're in New York now; you need to forget about that Neil Young, small-town shit." There's no one that you can meet in Williamsburg right now that's going to dis Neil Young. The sound of New York became: everything. You're mixing your whole iPod together, and that's what your band sounds like. I want to point out that that guy in the previously cool band, his band was not cool for much longer.

EZRA KOENIG: When my friend first showed me Napster, I was in high school. We immediately downloaded this weird rarity called "The Little Drum Machine Boy." It was this weird Christmas song that eventually goes into "Hava Nagila" over this electro beat. That was also when I first heard "Wuthering Heights" by Kate Bush. I'd read some *Q* magazine online feature, and then I took two hours to download it and now it's one of my favorite songs of all time. That was my first instinct when he showed me Napster: "Wow, we can find some weird shit now."

JOHN HEILEMANN: I like Guns N' Roses and I like Tribe Called Quest and I like the Cure and the Smiths. It used to always make me crazy that somehow if you said you like this, you couldn't like that. In the aughts, everything stopped being quite so Bloods and Crips, Jets and Sharks. You could like Nas and LCD Soundsystem and the Strokes and people wouldn't look at you funny. No one would think that somehow that was unduly promiscuous. It's mashup culture.

MOBY: The Strokes were a rejection of the nineties. When you're talking about this period of 2001 to 2011, the subtext is that the nineties didn't happen. I remember when I owned Teany, the kids who worked there were all very hip twenty-year-olds. They would only play records from the seventies and eighties. For them, it was literally like, "Nope, the nineties didn't happen." Except for Pavement, Blur, and Pulp; those things from the nineties were okay. Even with Sonic Youth, they'd probably play Sonic Youth from the eighties. The Strokes were so nostalgic, and Interpol sounds like Joy Division. Everybody referenced, unapologetically, something that happened quite a long time ago. But that in and of itself was new. When I was growing up, your credibility and your coolness was based on what new records you knew, and then suddenly, by like 2000, your credibility was based on what old records you knew. Like a really cool nineteen-year-old in 2000, if they had a Pixies seven-inch, they were cool. If they had three Brian Eno albums, they were cool. But if you had a record that was made a week ago, who cares?

SIMON REYNOLDS: I think this definitely existed already. It was beginning to happen in the late eighties with fanzine culture, but it really went nuts with the Internet. Because then you could actually dig up these really obscure things. You could find all kinds of strange things, things from other countries. Soviet new wave—that was trendy amongst a clutch of L.A. people, I think, for about a year. Archival knowledge became the supreme knowledge.

JOHN HEILEMANN: That's the other thing. Every era and every system of distribution, every set of technological realities, business structures, industrial structures, all of it, every era has a bunch of shit wrong

with it and a bunch of shit right with it. I could make a list on any era. The fifties, sixties, seventies, and eighties. I could sit down and say, "These are the new opportunities and this is the shit that we lost and some of this stuff is actually regrettable and some of it is not regrettable at all," but it's always a mixed bag. Some problems get solved, new ones get created, and the next wave of innovators try to solve the new problems.

ALISON MOSSHART: When we started everyone was behaving like it was the same as it always had been. But meanwhile we're watching everything change before our eyes. Everybody's on the Internet, and everybody's reacting to music in a different way; shows are changing, kids are changing, what they want is changing, everything was changing all at once and you're right in the fucking middle of it! But you had all these guys that were, like, in their forties and fifties running record labels who were just so fucking hell bent on radio play. And like I said, I turned my radio off when I was eleven, so I was like, that doesn't make any sense to me. To me that's not the most important thing. The Kills have never played on the radio but we can perform two nights at Terminal 5. We don't need the radio. It's all part of why still I don't know where to land but that's because there isn't a place to land. That's my theory completely now, that nothing's going to stay the same for any period of time anymore, so we might as well just start behaving that way, you know?

HAR MAR SUPERSTAR: You know what? With Napster, I was like, "Great, now more people can hear my stuff and they'll come to the show and buy a shirt from me." That's fine, whatever. No one's making money off of record sales anyway, it's all advances. Nobody ever made money off record sales. I made maybe twenty grand off one record, once. So as long as people are hearing shit, this is awesome. The Internet rules, fuck it.

DISNEYFICATION

CASEY SPOONER: It all starts in the twentieth century and then becomes the twenty-first century. New York was an isolated twentieth-century city and then all of a sudden it becomes part of this global underground.

ALAN LIGHT: New York stories in a way are always real estate stories. It's always, "Where is the next community of creatives able to land? And what does that mean? How on top of each other are they piled? And with access to what?"

JOE LEVY: What people love about New York is what they hate about New York: it's constantly changing. So it was always better before, whenever "before" was—basically whenever the person talking was twenty-two.

MARC MARON: Yeah, I remember when I moved back to New York in the mid-2000s, there was a restaurant there where the drugs used to be. There was a nice Italian restaurant, and I was like, "Well, this is different."

JOE LEVY: You know that Ramones documentary, *End of the Century?* Debbie Harry talks about how she and Joey Ramone would ride their bikes around the Lower East Side, feeling like they were kids and all the adults had abandoned the city. It still felt a little bit that way in the late eighties. Sure, Soho was already Soho. But people protested outside the Christodora on Avenue B in 1986 when it went condo, because gentrification was going to fuck up the neighborhood. The Tompkins Square Park riots and the stock market crash killed gentrification there, but it came back with Giuliani.

And then it never stopped. Rental prices start going up in '94, as soon as Giuliani comes into office, and keep going up—way up—until they take a pause in 2001. Apartment sales prices take a few more years to spike, until '97, but then it just gets ridiculous—a ten-year run up a mountain. A steep fucking mountain. I have neighbors in the East Village who moved to the neighborhood in '94. Within five years, they're talking about how Internet millionaires are buying places in their building. Ten years after that, they're selling their place so they can retire.

MARC MARON: Manhattan is like a vacation town for people who are not from here. It feels like a weekend retreat for Europeans. "We read about it on the Russian Yelp or the French Yelp." It's hard to determine whether we just got old or what, but it definitely is sort of devoid of a personality now.

APRIL LONG: The mid-2000s, that was the beginning of the Disneyfication of the Lower East Side.

GIDEON YAGO: The Pianos era.

JOE LEVY: Pianos is a club on Ludlow Street, a block north from where the Beastie Boys shot the *Paul's Boutique* cover and a block south of the Mercury Lounge. A former piano store given a deluxe rock club makeover—two performance spaces. When they made it a club, they kept the sign, so you could feel like the neighborhood wasn't changing as much, or as fast, as it was.

SARAH LEWITINN: Pianos opened up after the Strokes blew up and was this new venue where all the New York bands would play hoping to catch the right person's eye. Sometimes bands from overseas would play there too. I remember seeing Franz Ferdinand with twenty other people.

APRIL LONG: I never particularly liked Pianos.

JAMES MURPHY: Someone made a shirt that said "Anywhere but Pianos."

APRIL LONG: It was very clean, perhaps too clean. Perhaps that was the problem; we liked things dirty. Dirty and dark. It was too bright and too clean.

JONATHAN GALKIN: I wouldn't wish Pianos on anybody.

JAMES MURPHY: I remember a guy coming up to me at Pianos and saying, "I'm really interested in DFA." And I just turned to him and said, "We would bankrupt you."

GIDEON YAGO: Around when Yeah Yeah Yeahs had their first appearance on Conan O'Brien, they had a little after thing upstairs at Pianos and some girl who I had never seen in my life comes up to me and said, "What the fuck are you doing here?" and I said, "Excuse me?" And she said, "MTV," and gave me the middle finger, and she stuck it down her throat like she was gagging to throw up. I was just like, "Are you fucking kidding me!? Who the fuck are you, first of all, and second of all, regardless of whatever art school you just left to come to New York City to have your 'experience,' I grew up here, you know? Like, I have been doing this shit for the majority of my adult life. And these people are my friends! Don't fucking tell me I don't belong here."

MARC MARON: That was long after Giuliani, man. That's a Bloomberg thing.

GIDEON YAGO: Those people, they wanted the weird, the edgy, the marginal, the bohemian out of there so that they could start putting in the boutique and the commercialized version of what the real thing was.

CARL SWANSON: They rezoned like a third of the city during Bloomberg's administration. Under Bloomberg, it became not ideological—it wasn't a cultural structure during Giuliani, like white versus black, religious versus irreligious—but more data driven and systematic. And thoughtful, in a way. Bloomberg is not someone who sees people as enemies, I don't think. It was about making the city into this prosperous playground.

APRIL LONG: I lived on East Third between C and D and when I first moved there, 2002, I had to step over drunks to get in my door on a regular basis. It was sketchy over there. A couple years pass and it was suddenly people coming in from outside the city, or down from uptown, to experience this, you know, gritty, cool downtown New York scene. And then it just got worse and worse from there, to the point where it's like Bourbon Street for douchey college kids.

It started with the Strokes drinking at 2A. You'd go there on any given night, and there were these people in these bands hanging out. People heard they hung out there, so they came to look for them. It's a domino effect. Next thing you know, high-rises are getting built next to the Mercury Lounge and bankers are moving into the Lower East Side.

ALEX WAGNER: The hollow commodification of downtown culture was absolutely real. It's like Disneyland now. And you could see the beginnings, the green shoot of that commodification back then. And it does parallel the Bush administration, though I wonder if there was enough deep analytical thinking at that point to kind of connect the two. But what you saw was an encroaching—I won't say "us versus them," because I think that's too extreme, but authentic people with all their attendant authentic desires and pursuits being encroached upon, or pushed out, or in other ways marginalized by inauthentic, characterless people. Whether they were government, business, whatever it was. And there was—I won't say soul sucking, but there was this kind of vacuum-y succubus effect. Either, like, practically, geographically draining, as in, you couldn't afford the rent in the place you used to live, or spiritually, as in, you were an American living under the Bush/Cheney administration.

DAVE GOTTLIEB: George Bush gets elected, suddenly 9/11 happens, and all these people are like, "Wait, this guy's in charge? What's going to make us comfortable? Well, being angry will." The Strokes are angry. All the great things about music come up from that, from anger, from outrage, and from a need to connect with anger and outrage.

ALEX WAGNER: I absolutely think that those were moments of national trauma for generations that moved through it, and generations that just kind of heard about it. It's a triptych: the election, 9/11, and then the invasion of Iraq. I don't think you can underestimate how much that has changed the internal and external landscape of American identity.

MARC MARON: I originally got involved with Air America to fight the Bush presidency because we saw it as a coup, or I did. It wasn't a conspiracy; these motherfuckers took the opportunity and ran with it. Around 9/11 there was a nationalized sense of "We gotta deal

with the reality here." There were a lot of people that were killed and now we're not safe, so that was what they exploited.

GIDEON YAGO: I started covering politics for MTV, in addition to music. And I remember coming home from Iraq after my first trip, or maybe my second. I was all jet-lagged and walking around the streets downtown. The bars are packed at this point, because the word is out that there is something cool happening in downtown Manhattan. There were all these people shrieking and laughing and joking on the street. I wasn't used to someone screaming on the street without a really negative contact of some kind. And I just remembered getting super pissed. I just went home and locked the door and drank by myself.

JOE LEVY: After the chill of 9/11 passes, you start getting the hotels on the Lower East Side, and on the West Side, places where clubs used to be—all sorts of clubs, rock clubs, sex clubs, gay clubs, sometimes all three at once. Boom—good-bye clubs, hello twelve- or sixteen-floor glass cubes, built for the people whose vision of New York was set by *Sex and the City*. The Rivington hotel is practically on top of the Tenement Museum. Think about that for a second.

ROB SHEFFIELD: The economy was crashing, clubs were closing. People were worried about their day jobs in a way that they weren't, like, three years earlier. Unemployment became a thing. That all has a big impact on what people think of as possible and what people fanaticize about and that's where all music begins, really. I mean, the economy crashed and then a war started and an election gets stolen and all this shit is happening at the same time.

"WHEN THE PRESIDENT TALKS TO GOD"

MARC MARON: It's very tricky to find a way to write political music that isn't seen as trite or hackneyed, because the message is always the same: "Fuck the powers that be. Fuck the liars. Fuck the rich." Those tropes are kind of well-worn.

SIMON REYNOLDS: Bohemia generally had a problem with the idea of being earnest. During the post-punk era there was a lot of political stuff, but going through the eighties into the nineties, irony, a kind of super-cool disengagement, became more the response to things. It's quite hard to do politics as a musician. You risk being very obvious and being very earnest—all kinds of things you don't want to be. Most bands would either do it very obliquely or they would just avoid the area altogether.

MARC MARON: Maybe someone like Bright Eyes was doing it a bit?

JENNY ELISCU: Well, yeah. Conor's one of the only people from our generation that's willing to say anything about lots of things.

CONOR OBERST: I'd never thought about politics before 9/11. Then, truly out of fear and panic, I started reading and watching—I became a cable news junkie and started reading the *New York Times.* I was just trying to figure out what was happening.

MARC SPITZ: Conor Oberst, who was from Omaha, which is about as far from the Lower East Side as you can get and still be in America, was besotted by Ryan Adams, who was besotted by the Strokes, who besotted the British press, who besotted the American press because they had more humor and style, and so suddenly Oberst was on the *NME* Cool List. You didn't have to be in a "garage

rock" band anymore to place, because the Strokes had ignited a sensibility more than a sound. You could say that Conor was the best songwriter of them all, by the way.

CONOR OBERST: I moved officially in January of 2003 but in 2001 and 2002 I was coming here a lot to play but I'd find excuses to stay. But with the exception of Nick Zinner, who became a close friend of mine, I didn't know anyone from the New York rock world.

ROB SHEFFIELD: It's a tragedy that they're not gay. Imagine the children they would have! You would see Conor and Nick together and you'd be like, "Oh my god, bookends." They were the Harry Styles and Lou Tomlinson of this particular era.

CONOR OBERST: I had a weird crew. I met Ryan Adams and Leona Naess really early on. He was in his wilder days. I would get some late-night phone calls from him. Same thing with Chan Marshall. I'd get invited to a dinner party at her apartment and I'd be on cloud nine. Through another set of friends I met Michael Stipe and Rain and Joaquin Phoenix, and I would end up way on the West Side in this whole other world. I'd end up with Zinner at Lit when they'd lock the door behind you and there'd be cocaine on every table and you'd have to wait till six to get out. I was routinely having these experiences. I happened to be here and I was making music and I knew all these people but I was certainly not part of any New York scene.

MARC SPITZ: Oberst had been around even longer than the Strokes; he was putting out cassettes when he was in diapers, on Saddle Creek records.

APRIL LONG: Saddle Creek was started by Mike Mogis and Conor's brother Justin in the nineties. At first they just put out records by local Omaha bands, but the kind of cool family-vibe scene they created became something everyone wanted to be a part of. The label held on to that DIY ethos even when some of the bands—like Rilo Kiley, the Faint, and Bright Eyes, obviously—got pretty big.

JOE LEVY: The records they put out didn't have a lot in common—the Faint was throwback synth stuff, Cursive was proggy hardcore,

Rilo Kiley was Jenny Lewis. But, Christ, those were some good records. At that point, indie was an idea. It didn't matter if it was Brooklyn, or Los Angeles, or Omaha.

APRIL LONG: And he was a bona fide prodigy.

JOE LEVY: This is a guy who started recording at twelve or thirteen, and who had a band when he was fifteen, Commander Venus, which was signed to the label that ended up putting out Creed. By the time he got to Bright Eyes, he was a veteran, and I don't think he was out of high school.

APRIL LONG: He has this rickety little voice and these incredibly perceptive, stab-you-in-the-heart lyrics. In the beginning, he was a bit mysterious. It was like, "Who is this kid?"

HAR MAR SUPERSTAR: Minneapolis, where I'm from, and Omaha are close. I'd stay at the Faint's house and Conor would be recording underneath the kitchen table, skipping a math test or whatever.

JOE LEVY: Bright Eyes was all about intensely personal songs but he had a whole other band—Desaparecidos—which was pure guitar rock with a social/political edge.

DAN OZZI: Bright Eyes had a bit of a stigma to it in the early 2000s, as if it was wuss rock, or not manly enough for dudes to enjoy or something. I get it; Conor is a good-looking guy with a shaky voice, singing about feelings on an acoustic guitar. I think Desaparecidos was what legitimized him for those dudely dudes who assumed he was just singing about breakups like the rest of his moppy-haired peers. He actually had real shit to say.

CONOR OBERST: It's a little Politics 101, that first Desaparecidos record. We were just saying, "Look what's happening to our hometown. It's just like . . . strip malls . . ." Omaha, I don't want to dog it, but it's an extremely segregated town. It's homogenous in ways I find unhealthy. I know there are cool artistic and thoughtful people there but the overall feeling is that it's college football, insurance companies, and agriculture. So, it's that classic suburban malaise of how boring and shitty our town is. That's really what that record is about.

SIMON REYNOLDS: There was some political activism in the New York music community during this time. There was an organization called Downtown for Democracy, and they had a benefit out in Brooklyn, I remember, and the whole thing was to raise money to send people to Ohio to get the vote out for Kerry. Thurston Moore started a label for protest records. I remember getting the press release, and it said something like "records that are opposed to war, hatred, division," etc., something like that. It was meant to be the New York local avant-garde making a gesture against what was happening in the country.

MARC MARON: And then there were protests in New York at the Republican convention. That was some big scene.

CONOR OBERST: I went to the big march. We got up early, and got all our friends, and walked uptown. We're on foot, and there were all the cops on horseback and in the street, and all the barricades, and everything was like . . . it was just really intense. But it also felt good, and important. I felt more like a citizen than I ever had. I felt like, "I need to be observant, and I need to be a part of this, because this is going to affect us, and if we just let the powers that be, like, have their way, what will we be left with?" It was already clear, even at the age of twenty-three, or twenty-two, whatever, and being pretty uninformed, I knew. Instinctively, I knew. These people are dangerous. It's crazy what they're talking about. The whole "Get duct tape to seal your windows" and just, like, the fearmongering . . . The fearmongering at that point was so insane, and I was very much affected by it. I look at the songs I wrote even after that. Even if they weren't political, they were tinged with all that from then on.

ALEX WAGNER: In the '04 election, I voted absentee. I was at a bar in Costa Rica when the returns came in, and I just remember— well, because Bush actually won the 2004 election, it was more of a violent wake-up call. It was like, "How could we double down on this? We already know how bad it is." At least back in 2000 we didn't know how bad it was going to be. Well, you wanted to believe that there was going be a course correction, but of course there wasn't.

CONOR OBERST: I wrote "When the President Talks to God" a day or two after the election. I had done the Vote for Change tour with Bruce Springsteen and REM. I had to fly to Europe for a month just to do interviews, so I was sitting at the airport, and I was obviously so bummed about the election, just feeling really disillusioned. Chloe [Walsh] called and said, "Your phone's going to ring in five minutes. It's Bruce Springsteen. Pick up." So I'm at JFK, and sure enough, my phone rings and it's him. Bruce says, "I just want to thank you again for doing the tour. It meant so much to have you." And he said, "I understand you're going to Europe today. They're going to be asking you a lot of questions about the country, and you have to tell them there's half of us over here that don't feel that way. Keep your head high. Tell them we tried our best, and we're going to keep working over here." He just gave me this pep talk. It was super sweet. So that's what I said to people when they asked me the question. I was over in Europe, taking the ferry from one stop to another, and I just wrote that song really quick on the boat. I played it that night in London. I guess there's a certain tradition of talking blues and that kind of thing, but it's not a well-written song. It was just to make this point. I felt obligated.

DAN OZZI: Conor was scheduled to play Leno. That was before You-Tube would have the clip up the next morning. So when a cool artist from your scene got on a big show like that, you had to tune in or you'd miss it.

CONOR OBERST: There was a thing for weeks between me and Chloe and the head booker. I kept saying, "I think I want to do the president song," and Chloe's like, "That's awesome. But, really?" She stuck with it, and it went up the chain of command, past the booker. I forget the woman who was the head producer, but she and Chloe talked, and then I think it even went to Jay's desk, and they agreed.

DAN OZZI: This is 2005; George W. Bush had just somehow gotten reelected off of his campaign of lies and fear and was fucking the country up with two wars. The U.S. was going down the shitter but no one was saying anything! The Dixie Chicks protested the

war and were slammed over it. People were afraid to seem anti-American.

CONOR OBERST: When we showed up that day, I was super nervous, and there was a weird feeling in the air—people that worked there knew it was going to happen. There's a knock on the door of my dressing room and it was Jay, and he's like, "I think it's great, what you're doing," and he told me this story about how during the Vietnam War, he and other comedians had done this tour through Canada for all the draft dodgers. He was very supportive.

DAN OZZI: There was this rumor going around afterward that Leno did not want him to play that song, which was believable since it wasn't on either of the albums Conor was promoting, and because Leno was waving the flag of patriotism a lot then.

CONOR OBERST: So there I am, talking to my mom on the phone, and I did the sound check like "whatever" in my hooded sweatshirt. But there are three or four hours between the check and the taping. Something about it just didn't feel right, and so I said to my tour manager at the time, this old-school rock dude, "I don't know, man. I'm feeling weird. Do you think you can get in a costume or something?" He said, "Yeah, you want to be a cowboy?" And because we were in L.A., he called the prop house and got me that rhinestone suit in the nick of time. And I cruised out there, and no one had seen me get dressed. It was secret. I stepped out and I saw their faces. Now I'm this cowboy, and I can do it. If you pretend, you can do anything.

DAN OZZI: Conor gets up there on national TV and it's just him, playing an acoustic guitar, dressed like a cowboy. The whole song is a fuck-you to Bush and the fake religious shit he would hide behind. Called him out on ignoring the lower class, about hiking the price of oil, about raping women's rights, even his fake accent. Holy shit! You don't get to see stuff like that on national television every day. And the weird thing was, you could hear voices in the crowd in between verses, screaming like the guy was Elvis. Because it was such a punk thing to do, to get on TV and punch the president right in his mouth, you wanted to believe someone told him not to do that but he did it anyway.

"WE WERE ALL STARRING IN OUR OWN NIGHTLIFE TYPE OF REALITY TV"

JENNY ELISCU: The more promotional, or at least slightly cheesier, and therefore also more commercially palatable, version of Tiswas was Misshapes.

JUSTINE D: Things started to change in the mid-2000s, because of PR, online social media, and online marketing. With all my parties and anyone that I've been affiliated with, it's never been about celebrity. And I've always said that it's about playing good music first and foremost, it's not about who's at your party. Unless you're David Bowie, Siouxsie Sioux, or Mick Jagger, I couldn't really care less about you. If anything, the freaks who come to our parties, they were the celebrities in my eyes, because they were outcasts. But it all started to change in like 2005, and I think a lot of it had to do with Misshapes.

TRICIA ROMANO: The Misshapes were the embodiment of anyone being able to become a celebrity.

LEIGH LEZARK: We started Misshapes because everything was boring.

THOMAS ONORATO: New Year's 2004 was the first party. It wasn't at a club, it was at their house.

LEIGH LEZARK: We did it on a whim in our apartment.

GEORDON NICOL: On Eleventh Street across from Webster Hall.

LEIGH LEZARK: I made my dress. We all made our outfits.

SARAH LEWITINN: If a bomb went off at that moment in that exact spot, who the hell knows what pop culture would be like today, but I can tell you that everyone at that party would've died happy.

GEORDON NICOL: Then somebody said to us, "We have a bar space, do you want to do a party there?" We thought it was sort of a joke and didn't really take it seriously, until we saw how successful it was becoming and how fun it was.

SARAH LEWITINN: The party started off as a place where people that knew each other from Motherfucker would go and make out and get drunk and just have a dumb fun time. I often had to be told—very politely—to stop spraying people with champagne. I made out with more gay boys and women during that weekly party than I had in my life.

THOMAS ONORATO: The Misshapes were all underage at Tiswas; that's how I met them. They were little babies.

LEIGH LEZARK: I was DJing at Lit on Mondays when I was seventeen. I didn't have a fake ID at the time, but I had records. So I would bring the records and it was like that was my ID.

GEORDON NICOL: If you say, "I'm DJing," they're like, "Go right in!"

THOMAS ONORATO: Misshapes was always on Saturdays. The first months were nothing special. I mean, it was a cute party, but, like, if we got a hundred fifty people, we kicked ass.

SARAH LEWITINN: Eventually the party just kept on growing and growing with a line out the door. Thomas Onorato did an amazing job at curating who could and couldn't come into the party, so there were a lot of really good-looking people and media professionals, which ultimately caused the party to get a lot of press.

THOMAS ONORATO: The initial build was very true to the audience.

TRICIA ROMANO: The Misshapes' whole thing was, stars from the eighties and nineties or 2000s spinning records or playing their iPod.

GREG KRELENSTEIN: The second week was Boy George.

GEORDON NICOL: The third week was the Rapture. Obviously there was something going on in New York at that time with music. All those bands that were coming up during that time all lived and hung out where we lived and hung out.

GREG KRELENSTEIN: We never really, like, went through a manager . . .

GEORDON NICOL: We never did it professionally, only when someone

like Madonna came, and even then, they contacted us. There was no fee. No one asked for a fee and we didn't give any. We made like a hundred dollars.

LEIGH LEZARK: You could be the best DJ or the person that's never DJed and it's all good.

TRICIA ROMANO: The whole idea that anyone could be a DJ, at the time I was very resistant to that, because I spent the majority of my career telling everyone that no, not everyone can be a DJ, it actually takes talent. But what the Misshapes were doing is they were taking the talent out of it and they were just letting people be selectors. And anybody's selection was as valid as the next person's.

GEORDON NICOL: You could play anything you wanted. That was the point.

LEIGH LEZARK: We literally had people playing wolf songs once.

GEORDON NICOL: What we've always said is that we understand the difference between trying to school people and going to a party where it's about fun first. I don't want to go to a party and get schooled.

LEIGH LEZARK: Like it's an intellectual thing.

GEORDON NICOL: People just want to have fun.

LEIGH LEZARK: It was always supposed to feel like a house party. You want to feel comfortable and let loose.

THOMAS ONORATO: It was the natural evolution of Tiswas. They understood the collision between dance music and indie.

MOBY: I loved Misshapes—it was attractive people dancing to interesting records, and they had the decency to sell alcohol.

SARAH LEWITINN: It was a very young crowd—they drew all the people who would have been waiting for Motherfucker or other parties, except now they had somewhere to go every single week.

MARK RONSON: I started going to Misshapes. I was even a little jealous—"This is the younger crowd, this is hipper than our scene, this is what's going on now." The kids couldn't mix or blend for shit, but it was a good energy.

GEORDON NICOL: There wasn't anything that was really, like, pushing new, of-the-moment music. At the time, Friendster and MySpace

were on the rise, and there wasn't any party that understood what that could do for you. Misshapes just came during a perfect storm of no one doing anything exciting, the music scene exploding, social media, and we had access.

THOMAS ONORATO: They were obsessed with new talent and new material.

GEORDON NICOL: We had Napster in high school, sure. By the time we were about to do our party, that was the best way for us to get music. We were burning CDs every week. People would say, "What was that? What are you playing?" And they were always pushing for new music and new bands. We had, like, the Killers when they were starting, Franz Ferdinand, the Gossip, Bloc Party. We had them either perform or DJ there. Especially in the beginning, it was part of their promotional stop to come DJ Misshapes before the album comes out.

THOMAS ONORATO: The first year we started it was like, "Oh my god, there's this new band you have to hear, they're called the Killers, the lead singer is so cute." Cut to eight months later, I'm holding Brandon Flowers's hand, walking him through the club.

GEORDON NICOL: At that time, everyone was throwing those other parties and we couldn't relate to all of them; they were all ancient.

THOMAS ONORATO: The Misshapes didn't care about what came before them. They did not care about the people that were ruling the scene. What they cared about was their party, making it amazing and being true to that whole group of kids that they felt like were Generation One.

NICK MARC: The Misshapes kids were all regulars at Tiswas, then decided to start their own party.

GEORDON NICOL: I will say this: none of those people supported us. None of those people came to anything, and for the entire time we did Misshapes we only got negative feedback from them.

THOMAS ONORATO: There was a lot of "Who are these kids?! They came out of nowhere! I didn't know who they were eight months ago and all of a sudden they have this big party." And also, "Why haven't they asked us to DJ their party?" All this dumb shit. I was stuck

in the middle and a few people got really mad at me. And a few people were not my friends for years. The Misshapes were really unapologetic about these kinds of things. Which is also very rock and roll. Their attitude was "We're gonna do a good party and not give a fuck about any of you," and I thought it was great.

NICK MARC: It always seemed to me that it was more about fashion than it was about music, and I kind of resented it.

GEORDON NICOL: In the beginning it was, like, Yeah Yeah Yeahs, Franz Ferdinand, James Iha, Block Party, the Hives . . . Then later it was the Killers . . .

GREG KRELENSTEIN: . . . My Chemical Romance . . .

GEORDON NICOL: . . . Kelly Osborne.

LEIGH LEZARK: Sienna Miller DJed once.

GREG KRELENSTEIN: Recently I found out that Lena Dunham went to the party.

GEORDON NICOL: She says she has photos of her on the wall.

GREG KRELENSTEIN: Paul Rudd.

GEORDON NICOL: Sarah Jessica . . . I feel like, I think a big thing for us was when Chloë Sevigny came, because she came by herself, or with maybe one friend, just to dance.

LEIGH LEZARK: When Kathleen Hanna came, and all of Le Tigre came, I kind of died. I literally just stumbled over every word. They came for Jarvis.

GREG KRELENSTEIN: We were named after a Pulp song and had been very inspired by Pulp and Jarvis Cocker.

LEIGH LEZARK: And when he agreed to DJ the party we were like, "Whoa." It was almost too real. He started playing Joy Division, that was his first song he played, and literally the entire dance floor—I've never seen this before—it went silent, and then everybody started clapping and I got weird goose bumps. I had to kind of take a second.

GEORDON NICOL: I remember Greg freaking out when Michael Stipe came.

THOMAS ONORATO: Yoko Ono came. She did interpretive dance in the DJ booth.

GEORDON NICOL: For me, I think the time when I was like, "This is insane now," was when MIA came and then spent the whole entire time fighting in the car with Diplo outside. There was all this drama trying to get her out of the car and the police came.

THOMAS ONORATO: In the first year one night, out of the blue, Gavin McInnes from Vice showed up with Selma Blair. They're were plastered and having the best time. We didn't have a real coat check, so friends and family stashed their stuff up in the DJ booth. Of course Selma's wallet fell out of her purse. Cut to two hours later, it's mobbed, she can't find her wallet, and all of the sudden the music turns down and I hear Geordon's voice on a microphone: "Did anyone find Selma Blair's wallet?" We were not a celebrity-driven party. Every celebrity who came would leave completely sweaty, just like everyone else.

GEORDON NICOL: The only time that we ever did anything special for somebody was Axl Rose. We made this little, like, area for him. It was Leigh, Axl, and some other dude.

LEIGH LEZARK: Sitting there was so weird.

GEORDON NICOL: I think he was expecting the bottle-and-models situation. It was like, "You're at the wrong party. There's, like, some homos having sex behind the curtain over there and people dancing on the bar. You got the wrong place."

TRICIA ROMANO: Misshapes had the celebrity aspect, and this was right around the time that reality TV was also getting big. So we were all watching reality TV and we were all starring in our own nightlife type of reality TV online with blogs everywhere, celebrity culture, and you had all these things converging. Anybody could become a celebrity.

THOMAS ONORATO: They were really smart. They showed up, they did their job, they were so smart with those bookings, they hired a PR person really early, they hired a door person really early. Like, they met with me before they started the party. "Would you please be our door person?" And I was sitting there going, "Oh my god, they are so gonna be the next big thing." And there they were in all black, looking like these interesting little characters out of an Edward Gorey book.

GEORDON NICOL: We had a friend we hired to do the photos, and he was there from the beginning.

LEIGH LEZARK: His name was Scott. He was perfect because he was really tall, so the photos were really flattering.

JUSTINE D: They had that white wall that everyone took photos in front of, then they'd post them online. They really documented everything, and they were savvy in that way where kids were clamoring to get on their website on Monday morning to see if their picture had made it.

TRICIA ROMANO: It took on a life of its own. It became all about what everybody was wearing. Misshapes started taking on this totally different thing, and part of that was where everybody else became the star. They were posing in front of the wall and paparazzi were there.

THOMAS ONORATO: Mark Hunter, the Cobrasnake, and then little Nicky Digital, those were the photo sites. These were the guys documenting what happened last night. Before that, because I'm old enough to remember this, you felt really amazing if you got your photo in *Paper* magazine. That's when you were like, "Oh god, I'm so cool. I have arrived," and then it was like, "Oh my god, I'm on Last Nights Party." It all keyed into the rise of social media and the web and this new generation of kids.

TRICIA ROMANO: Suddenly there were all these photographers at clubs. All of this coincided with the time that digital photography became affordable for everyone. The ability to buy a basically professional-grade, fast-speed digital camera at a cheap rate; all of a sudden people were becoming photographers that had no formal training. These people were going to clubs and suddenly it was like we were all stars in our little minds. And in New York everybody already thinks they're the star. It was a perfect culmination of narcissism, exhibitionism, and the Internet, and Misshapes was right there for it.

CHRIS LOMBARDI: People wanted to see themselves or friends looking trashy or making out with somebody.

GEORDON NICOL: I don't know why we thought it was a good idea to take photos in the beginning, we just did, but then after the first month or two, whoever was helping us with our website explained to us how to see the back end, where you can see how many people

are looking and where they're coming from. There were a lot of people looking at our website. And they were from all over. Not just New York. It was from all the United States and also in London and lots of other places. We were like, "Let's keep doing this."

THOMAS ONORATO: It helped us push that party forward into the national spotlight.

JUSTINE D: I don't think it's a bad thing, I just think it was the next step.

THOMAS ONORATO: My downstairs neighbor was Jessica Coen, who was the editor of Gawker at the time. And she came up with the idea of "Blue States Lose." Every single week she would do a recap of all the photo websites. She would do her top ten photos and she would do a description of each photo. It was very funny and sometimes really mean, but that's what was great about it. Misshapes would always be half the photos. This was when Gawker was at the height of its power.

LEIGH LEZARK: That was the best press ever, no kidding.

GEORDON NICOL: You went to Misshapes because you wanted to get your picture taken there, and also because you never knew what band would be DJing. Sometimes it was Joe Blow from down the street, sometimes it was Madonna.

THOMAS ONORATO: I thought the floor was going to give way that night.

ROB SHEFFIELD: That floor—you would be like, "This is seriously how we're going to fucking die. I don't care, though. It's fine."

LEIGH LEZARK: She had to do a sound check. Our first sound check ever.

GEORDON NICOL: It was just us and Madonna.

LEIGH LEZARK: She came and did a sound check, which was all of five minutes, and then went downstairs and said, "So where is the photo wall?"

GEORDON NICOL: Because she had seen our website.

LEIGH LEZARK: And we're like, "Right this way, Madonna." And right away, without skipping a beat, she stood on the wall and posed.

THOMAS ONORATO: She played thirty minutes of her own music as a set. Of course, she can get away with that. She was with Lenny

Kravitz and her nannies, which I thought was so funny. She also had a camera crew. It was like Princess Diana was coming. There was security and armed guards. She was wearing the whole disco look: a blue dress with the Harry Winston diamond eyelashes. Her arms are amazing. Her being there also represented something crucial. It reflected that the dance culture and indie rock had all fused. All those crowds that were rock people or indie people then became indie-dance people. It had all fused, and we saw it and her team saw it.

TRICIA ROMANO: There was a sweetness to the brand of cool that the Misshapes were exporting. They were so pop. They were such figureheads for a relatively clean and safe version of this New York debauchery. In comparison to Darkroom, Misshapes was like Candyland. It was younger and lighter and freer. It's crazy. Now they DJ fashion parties all around the world and she's this big model.

THOMAS ONORATO: The first scene outside of New York that took Leigh's face and said "You are our generation's It Girl" was the UK. And then it happened everywhere. They play, like, Singapore and all these markets where they DJ these huge, crazy dance parties.

GEORDON NICOL: The craziest thing for us is when we go anywhere, people know us. Even far-reaching places in Jakarta, Indonesia, Japan or China or Australia or South America. On the street or in the airport, or if we're DJing somewhere, they come up to us. "Where's a cool place to shop? What's a cool place to eat? What do you do, where do you go, what do you like, where do you live, what's the cool thing?" People are fascinated by New York City, fascinated by your lifestyle here, or just anyone's lifestyle here.

TRICIA ROMANO: Really, they were just little kids from New Jersey that did the thing that everybody dreams about doing, which is coming to New York and reinventing themselves. And they made it. They really made it.

LEIGH LEZARK: It's surreal.

GEORDON NICOL: Because it wasn't intentional.

LEIGH LEZARK: Nothing was intentional.

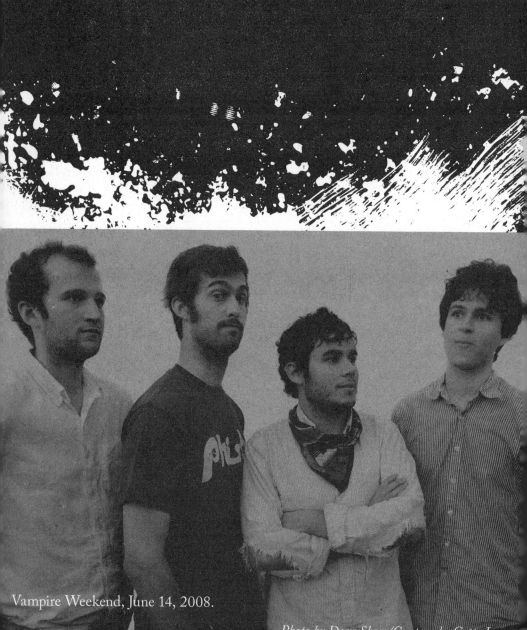

Vampire Weekend, June 14, 2008.

Photo by Dove Shore/Contour by Getty Images

PART IV

BIRTH OF BROOKLYN

"RECORD COLLECTION ROCK"

RZA: In the old days, you could walk down the street and there would be a guy on the side of the sidewalk with a hundred vinyls and you'd buy them for a dollar apiece. I was one of those kids who would buy them and take them home and find samples, find things to make music out of. I've been inspired as a DJ sampling from soul music, rock music, to the music of Leonard Cohen to the music of Yes, you know? There was no limit. I actually sampled from a Peter Pan record, a Mickey Mouse record. We could take it in any direction as long as we were on that groove. My style of music came from having an ear. Around maybe 2004, 2005, what I noticed was, there was coming up a generation of bands that were able to play to that New York experience. Before, the bands weren't able to translate hip-hop, you know what I mean? And now they can. It could be the Internet, more access to music. It could have been that it takes time for something to settle in. In every generation we absorb the music we grew up with. The children of the seventies grew up—and when we got to the nineties, you hear our music is reflecting the seventies. Even Biggie Smalls is bringing in the Diana Ross sample and the Nile Rodgers vibe. It takes that cycle.

SIMON REYNOLDS: I always used to call it "record collection rock." It's an approach that really gels, that really blossomed with the Internet. Pre-Internet, you often found that bands had been clerks in record stores and so they have this enormous knowledge of records and info they picked up. Or they might be fanzine writers or editors. There was a sort of nerd approach. It was quite hard-won

knowledge. It involved a lot of digging, a lot of spending money, a lot of time. And then the Internet just made being that kind of nerd so much easier. What was a minority personality profile became much more widespread.

TODD P: TV on the Radio had a foot in the previous world, but they were the first one to get big on not going after the radio crowd. They were going for a certain kind of indie crowd, but an indie crowd that wasn't the punk indie crowd, an indie crowd that found out about things through NPR.

DAVE SITEK: When TV on the Radio started playing, when we started doing shows and everything, Tunde and I couldn't have been more shocked that anyone cared . . . We were more shocked than anyone.

TUNDE ADEBIMPE: My first instinct, during those years, whenever I saw anyone staring at me that I didn't know, I would always think I had something on my face.

DAVE SITEK: My window into knowing we were doing well was my mom calling me. Weirder than me being in *Spin* was my mom being excited.

ED DROSTE: One of our first support gigs was for TV on the Radio, right after *Yellow House* came out in the fall of 2006. That was really major for us.

AARON DESSNER: We've always had more in common with people who don't really present themselves as rock stars—we're more into the craft of making music. I would say the same thing about Dave Longstreth or Grizzly Bear. There's just a musical curiosity and a more varied, a more compositional thing happening.

MATT BERNINGER: There's some early footage of us at the Mercury Lounge and I'm hanging on the mic like I always do, smoking, and I think I even pick up a tambourine at one point. I don't fucking play the tambourine. I just didn't know what to do with my hands. We were just stiffs! We looked kind of stiff onstage, and I think we still do, compared to seeing the Strokes or Interpol. They were the Greasers and we were the Sox.

AARON DESSNER: In our little corner of Ohio there's a self-effacing

tradition in indie rock. I think of Kim and Kelley Deal, who were accidental rock stars as opposed to intentional leather-jacket rock stars. Those were the kinds of bands we idolized.

TIM GOLDSWORTHY: With the Grizzly Bear guys, they're all really lovely, but it's not scary. It doesn't feel like they're on the outside of popular culture pushing things forward at all, it's "I like your shoes where'd you get them oh I got them off the Internet."

TODD P: When you really think about it, where did Dave Longstreth come from, where did Grizzly Bear come from? From a world where musicianship was really important.

AARON DESSNER: Bryce and I grew up going to conservatory and we were very technical musicians as kids.

CHRIS TAYLOR: I was a jazz studies major at NYU, then I changed majors to audio engineering. Dan also comes from a jazz background.

ED DROSTE: We had been booking our own tours. We basically played to ten to twenty people a night around the country, crashing on people's floors. It wasn't until we released *Yellow House* in 2006 that we felt, "Oh, there is actually a path for us here." And it wasn't until much later, around 2008 to 2009, that we were able to quit our jobs and stuff.

AARON DESSNER: It was when we started to delve back into that musical background that we found our sound. *Alligator* is when you hear "Okay, that's the National."

TIM GOLDSWORTHY: This new generation, it makes me feel sick. It should be kids who are driven to express themselves in some way getting crap software or picking up a guitar or banging on things. Not kids playing fancy chords on fancy synthesizers just because they kind of sound cool. Rock and roll is about passion and the energy of transferring what you've got and you're feeling to somebody else, to a group of people. Can a technically skilled musician make great pop music? No you can't. It gets in the way. It's just not going to happen. You've got far too much baggage.

ALAN LIGHT: As the scene migrated to Brooklyn, it felt, to its credit, a little more self-sufficient, but also a little more detached. It wasn't just the millennial generation's version of boys with guitars.

MATT BERNINGER: It was something different. The Strokes were New York, the Strokes were Manhattan, the Strokes were the Lower East Side, and you can't repeat that story. You need a new story, and the new story became Brooklyn.

ED DROSTE: I feel like by the time that we were releasing music, Karen O had already moved to L.A. and was dating Spike Jonze or something.

"THERE IS A LOT OF CONFRONTATION BUT I THINK IT DOES COME BACK TO FAITH"

DAVID BURTON: In the grand scheme of things Yeah Yeah Yeahs got down to business, the business of being a successful business, if you will. They set parameters as far as how they were going to tour and in what fashion and how many shows they were going to do in a row, for the sake of everyone's mental and physical well-being. Because, I mean, she put out a lot onstage.

ASIF AHMED: It turned when Karen moved to L.A. She moved in February 2004 and . . . I mean, that's no secret that's just like . . . that definitely had an impact on her approach. Everyone changed.

KAREN O: I was just looking for change, you know? I just felt like if I didn't leave New York at that point that I probably never would. I came back pretty regularly to see my family and friends but when I moved there were definitely large periods of time where the band didn't see each other. We kind of got on with the business of our own lives.

ASIF AHMED: I ended up moving to L.A. because I had to. Karen's parents wanted me to keep an eye on her. I kind of convinced myself, "It's the thing to do." Also, it was kind of put in my ear that if I didn't go out there the band would find another manager.

APRIL LONG: At that point, it kind of seemed like they might not make another record. Karen decamped to L.A.; Nick was doing his photography thing. I'd still see him around, at Lit or whatever. It seemed like he was kind of holding down the New York fort. Nothing was really changing with him, but she was on this com-

pletely stratospheric trajectory, Hollywood and a completely different life. I mean, she started dating Spike Jonze.

ASIF AHMED: I remember when I busted them in a car outside a venue in San Francisco. Their headlights were glaring at me when I was leaving the venue. I think I dropped my phone or something. I looked over and they were just canoodling. I was like, "Scuse me!" The good thing about Spike was he broadened her world outside of just fucking Williamsburg. Got her out of her parents' shadow.

APRIL LONG: To go from Angus to Spike seemed kind of incredible. Striking, really. Personally, I thought it was incredibly cool. I was like, "What a freaking cool couple that is." But certainly a lot of people didn't. It indicated to them that she had crossed over into something they were skeptical of. That this girl who had crawled around pouring beer all over herself was now gallivanting around with Hollywood hotshots was just kind of a little bit hard to align.

ASIF AHMED: In L.A. she was pretty healthy. She stopped drinking as much—only when her nerves got the best of her. She had a colonic girl in Santa Monica. Aruna was her name. I remember Karen and I went on the same day, and we were just sitting there laughing and I said, "This is really . . . there's no boundaries now, you're seeing a speculum go in my ass!"

KAREN O: Nick came out and we started working on *Show Your Bones*. By this time, a lot of the New York scene that we came up in was already petering out. But it was terrifying because there was just no groundwork for what anyone would want to listen to in 2006. I knew I physically and emotionally couldn't make the same record—it's not in my nature, I have to move forward—but what I didn't know was what the fuck the next sound should be. It was already feeling like things were speeding up as far as the shelf life of bands and people's attention spans. I was already feeling the speed of that. So that was part of the enormous traumatic pain of conceiving *Show Your Bones*. The road hadn't been paved.

NICK ZINNER: Our second record, that was torturous.

KAREN O: There can be so much tension, really unhealthy tension, in the studio. I mean, you can't avoid it. It's going to be there no matter what you do. It's like trying to say, like, "I just wanna live life

without any pain or suffering . . ." It's just not realistic, you know? In the studio, you've got two days . . . two hours before you start overthinking it.

NICK ZINNER: It's torturous. It's really, really hard. I'm sure a million artists have phrased it a lot better than me but it's looking for this minutia that is not actively there—you're throwing everything against the wall to see what sticks.

BRIAN CHASE: We're trying out a lot of ideas and they came in really, really rough shape. I'd say over 90 percent of the ideas that we put on there don't get used. The final songs end up being a kind of distilled essence. And in that process of refinement comes a lot of saying no.

NICK ZINNER: That was another time Sitek picked me up and moved me, or like, shifted my world. We were doing our second record and I was on my fifth nervous breakdown. It was the worst, darkest time imaginable and I was freaking out, having intense panic attacks. He wasn't even producing that record, he was in the studio next door. This was at Headgear studios in Williamsburg. Stay Gold was the studio Sitek opened in the same building, so he was just next door. I was totally losing it and he picked me up and brought me back into the world and he was like, "Fucking play the guitar." He listed off a thousand reasons why it wasn't so bad and he totally saved my life.

DAVE SITEK: I physically picked Nick up and threw him into the recording booth and held the door shut. I said, "You're not coming out of that fucking room until you finish this fucking guitar part, and I want my studio back, so fucking do it now!" He was really mad, and he played so fast and so loud that it wound up being, like, the best thing ever.

ASIF AHMED: There were creative differences on how to get the next record off the ground, following her move and the Spike thing. All of a sudden, Spike's little brother Squeak E. Clean became producer extraordinaire, when I had Flood lined up, and I had Steve Lillywhite, I had Stephen Street, Steve Albini—people that would make better sense sonically. In the end I will say the album sounds great. It was his first big record and he did it. And I don't think

Karen had ever written and recorded at the same time, so god bless her for taking that on, but it took a toll on the band.

NICK ZINNER: Why was it so bad? I don't know. Karen and I hated each other. We didn't trust each other.

ASIF AHMED: Karen is very hard to fight with because she can turn a room cold. When she's happy, everyone around her is happy; when she's upset, everyone around her is upset. That's her star power, but that's also a tantrum, and I resented her for that quite a bit.

NICK ZINNER: Karen and I were like two thunderclouds rubbing up against each other.

ASIF AHMED: Those two were like brother and sister, very Wednesday and Pugsley.

BRIAN CHASE: There are great moments too. There is fun mixed in there. Hearing songs come to life is an amazing moment.

NICK ZINNER: I don't know if "fun" is the right word, but it can be totally enjoyable. It's more just like things work or they don't work and you can't really figure out the reasons why. I think what it comes down to is it's healthy to have a little bit of friction. It's probably essential to have a little bit but you just learn ways to have it not be a lot. There's no reason why it has to be a miserable experience.

BRIAN CHASE: There is a lot of confrontation but I think it does come back to faith.

NICK ZINNER: You know, I actually love that record now.

APRIL LONG: *Show Your Bones* didn't have the propulsive, slinky moxie of *Fever to Tell*, but it did have a tunefulness and a sort of intimacy that most critics responded positively to. The album was nominated for a Grammy and debuted in the Top 20. It felt like they had really made it to the big time, but also like they had lost a little something getting there. There was a lot of restraint on that record—and restraint was definitely not something you'd ever associate with Yeah Yeah Yeahs. You could tell that the dynamic of the band had changed.

ASIF AHMED: There was a term that Karen used on the second record: Gwenomics. Because she didn't want to be marketed as a pop star,

as the label also handled Gwen Stefani and No Doubt. It was hard to not notice how Gwen's solo career took off the same year *Fever to Tell* started getting more attention—that was a bit much for Karen at the time, being twenty-five and new to another level of label attention and marketing. I remember hearing Gwen was a little weird about Karen, because she was the new girl on Interscope and Gwen was the queen bee. Then Jimmy focused all of his attention on Karen because she reminded him so much of Patti Smith, Chrissie Hynde, Debbie Harry, and Siouxsie Sioux, all these girls rolled up in one. She was an amalgam of all that, whether or not she'll admit to it. But she didn't want to be marketed that way.

KAREN O: I always felt like because I was a woman I just had a completely different perspective. I felt like my brain literally worked differently than everyone around me, which was all men. And so therefore I was not beholden to the rules of the game, which is a big thing in the rock world. It's very dutiful. There's a legacy that is laid out. There's a cannon of rock, and a lot of men worship that and kneel at the alter of that. I didn't have to play by those rules. I mean, I felt super, super isolated and super lonely because I could never really fully relate to my male bandmates and peers. I could relate to them only to a certain degree. And they're the bomb! They're so progressive, wise, intuitive, really wonderful fucking rocking human beings. But they're dudes, you know? In the end they're not fellow ladies. And that was like . . . I mean, it's hard to know how much that's impacted my career and my drive as an artist but probably a fucking huge amount.

ASIF AHMED: They were also very threatened that I had other clients. I look back and I'm like, "Stupid, stupid, stupid!" Because they're not even that big! Who was bigger than Yeah Yeah Yeahs then? Everybody! Like the Killers! I'll never forget this, I booked the goddamn Killers as their opening act for their tour on the West Coast, the Killers' first big tour. And then I couldn't even meet with them. Yeah Yeah Yeahs would never let me go and work with other, bigger bands. Another one was the Distillers. Brody wanted me to be manager and then that mysteriously vanished!

KAREN O: We were competitive. Everyone was.

ALISON MOSSHART: This is a competitive sport. We all want to outplay each other. Think of the nature of all these bands—we were all dark, secretive fuckers, doing arty stuff. It is competitive! And brilliantly so. That's how it should be.

ASIF AHMED: You start resenting them for not doing the business aspect they're supposed to. They'll agree to do a tour and then they'll cancel it. "We don't like this label. Why did you sign us to this label?" And during that second record cycle, they had a different set of friends coming in to oversee things, whispering into everyone's ear. I couldn't win. After a certain point I just gave up. My feeling was "I'm not gonna win if the motherfucking girl who designed your handbags is telling you, 'Well, a friend of mine does this . . .'" I just thought, "Well, you know what? Go have your motherfucking dumb bitch friend who sells T-shirts manage your fucking band." I stopped caring about making them happy.

KAREN O: Asif just enjoys being adversarial with the label so much, which we loved for so long. In the beginning, it just totally worked in our favor. He totally got off on saying the wrong thing, humiliating these too-powerful rich men, and they loved the shit out of him. They loved being abused by him and he loved to abuse them. He had that sociopathic streak, which we also loved because it was what we felt like we needed at the time. But eventually it became, "Okay, this is a problem."

ASIF AHMED: Right after that I started working with Courtney Love. I saw Karen, Nick, and Brian as training for Courtney. Courtney e-mailed Karen about me; she wanted to know what Karen was like. And Karen e-mailed saying, "I can't believe you're doing this." I think the band got a little pissed. That whole second record was just a real line in the sand. It was brutal. We went from being super close, then super dysfunctional, to no one talking at all.

CHRISTIAN JOY: I think the interesting thing about Yeah Yeah Yeahs is that they do evolve. They could have stayed with her trying to still be a twenty-year-old maniac, but that would lose its appeal. It's nice that she still seemed able to embrace the performance and have these moments. She slowed down but she's still just incredible to watch. Every single time it's so captivating. And it doesn't

matter if she's a wild maniac or doing her slowed-down thing. She's extremely captivating.

KAREN O: For some people there's no boundary between life and art, you know? I think there's totally a boundary for me. That's why it could seem, like, as neat as flipping a switch.

ASIF AHMED: Karen always said this one thing: "I want to be successful but I don't want to be famous." She was like, "I want to be able to walk down the street and not have my life ruined." And I have to tell you, she's accomplished that.

HAR MAR SUPERSTAR: I think she liked to stir trouble and be more of a weird downtown art girl before she had attention, and then when she got the attention, she said, "No, I don't want the attention."

JALEEL BUNTON: I watched her become a superstar, a personality, which I could not fucking handle, man. And if you don't know Karen, you don't know that she is a fucking real person. She's not the kind of person that loves being like, "I'm the most powerful person in the room!" That's not her vibe at all, but when she gets onstage, she is that to so many people. She's iconic, which is weird to say, but she is. I just saw how difficult it is to maintain your humanity in that and watching her do it, I'm really grateful.

"THE CREATIVE PROCESS, WHILE IT CAN DEFINITELY REWARD THE EGO, IT CAN FUCKING BRUISE IT, TOO"

DANIEL KESSLER: Once it's on, it's on.

JENNY PENNY: After the *Antics* tour, which went on forever, Carlos finally came back, and said, "So what do we do now?"

DANIEL KESSLER: You're coming and going, going and coming. Anyone who has gone on vacation for a couple of weeks understands that a little bit, but it's nonstop. You feel like, "I don't even have time to clean my clothes."

PAUL BANKS: In general it's just a hard thing to do, to keep liking each other. Even *really* veteran bands, you realize the dynamics are all fucked up in between members. It's inevitable. Psychologically, it's just bedlam.

DANIEL KESSLER: You've got to look for the fun. Everybody has different ways for making tour life work for them. Part of mine is always to use your inner GPS to remember those cool places in different cities—"I love this café, I want to go back there! They had the best breakfast! That breakfast place stays open until two! Yes! I win!" It's like a bit of a victory.

PAUL BANKS: My entire philosophy has been that wisdom, self-awareness, and all thought should be fluid. When I was in college I loved this notion—it's from Thoreau—that your past self is this cadaver that you carry around with you and there's this sense that you need to stay true to who you were, not veer from your path in a way that will alienate your peers from you. According to Thoreau we needed to let all that go. He said that at any given mo-

ment we should be open to contradiction or self-contradiction or changing of paths. I've believed in that. So I didn't buy into fixed modes of working, fixed notions of what a band should do or a song should do. But then you work with people that do have that "I want to communicate this, and I want it to be like this" way of being. There's a tension there.

SAM FOGARINO: We went back to the UK a number of times during that period. But I wasn't going and hanging out with Paul and Carlos, going to these house parties where they would run into so-and-so from the Libertines or whatever. I was chasing my own kind of fun, which was just breaking off and hanging out with different people. If there was going to be a bag of drugs done, it would be at somebody's swank apartment or a swank hotel room in L.A. or New York or Chicago or wherever we were. Their partying was just annoying, you know?

HAR MAR SUPERSTAR: I loved just getting coked up with Paul and having him talk about how buttery Julian's voice is. "It's like butter, dude, I don't understand . . ."

PAUL BANKS: I would get in deep conversations with people, and I would feel like, "It's not just that I'm watching you be fucked up, it's like I'm interacting with you and we're talking about shit that we wouldn't be talking about if we weren't here at five in the morning high on coke."

SARAH LEWITINN: Sam never really hung out.

SAM FOGARINO: I really didn't care but it also didn't really didn't get in my way. I was too busy meeting Michael Stipe and Mario Batali and Bob Mould and all these other people. I felt, "These are the real fruits of labor here. I'm going to get shitfaced drinking a bunch of wine with Mario Batali, it's going to be so much more fun than doing rails of coke with some sluts at the Darkroom."

PAUL BANKS: I liked the raunchy, uninhibited quality of being out really late with people. But I'm prone to wanton self-abuse. It's sort of like going down a road and having to realize, "Okay, I've seen what's on this road, and I'd be repeating myself." The core you is there, the adventurer, so to speak, it's just that you have to move on and do other things.

SAM FOGARINO: Yes, I was worried. By the *Antics* era—hence the name of the record—it was like, "These guys are not just coke-heads, they're waking up with beers in their hands. They're full-on alcoholics." It's just not fun to be around. I did my share of junk. But I was like, "Time and place. It's not at twelve noon." I really didn't like it.

PAUL BANKS: Eventually, it became about survival. I was burning the candle . . . I mean, the candle was just going to go out. My personality and my work were suffering. My ability to do work. My life had become just the partying.

SAM FOGARINO: But then, you know, I didn't say anything because they would be fighting words. You couldn't tell those guys anything. They were just so in over their heads with this newfound lifestyle that nobody was going to penetrate any sense into them.

PAUL BANKS: Even when I was a real partier, I always had a voice of my own that said, "I'm on safari right now." I was making mental notes. I wanted to know how raunchy shit got, I wanted to feel it. I'm a pretty sleazy person. I liked it. I wanted to be there. But there were also other things that I wanted to do and to accomplish. It's still very exotic and awesome. I still would love to go back and be a fuckup for a couple years. But then I'd be repeating myself. Part of the reason why I wound up getting sober was an experience I had when I was really fucked up and I ran into Jaleel Bunton, the drummer for TV on the Radio. I've known him since forever, from when I went to Max Fish all the time. Also, Jaleel worked at Oren's coffee, across from NYU. I dated one of his co-workers, actually.

KAREEM BUNTON: Paul's still mad at Jaleel because Paul was in love with some girl. Paul said, "I told your brother that I was in love with this girl and he stole her." I said, like, "You never tell him that, dude. She wasn't hot until you said something."

JALEEL BUNTON: She didn't actually become my girl, but don't tell Paul that. Stewart Lupton actually stole the girl from me that Paul thinks I stole from him. So there you go. Stewart won that battle.

PAUL BANKS: I remember running into Jaleel one night when I was really fucked up, and I could see in his face what he was thinking:

"Dude, you're fucking slipping, man." He didn't say anything but it made me feel embarrassed for myself. It was just the look I saw in his eyes. I was never a Jekyll-and-Hyde drunk or anything. I never blacked out, I never did anything too crazy, but I could just see it register in his face that I was not looking good, that he wasn't really that excited to be standing in front of me in that moment. And it made me feel really, really bad. The look he gave me made me wince deep down inside.

JALEEL BUNTON: I do remember seeing him and having the thought, "You're better than this."

SAM FOGARINO: All the touring ended around October 2005. We got a rehearsal space in midtown Manhattan. I remember I broke in there with a friend to write some of my own music—it was my first foray working on music outside of Interpol. I was just kind of waiting for the band to get back to it. Our contract was fulfilled with Matador. There were major labels knocking at the door, lots of money's being talked about, and we kind of entered that phase where we were very cocky and felt we were invincible. And the writing sessions that took place were awful. Nobody liked each other.

PAUL BANKS: The band was just . . . yeah, we weren't getting along at all.

SAM FOGARINO: Everybody felt personally responsible for everything good about the band and everything good that had happened, and everybody felt insecure that the next person didn't like them anymore. So there was this big narcissistic, egotistical emotional conflict in the room.

PAUL BANKS: Carlos and I were at just constant loggerheads. We had a horrible relationship at that point. And Sam was in a very dark place, unbeknownst even to me, because he was kind of just dealing with his shit quietly.

SAM FOGARINO: I started taking liquid Vicodin out of a dropper because I couldn't stand to be around everybody. It got so argumentative. Everything was a debate. If anybody tried to pitch an idea that Daniel wasn't involved with he would retract. He would be in the room but he then was no longer present. Carlos and Paul were . . .

I think their egos didn't care. I just wasn't going to push buttons. And I wasn't happy though, so I made myself happy. And at the same time we're discussing Paul's situation, which was so over-the-top that he was about to go to rehab. And on the day that our mini-intervention took place I was high as a kite.

PAUL BANKS: Every artist that has longevity is constantly self-adjusting between having confidence, but not too much confidence, having ambition, but not too much ambition. I err more on the side of humility, because I'm depressive. A key ingredient that I've noticed to people that are really successful is they don't experience self-doubt in the ways that depressive people do.

SAM FOGARINO: The creative process, while it can definitely reward the ego, it can fucking bruise it, too.

PAUL BANKS: The first time I saw Jay Z in an interview, what dawned on me was whatever Michael Jordan has in his legs, that guy has in his brain chemistry. That dude's brain chemistry is so fucking right. Do you know what I mean? Not only is he very gifted and talented; many people are. But his brain chemistry is the serenest thing, he's just like so charismatic, calm, and cool. And I was just like, "Oh, I see. That's part of the package of gifts that he received." I wasn't coddled enough by life for that sense of "Everything I do is good." I more have a feeling that everything I do is not very good. As opposed to "Everything I do is amazing and people just don't get it." I feel like there are no real answers, it's just this fluid balance between narcissism and humility.

MATT BERNINGER: You need a certain amount of posturing to even have the guts to stand onstage and sing. It's humiliating. You have to turn yourself into a little bit of a caricature just to not hate yourself. It's so silly, the gall of thinking you can be a cool rock star. To be one, you have to be a delusional douchebag a little bit, right? But then, if you pull that off and deliver on inventive music and good lyrics and passionate performance, that's everything.

SAM FOGARINO: Both Paul and Carlos went clean. And Carlos had no qualms in talking about everything he did not like anymore. It was kind of sad. I mean, I was happy that he wasn't doing copi-

ous amounts of cocaine anymore, but that guy that was fun to be around was gone. He's gone and he's miserable. And he doesn't want to pick up the bass anymore. I don't know how, but we made it into the studio.

PAUL BANKS: What *Our Love to Admire* taught me was everything not to do in a creative process. I worked myself way too hard and tried way too hard. I got nodes on my vocal cords. I was sitting under a desk rocking one night in the studio. Just really wrong, wrong, wrong, wrong, wrong, overthinking everything.

SAM FOGARINO: Mentally, I was quitting the band every week.

PAUL BANKS: I should've gone to more movies and then walked back to the studio and seen what happened. At that point I still had this notion that I could make a great song out of anything. Then I realized, no, I can't.

SAM FOGARINO: I really don't know how the record got written. It was heavy. It was the band kind of coming apart at the seams, and that's what you hear on that record.

DANIEL KESSLER: Right before making it, we kind of knew that it probably wasn't going to come out on Matador.

SELLING OUT IS SO PASSÉ

PAUL BANKS: People made more of the switch to Capitol than we anticipated. I just assumed it would no longer be a point of discussion once you heard we hadn't made a sellout record. It was like, if the quality control is still contained within the band, what is there to lose? Also, by that point we were the only band left on an indie. All these super-hip indie bands were on majors.

ALAN LIGHT: When you're talking about those bands earlier in the century, they were still dependent on a label, a studio; they needed access to somewhere to record and needed someone to distribute. Five years later, technologically you don't need those things—you can record at home on a laptop. You can distribute—you just need somebody to notice. That's the only challenge that's left. Labels become either peripheral or an excuse to take an advance, but that's about it.

ROSTAM BATMANGLIJ: In college I had a friend who was obsessed with getting signed to a major label. I was fascinated by the idea of it. I just found it interesting, on an anthropological level. The idea of these games built around these major, dying corporations.

KIM GORDON: There was definitely a change. It's definitely different than when we started.

JAMES BARBER: Why is it bad to sell out? Isn't that supposed to be a self-evident thing?

MOBY: In the seventies, eighties, nineties—and I watched this with some friends of mine—they could make idiosyncratic music and do nothing, or compromise and sell five million records. So there was a lot of pressure put on people to compromise. And the carrot that they dangled in front of these bands was, if you compromise, and

you make a record that sounds like Hoobastank or Bush, you will suddenly be playing Madison Square Garden and have a humidor in the back of your Rolls-Royce.

JUAN MACLEAN: There were bands that were on independent labels and the major labels would sign them and subsequently clean up their sound and make it more palatable for a larger audience. These bands that had big underground followings would lose their entire fan base in exchange for a much bigger, mainstream fan base and in the process, they had to make their recording sound a lot different. They had to be able to be played on mainstream radio.

MOBY: Of course, that became very distasteful, and so a lot of indie—not just music, but art, movies and everything—started moving away from that path.

JUAN MACLEAN: In the nineties, just by being immersed in this underground music scene, you socially had taken a stance and were a member of a group. It was a group that generally had a set of ideas and behaviors and ways of doing things that were pretty universal from place to place. Even by the clothes that you wore back then, you really stuck out as being different. There was this sort of rallying cry of "Oh, we're not normal people." It was all in the way you dressed and the music that you listened to.

CARL SWANSON: The concepts of the mainstream and the non-mainstream, and all of that coming up through punk and in the post-punk era in the eighties, was in opposition to the mainstream rock era, which itself was just like a luxury suede-and-cocaine version of hippie thing, which itself was another reaction to something else. It's all just about being in opposition to, the antithesis to, the thing going on at the time.

JONATHAN GALKIN: Back then there was always that shop in every town, the one place that sells Doc Martens, and that would be *the* place. They'd have a shoe place upstairs, and downstairs was all vinyl. Because you used to be able to go to, like, the goth army-navy record store place. That New Order poster on the wall in the DFA office? That's from one of those places. I had it on my bedroom wall in junior high school.

JUAN MACLEAN: I've been in my share of fights over the years, and many of them were started by something as trivial as wearing Chuck Taylors in the eighties, which seems insane now. It seems inconceivable. But riding on the subway in Boston wearing Chuck Taylors and having a funny haircut made me the target of just about any other kid my age. And that was part of the appeal. We were people who looked around at the mainstream and were like, "I don't want to be a part of this."

KIM GORDON: There was the whole "Put it out yourself!" thing, the "Indie labels!" thing. But it was also about "Why are you doing it? Why are you making music? Are you doing it because you want to have a hit record and be famous and rich? Or are you doing it because you really want to play music and you don't care if you actually end up having some day job?" Being in an indie rock band was like being a blues musician or a jazz musician, all the noise musicians, or like, most musicians—you're just eking out a living so you could play.

JAMES BARBER: You're always going to get me back to the class thing. One thing that happened in the eighties is a generation of kids who went to college started playing music for a living, and Sonic Youth are the first of that. All of a sudden there are kids who went to Brown, who went to Harvard, who went to Michigan, who went to Berkeley, who are forming these underground bands, and they come from a background that's way different than the working-class kids who had historically been the rock musicians. Or the jazz musicians. Or the R & B musicians. So, in a way, the rise of "dealing with the man is bad" is connected with the entry of people who can afford to have those attitudes. Look at it this way: historically, musicians are people who are "If I can make this work, I don't have to go work at the tuna-canning plant or pump gas at the gas station." But all of a sudden, it became "If I can make this band work, I don't have to go to law school."

CHRIS LOMBARDI: There were rock stars. They were famous people. And then there were the New York rock stars, the indie rock stars.

JAMES BARBER: It's like, we don't *want* that many people to hear our music, because the people that we don't want to hear our music don't deserve to hear it.

CARL SWANSON: The idea of selling out came from a time of plenty. It's a luxury idea, the idea that you're avoiding your otherwise boring prosperous fate. That idea of worrying about your credibility is a luxury notion.

JUAN MACLEAN: That sense of community is something I tried to hold on to with DFA, which is less a record label and more a group of friends doing the same thing. It's kind of like a tightly knit social group.

CARL SWANSON: My boyfriend is from Detroit, grew up in the projects, and selling out is not something he worries about.

JAMES BARBER: I actually think that though there was a very vocal, articulate group of people who've claimed these politics, the overwhelming majority of people who were in bands would have jumped at the opportunity to sell out if they could get a look at it. The sort of poison underneath this whole, like, it's not cool to want to be successful goes back to art school people, right? If you're an opera singer or a painter or whatever, there's gotta be a sense that you don't give a fuck about what people think about you, 'cause you're a fine artist and it's built into the notion of being a fine artist in the second half of the twentieth century. You are performing for art's sake, because there is no possibility of becoming Elvis Presley. So when people from that culture, from that educated culture, from Kim Gordon's background, start wandering into rock, they bring this "Oh man, I like the Fugs and the Velvet Underground, and people who were real artists, who didn't go on the Ed Sullivan show." Someone like Iggy became a polestar for people who saw the world that way. But would Iggy have been happy to dance around for Ed Sullivan? Fuck yeah! He just didn't get the opportunity. Would the MC5 have been happy to be on the episode of the *Brady Bunch*? Yes!

CHRIS LOMBARDI: Then Sonic Youth signed with a major label.

JAMES BARBER: That was a huge moment. Geffen didn't have its nineties reputation yet. Sonic Youth kind of made that reputation hap-

SELLING OUT IS SO PASSÉ **505**

pen. Geffen was Whitesnake and Guns N' Roses. It's almost like signing to Geffen was a piece of performance art, it was so ridiculous. So Sonic Youth did not fit the model of aspiring rock-radio corporate rock at all. And they sort of changed the notion of what corporate rock could be.

CHRIS LOMBARDI: It was Nirvana that opened it all up. They were the ones.

JAMES BARBER: Nirvana said they signed to Geffen because Sonic Youth made it okay. And at least inside the company, Kim Gordon got the credit for hipping the label to Nirvana in the first place. And at some point, Sonic Youth renegotiated their recording contract, and they got rewarded for Nirvana. They got a ridiculous amount; I don't know the numbers exactly, because there was a nice lid on it, but Sonic Youth's contribution to bringing Nirvana to Geffen was recognized by the company and they were rewarded for it.

CHRIS LOMBARDI: When Nirvana came on board, the thing that was our thing was becoming everybody else's.

DAVE GOTTLIEB: They opened it up just enough so that these other bands could break through.

JAMES BARBER: There was this moment from, say, spring of '92 through '97 when labels all realized that they didn't see Nirvana coming, and so the senior people at major labels said, "We don't know anything, we'll try everything."

CHRIS LOMBARDI: It was this crazy circus where there was so much money being thrown around at bands. And there were copycat bands like Stone Temple Pilots who came along and sold millions of records because they were the poor man's Nirvana.

JAMES BARBER: There aren't any more Nirvanas. But at the time, people didn't understand—at least, people in the business didn't understand—why they had been so successful. So King Missile got signed to Atlantic Records. Guided by Voices had a major-label deal. People who couldn't write songs that lasted more than ninety seconds. Then the giant consolidation happens in '98, '99, when all the labels that were out there signing everything in the world got merged. We went from five to three pretty quickly, didn't we?

And then there were hundreds of records that never got released. Bands got dropped. You could write a book about the bands who got signed to labels and never had an album come out in '97, '98, '99, 2000. That's a whole story. So what's really interesting is this moment that we're talking about, for the bands we're talking about, the evil warnings of getting swallowed by the system had actually really just happened to a bunch of artists. They had reason to be worried.

JUAN MACLEAN: By the time DFA formed in the late nineties, we're talking about a time where indie rock in general, which was what it was all starting to be called, had gone in a direction that I really hated. All the important bands that I had been really excited about and got me into making that music had gone away or signed to major labels or something. Swans. Butthole Surfers. Jesus Lizard. Even Sonic Youth. In the beginning I was a huge fan of them and they ended up signing to a major label; they just became very uninteresting to me. Indie rock became a sound, and that sound was guys wearing sweaters strumming guitars.

HAR MAR SUPERSTAR: The DIY thing is supposed to be about inclusivity but it can sometimes just be super exclusive.

CONOR OBERST: We were brought up on that hyper-indie militant myth. Our heroes were Fugazi and Dischord and Merge and Matador. We had the archetypal record store with the really snooty guy, and looking back you can see what a joke it was and how limited in scope his vision of the world was. He was a great guy and he changed my life so much, but he didn't have any idea about the music industry and his visions were uninformed. The more I learned, the more I realized it isn't about indie versus major; it's about getting a lawyer to look at your contract.

CARL SWANSON: What was becoming the dominant force in pop culture—as it is now with Jay Z and stuff—was a celebration of success, and a celebration of making it.

HAR MAR SUPERSTAR: We were coming out of that era where everything was precious and everybody was fucking concerned about the sellout conversation. I was like, "Dudes . . ." I was a big advocate for selling out as much as possible.

JAMES MURPHY: I came to this conclusion that Bjork is consistently more ambitious than most indie bands that are supposed to be the underground, so what's the point of the indie bands, if there's just another little set of little rules? How is that more freedom?

HAR MAR SUPERSTAR: I am kind of antipunk, because I grew up living by Ian MacKaye's morals, and they're cool, it's cool that he got away with it, but literally, he's one of ten dudes that can go on tour and play five-dollar shows and still survive. The rest of us are just dragging our faces through dirt and sleeping in vans and eating dry cornflakes. You think, "It would be cool to get paid for this at some point." It's more punk, I think, saying, "I want to get paid for all this work I'm doing." Or would you rather someone work at a video store and not make that album that you're about to freak out about for two years?

CHRIS LOMBARDI: We finally grew up and realized that the bands have to want to be successful; there does have to be an element of ambition.

JAMES MURPHY: The Stooges wanted to take over. Suicide wanted to be big. Some bands say, "I don't care if people listen." And I was like, "Well, what's the fucking point of that?" To me it's all about communication. I wanted it to be personal, but we were pretty ambitious. I was just getting out of my indie rut.

CARL SWANSON: That idea of reluctance toward mainstream success, that entire concept was destroyed by changes in technology.

MARC SPITZ: Any differentiation between indie and major labels became moot because of global digitization. It erased any distinction between those terms, both in a literal way, as in indie labels were no longer any different, practically, from major labels, and also on an ideological level, as in indie culture was no longer uniformly cool and mainstream culture uniformly square. The whole indie-versus-mainstream thing became quaint. The labels were eventually indistinguishable from one another. The only difference between a Merge and an Interscope was that an Interscope publicist would buy you sushi instead of beer.

JAMES BARBER: And you know what? The line between indie and major was never as black and white as you'd like.

MARC SPITZ: The people Kurt Cobain feared wore suits and ties and pantsuits from Barneys or Fred Segal. It was the slickness that I guess stayed with the majors and the lack of slickness that stayed with the indies, but if you have a platinum card and you're wearing an old Slint T-shirt and Dickies it's almost more honest to wear a suit.

MOBY: When people weren't buying records, there was no way to sell out even if you wanted to.

HAR MAR SUPERSTAR: I used to stay with the Shins at their house when they all still lived in Albuquerque. They were recording their first album in the basement. I said, "You guys should maybe take this to a real studio." Then they released it and did pretty well. When they did that McDonald's commercial, everyone was pissed at them. My response was "Dudes, they got ten thousand dollars; that pays their rent for like a year, and now they can continue being musicians like you want them to be. What's the problem?" McDonald's owes me ten thousand dollars?! I would take it if they offered it. Now it's what you do. The Strokes were in the middle of that debate, Yeah Yeah Yeahs, "They're getting too big, they're selling out," and I just thought, "To what? They're still doing exactly what they want to do, they have their own imprints on these giant labels and can do whatever the fuck they want to, what's cooler than that?" I said, "Fucking do it, do that car commercial, who gives a fuck, it's going to go away in six months and that money is going to float you for the next two years; do it. I would." Then over the course of four or five years, it all just disintegrated, and now it's the only way to make money.

DAVE LONGSTRETH: In a world in which music is a democratically supported phenomenon, who's going to support it but the extreme rich and the corporate paymasters? There's no one else.

JAMES BARBER: You do kind of have to separate from each other the idea of licensing versus being on a major label. They're parallel issues, but they're not the same issue.

MARC SPITZ: Moby's *Play* was really the first album to thumb its nose at the very idea of selling out in the nineties sense. He ended up licensing every song on that album, and MTV and radio came

around because of that and not vice versa. It came out at the very end of the decade and was a kind of bridge to the new century.

GIDEON YAGO: I remember there was this ad guy who bought, I think it was, an Apples in Stereo song for Gap. They had just released a record and they put a song in a Gap ad in 2000. And it was this thing that got gossiped around in bars, "I can't believe they sold the rights to their song for forty thousand dollars, fifty thousand dollars, or seventy thousand dollars." "Sellout" was the term you used, and you used it with great derision. Flash forward to four years later or five years later, the music business is so annihilated, the indie record labels are so annihilated . . . I mean, Yeah Yeah Yeahs were in a fucking Cadillac ad. That was unheard of. But these bands needed to survive.

JAMES BARBER: The period you're talking about is at the end of an economic and cultural bubble. From the time the Beatles invented the album as a commercial concept to the time when album sales just collapsed, there was an era, even up to the late eighties, early nineties, where you could make a living by making albums and making videos that got played on MTV, and not even really have to tour. You know, you could live in a house in the Hollywood Hills and make three hit singles and some videos and play a hundred shows and get wealthy.

PAUL BANKS: I don't want to pooh-pooh it like it's bullshit, the whole selling-out thing. I was bummed when I saw a Nirvana song on a commercial because that was a really good song from *Nevermind,* and it was really important to me as a kid, and you don't use music that is that relevant to sell video games. But now things are different.

RYAN GENTLES: Getting Strokes T-shirts in Target was a really big deal. *Transformers* was about to come out, and Shia LaBeouf wears a Strokes T-shirt for much of the movie. The costume design lady asked her daughter, "Who's the coolest band?" and she said, "The Strokes!" When the trailer started circulating, the reps from Target knew that it was going to be a hit, and it was a no-brainer. "Target wants to sell Strokes shirts because *Transformers* is a big mega-blockbuster and the kid is wearing a Strokes shirt." I did

that deal. I sold twenty thousand units to Target. It was a coup. It was amazing.

PAUL BANKS: My policies have changed on where I'll license our music. Because, fuck, man, I deserve to make a living too. So you can judge all you want about how we might license our song to a commercial, but start paying for the fucking CDs and I'll stop doing that! But the cool factor and the outsider thing really does speak to me and I get that we represented a kind of counterculture, or a subculture, or an outsider culture, and that when you go really mainstream that puts that illusion in jeopardy. I buy that, I can understand that.

RYAN GENTLES: I remember being fifteen and I could buy a Nirvana T-shirt at Target. I thought it was awesome. It was "They sell Britney Spears here, they sell Christina Aguilera here," so other bands may think, "That's not cool, I don't want to be sold next to those bands." But the Strokes were like, "Wouldn't it be cool if our kind of band were sold next to them? It would be like, 'Yeah, we took over your fucking shit!'" That was the goal. It wasn't, "We aren't going to sign to a major label, fuck major labels." No, it was "Let's sign to a major label and flip the script on the music industry," so getting T-shirts into Target was a big thing.

MOBY: Now you could reach your audience more directly. In the eighties and nineties, there were five outlets—there was *Spin, Rolling Stone*, MTV, VH1, and alternative rock radio—and if you didn't have the support of those five things, your label was going to drop you and no one would hear your records. Suddenly, with the Internet, people could reach people directly, bypass the gatekeepers, and have almost, in a weird way, a more authentic experience. The art was more authentic and the relationship the artists had with the audience was more authentic. Personally, I think very much the Internet has benefited music, because there's less profit motive, so I think that people have no incentive to compromise.

DAVE GOTTLIEB: What's changed is advertising has got better. That's what made it more palatable for artists to say yes. Advertising got better. It's Apple. It's VW. Putting ELO in a VW ad the way they did. It changes it. The platform got better and I think that artists

got a lot pickier about saying, "All right, you want to use my song? I get to be involved in the creative. I'm not saying yes until I see the ad."

CASEY SPOONER: *NME* would always deride me, saying the only thing that was ever important to me was whether we had a good picture or not. But now look at the world we live in. We live in a world of Kardashians; all you have to do to be important is look hot and make amateur porn. It's entirely about image now. And the reason corporate sponsors partner with people who look hot, who take a good picture, is for exposure, is for traffic. Someone has made a logarithm out of our behavior and they're profiting from it. That's why Red Bull can give an artist X amount of dollars or give them ad space—they can invest because what they're going to get back in terms of exposure is advertising. It's all advertising. We're all advertisers now. We're all monetized.

MARC SPITZ: Licensing became the new radio. iPod commercials became the new *TRL*.

ANDY GREENWALD: The story of the last fifteen years is the story of the abdication of struggle. And it's good and bad in ways that are legitimate and ways that are just nostalgic, like the struggle of finding the record, literally finding the band, going to the record store, hearing the recommendation from your friend's older brother or sister or whatever—that's gone, gone forever, and I have nostalgia for that, certainly. But the other part of the struggle that I just inherited and never really questioned was this idea of all the old nineties struggles of success. I remember Vampire Weekend basically telling me, "Yeah, we got a tour bus, and it's great!" And I was, you know, judging them for that. But of course it's great! There's a fucking bathroom in it! If you can afford it, you *should* get a tour bus, by all means. But I was still carrying baggage, baggage that they didn't have. Those battles of authenticity and credibility and selling out, those battles completely went away. The marketplace that Vampire Weekend went into was completely different from the one that even the Strokes went into. The Strokes and all those bands were the last time the major-label machine tried to get its rusty bones together and say, "We're going to do this, we're going

to do one more scene. And we're all going to get rich and do a lot of blow." But none of those scenes got them over the hump and then they still all collapsed.

CHRIS TOMSON: Our music is in a very post-genre world. I feel like kids won't go to the mat for one genre or another now. Whereas someone in the nineties with a Sonic Youth T-shirt would be like, "Fuck you, this is my thing, this is what I listen to," now it's like, "Oh, cool, you like Sonic Youth? Have you heard the Harlem Shakes?" You get picked on because your Twitter humor is bad, not because you like the wrong records.

"WE COULD BE THAT BIG"

KAREN O: To be a band coming up in a real fucking moment there's no question that it baptized us as special. Just being able to evolve and somehow not lose all our fans. Taking our time. For us, being in the shadow preserved us. I wonder, for the Strokes, if it was a massive disadvantage to be first and to be so huge.

JENNY ELISCU: There are very few examples—Green Day being one of them—but very few examples of something that was genuinely underground that ever made it that big. Because if you're genuinely underground, you're going to take risks that don't pay off, you're going to make music that's deliberately abrasive and impossible to listen to, like Julian Casablancas has done. If you're a real artist. You know what I mean?

MARC SPITZ: Julian seemed like a different person when I met him for the third-album cover story. He was with Juliet, who is now his wife, and he was sober. They were living in Juliet's little apartment and he seemed happy. He seemed like he was making music that he was really proud of. But nobody liked that record. So basically what Julian likes is what Julian likes, and what everyone else thinks is great makes him miserable.

GORDON RAPHAEL: There was one thing on Julian's mind all the time: how can a band be cool and still sell? Just that short phrase was in his mind and on his lips. "How can a band be cool and still sell?"

NICK VALENSI: We had conversations that went along the lines of "Gosh, I think our songs are better than 'Mr. Brightside' by the Killers but how come that's the one everyone is listening to? They

did it a different way. They recorded it in a different way. They promoted it in a different way. We could be that big."

GORDON RAPHAEL: Julian would tell me, "Gordon, all these fans came after us and kind of took some of my ideas and now they're selling a lot more. When I hear my songs from *Room on Fire* come on, and then I hear Franz Ferdinand or I hear the White Stripes, their music sounds so much bigger. What can you do to make our music sound that big?" I flew over for a special meeting with the band. They said, "We want you to build us a studio in our practice room. You'll be in charge so we won't feel any time constraints." So I designed and built them a studio in the practice room. Then I went there after the tour in June of 2004 and they had no songs prepared.

RYAN GENTLES: Julian can't write on the road, that's the problem; that's why he never wants to tour.

MARC SPITZ: It's not heavy lifting, and it's not working in a slaughterhouse, you know; it's not going to war, but you do have to have a certain wiring.

RYAN GENTLES: He said it destroys him; he can't write, he can't think. He tells me when I talk about touring, "I know you're going to think I'm crazy, I know you're going to think this sounds nuts, but I'm still just barely getting over the tour from two years ago."

JULIAN CASABLANCAS: I consider the main thing that I do writing, working on music. When you go on tour for a lot of time, that gets taken away.

RYAN GENTLES: And I say to him, "That does sound crazy and nuts. It was fucking two and a half years ago!" Julian says, "That's how badly it fucks me up, mentally and physically." I'm like, "Dude, this is our entire livelihood, if you don't have thicker skin than that, we're fucked." "I can't do it, I can't write, I'm not creative, I get depressed, I come home, I'm under a pile of shit, I'm trying to dig myself out, then I can't write at home because I'm catching up."

JULIAN CASABLANCAS: We had toured for so long I felt like I had to almost start over musically, which was a real bummer, and I promised myself that I wouldn't do that ever again.

RYAN GENTLES: It's real hard to argue with someone when you're saying, "We need to do this tour, we need to do this show, it's going to be good for your career," and he's saying, "Okay, I'll do that, then we're going to break up, because I'm going to want to kill myself, or we don't do it and at least we'll have a career next year." I'm forced to say, "Okay, I choose the career next year."

ALBERT HAMMOND JR.: At the beginning of recording *First Impressions,* that's when the solo stuff started.

GORDON RAPHAEL: One day Albert came up to me in the studio and says, "I've been hanging out with my best friend, Julian Lennon, and he is making a solo album and they're working with this engineer named David Kahne. So you think when we start the album that we can just use this guy to get some cool sounds?" My thought was "I don't mind if that's what the band wants."

JULIAN CASABLANCAS: Yeah, it was tricky. We were hoping Gordon and David would get along and get the best of both worlds, but it became battle of the producers. We were sounding different, which I think some people wanted, so we just saw it through with David.

GORDON RAPHAEL: After Christmas break I came back to start the Strokes record and on the fifth day they had a meeting. Julian took me for a cup of soup: "Hey, we want to record with David Kahne, do you mind if you don't record this album?

MARC SPITZ: That record's just a big rock record. I mean, the guy who made it made that Outfield song "Your Love." He made "Walk Like an Egyptian."

JIM MERLIS: I like half of the third album, and the songs I like I think are maybe their best songs. But then I get the feeling they were making a record just to be different than the other records, and that doesn't work.

ALBERT HAMMOND JR.: With *Room on Fire,* people were giving us shit because they said we were sounding too much the same. With the third album we were getting shit that we don't sound like *Room on Fire.* I feel like I got fucked by the same thing twice!

JIM MERLIS: There was bad stuff going on with the band—a lot of fighting, arguing, and the shows were bad. They were really, really

drunk, it just wasn't fun, everything was becoming a bummer, they didn't want to tour. They didn't want to do anything. It was just not fun to be around them anymore.

DAVE GOTTLIEB: Go back to when I said to the band, "What's your vision?" And they couldn't answer that question. They had that vision on the first eight months of the first album and then they stopped, probably because the roller coaster was so crazy. They just couldn't see.

MARC SPITZ: They seemed a lot older. A *lot* older. And it had only been, like, two years. They looked older. And they seemed defeated in a weird way. And impatient, like they just wanted it to be over, you know? Fab was doing things like showing up for a remixing session in a Darth Vader mask. They each had their own perspective on life at that point. I had a sense of them knowing the game. They weren't trying to convince me it was a unit. They were not deluded that maybe it was over, their moment was over. They were very wised up. And sober and older, just older. Not sober as in not drinking. Albert was most definitely not sober. Nikolai was not sober. I did the interview with Albert in a bar. I did the interview with Julian in his apartment. I did the interview with Nick over lunch. And I did the interview with Fab in the rehearsal space, and then Drew Barrymore met him, and they said, "We're gonna go have sex now." And I went home.

ALBERT HAMMOND JR.: That's probably the first time I noticed it had stopped being fun, the recording of *First Impressions*. That's when things started getting into the gap: friends, girlfriends, people who worked with us, other people, strangers would all just start coming in, being like, "You should be a bigger band," and I was like, "Yeah, we *should* be a bigger band . . ." For as strong as we were and as close as we were, we weren't close or strong enough to fight it.

FABRIZIO MORETTI: That's the house of cards that is being in the Strokes. There was a lot of emotions that were kept secret, but were so evident. We didn't know how to process them, A, because we were children and, B, because it's hard to process subliminal subconscious volcanic emotions. We were kids that wanted to conquer the world, but we had no idea that we were going to be given the

chance to. We had been, like, physically primed for some kind of release that we didn't know was coming, necessarily, and that tension, the fact that friendships could form in little cliques and stuff, meant that everybody felt like an outsider.

STEVEN TRACHTENBROIT: Jules doesn't let anybody else speak their mind, and I feel like a lot of resentment comes from that, especially moving forward after *Room on Fire*.

RYAN ADAMS: I don't think that meeting I had with the guys ever was about heroin. I think it was about jealousy. And I think that maybe the idea was that this world they were in was slipping out of their hands and maybe Julian felt like it was slipping out of his control.

MARC SPITZ: Julian would have liked to have been more of a Beck figure. You know? Where he could work with Nigel Godrich, he could work with the Dust Brothers, he could make his own Serge Gainsbourg *Histoire de Melody Nelson* or something.

STEVEN TRACHTENBROIT: Julian got what he wanted, he wanted to be the next Guided by Voices. He's capable of writing those big hit songs, but he won't let it get that far. He's really creative, he has all of these ideas, he's a great songwriter, but he stops himself or won't play the game to get further.

MARC SPITZ: Even when *Spin* made the Strokes Band of the Year after the *Is This It* tour, it was already starting. I mean, they played like they believed onstage. They went out there to kill, every fucking night. I still haven't seen a better band. I didn't see the Clash, but it was like what you imagine they were like. They came out and punched the audience in the fucking mouth every night. You went home with stars spinning around your head. But I remember Nick saying, even then, "Man, this is all bullshit. Like, we're not even Band of the Year. We shouldn't be here. The White Stripes are Band of the Year." They didn't want to own it, you know?

DAVE GOTTLIEB: One of the detriments of the Strokes being from New York is that they're savvy—you always have to have an answer for everything. If you're a couple kids from rural Tennessee and your father is a whacked-out preacher and you have this opportunity,

well, yeah you're going to listen. If you're Brandon Flowers and you're from a Mormon family and you're in fucking Las Vegas, you're going to listen.

CALEB FOLLOWILL: At the heart of it, the Strokes don't take shit . . . at all. I've gotten into fights with 'em. I've been on their side and had to fight other people; we've done lots of crazy shit together. They don't ever compromise, they don't ever want anyone to tell them what they should do or what they shouldn't do, and that's a part of who they are.

JULIAN CASABLANCAS: My biggest regret in general is that I drank so much. I warded off any kind of intense introspection. We never really had those moments where we're all cheering in a freeze frame, credits roll. If anything, not to be dark and foreshadowing about the things that hurt the band, but I think if anything it was always a sense of like, we're not doing the right thing, we're not . . . It was always why are we? . . . I don't know . . .

MARC SPITZ: Julian was a perfectionist. And you saw Jack White was too, but something about the whole thing sat better with Jack. He acted more like a rock star. He crashed his car, he dated Renée Zellweger, he punched out that guy from the Von Bondies. He seemed more suited to act out that role. Maybe because instinctively he knew that he would survive, I don't know. His vision seems pretty strong. And Jack didn't have the burden of New York City.

JACK WHITE: Sometimes being thrust out there immediately pushes you to hurry up and figure yourself out and do away with years of fumbling. That happened to the Strokes; they had to get it together fast and it worked for them. Meg and I had three albums out and an almost too realistic view that nobody was ever going to care about our music. We were already assuming we had a life of playing in bars for thirty people in our future. So the extra time to get our things together was good for us mentally. It still shocks me that the mainstream accepted that music; it doesn't add up.

JULIAN CASABLANCAS: We became as big as you can become while still staying under the radar, which is amazing, and maybe ideal, but it was never this big breakthrough, you know what I'm saying? There was never this MC Hammer moment where you're like, "There's

so much money, the success is gonna last forever!" And then you squander it. To us it always felt amazing but like it could disappear at any second, or it wasn't that huge.

RONNIE VANUCCI: It's such a weird profession. It could really warp you or make you into something cool, but it's kind of down to luck which way it all plays out.

AUSTIN SCAGGS: I saw the Strokes' bubble burst when I went to South America and Brazil for a bunch of shows with Kings of Leon and Arcade Fire and the Strokes. It wasn't for *Rolling Stone*, I just wanted to go. I was like, "Ryan, I'll take the video camera, I'll document this trip, I'll just shoot everything and you can have whatever you want." I'll pay for my own ticket. Honestly, I was thinking it was going to be like Led Zeppelin, like you walk into the room and there's a bed full of women. I thought it was going to be a giant debaucherous orgy of booze and drugs. It was the absolute opposite. To be super blunt about it, the Strokes were crumbling right in front of my eyes, right in front of the camera. There was a lot of resentment and there was a lot of tension. We would have a lobby call at like nine in the morning to go to a rehearsal or to go get a plane, and it would be eleven thirty and nobody was there. These are things that don't happen. I remember driving an hour and a half to some rehearsal space before these big festival shows that they were doing and they never played a note. They ended up having a very big serious band meeting when this rehearsal was supposed to take place. They didn't let me in, even as a fly on the wall; it was so intense. It wasn't even really drugs, that I remember, it was more like everyone was just sick of each other. Obviously Julian was resentful of everyone putting out solo records and not contributing to the Strokes records. It was a power trip. When I got home I was like, "Wow, that was not what I expected." I didn't see one naked girl the whole time.

KELLY KILEY: They were all best men at Julian's wedding, and I think that might be the last time that I saw them all together as that gang.

RYAN GENTLES: When I found out Julian and Juliet were dating, I was so mad. I was like, "What are you doing?! You can't fuck the lead

singer! I can't have my assistant fuck my boss!" I said, "You can date him and quit or you can have the job and stay, what do you want to do?" And she just said, "No, nothing's happening," and I said, "Good, get your head out of your fucking ass, you're being an idiot." She kept it a secret for a long time.

NICK VALENSI: People knew that they liked each other and they'd have flings; it was normal and fine.

RYAN GENTLES: How did I find out about it? Back in the day, she'd come on tour with us if I needed an assistant, and she'd share a room with me; she was my buddy, it was no big deal. I woke up to Julian making out with Juliet in my room, and I just left the room. I was like, "This is bullshit, what the fuck was that?" They were both shitfaced.

NICK VALENSI: She was our assistant manager. She's an amazing person, she's an awesome, awesome woman. She was really instrumental in us getting to where we got to at that point. I'd be lying if I didn't admit that when they announced they were getting married, I was kind of like, "Okay, what does this mean now for this kind of managerial relationship that we have?" but that wasn't a concern so much as a logistical question. "How is this going to work?" I was surprised that they were engaged to be married, and I was super fucking happy for them. I love the both of them. And you know what? They fucking love each other so much.

DAVID CROSS: Juliet's awesome. She grew up on a farm in Connecticut, and you'd never guess that about her; she's tough, smart, sensible, allows Julian to be Julian. They're perfect together.

ALBERT HAMMOND JR.: After I moved in with Catherine and he moved in with Juliet, we just didn't hang out the same way anymore. I missed his energy. I got sad; I felt a distance between us. That was a big part for me in this band—just hanging out with him, just being friends with him. We lived together for seven years. I've never lived with a girl that long.

JULIAN CASABLANCAS: Does that mean anything to me? I mean, of course. The way I remember it, we were roommates and we moved

places and I wanted to stay roommates and I feel like maybe he was not so into it anymore. Albert, you don't know what you've got 'til it's gone, baby!

RYAN GENTLES: Julian told me that if he ever felt that being fucked up was going to get in the way of music, that he'd cut it out. One day he decided, during *First Impressions of Earth,* that he had a real bad session, and he trashed the studio. He realized the next day that he had trashed it out of frustration, because he couldn't find the lyrics, and he realized it was because he was hungover. He realized it was getting in the way of music.

JULIAN CASABLANCAS: I couldn't really function without drinking. That's a problem. I just got sloppy. It was bad.

RYAN GENTLES: He quit smoking, drinking, and doing drugs all on the same day without a program or anything, and never looked back, never had a falter. That's a man of will.

HAR MAR SUPERSTAR: Julian got his shit together. When he got sober, it was really good. I didn't see him for years. He was just drying out and being normal and getting into sports, which is awesome.

RYAN GENTLES: He was a drunken nightmare to society as a whole, let alone the people he worked with. The people he worked with got it the worst, but it was society as a whole. He got sober, and it was awesome. So did his wife with him; isn't that amazing? They're still together and they're fucking rad.

ALBERT HAMMOND JR.: During the recording of our third record, I was just sad. I have a very easy ability to spiral. There could be all this amazing stuff happening to me, and within two minutes, I could convince myself why there's no reason to live—that kind of thing, that extreme.

MATT ROMANO: When they were shooting with Dan Winters for *First Impressions* and Albert came to the shoot and he was fucked up, things changed.

ALBERT HAMMOND JR.: At that point I'd come in and the band would think, "Why is he so moody and bummed out?" It was also Catherine and me, "Why aren't we having sex anymore?" "Because I'm

fucking my drugs." You don't want to have sex when you do those drugs, and you really can't. To come is, like, a pain in the ass, it's like a job. You have to plan it out. "I know she's going to want sex tonight . . . fuck."

CATHERINE PIERCE: He confessed to me that he had been doing heroin. I knew something was wrong. He always told me it was pills. He was gone more and more. I didn't know what was happening. He'd come home and he seemed different. He'd say he was exhausted from tour. "I'm exhausted from tour, so I'm going to sleep for days." But I'm the kind of person who believes what I'm told. If someone I love is promising me something, I believe it, to a point. I think I was scared to leave him, too. I didn't know what my life would be like, I didn't know who would remain my friend. So he confessed to me that he was a heroin addict, he'd been snorting, and I stuck with him. He went through rehab, and things got better for a while.

ALBERT HAMMOND JR.: It wasn't until we got back from Japan in 2007, that's when I started shooting up. I'd just do it when we were home.

CATHERINE PIERCE: It just started creeping back in. "It's okay if I smoke a little pot, it's okay if I take some pills," and it just started back up again.

KIM TAYLOR BENNETT: During what would stretch to a five-plus-year gap between the release of *First Impressions of Earth* and the Strokes' fourth record, *Angles,* Albert released two solo albums and toured the world, with Matt Romano in his band.

MATT ROMANO: Albert sets out to do something and he wants to be the best at it. If he wants to fucking be a junkie he's going to be the best junkie out there, and he also had a very romantic outlook on it, like, "All of my favorite people and influences had their junk phase."

CATHERINE PIERCE: We were at a friend's wedding, and he promised me he would not do drugs. He'd make all these ridiculous promises: "If I do drugs again, I'll buy you . . ." And I'd say, "Okay," not because I wanted a pony, but because I wanted to believe him. But he couldn't help himself, and the wedding was just a disaster. The night before the wedding, a group of them were downstairs doing drugs until five in the morning. We had to get up and do

wedding-day preparations the next day, and I was just so heartbroken. That was it. I was done. You know when you're done, and I knew. He started dating someone else, and then he got really deep into heroin.

ALBERT HAMMOND JR.: At the time, I tried everything to get fired from the band. I'd show up late, fall asleep at the studio—I was just fucked up. I didn't like things. I tried to help out but I wasn't playing that well. I wasn't at my peak of playing.

JULIAN CASABLANCAS: Did we ever consider replacing Albert—ummmmmm, I don't know how to answer that. I don't wanna start shit. I'll say this: it was never an option for me.

MATT ROMANO: You know, Albert also had a very healthy competition with Julian. It was always, "I want to beat the Strokes."

ALBERT HAMMOND JR.: I finished the *First Impressions* tour and then I went on a nine-month solo tour and did 128 shows, detoxing on the road. I didn't really think of what I had done as an album. I was literally going to put it out online or something like that; I wasn't even going to do any shows. It was Matt who kept saying, "We have to do some shows," and I said, "Matt, I don't want to play shows." He pushed, "Oh, let's do these three," and it turned into 128 shows in nine months.

MATT ROMANO: After touring *Yours to Keep* and in between making *Cómo Te Llama?*, that's when the Crossroads thing happened. He would always talk about, "If I was ever going to go to rehab, I would want to go to Crossroads." You know, Clapton's place in Antigua? So I get him a bed there. This was me, Julian, Albert's parents, and Albert's then girlfriend, Lisa. It was . . . it was awful. He was sooooo mad at me. He said the meanest things to me. He made me cry. He didn't end up going to Crossroads.

ALBERT HAMMOND JR.: I finally had a breakdown at the end of finishing the second solo record. I said to myself, "Okay, that's it, I'm done with doing drugs," and I did get clean for a while, eight months or something like that. Then I started doing it again. I got back into it. I was like, "I'm not going to do heroin"; I started drinking and sniffing a little coke on the weekend. "As long as I don't do heroin, I'll dull my pain in some way, but I'm not doing heroin." So I

started shooting cocaine and ketamine. Weirdly, I thought, "That's okay, because I'm not doing heroin." I was making my own crack. The ketamine I would just shoot. I was shooting it intravenously. Twenty times a day. Everything was black and blue.

MATT ROMANO: That was so scary.

ALBERT HAMMOND JR.: It was scary for them, not for me. They saw me in a pretty extreme place. When you puncture yourself constantly, your arms are destroyed. When they catch you out of it, you are seriously out of it. You are, like, retarded. Sometimes when you're sniffing it's like that, but it's very different when you're shooting cocaine and ketamine and then heroin and cocaine. Sometimes I could be sitting here with my eyes open, just gone.

MATT ROMANO: He was just a different person.

ALBERT HAMMOND JR.: There were so many times when I was just so close to dying, where my body was shaking. I heard voices. I stayed up for ninety-something hours. I'd be in the shower and hear whole conversations, or I'd spend hours looking out the peephole, thinking I could hear someone walking up. Crazy stuff.

RYAN GENTLES: They were never broken up. They never talked about *not* making another record. It was just Albert wanted to release some music and Julian wanted to release some music and Nikolai wanted to release some, and Fab did some . . . it wasn't really planned to go that long, it was just, "I need a few more months," "Now I want to put out a record." I think that caused them to think, "Couldn't you have done that when I was doing my record?" It was all ill timed and they would disagree on when they'd get back together.

JULIAN CASABLANCAS: That was transition time. I mean, I put so much of my energy, life, blood, sweat, and tears into the band. And to be honest, it took me a while to recover from drinking. It took years to get normal. I started young, so I was kind of starting over.

MATT ROMANO: Albert was supposed to be a guest judge on *Iron Chef.* I was supposed to go with him for his walk-through of the studio and he wasn't answering his phone. He wanted to do this for so long because he's a total foodie. Juliet calls me and she's like, "What the fuck is going on? There's no way he would miss this."

She was mad. She said, "Tell me right now what the fuck is happening." So she knew something was up. I told her, "Listen, I've been trying to help him on my own and I can't do it anymore." She said, "Okay, I'm calling Julian." I'm like, *"Noooo,* nooo, not Julian." She calls Julian. Julian calls me. We talk. And immediately he says, "All right, I'm calling Albert Sr."

ALBERT HAMMOND JR.: I went through a downward spiral. We met up to start writing *Angles* in 2009, and then I just hit the lowest point in June, July, and August. Everyone came out to record at my house upstate and I was fucked. I went to go pick up Nikolai and I bought truckloads of candy and I was late. I was crazy. Everyone knew, "Oh, Albert's definitely high," and then two days later they came up and said, "You have to go." Not all of them; Julian didn't come up. But my mom was there, and so the choice was that basically everyone would forgive me if I went to the three months of rehab, so I did. In L.A., a month in a detox place and two months in sober living.

CATHERINE PIERCE: We are really good friends now, but it took a few years. There was a moment when we hated each other. Then I had a dream about him. I had a dream that he was at the top of a building and that he was going to jump off, and I was pleading with him, "Don't jump!" and he was saying, "I have to," and he jumped off, and the next day, I read somewhere that he went to rehab, again. I wrote to him, and then we started confiding in each other and talking about new loves. Now we have a really nice relationship. I know him so well. It's in such a different way now. We've talked about it. He says, "I'm so sorry I was a drug addict." And I say, "I'm so sorry I was trying to stop you and control you."

ALBERT HAMMOND JR.: I'm sorry I killed everyone's dreams. I don't know if they're still mad at me. We'd worked so hard and we'd gotten so good. We were just like a machine. A well-oiled machine. Even when we sucked we were awesome. We were emotionally disconnected, but physically and musically what we built was at its peak.

"BREEZIER AND LIGHTER AND QUICKER"

SIMON REYNOLDS: Bands always come about through some mesh of individual quirks. In the nineties it was still more organic, how that happened, more happenstance. So, there was a degree of limitation. But now it's almost like every musician growing up is exposed to so much music that they can just assemble themselves in an almost mechanical way. That's why Vampire Weekend have all these unusual rhythms from different cultures—it's a really, really wide smorgasbord. Young musicians are just exposed to so much stuff now, from very early on, that their whole relationship with music is different.

RYAN GENTLES: Jenny Eliscu was the one who first told me about this band Vampire Weekend.

JENNY ELISCU: I had heard about them through a friend who went to Columbia with them.

RYAN GENTLES: They were the next thing, for sure.

JENNY ELISCU: I told them they reminded me of the Strokes and they said, "We love the Strokes!" They were in high school when *Is This It* came out. They wanted to be the Strokes in a way, but they were smarter about it.

STEVE RALBOVSKY: There was a uniformity of musical inspiration that characterized a lot of the downtown New York bands at the time, as well as the White Stripes and Kings of Leon. It was more of a rock-and-roll thing. Vampire Weekend were quirky and folky and had these African rhythms, lyrics that were kind of dreamy, whimsical, kooky, and non-narrative. Ezra had a voice that didn't suffer from irony, angst, and heaviness—that minor-chord rock-and-roll

stuff. It was a breath of fresh air. And maybe it wasn't intended as a breath of fresh air, but whatever the music was that was going on in their heads at the time, they provided a different, lighter, more buoyant, less heavy alternative, while still belonging to a common aesthetic. Sort of like the way Talking Heads in the beginning were this quirky folk-rocky band that were around at the same time as the Ramones. It was aesthetically compatible, but musically much breezier and lighter and quirkier.

CHRIS TOMSON: The Strokes have been one of our touchstones for when we've made decisions about career stuff. But when we came out, the Strokes were on hiatus. It just kind of seemed like, "Oh, they had a tough time," or "They did really well, but somehow something about their career got annoying."

JENNY ELISCU: Vampire Weekend learned from the Strokes' mistakes in an important way. They were college kids, and very bright, and they seemed, just generally speaking, to be more grounded people. Maybe less sensitive in a way. That, I think, is often the difference between artists who can really keep it going and those who can't.

EZRA KOENIG: I grew up in New Jersey, thirty minutes away on the train, definitely the burbs.

ROSTAM BATMANGLIJ: I'm from DC, originally.

CHRIS TOMSON: I don't know if you've ever been to Great Adventure, Six Flags, in New Jersey? I grew up like five minutes from there. I was a lifeguard at the water park there for a summer.

CHRIS BAIO: I grew up in Westchester, New York.

EZRA KOENIG: I was a massive music fan and collector as a teenager. I would buy a shitload of records at yard sales, and I got deep into my parents' record collection. In the middle of high school, I started hanging out with a group of kids who were really into early nineties hip-hop—the Roots and Tribe Called Quest. Also DJ Shadow and trip-hop—these kinds of things. My other main interest was punk. My dad had the first few Clash albums, Blondie, and the Ramones, and I had another tight group of friends that was really into that stuff.

JENNY ELISCU: Vampire Weekend are a band of guys who went to

college, like Pavement or the Talking Heads. And the Strokes are guys who didn't go to college. They were middle-class. Actually, sort of upper middle-class. Not as rich as the Strokes, but comfortable.

ANDY GREENWALD: That's always the third rail of writing about bands. Because, if you wanted to bring it to that realm, there is the part that Ezra and Rostam came from quite upper-class Ivy League backgrounds and probably would not go hungry if they decided to do other things.

CHRIS TOMSON: What really fascinated me about Ezra early on was that he had this blog called Internet Vibes. There was one ad for an early Vampire Weekend show on there where he put a picture of Derek Walcott! He used a picture of an African American writer to promote a Vampire Weekend show. The things he was interested in seemed a little bit more sophisticated than the shit that I was interested in.

EZRA KOENIG: My dad was really up on good new music right until when I was born. The last new album he had was the first Run-DMC album, which came out in 1984, the year I was born. I'm glad that my parents more or less stopped listening to new music, that we listened to old stuff, rather than them slowly morphing into listening to parent-type music.

ROSTAM BATMANGLIJ: I actually wanted to be a painter when I was a kid. I was sure that I was going to go to Cooper Union. Brian Eno was studying to be a painter. He's said that recording music is like being able to paint with sound, like a graphical interaction, especially on the computer. I must have been about fourteen when I started making music on the computer, but I started writing melodies when I was really young, like six. I had a really cool guitar teacher, and he said, "You can learn whatever you want, what do you want to learn?" I wanted to learn "High and Dry" by Radiohead, I wanted to learn "Mr. Jones" by the Counting Crows, and that was a beginning. I have memories of trying to play "Wonderwall" for hours and not being able to make my fingers stick. At some point, I decided, "I don't want to learn guitar anymore, just teach me music theory." By the time I was eighteen, I felt like I knew pretty much everything I wanted to know about guitar, but

with music theory, there was more of a code that I wanted to see unlocked before my eyes.

EZRA KOENIG: I wrote for my school newspaper. I'd write music articles, which is hilarious, because my school was so small. You'd write an article in the paper, and you might as well go directly to the one person who's going to read it and tell them what you had to say.

CHRIS BAIO: I had an awareness of what CBGB was. I went to CBGB when I was seventeen. It was to see a Good Charlotte show, because my little sister was obsessed with Good Charlotte.

EZRA KOENIG: I remember I really bonded with one of the gym teachers, because I wrote something about Bruce Springsteen, and he became my buddy after that. He burned me a White Stripes CD.

CHRIS BAIO: I was sixteen when the first Strokes record came out. I remember a friend saying, "Oh, the Strokes are a bunch of rich kids." Which is funny in two ways, because I was growing up in Westchester and my parents are lawyers and I thought, "Okay, yeah, I won't listen." And then eight years later when our band came out that was all that anyone said about us. So maybe there was some karmic justice in that.

CHRIS TOMSON: Growing up in suburban Jersey, right between New York and Philly, I had heard of the Strokes mainly because they were on MTV. I knew, like: leather jacket, downtown New York, probably drinking a bunch.

EZRA KOENIG: I also wrote an article about the connections between punk and hip-hop. I don't think I had some particularly interesting insight, but it was very obvious to me, based on the records that my dad had, Blondie, and Grandmaster Flash using Tom Tom Club. So my vision of punk was already more like the arty downtown New York variant than vegan hardcore shit. And the Clash, too, who straight up made hip-hop. It seemed like it was more or less the same thing, which was this kind of open-minded approach toward references. And then of course I loved the Beastie Boys. Already at that point there was that nineties *Kids* vibe of skateboarders who listen to Ice Cube and some kind of weird guitar music. That was normal.

IMRAN AHMED: There's quite a big gap between that first group of kids in bands and the kids that followed, because they pretty much always had the Internet. They grew up with AOL. There's quite a big—not philosophical, but there's a fundamental gap there. These guys, their generation, they were the first to be given these tools— the Internet, mobile phones—they were the first generation to be given these tools as teenagers. And they came to grips with them really quickly.

EZRA KOENIG: I was about to go to college; I wasn't really thinking about "How do I get in the music game?" But we had this band that would meet at my and my friend's house, and we'd record stuff. We'd make shit that sounded like Mogwai, then we'd make weird punk songs, make rap songs. I remember when the Strokes came out, we'd obsessively play "Someday"; we just loved that song.

CHRIS BAIO: When I moved into the city, that was when *Room on Fire* came out. That was my first semester of college. I got both Strokes records then, and got really into them at the same time I got into the first Interpol record.

ROSTAM BATMANGLIJ: I did have a crush on New York.

EZRA KOENIG: I was pretty into New York City. It's where I was born, it's where my family comes from, so I always had a slight sense of having been taken away from the place I belong, which is how I think my dad always felt. He was born and raised in the Bronx and lived in Manhattan his whole young adult life, so I think for him, moving to the suburbs was awkward. That probably rubbed off on me a little bit. I always had this sense that the city was where I belonged.

ROSTAM BATMANGLIJ: I think it was because my parents took me to see *Basquiat* when I was eleven. That fucked me up real good. It made me look at New York as this place of infinite possibility.

CHRIS BAIO: I'd go to Bowery, I'd go to Mercury Lounge. I remember going to see Interpol at Radio City in 2005.

CHRIS TOMSON: I saw Antibalas in 2001 at this Jewish community cultural thing. I just remember, that flipped me out. That was when the Internet was coming into play. I read about them on their web-

site and then I was able to go the Princeton Record Exchange and get Antibalas and Fela Kuti the Tuesday after I got back. That was the first time I remember, like, using the Internet for that specific purpose—seeing this thing randomly, being totally blown away, and then being able to go read about it.

EZRA KOENIG: A lot of times, the critics, or journalists, want a story that's about a band making a new album and they discovered something—like they went into a record store and found this album they couldn't stop listening to, or they were traveling and they got inspired; that's a classic story. "I was traveling somewhere, and the music in India or New Orleans really took me into a new place." I don't think this is a brag in the Internet era, but by the time I was eighteen, I probably had a rough familiarity with just about every type of pop music, internationally, so there wasn't that much left to blow my mind. That is what it is to be a music fan these days; you grow up surrounded by everything, so every album you make is not so much about finding new things, it's about dismissing things and actually zeroing in on what you think is cool at the moment. You can always rediscover things and recontextualize things.

CHRIS TOMSON: When Vampire Weekend started, specifically a lot of what we did was in opposition to the Mercury Lounge sound.

EZRA KOENIG: No disco beat, no post-Strokes beat; even though we were all massive Strokes fans, we recognized how many shitty bands had tried to copy them, so it felt really important to find a new kind of guitar identity and rhythmic drum identity.

CHRIS TOMSON: The Mercury Lounge was the place where a band, even of our small stature, could play first. But also, that place sticks in my mind because it's where Ryan Gentles met the Strokes. It's an important place in modern rock history. But the Strokes sound was sort of over. So one of the explicit goals was "We don't want to sound anything like that."

"ERUDITE AS FUCK"

EZRA KOENIG: I always had a fairly pragmatic streak that made me not ever fully commit to the dream, which is an ongoing issue. I think it's important to always feel like you're doing music as a hobby because if you start looking at it as a job, you start making terrible decisions. I like the idea of it as a serious hobby, because if you start taking it for granted, that it's your job and you get to do it for a long time, you go on tour, and it's like, "Oh, nice, we came back to this city and the show got bigger, we got paid more money for that thing, our song was in that movie, I met this person," it starts to feel effortless. And you forget that all of this cool stuff that happens to you is predicated on this weird, tumultuous, fickle creative energy that doesn't care about money or status. If you start to act like, "Yeah, I'm a musician, I'll be doing this in ten years," I think that's poisonous.

IMRAN AHMED: You could say that the Arctic Monkeys formed a band because of the Vines, for example, but I never got the sense that Vampire Weekend formed a band because of the Strokes or anyone else. They definitely knew their music, they were definitely very passionate about music and very knowledgeable, but they didn't sign up to be guitar heroes.

JENNY ELISCU: Ezra, one of his principal gifts is being all-around erudite as fuck, you know? And that will serve him in everything he does for the rest of his very successful and interesting life, I'm sure. He's definitely no Julian, you know?

ALEX WAGNER: Come on. Ezra is not Julian, right? They are not the same, they are not battling the same demons. Constitutionally

they're different people. I mean, there's this very reasonable millennial idea of your art form as a fundamentally manageable thing. Like, you could go and be an artist, as opposed to you can't be anything but an artist and it's this all-encompassing demon you have to wrestle with. There's just a completely different attitude about the musical output between the generations. The millennials are more practically minded, for sure.

EZRA KOENIG: I thought I might major in evolutionary biology. I didn't know what I was going to do.

ROSTAM BATMANGLIJ: I pictured myself coming to New York and forming a band, but I didn't know exactly what that looked like.

CHRIS TOMSON: There was a weekend in the middle of the summer before classes started where there was this one-hour talk of all the kids that lived in the area that were going to Columbia. The shtick was you got a free copy of *The Odyssey,* which you were supposed to read over the summer. I don't remember this but Ezra remembers seeing me. He thought I seemed kind of chill, probably liked drugs, which I didn't and still don't. I did have longer hair.

EZRA KOENIG: Rostam and I knew people in common, and once we had our first real conversation, we were talking about making music.

ROSTAM BATMANGLIJ: The first time we hung out at a party, we talked about starting a band together, half-jokingly.

EZRA KOENIG: He told me his favorite band was Coldplay.

ROSTAM BATMANGLIJ: We used to IM each other MP3s of stuff.

EZRA KOENIG: He felt like he really didn't know what he was doing yet, musically.

ROSTAM BATMANGLIJ: Throughout college, I was recording these—I guess they were covers. They were just my version of a song by one of my favorite bands. One was a cover of Prince's "I Would Die 4 U," where I literally re-created every drum part, every synth part, and sang every vocal part, even the three-part harmony in the second verse. I was thinking about the ingredients that go into a recipe and how you cook them.

EZRA KOENIG: The stuff he'd play me would be very referential and would sound like the Strokes or Walkmen. But even then, I was

very impressed by his ability to zero in on the harmonic identity of these bands. Even though the stuff he was doing wasn't particularly original, there was something that impressed me about the fact that he wrote something that sounded a lot like a Walkmen song, because that's not something that anybody can just do. In the meantime, I was doing my own weird stuff.

CHRIS BAIO: I have a memory of Ezra, from when we were living together. I was in my room working on some stupid Russian lit paper and I remember hearing him, down the hall, blasting this one song on repeat. It was the first single on the last Destiny's Child record. Over and over and over again. He was listening to it and dissecting it.

EZRA KOENIG: I had a band all through high school, then I got to college and was like, "Fuck that, I'd rather just make beats on my computer and go rap." So I was mostly making these weird electro-y rap songs that I think were kind of good, maybe aside from the rapping.

IMRAN AHMED: Ezra was in a hip-hop duo called L'Homme Run. And I believe Chris Tomson was also playing with him.

EZRA KOENIG: One of our better songs was called "Bitches." It was this very poppy dancehall song, and Rostam helped me work on that. So already there was kind of an established way of working: I'd bring an idea to him, and he'd flesh it out and help record it.

CHRIS TOMSON: There's a [L'Homme Run song called] "Interracial Dating" where I played the guitar solo, and this was back when I was a little more of a shredder. I was told to make it sort of "Thriller"-ish, like a little bit Van Halen. There was some foreshadowing there.

EZRA KOENIG: Why bother to play actual instruments? Why not just make everything on the computer?

CHRIS TOMSON: I think Ezra realized the limitations of the L'Homme Run setup.

EZRA KOENIG: Because I liked the idea of having more power when I performed live, having an actual drum set, feeling a sense of stability. I liked the songs we were writing, but just being up there with a microphone and an iPod felt weak. I felt a little powerless. Also,

there were these other ideas of preppiness or whatever. We all really wanted to play this really preppy coed society house at Columbia. They would have these fancy parties and there was something romantic about that to us. I envisioned this Elvis Costello/Squeeze vibe, this real smart, punky energy that was preppy. That was my vision. So, yeah, I started to like the idea of having a band again, and Rostam had always been interested in having a band.

CHRIS BAIO: Their senior year, my junior year, they were talking about starting a band that was more like a rock band. We'd be at parties and they'd kinda talk like, "Would you be interested in playing?" I was officially asked at some party in maybe January 2006. I think a friend was DJing at Ding Dong Lounge, which is a bar on 106 and Columbus. We were sitting at a table and Ezra said, "So do you want to be in Vampire Weekend?"

ANDY GREENWALD: I wrote Vampire Weekend's first *Spin* cover story and I just could not fucking wrap my head around them. They didn't make sense because they didn't come from the same world and they didn't play by any rules. I realized that I had been locked into a prehistoric mind-set, basically, because I went in being like, "Who are you preppy twerps to do this?" Now, that's totally hypocritical because I liked mixing up genres and felt a deep affinity to hip-hop. So look at me. But for some reason, when they did it, it was "Tut tut tut," like I was some kind of old-world gatekeeper. I could not crack them. Ezra is uncrackable. I literally was like, "Who are you to do a rap song? You white Jew who went to an Ivy League school." As opposed to me, right? But he was allowed to do it because everyone was always allowed to do it. It was just a different mind-set, and it was just because of a few years' age difference where he grew up downloading everything and he never felt allegiance to anything and could easily move between genres and just pick the parts he wanted and it was fine.

EZRA KOENIG: By the time we started Vampire Weekend, it's not like we were just picking up instruments, like, "Let's start a band." It was like, "Let's start a preppy band and make the guitars have this Johnny Marr African tone." We already had some pretty strong ideas going.

CHRIS TOMSON: February sixth of '06 was the first practice. Ezra sent out e-mails: "Hey, you know, when we meet up we can practice a few songs, see if we can figure something out." It was a Monday night and we had to finish by eight forty-five because Baio wanted to get back to his dorm to watch *24*. He was really into *24*.

"THEY CAME FROM THE ASHES OF

JONATHAN FIRE*EATER"

DAVE SITEK: I only really knew Jonathan Fire*Eater because then they turned into the Walkmen. Stewart was a little bit out of my thing. He was such a cocky, crazy dude. But I always sensed greatness for them.

JASON GORDON: With Jonathan Fire*Eater, you wished they had gotten to be a part of the whole ride. And that's why when the Walkmen appeared, I was so happy to see those guys playing music, but I was so heartbroken that it wasn't with Stewart. It took me a while to get into them, but of course I eventually did. They were amazing.

MATT BERNINGER: The Strokes are undeniable, but for me the Walkmen were the New York band that I held in high regard on multiple levels: cool factor, songwriting, inventiveness, originality.

EZRA KOENIG: When I was deciding on colleges, it was between Columbia and Brown. I thought, "Oh, Providence, I heard there's some interesting stuff going on, that band Lightning Bolt seems kind of cool." But then I thought, "Yeah, but Columbia is bigger. And there's the Walkmen."

DENNIS CAHLO: They came from the ashes of Jonathan Fire*Eater.

PAUL MAROON: We kept playing and writing music and we just went back to school. Then at one point, as a way of committing to one another, we decided to start a studio.

WALTER MARTIN: It wasn't built on Fire*Eater money even though it says that on our Wikipedia page, which makes us seem like we

were smart or something. We didn't actually have any money. We borrowed money from friends . . . successful friends. And family.

PETE BAUER: We're all from Washington, DC, and some of us knew each other since we were kids. We were all the kids who liked music, and there weren't that many of us in DC. It was all very archetypal: we'd go play basketball and then go play some absolutely god-awful music and then, you know, go drink malt liquor.

WALTER MARTIN: I mostly liked the idea of the studio because it was like, we're taking on investors and financial commitment, so we are bound to continuing and to make it work. I was thrilled because we were doing it again. The only problem was, we didn't have a singer. We had the studio and we started trying stuff with different singers. And then came Ham. He's actually my first cousin; we lived across the street from each other.

PETE BAUER: When the Jonathan Fire*Eater guys got the big major-label contract, Hamilton and I figured we should move to New York.

WALTER MARTIN: We're kind of like brothers. Ham had moved to New York and his band the Recoys had been playing around. I loved the Recoys.

PAUL MAROON: At some point we were like, "We should try playing with Hamilton," who was Walt's cousin, and that took off very quickly. Much, much faster than Jonathan Fire*Eater. With the Walkmen, it felt like we should make a record. With Jonathan Fire*Eater it felt like we should be playing shows, and making a record was a fun prospect.

PAUL MAROON: It was harder to say what this music was, but the external drive was to get away from being rock-and-roll rock and roll. We just wanted everything to be weird.

SCOTT DEVENDORF: They were more of a direct influence for us than the other bands of that era.

PETE BAUER: We wrote "The Rat." We had that song and we were like, "This has got to be worth something. It just has to be. If anything's worth something it's got to be that."

SUROOSH ALVI: The Walkmen's "The Rat" should have been a fucking monster. That's the biggest miss of the decade.

PETE BAUER: We had talked to everyone in the music business that we had ever met, and everyone the Fire*Eater guys knew, and no one wanted to put out our record, so we put it out ourselves and sold it online for a little while. But then we got a record deal with Warner Bros., but then after we signed they said, "No, you're going to this other label." So we were on a subsidiary of Warner Bros.—total lunatics from different companies would come and watch us practice, incredibly cheesy situation. The guys would be telling us stories about Metallica and stuff. We were pretentious young jerks. Obviously we are not the most social people but we were particularly, off-puttingly bad at that stage. We would act like we just didn't understand what they were talking about.

WALTER MARTIN: We came out of the gate pretty well because people liked our first record, we got on TV, and then we had "The Rat," so people thought we were cool. The attention thing was ramping up, but it was much slower. For some reason, it just didn't have the intensity of the way that the Fire*Eater thing happened at all.

PETE BAUER: Hamilton and I wanted to be really cool and have the bigger record contract and do the whole rock-and-roll thing, and we just failed miserably.

EZRA KOENIG: My group of friends in New Jersey was also really up on the Walkmen. I had a friend who became obsessed with their early EPs and had these hand-silk-screened records before their first album came out. I loved the way they dressed. They wore sweaters and button-down shirts, and I thought, "This is a cool way to dress." I was already starting to have this half-ironic, half-serious interest in preppy clothes when I was at the end of high school.

WALTER MARTIN: We decided at our studio that we needed an intern. So we put out flyers that somehow spread the word and we interviewed a few people. The moment Ezra walked in the door, we were like, "That guy is the coolest dude ever."

EZRA KOENIG: As soon as I got to college and I found out they had a

studio twenty blocks from campus, I e-mailed them and had this random internship. I remember being so psyched to get to go work for my favorite band, even though nothing particularly came of it.

WALTER MARTIN: He was just so . . . you know the way he talks. He was just cool. And he's so funny and so smart and we immediately loved him.

EZRA KOENIG: I liked everything about them; I loved the lyrics and the grandeur of the music.

WALTER MARTIN: So we hired him, but there wasn't much for him to do, and I was his contact, so he would call me and I would never pick up because I didn't have anything for him to do. He would leave a message: "Hey, this is Ezra. Just wondering if you guys need me to do anything." I didn't even know that he liked our band. I decided he was just this cool college kid. Then we shot the video for "The Rat." I remember that he was there helping that day. I was glad that he was there and that we actually had something for him to do.

EZRA KOENIG: They weren't particularly prepared to run a studio full-time, they didn't have that much need for an intern, but to even just walk up there and sit around at some sessions—and I think I even did something when they filmed a video for "The Rat," hitting play or something—it was cool.

PETE BAUER: We'd always say we were from Washington, DC, not New York. We just didn't want to be smaller than the next guy. You didn't want to be somebody else's bag carrier. And onstage we were very defiant. We never spoke. We were very aggressive and nasty and, you know . . . it was fun. And it was so loud. That was definitely the gag. I remember being able to just take people's heads off. And we'd do that at these pop shows where we were opening for these horrible bands.

WALTER MARTIN: I never knew any of the Strokes. We played a couple of shows with them, so we met them, but we were never bros. We were friendly with Interpol and Yeah Yeah Yeahs, though.

PETE BAUER: I mean, we always fought being associated with that downtown New York band world, to the point of detriment. Which was dumb. It was really stupid.

"IT DOESN'T ACTUALLY MAKE ANY SENSE TO DESCRIBE MUSIC AS PREPPY"

ROSTAM BATMANGLIJ: If you'd come to any of our early shows, we did kind of sound like a messy garage band. Chris had never played drums in a band before.

CHRIS TOMSON: I approached it mostly as a physical sport.

EZRA KOENIG: I found the music scene at Columbia kind of depressing. You felt like, "Fuck, I should have gone to Brown."

CHRIS TOMSON: Our first show was this battle of the bands in the basement of the student center at Columbia. Not a particularly warm room.

CHRIS BAIO: It was the engineering students' battle of the bands.

CHRIS TOMSON: We played second.

CHRIS BAIO: To this day we're not a very heavy-practicing band but we probably had, like, three practices before this first show. We played our twenty-minute set or whatever, and then they go to the judges' table. One person's like, "You know, I don't really like hipsters but I like some of your songs." Someone else said, "You know, I like some of your stuff; you should try not to sing with a British accent."

CHRIS TOMSON: I also played in a bluegrass band that went fourth. The bluegrass band won! It was not very contentious, although there was a cash prize . . . It was two hundred dollars. Our first real, real show was a few weeks later when we played at this place Saint A's. It wasn't a frat. It was a coed. I don't exactly know what it was, some old-money thing.

ROSTAM BATMANGLIJ: Our early shows, we were basically performing for a group of friends, and the only reason we'd write new songs was because we were afraid that our friends would hate us for forcing them to watch the same show that they'd seen two weeks previous. There were no monitors; you're playing for yourself as much as you're playing for everyone. Those are still my favorite shows.

CHRIS BAIO: I think it was maybe our third show, where two girls that I knew very faintly said, "Oh yeah, we saw you at the last show, we wanted to come again and see you again," and we thought, "All right, this is it, here we go."

EZRA KOENIG: At our first show, we had "Oxford Comma," "I Stand Corrected," and "Walcott," and the next couple of months, we had "Cape Cod Kwassa Kwassa" and "Campus," the songs that really kind of laid the foundation for what we were all about. Given that before that, I'd been rapping with an iPod, starting a band was a kind of funny new set of constraints. Putting together the band was a constructed idea of trying different things, and that also made it easy for us to zero in on things we wanted to avoid.

LAURA YOUNG: Vampire Weekend are great. I always say that when you go to a Vampire Weekend show it's like a best-of Vampire Weekend. Every song you're like, "Yes!" It's just like a reunion tour. Every time. And there are always frat dudes.

CHRIS BAIO: When we played for the engineering students, we were all wearing button-down shirts. That was definitely part of the identity—the idea of presenting something visually and having a unified aesthetic, that was very important.

CHRIS TOMSON: The connection to Columbia and button-up shirts can be a little too strong and too overstated. We wanted it to be that if people come to a show, even if it's just in a basement or in this weird party thing, we want them to feel like they're watching a band, a capital-B band. The main thing was we didn't want to be four bros in T-shirts. That just felt lazy and easy. At that point it wasn't really a statement anymore to get onstage in T-shirts, in the same way that we felt that using a very distorted guitar was no longer an act of rebellion. The opposite was more interesting and in some ways

more rebellious. We didn't know people would be more interested in writing about our clothes than the music.

ROSTAM BATMANGLIJ: I definitely did talk about how it's lame to see a band that looks like every other band, and in college, that meant shorts and T-shirts. We weren't taking it to an extreme place—we weren't putting leather on, we weren't wearing suits—but we wanted to be unified. The first time Ezra and I hung out, we were both wearing Lacoste. I was specifically into Lacoste long-sleeved polo shirts. I had a green one, a blue one, a gray one, and that was all I wore.

CHRIS TOMSON: One of the National dudes went to Columbia—there's so many people in these bands who went to Columbia—but for some reason, just because we wore sweaters or whatever, we're the assholes.

APRIL LONG: Aesthetic-wise, what they were offering was quaint.

EZRA KOENIG: I don't totally know why I was interested in preppiness. I think it's a combination of finding it incredibly stupid and incredibly appealing. It's a love-hate relationship. My family is very un-preppy. My parents are both old-school Upper West Side Jews. My dad grew up in housing projects in the Bronx. And then also I got on this intellectual trip in college of starting to realize that the origins of some of these fabrics were rooted in British colonialism, so I thought there was this whole deeper vibe to it that people weren't picking up on.

ROSTAM BATMANGLIJ: One thing that was always important to me, and it goes back to Basquiat—his handwriting, he used to write his E's in this very specific way where there was no vertical line, so all of his E's are just three lines across. When you see that, you know it's him. At a very young age, I was very interested in what constitutes style, what constitutes identity in terms of art. To this day I want whatever I do to have an identity that's identifiable.

EZRA KOENIG: I wouldn't call the dressing reactionary, because I never even remotely considered wearing a motorcycle jacket as an option. Some of the music, some of the guitar playing and drum playing, was more reactionary.

ROSTAM BATMANGLIJ: I had a rule that on our first album there be no acoustic guitar, because acoustic guitar is a tricky thing. It does make you sound like a lot of bands very quickly. It connects with a whole tradition of nineties alterna-rock, which I didn't want Vampire Weekend to be connected to.

BRIAN LONG: It's really smart. It's reductionist and makes sense in this era of information overload.

EZRA KOENIG: We weren't just a bunch of dudes who always had a band, a bunch of dudes in the basement saying, "What should our new sound be?" It wasn't like *Not Fade Away*.

BRIAN LONG: They may be the first major popular band to actually think that way.

EZRA KOENIG: When we first started getting press, I felt the most excited when I'd see people describe the music as preppy, because I loved the fact that we were getting people to have synesthesia. It doesn't actually make any sense to describe music as preppy, but suddenly people were describing it as if preppy had been a genre for the past forty years. I especially loved when people would describe us onstage and misidentify what we were wearing. They'd be like, "Taking the stage in sweaters and polo shirts . . . ," on a night when nobody is wearing a sweater or polo shirt. I started to feel like, "Damn, we're really building something. We're getting people to see things."

"IT WASN'T LIKE WE WERE A PARTY BAND"

HAR MAR SUPERSTAR: The whole Grizzly Bear scene, MGMT, do they even party? They're more collegiate, well-tempered Yale dudes that probably never even partied at Yale. Maybe they had a kegger or something. They just never lived that grimy thing. I don't think they even came to the East Village until after we were done with it, until we destroyed it.

ROB SHEFFIELD: Manhattan was different. There was less focus on DIY spaces and much more drugs. In Brooklyn, if people were doing drugs, they were doing them in a discreet way.

DAVE SITEK: It wasn't like we were a party band.

JALEEL BUNTON: When Yeah Yeah Yeahs played, it was like a fucking party, man, and when the Strokes played, it was a fucking party. When we played it was, "Me and my girlfriend love your band." It was a lot of that kind of vibe. Music for cats, music for couples, you know? If I had a nickel for every time some girl came up to me and said, "My husband and I love your band. Do you guys want to go get a coffee after?" It's like, "What a rock fucking nightmare. Like, really? This is what I get? I'm on the poster and that's what I get: coffee with you and your fucking husband? Man, give me a break."

DAVE SITEK: We were living an eighteen-year-old's dream but we were in our thirties, which felt corny.

JALEEL BUNTON: I'm trying to think of how to put it; the sex was missing, somehow. And it's a fundamental thing. I'm sure people had crushes on guys in the band but it wasn't, like, *the* thing. We weren't selling that, in a way. I had plenty of good times, but it wasn't like

Mötley Crüe, it wasn't even like Interpol. Interpol didn't have to go looking for trouble; they could walk on the bus and trouble was like, "Hi!" That's the whole myth. Am I jealous-ish? Not-ish. Just straight-up jealous.

ANDY GREENWALD: Here's the thing: the rock star mythology started to break down from all sides, from all angles.

ROB SHEFFIELD: In the nineties we thought rock stars were real people, as in they were our flesh and blood. Mary J. Blige and Kathleen Hanna—these were real people to us, and we felt their pain. TV characters were imaginary. Now it's the other way around. But part of what was so appealing and innovative and attractive about the Strokes is that they were not at all asking for any hand-holding emotionally. Like Destiny's Child. Very slick. No introspection. The change between, say, Eddie Vedder and the Strokes is like the change between Mary J. Blige and Beyoncé. Eddie Vedder was the one that you had imaginary conversations with, but not even the world's biggest Strokes fan is like, "I wonder how Julian would really feel about what happened to me in the school cafeteria today?"

KAREN O: With the millennials, there's a big divide, a big divide. And I was right on the edge of that, but definitely falling into the "angst-ridden, more sex in our entertainment" side of that divide.

EZRA KOENIG: Partying is just not really my vibe. We partied, some people partied more than others, but it never seemed that important. I get a lot of my best ideas after drinking coffee, which, of course, is a drug. That's probably my favorite drug; my favorite type of drug is one that makes you feel sharp and on top of your shit. When I picture people who consider getting fucked up on drugs or getting naked as some sort of rebellion, I picture people from my parents' generation, and it feels deeply boring and done.

CHRIS BAIO: I would imagine our record label would not like me saying this, but when Rostam and I were in Spain on our first promo trip, just in the office, there was a guy who's since left the company, but he left while we were doing press and went and got some coke and was offering it to journalists coming to interview us. That's, like, the closest to a dumb excess story I have.

ANDY GREENWALD: There's something a lot saner, I think, about the careerism of contemporary bands and how they want to be seen and how they want to be known for their songwriting or whatever. But doing that means you cannot be at the Library bar at three in the morning. You just can't.

HALSEY HOUSE

DAVE LONGSTRETH: I'm trying to think of when the Halsey House happened. I think in the late summer or fall of 2006.

EZRA KOENIG: Before Vampire Weekend started I toured with Dirty Projectors. Dave, he was an interesting guy.

DAVE LONGSTRETH: I am really curious. I wanted to expose myself to as much music as possible. I liked the idea of knowing how to orchestrate Mahler. I studied the shit out of the score of *Kindertotenlieder*, the cycle of *Songs on the Death of Children*.

ROSTAM BATMANGLIJ: One thing that's pretty interesting about Dave is that he'll just say it's time to dream up a whole new vibe and then that's what he'll do. The most obvious example of this is how the whole lineup of Dirty Projectors would change.

DAVE LONGSTRETH: I don't even like Mahler that much, I'm just using him as an example. I believed in that model that you should absorb the rules before you decide whether you want to break them or not.

EZRA KOENIG: Dave's always been incredibly driven, so as a student, he'd be constantly writing music and renting a practice space. I'd be taking the train up to New Haven and we'd be sleeping on the floor of this weird, dark, windowless room. It's the Protestant work ethic.

DAVE LONGSTRETH: When I first moved to New York, Todd P had just taken out a lease on 210 Kent, he was running some practice spaces for rock bands, and there was a weird crawl space under the basement, which was filled with trash and broken beer bottles. I went to Todd and said, "Dude, can I live in there?"

EZRA KOENIG: I remember, on the road, occasionally being alone in the minivan with him, doing typical early touring bullshit, like driving back to some horrible motel to pick something up that somebody left, and we'd always have very interesting conversations about music. I remember listening to, whatever, the new Destiny's Child song, and talking about it with him. We both approached pop music with a similar type of intellectual vibe, which—obviously there's no shortage of pretentious people in the world, but there was something unique that I didn't experience with other people.

ROSTAM BATMANGLIJ: Dave, like me, studied composition in college and doesn't want to ignore that side of himself in the music that he makes.

DAVE LONGSTRETH: Ezra knew all about the eighties. And he had a great respect for pop music in every form. All of the conventions and clichés, he had a reverence for them. Not only a reverence, but an encyclopedic knowledge of them. Lyrics, synth solos, videos. My parents weren't into TV, so I barely watched it growing up. I didn't know anything about music videos, but for Ezra, pop music was part sound and part image.

EZRA KOENIG: Have you talked to Dave? After you interview him, I can annotate his answers. "Untrue. False."

DAVE LONGSTRETH: My friend had been living in this large, dilapidated brownstone on Halsey Street in Bed-Stuy. I think the address was 615 Halsey Street. And every time it rained, it would rain all the way to the ground floor. It was in awful, awful shape. I had this idea of having a music house, so I got together a bunch of people that would want to be a part of it. Ezra was doing Teach for America in Bed-Stuy so he had a room there. He spent a lot of time with his girlfriend, who had an apartment somewhere nicer. I think he, like, felt that he needed to get out of Bed-Stuy sometimes.

EZRA KOENIG: I graduated from college, did this training program for Teach for America, then Dave hit me up and said, "Oh, there's this house in Bed-Stuy, you want to get in on this?" Dave said, "It's going to be a lot of musicians." I didn't realize at the time that I'd be the only person with a real job.

CHRIS TAYLOR: Oh yeah, that house in Bed-Stuy where Ezra was living upstairs. He was a little bit that kind of awkward, long-haired, mopey teacher bro that would get up at eight A.M. and make cereal and then go off to go teach. All the while he was somehow writing their massive smash-hit record quietly upstairs.

EZRA KOENIG: That was an intense time for me, suddenly having my first real job while trying to, in our free time, record a Vampire Weekend album and play shows, living with a bunch of musicians. I remember being in the kitchen and meeting Chris Taylor from Grizzly Bear. He was producing Dave's Dirty Projectors album on a few nights where I was trying to sleep. Just typical roommate stuff.

DAVE LONGSTRETH: We recorded *Rise Above* in that house. I remember a lot of pasta.

CHRIS TAYLOR: I was there every day for like two and a half, three weeks.

DAVE LONGSTRETH: It was probably my deepest experience of bumming people out by obsessively working long hours or being a control freak.

EZRA KOENIG: That was right when things were starting to pop up for Dirty Projectors.

DAVE LONGSTRETH: We were starting to get asked to go on national tours.

EZRA KOENIG: And for us, we were starting to get a little more attention. By the end of my school year, I was getting phone calls. I remember on my lunch break, walking around the playground, talking to Geoff Travis of Rough Trade on the phone, and I was like, "Okay, maybe something is going to happen." It all worked out perfectly for me; right at the time when it started to feel like we had to go on tour and take advantage of the situation, it was summer, so I didn't have to fuck over the school too much.

CHRIS TOMSON: Luckily for us, we had pretty much our entire first album done before we met anybody in the industry, so we were given a certain level of leeway. If someone tried to say, "No, this is what

you should do," it was "Fuck you" or "Well, why?" We felt, "We made this whole thing on our own, and it's obviously serving us quite well; why does your opinion all of a sudden change things?"

JENNY ELISCU: I'd told Steve Ralbovsky about Vampire Weekend, but it wasn't until Geoff Travis also started talking about them—then he was like, "Oh shit."

STEVE RALBOVSKY: Jenny was talking to me about Vampire Weekend around the same time as Brian Beck, who was our A & R guy at the time.

JENNY ELISCU: They met with Ralbovsky. Ralbovsky was dedicated. I mean, he was fucking dedicated. He really wanted to sign them.

STEVE RALBOVSKY: They came to my office and they were very polite, all sat four in a row on the couch, hands folded on their laps. They were appropriately shy and reserved, young postgraduate kids. There wasn't a lot of lively conversation back and forth. They were just kind of taking it all in. We left it that we would go out and have a dinner together in a couple of weeks, thanks for your time and thanks for considering and we really love what you're doing.

CHRIS BAIO: We had this link with what would become most of our record, called the *Blue CD-R*. It was ten songs and I think only two were online, "Oxford Comma" and "Cape Cod Kwassa Kwassa."

CHRIS TOMSON: Almost everyone who bought our first record the first week probably had it on the *Blue CD-R* or some form from the Internet first.

IMRAN AHMED: I wouldn't have been made aware of Vampire Weekend if it hadn't been for a blogger. I was working at XL doing A & R. I was going through New York for South by Southwest. I met up with a guy who ran a blog called Good Weather for Airstrikes. Derek Davies. I asked him what music he was into apart from the stuff I could read about. He said, "I really love this terrible indie band Longview and loads of, like, British indie bands." I said, "What about any stuff in New York? Do you see any stuff that's really good?" And he said, "No, nothing." Then he e-mails me two weeks later and says, "Actually there is one really good band,

they're called Vampire Weekend." So I suppose there was a person involved, technically, but Vampire Weekend was really an Internet discovery. I checked out the MySpace and it had "A-Punk," "Cape Cod Kwassa Kwassa," "Oxford Comma," and one other song on it. Those three ended up getting A-list radio rotation in the UK on Radio 1.

CHRIS TOMSON: At that point we were all still hedging our bets with our jobs.

CHRIS BAIO: I was still in school. Islam in Russia was probably my favorite class senior year and it would be very, very weird trying to focus on a lecture on Kazakhstan. There was a lot going on; it was exciting.

CHRIS TOMSON: More labels were getting in touch and the gigs were getting bigger. We played Glasslands the month before our first tour and it was packed. Ezra, Rostam, and Baio knew XL was good because of MIA and the White Stripes. So when they e-mailed it was like, "Wow."

IMRAN AHMED: It doesn't happen that often but when you find a band that good you get on a plane. I had never really pursued an American band before and I kind of realized that in order to sign a U.S. band, we were going to probably need one or two people in our U.S. office on board. So as soon as I heard the music, I e-mailed a couple of people in our U.S. office, and Kris Chen got back and said that he loved it, which was great. We spent the next six months, basically, trying to sign the band.

CHRIS BAIO: I had accepted a job at Teach for America my senior year; I took the LSAT my senior year. I didn't know what I was going to do, but playing in this band was what I wanted to do. By the last month of college we were meeting with XL, which was surreal.

STEVE RALBOVSKY: A few weeks after our meeting, I checked in to confirm our dinner date and got the note from Rostam saying, "You know, thanks, but we've decided to sign with XL." Of course you're disappointed that you can't get a second date, but it's hard to argue with the likes of XL. I had the sense that's what they really wanted anyway.

JENNY ELISCU: As much as I love Steve, I think he'd agree that they made the right choice by staying indie.

CHRIS BAIO: It was something that we thought about and talked about, the difference between a major and an indie. A lot of people were doing small imprints within major labels. It was never "Hey, we're going to sign you to Capitol," it was "Oh, we're going to give you the independent-label experience within a major-label system," which, I understand why you'd pitch that to a young band but . . . XL had Radiohead and MIA.

IMRAN AHMED: We signed them worldwide, which is important because—and this is not to talk down any of the achievements of any of these other bands, but I mean, the music these guys made was independent feeling and sounding. And they ended up having two U.S. number one records. They did it differently than their peers, and they did it differently from the people that preceded them. They inherited that New York band mentality, but they did it on their own terms.

GEOFF TRAVIS: They were just canny. Those kids have got a huge sense of musical history and the industry and are making informed decisions about it. Vampire Weekend could have been signed by any major, had they wanted to be, but they want to be with independent labels. The game had changed.

CHRIS BAIO: It was right after that that we went through the process of meeting with, it felt like, thirty different managers. Ryan Gentles was one of them.

RYAN GENTLES: I went after them, big-time.

JENNY ELISCU: They met with Ryan . . .

RYAN GENTLES: I wanted that band so bad.

CHRIS TOMSON: It was pretty much between him and Ian.

RYAN GENTLES: They fucking chose Ian Montone, that bastard. That was a fucking killer.

IMRAN AHMED: We signed them before they had a manager and the Ian Montone suggestion came from here. We had a good relationship with Monotone because of the White Stripes and at that time Ian also managed MIA. They loved MIA.

RYAN GENTLES: After Jenny told me about them, I went to see them. Some free summer show. Two hundred people there, sitting in seats. They weren't signed yet to XL, or the record hadn't come out yet; they had no manager. They were brilliant. I had them come by the office, and I knew they were big Strokes fans, and I just fucking killed it, man. I nailed the meeting. I was so good. I was artist-whispering with them, "Yeah, totally, bro." One of them told me that he and Ezra were in a cover band that covered the entire Strokes set in high school, and I was like, "I got this job locked!" I'm talking a three-hour meeting. A week went by, and I got an e-mail, "We loved your meeting . . ." I remember the feeling so much. I was in bed; I'd overslept. It was eleven thirty. I read the beginning, "But unfortunately . . ." and I think I stayed in bed until five after that. I wanted that band.

CHRIS BAIO: There's this book, *Bit of a Blur* by Alex James. He's Blur's bass player. And he said something that I thought was kind of funny: "You want the manager who's too busy to take your meeting." We met Ian when we were out in L.A. on our first tour. We went to an Italian restaurant up the street from Troubadour; none of us were hungry, I feel like I had a Diet Coke. I think none of us were drinking, none of us were eating, just kinda talking. He seemed incredibly intelligent and managed a bunch of different artists that we really liked . . . again, MIA. I think we got a version of *Kala* when we were in L.A., 'cause I remember that was the first time I heard "Paper Planes," when we were there. So we were all very excited about that and then he hung out after our show, which he really enjoyed, and then we kinda didn't hear anything from Ian for six weeks, maybe even two months. Ezra even e-mailed him and said, "We really want you to be our manager," and then it wasn't until September, I think, when he called us back and said, "I want to manage you guys." He was busy being MIA's manager, and the Shins and the White Stripes.

THE SPEED OF BUZZ

CHRIS BAIO: Getting a record deal, being able to live off music and playing Bowery Ballroom—everything after that has been icing on the cake.

JENNY ELISCU: It was the same pace as the Strokes. Yeah. To me it felt like it happened at almost the exact same pace.

ED DROSTE: I wrote to Vampire Weekend when they had the *Blue CD-R* on MySpace. They hadn't officially released anything. We had a show at this cool church space on the Upper West Side, and I wanted to see if they wanted to open for us. They wrote back, "Oh, sorry, we're really busy." They were already at the level where it was like, they wouldn't open for us, it wouldn't make sense. But it was super sweet, and we became friends, and within a few weeks of that, they were already massive.

ANDY GREENWALD: To *Spin* it was a much bigger deal than to anyone else, like, "We're going to put a band on the cover before they put a record out." I had heard Vampire Weekend like everyone else had, probably on Fluxblog or Stereogum, and I thought it was great. I thought "Cape Cod Kwassa Kwassa" was fantastic and I guess I was already aware of the snark going around toward them. The challenge was—and this is always the case with *Spin*—is that they didn't want a story on Vampire Weekend, they wanted a story on Vampire Weekend that was really about blog culture. And blog rock. The cover line was like, "The Speed of Buzz."

SCOTT LAPATINE: What happened in 2006? A major, major shift was occurring. Aside from the sound becoming more expansive, there was the move from Manhattan to Brooklyn. That was the last time

that you could say that Manhattan had any sort of music scene. You had more progressive, artsy bands in Brooklyn, like Grizzly Bear, Dirty Projectors, Vampire Weekend—though they are not a Brooklyn band, I lump them in there—and the National. These were bands that were born out of the web.

CONOR OBERST: Being a slight dinosaur of the music industry and culture . . . I notoriously hate the Internet. And I don't do social network shit. I think it sucks. So I was talking all kinds of shit about that whole scene—Pitchfork, whatever, is completely up its own ass, and not anything I ever agree with. But, all that being said: I'm also wrong. Being around New York, when I first heard about Vampire Weekend, it was "All the blogs like them," and da-da-da. Then I got over myself and I listened to them, and they're an awesome band.

JENNY ELISCU: A lot of people learned from their mistakes with the Strokes. Some people felt like they didn't put their foot on the pedal soon enough, in relation to how quickly it happened, and they didn't want to make the same mistake. I experienced that just in my endorsement and support of Vampire Weekend; as opposed to the Strokes, it was just an easier path. People believed you. If you had said the Strokes were good, and then you said, "This is the next one," people believed you 'cause you were right last time.

IMRAN AHMED: They were self-managed when they got their deal signed; no one really helped them do the deal. And then they were touring until a month after the record came out. Chris Thompson was still driving them; they didn't have any crew. They made all the key decisions and they made all the right ones and it was a real credit to them, you know? Imagine all that stuff: managing yourself and getting a deal done and your own track list of your record, putting it all together. There was never a point in which we said to them, "You need to choose this one as the single," or anything like that. It was all them.

CHRIS TOMSON: There were definitely times where I thought I was in over my head, namely *Saturday Night Live*. For "M79," the second song, my eyes are pretty much closed the whole time. I was like, "Just don't look at anything." The first Coachella. The first time we

played Glastonbury. At that point England was still a very mysterious place to me. We played on a Friday afternoon at two thirty but it was insane. Rostam's word for it was "Braveheartian." It was a sort of a gray shitty day and they had that thing where people hold big tall flags so when a bro gets lost he can say, "Oh, there's my friend's flag." Looking out at that I was just, "Are you fucking kidding me with this?" There were forty thousand people. There's just such a mass of humanity there. I felt like John Bonham.

JENNY ELISCU: So how did Vampire Weekend eventually have a number one album and the Strokes never did? Well, it's a few things. One would be that it's the actual music. A lot of people who initially were reserved in their estimation of Vampire Weekend, including *Rolling Stone*, because of the mishmash of influences, the multiculti-vibe thing, they were failing to see a generation of kids like Chris Tomson who loved Phish, and kids like Ezra, who was young, fairly aesthetically sophisticated, with parents who had been into Paul Simon and Madness and the Specials. Millennials have a much more beautiful cultural homogenization going on. Something about that is part of why it genuinely appeals to a larger group of the current youth aesthetically than the Strokes did. It felt fresher and more modern and like something new, even if its references were obvious to people of a certain generation. It was more of a surprising combination of things.

ANDY GREENWALD: What I remember most is Ezra saying, "We are making this so it will be played on Hot 97. This isn't a joke. We love Usher." And frankly the single best thing about being alive now is hearing Rostam produce, like, Carly Rae Jepsen. It's some of the best pop music of my life. And you look at Ezra and just his confidence in what he does on his radio show on Beats 1 . . . I mean, Vampire Weekend's career has been immaculate. They're just so good.

82

"I *WANTED* TO GET IN THERE LIKE A MOTHERFUCKER AND THAT'S WHAT I DID"

DAVE SITEK: Everyone who knows me personally knows that I'm just winging it. I'm the king of guesswork. Like, "What the fuck do I know? I'm just a drug addict with emotional problems who just happens to be messing with this here." And I think that spilled over. I think that sense of wonder is the thing that made me and Karen connect on an outside-of-the-music-business level. Just being like, "I wonder what would happen if . . ."

BRIAN CHASE: We recorded *It's Blitz!* at this ranch studio outside of El Paso. It's three thousand acres of pecan orchards. And the guy who runs it is just a music lover. He turned part of his property into a state-of-the-art recording facility. You're in a desert surrounded by pecan trees and dust, on the border of Mexico, staying in a hacienda with this super-cool guy. He made it comfortable for us. And we had Dave, who is good at being the mad scientist.

DAVE SITEK: When everyone was telling them that they should work with bigger people or bigger names, they were like, "No no no, these are our people." There was always that suggestion of what the outside world thinks and with Karen and Nick, I always turned their voices way up and everyone else's down. "You tell me what you want and when someone tries to fill you with doubt, I will try to defend what you told me was important to you even if you forgot," you know? Nick will tell you. I fought with them like dogs. I would dig my heels in. Mostly just if I sensed that someone's opinion is too strong, I'll just say, "No no no no, they can start

their own band." You know what I mean? They are like family to me. And for us, doing things on our own terms is, like, the most important thing. Yeah Yeah Yeahs, they were such a juggernaut that a lot of people attached themselves to the band, and I was really wary of those people. With us it was always a community effort. "Let's make the most of our time." I'm like, "This is our place in the world, and when we look at it later, it should read as a really great story." And just, like, worrying about what other people think is not a good story.

KAREN O: Before we recorded, we wrote at this little bunker practice space studio in the city. We just went there in spurts, so it never felt like we're there for an extended period of time. When you're in there you're excited about it and it's been a while since you did it last and there's that energy. Nick and I were just playing and not thinking about it. We were just jamming and doing our thing and playing really unself-consciously, just being in the moment. That's how we did *Fever to Tell*.

NICK ZINNER: The *It's Blitz!* record was so fun to make. It was also difficult. We spent so much time going over things, and obviously there are always some of the same issues, but it felt like we were embracing ourselves and our music and just going for it.

BRIAN CHASE: There was a lot of community; we'd eat lunch and dinner together. There was no screaming or fighting. Maybe there was, like, the occasional outburst, but hardly ever.

NICK ZINNER: These days there's less brooding on my part. I don't really brood so much anymore. I try not to.

KAREN O: I'm not as detail oriented about it, you know? It can be imperfect. Now I like to get it done before the soul starts getting sucked out of it, you know?

BRIAN CHASE: Hindsight, looking back, is in some ways kind of dangerous.

KAREN O: It's kind of like texting while you're driving.

BRIAN CHASE: But one factor that has contributed to longevity is the way we have paced ourselves. There's always the opinion to go immediately as fast and hard as you can, and we've done that in some

ways, but we have managed to stretch out what we do in cycles. It takes years to unfold. But the long period of time allows for a lot of evolution.

KAREN O: We've always been coming from the position of being the underdog. Of the one female-fronted outsider band. We came up when the Strokes exploded. I remember playing a show with the Strokes at Don Hill's, and before we knew it they were the band that saved rock and roll or whatever. Then we released *Fever to Tell,* and the White Stripes released *Elephant* at the same time. We were, like, definitely always the underdog. And being the underdog is a great fucking position to be in, man! It is so good. For a little while I grappled with it but I think that's why we're doing what we're doing and we're still around and people still care. It's like growing up not being incredibly good-looking. If things don't come easily to you, you're always struggling, you're always fighting, you never expect anyone to ever pay attention.

BRIAN CHASE: Part of it was us finding what works best for us. Obviously the first years it takes a lot of trial and error but I think now we have our rhythm. It takes some time to find it but it became natural. I think it is good for bands to find that, to be aware of what wears them down and what allows them to continue.

KAREN O: We're used to asking the question "Why should anyone give a shit?" We're used to feeling like the underdog. And it fosters a very serious work ethic. It helps that we had an amazing record deal, a really fucking good one. We had so much autonomy. We had creative control, always. Never did they say, "No, that can't be your single, none of that, blah blah blah." It's pretty absurd in a lot of ways that we achieved that from the start too, because who does that?

NICK ZINNER: From the beginning, we wanted to write those songs, you know, those songs that change people's lives, a song that encapsulates a moment for people, rather than, like, "Oh, I like this song. I hear it on the radio sometimes."

DAVE SITEK: Karen is an extremely courageous woman. She inspires some people and influences other people. Sometimes that means influencing you to drink sixteen margaritas and get sent home in a

cab. But with Karen there was nothing past "Let's make this for the kids." That intention overrode what anyone else was saying. And that was a really special thing. Seeing it firsthand, up close, was just like, "Oh, wow, life can be what you want it to be, you know?"

KAREN O: Every now and then I'll hear, "Thank you so much, you really got me through high school." Or "Thank you, you really got me through freshman year of college." Or "Thank you so much, you really . . ." I have heard that from fans who don't really know what to say to me and I don't know what to say back, except for "Oh, really? Thank you! I'm happy I got you through that." But really in my head I'm like, "I manifested that shit for you! I *wanted* to get in there like a motherfucker and that's what I did."

CONSIDER YOURSELF SERVED

TYLER BRODIE: After Tim left, we couldn't find him. We had to track him down.

JONATHAN GALKIN: We couldn't reach him. We couldn't reason with him. There was no clean break or any sort of paperwork.

TIM GOLDSWORTHY: When you're in a long-term relationship with any-body, you can feel when it isn't right. It gets to this point where you're almost like a butterfly that's come out of the cocoon and there's the husk and you're looking at the situation and there's no way of going back. You're not going into that old body again.

JONATHAN GALKIN: I couldn't change banks. Simple things like that. There were hundreds of things we couldn't do.

TIM GOLDSWORTHY: It had gone strangely full circle because the music we made at the beginning was trying to get rid of bad nineties house music, to get back to that feeling of being a kid in the eight-ies where there was a clear divide in pop music. Suddenly I had this realization that half the bands on DFA were making shit nineties dance music and the other ones were trying to sound like Hall and Oates, and I was like, "This is horrible." And I wasn't going to kick up a fuss—"Sorry, guys, I think your music is shit"—because at this point I didn't even know James's cell phone number. It was impos-sible to get in touch with him. He thought I was poison, because I had tried to stand up for the artists.

JAMES MURPHY: Tim disappeared. He went really quiet on me over the years. I think he just hits a point where he has to go. I even knew it was coming because I knew his history. You know, he'd say, "James Lavelle was a fraud," Lavelle was this and that. There's a trail of

tears. I was like, "What are you going to do now? I'm not on drugs. I play everything and I'm not a fraud." I feel like he must have made me into some kind of enemy in my absence and justified that.

TIM GOLDSWORTHY: Before I left, when I was working with Holy Ghost, I tried to reach out to James for old times' sake and be like, "We need to talk about this because you're out touring and doing something else and even though we don't get on, we need to sort this out, otherwise it's over." So we had a chat. At the DFA offices. And I suggested that we keep it legendary and just pull the plug right then, in 2008. That we do one final gig, where we do all the DFA remixes, we have everyone from Justin Timberlake to Jon Spencer, all the bands play. And then we announce, "Thanks for everything, good luck to all the artists, you can have your back catalog. Go on, we're fine." James laid into me, saying that me getting married to Jen and having kids was the worst career decision I could make in my life. I literally could have stabbed him in the throat quite easily. I had weird reoccurring dreams of *Games of Thrones*–style deaths for him. He had me at the point where that's it, that's done, I'm at the edge of the windowsill and he's just like, "See ya." But it was genius, because then I left. That was his plan.

JONATHAN GALKIN: He was probably thinking, "Well, I'm going to leave and I'm going to disappear for two years. And then when they finally reach me, I'm going to sell them back my share. I'll make all this money. This company is worth so much." LCD being the exception to the rule—DFA is still like a day-to-day indie label, in a time when people are not buying records.

JAMES MURPHY: Jonathan is pissed.

JONATHAN GALKIN: The first person to ever break the story of Tim leaving DFA was Resident Advisor. Todd Burns was at that time the editor in chief, and I had gotten totally drunk in Berlin and I told him everything. He asked, "Can I write about this?" I said, "I don't give a shit, just fucking let it out of the bag." That day Tim called me and left a voice mail on my phone saying, "How could you guys do this?" That was the last time I ever heard from him.

TYLER BRODIE: But we still didn't know where he was.

JONATHAN GALKIN: I heard from a friend, who said, "Hey, I read you guys are having a breakup with Tim Goldsworthy and I heard you guys were trying to find him. He's actually producing the band my friend manages, on Secretly Canadian, and they're working in a studio in Michigan." We served him on the very last day of recording. I was very polite; I did not interrupt their recording process, as I didn't want to fuck up the band. I got an e-mail from the processor: "At 2:34 P.M. this afternoon, Tim Goldsworthy was served." And I was just thrilled—"We got him!" As soon as the paperwork was filed, some court reporter who has his ear to the streets, or might be a fan of LCD, saw the name in the report and he broke the news. Within twenty-four hours Pitchfork and everyone else had picked it up.

JEN GOLDSWORTHY: Galkin leaked the news. Why would it have reached all these press outlets if someone hadn't leaked it?

JONATHAN GALKIN: The deal was "Look, we're going to either come after you for all this money, and for all the shit we think you stole, and we will go to the mat trying to prove it, or go away. Literally walk away. Just walk away. We owe you nothing, you owe us nothing. Good-bye."

TIM GOLDSWORTHY: They wanted to write me out of everything. They wanted me to give up not only the writing and my credits on LCD, but everything on DFA. James had already started saying in interviews, when speaking of me, that I was not his partner in DFA but the programmer for David Holmes, who they met at Plantain.

JEN GOLDSWORTHY: It was very traumatic for us, just getting over the shock of the latter part of our lives in New York City. We were really taken advantage of. We lost all these friends. We had no money while raising a family of two young children. It was just horrendous.

MARCUS LAMBKIN: Tim and Jen, they feed each other's little stories. "I'm fucking you over," when James has no intention of fucking anyone over. He said to me he really missed Tim, that he would never have anyone else that he can talk to about music in the same way.

JAMES MURPHY: He feels slighted? Slighted by who? The outside world is out of our control. I never said DFA ain't Tim. I've said the opposite!

JEN GOLDSWORTHY: We'd been so oppressed for so long, like seriously. There are moments where it was like, "Is this really happening to us?"

JAMES MURPHY: I'm just dying to find out what I did wrong.

"WHEN MY MOJO PHASE HAS PASSED, I DON'T THINK THAT I'LL STOP MAKING MUSIC AND START GARDENING"

KIM TAYLOR BENNETT: *Our Love to Admire,* Interpol's third album, came out on Capitol. That was a surprise for people. They were intrinsically identified with Matador. They started to feel a bit faraway— here they were, this major-label band, playing these big tours. I remember the reviews for that record were just okay.

SAM FOGARINO: Critically, we started to lose a little ground, but where we were playing in front of twenty-five hundred people before, now it was seven thousand people. We were playing small arenas in Paris and in Amsterdam and in Brussels. That really soothed the blow in terms of what we put each other through. I mean, we played Madison Square Garden on that tour.

DANIEL KESSLER: That was a lot of fun.

SAM FOGARINO: But after that tour, we needed, and we took, a very long break.

PAUL BANKS: I went through a phase where I lived in New Jersey and I didn't have a social life. I just worked. I totally isolated on purpose for three years. And I liked it. But I did eventually realize that I'm one of those personality types that can go too far that way. I could go all Howard Hughes. I did my solo record when I was living out in New Jersey.

SAM FOGARINO: I'd had enough of certain aspects of the city, like the high cost of living and no space. I had been coming down to

Athens, Georgia, for a couple years and realized that I liked it, knowing that I'm never going to get rid of New York and New York's never going to get rid of me. It's kind of a fail-safe. You know what I mean? I get my fill on both sides.

PAUL BANKS: I'm not the songwriter of Interpol. I'm not the dictator or the director of those songs, I'm the guy that writes the vocals and some guitar parts. But I don't define the textures or the tones, or introduce the progressions that become Interpol songs. That's Daniel. And I need an outlet where I do that. If Daniel didn't impress me so much with his songwriting, then I would just go do my own shit all the time.

JENNY PENNY: Carlos hated being on tour. When we were on tour, it was super fun, but the next day, he'd have a panic attack about something. We weren't together anymore, but when I heard he quit, I was like, "That's awesome, he's going to be so happy." Because he loves New York and he loves being here.

PAUL BANKS: There was a lot of tension, especially in the age of Carlos.

SAM FOGARINO: If it was something that he did, Carlos thought it should be heard.

PAUL BANKS: I mean, I love Carlos. I really am deeply fond of that guy. We had an interesting relationship. I think he would absolutely disagree, but I believe that I know him fairly deeply.

JENNY PENNY: They were really close. Closer than the rest of the guys.

SAM FOGARINO: It just increasingly got worse.

PAUL BANKS: When we started off I used to be very frustrated because he had that extremely pretentious affectation all the time. Everything was very, very serious and rigid. I could play along, fire back, or be sarcastic with him, however, because I thought, "He can't be serious, he's not really *that* pretentious." But I think at a certain point I realized that, "Nah, he wasn't really kidding." After that, we started seeing each other differently.

SAM FOGARINO: He was conflicted, and then there was one day when he walked into the room and said, "I'm really leaving the band." And that was that. I gave him a hug and that was the last time I saw him.

KAREN RUTTNER: Carlos fully dropped out. He's a theater dude now.

SAM FOGARINO: Which makes sense. He fancied himself a composer. On his website there was a picture with him in a cardigan sweater and his dogs. He started going to acting school while we were making the fourth record. In hindsight that's what it was, he did kind of play a role, and then he was done. And that's fair. When you're done, you're done. And good luck to you. The timing wasn't so good but ultimately that was a great thing because we weren't done with being a rock band.

PAUL BANKS: If you're in the professional world and you start showing up acting all fucked up at the office you get fired. If you're in a rock band, no one fires you. No one says, "Dude, you're being a jackass, go talk to HR and pack up your desk." In the rock world you can be a big fucking mental case all day every day and that's fine. Of course, I'm not speaking about my bandmates, or myself, god forbid. But that's why it's so volatile and hard to keep bands together. But they do stay together if they can just keep in mind that they're in a very privileged position. Ultimately, what's important is we are all aware it's a miracle that we found each other in the first place, that we're able to write songs together. We are more than the sum of our parts and that's magic.

SAM FOGARINO: Well, here's another cliché: all the great staff that signed us to Capitol, that signed Radiohead, they all got fired. They had been there for ages and courted us for five years, and literally as soon as we press record on the tape machine, they're gone. So, midway through the *Our Love* album cycle, we had nobody there. The record still sold well, relative to the climate of the industry. Our touring excelled and increased. And all this in defiance of not having any champion at the record label. But by the time we were meant to deliver a second record to Capitol, we kind of just agreed to shake hands and not do it. Then we went back to Matador. It took a minute.

DANIEL KESSLER: We were always clearly more of an indie band than a major-label band. So we tried seeing what it would be like to be on a major label. We tried it. We saw what it was all about.

SAM FOGARINO: Were there any sort of, like, pouty-girlfriend moments with Matador? Yeah, because while they are great businesspeople,

we were friends. They were hurt. And then maybe a few months later when everything was sorted, the record was going to come out on Matador, I remember talking to Nils Bernstein and saying it felt like we didn't even leave. It was such a blip in time. And now there's no turning back.

PAUL BANKS: If someone like me thinks, "What if I'd just done my own thing from the get-go? What if I made the wrong decision about being in a band?" what I always have available and accessible is, "Yeah but the fans can't all be wrong." Man, are we lucky that these people want to come and see us. That's what reminds me, "No no no, this is worthwhile, because all these people believe in what we do." That's always a very grounding thing. Fans don't fuck around.

DANIEL KESSLER: We do have fun.

PAUL BANKS: Having outside interests helps. Now I paint and surf. I just paint realism. I just do portraiture, it's just reproductions. My dad asked me, "So do you plan on doing anything original?" And I was like, "Nope." I'm not trying to make any statement with painting, I just like to paint.

DANIEL KESSLER: We're all really private, and we're need-time-alone people.

PAUL BANKS: For me, making music is a bit like a biological function; it's a reaction to my daily life. Life made me need to express myself through music, and I have not suddenly become very satisfied with life or the human condition isn't all of a sudden cool by me. It's a fairly self-sustaining system. You have to learn how to protect yourself. Don't read anything about yourself. Don't take anything too seriously. Just do what you want to do. And know that the real lucky thing is that you have something you really want to do. I do also believe that if, say, I had a family and I wanted to cool down, I would still write music. I think we're safe that even if society does evolve and we become a good species, I don't think that'll be at the expense of art. When I'm an old fucking dude, when my mojo phase has passed, I don't think that I'll stop making music and start gardening.

DANIEL KESSLER: The fact that we've done all these tours, put out all these records, played and had people actually want to hear our music, seen all these places throughout the world . . . of course it's tiring and taxing but I don't forget that it's amazing. This is all I ever wanted to be doing. That's the bottom line. That's the bottom line. I wanted to do this. And it almost didn't happen. But then it did. That never gets old.

PAUL BANKS: Back when we were touring *Our Love to Admire* and starting to see the next generation of bands coming up, that was an interesting vibe. You're starting to feel, "Oh wait, to them we're an established band. That's a weird thing. Like, now to college kids, we're old people?! How the fuck did that happen?" I don't feel like I look that different but apparently I'm an old guy now. You know, I'm the guy trying to pick up eighteen-year-olds. "Hey, kids, want some reefer?" Just kidding.

PETER KATIS: People do not understand Paul's sense of humor. He is a really funny guy.

PAUL BANKS: There's that point where you become Kevin Costner in *Bull Durham*. You go from Tim Robbins, all the raw potential in the world but you're just being a fucking idiot. And then you get older and there's this respect from people, not necessarily because they love your record, but because they're like, "Yo, that's their fourth record and they're still here." I like the feeling of "Oh, shit, man, in some contexts, we're established now!" That's one of the perks of getting older. It's like, "Oh, I guess I do know some shit. I've managed to not OD or break up this band."

"WE WARMED IT UP FOR YOU FUCKERS"

KAREN O: Fuck, man, modern times. It's so complicated. I do remember being really genuinely excited and feeling like it was a moment. Like we were part of a real moment but nobody would let you enjoy that. None of the bands. None of the press. It was still postmodern type bullshit where it was like, always question it, always be suspicious of it, never take it at face value. So here we were in a real fucking moment, which hadn't happened for New York since the late seventies/early eighties, and everyone kept referencing that other time. You're just like, "Shut up!" Everyone kept questioning it, like, "Is this real? Or is it just hyped up to be real?" But it was real! And I had a hard time just embracing it completely and being able to fully enjoy it because I was suspicious. The cynicism about it and the questioning of it really got under my skin. I remember one time at this vintage store in Cleveland, I picked up an old copy of *New York Rocker,* which was a music publication, but you know, one that was on newsprint. I still have it. It was from when *that* was happening: Blondie on the cover, and what's-his-name, fucking Blank Generation [Richard Hell], and the Ramones. It was the Year in Review issue, and it was the same fucking shit! There was a real cynicism about, like, were these people for real? Questioning the authenticity of it all. When you think about it, that's so crazy! People to this day think of that era as one of the most authentic moments in rock history. So seeing that did make me feel better, but it was almost too late. I mean, we were still pretty good at enjoying ourselves. Don't worry. But it was more like, "How seriously do we take the collective experience? How seriously to take this as

a moment, a *real* moment that's happening to us and all these other bands in the same city?" We were swept up in it but we also questioned how authentic it was because everyone else was questioning it, and that's a shame because there hasn't been a moment like that since. And there might not be for a long time.

JAMES MURPHY: "Scene" was never a dirty word. "Scene" was a good word pre-hipster. A scene was what you were proud of. We were *trying* to build a scene. At the same time we were myth building, we were scene building. Now it seems grotesque. But before universal hipster-ism, that was what you were proud of—where you were from, your family. As a kid you were defined by what you listened to. These days, everyone strives to be the surprise. But everyone is striving to be the surprise in the exact same way. "Oh, you have a unicycle and antlers and a wax recorder? Surprise!"

APRIL LONG: All of the things that would go on to be cycled through Brooklyn in the following ten years, from trucker hats to mason jars to home-brewed beer, all of the stuff that has become cliché Brooklyn, did start with music, more or less.

ALEX WAGNER: The music being made by the earlier bands, it wasn't sustainable. Can you keep those emotions and that kind of process going for the long run? The answer is: no. Julian Casablancas lives in the country now. And Albert Hammond is making music that is inheriting, you know, the mantle of Grizzly Bear and Vampire Weekend. I am not putting value on either one, but what is being made by those bigger kind of quote-unquote "Brooklyn bands" is a much more sustainable and exportable form of New York.

ROSTAM BATMANGLIJ: There were no leaders of the Brooklyn scene. And aesthetically, we were all in our own world. That's less true about the early 2000s. The Strokes, the Walkmen, Yeah Yeah Yeahs, Interpol—aesthetically, they're way more united than Yeasayer and Vampire Weekend.

EZRA KOENIG: I always hated our association with Brooklyn, and I've lived in Brooklyn, and it's a beautiful place, and I have nothing against it, but it always felt . . . it just felt so untrue to me. That Brooklyn aesthetic, to me, had nothing to do with our thing, and

in fact, that Brooklyn aesthetic drags ours down a little bit, if we associate too closely with it. I really felt, if anything, Vampire Weekend was the Manhattan branch of a little New England burgeoning scene.

ANDY GREENWALD: When I interviewed Vampire Weekend, they didn't even live in Brooklyn. That was the thing that I kept having to pretend was true, exactly. When I interviewed Ezra he lived in Manhattan.

MATT BERNINGER: Williamsburg was the flagship neighborhood. Brooklyn and Williamsburg and New York all became the same thing on a world level, on an international level.

NIC OFFER: One time, halfway through an interview the lady said, "Wait, where's Karen?" and it was like, "Yeah, we're !!! Karen's not in this band." Another time a different woman was like, "So you recorded a song called 'North American Scum,'" and we were like, "Actually, we didn't," and then later in the same interview she goes, "So you did this song for Nike," and I was like, "No, we didn't." It's superficial. What they know is: band from New York.

MATT BERNINGER: It wasn't "The National is coming to Germany," it was "Brooklyn is coming to Germany."

IMRAN AHMED: The rise of these bands coincided with a rebranding of New York and the New York–ification of the world. You could argue that London has more in common with New York these days than Newcastle. Tokyo has more in common with New York than Osaka.

TUNDE ADEBIMPE: I was talking to somebody about another project I have. And just to get us a little publicity, my friend Jenny got us a *Rolling Stone* interview. I just wanted to talk about the project and the band and the video I animated for it. But at one point I mentioned that I was moving to L.A., and a journalist asked, "Oh, why are you moving to L.A.?" "Oh, I've got a gig and New York will be here when I get back." The title of the article was not about the band when it came out, it is "Tunde Bails on Brooklyn, Opens Up About Moving to L.A." And I was just like, "What the fuck?" And

it also described me as a "pillar of Brooklyn hipsterdom." I wish I had known I was a pillar of Brooklyn. I would have abused that so much more. Why did I just find out about this now? I could have gotten away with so much shit. And now it's over.

DAVE SITEK: I still don't have perspective. Everyone reading this has more perspective on what happened in New York. My perspective was "Oh yeah, and then I replaced that tape machine."

JALEEL BUNTON: What's so funny is that we started playing in 2003, and we started touring right away, so this whole thing about representing Brooklyn and New York—we weren't even fucking here! It wasn't until ten years later that I was like, "What the fuck happened to this place, man? Like, I just got off the bus, and this shit is totally different." It's very surreal to miss this whole evolution. It's your fault and you don't even live here.

APRIL LONG: I mean, when, exactly, did Brooklyn . . .

SUROOSH ALVI: . . . get boring and shitty?

ELEANOR FRIEDBERGER: At some point, and I'm not sure when, it became cool to be rich.

SUROOSH ALVI: There was the building boom. Two thousand seven feels like it was a big turning point, and I don't know specifically, but I do know that whenever that building boom happened, it changed the vibe, the aesthetic, the landscape, how everything felt in the neighborhood. Somehow, boom, the buildings were all full.

ELEANOR FRIEDBERGER: When did rich become cool? I feel like when I got home around 2007, we would walk around just thinking, "What the fuck?" Seeing somebody's car or seeing people sitting outside drinking wine at a restaurant. I don't remember one single instance but it was just a general lifestyle shift. And then, part of what was dark about it was, I was seduced by it. In my own way I started being seduced by it. I wanted those status-symbol things. There was a woman who worked for Prada or Miu Miu and she was a big Franz Ferdinand fan. Alex [Kapranos] was my boyfriend at the time and we were living in this house he bought in Greenpoint. It was her idea to get us to model together in a campaign and he

said no, but my name was still in the pool for some reason, so I got to do it with these other girls. Franz Ferdinand were given like a gazillion dollars—I can't even think of how much money they were given—in merchandise. So much shit. And all the guys had girl-friends and wives and I just remember feeling like, "I *want* that." I wanted shit I never wanted before. And we would get into, like, weird fights. It was horrible. It was so stupid. Like, "I want that coat!" It was fucked up.

MATT BERNINGER: It was like the gold rush in the cool zone. Everybody wanted to move here. Everybody, every brand, wanted a little shop or something to do with Brooklyn, you know? Ultimately that all comes down to marketing, and the real estate moguls who know how to make it all sound sexy.

SUROOSH ALVI: It was a fucking super-sudden, instantaneous, incred-ibly aggressive expansion in the neighborhood that permanently changed the vibe of Williamsburg, but not for a bad thing.

MATT BERNINGER: Brooklyn just became the surrogate New York City. And New York City is the center of the universe in culture, the way Rome was at some point. The city in the nineties and early 2000s was Rome. It was the coolest place. I loved it. I'd be miserable, I'd be heartbroken, I'd be just bored, depressed, totally broke, but it was like, I'm here, I'm in the movie, I'm in New York City. I'm not in Cincinnati. I mean it was dead chickens and burning cars and double-ended dildos and rotten milk outside my door everyday, but it was New York, even though it was Brooklyn.

SUROOSH ALVI: Look, we came out here because we were poor and couldn't afford not to come, and now *Vice* employees are moving to Manhattan because it's cheaper to live there than in Williamsburg. Things shift.

ALEX KAPRANOS: When Eleanor and I lived in Greenpoint, we'd go into Manhattan on our bikes, we'd circle back, and on our way, I'd always want to cycle down Bedford just to gawk at people. I used to love that, like, "Look at that!" But she wouldn't do it—it started these huge fights. She wouldn't want to go anywhere near them, whereas I used to just love it. It was like going to the zoo.

ELEANOR FRIEDBERGER: The reason why I didn't like riding down Bedford is there were a lot of people and I didn't want to ride my bike with all the distraction, I just wanted to get to where I was going. Alex liked it because he liked to gawk and look around at everything. And that annoyed me. He was really into New York because he felt like there was a scene there and he really wanted to hang out with other musicians. Eventually I realized, "I really am part of this amazing community. I know so many musicians, especially in this one part of Brooklyn, and I love walking down the street saying hey." I didn't appreciate it until then. It was immaturity on my part. And I also had all the classic complaints about gentrification, which are of course legitimate.

IMRAN AHMED: The reinvention of New York as the world's aspirational brand absolutely happened. People around the world were looking to New York for how they should live their lives.

ANDY GREENWALD: We have exported this idea. And it's our number one export to the world to this day. Last summer I was in Paris. I got there and I was jet-lagged, walking around at dusk, and it was beautiful and summer and I couldn't believe where I was; it was very disorienting. I look across, like, a beautiful archway and there's a restaurant that looks amazing, with natural wood and a line out front. I think, "Holy shit, this must be the spot! This must be the new bistro cuisine being invented in Paris!" And I get closer and I see crowded tables and there's something on every table. I get closer and closer and I realize there are bottles of ketchup on every table because it's a burger place, and it looks like Momofuku. And there's a clothing store nearby that just sells everything that Steven Alan sells. And I couldn't tell you the place in Brooklyn that looks like any of this, but it's the sweaters and the artisanal hamburgers and the soundtrack, and that has absolutely gone around the world and it has nothing to do with Brooklyn itself anymore. It's an idea. And it was always an idea.

JAMES MURPHY: I want to be pro-Brooklyn. I don't want to be grumpy. I don't want to be that guy.

JALEEL BUNTON: I'm trying to think about what to say without sounding like a bitter fucking snob.

TUNDE ADEBIMPE: At some point along the way I started taking every show poster or flyer from where we and our friends played, so now I have a ton of these. A friend recently said, "You should really put those together into a book." And I said, "Yeah, it should be like a Taschen-style book, really fancy, with all these posters and a little writing, and we should call it *We Warmed It Up for You Fuckers.*" On the front it should be a close-up of a woman in a pink bathrobe with a shot from the "Maps" video. She would be on her computer holding her cell phone and doing her nails, and watching the laptop on her lap, and it would be like an Edward Hopper painting but there would be a shot from *Girls* on the laptop. That will be the cover. I think it will happen. Put a little something in the tip jar.

DAVE SITEK: You can look at it in the sense that Brooklyn's gotten smaller, Brooklyn is happening anywhere. You can look at any city from Baltimore to Saint Louis in the same trajectory. "Clean up downtown and push the people out." I think that there's great music happening all over the world. I wish that NYC still had the potential that it had for us for kids who are moving there now, that they could be as reckless and carefree as we were, but maybe they're not supposed to be, maybe they're supposed to do it in Austin or Detroit. There are so many cities that you go to now and you're just surprised, like, "Oh, wow, it's happening in Arkansas?" That's the best part about it. It's not supposed to stay in NYC.

James Murphy performs with LCD Soundsystem at Madison Square Garden, April 2, 2011.

Photo by Theo Wargo/WireImage for NY Post

PART V

"NEW YORK, I LOVE YOU BUT YOU'RE BRINGING ME DOWN"

"I MEAN, WHAT'S MORE ROCK AND ROLL THAN MADISON SQUARE GARDEN AND A MIC DROP?"

PHIL MOSSMAN: There's nothing wishy-washy with James. He has epiphanies on accident. And they're very clear, obvious things, but quite amazing, really. He said to me, "I woke up in the middle of the night, and I have an idea for the second record. It has to be better than the first one." Totally simplistic but he actualized it. *Sound of Silver* was huge.

JAMES MURPHY: The end-of-decade polls in 2010 changed everything. *Sound of Silver* had done well. People liked it.

MARK RONSON: The DFA stuff was exciting, but it wasn't until the second album that I absolutely fell in love with LCD.

THOMAS ONORATO: I have this really clear memory of getting a root canal, sitting there and the dentist is doing the root canal and I'm listening to the music he's playing on his iPod and "New York, I Love You but You're Bringing Me Down" comes on. He has *Hair*, the musical, and then LCD Soundsystem.

JAMES MURPHY: After the polls came out and we were so high on the decade's Best Of with *Sound of Silver*. We got this second lift. I'd taken a year off. My marriage was hard and my life was crazy and I needed to breathe. The polls came out, and I went to record another record. And that was the first time I made a record with expectation. It was a fuck-you to everybody: Interpol, Bloc Party, all the bands that were bigger than us. British Sea Power. Everybody who was above us at festivals. Bands that were so nice to

us: "Have a great show!" "Yeah, we're going to fucking bury you."

JONATHAN GALKIN: He has this tour booked for the third record, for *This Is Happening.* Madison Square Garden was something that was just on the calendar, "You know, instead of doing three nights at Terminal 5, we'll do one night at Madison Square Garden. The venue's open and it routes perfectly here . . ." Suddenly, it was just on the calendar.

PHIL MOSSMAN: It was the same thing with the final show. He just called me and said, "We'll just end it with a big party," like a definitive, big celebration, no drama, and it's done. It was very James.

JONATHAN GALKIN: I just remember, within a certain amount of time after seeing MSG on his routing sheet, he said, "Did I tell you? I think it's going to be the final show." That's pretty much how it happened. "You know what? Let's just end it there." It's almost like he backed himself into the myth. I mean, what's more rock and roll than Madison Square Garden and a mic drop?

JAMES MURPHY: I knew it was the last record. I just felt: three and out. With punk bands, the first three are good and the rest suck. Did I think I'd start to suck? I'm not in charge of that. I was thinking about *Little Creatures* by Talking Heads. That's their biggest record and I don't like that record. And that's a band I love. What would be the point of continuing? I like to fight. I'm an underdog by nature and I like to be fighting. I don't make music for myself. I make music to fight.

TIM GOLDSWORTHY: Fucking hell, they played Madison Square Garden. And the Strokes played the same place the next night.

THE LAST ROCK STARS

LAURA YOUNG: The Strokes are one of those bands that other bands are going to reference for the rest of rock and roll.

JAMES MURPHY: After MSG was booked but before it was announced, we were arguing with the promoters about who was going to play with us. They were concerned it wasn't going to sell out. They said, "How about Big Boi from Outkast?" Why the fuck would Big Boi play with us?! I mean, they had no faith in us. So I said, "Fuck it, it's our last show—give me another date. We'll sell it out in two weeks. I want a second date." I asked for a second date and the Strokes already had it.

LAURA YOUNG: To me, the Strokes' first album is one of the greatest albums that will ever be. So they've got that going for them. But, they represent such a moment in time that sometimes it's hard to break out of unless you really reinvent yourself. I mean, unless you're the Beatles and you make *Sgt. Pepper* you're not going to break out of that mold of "Oh, this is that band that came out of the early 2000s and defined a moment." Nothing they do will ever be as cool as that first album.

CHRIS TAYLOR: I still listen to *Is This It*. I'll go to the gym and put that on, as thirty-something as that sounds. But fucking hell, it's so good.

ADAM GREEN: I saw them play that Madison Square Garden show.

LAURA YOUNG: I was there. I had seats but I traded with somebody so I could be in the pit. I thought, "I know I'm a little bit too old for this but I'm going anyway." I remember seeing these kids that were fifteen years old. I was either talking to them or overhearing them

and they were saying, "This is the first time I'm seeing the Strokes. I listened to them all through elementary school and middle school." It was so cool to see them there and so excited. I don't know, maybe somewhere, somehow, years from now Vampire Weekend will do some kind of a reunion show, but I can't imagine young kids being there saying, "I love Vampire Weekend so much. I'm so excited about them. I've been listening to them since elementary school." And if they are, they should be punched in the face.

ALBERT HAMMOND JR.: We're all six feet tall plus, and I think people don't know that, so when we walk in the room, it's five guys, we're all really tall and all kind of nervous. And Julian had a look of not giving a shit, which is awesome, when you're young. I'm not saying any of this is something we thought of, I'm just saying, when I look back and I see pictures of us, I feel that energy. I was one of them and I look back and say, "I want to be one of them."

KIMYA DAWSON: I'll be walking into a store somewhere random and one of their songs will come on overhead and it paralyzes me. I get choked up thinking about those guys and how awesome they were and how fun they were to be around. They were our good friends and they busted ass and they took care of us.

CHRIS TOMSON: I feel a little bit bad for the Strokes at this point because they signed at the tail end of a certain system of doing things. And we signed during what was . . . not the beginning, but a kind of nascent time, a time of something new.

ALBERT HAMMOND JR.: There was this amazing time, before we had to record the first record, we'd play to eighty people or something like that, but no one really knew us. We could just walk around town and think, "I'm in this band, we can bring people to shows," and that was, by far, the best time. Everything was so innocent. Somehow you lose the innocence through time and through doing too much, then you spend a lot of time chasing that same innocence.

KAREN RUTTNER: I didn't like them. But even I can see they were a much bigger cultural phenomenon than any of those other bands ever were.

JAMES MURPHY: I did say the Strokes was my record of the decade. *Is This It.* Whenever people were pooh-poohing that record I was like, "You're saying that now but I guarantee you you're going to have a barbecue in ten years, play that shit, and say, 'I love this record.'"

SUROOSH ALVI: For all the talk about the Strokes, how they fucked it up, that their records suck now, there is still no one cooler. They are still the last imprint of that particular brand of rock cool. They are the last real rock stars. And live, they're still so spectacular. They don't do anything, they just stand up there and kill it. I saw them at Coachella right before that MSG show and Julian was like, "I just flew in, I don't know what the fuck is going on, I just got on my gold-plated jet." Such a bored rock star. And then he gets onstage and didn't do anything but kill it.

ACKNOWLEDGMENTS

I started working on this book in early 2012 and almost immediately began keeping notes on who I would thank should I ever manage to finish it. Like Frodo on his way to Mordor, I needed signs of hope.

"Café Delmas," I wrote in the fall of 2015, "thank you." I was referring to this restaurant in Paris where I worked on the book for a few days while tagging along with my dad on a work trip. The waiters let me spread out in a corner banquette and plug my gauche American adaptor into their elegantly grotty French plugs. They brought me radishes and salty butter and were rude to me in a way that made me feel like a real writer. "Magic yurt," I wrote in June 2015, in reference to the fancy tent in which I slept during Glastonbury that year. I charged my computer by night on the generator-powered strip in the main tent, guarded by a jolly toothless punk in Wellies and a floor-length moldy mink, so I could transcribe in the early afternoons when there was a lull in the mayhem. "Thank you, Tom Cruise," I wrote in the spring of 2013, "for making all those '90s movies" like *A Few Good Men* and *Jerry Maguire*, which work like an analgesic when I'm really spun out and need to come down. (Honorable mentions in this category go to the Kevin Costner sports trilogy: *Field of Dreams*, *Bull Durham*, and the highly underrated *Tin Cup*, as well as any filmic adaptation of a John Grisham novel). "Thank you, Taos," I wrote in January 2016, after I holed up in northern New Mexico with the pile of more than a thousand pages, which I thought was a book but, as it turns out, was not a book yet at all. (And you thought the book is long

now). "Just start at page one," I wrote on the back of a receipt from Orlando's (best enchiladas in New Mexico. Thanks, Orlando's). I made notes to thank every café and bar I wrote in as well as Jason Bourne, Maria Sharapova, and my brother's friend Fed "for that conversation in DC." (I do not remember this conversation, but apparently it helped get me through, so thanks, Fed.)

There's this line a college professor of mine used on us when we were preparing to read *Ulysses*: "You don't read it; it reads you." I didn't write this book; it wrote me. It rewrote me, more like. I was one person when I started it, and I'm someone else now that it's done. To call out everyone who helped me along my way, the fellowship of *Meet Me in the Bathroom*, would be to chronicle my whole life for the last five years. I might as well write, "Thanks to everyone who pissed me off or made me smile in my thirties thus far," and just leave it at that.

But I won't.

To my parents, Anne and Russell Goodman: Thank you for teaching me to ask questions and actually listen to the answers, and to pursue creativity and intellectualism as paths to a substantial life. Everything I am is because of you. To my brother, Jake Goodman: Thanks for always being available to remind me that I'm not cool, and thanks for all your help with the intro. You are hired for all future editorial duties. (Get psyched!) I would also like to thank Jake's wife-to-be, Sophie Sutcliffe, who appears to be willing to marry him. (You are both very lucky.) Welcome to the family, Sophie. I would also like to thank Ruth Goodman, who has been there for me since the very beginning. Thanks, Nana.

I'm writing these acknowledgments less than a month after Marc Spitz, to whom this book is dedicated, passed away. I am not yet capable of expressing what he meant to me or what he meant to this project. Because deadline calls, for the moment I'll just say, thank you, Marc. You are already missed beyond words.

Huge thanks to everyone at HarperCollins, especially my incomparable editor Carrie Thornton, who wanted to publish this book before I'd even written a proposal, and who stuck by it even though the project attempted, at one point or another, to ruin the lives of pretty much everyone who had to wrestle with it. I'm look-

ing at you, too, Sean Newcott. You are some kind of angel sent by the lit gods. Thanks also to PR powerhouse Katie Steinberg, a crucial addition to the *Meet Me* team, as well as to Susan Amster, who took a book in which rock stars talk about making their own crack and made it legally publishable.

Thanks to my agent, Daniel Greenberg, whose patience, resilience, and general tendency toward calm in the storm makes this whole being-a-writer-for-a-living thing seem almost possible.

Speaking of being a writer and the people who make it seem possible—every lunatic who decides to put words to the page for a living needs other lunatics to talk to about what a questionable choice this is. And by "talk to," I of course mean "call in a panic late at night" and/or "meet at the bar for martinis." This book would not exist without those I've-been-there lifelines provided by Rob Sheffield, Irina Aleksander, Jenny Eliscu, Maureen Callahan, Tracey Pepper, Sloane Crosley, John Heilemann, Nathan Deuel, Dan Ozzi, David Swanson, April Long, Joe Levy, and Jason Fine.

Big thanks to everyone at *ELLE,* especially Laurie Abraham, Maggie Bullock, and Rachel Baker. Thanks also to everyone at *New York* magazine, especially Lauren Kern. Special thanks also go out to Hugo Lindgren, whose unwavering support and guidance on this book and in my career for the last decade or so have often been the difference between keeping at it and bailing.

There is a small subgroup of the *Meet Me* cast who were not only willing to let me grill them about what exactly happened that night in 2002, but who also moved mountains behind the scenes get me access to other crucial voices. Imran Ahmed and Ryan Gentles believed in the book (and in my ability to write it) well before there was any evidence to support such faith. Thank you. Also thanks to Dave Sitek ("overfeel"), Paul Banks, Kim Taylor Bennett, Jonathan Galkin, Jim Merlis, Ken Weinstein, and Thomas Onorato who generally vouched for me (to others, and to myself when the doubt kicked in) throughout this insane process.

Thanks to the extraordinary photographers who allowed me to use their images, especially Nick Zinner, Colin Lane, and Ruvan Wijesooriya, and those artists who opened up their private collections of snapshots and memorabilia.

I conducted hundreds of interviews for this book. I'd like to thank everyone who generously donated their time, as well as the members of their teams who worked tirelessly behind the scenes to set up interviews. I especially want to shout-out those people I interviewed who don't appear in the cast of characters. Your names may not be listed but your influence is deep. Thank you.

A small army of interns and transcribers sweated blood for this opus: Eva Hendricks, Joseph Staten, Jenn Arko, Nicholas Das, Derek Pierce, and Jodi Gerver, thank you guys. Especially giddy thanks to Ms. Maggie Rogers, who I hired as one of the book's interns when she was a freshman at NYU, who transcribed literally hundreds of hours of often-drunken blathering in often-very-loud bars, who became more like my assistant editor than anything else, and who somehow found time during all that to graduate from college and become a rock star. Mags, it was fate.

Huge thanks to my West Tenth Street family: Shaun Cottle, Dusty Hollensteiner, Laura Connors, Christian Ellermann, Shino Moffitt, Kerrilynn Pamer, and John Von Pamer.

And to my chosen family, Niki Kanodia, Ariel Ashe, and Jillian Pena: You are my sisters. Thank you for being witnesses to my life and for allowing me to witness yours. Sarah Lewitinn, the queen of beneficent debauchery, thank you for spending the better part of two decades trying to teach me how to make out. (Don't give up!) I am forever your humble plus one. Ms. Katie Tunstall, aka Rat 1, here's to finding each other in the rubble and rebuilding it all together. Thank you for offering me respite when I really needed it and for seeing the bigger picture when I can't seem to. Alexander, keeper of Rats, I always needed a big brother; it's about time you showed up. Thanks also to Carrie and Ezra Firestone, Tiiu Kuik, Eleanor Friedberger, Chris Sellers, Milton Carter, Leslye Headland, Whitney Cummings, Nadya Tolokonnikova, Mike Berens (thanks for that life-changing mixtape), David Modigliani, Michelle Guzman, Alison Cramer, Sam Simon, Eliot Sumner, Ed O'Brien and Susan Kobrin (for inviting me into the tribe), and of course, Mr. John Gray—sorry, but somewhere around 1996 you earned yourself the right to be thanked for everything I write forever and ever.

Throughout the writing of this book, I kept insisting that it didn't belong to any one person or band. It wasn't Karen O's story or James Murphy's or Dennis Cahlo's or Sarah Lewitinn's or the Strokes'. I kept saying that the main character was New York City, which is itself a kind of mirage. New York is an apparition generated by those who come together to breathe life into something not quite temporal, something that has to be conjured. And it's not possible without the particular alchemy generated when every last person who happens to be there at that precise moment—the famous and the anonymous—come together serendipitously. So, finally, thank you to everyone who was there. And to everyone who wishes they had been. This book is for you.

INDEX

NOTE: Page references in italics refer to photos.

A

Above the Right Bank (club), 310
Adams, Ryan
 Gentles as manager of, 377–384, 389–395
 Heartbreaker, 409
 on New York's appeal, 5
 Oberst and, 466
 Strokes and, 131, 223, 225, 325, 326, 331, 517
 on Vines, 350
 White Stripes and, 325
Adebimpe, Tunde
 Brooklyn music scene and, 95, 373, 397, 484, 579–580, 583
 on Internet and music industry, 454
 on Jonathan Fire*Eater, 19
 on 9/11 terrorist attacks, 198–199, 203, 205, 207
 TV on the Radio's formation, 299, 300–302, 303–304, 305, 311
 on UK bands, 354
Ahmed, Asif
 on Karen O's role in Yeah Yeah Yeahs, 166, 443, 487, 488, 489–491, 492, 493
 on "Maps" (Yeah Yeah Yeahs), 296, 297, 298
 on New York/Brooklyn music scene, 94
 on 9/11 terrorist attacks, 204–205
 Rapture and, 278, 279, 280, 281
 Yeah Yeah Yeahs' early success, 229, 230, 231, 233–234, 235–237, 294, 295
 on Yeah Yeah Yeahs' image, 246, 247
 Yeah Yeah Yeahs' management by, 167, 271–274

Ahmed, Imran
 on blogs, 336, 339
 Franz Ferdinand and, 353, 354, 357
 on Internet and music industry, 531
 on Kings of Leon, 411–412
 on New York/Brooklyn music scene, 579, 582
 at *NME*, 335
 Vampire Weekend and, 533, 535, 554–555, 556, 560
 on Vines, 348, 349
Air America, 462–463
Almqvist, Pelle, 345, 346, 347, 350
Alvi, Suroosh
 on Brooklyn music scene, 93, 95, 96, 97, 98–99, 580, 581
 on "House of Jealous Lovers" (Rapture), 278, 281
 on "Maps" (Yeah Yeah Yeahs), 296
 on 9/11 terrorist attacks, 205
 on Plant Bar, 87
 on Strokes' influence, 591
 on Walkmen, 541
 on Williamsburg, 397, 400
 on Yeah Yeah Yeahs, 231, 232, 271, 272
Andrew, Angus
 on Brooklyn music scene, 307, 308
 Karen O and, 235–236, 308, 445
 on New York's appeal, 3
 on 9/11 terrorist attacks, 202, 207
 on Twisted Ones, 309
 on Yeah Yeah Yeahs' fame, 296
Angles (Strokes), 522
Antics (Interpol), 261, 447–452, 453, 497
Arcade Fire, 336, 519
Arctic Monkey, 349, 533
Aronofsky, Darren, 54, 56, 89
Atlantic Records, 410

B

Back to Black (Winehouse), 189–190

Baio, Chris
on Internet and music industry,
453
Vampire Weekend's formation
and, 528, 530, 531, 535, 536,
537
Vampire Weekend's image and,
543, 544, 548
Vampire Weekend's management
and, 554, 555, 556, 557
Vampire Weekend's success and,
559

"Bang" (Yeah Yeah Yeahs), 167, 235

Banks, Paul
Antics (Interpol) and, 448, 450, 451
on Darkroom, 320
on Internet and music industry,
453, 454
Interpol formation and, 119,
120–121, 155, 156, 157
Interpol's early success and,
240–241, 243, 244
Interpol's image and, 318, 319,
320, 321, 322–323
on Interpol's interband dynamics,
495–496, 497–498, 499, 500,
571, 572, 573
Interpol's recording sessions and,
259–261
Jonathan Fire*Eater and, 14, 19,
20, 21
9/11 terrorist attacks, 197, 198,
200
on older bands' perspective, 575
on "selling out," 501, 509, 510
at Sidewalk Cafe, 145
singing voice of, 260–261
Strokes and, 126, 186, 213, 221
TV on the Radio and, 299
on UK bands, 357, 358

Bar 13, 41, 126

Barât, Carl, 187

Barber, James
Gentles, Adams, Strokes, and,
380, 389, 392, 394

on Internet and music industry,
81–82
on "selling out," 501, 503, 504–
505, 507, 509

Baron, Jason, 243–244, 320, 321, 322,
323

Barrymore, Drew, 44, 226–227, 516

Batmanglij, Rostam
on Brooklyn music scene, 578
on *Room on Fire* (Strokes), 436
on "selling out," 501
Vampire Weekend and Dirty
Projectors, 551, 552
Vampire Weekend's formation and,
528, 529–530, 531, 534, 535
Vampire Weekend's image and,
438, 543, 544, 545, 546

Bauer, Pete, 540, 541, 542

Bear, Chris, 310

"Beat Connection" (LCD
Soundsystem), 285, 286, 289, 432

Beck, Brian, 554

Bell, Laurence, 354

Bennett, Kim Taylor, 184, 409, 410,
449, 450, 451, 522, 571

Berlinium, 101, 102, 103

Berninger, Matt
Interpol and, 499
Jonathan Fire*Eater and, 20
National's formation and, 311–313,
314
on New York/Brooklyn music
scene, 4, 5, 476, 484, 579, 581
Strokes and, 126

Bernstein, Nils, 240, 244, 317, 318,
451, 452, 574

Bezozi, Alan, 403

Birdland, 374

"Bitches" (L'Homme Run), 535

Bit of a Blur (James), 558

Black Dice, 399, 401

Blackwell, Ben, 220, 325, 326, 335,
378, 405, 421

Blair, Selma, 476

Bloc Party, 449, 474

blogs/bloggers, 335–344. *see also*
Blackwell, Ben; Gordon, Jason;

Lapatine, Scott; Lewitinn, Sarah;
Neustadter, Audrey; Young, Laura
Blue CD-R (Vampire Weekend), 554,
559
Blues Explosion, 235, 236
Bowersock, J. P.
on freak folk, 141
on *Room on Fire* (Strokes), 433,
435, 436
on Strokes' guitar instruction,
130–131
on Strokes' music production, 387,
388
Strokes' promotion and, 123–124
Bowery Ballroom, 239–240
Bright Eyes, 465, 467
Brodie, Tyler
DFA and drug use, 63, 64
DFA and Murphy-Goldsworthy
partnership, 70, 71
DFA inception and, 52, 53–54, 59,
61
DFA-Rapture contract and, 264,
265, 266, 267
"House of Jealous Lovers"
(Rapture) and, 277–278,
279–280, 282–283
"Losing My Edge" (Murphy) and,
286
on Murphy-Goldsworthy fallout,
430, 441, 567, 568
Plantain Records and, 71
on Plant Bar, 88
Brooklyn music scene. *see* New York
City; *individual names of clubs*
Brownies (club), 40, 41, 52, 233, 234
Bunton, Jaleel
Brooklyn music scene and, 97, 580,
582
on DFA inception, 55
on Interpol's interband dynamics,
497, 498
on Jonathan Fire*Eater, 20, 21
on New York's appeal, 3–4
Pleasure Unit and, 299
on rock star appeal, 155
on Strokes, 220

TV on the Radio's formation, 299,
300, 302–303, 304, 305, 311
TV on the Radio's image and,
547–548
on UK bands, 355
on Yeah Yeah Yeahs, 138, 296,
297, 493
Bunton, Kareem, 20, 31, 299, 497
Burton, Dave
on Jonathan Fire*Eater formation,
18, 19
on Karen O's role in Yeah Yeah
Yeahs, 445, 487
"Maps" (Yeah Yeah Yeahs)
produced by, 297
White Stripes and, 175
on Yeah Yeah Yeahs' early fame,
293–294, 295–296
Yeah Yeah Yeahs' formation and,
168
on Yeah Yeah Yeahs' image, 245,
248

C

cabaret laws, 373–376
Café Noir, 159–160
Cahlo, Dennis, 18, 40, 131, 132, 137,
539
Can, 57, 64, 70, 286
Candy Darlings, 175
"Cape Cod Kwassa Kwassa" (Vampire
Weekend), 544, 554, 555, 559
Capitol, 501, 573
Casablancas, John, 171, 221
Casablancas, Julian
drinking by, 518
early jobs of, xv
Gentles's management of Adams
and Strokes, 377, 382–383
on Hives, Vines, White Stripes,
and Strokes' influence, 345
image of, 221
Kings of Leon and, 413
Libertines and, 187, 188
at Madison Square Garden, 591
marriage of, 519–520
Mooney Suzuki and, 39, 40

Casablancas, Julian (*continued*)
 on 9/11 terrorist attacks, 197, 199,
 201
 photo, *106*
 at Plant Bar, 91
 Room on Fire (Strokes) and, 433,
 434–435
 on Spektor, 404
 Strokes, Spektor, Kings of Leon
 tour, 419, 420, 421, 422
 Strokes and Adams, 390, 391,
 392–393, 394, 395
 Strokes and RCA, 172, 174
 Strokes and White Stripes, 325,
 326, 330
 Strokes' early success and, 148,
 149, 152, 162
 Strokes' formation and, 109–110,
 111, 112, 113, 114, 115, 116,
 117
 Strokes in UK, 184
 Strokes' lifestyle and, 131, 132,
 133, 134
 Strokes' management and, 127
 Strokes' music and, 129, 287
 Strokes' post-9/11 popularity and,
 222, 223, 224
 Strokes' interband dynamics, 514,
 515, 518–519, 520–521, 523
 Strokes' promotion and, 124, 126
 at *$2 Bill* show, 251, 252, 253,
 257
 VMAs and, 332
Casablancas, Juliet Joslin, 152, 222,
 513, 519–520, 524–525
CBGB's, 7, 40, 153, 194, 333, 530
Challenge of the Future, 137
Chase, Brian
 early Brooklyn music scene and, 94
 Karen O's role in Yeah Yeah Yeahs
 and, 489, 490
 photo, *370*
 TV on the Radio formation and,
 299
 White Stripes and, 177, 181
 Yeah Yeah Yeahs' formation and,
 138, 139, 166

 Yeah Yeah Yeahs' management
 and, 272
 Yeah Yeah Yeahs' success and, 229,
 296, 311, 563, 564–565
Chearno, Justin, 85
!!!, 400, 428, 579
Chen, Kris, 555
Christensen, Shawn, 45
Club Luxx, 101–102
Coachella, 225, 226
Cocker, Jarvis, 475
Coen, Jessica, 478
Cohen, Lyor, 279, 281
Copeland, Bjorn, 78
Coppola, Roman, 435
Cornerstone, 333–334
Cosloy, Gerard, 241, 242, 305, 311
Cross, David
 on Casablancas's marriage, 520
 on Interpol, 323
 Strokes and, 221, 222, 223, 224,
 225, 226
 on Yeah Yeah Yeahs, 231, 232
Crossroads, 523
Cure, 447, 448
Curiosa tour, 447, 449

D
Darkroom, 320, 321
"Darts of Pleasure" (Franz Ferdinand),
 353–354
Davies, Derek, 554
Dawson, Kimya
 Moldy Peaches' contract with
 Rough Trade, 191
 Moldy Peaches' formation and,
 141, 142, 143, 144, 145, 146
 on 9/11 terrorist attacks, 201
 Strokes and, 130, 144, 150, 211,
 221, 590
"Dead Leaves and the Dirty Ground"
 (White Stripes), 328
De Cadenet, Amanda, 184–186,
 254–255, 256, 383
Deitch, Jeffrey, 103
Dengler, Carlos
 Antics (Interpol) and, 448, 450, 451

DJing by, 399
Interpol's formation and, 121,
 156–157, 242, 243–244
Interpol's image and, 319, 320
Interpol's recording sessions and,
 259–260, 261
Interpol's split with, 495, 498,
 571–575
Killers and, 364
Desaparecidos, 467
Dessner, Aaron, 311, 312, 314,
 484–485
De Stijl (White Stripes), 177, 327
Deutsch, David, 63
Devendorf, Scott, 20, 311–312, 313,
 314, 540
DFA. *see also* Brodie, Tyler; Galkin,
 Jonathan; Goldsworthy, Tim;
 Murphy, James
 drug use by, 63–66
 electroclash and Fischerspooner,
 75–80
 formation of, 47–50, 51–61, 504,
 506
 as Manhattan-centric, 94
 Murphy and LCD Soundsystem
 formation, 285–291, 429, 430,
 431, 432
 Murphy-Goldsworthy fallout,
 439–442, 567–570
 Murphy-Goldsworthy partnership,
 67–73
 Rapture and, 85, 263–269,
 275–284
Dick, Andy, 223
Dirty Projectors, 551
Dishel, Jack, 145
Dixie Chicks, 469–470
Doherty, Pete, 187
Domino, 354
Don Hill's (club)
 Killers at, 367
 LCD Soundsystem played at, 289
 popularity of, 41, 43, 44, 45
 Strokes at, 126, 133
 Yeah Yeah Yeahs at, 237
Doves, 3, 169, 171, 172, 239–240

DreamWorks, 34, 421
Droste, Ed
 on Brooklyn music scene, 308,
 400, 476, 484, 485
 Grizzly Bear's formation and, 307,
 313–314
 on 9/11 terrorist attacks, 205
 Vampire Weekend and, 559
drugs
 addiction/use by Strokes members,
 220–221, 255–256, 389–395,
 516, 518, 521–525
 after 9/11 terrorist attacks, 206
 Brooklyn music scene and cocaine,
 92, 98
 ease of buying, 93
 ecstasy and raves, 48
 ephedra, 149
 heroin use in New York clubs,
 18
 Jonathan Fire*Eater and, 29–31,
 35–36
Durkacz, Walter, 3, 16, 25, 26, 32–34,
 35, 36

E
Echoes (Rapture), 275, 277, 279,
 280–281, 283, 285
electroclash, 75–80, 102, 104–105
Elektra Records, 34
Eliscu, Jenny
 on Gentles's management of
 Adams and Strokes, 382
 on Hives and Vines, 350
 on Jonathan Fire*Eater, 13, 31, 32,
 35, 36
 on Kings of Leon, 405, 407–408,
 411
 on Misshapes, 471
 on Moldy Peaches, 143, 144, 145
 on New York music scene, 10, 41,
 42, 43, 44, 46, 132
 on Oberst, 465
 on Spektor, Kings of Leon, 419,
 423–424
 on Strokes' interband dynamics,
 513

Eliscu, Jenny *(continued)*
 on Strokes' success, 124, 128, 147,
 150, 152, 209, 214–215, 216,
 224, 437
 on Vampire Weekend, 527,
 528–529, 533, 554, 556, 559,
 560, 561
 White Stripes and, 327, 329, 330,
 331, 333–334
Elite Modeling Agency, 115, 116, 123
Elliott, Rennie, 167, 177
"Emerge" (Fischerspooner), 104, 105
EMI, 272, 279, 283, 285, 288, 430
Endeacott, James, 128, 185–186, 290,
 358, 393, 395
End of the Century (documentary),
 459–460
Ertegun, Ahmet, 410

F
Face (magazine), 341
Factory, 7, 76, 147
Fallon, Jimmy, 221–222
Fateman, Johanna, 290
Felix da Housecat, 91, 277
"Fell in Love with a Girl" (White
 Stripes), 327
Fever to Tell (Yeah Yeah Yeahs), 293,
 303, 443, 444, 491, 564
Fiery Furnaces, 192
Finn, Craig, 149, 210, 211
First Impressions of Earth (Strokes), 515,
 516, 521, 522
Fischer, Warren. *see also* Fischerspooner
 DFA and Fischerspooner, 75–80
 on DFA formation, 53
 on DFA-Rapture contract, 269
 on Murphy-Goldsworthy fallout,
 442
 on record company contracts, 104
Fischerspooner
 DFA and, 75–80
 "Emerge," 104, 105
 money made by, 102, 103, 104
Flowers, Brandon, 361, 362, 363,
 364–365, 367, 368, 474
"Flowers, The" (Spektor), 404

Fogarino, Sam
 Antics (Interpol) and, 447,
 448–449, 450
 Brooklyn music scene and, 98
 on Capitol, 573
 Interpol formation and, 155, 156,
 157
 Interpol's early success and, 241,
 242, 244
 on Interpol's image, 319
 on Interpol's interband dynamics,
 496, 497, 498–500, 571–572
 Interpol's recording sessions and,
 259, 260, 261
 on Matador, 573–574
 on 9/11 terrorist attacks, 194, 197,
 205–206
 Strokes and, 214
 on UK bands, 358
Followill, Betty Ann, 409, 411
Followill, Caleb
 on Ryan Adams, 378
 on Strokes, Spektor, Kings of Leon
 tour, 421, 422, 425
 Strokes and Kings of Leon,
 186–187, 405–406, 407, 408,
 410, 411, 412, 413
 on Strokes and White Stripes,
 330
 on Strokes' interband dynamics,
 518
Followill, Jared, 408, 410, 411, 422,
 423–424
Followill, Nathan, 403, 406–408, 409,
 410, 411, 412, 422, 423
Fraiture, Nikolai
 on Mooney Suzuki, 39, 40
 photo, *106*
 Strokes, Spektor, Kings of Leon
 tour, 421, 422
 Strokes and Adams, 394
 Strokes' formation and, 109–110,
 111, 114, 116
 Strokes' image and, 134
 Strokes' music and, 128
 Strokes' interband dynamics, 516
 Strokes' promotion and, 123, 125

Strokes' success and, 143, 160, 163
Franz Ferdinand, 353–355, 357–359, 460, 474, 590–591, 592
freak folk, 140, 141–146
Friedberger, Eleanor
 Brooklyn music scene and, 94–95, 98, 308, 310–311, 580–581, 592
 Fiery Furnace's formation and, 315
 on New York's appeal, 4–5
Friends (television show), 317
Frost, Sadie, 424
Future Days (Can), 286

G

Galkin, Andy, 58
Galkin, Jonathan
 DFA and Rapture, 266, 267, 269, 277, 279, 280, 283–284
 DFA formation and, 49, 52, 54, 58, 69–70, 71
 on DFA split from Goldsworthy, 439–440, 441, 442, 567, 568, 569
 LCD Soundsystem formation and, 285, 287, 288, 289, 428, 429, 430, 431–432, 588
 on NYC gentrification, 460
 on "selling out," 502
Gap, 509
Gawker, 478
Geffen Records, 34, 35, 126, 504–505
Geist, Morgan, 276
Gentles, Ryan
 management of Adams by, 377–384, 389–395
 management of Strokes by, 126–128 (*see also* Strokes)
 on Mooney Suzuki, 39
 on 9/11 terrorist attacks, 201
 Sean Lennon and, 330
 on "selling out," 509–510
 on Strokes, Spektor, Kings of Leon tour, 403, 404, 413, 419–420, 421, 425
 on Strokes and White Stripes, 325, 330, 332–333
 Strokes' early success and, 135, 148, 149, 150, 152, 153, 161, 162

Strokes' formation and, 113
Strokes image and, 131
Strokes in UK and, 188, 189
Strokes' music production and, 385–386
on Strokes' post-9/11 success, 209, 221, 225, 226
on Strokes' interband dynamics, 514, 515, 519–520, 521, 524
on Strokes' promotion, 124
Strokes' recording contract with RCA, 169, 171–172, 173–174
$2 Bill show and, 251, 252, 253, 254–255
Vampire Weekend and, 527, 556, 557
Girl Harbor, 45
Girls Against Boys, 237
Glasslands, 555
Go, 42
Godrich, Nigel, 386–388
Gold (Adams), 378, 389
Goldsworthy, Jen, 42, 64, 264, 431, 441, 569, 570
Goldsworthy, Tim
 Brooklyn music scene and, 102, 485
 DFA and drug use, 64, 65, 66
 DFA formation and, 47, 48, 51, 55, 57, 59, 61
 DFA-Rapture contract and, 85–86, 263, 264, 265–266, 267, 268, 269
 DFA split from, 439–442, 567–570
 early career of, xv
 "House of Jealous Lovers" (Rapture) and, 278, 279, 281–282, 284
Goldsworthy, Tim
 Murphy and, 67–73, 105, 288, 429, 430, 431, 432, 439–442, 567–568, 570, 588
 on Plant Bar, 89, 92
 on record company contracts, 103–104
Goodman, Lizzy, xiv–xvii

Good Weather for Airstrikes (blog), 554
Goodwin, Jimi, 3, 398
Gordon, Jason
 blogging by, 336, 339, 341, 342, 344
 on Internet and music industry, 82
 on Jonathan Fire*Eater, 13, 27, 32, 33, 36
 on 9/11 attacks, 194
 on NYC clubs, 45
 on Rapture, 275
 on Strokes, 125, 135, 209
 on Walkmen, 539
 on Yeah Yeah Yeahs, 235
Gordon, Kim, 272–273, 501, 503, 504, 505
Gottlieb, Dave
 on alternative music, 47
 on Internet and music industry, 82, 83, 453, 454
 on New York music scene, 8
 on 9/11 terrorist attacks, 201, 462
 on *Room on Fire* (Strokes), 434, 435, 436
 on "selling out," 505, 510–511
 on Strokes, 169–170, 171, 172, 211–212, 516, 517–518
 on *$2 Bill* show, 252, 253
Gravity Records, 86, 87
Great EP, The (Interpol), 157
Green, Adam
 on electroclash, 78
 on freak folk, 141
 Hives and, 188
 Libertines and, 187
 management of, 377, 382
 Moldy Peaches, post-9/11 attacks, 210
 on Moldy Peaches' contract with Rough Trade, 191
 Moldy Peaches formation and, 142, 143–144, 145, 146
 on Moldy Peaches in UK, 193
 Strokes and, 117–118, 150, 151, 183–184, 212, 390, 589
 Yeah Yeah Yeahs and, 140

Green, Isaac, 346
Greenwald, Andy
 on Brooklyn music scene, 579, 582
 on Guided by Voices, 427
 on image of bands, 548, 549
 on Internet and music industry, 83
 on Interpol, 240
 on LCD Soundsystem and DFA, 287, 291, 429
 on music journalism and blogs, 337, 338, 339
 on Rapture, 275
 on "selling out," 511–512
 on Strokes' success, 433
 on Vampire Weekend, 529, 536, 559, 561
 on Yeah Yeah Yeahs, 296
Grizzly Bear
 Brooklyn music scene, 484–486
 formation of, 307–310
Guccione, Bob, Jr., 214
Guided by Voices, 172, 173, 225, 427, 505

H
Habacker, Camille, 216
Habacker, James, 47, 49, 109, 216, 373–374, 375
Halloween show (2001; Strokes), 209–212
Halsey House, Dirty Projectors and, 551–553
Hammerstein (club), 209–212
Hammond, Albert, Jr.
 addiction of, 390, 391–392, 395, 516, 521–525
 Jonathan Fire*Eater and, 24
 Moldy Peaches and, 144
 Mooney Suzuki and, 40
 9/11 terrorist attacks and, 197, 199, 201, 220, 221, 222, 223, 224, 225
 photo, *106*
 Strokes, Spektor, Kings of Leon tour, 421–422
 Strokes' early success and, 135, 147, 149, 160

Strokes' formation and, 113,
115–116, 117, 118
Strokes' Halloween show (2001),
211˙
Strokes' image and, 131, 132–133,
134
on Strokes' influence, 590
Strokes in UK, 183, 184, 187
Strokes' management and, 127,
128, 377, 380, 381–382, 383
Strokes' music and, 129–130
on Strokes' interband dynamics,
515, 516, 520, 521–522,
523–524, 525
Strokes' promotion and, 123, 124
Strokes' recording contract with
RCA, 172, 174
$2 Bill show and, 251, 252, 253, 254
White Stripes and, 330, 333
Hammond, Albert, Sr., 124
Happy Birthday Hideout, 308
Harry, Debbie, 233, 459
Headgear Studio, 489
Headon, Topper, 348
Heartbreaker (Adams), 378, 409
Heilemann, John
on hip-hop, 9
on Internet and music industry, 81,
82–83, 453, 455, 456–457
on music journalism and blogs,
335, 338, 339, 342
9/11 terrorist attacks and, 200,
203–204
on *Room on Fire* (Strokes), 436
Henderson, Doug, 156–157
Hickey, Matt, 135
Highly Evolved (Vines), 347–348
Hince, Jamie, 34
Hirschorn, Michael, 82, 337
Hives, 188, 332, 333, 345–351
Hold Steady, 398
Holmes, David
DFA and drug use, 63, 64, 65, 66
DFA formation and, 59–61
Murphy compared to, 429
Murphy-Goldsworthy partnership
and, 68–73, 288–289

"Holy Roller Novocaine" (Kings of
Leon), 412
Horovitz, Adam, 55, 287
"Hotel Yorba" (White Stripes), 327, 328
House of Blues (Las Vegas), 256
"House of Jealous Lovers" (Rapture),
263, 264, 265, 275–284, 290, 356

I

In Alphabet City (Kern), 26
Index magazine, 102
"In Her Prime" (Strokes), 128
Internet Vibes (blog), 529
Interpol. *see also* Banks, Paul; Dengler,
Carlos; Fogarino, Sam;
Kessler, Daniel
Antics, 261, 447–452, 453, 497
blogs about, 338, 340, 341,
343–344
Capitol recording contract, 501
early Brooklyn music scene and,
95, 97
early success of, 239–244, 317–318
formation of, 119–121, 155–158
Franz Ferdinand and, 357, 358
The Great EP, 157
image of, 239, 243, 317–323
interband dynamics, 495–500,
571–575
Jonathan Fire*Eater's influence on,
33
9/11 terrorist attacks and, 206, 212
Our Love to Admire, 500, 571, 573,
575
at Plant Bar, 90
recording by, 259–262
Spin feature on, 314
Turn on the Bright Lights, 244,
259–260, 261, 317, 358, 447,
452
"Interracial Dating" (L'Homme Run),
535
Interscope, 272, 273
Iovine, Jimmy, 273, 281
Island Def Jam, 343, 344
I Spent a Week There the Other Night
(Tucker), 30

Is This It (Strokes)
 Adams and, 378
 influence of, 363, 589, 591
 recording of, 129, 173, 223,
 403
 release of, 201, 209, 212, 219
 rights to, 172
 success of, 385
It's Blitz! (Yeah Yeah Yeahs), 563

J

Jackson, Janet, 283–284
James, Alex, 557
James, Sammy, Jr., 40–41
Jamieson, Bob, 410
Jay Z, 9, 499
Jenner, Luke
 on DFA formation, 51
 DFA-Rapture contract and, 85,
 86–87, 263, 264, 265, 267
 on Go, 42
 "House of Jealous Lovers"
 (Rapture) and, 275, 276–277,
 280, 282, 283
 on LCD Soundsystem, 285–286,
 427
 on New York/Brooklyn music
 scene, 3, 4, 93, 373, 375, 376
 on 9/11 terrorist attacks, 192,
 194
 on Plant Bar, 89–90, 91
 on UK bands, 356
"Jenny Was a Friend of Mine" (Killers),
 365, 366–367
Jive Records, 284
Johns, Ethan, 7, 409, 410
"Jolene" (White Stripes), 327
Jonathan Fire*Eater
 breakup of band, 36–37
 drug use and, 29–31, 35–36
 formation of, 13–21
 influence of, xvi
 Lupton and, xviii
 management of, 23–28
 recording contracts of, 31–35
 Walkmen and, 539–542
Jonze, Spike, 488

Joy, Christian
 Karen O's costumes by, 246–247,
 248
 on Karen O's role in Yeah Yeah
 Yeahs, 443, 444, 446, 492–493
 on New York's appeal, 4
 on Yeah Yeah Yeahs' early success,
 234
 Yeah Yeah Yeahs' formation and,
 139, 166
Joy Division, 317, 318
Justine D
 on freak folk, 141
 Interpol's early success and, 239,
 243
 on Jonathan Fire*Eater, 23
 "Losing My Edge" (LCD
 Soundsystem) and, 289
 on Misshapes, 471, 477, 478
 on Mooney Suzuki, 39
 on New York clubs, 43, 44, 45–46
 Strokes and, 125, 126, 191
 on UK bands, 355
 on Yeah Yeah Yeahs' early success,
 231

K

Kahne, David, 515
Kaplan, Dave, 175, 178, 179
Kapranos, Alex
 Franz Ferdinand popularity in UK,
 354–355, 356, 357, 358, 359
 on LCD Soundsystem, 428
 on New York/Brooklyn music
 scene, 98, 373, 581
Karelia, 354
Karen O
 early career of, xv
 Face profile, 341
 fall from stage by, 443–446
 Jonathan Fire*Eater and, 13, 14, 27
 Killers and, 364
 "Maps" (Yeah Yeah Yeahs), 296,
 297, 298
 move to L.A. by, 487–493
 on New York/Brooklyn music
 scene, 4, 5, 40, 95, 96, 98, 308

on 9/11 terrorist attacks, 198, 199, 443

photo, *370*

on Plant Bar, 91

Strokes and, 220, 513

TV on the Radio and, 299, 301, 303

voice of, xix

White Stripes and, 175, 177, 179, 180

writing by, 229

Yeah Yeah Yeahs' continuing success, 563, 564, 565, 566

Yeah Yeah Yeahs' early success, 229, 230, 231, 232, 233–235, 236, 237–238, 293–296

Yeah Yeah Yeahs' formation and, 137, 138, 139–140, 165–167, 168

Yeah Yeah Yeahs' image and, 245, 246–247, 248–249, 307, 311, 548

Yeah Yeah Yeahs' influence, 577–578

Yeah Yeah Yeahs' management and, 272–274

Katis, Peter, 120, 259, 317, 447, 575

Kaye, Lenny, 129

Keegan, Dominique

DFA formation, 48, 51, 52, 54, 55, 56, 57, 58, 59, 61, 68, 71

DFA-Rapture contract and, 264, 269

"House of Jealous Lovers" (Rapture) and, 275, 276, 277, 282, 283

on Internet and music industry, 81

LCD Soundsystem and, 285, 286, 287

on New York/Brooklyn music scene, 29, 30, 64, 93, 373, 374, 375–376

on Plant Bar, 87, 89, 90, 91–92

Rapture and, 87

Kern, Richard, 26

Kessler, Daniel

Antics (Interpol) and, 447, 449, 450, 451

Franz Ferdinand and, 357

on Internet and music industry, 453, 454

Interpol's formation and, 112–113, 119, 120, 121, 155, 156, 157–158

Interpol's image and, 318, 319

Interpol's problems and, 495, 498, 500, 571

Interpol's recording sessions and, 260, 261

Interpol's success and, 240–241, 242, 317, 573, 574, 575

on Jonathan Fire*Eater, 14, 27, 33, 36, 37

on LCD Soundsystem, 427

on music journalism and blogs, 338–339

on New York/Brooklyn music scene, 10, 40, 95, 96, 192

Strokes and, 149, 214

on UK bands, 358

Keuning, Dave, 362

Kid Capri, 332

Kiley, Kelly

on Strokes' interband dynamics, 519

Rough Trade and, 148

on Strokes' drug use, 391

on Strokes' early success, 147

on Strokes' image, 124, 125, 126, 160, 161, 162, 253

Strokes in UK with, 183, 184–185, 186, 415

Killers, xvi, 191–192, 343, 361–369, 474, 491

Kings of Leon

influence of, xvi

tour with Strokes, 405–413, 419–425, 519

Knoxville Girls, 178

Koenig, Ezra

on Brooklyn music scene, 578–579

on Internet and music industry, 455

Vampire Weekend and Dirty Projectors, 551, 552, 553

Koenig, Ezra *(continued)*
 Vampire Weekend's formation and,
 527–528, 529, 530, 531, 532, 533,
 534–536
 on Vampire Weekend's image, 543,
 544, 545, 546, 548
 Walkmen and, 539, 541–542
Kokie's (club), 98
Krasnow, Bob, 32, 33
Krelenstein, Greg, 472, 475

L
Lambkin, Marcus
 on DFA and drug use, 63, 64, 65,
 66
 on DFA formation, 51, 54, 55, 56,
 57, 58, 60–61, 67
 on LCD Soundsystem, 287, 428
 on Murphy-Goldsworthy fallout,
 439, 440, 441, 569
 Plant Bar and, 87–88, 90, 91
 Shit Robot and, 269
Lapatine, Scott, 336, 342, 344,
 559–560
"Last Nite" (Strokes), 130
Lavelle, James, 58
La Zona Rosa, 245–249
LCD Soundsystem
 "Beat Connection," 285, 286, 289,
 432
 formation of, 269, 427–432
 influence of, xvi
 "Losing My Edge," 269, 285–291,
 356, 428, 430
 at Madison Square Garden, 584,
 587–588
 Murphy-Goldsworthy fallout,
 439–442, 569
 in Scotland, 356
 Sound of Silver, 587–588
 This Is Happening, 291
 Williamsburg (Brooklyn) music
 scene and, 399
Lee, Jeannette, 160, 161, 187, 188,
 189
Lennon, Julian, 515
Lennon, Sean, 330

Let's Get Killed (Holmes), 60
Letterman, David, 349
Levitan, Ken, 405
Levy, Joe
 on Interpol, 318
 on New York City gentrification,
 459–460, 463
 on Oberst, 466–467
 on Strokes, 123, 129, 215–216
 on Yeah Yeah Yeahs, 232, 233,
 234, 235, 246, 298
Lewitinn, Sarah
 on *Antics* (Interpol), 447, 448, 449,
 451–452
 on blogs and blogging, 336–337,
 338, 342, 343–344
 on Darkroom, 321
 on Interpol's success and lifestyle,
 239, 243, 261–262, 317, 320,
 496
 on Killers, 362, 364, 365, 366–367,
 368
 on Misshapes, 471, 472
 Moby and, 132
 on Muse, 216
 on New York City gentrification,
 460
 on 9/11 terrorist attacks, 205
 at *Spin*, 343–344
 on Strokes, Spektor, Kings of Leon
 tour, 419
 on Vines, 346, 349
Lezark, Leigh, 471, 472, 473, 475, 476,
 477, 478, 479
L'Homme Run, 535
Liars, 91, 235, 236, 274, 278, 303, 304.
 see also Andrew, Angus
Libertines, 187–190, 321, 348
Life (club), 43
Light, Alan
 on Adams, 378
 on Internet and music industry,
 454
 on music journalism and blogs,
 337–338, 343
 on New York/Brooklyn music
 scene, 9, 459

on Prodigy, 49
on "selling out," 501
on Strokes, 214, 217
Lipez, Zack, 19, 40, 175, 176, 178
Lit (club), 132, 239, 330, 466, 472
Livid festival, 443–446
Lombardi, Chris, 19, 241–242, 243,
 477, 503, 504, 505–506, 507
Long, April
 on Interpol, 119, 239, 243, 452
 on New York/Brooklyn music
 scene, 45, 460, 461–462, 578,
 580
 on Oberst, 466, 467
 on Strokes, 161, 186, 213, 219,
 256
 on Vampire Weekend, 545
 on Yeah Yeah Yeahs, 234, 246,
 247, 487–488, 490
Long, Brian, 433
 on DFA, 52, 63, 68
 on Gentles' management of
 Adams and Strokes, 382
 on Interpol, 121, 240, 243
 on Rapture, 263
 on Rough Trade, 147
 on Strokes, 126, 170–171
 on Vampire Weekend, 546
 on Yeah Yeah Yeahs, 137
Longstreth, Dave, 309–310, 484, 485,
 508, 551, 552
Longwave, 10, 348, 433
"Losing My Edge" (LCD
 Soundsystem), 269, 285–291,
 356, 428, 430
Love, Courtney, 248–249, 253–254,
 380, 381–382, 392, 492
Love Life, 302
Luna Lounge (club), 39, 40, 129–130,
 134
Lupton, Stewart
 on drug use, 30, 31
 Jaleel Bunton and, 497
 on Jonathan Fire*Eater's breakup,
 36
 on Jonathan Fire*Eater's
 formation, 14, 15, 17, 18, 19, 20

on Jonathan Fire*Eater's lifestyle
 and management, 23–25, 26–27,
 28
on Jonathan Fire*Eater's recording
 contracts, 33, 34, 35–36
photo, *xviii*
Walkmen and, 539
Luxx (club), 101, 102
LVLocalMusicScene.com, 364–365
Lyons, Leslie, 159–160, 161

M
MacLean, Juan
 Brooklyn music scene and, 93–94,
 101, 399
 on DFA, 52, 53, 72, 73, 75, 268,
 269, 441
 on LCD Soundsystem, 428, 432
 on "selling out," 502, 503, 504,
 506
Madison Square Garden, 584,
 587–588, 589–591
Madonna, 478–479
Malin, Jesse
 on Gentles's management of
 Adams, Strokes and, 377, 378,
 379
 on New York/Brooklyn music
 scene, 7, 30, 398
 on 9/11 terrorist attacks, 197,
 200–201, 205
 on Strokes' success, 123, 212, 220,
 433
Malkmus, Stephen, 204
Malone, Kyp, 304, 311
 early Brooklyn music scene and,
 98
Manhattan music scene. *see* New York
 City
"Maps" (Yeah Yeah Yeahs), 296–298
Marc, Nick
 on cabaret laws, 374
 on Interpol's early success, 244
 on Misshapes, 474, 475
 on Mooney Suzuki, 39
 on New York music scene, 43, 44,
 45

Marc, Nick *(continued)*
on 9/11 terrorist attacks, 204
Maron, Marc
on music with political message,
465, 468
on New York/Brooklyn music
scene, 7, 29, 459, 460, 461,
462–463
on 9/11 terrorist attacks, 202
Maroon, Paul, 14, 15–16, 17–18, 24,
25, 27
on Jonathan Fire*Eater and
recording contracts, 35
on Walkmen formation, 539, 540
Mars Bar, 18–19, 126, 137
Martin, Jack, 167
Martin, Vince, 401
Martin, Walter
on drug use, 31
Jonathan Fire*Eater's breakup and,
36
Jonathan Fire*Eater's formation
and, 14, 15, 16, 17, 18
Jonathan Fire*Eater's lifestyle and
management, 23, 24, 25, 27, 28
Jonathan Fire*Eater's recording
contracts and, 32, 33, 34, 35
Walkmen and, 539–540, 541, 542
Massive Attack, 48
Master (Yeah Yeah Yeahs), 231
Matador, 19, 240–241, 343, 447,
498, 500, 573–574. *see also*
Interpol
Matthews, Patrick, 333, 347–348, 349,
350, 351
Max Fish (club), 19–21
Maxwell's (club), 40, 225
Mayer, John, 379
MCA, 170
McGee, Alan, 346
McInnes, Gavin, 476
McNicholas, Conor, 3, 189, 190, 192,
346, 353, 356, 366
"Meet Me in the Bathroom" (Strokes),
386–387
Melody Nelson (blog), 340. *see also*
Audrey Neustadter

Mercury Lounge
National at, 313, 484
popularity of, 40, 41, 126
Strokes at, 135, 148, 149–152, 159,
223
Vines at, 333
Yeah Yeah Yeahs at, 168, 180
Merlis, Jim
at Geffen Records, 126
on Gentles's management of
Adams and Strokes, 382
on Interpol, 242, 243
on *NME*, 194
on Strokes' interband dynamics,
515–516
on Strokes, post-9/11 attacks, 209,
211, 212, 214–215
on Strokes, Spektor, Kings of Leon
tour, 420
on Strokes and *$2 Bill* show, 251,
252, 253–254, 256
on Strokes and White Stripes, 333,
334
on Strokes' influence, 144
Strokes in UK, 185, 186
Strokes' lifestyle and, 133–134,
185, 186
on Strokes' music production, 387,
388, 433, 435
Strokes' success and, 148, 152, 153,
163, 191, 219–220, 226
Merrick, Braden, 365
Metallica, 454
MIA, 556, 557
Michael T, 45
Michel, Sia, 214, 217, 340–341, 343
Mighty Robot, 309
Misshapes, 471–479
Moby
on Internet and music industry, 456
on Interpol, 317
LCD Soundsystem and, 289–290
on Misshapes, 472
on New York music scene, 7–8, 29,
30, 49, 50
on 9/11 terrorist attacks, 198, 205,
209

Play, 508–509
 on "selling out," 501–502, 508, 510
 Strokes and, 131, 132, 223, 437
 on TV on the Radio, 303
Modern Age (blog), 335, 340–341
"Modern Age, The" (Strokes), 128,
 129, 130, 159, 169, 363
Mogis, Mike, 466
Mojo (magazine), 291
Moldy Peaches. *see also* Dawson,
 Kimya; Green, Adam
 freak folk and, 142, 143
 management of, 380, 382
 post-9/11, 210, 212
 Rough Trade contract, 191
 Strokes and, 150, 162
 in UK, 193
"Molly's Chambers" (Kings of Leon),
 412
Molotow (club), 347
Montone, Ian, 556, 557
Mooney Suzuki, xvi, 39–40
Moore, Thurston, 468
Moretti, Fabrizio
 Barrymore and, 226–227
 Mooney Suzuki and, 39
 photo, *106*
 Strokes, Spektor, Kings of Leon
 tour, 413, 419
 Strokes and Adams, 379, 381, 382,
 393, 394
 Strokes and White Stripes, 326,
 330
 Strokes' contract with RCA, 173
 Strokes' formation and, 109, 110,
 111–112, 113, 114, 116, 117
 Strokes in UK, 184
 Strokes' lifestyle and, 133
 Strokes' interband dynamics,
 516–517
 Strokes' promotion and, 123
 Strokes' success and, 128, 149, 150,
 162, 220
 $2 Bill show and, 253, 254
"Morning of Our Lives, The"
 (Richman), 210
Mos Def, 333

Moss, Kate, 184, 424
Mosshart, Alison, 5, 191–192, 457,
 491
Mossman, Phil
 on DFA, 59–60, 64, 66, 68–69, 70,
 71, 72
 LCD Soundsystem and, 428, 429,
 430–431, 432, 587, 588
 on Murphy-Goldsworthy fallout,
 439, 440
 on Plant Bar, 89
 on UK bands, 356, 357
Motherfucker (club), 43, 45–46, 472
Mo' Wax, 58, 68
"Mr. Brightside" (Killers), 364
MTV
 political coverage by, 463
 Strokes and, 253
 24 Hours of Love, 380, 381–382
 $2 Bill show, 251, 252, 253–254,
 255, 256
 White Stripes on, 326, 332–333
 Yago and, 213
Mudbone, 299
Murphy, James
 DFA and drug use, 64, 65, 66
 DFA formation and, 51, 52, 53–57,
 58, 59, 61, 63
 DJing by, 102, 399–400, 401
 early career of, xv
 on electroclash, 75, 76, 104, 105
 Goldsworthy and, 67–73, 105, 288,
 429, 430, 431, 432, 439–442,
 567–568, 570, 588
 "Losing My Edge" and, 269,
 285–291, 356, 428, 430 (*see also*
 LCD Soundsystem)
 at Madison Square Garden, 584,
 587–588
 on music production, 268
 on New York/Brooklyn music
 scene, 43, 92, 460, 461, 578,
 582
 Plant Bar sound system and, 88
 Rapture and, 85, 263, 264, 265,
 266–267, 269, 275, 276, 278, 279,
 280, 281, 282, 283, 356, 357

Murphy, James (*continued*)
on "selling out," 507
Six Finger Satellite and, 53, 68, 72, 291, 427
on Strokes, 589, 591
Muse, 216, 343
music industry. *see* recording industry
Muzu, 88
"My Baby Looks Like Santa Claus in Red Drawers" (TV on the Radio), 304
My Chemical Romance, 343

N
Napster, 81, 335–336, 339, 453–457
National, 311–315, 484–485. *see also* Berninger, Matt; Dessner, Aaron; Devendorf, Scott
Neustadter, Audrey, 239–240, 340, 341
"New, The" (Interpol), 157
"New York" (Doves), 3
New York City
Alphabet City neighborhood, 29
appeal of, xiv–xvii
Brooklyn music scene, 93–99, 101–105, 307–308
cabaret laws, 373–376
clubs, 39–42, 43–46 (*see also individual names of clubs*)
DJ culture in Williamsburg (Brooklyn), 397–401
East Village music scene, 129, 308
gentrification of, 262, 459–463
indie music reinvention of music scene, 577–583
9/11 terrorist attacks, 197–207
in 1970s–1990s, 7–11
post-9/11 music scene in, 191–195, 209–212
smoking ban in, 397–398
"New York City Cops" (Strokes), xvii, 201, 326
New York Rocker (magazine), 577
Nicholls, Criag, 346, 347, 348, 349, 351
Nicol, Geordon, 471, 472–474, 475, 476, 477–478, 479

Nirvana
commercial success of, 505, 509
influence of, 47, 79, 111, 112, 185, 505
Merlis and, 152
NME (magazine)
April Long and, 247
early image of, 41–42
on early rap music, 8–9
Imran Ahmed and, 335, 353
Interpol and, 320
Kings of Leon and, 423–424
music blogs and, 336, 341
New York music scene (2001) and, 192, 193, 194
Rapture and, 273
Spooner and, 511
Strokes and, 159–160, 186, 213, 240
Winehouse and, 190
Norris, Erin, 24, 26–27, 29, 30, 32, 34, 36
Northsix (club), 398, 399
"Note to Self: Don't Die" (Adams), 392

O
Oakenfold, Paul, 366
Oberlin College, 138, 139
Oberst, Conor, 137–138, 188–189, 200, 465–470, 506, 560
"Obstacle 2" (Interpol), 260–261
Offer, Nic, 4, 79, 86, 200, 308, 455, 579
OK Calculator (TV on the Radio), 302
Okereke, Kele, 161, 162
Oldham, James, 159
Onorato, Thomas
on De Cadenet's career, 185
on Interpol, 317
on LCD Soundsystem, 286, 587
on Misshapes, 471, 472, 473, 474–475, 476, 478–479
on NYC clubs, 44, 45
at Piano's, 243
on Rapture, 276
on Yeah Yeah Yeahs, 180
"On the Esplanade" (Interpol), 145
Optimo (club), 355, 356

Origin of Symmetry (Muse), 216
Our Love to Admire (Interpol), 500, 571, 573, 575
"Our Time" (Yeah Yeah Yeahs), xvii, 230, 274
Out of the Races and onto the Tracks (Rapture), 267, 277
Owen, Frank, 290
"Oxford Comma" (Vampire Weekend), 544, 554, 555
Ozzi, Dan, 467, 469–470

P

Pandora's Box (club), 26
Paradiso, 450
Parker, Charlie, 374
Patti Smith Group, 129
PCP, 27
Penny, Jenny
 on Darkroom, 320
 on Interpol, 243, 317, 319, 321–322, 448, 450, 451, 495, 572
 Strokes and, 186
Pepper, Tracey, 83, 214, 216, 217, 338, 341–342, 343
Pershing Square (café), xiv–xv
Petraglia, Angelo, 406–407, 410
photographers, at clubs, 477–478
Pianos (club), 373, 460, 461
Pierce, Catherine
 Hammond and, 133, 520, 521–523, 525
 on Strokes and drug addiction, 390, 391, 392
 on Strokes' success, 223–224, 225, 226–227, 377
 on *$2 Bill* show, 255
Pinfield, Matt, 39, 112, 345, 347, 348, 366
Pitchfork (online magazine), 272, 335, 339, 344, 560, 569
Plantain Films, 55
Plantain Records, 53–57, 61, 71
Plant Bar, 87–92, 277, 373, 375–376
Play (Moby), 508–509
Pleasure Unit, 299
Plush (club), 49, 373, 374

Poneman, Jonathan, 266, 267
Pony, 52
"Poor Little Rich Boy" (Spektor), 404
Poptones, 346
Powers, Kid Congo, 175, 176, 178, 179, 180
Prodigy, 49
Product Shop NYC (blog), 339, 341, 344

R

Radio City, 325, 330, 331
Radiohead, 451–452, 556
Rags-A-Gogo (store), 143–144
Ralbovsky, Steve
 Room on Fire (Strokes) and, 433, 435, 436
 on Strokes, Spektor, Kings of Leon tour, 405, 406, 407, 408–409, 411, 413, 419, 420–421
 Strokes' contract with RCA, 169, 171
 on Strokes' formation, 109
 on Strokes' music production, 386–388
 Vampire Weekend and, 527, 554, 555, 556
Ramone, Joey, 459
Random House, 82
Raphael, Gordon
 Is This It (Strokes) and, 173
 as Spektor's producer, 403, 404
 Strokes' music production and, 386, 387, 388
 on Strokes' interband dynamics, 513, 514, 515
 as Strokes' producer, 134, 135
 on *$2 Bill* show, 251
Rapture. *see also* Ahmed, Imran; Jenner, Luke; Roccoforte, Vito
 Brooklyn music scene and, 95, 472
 DFA and, 85–92, 263–269
 "House of Jealous Lovers," 263, 264, 265, 275–284, 290, 356
 in Scotland, 356
"Rat, The" (Walkmen), 540, 541, 542

raves, 48
RCA, 169–174, 408, 410, 411, 435.
 see also Ralbovsky, Steve
Reading Festival, 294
recording industry. *see also individual*
 names of blogs; individual
 names of magazines; individual
 names of record companies
 blogs about, 335–344
 CD sales of 1990s, 77, 81–82, 83
 commercial success and "selling
 out," 501–512
 dot-com bubble and, 81–83, 89,
 94, 96
 early social media and, 473–474,
 477
 Internet music downloads and,
 79–80, 81–83, 435, 436, 437,
 453–457
 money offered by record labels,
 102–104
Recoys, 540
"Rehab" (Winehouse), 190
Retromania (Reynolds), 427
Return to Cookie Mountain (TV on the
 Radio), 454
Reynolds, Simon
 on DFA, 51, 52, 57, 58, 60, 67
 on "House of Jealous Lovers"
 (Rapture), 277
 on Internet and music industry,
 456
 on Jonathan Fire*Eater, 13, 18
 on music with political message,
 465, 468
 on New York/Brooklyn music
 scene, 3, 8, 48, 49, 102, 375,
 483–484
 on Plant Bar, 87
 Retromania, 427
 on Rough Trade, 147
 on Vampire Weekend, 527
Rhodes, Sylvia, 34
Rhymefest, 189
"Rich" (Yeah Yeah Yeahs), 444–445
Richardson, Ron, 337
Richie's Guitar Shop, 130

Richman, Jonathan, 210
Rimkus, Ulli, 21
Rise Above (Dirty Projectors), 553
Robinson, Chris, 59–60
Robinson, Craig, 243
Roccoforte, Vito
 on Brooklyn music scene, 42, 309,
 398, 399
 DFA and Rapture, 263–264, 265,
 267
 "House of Jealous Lovers"
 (Rapture) and, 280–281, 282
 on 9/11 terrorist attacks, 201–202,
 203, 204, 205
 Rapture formation and, 86, 87
 on record company contracts, 103
 on Strokes, 213, 214
 on UK bands, 356
Rockit Scientist, 328
Rock n Roll (Adams), 389
Rolling Stone (magazine)
 Fischerspooner and, 103
 Light at, 9
 Lit party by, 330
 Strokes and, 214–217, 425, 436
 TV on the Radio and, 579
 Vampire Weekend and, 561
 Vines and, 350–351
 Yeah Yeah Yeahs and, 233, 296
Romano, Matt
 Hammond and, 522
 on Kings of Leon, 413, 424
 on 9/11 terrorist attacks, 195, 201
 on Strokes' formation, 110, 111,
 114
 with Strokes in UK, 184
 on Strokes' interband dynamics,
 521, 522, 523, 524–525
 on Strokes' success, 221
Romano, Tricia
 DFA and Fischerspooner, 77, 79
 on LCD Soundsystem, 290
 on Misshapes, 471, 472, 473, 476,
 479
 on New York/Brooklyn music
 scene, 102, 374, 375, 399
 on record company contracts, 103

Ronson, Mark
 on Internet and music industry,
 454–455
 on LCD Soundsystem, 587
 on Libertines, 188
 on Misshapes, 472
 New York/Brooklyn music scene
 and, 9, 192, 377
 on Rapture, 276
 on Strokes, 173, 221–222,
 436–437
 on UK bands, 358
 on White Stripes, 330, 332
 Winehouse and, 189–190
Room on Fire (Strokes), 342, 385, 387,
 403, 405, 433–437, 514, 515
Rose, Axl, 323, 476
Rosser, Hamish, 348
Rossomando, Anthony
 on Darkroom, 320, 321
 on Interpol, 319–320, 322
 on Jonathan Fire*Eater, 13
 on Mooney Suzuki, 39
 Moss and, 424
 on New York/Brooklyn music
 scene, 10–11, 193
 on Strokes, 151
Roth, Jason, 289
Rough Trade Records
 image of, 147, 148
 Libertines and, 187
 Moldy Peaches and, 191–192
 Strokes and, 135, 136, 153, 159,
 160, 161, 169, 187
 Vampire Weekend and, 553
Royal Trux, 329
Ruttner, Karen, 239, 240, 323, 572,
 590
Rvner, Jack, 219–220
RZA, 205, 483

S
Saddle Creek, 466
Safer, Mattie, 90, 280
Saturday Night Live, 219–220, 446, 560
Scaggs, Austin, 93, 129, 215, 330, 331,
 378, 425, 519

Schiltz, Steve, 10, 11, 193–194, 251,
 347, 348
Schreiber, Ryan, 339, 344, 454
September 11, 2001 (9/11) terrorist
 attacks
 effects of, on New York, 209–212,
 443, 462–463
 events of, 195, 197–207
7B, 222, 326
"Seven Nation Army" (White Stripes),
 332
17 Nautical Miles (club), 309
Sheffield, Rob
 on DFA, 263, 265
 on electroclash, 104–105
 on Interpol, 317–318
 on Killers, 367
 on LCD Soundsystem, 289, 290,
 291
 on Misshapes, 478
 on music blogs, 340, 341, 342,
 343
 on New York/Brooklyn music
 scene, 8, 43, 44, 45, 46, 101,
 102, 194, 398, 399, 401, 463,
 547, 548
 on 9/11 terrorist attacks, 204
 on Oberst, 466
 on Portland, 142
 on Rapture, 265, 275, 276, 281
 on Strokes, 150, 151, 209,
 210–211, 215, 216
 Todd P and, 309
 on UK bands, 353–354, 359
 on *Vice*, 96
 on Vines, 350–351
 on White Stripes, 327, 328,
 329–330
 on Yeah Yeah Yeahs, 167, 233, 248,
 274
Shins, 508, 557
Shit Robot, 269
Shout! (club), 41, 43
Show Your Bones (Yeah Yeah Yeahs),
 488, 490
Sidewalk Cafe, 140, 141, 144, 145
Sire, 32

Sitek, Dave
 on New York/Brooklyn music
 scene, 3, 10, 94, 98, 484, 580, 583
 on 9/11 terrorist attacks, 199, 205
 on Todd P's shows, 310
 TV on the Radio and, 299, 300,
 301–302, 303, 304, 305, 315,
 547
 on Walkmen, 539
 Yeah Yeah Yeahs and, 165–166,
 230, 237–238, 245, 248–249,
 274, 489, 563–564, 565–566
Six Finger Satellite, 52–53, 68, 72,
 268, 291, 427
Slipper Room (club), 216, 374
"Slow Hands" (Interpol), 449
Smashing Pumpkins, 30
Smith, Elliott, 20, 53, 156
Smith, Patti, 129
Smith, Robert, 448
So Boring [Ever] Since [She] Stopped
 Drinking (blog), 336–337, 340
Social Network, The (film), 82
"Someday" (Strokes), 189
Sonic Youth, 504–505, 506
Sound Factory, 332
Sound of Silver (LCD Soundsystem),
 587–588
South by Southwest, 237, 245,
 265–266
Soviet Kitsch (Spektor), 403–404
Spa (club), 43, 231
Spears, Britney, 283, 284
Speed King, 52
Spektor, Regina, 145, 146, 202, 403,
 404, 405, 419–425
Spencer, Jon, 68, 69, 235, 236, 295
Spin (magazine)
 Greenwald at, 240
 Interpol and, 314
 Killers and, 367
 in late 1990s, 47, 49
 LCD Soundsystem and, 289
 Lewitinn at, 338–339, 343
 Spin.com, 83, 337
 Strokes and, 124, 214–217, 517
 TV on the Radio and, 484

Vampire Weekend and, 536, 559
Vines and, 348–349
Yeah Yeah Yeahs and, 232
Spiral (club), 118, 135
Spitz, Marc
 on Adams, 378, 380, 389–390,
 392, 393
 on De Cadenet, 185
 on Fischerspooner, 105
 on Hives, 271, 346, 349–350
 on Internet and music industry, 81,
 83
 on Interpol, 241
 on Jonathan Fire*Eater, 19–20, 21,
 32
 on Killers, 361
 on LCD Soundsystem, 289
 on music journalism and blogs,
 337, 341, 343
 on New York/Brooklyn music
 scene, 8, 30, 43, 44, 49, 50
 on Oberst, 465–466
 on *Room on Fire* (Strokes),
 434–435
 on "selling out," 507, 508–509, 511
 on Strokes' music production,
 385–386
 on Strokes' interband dynamics,
 513, 515, 516, 517, 518
 on Strokes' success, 133, 151, 214,
 215, 216–217, 219, 220–221, 222
 on Vines, 347, 348–349, 351
 on White Stripes, 327, 328, 331
 on Yeah Yeah Yeahs, 137, 166,
 232, 293
Spooner, Casey
 DFA and, 75–80
 Fischerspooner's success and, 102,
 103, 104, 105
 on image and popular culture, 511
 on New York music scene, 459
Springsteen, Bruce, 469
Starbucks (Astor Place, New York
 City), 78
Stay Gold, 489
Stefani, Gwen, 491
Stein, Seymour, 32, 34, 271, 365

Stereogum (blog), 336, 339, 340–341
Stevenson, Rob, 343, 365
Stinger (club), 304
Stolen Transmission, 343–344
Stooges, 13, 42, 437, 507
"Stop Breaking Down" (White
 Stripes), 327
Strokes. *see also* Casablancas, Julian;
 Fraiture, Nikolai; Gentles,
 Ryan; Hammond, Albert,
 Jr.; *Is This It* (Strokes);
 Moretti, Fabrizio; Valensi, Nick
 Adams and, 377–384
 addiction problems of, 220–221,
 255–256, 389–395, 516, 518,
 521–525
 Angles, 522
 blogs about, 335, 336, 341, 342,
 344
 First Impressions of Earth, 515, 516,
 521, 522
 first show of, 45
 formation of, 109–118
 Halloween show at Hammerstein,
 209–212
 Heineken commercial, 383
 Hives and, 347
 image of, 128–131, 239, 246
 influence of, xvi, 345, 527–532,
 533–534, 589–591
 interband dynamics, 513–525
 Killers and, 361, 363, 365
 Kings of Leon and, 405–413
 lifestyle of, 131–135
 Lyons's photo of, 106, 159–160
 at Madison Square Garden,
 589–591
 management of, 126–128, 377–384,
 519–520 (*see also* Gentles, Ryan)
 marriages of band members,
 254–255
 Moldy Peaches and, 144
 music production for, 385–388,
 515 (*see also* Holmes, David;
 Raphael, Gordon)
 Plant Bar and, 91
 promotion by, 123–126, 152

RCA and, 169–174
Room on Fire, 342, 385, 387, 403,
 405, 433–437, 514, 515
Rough Trade Records and, 135,
 136, 153, 159, 160, 161, 169, 187
Saturday Night Live, 219–220
Spektor and, 403–404, 405
as *Spin* Band of the Year, 217
success of, 104, 135–136, 147–153,
 162–163, 191–195, 209–211,
 213–217, 219–227, 325–334,
 509–510
$2 Bill show, 251–257
in UK, 160–163, 169, 183–190,
 353–359
Yeah Yeah Yeahs and, 220, 565
Strummer, Joe, 254
Sub Pop, 42, 86, 263, 266, 276
Superstar, Har Mar
 on Hives, 345
 on Internet and music industry,
 457
 on Interpol, 244, 496
 on Killers, 362, 364, 367, 368
 on Kings of Leon, 424
 on Moldy Peaches, 144
 on New York/Brooklyn music
 scene, 547
 on Oberst, 467
 on "selling out," 506, 507, 508
 on Strokes, 251, 252, 253, 254,
 255, 256, 385
 on White Stripes, 175, 177, 327,
 330, 333
 on Yeah Yeah Yeahs, 443, 444–445,
 446, 493
Sutherland, Steve, 160
Swanson, Carl
 on Fischerspooner, 75
 on Jonathan Fire*Eater, 32, 33,
 34, 35
 on New York/Brooklyn music
 scene, 3, 4, 102, 461
 on 9/11 terrorist attacks, 203, 207
 on New York gentrification, 461
 on "selling out," 502, 504, 506,
 507

Swanson, Carl (*continued*)
 on Strokes, 129, 435
Sway (club), 41, 43

T

Tarquin Studios, 259–260
Taylor, Chris, 296, 307, 310, 313–315,
 399–400, 553, 589
Tee, Larry, 75, 76–77, 101, 102, 103
"Teenage Dirtbag" (Wheatus), 10
Television, 129, 172
This Is Happening (LCD Soundsystem),
 291
"This Is It" (Adams), 392
Tiswas (club), 43, 44, 45, 125, 204
TMF Studios, 403, 404
Todd P
 Dirty Projectors and, 551
 on electroclash, 75, 76
 on New York/Brooklyn music
 scene, 89, 93, 397–398, 400, 484,
 485
 shows by, 86, 274, 309–310
Tommy's Tavern, 400
"Tomorrow Never Knows," 66
Tomson, Chris
 on National, 311
 on New York music scene, 3
 on "selling out," 512
 Vampire Weekend's formation and,
 528, 529, 530, 531–532, 534,
 535, 536
 on Vampire Weekend's image and
 success, 543, 544–545, 560–561
 Vampire Weekend's recording
 contract and, 553–554, 555
Touch and Go, 272
Trachtenbroit, Steven
 on Kings of Leon, 423
 on Spektor, 420
 on Strokes, 124, 211, 212,
 222–223, 424, 517
 on White Stripes, 331–332
Tramps (club), 14, 40, 115–116, 364
"Trani" (Kings of Leon), 410
Transformers (film), 509–510
Trash (London), 186

Travis, Geoff, 159, 382. *see also* Rough
 Trade Records
 Libertines and, 188
 Moldy Peaches and, 191, 192
 Rough Trade Records and Strokes,
 135, 136, 153, 159, 160, 161, 169,
 187
 Rough Trade Records management
 by, 147, 148
 on Strokes' influence, 190
 Vampire Weekend and, 553, 554,
 556
Tremble Under Boom Lights (Jonathan
 Fire*Eater), 33–34
Triple Five Soul, 96, 98
Troubadour (club), 251–257
"Trying Your Luck" (Strokes), 128
Tu Casa Studios, 168
Tucker, Maureen, 30
Turn on the Bright Lights (Interpol),
 244, 259–260, 261, 317, 358, 447,
 452
TV on the Radio. *see also* Bunton,
 Jaleel; Sitek, Dave
 Ahmed and, 278
 Brooklyn music scene and, 98
 Cookie on the Mountain, 454
 formation of, 299–305, 311
 image of, 547–548
 9/11 terrorist attacks and, 205
 Rolling Stone on, 579
 success of, 484
24 Hours of Love (MTV), 380, 381–382
Twisted Ones, 309
2A (club), 239, 408–409
$2 Bill show (MTV), 251–257

U

U2, 47, 216, 217
Ultragrrrl (blog), 337, 341
Under Acme (club), 49
Unitard, 140, 165
United Kingdom
 Britpop collapse, 340
 dance music of late 1980s in, 47–48
 raves in Belfast, 59–60
 rock music influence of, 276–277

UK bands inspired by Strokes and Stripes, 353–359
Unkle, 48, 68
"Untitled" (Interpol), 318

V

V (magazine), 125
Valensi, Nick
 early jobs of, xv
 on Jonathan Fire*Eater, 37
 on Killers, 363
 on Kings of Leon, 405, 423, 425
 on Mooney Suzuki, 39, 40
 on 9/11 terrorist attacks, 201
 photo, *106*
 Spektor and Strokes, 421, 422
 on Strokes and drug use, 394
 Strokes' formation and, 109, 110,
 111, 112–114, 117, 118
 Strokes' lifestyle and, 131, 133, 134
 on Strokes' music, 129, 130, 385
 on Strokes' interband dynamics,
 513–514, 520
 Strokes' promotion and, 123, 124,
 125, 126
 Strokes' recording contracts and
 management, 128, 171, 172–173,
 382
 Strokes' success and, 148, 149, 186,
 187, 189, 192, 220, 222
 at *$2 Bill* show, 255–257
 White Stripes and, 326
Vampire Weekend. *see also* Baio, Chris;
 Batmanglij, Rostam; Koenig,
 Ezra; Tomson, Chris
 Blue CD-R, 554, 559
 Brooklyn music scene and, 579
 formation of, 527–532, 533–537
 image of, 543–546, 548
 management of, 551–557
 photo, *480*
 success of, 559–561
Vanity (club), 63, 64
Vannucci, Ronnie, 362–363, 364, 365,
 366, 368–369, 519
VanWyngarden, Andrew, 18, 203, 205,
 310

Velvet Underground, 128, 129
Veni Vidi Vicious (Hives), 346
Verlaine, Tom, 172
Vice (magazine), 95, 96, 98–99, 231,
 232, 397, 400
Video Music Awards (MTV), 332–
 333, 350
Vines, 332, 333, 347–351, 354
Voice (New York City), 290
Vote for Change tour, 469

W

Wagner, Alex
 on New York/Brooklyn music
 scene, 311, 333, 397, 399, 400,
 462, 578
 on 9/11 terrorist attacks, 199, 202,
 203
 on Oberst, 468
 on Strokes' early success, 191
 on Vampire Weekend, 533–534
Wainwright, Rufus, 34–35
Walkmen, 13, 539–542
Walsh, Chloe, 176, 327, 328, 469
Warby, Russell, 162–163, 184, 325,
 326
Wareham, Dean
 on clubs, 42
 on New York/Brooklyn music
 scene, 7, 8, 9, 29, 193, 325
 on 9/11 terrorist attacks, 203
 on Strokes, 213, 437
Warner Bros., 271, 343, 365, 541
Weatherall, Andy, 277
WestBeth (theater), 33
Whalley, Tom, 365
Wheatus, 10
"When the President Talks to God"
 (Oberst), 465–470
White, Jack. *see also* White Stripes
 in Go, 42
 on Hives, 345–346
 on New York music scene, 5
 Strokes and White Stripes, 91,
 325, 326, 327, 331–332, 334
 on Strokes' interband dynamics,
 518

White, Jack *(continued)*
White Stripes' success and, 175,
176, 178–179, 180–181
on Yeah Yeah Yeahs, 180
White, Meg
Strokes and White Stripes, 325,
326, 327, 329
White Stripes' success and, 175,
176, 181, 518
White Blood Cells (White Stripes), 326,
327
White Stripes
blogs about, 335, 336
De Stijl, 177, 327
Killers and, 365
management of, 557
success of, 42, 325–334, 345
U.K. bands inspired by, 353–359
White Blood Cells, 326, 327
Yeah Yeah Yeahs and, 168,
175–181, 565
Wichita, 272, 273
"Wicker Chair" (Kings of Leon), 410
Williams, Pharrell, 286
Winehouse, Amy, 189–190

X
XL, 554–555, 556, 557

Y
Yago, Gideon, 132
on clubs, 40–41, 42
on Gentles's management of
Adams and Strokes, 379,
383–384
on Internet and music industry, 82
on Jonathan Fire*Eater, 13, 35
on New York/Brooklyn music
scene, 10, 29, 30, 47, 94, 95, 96,
98, 460, 461, 463
on Plant Bar, 87, 88–89
on "selling out," 509
on Strokes, 150, 151, 209, 210,
211, 212, 213, 221, 224, 225,
239
on Yeah Yeah Yeahs, 140
"Yeah" (LCD Soundsystem), 432

Yeah Yeah Yeahs. *see also* Ahmed, Asif;
Burton, Dave; Chase, Brian;
Karen O; Zinner, Nick
Cadillac commercial, 509
Face profile, 341
Fever to Tell, 293, 303, 443, 444,
491, 564
formation of, 137–140, 165–168
image of, xvi, 245–249, 272–274,
307, 311, 548
It's Blitz!, 563
Jonathan Fire*Eater's influence on,
27
Karen O's fall from stage, 443–446
Karen O's move to L.A., 487–493
"Maps," 296–298
Master, 231
New York/Brooklyn music scene
and, 41, 90, 95, 102, 461
photo, *370*
recording contracts and
management of, 104, 271–274,
278, 487, 491–492
Show Your Bones, 488, 490
Strokes and, 220, 565
success of, 104, 212, 229–238,
293–296, 563–566
White Stripes and, 168, 175–181,
565
Yellow House (Grizzly Bear), 484
Young, Laura
on Internet and music industry, 81
on Interpol's early success, 239
on Killers, 361, 368
on music blogs and blogging,
335–336, 342, 343, 344
on Strokes, 183, 210, 589–590
on Vampire Weekend, 544
Young Liars (Liars), 303, 304
"You're Pretty Good Looking (For a
Girl)" (White Stripes), 328

Z
Zinner, Nick
DJing by, 399
Face profile, 341
image of, 311

on Karen O's role in Yeah Yeah
Yeahs, 179, 487–488, 489, 490
on "Maps" (Yeah Yeah Yeahs),
297
New York/Brooklyn music scene
and, 90, 95, 98, 211
Oberst and, 466
photo, *370*
White Stripes and, 177, 178, 180,
181

Yeah Yeah Yeahs' formation and,
137, 138, 139, 140, 165, 166, 167,
168
on Yeah Yeah Yeahs' image, 245,
249, 311
on Yeah Yeah Yeahs' management,
272, 273, 274
Yeah Yeah Yeahs' success and, 229,
230, 231, 235, 237, 294–295,
564–565

ABOUT THE AUTHOR

Lizzy Goodman is a journalist whose writing on rock and roll, fashion, and popular culture has appeared in the *New York Times*, *Rolling Stone*, and *NME*. She is a contributing editor at ELLE and a regular contributor to New York magazine. She lives in upstate New York with her two basset hounds, Joni Mitchell and Jerry Orbach.